Art in Latin America

Art in Latin America

The Modern Era, 1820-1980

Dawn Ades

with contributions by Guy Brett, Stanton Loomis Catlin and Rosemary O'Neill

The Hayward Gallery, London 18 May to 6 August 1989

The South Bank Centre

The exhibition has been organized by the South Bank Centre in collaboration with the National Swedish Art Museums and the Spanish Ministry of Culture. It will be shown at

The Hayward Gallery, London, 18 May-6 August 1989 The Nationalmuseum and Moderna Museet, Stockholm, 16 September-19 November 1989 Palacio de Velázquez, Madrid, 19 December 1989-31 March 1990

Exhibition organized by Susan Ferleger Brades Assisted by Fiona Platts and, from February 1989, by Greg Hilty

Translations of manifestos from Spanish and Portuguese by Polyglossia except 'White Manifesto' from: *Devenir de Fontana*, Turin, Edicione d'Arte Fratelli Pozzo, n.d.

Designed, produced and distributed by Yale University Press on behalf of the South Bank Centre.

Typeset in Linotron Bembo by SX Composing, Rayleigh, Essex.

Printed in Italy by Amilcare Pizzi SpA, Milan.

Text © 1989 the South Bank Centre and the authors.

Softback ISBN 185332 042 0

All rights reserved. No part of this publication may be reproduced, stored in a retrieval system or transmitted in any form or by any means without the prior permission in writing of the publisher.

Cover illustration: José Gil de Castro, The Martyr Olaya (Pl. 1.20).

A list of all South Bank Centre and Arts Council exhibition publications may be obtained from the Publications Office, South Bank Centre, Royal Festival Hall, London SE1 8XX.

Contents

Sponsors of the Exhibition	vi
Advisory Panel	vii
Exhibition Committee	viii
Foreword	ix
Acknowledgements	xiv
Lenders to the Exhibition	xix
Introduction	1
1. Independence and its Heroes	7
2. Academies and History Painting	27
3.i Traveller-Reporter Artists and the Empirical	
Tradition in Post-Independence Latin America	
by Stanton Loomis Catlin	41
3.ii Nature, Science and the Picturesque	63
4. José María Velasco	101
5. Posada and the Popular Graphic Tradition	111
6. Modernism and the Search for Roots	125
7. The Mexican Mural Movement	151
8. The Taller de Gráfica Popular	181
9. Indigenism and Social Realism	195
10. Private Worlds and Public Myths	215
11. Arte Madí/Arte Concreto-Invención	241
12. A Radical Leap by Guy Brett	253
13. History and Identity	285
Notes	301
Manifestos	306
Biographies by Rosemary O'Neill	338
Select Bibliography	360
Photographic Credits	361

Sponsors of the Exhibition

The exhibition in London has been generously supported by

Christie's Fine Art Auctioneers
Dos Equis Mexican Beer/Maison Caurette
Banco Consolidado, Venezuela
Mr and Mrs Gustavo Cisneros, Venezuela

In Stockholm the exhibition is presented with the support of SIDA (Swedish International Development Authority).

Advisory Panel

Sir William Harding KCMG, CVO, Chairman Mrs Patricia Phelps de Cisneros Sir Kenneth James KCMG Mr Leopold de Rothschild CBE Mr David Thomas CMG

Exhibition Committee

Dawn Ades Guy Brett Stanton Loomis Catlin Helen Escobedo Carmen Giménez Olle Granath Angel Kalenberg Waldo Rasmussen

Joanna Drew Andrew Dempsey Susan Ferleger Brades

Foreword

1992 is not only the year when the European single market comes into being but marks the 500th anniversary of an earlier phase of European expansion: Columbus' landing in America. We embarked on our journey of discovery of Latin American art some years ago and bring back to show in Europe the artistic treasure of the cultures that succeeded those the Europeans found. Our exhibition explores the period after the countries of Latin America won their independence from Spain and Portugal around the 1820s.

To seek to present a view of 160 years of the art of Latin America within one exhibition is hardly a modest aim. It has not been attempted before in Europe and as works of the period are almost wholly absent from public collections in Britain a small number of exhibitions have provided the only opportunities to acquaint ourselves with the art of the continent. The Mexican muralist Siqueiros, for example, has not been seen here since the great Mexican exhibition at the Tate Gallery in 1953 although retrospectives of Orozco and Rivera, Torres-García, Frida Kahlo and Manuel Alvarez Bravo have been held here in the 1980s.

The exhibition explores thematically and historically the emergence of what may be called a Latin America aesthetic and the questions of national and cultural identity associated with it. We are proud to be able to show some part of this distinctive, diverse and vibrant art to the public here and delighted that it will then be seen by a wider European public in Stockholm and Madrid, thanks to the collaboration of the National Swedish Art Museums and the Spanish Ministry of Culture. We are especially grateful to our colleagues in Sweden, Olle Granath, Director of the Moderna Museet and Görel Cavalli-Björkman, Head of the Department of Paintings and Sculpture in the Nationalmuseum, and in Spain to Carmen Giménez, Directora del Centro Nacional de Exposiciones and Rosa García Brage, Coordinadora General de la Exposición en Madrid, for their interest, support and willingness to entrust to London in large measure the selection and administrative arrangements for the exhibition.

We have benefited greatly from the advice of the distinguished members of the Advisory Panel: Sir William Harding KCMG, CVO, Mrs Patricia Phelps de Cisneros, Sir Kenneth James KCMG, Mr Leopold de Rothschild CBE and Mr David Thomas CMG and of Viscount Montgomery of Alamein, CBE, invited by Mr Ronald Grierson, Executive Chairman of the South Bank Board, to give guidance on the project. Their interest has been a particular source of encouragement.

An exhibition of this scale and magnitude could not be presented without substantial financial support. The South Bank Centre would therefore especially like to acknowledge Christie's Fine Art Auctioneers, Dos Equis Mexican Beer/Maison Caurette, Banco Consolidado and Mr and Mrs Gustavo Cisneros for their generous

sponsorship. At Christie's, particular thanks go to Lord Carrington, Mr Charles Allsopp and Mrs Robin Hambro and, at Dos Equis Mexican Beer, to Mr Ernest Corrett, Managing Director, and to Mr John Humphries.

The exhibition has been devised and selected by Dawn Ades, Senior Lecturer at the University of Essex. It has been a joy to work with her. We are indebted to her for her novel approach, her commitment to the project in all its aspects and her enthusiasm and energy throughout the years of its preparation. We are also indebted to Guy Brett, who in the 1960s promoted in this country the work of Lygia Clark and Hélio Oiticica, among others, for his selection of the section of the exhibition (Chapter 12 in this catalogue) devoted to the development of constructivism and optical and kinetic art. He has done so with characteristic sensitivity and care.

We would like to extend our warmest thanks to the members of the Exhibition Committee who advised and guided us throughout, particularly Stanton Loomis Catlin, Professor Emeritus, Museum Studies and Art History, Syracuse University, who co-organized the exhibition, 'Art of Latin America Since Independence', at Yale University Art Gallery in 1966; Helen Escobedo in Mexico; Angel Kalenberg, Director, Museo Nacional de Artes Plásticas, Montevideo; Waldo Rasmussen, Director, International Program, The Museum of Modern Art, New York; and to our partners Carmen Giménez and Olle Granath. Our initial thoughts about the exhibition were much stimulated by John Golding and the late Edward Wright. We are grateful as well to Anthony Shelton of the Museum of Mankind, London for his advice in the area of popular art.

The exhibition could not of course have been achieved without the co-operation of the Latin American countries involved and, in particular, the loan of specific works, some of which form part of national patrimonies and many of which have never before left their country of origin. We are therefore especially grateful to our lenders. Many kindly shared with us as well their knowledge and their hospitality. Their willingness to entrust their works to us for a long exhibition tour is deeply appreciated.

Support of the exhibition and assistance in the complicated negotiations of loans for it was unstintingly given by Their Excellencies the Brazilian Ambassador Senhor Celso de Souza e Silva; the Uruguayan Ambassador Dr Luis Alberto Solé-Romeo; the Venezuelan Ambassador Dr Francisco Kerdel-Vegas CBE; the Colombian Ambassador Dr Fernando Cepeda; the Ecuadorian Ambassador Señor José Correa; the Mexican Ambassador Señor Bernardo Sepúlveda GCMG; the Cuban Chargé d'Affaires Lic. Maria Luisa Fernández and the Peruvian Chargé d'Affaires Señor Gilbert Chauny, as well as the former Ecuadorian Ambassador Señor Rafael Pérez y Reyna; the former Mexican Ambassador Señor Jorge Eduardo Navarrete and the former Peruvian Ambassador Señor Carlos Raffo. The exhibition could not have been realized without them.

We are also grateful to the ambassadors and their staff in the British Embassies in Latin America; in Mexico, the Ambassador Mr John Morgan CMG; in Venezuela, the Ambassador Mr Giles FitzHerbert CMG; and in Cuba, the Ambassador Mr David Brighty CMG CVO, as well as the former Ambassador Mr Andrew Palmer CMG CVO and Mr Andrew Jackson, Vice Consul. We would like to thank as well Mr Richard Cowley, the Honorary British Cultural Attaché in Uruguay for his assistance. In addition, the support of the Foreign and Commonwealth Office, particularly that of Mr Nick Elam, Head of the Cultural Relations Department, and Mr Charles de Chassiron, Head of the South American Department, has been most welcome.

Within the Latin American embassies in this country, we are also grateful to Senhor Marcos Camacho de Vincenzi, Counsellor (Cultural and Press Affairs), Brazil; Dr Ricardo Samper, Minister-Counsellor and Mrs Marcella Montes, Colombia; Señor Lic Jorge Valdés Martinez, First Secretary (Cultural Affairs), Cuba; Señora Ximena Martínez de Pérez, Minister and Señor Juan Larrea, First Secretary (Consular Affairs), Ecuador; Dra Margo Glantz, former Minister (Cultural Affairs) and Dra Elena Uribe de Wood, Press Officer, Mexico; Dr Carlos Zavaleta, Minister for Cultural Affairs, Peru; and to Dra Miriam Blanco-Fombona de Hood, Counsellor (Cultural Affairs) and Señor Carlos Diaz-Sosa, Attaché (Press and Cultural Affairs), Venezuela for their interest, advice and practical assistance.

Because the exchange of works of art between Latin America and this country has been infrequent, the practical and administrative arrangements for the exhibition have been exceptionally complex. In addition to the generous support we have received from government departments and ministries, we have relied heavily on our colleagues at the British Council for help on the spot. We are most grateful to Claus Henning, Director, Visiting Arts and to Henry Meyric Hughes, Director, and Muriel Wilson, Deputy Director, Visual Arts Department, British Council, London for their initial offer of assistance and their continuing interest in the project. We would also like most warmly to thank Michael Potter, Regional Director, Rio de Janeiro; John Coope, Representative, Colombia; J. T. Wright, Representative, Ecuador; Richard Watkins, Representative, Mexico; Andrew Moore, Representative, Peru; V. A. Atkinson, Representative, Venezuela; John England, former Representative, Peru; and Patrick Jackson, former Regional Director, São Paulo for their willingness to give so much of their time, and that of their staff, to a project which in some ways falls outside their remit.

Very special thanks must be expressed to particular members of staff in the British Council offices, notably to Marcela Ramírez, Cultural Officer, Mexico; Justin Gilbert, Assistant Representative, Peru; Martin Fryer, Assistant Regional Director and Rozanne M. C. de Leite, Arts and Educational Assistant, São Paulo; Diana Pinto, Cultural and Educational Co-ordinator, Rio de Janeiro; and

FOREWORD

Martha Malo, Librarian, Ecuador for their virtual organization of the exhibition in these countries; it could not have been achieved without their commitment and tireless work.

We are similarly indebted to Rosa Amelia Sosa in Venezuela and to Luciano Figueiredo of the Projeto Hélio Oiticica in Rio de Janeiro.

The catalogue of this exhibition is the most substantial and comprehensive publication on the art of Latin America during the past 160 years to be produced in English. We are especially grateful to Dawn Ades, its primary author, for her essays and attention to all aspects of the publication, and to Guy Brett and Stanton Loomis Catlin for their contributions. Angel Kalenberg suggested and helped to shape the artists' manifestos which form the Appendix – most of which appear here in English for the first time – and we are grateful to him for the knowledge and skill he brought to this. We would also like to thank Rosemary O'Neill who valiantly researched and wrote the biographies. Polyglossia translated the manifestos, and we would like to acknowledge Anne Wright and Amanda Hopkinson for their work on those from Spanish and Chris Whitehouse for those from Portuguese.

The catalogue has been co-published with Yale University Press. We are immensely grateful to John Nicoll, Gillian Malpass, Catharine Carver and Juliet Thorp for their collaboration, attention to detail and good humour, all the more so given the pressure of time under which the catalogue was produced.

We would also like to thank Liliana Dominguez, Matthew Gale and Keith Robinson for the research they undertook on our behalf both in terms of the selection of works for the exhibition and material for its catalogue.

We had originally hoped to commission the great Brazilian land-scape architect, Roberto Burle Marx, to create a garden on one of the outdoor terraces of the Hayward Gallery. In the event this has not been possible but we would like to express our warm thanks to Roberto Burle Marx for his enthusiastic response to our initial approach, to John Miller and Su Rogers, Tim Rees and Georgie Wolton for their assistance during and following Roberto Burle Marx's visit to London and to the Brazilian Embassy for generously providing the airfare for this visit.

Art in Latin America will be the centrepiece of a Latin American season of classical and popular music, literature programmes and craft exhibitions planned by the South Bank Centre for its concert halls and Jubilee Gardens in July. In addition, there will be a season of films by Latin American women film-makers at the National Film Theatre, and a series of public lectures on the history of Latin American art is planned in co-operation with the Institute of Latin American Studies of the University of London. The South Bank Centre will also tour the exhibition, Posada: Messenger of Mortality in Britain, starting at the Museum of Modern Art, Oxford in May. It is hoped that these events will further stimulate the growing interest here in the richness and vitality of Latin American culture.

FOREWORD

An undertaking of this magnitude involves an immense number of people and we would like to extend our warmest thanks to all those with whom we have had dealings in Latin America and whose enthusiastic response has been one of the most rewarding aspects of the venture. The South Bank Centre and the selectors of the exhibition would like particularly to thank for advice, support and hospitality those mentioned below. We would also like to record our appreciation of the hard work of our own colleagues in the Exhibitions Department and in other departments of the South Bank Centre.

Joanna Drew Director, Hayward Gallery South Bank Centre

Susan Ferleger Brades Senior Exhibition Organizer South Bank Centre

Acknowledgements

ARGENTINA

Laura Buccellatto; Jorge Glusberg, Director, Centro de Arte y Comunicación; Daniel Martínez, Director, Museo Nacional de Bellas Artes; Ing. and Mrs Meyer Ochs; Nelly Perazzo.

Australia

Leon Paroissien; John Stringer.

BOLIVIA

Teresa Gisbert.

Brazil

Marilena S O Almeida, Vice Presidente, Sociedade de Amigos dos Museus SAM Nacional; Aracy Amaral; Irma Arestizábal, Curator of Collections, Museu de Arte Moderna do Rio de Janeiro; Raquel Arnaud, Gabinete de Arte; Riveke P Aronis, Assessor Cultural, Acervo Artístico-Cultural dos Palácios do Governo do Estado de São Paulo; Ana Mae Barbosa, Diretora, Museu de Arte Contemporânea da Universidade de São Paulo; P M Bardi, Director, Museu de Arte de São Paulo; Helena Bianchini, Museu Histórico Nacional; Jacques Bisilliat; Ruben Britman, Coleçeão Sattamini, Rio de Janeiro; M F do Nascimento Brito KBE; Ester Emilio Carlos; Gilberto Chateaubriand; Aida Cristina Cordeiro, Museu de Arte Contemporânea da Universidade de São Paulo; Luiz Diederichsen Villares; Helena Dodd Ferrez, Coordenadora, Museu Histórico Nacional; Gilberto Ferrez; Dan Fialdini, Assistant, Museu de Arte de São Paulo; Amália Lucy Geisel, Diretora, Instituto Nacional do Folclore; Ricardo Gomes Lima, Vice Director, Instituto Nacional do Folclore: Lucia Gouvêa Vieira. Assessora. Museu Histórico Nacional; Paulo Herkenoff, Chief Curator, Museu de Arte Moderna do Rio de Janeiro; Alcidio Mafra de Souza. Diretor, Museu Nacional de Belas Artes; Carlos Martins; Pedro Martins Caldas Xexéo, Museu Nacional de Belas Artes; Greville Mee and the late Margaret Mee; Ivo Mesquita; Mr and Mrs José Mindlin; Lucia Olinto de Carvalho, Superintendente, Museu Chácara do Céu, Museus Raymundo Ottoni de Castro Maya; Max Perlingeiro, Acervo Galería de Arte; Lawrence Pih; Roberto Pontual; José Resende; Nickolau Sevcenko; Judy Valentin, Assistant Coordinator, Projeto Hélio Oiticica; Maria Laura Viveiros de Castro, Instituto Nacional do Folclore; Vera Waller de Oliveira, Superintendente, Fundação Maria Luisa e Oscar Americano.

COLOMBIA

Edgar Negret; Luis Perez; Olga Pizano, Directora, Museo Nacional de Colombia; María Victoria de Robayo, Ministerio de Educación Nacional, Instituto Colombiano de Cultura, Sección de Artes Plásticas; Carlos Rojas; Eduardo Serrano, Curator, Museo de

Arte Moderno de Bogotá; Gloria Zea de Uribe, Directora, Museo de Arte Moderno de Bogotá.

Cuba

Hernández Abdel; Alejandro G Alonso, Vicedirector, Museo Nacional, Palacio de Bellas Artes; Nisia Aquero, Fondo Cubano de Bienes Culturales; José Bedia; Lesbia Bendumua, Casa de las Américas; Sandú Darié; Mario García Joya (Mayito); María Eugenia Haya (Marucha); Zoila Lapique, Biblioteca Nacional José Martí; Marcia Leiseca, Presidenta, Consejo de Artes Plásticas, Ministerio de Cultura; Llilian Llanes, Directora, Centro Wifredo Lam; Minerva López; José Luis, Director, Museo Nacional de Guanabacoa; Ruperto Matamoros; Jorge Nasser, Museo de San Miguel del Padrón; Rolando Pots, Especialista Principal del Fondo Cubano de Bienes Culturales; Berta Rivas, Especialista, Dirección de Relaciones Internationales, Ministerio de Cultura; Alfredo Sosabravo; Rubén Torres Llorca.

CZECHOSLOVAKIA

Jirí Kotalík, Director, Národní Gallerii; Olga Puymanova, Národní Gallerii; Lubomír Sršeň, Národní Muzeum; Pavel Stepanek.

ECUADOR

Dory Carrión W., Directora Interina, Museo Jacinto Jijón y Caamaño de Arqueología y Arte Colonial; Magdalena Gallegos de Donoso, Head of the Art Gallery, Museo Arqueológico y Galerías de Arte del Banco Central del Ecuador; Olga Fisch; Verenice Guayasamín, Fundación Guayasamín; Alberto Guerra Paz, Restaurador, Museo Municipal; Eduardo Kingman; María del Carmen Molestina, former Directora General Museos, Museo Arqueológico y Galerías de Arte del Banco Central del Ecuador; María Victoria Páez, Museo Jacinto Jijón y Caamaño de Arqueología y Arte Colonial; Cumandá Sáenz, Head of the Art Gallery (in charge), Museo Arqueológico y Galerías de Arte del Banco Central del Ecuador; Francisco Serrano, Director, Museo Municipal; Yolanda Terán, Museo Arqueológico y Galerías de Arte del Banco Central del Ecuador.

FRANCE

Damian Bayón; Pedro Elia Kari; Roberto Matta Echaurren; Alexander de la Salle, Galerie Alexander de la Salle; Franz Spath, Assistant, Atelier Cruz-Diez.

ITALY

Valeria Ernesti, La Segretaria, Fondazione Lucio Fontana.

Mexico

Víctor Acuña; Colette Alvarez Urbajtel; Luz del Amo, former Dirección General de Asuntos Culturales, Secretaría de Relaciones

ACKNOWLEDGEMENTS

Exteriores; Alicia Azuela; Javier Barros Valero, Subsecretario de Cooperación Internacional, Secretaria de Relaciones Exteriores; Ruben Bautista; Jorge Bribiesca, former Director de Artes Plásticas, Instituto Nacional de Bellas Artes; Juan Carlos Cedeño Vanegas; Manuel de la Cera, former Director General, Instituto Nacional de Bellas Artes; Armando Colina, Galería Arvil; Carlos Córdova Plaza; Juan Coronel Rivera, Fotogalería Kahlo-Coronel; Leonor Cortina; Ignacio Durán; Rita Eder; Víctor Flores Olea, Presidente, Consejo Nacional para la Cultura y las Artes; Cristina Gálvez Guzzy, Directora, Museo Rufino Tamayo; Fernando Gamboa, Director de Museos, Consejo Nacional para la Cultura y las Artes; Elisa García Barragán, Directora, Instituto de Investigaciones Estéticas; Margarita García Luna, Directora, Museo de Arte Moderno del Centro Cultural Mexiquense; Roberto García Moll, Director General, Instituto Nacional de Antropología e Historia; Blanca Garduño, Directora, Museo Estudio Diego Rivera; Elena Horz de Via; Miriam Kaiser; Miriam Korzenny, Registrar, Centro Cultural Arte Contemporáneo; Eréndira de La Lama; Amelia Lara Tamburrino, Directora, Museo Nacional de Historia; Robert R Littman, Director, Centro Cultural Arte Contemporáneo; Jorge Alberto Lozoya, former Director en Jefe para Cooperación Internacional, Secretaría de Relaciones Exteriores; Antonio Luque, Subdirector de Artes Plásticas, Instituto Nacional de Bellas Artes; Jorge Alberto Manrique; Alfonso de Marta y Campos, Director General de Asuntos Cultures, Secretaría de Relaciones Exteriores; María Fernanda Matos Moctezuma, Directora, Palacio Nacional de Bellas Artes; Barbara Meyer, Museo Nacional de Historia; Luis Ortíz Macedo, Director, Museo de Arte Moderno; Patricia Ortíz Monasterio; Sylvia Pandolfi Elliman, Directora, Museo de Arte Alvar y Camen T de Carrillo Gil; Salvador Reyes Nevares, Director General del Instituto Mexiquense de Cultura; Francisco Reyes Palma, Subdirector de Investigación, CENIDIAP, Instituto Nacional de Bellas Artes; Graciela Reves Retana, Directora, Museo Nacional de Arte; Víctor Sandoval, Director General, Instituto Nacional de Bellas Artes; Raquel Tibol; Luis Felipe del Valle Prieto, Director de Intercambios Culturales, Consejo Nacional para la Cultura y las Artes; Mario Vázquez, Director de Museos del INAH; Beatriz Vidal de Alba, Directora, Museo Nacional de la Estampa; Adrián Villagómez Levre, Director de Artes Plásticas, Instituto Nacional de Bellas Artes; Sabino Yanos, Director del Centro Regional del INAH; Mariana Yampolsky; Alejandra R de Yturbe, Galería de Arte Mexicano.

THE NETHERLANDS Else Barents, Stedelijk Museum.

PERU

Cecilia Alayza de Losada, Directora, Museo de Arte de Lima; Jorge Bernuy Guerrero, Jefe de Actividades Culturales, Instituto Nacional de Cultura; James M and Rosita Birkbeck; Amalia Castelli Gonzalez, Gerente Cultural, Association Cultural Peruano Británica; Jorge del Castillo Galvez, Alcalde de Lima Metropolitana; Cesar Coloma Porcari, Director, Museo Nacional de Historia; Marita Custer; Jorge Falcón, Presidente Fundador, Instituto Sabogal de Arte; Gaston Garreaud, Trilce Galería de Arte; Mirko Lauer; Federico Letona Muñoz, Director de Museos, Instituto Nacional de Cultura, Cusco; Elvira Luza; Marina Nuñez del Prado; Germán Peralta Rivera, Director General del Instituto Nacional de Cultura; Luis Repetto Malaga, Director General del Museo Nacional, Instituto Nacional de Cultura; Elida Roman, Galería Nueve; Mari Solari, Artesanía y Arte Popular; Francisco Stastny.

SPAIN

Concepción García Sáiz, Conservadora Jefe Sección Colonial, Museo de América.

United Kingdom

Peter Adam; Harry Ades; Robert Ades; Thomas Ades; Tim Ades; Eduardo J Benarroch; Leslie Bethell, Director, Institute of Latin American Studies, University of London; Ruth Breakwell; Gordon Brotherston; Kate Buckely, Allen & Overy; Elizabeth Carmichael, Museum of Mankind; Zelda Cheatle; Prunella Clough; Sylvia Chittenden de Condylis, Chairman, Latin American Arts Association; Malcolm Deas; Rosie Eager, Curator, National Art Library, Victoria and Albert Museum; Valerie Fraser; Guy Goudchaux; Peter Hulme; John King; Ann de Lara, Exhibitions and Education Service, The British Library; Tim Laughton; Harry Lubasz; Simon J Mayo, Royal Botanic Gardens, Kew; John Orbell, Baring Brothers & Co., Limited; Maureen Reid; Bryan Roberts; Desmond Rochfort; Patricia Semple, Head of Education Department, The Hispanic and Luso Brazilian Council; Glen Sujo; Nissa Torrents; Elisa Vargas.

United States of America

Edgar John Bullard, Director, New Orleans Museum of Art; Luis R Cancel, Executive Director, Bronx Museum of the Arts; Barbara Duncan; Julia Herzberg; Anne Horton, Director, Latin American Department, Sotheby's, New York; Audrey Isselbacher, Associate Curator, Department of Prints and Illustrated Books, The Museum of Modern Art, New York; Beatrice Kernan, Assistant Curator, Department of Drawings, The Museum of Modern Art, New York; Mary-Anne Martin; Andrea S Norris; Cora Rosevear, Associate Curator, Department of Painting and Sculpture, The Museum of Modern Art, New York; Carla Stellweg, Curator, Museum of Contemporary Hispanic Art; Clara Diament Sujo, CDS Gallery, New York.

URUGUAY

Jorge R Castillo, Galería Sur; Felisa Kalenberg; Francisco Mata; Nelson Ramos; Iphigenia Torres; Olimpia Torres Díaz; Manolita P de Torres-García.

xvii

ACKNOWLEDGEMENTS

Venezuela

José Antonio Abreu, Ministro de Estado para La Cultura; Miguel Arroyo; Lourdes de Blanco; Sylvia Boulton; Nelly Diaz, Estudio Actual; Isabel Cecilia Fuente, former Directora de Museos, CONAC; Sofia Imber de Rangel, Directora, Museo de Arte Contemporáneo; Humberto Mata, former Director(E), Galería de Arte Nacional; Miguel Henrique Otero; Pedro and Roselia Pérez Lazo; Sagrario Pérez Soto; John H Phelps; José María Salvador, former Subdirector, Museo de Bellas Artes; Eleonora Stein, Galería Mendoza; José Francisco Sucre Figarella, former Minstro de Estado para La Cultura; Jeannine Sujo; Ildemaro Torres, Dirección de Cultura, Universidad de Venezuela; Sonia H Torres; Oswaldo Trejo, former Director, Museo de Bellas Artes; Ofelia Ventura; Ana Yilda León U, Directora, Museo de Petare.

Lenders to the Exhibition

ARGENTINA

Roberto Aizenberg
Galería de Arte Ruth Benzacar
Felisa and Mario H Gradowczyk, Buenos Aires
Marion and Jorge Helft, Buenos Aires
Matilda Herrera
Enio Iommi Girola
G Kosice
Galería Kramer, Buenos Aires
Raúl Lozza
Juan N Mele
Washington Pereyra

Brazil

Acervo Artístico-Cultural dos Palácios do Governo do Estado de São Paulo

Biblioteca Municipal Mário de Andrade, São Paulo

Fundação Maria Luisa e Oscar Americano, São Paulo

Fundação José e Paulina Nemirovsky

Ministério da Cultura/FNPM/Museus Raymundo Ottoni de

Castro Maya, Rio de Janeiro

Museu de Arte de São Paulo

Museu de Arte Contemporânea da Universidade de São Paulo

Museu de Arte Moderna do Rio de Janeiro

Museu de Folclore Edison Carneiro, Instituto Nacional do

Folclore/Fundação Nacional de Arte, Rio de Janeiro

Museu Lasar Segall, São Paulo

Museu Imperial, Petropolis

Museu Nacional de Belas Artes, Rio de Janeiro

Museu Paulista da Universidade de São Paulo

Pinacoteca do Estado de São Paulo

Projeto Hélio Oiticica, Rio de Janeiro

Jacques van de Beuque, Rio de Janeiro

Jean Boghici

Luiz Buarque de Hollanda

Sergio Camargo

Alvaro Clark

Leon Ferrari, São Paulo

Lélia Coelho Frota

Fulvia and Adolpho Leirner, São Paulo

Sonia Lins

João Marino, São Paulo

Anna Mathilde Penteado Millan

Vivi Nabuco

Lygia Pape

Luiz de Rezende Puech

LENDERS TO THE EXHIBITION

CHILE

Claudio Girola

Colombia

Museo de Arte Moderno de Bogotá Museo Nacional Quinta de Bolívar, Bogotá Galería Garcés Velasquez

Cuba

Museo Nacional, Palacio de Bellas Artes, Havana

Czechoslovakia

Národní Muzeum, Prague

ECUADOR

Museo de Arte Moderno, Casa de la Cultura Ecuatoriana, Quito Museo 'Guillermo Pérez Chiriboga' del Banco Central del Ecuador Museo Jacinto Jijón y Caamaño, Quito Oswaldo Viteri

France

Bibliothèque Nationale, Paris Carlos Cruz-Diez Arden Quin

FEDERAL REPUBLIC OF GERMANY

Kristina and Ernst Schennen, Bad Homburg

ITALY

Fondazione Lucio Fontana, Milan

Mexico

Instituto Nacional de Antropología e Historia (INAH):

Foteca del INAH

Museo Nacional de Historia, Mexico City

Instituto Nacional de Belles Artes (INBA):

Museo de la Alhondiga de Granaditas, Guanajuato

Museo de Arte Alvar y Carmen T de Carrillo Gil, Mexico

City

Museo de Arte Moderno, Mexico City

Museo Casa Diego Rivera, Guanajuato

Museo Nacional de Arte, Mexico City

Museo Nacional de la Estampa, Mexico City

LENDERS TO THE EXHIBITION

Museo del Palacio de Bellas Artes, Mexico City

Oficina de Registro de Obras

Banco Nacional de México, S.N.C.

Museo de Arte Moderno del Centro Cultural Mexiquense,

Toluca, Estado de México

Manuel Alvarez Bravo

Galería Arvil

Mr and Mrs Ignacio Cantú Montenegro

Fernando Gamboa

Jacques and Natasha Gelman

Mathias Goeritz

Marte Gómez Leal

Pascual Gutiérrez Roldán

Salomon Laiter

Fernando Leal Audirac

Vicky and Marcos Micha

Mariana Perez Amor

José Sánchez Aguilar Luis Felipe del Valle Prieto

Arsacio Vanegas Arroyo

PERU

Instituto Nacional de Cultura

Instituto Nacional de Cultura - Cusco; Museo Histórico

Municipalidad de Lima Metropolitana Museo de Arte de Lima

Museo Nacional de Historia, Lima

Pinacoteca de la Municipalidad de Lima

Jaime and Vivian Liébana

Francisco Moreyra G S

Luis Rivera Davalos

John Stenning

SPAIN

Museo de América, Madrid

SWITZERLAND

Schweizerische Stiftung für die Photographie

United Kingdom

The British Library Board

Trustees of the British Museum

The Trustees of the Tate Gallery

The Board of Trustees of the Victoria and Albert Museum

Baring Brothers & Co., Limited

Guy Brett, London

A Burton-Garbett

LENDERS TO THE EXHIBITION

David Medalla, London
Royal Institute of British Architects, British Architectural
Library
Anthony Shelton
Tragopan Corporation Limited (The Edward James Collection)
University of Essex

United States of America

The Art Institute of Chicago Archer M Huntington Art Gallery, The University of Texas at Austin The Minneapolis Institute of Arts The Museum of Modern Art, New York Museum of Modern Art of Latin America, Organization of American States New Orleans Museum of Art San Francisco Museum of Modern Art Solomon R Guggenheim Museum, New York The Chase Manhattan Bank Hoffenberg Collection Mary-Anne Martin/Fine Art, New York Spencer and Myrna Partrich, Bloomfield Hills, Michigan Selden Rodman Maurice C and Patricia L Thompson Augusto Torres, New York Cecilia de Torres, New York Estate of Torres-García, New York

URUGUAY

Museo Municipal Juan Manuel Blanes, Montevideo Museo Nacional de Artes Plásticas, Montevideo Wifredo Díaz Valdéz

VENEZUELA

Fundación Museo de Arte Moderno 'Jesús Soto', Ciudad Bolívar Fundación Anala y Armando Planchart
Galería de Arte Nacional, Caracas
Museo de Bellas Artes, Caracas
Oscar Ascanio
Alfredo Boulton
Patricia Phelps de Cisneros
Maruja Delfino
Sawas Colección
Jesús Rafael Soto
Colección Villanueva, Caracas

and those private collectors who wish to remain anonymous.

Introduction

THE EXHIBITION that this book accompanies was conceived with the aim of presenting to a European audience the relatively unknown art of Latin America of the modern era – that is, of the period since the independence movements of the early nineteenth century.

Although the exhibition is therefore on an extensive scale, it is not intended as a survey, and certainly does not pretend to any completeness. The idea has in a sense been to create a temporary museum of Latin American art, which offers a necessarily selective and partial, rather than comprehensive view. However, the wide geographical and historical perspective has enabled an exploration of shared and continuous themes and preoccupations: the tortuous and fascinating relationship with European art, from the time of Independence, when political freedom was accompanied by an official dependence on the European neo-classical academic model, through to the ambiguous interaction with modernism; the debates between those committed to a tendentious political art and those who affirmed art's autonomy; indigenism, nationalism and the resurgence of 'popular' art; the rôle of the visual artists in the construction of history; and above all the conflicts and tensions involved in the search for a cultural identity.

These themes are examined within a structure that is broadly chronological. Each section, or room, in the exhibition corresponds to a chapter in the book, and is concerned with a specific movement, theme or moment – 'Private Worlds and Public Myths', for instance, takes as its starting point the 1940 International Exhibition of Surrealism in Mexico City.

There are obviously many absences – much of the post-war abstract painting and sculpture, for example, has not been included, and, because this is an historical exhibition, no attempt has been made to give anything approaching an overview of contemporary art in Latin America. This would be the job of a different book and a different exhibition. The few artists included in the final section – which involved a particularly difficult series of exclusions – are among those whose work has most clearly been engaged with the historical, political and cultural issues that run through the post-Independence area.

The year 1992 is the five-hundredth anniversary of what is known from a European perspective as 'the Discovery of America'. The inequality of this phrase from an American point of view is obvious, and the term now generally adopted in Latin America and in Spain is 'el encuentro de dos mundos', the encounter between two worlds. It was with this first encounter in mind that this exhibition was initially planned.

'Latin America' is clearly a cultural and political designation, as opposed to a neutrally geographical one. It originated in the context of French foreign policy of the 1850s, to cover both those lands that

INTRODUCTION

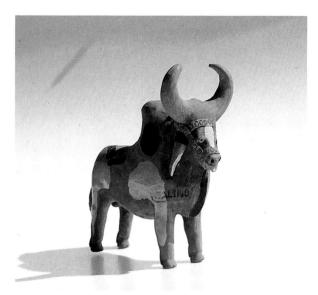

1 Mestre Vitalino, *Bull*, 1945, pottery, 27×12×25 cm., Collection Jacques van de Beuque, Rio de Janeiro.

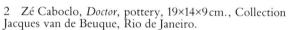

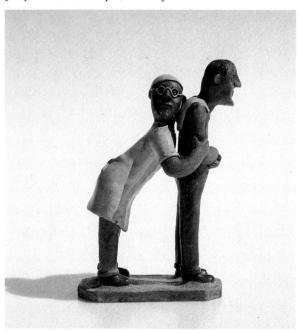

were former Spanish and Portuguese colonies from the Rio Grande in North America south to Cape Horn, and the French- and Spanish-speaking Caribbean. Although not, therefore, arising initially from an internal sense of unity, by the end of the century it had become a very useful term in the continental political argument promoting economic solidarity and mutual support against neocolonial exploitation. Culturally, it remains, in a sense, a highly problematic term, in that it covers populations that are so diverse, and cultural traditions and practices that differ so widely.

The approach in this exhibition has to a large extent precluded the detailed presentation of the art of individual countries. It could be said that there is a contradiction in this, given that a major concern of the art in most Latin American countries has been precisely to construct a 'national' cultural identity, and to a certain extent this charge is true. Moreover, at certain moments the issue of identity is considered here in detail in the context of a particular country – the Mexican Revolution and the muralists, for instance. But the approach on the whole is justified, given the widespread presence of the themes outlined above, within which the problem of identity is common, whether considered on a continental, national or local scale. The idea of America itself as a source of identity, the ambition to encompass the whole continent and its geography and history, has in literature been embraced by Pablo Neruda, in his great epic poem Canto General. A comparable ambition is found, in different ways, in the murals of Orozco and Siqueiros, and above all in those of Rivera, who takes as subject not only American history, but man in his relation to nature and culture in the New World.

The shared experience of colonization through the continent, which imposed a degree of unity of language and religion, was succeeded by the almost equally universal struggle for independence, which has remained a central myth in the search for cultural and political identity, however diverse the subsequent history of an individual country may be.

Closely bound up with the idea of America, and often problematic in relation to the question of 'national' identity, is the notion of 'Indian America'. Here different grounds arise for the 'continental' approach. The original inhabitants of America, the 'Indian' populations, remain in many ways other nations within a given territory, whose own divisions do not necessarily correspond with the boundaries of the new countries created after Independence. The adoption of a single term to identify the original inhabitants (based on the famous misapprehension of the first Europeans to reach America: that they had discovered the western route through to the Indies, and therefore called the inhabitants they found there 'Indios' (Indians)) has imposed a spurious unity on them, a unity that effectively flattens and distances social and political reality. The colonial imposition of a single language and religion over the vast area, populated by a large number of different tribes and nations, speaking different languages, with different belief systems and different social, political and economic structures,

neither entirely effaced these differences nor achieved the complete assimilation of these peoples into the Spanish or Portuguese cultures.

Independence when it arrived was largely achieved by and on behalf of the creoles (*criollos*) (people of Spanish descent born in the New World) rather than the Indians. In some parts, the process of colonization itself began rather than ended with Independence, as it did in the United States. As Jorge Luis Borges wrote of the River Plate region (Argentina and Uruguay), 'The conquest and colonization of these kingdoms was such an ephemeral operation that one of my ancestors, in 1872, led the last important battle against the Indians, thereby realizing, after the middle of the nineteenth century, the work of conquest begun in the sixteenth.' In Guatemala, and in the Amazonas region of Brazil, the process of colonization, in a particularly deadly and destructive form, continues.

This is not just to raise what might be dismissed as the 'anachronistic preoccupation of a few anthropologists'. Although it would not be possible here to present the post-Independence art of 'Indian America', to examine change and tradition in its different societies, and the undeniable ontological unities that still link them, it is impossible to deny their presence, or their crucial role in the formations of what is officially regarded in many countries as the majority mestizo, or mixed culture. All this contributes to make the problem of identity in Latin America political as well as cultural.

This issue of identity, both in relation to internal considerations and in terms of the relationship with Europe and the United States, unresolvable as it may be, has remained an important factor for many artists. A persistent sense that the artistic centre lies elsewhere has prompted many Latin American artists this century to continue to seek their models in the metropolitan capitals of the West, just as the post-Independence academic painters of the nineteenth century had done. But at the same time, apart from artists like the surrealist Roberto Matta who naturalized away from their initial roots, the urge to reveal their own independence and difference often led to imaginative re-inventions and transformations of the European model through contact with an American reality. Tarsila do Amaral's Brazilian 'Purism', Rafael Barradas' cubist gauchos and nativities, José María Velasco's nationalist plein air landscapes or Pedro Figari's blocky intimiste treatment of the dramatic African candomblé ceremonies confront a European audience simultaneously with the familiar, and the utterly strange.

But these were on the whole idiosyncratic flowerings which did little to foster the growth of independent traditions. 'Latin America is characterized by a lack of faith in artistic tradition. Tradition is born and dies with the next generation. The artist from one generation does not discover the artists from the preceding generation.' Less true now perhaps than it was during the first half of the century, this jerky and disjunctive pattern has been an uneasy one for Western art historians still conditioned by ideas of stylistic development, and by the fact that the dominant Western tradition has

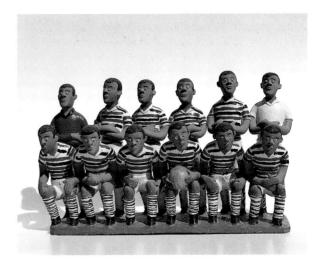

3 Zé Caboclo, *Football Team*, 1970, painted clay, 34.5×54×14cm., Collection Jacques van de Beuque, Rio de Janeiro.

4 Anonymous, Kero with jaguar design, 18th century, wood, 18cm. high, Collection John Stenning.

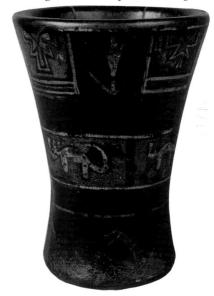

INTRODUCTION

COUSION OF THE PARTY OF THE PAR

5 Anonymous, Textile with the arms of Peru, 19th century, wool, 154×161 cm., Collection John Stenning.

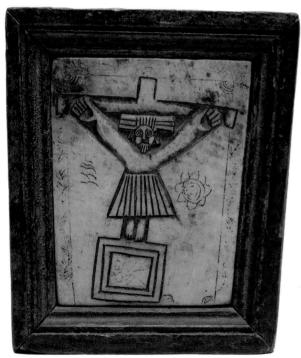

6 Anonymous, Table with image of the Crucified Christ, 20th century, Puno, incised alabaster, 9.5×8.5 cm., Collection Jaime and Vivian Liébana.

7 Anonymous, Painted wooden house beam, 5 September 1966, Sarhua, 233×21×5 cm., Collection of Jaime and Vivian Liébana.

been of an art that is self-referential, autonomous and self-perpetuating.

A belief in the social purpose and responsibility of the artist, which is hardly surprising given the 'vast and inescapable' political, social and economic problems in Latin America, has been a dominant factor, influencing both the re-workings of European traditions and the development of a responsive and accessible artistic language. This sense of social responsibility, which operates at several levels and not just in terms of a manifestly 'committed' art, is nevertheless most evident in the work of the Mexican muralists, who came together in the early 1920s after the great social upheavals of the Mexican Revolution and continued to paint in its name. They have probably had the most far-reaching impact of any artistic group in Latin America. Although their work – diverse as it is – tends to be called 'social realist', this is not really an adequate term to describe it, for it incorporates not only social observation, but also complex allegory and historical narrative.

The Mexican muralists were also highly influential in asserting their faith in indigenous and popular art, going beyond the taste for the picturesque that had initially stimulated artist interest in these fields to make them crucial elements in the realization of their political ideal of an art for the people. And here we return to the extremely complex issue of popular and *mestizo* art.

The conventional division between 'high' and 'popular' art has continually been challenged by Latin American artists in both theory and practice, and the rejection by the Union of Mural Painters of the 'bourgeois individualist' art of easel painting (see Appendix, 7.1) was an aspect of this challenge. The fact that 'popular' art has been seen as the true manifestation of mestizo culture has also contributed to its re-valuation this century, and led to numerous and inconclusive attempts to define it. 5 Mestizo is an elastic term, sometimes linked to the creole population, sometimes to the indigenous in opposition to it. It may also be used with reference to the mixed urban populations as opposed to the rural indian populations. In those parts of Latin America, moreover, where there had been large slave importations to work the plantations or the mines - Brazil and the Caribbean, for instance - and where escaped slaves had settled, there is also a strong African influence. 'In Latin America', the Colombian novelist Gabriel García Márquez wrote, 'they teach us that we're Spaniards. It's partly true, of course, since the Spanish ingredient is undeniably an important part of our cultural make-up', but, he goes on to say, 'we're Africans as well. . . . There are forms of culture with African roots in the Caribbean, where I was born, very different from those of the Altiplano where the indigenous cultures were very strong. '6

An important point that needs to be made in this context, and also in relation to the barrier between 'high' and 'popular' art, is that neither the indigenous nor African cultures possessed a tradition of easel painting as such. It is sometimes argued that the 'popular' arts and crafts like basket-weaving, textiles, ceramics, metal and

feather-work represent what was left over after the art of the indigenous élite disappeared after the Spanish invasions (their stone carvings, architecture, murals and painted books swept away to be replaced by or subsumed into European modes in art, architecture and writing), but were inherently inferior. This is misleading, not least because it is based on an erroneous notion of a hierarchy of materials. Far from being inferior, or purely decorative, crafts like textiles or ceramics, have always had the possibility of being the bearers of vital knowledge, beliefs and myths.

Although popular and folk art, and indigenous or ethnic art are often treated as identical – not least in the context of the *artesanía* shops – these terms in fact cover diverse fields of art and production, with different traditions, functions and status, and a variety of sources in European or native American artistic and cultural practices. They also reveal different degrees of mixture, 'acculturation', or the development of new forms. Some forms of popular art are clearly of European origin, like the ex-votos [Pls 3.94-8] which are found all over Catholic Europe too.

There are sometimes close similarities in the popular traditions of village pottery in different countries – for instance, the ceramic bulls that are found in both Peru and Brazil, but in fact have different derivations. The pottery bulls of the Puno region in Peru have an extremely long and curious history, which can be traced back to the figurines of llamas of the Inca period and earlier; they retain the circular depression in the back which originally existed in the Inca figurines to receive ritual offerings. In Brazil the pottery bulls are of relatively recent origin, and belong to a kind of modern costumbrismo (see Chapter 3) incorporating the figures of the doctor and psycho-analyst [Pls 1,2,3] as well as street and factory scenes.

Native traditions, though, are sometimes pointed to as having a permanence and continuity in striking contrast to the disjunctions described above in modern 'Latin American' art. To an extent this is true, though there are also considerable changes and adaptations here during the colonial and post-Independence periods, as well as responses to political events. There are examples of *keros*, for instance (the-flared drinking vessel of the Inca) with scenes of independence engraved on them [Pl. 4]. The costumes used in the *negrería* dance in Peru include appliqué portraits, not only of both Indian and creole independence heroes (Tupac Amaru and Bolívar), but also of recent presidents and dictators. The great indigenous tradition of mask-making continues, above all in the Guerrero region; the imaginative syncretism of imagery related both to catholic and native beliefs of the Guerrero masks has been particularly admired by the surrealists.

To assert the value and interest of indigenous and popular American visual traditions in their own right, is not to underestimate the problems that may thereby be exacerbated for Latin American artists in search of a modern identity. It is nonetheless important to recognize their presence not least because of their role in the formation of the rich *mestizo* art of Latin America.

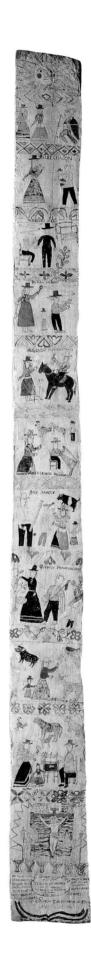

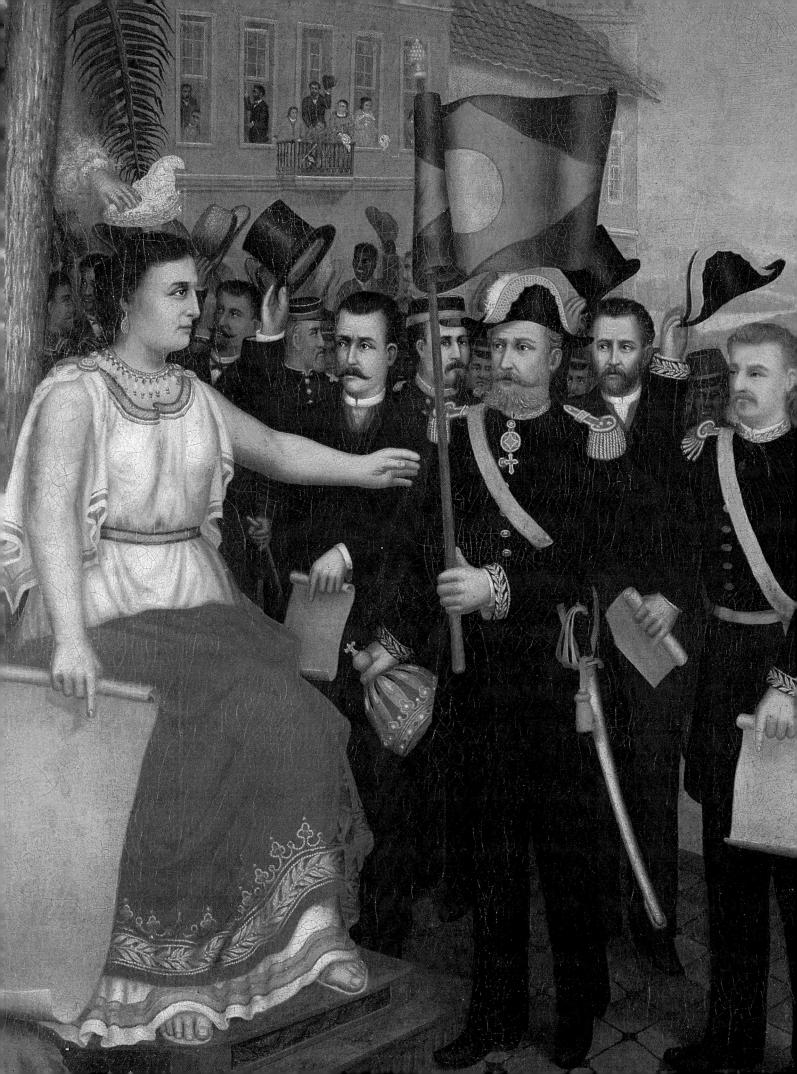

1 Independence and its Heroes

THE SUCCESS of the Independence movements in the Spanish colonies of America gave birth to new countries, new political orders and to lasting debates about national identity, but not immediately to any flowering of the arts. Material existence, both during and after the wars against the Spanish colonizing powers, was too precarious, the general state of affairs too unstable, for the formation of artistic communities. No claims were made for any 'movement' in the arts that might have embodied the political ideals of Independence, in the way that neo-classicism in the hands of David had for the French Revolution. Although neo-classicism, whose influence was felt in the Academy in Mexico by the end of the eighteenth century, was associated with the reforming currents of thought in intellectual circles, there was little opportunity for its development. 'Twenty years of civil war and insurrection', the English traveller and collector William Bullock wrote in 1823, 'have produced a deplorable change in the Arts . . . today, there is not a single pupil in the Academy . . . '. 1

'By 1830, nearly every part of the sub-continent presented a spectacle of civil war, violence or dictatorship; the few writers and intellectuals were either tossed to one side or forced into battle.' The situation, however, was a little less dire in the visual arts, in that official and popular demand for portraits ensured some livelihood for painters. If there was not a flowering, there was at least some response in the visual arts to the drama, turbulence and excitement of political life in Latin America in the first half of the nineteenth century.

In fact, the visual art that was produced at the time of Independence has taken on an almost disproportionate importance subsequently, not only as 'authentic' historical document, which is the way it is usually presented in Latin America now, but also as witness to and assistant in the process of construction of a national identity. For Independence, whatever succeeded it in terms of discord and strife, and however far its ideals became distanced from political reality, remained by far the most important moment for the new nations that emerged; representations of its heroes and martyrs have become talismans or icons signifying those beliefs, and reinterpreted with reverence, or with irony, by artists in the twentieth century for whom national or Latin American identity in cultural and political terms remains an unresolved and therefore potent issue. The contemporary imagery of Independence: portraits of its heroes, leaders and martyrs [Pls 1.2,3,4,5,6,9,10], pic-

1.1 Detail of Pl. 1.7.

1.2 Antonio Salas (attributed), *Portrait of Simón Bolívar*, 1829, oil on canvas, 59×47 cm., Collection Oswaldo Viteri.

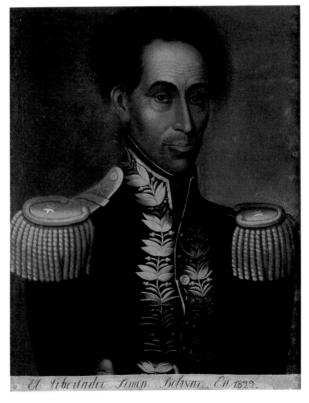

- 1.3 Anonymous, *Policarpa Salavarrieta Goes to Her Execution*, 19th century, oil on canvas, 76×95 cm., Museo Nacional, Colombia.
- 1.4 Epifanio Garay Caicedo (attributed), *Portrait of Policarpa Salavarrieta*, 19th century, oil on canvas, 138.5×91.9cm., Museo Nacional, Colombia.

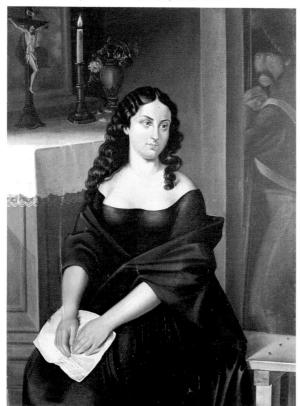

1.6 Anonymous, Execution of the Heroine Rosa Zarate and of Nicolas de la Peña (in Tumaco), 1812, oil on canvas, 101.3×142.6cm., Museo de Arte Moderno, Casa de la Cultura Ecuatoriana, Quito.

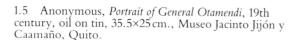

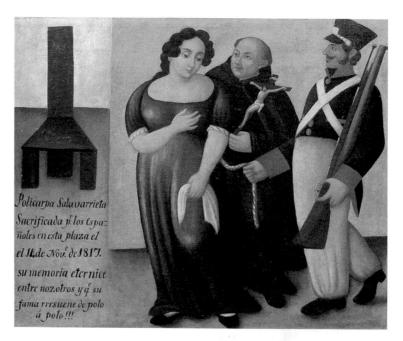

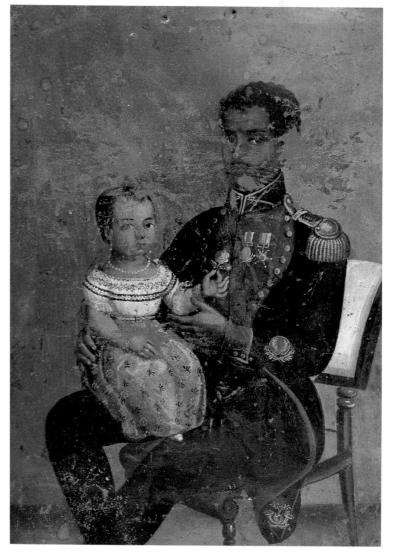

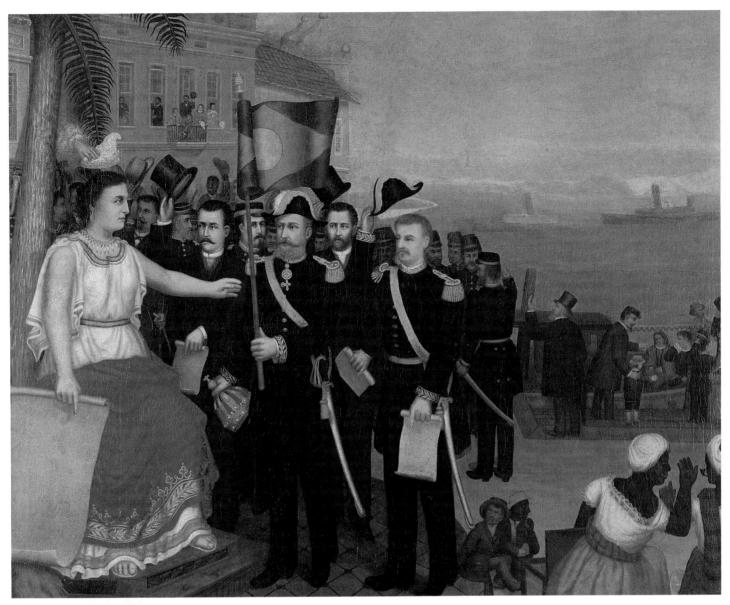

tures of recent historical events and victories against the Spanish army, allegorical scenes and personifications of America or of individual republics [Pls 1.7,8], was produced in a variety of styles, ranging from the neo-classical to the naïve. These works involve both a continuation and a rejection of traditions established during the colonial epoch.

For three hundred years, since the Spanish invasions of the early sixteenth century, Spain (or in the case of Brazil, whose history took a different turn in the nineteenth century, Portugal) had ruled from Europe, through a succession of viceroys, the different provinces into which Spanish America was divided; high official positions were reserved exclusively for Spaniards from Spain, although creole (*criollo*) society (that is, Spaniards born in the New World) settled in those provinces and became rich. It was members of this class who were largely instrumental in achieving Independence. The majority of the population, at least in the Andean countries and

1.7 Anonymous, Allegory of the Departure of Dom Pedro II for Europe after the Declaration of the Republic, 1890, oil on canvas, 82×103 cm., Fundação Maria Luisa e Oscar Americano, São Paulo.

1.8 Jean-Baptiste Debret, Landing of Doña Leopoldina, First Empress of Brazil (study), n.d., oil on canvas, 44.5×69.5 cm., Museu Nacional de Belas Artes, Rio de Janiero.

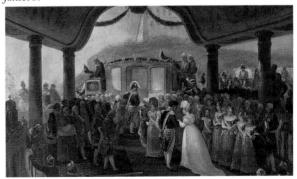

INDEPENDENCE AND ITS HEROES

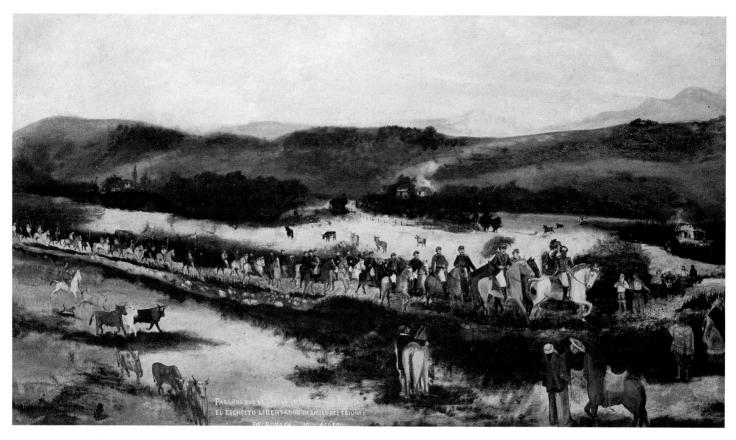

1.9 Francisco de Paulo Alvarez, *Riding to Bogotá with the Liberation Army*, 19th century, oil on canvas, 65.5×116cm., Museo Nacional, Colombia.

1.11 (facing page) Circle of the Master of Calamarca, Lake Titicaca School, *Archangel with Gun*, late 17th century, oil on cotton, 47×31 cm., New Orleans Museum of Art.

1.10 José María Espinosa, Battle of Maracaibo Castle, 1878, oil on canvas, 90×127 cm., Museo Nacional, Colombia.

in Mexico and Central America, was 'Indian' - a term we have perforce to use, since there is no other single term to describe the original peoples of the continent, but one which imposes a spurious unity only demanded by the colonizing process itself. With the exception of those people who remained physically and geographically out of reach, the populations became Catholic, although beliefs were frequently syncretic, involving elements of the old religions mingled with the new and with significant local variations. Out of this mestizo, or mixed, culture sprang a flourishing popular art, with paintings (on cloth, wood, tin, skin, paper and canvas) and carvings in wood and wax, alabaster and stone. At the levels of both popular and official art, the Church was the dominant factor, and with the exception of society and campaign portraits, which became extremely popular in the eighteenth century, the visual arts were almost exclusively at the service of the Catholic religion. Occasionally a strikingly original talent arose, like Diego Quispe in seventeenth-century Cuzco, or wonderful transformations of Christian iconography occurred, as in the motif of the Angel with a Gun, again in the Cuzco school. Usually anonymous, these paintings depict divine figures like the archangels Michael or Barachiel (Uriel), dressed in the flamboyant secular attire of the seventeenthcentury dignitary - or perhaps the viceroy himself - carrying, prominently, a musket, their poses based on military handbooks of the period [Pl. 1.11]. Other Cuzco school paintings depict saints or angels in more baroque military garb.4

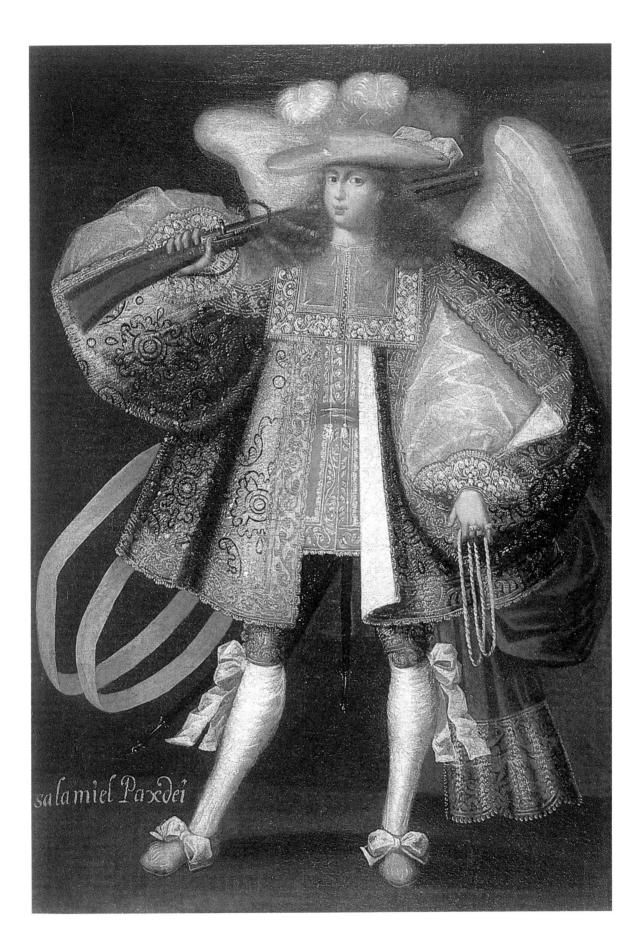

INDEPENDENCE AND ITS HEROES

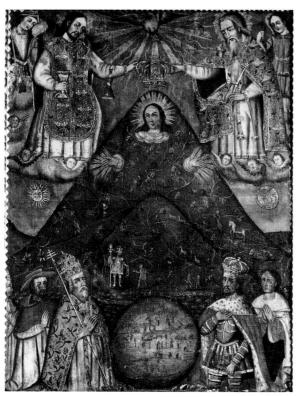

1.12 Anonymous, Virgin of the Hill, before 1720, oil on canvas, Casa Nacional de Moneda, Potosí.

Paintings of the Virgin in Peru and Bolivia, which often include a portrait of the donor, share with these a remarkable elaboration of decorative detail, especially in the clothes, often embroidered in fine gilt. It is a decorativeness that has little to do with the sinuous rococo of eighteenth-century Europe, favouring rather a symmetrical and hieratic stiffness. Possibly the labour spent on painting the cloth carries some of the dignity textiles possessed in the Inca and pre-Incaic cultures (Paracas and Nazca, for instance), whereby the new religion is endowed with some of the values of the previous cultures. One of the most significant images is that of the *Virgin of the Hill* of Potosí, whose skirts spread to become the hill of the silver mines, thereby taking on the identity of Pachamama, the Andean earth and creation goddess [Pl. 1.12].

With Independence, the Church's role as patron of the visual arts lessened, although the battle between civil and ecclesiastical authorities, sparked by Independence, continued. But portraits of the leaders and heroes of Independence sometimes take on the aspect of a votive image, now in the service of a secular idealism.

The ideology of Independence was fundamentally that of the Enlightenment: 'The revolutionary message came from France and North America under the priest's cassock, and in the minds of the cosmopolitan statesmen to sharpen the discontent of the educated and well-bred Creoles, governed from across the seas by the law of tribute and the gallows,' wrote José Martí, the Cuban writer and revolutionary who died in action on the eve of Cuban independence in 1895.

Simón Bolívar, from a wealthy creole family long established in Caracas, spent periods of his youth in Europe, where he witnessed Napoleon's coronation. He was thoroughly educated in Enlightenment thought, familiar with Rousseau, Mirabeau and Voltaire (his favourite author), in common with other American revolutionary thinkers of the time, including Hidalgo, whose abortive insurrection of 1810 is taken as the start of the Mexican struggle for independence. Bolívar was in turn immensely admired by liberal Europe. Byron named his schooner Bolívar, and hesitated between joining the struggle for independence in South America or in Greece. Bolívar was the subject of numerous sympathetic caricatures, as well as often being compared with Napoleon. Such comparisons frequently find their way into the Bolivarian iconography, as in the 1857 portrait by the Chilean artist Arayo Gómez, which places Bolívar on a white horse, rearing against a background of the Andes rather than the Alps, in direct reference to David's portrait of Napoleon Crossing the Alps. The earliest such use of David's dramatic equestrian portrait was probably an 1824 engraving by S. W. Reynolds, which adds the names 'Bolívar' and 'O'Higgins' to the 'Bonaparte' inscribed in the Alpine rock. Bolívar rejected such comparisons, however, saying, 'I am not Napoleon, nor do I wish to be him; neither do I wish to imitate Caesar. . . . the title of Liberator is superior to the many I could have received.'6 (He had been honoured with the title 'Libertador' in Mérida, Venezuela, in June

1813.) Bolívar's terms of reference were strikingly and persistently European, borrowing especially from the Enlightenment the language of classical republican ideals. He described himself, for instance, as having to play the role of Brutus to save his country, but being unwilling to play that of Sulla.

Disagreement about the form new governments were to take, and deeper conflicts that had been both masked and unleashed by Independence, led to continuing violence. 'It is easier for men to die with honour than to think with order. It was discovered that it is simpler to govern when sentiments are exalted and united, than in the wake of battle when divisive, arrogant, exotic and ambitious ideas emerge,' wrote Martí. Thereafter, for the next half-century, 'An extraordinary procession of eccentric despots, mad tyrants and half-civilized "men on horseback" sweeps across the historical scene'. 8

Bolívar was faced with the collapse of his dream of a peaceful and united federation of Gran Colombia; the Republic he managed to create, out of the former viceroyalty of New Granada and part of the viceroyalty of Peru (now the nations of Colombia, Venezuela, Ecuador and Panama), was disintegrating amid conspiracies, rebellions and campaigns to discredit Bolívar. He resigned as President in 1830, and later that year died at Santa Marta on his way into voluntary exile, aged forty-seven. He had written to his closest companion at arms, General Sucre, 'It will be said that I have liberated the New World, but it will not be said that I perfected the stability and happiness of any of the nations that compass it.'9

Martí blamed Bolívar for attempting to impose foreign notions on an alien reality:

America began to suffer, and still suffers, from the effort of trying to find an adjustment between the discordant and hostile elements it inherited from a despotic and perverse colonizer, and the imported ideas and forms which have retarded the logical government because of their lack of local reality. The continent, disjointed by three centuries of a rule that denied men the right to use their reason, embarked on a form of government based on reason, without thought or reflection on the unlettered hordes which had helped in its redemption. . . . ¹⁰

Indeed, as this last passage hints, the problem of the type of government to be adopted conceals a more radical problem: that of a basic alternative between the Indianization or the Westernization of America. The very term 'New World' belongs irrevocably to the latter, as does the term 'American Spain', a concept accepted by Bolívar and other revolutionary thinkers, which immediately alerts us to the presence of a Western discourse.

Very few of the innumerable tracts printed during the Independence struggles were addressed to the Indian inhabitants, let alone written in a native language. One of the few exceptions was, significantly, addressed to the indigenous people of a neighbouring

country, for transparent political reasons: Bernardo O'Higgins, the 'Supreme Director of the State of Chile', as he titled himself, addressed the 'Natives of Peru' in Quechua, exhorting them to invite him and his army of liberation in, to help their own fight for independence.¹¹

On the whole it was in those countries where the original inhabitants had possessed a civilization that was recognizably advanced according to European standards, with writing, stone architecture, painting and sculpture, elaborate tax and tribute systems and clearly defined social and ritual hierarchies, that there had been continuing resistance to Spanish colonial rule. Active struggles for independence in colonial America cannot be subsumed automatically into the successful movement against Spain of the early nineteenth century, but they provided important precursors for it. The most famous of the native insurrections that preceded Independence was that of Tupac Amaru. A descendant of the Incas, Tupac Amaru had a grand political vision of government by the Indians and the restoration of their lands. His campaign of 1781, which had much popular support, ended in his capture and death, and only two portraits of him have survived: one by the Indian Simón Oblitas, from Cuzco. These were probably painted from life, and intended, as were so many such portraits of revolutionary leaders, to spread Tupac Amaru's image among the people and keep his memory alive. It is not surprising that so few have survived, given that such portraits were 'considered punishable and witnesses of subversive activity'.12

There were, however, conflicting ideas and interests among indigenous restoration movements. Pumacahua, also of Inca blood, was Tupac Amaru's bitter enemy, and helped defeat him at the battle of Tinta. He espoused a conservative ideology, and, although calling himself Inca, was at the same time sufficiently valued by the Spanish authorities to be named by the Viceroy in 1807 'Presidente Interno de la Real Audiencia de Cuzco', the highest position an indigene reached under viceregal government. In 1814 Pumacahua joined what was the most formidable uprising against the Spanish in Peru until San Martín, being finally defeated by General Ramírez on the heights of Umachiri.

Between 1781 and 1814 ideas of establishing an Inca monarchy remained very much alive; there was in 1805, for instance, a plan to restore the Inca socio-political structure, the Tahuantinsuyu, and to crown an Inca. The influence of these ideas was still felt when later debates concerning the form of government turned to the possibility of monarchy. At the Congress of Tucumán in Buenos Aires in 1816, Belgrano promoted the idea that a new government should be inspired by the Inca empire, an idea bitterly opposed by others who mocked 'la monarquía de las ojotas' (the monarchy of sandals). ¹³

Teresa Gisbert examines the iconography associated with ideas of the restoration of the Inca dynasty in the context of Independence, and reveals the odd legitimation it offers to Independence heroes, eventually fading into nostalgia [Pl.1.13]. San Martín, who

1.13 Anonymous, Allegorical shield in honour of Bolívar, 1825, 108×102 cm., Instituto Nacional de Cultura-Cusco; Museo Histórico Regional.

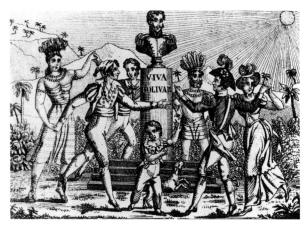

1.14 Anonymous, Allegorical Theme: Homage to Bolívar; 'Viva Bolívar; Viva Bolívar', 19th century, engraving, Fundación John Boulton, Caracas.

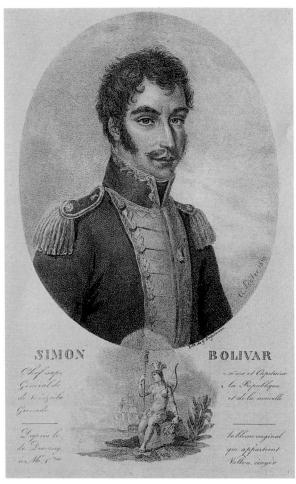

1.15 A. Leclerc, Simón Bolívar, 1819, lithograph, Bogotá.

was, it seems, not averse to accepting a crown, is depicted in one biombo (screen) at the end of a sequence of Inca kings; Bolívar, who was averse to it, is also shown in a lienzo (canvas), his head painted over that of Carlos III, in a sequence of monarchs beginning with the Inca rulers, and with fellow Independence leaders, including Paez and Sucre, superimposed over other Spanish kings. Sahuaraura's Recuerdos de la Monarquía Peruana o Bosquejo de la Historia de los Inca (1836–8, published Paris 1850) portrays the genealogy of the Inca, in the tradition that extends back to Guaman Poma de Ayala's Nueva Corónica y Buen Gobierno of the early seventeenth century, to demonstrate the author's royal blood. But, like the engraved copies of the Inca dynasty made for European travellers in the nineteenth century, Sahuaraura's images lack the polemical and revolutionary import they would have had at the time of Tupac Amaru, having even in a sense become safely picturesque. As Gisbert writes:

The characteristics of autochthonous art of the colonial era bear witness to the existence of an Indian nation within the viceregal structure, fighting to maintain its identity and to remain in evidence. In the eighteenth century the natives channelled their aspirations into politics, only to see them wrecked by the collapse of the rebellion of 1781; from that date what had been combative and committed art (paintings, architectural façades, etc.) turns to nostalgic reminiscence, even though the creole patriots did not identify themselves with Indian ideology and employed these values – which they knew by the light of encyclopedists more than through their own experience – within a somewhat lyrical setting.¹⁴

By the time the creole patriots had driven out the Spanish, it was possible to invoke the figure of the Inca as part of a symbolic or allegorical system indicating national unity. A silver candlestick struck in Britain to commemorate British support for Independence unites the three figures of Bolívar, Britannia and an Inca. An engraving in the Boulton Foundation in Caracas shows a ring of figures including Indians, mestizos and creoles dancing round a bust of Bolívar [Pl. 1.14]. Other engravings show the Indians, significantly, in the background. One by Dubois, intended for popular distribution in America, depicts a possibly mulatto father holding up a framed engraving of Bolívar for his family's admiration, while in the distance a troop of Indians in single file, with the characteristic erect and squared-off feather head-dress with which they were usually represented at the time, emerging from behind a church carrying a flag, presumably symbolic of national unity. Underneath is the inscription 'Aquí está su Libertador' (Here is your Liberator) [Pl. 1.16]. The engraving of Bolívar is clearly based on the earlier widely disseminated engraved portraits by Bate, or Leclerc [Pl. 1.15], where he has curly hair growing over his forehead and a moustache. 15

Representations of America have from the colonial period on taken the form of an indigenous woman. ¹⁶ An interesting variation

on this occurs in the canvas painted by the Bogotá artist Pedro José Figueroa, Simón Bolívar, Liberator and Father of the Nation [Pl. 1.17], to celebrate the final independence of New Granada following the battle of Boyacá on 7 August 1819. The picture was presented to Bolívar in the main square of Bogotá during the victory fiesta on 18 September. The young Republic is shown as an Indian woman wearing the upright feather head-dress already noted, carrying bows and arrows and seated on the head of a mythical cayman. She stands in relation to Bolívar as daughter (he is named Father of the Patria). However, she also – unlike many personifications of America which show her as naked or lightly draped – is dressed as and wears the pearls and jewels of a European, and her features are at most mestizo; her gesture is clearly derived from Christian iconography, and she presents something of the aspect of a virgin or saint.

The most familiar images of Bolívar, and those which cast their influence over many descriptions of him, such as Martí's ('that man of high forehead above a face devoured by eyes indifferent to steel or tempest . . .'), are those painted by Gil de Castro and by José María Espinosa. Espinosa painted Bolívar from 1828, while he was in Bogotá, and made pencil sketches from life, including one just before he died, showing him worn and prematurely aged [Pl. 1.22]. He continued to make numerous portraits of Bolívar after his death, for foreigners and his countrymen, the grandest of which is the 1864 portrait (*Bolívar: Portrait of the Liberator*) [Pl. 1.18], with its insistent echoes of Napoleon, with arms crossed and an elaborate sofa behind. This large painting now hangs in solitary pride of place in the central Cabinet room of the Government Palace in Caracas.

By contrast with this, Gil de Castro's portrait of Bolívar, and that of Olaya, the martyr of Peruvian independence [Pl. 1.20], still hark back to a colonial tradition, with a lengthy inscription carefully lettered on to a framed plaque, although the red banner above the subject's head clearly at the same time announces him as a modern revolutionary. The attributes are carefully arranged in each: the globe and writing material on the desk in the portrait of Bolívar [Pl. 1.19] refer to the extraordinary geographical scope of his achievement, and, having ridden with his army across a continent, his extraordinary energy in writing tracts and issuing edicts to the liberated countries. Gil de Castro, a mulatto who had painted society portraits before the Independence movement, joined the struggle enthusiastically, and entered Santiago with the liberating army. Thence he came with San Martín's army to Lima, where he became 'Primer Pintor del Gobierno del Perú', and designed the army's uniforms. He painted most of the heroes of Independence, and reserved for them, and for heads of state, the full-length portrait, which in his hands takes on something of a votive image. The faintly primitive, chiselled neo-classicism of his portraits of Bolívar maintains a delicate and appropriate balance between the local and the European: it is a 'provincial and festive version of neo-classi-

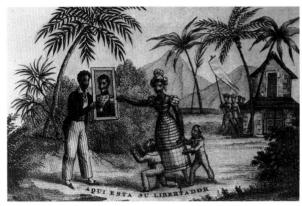

1.16 Dubois, Here is Your Liberator, 19th century, hand-coloured engraving, Collection Bosque García, Caracas.

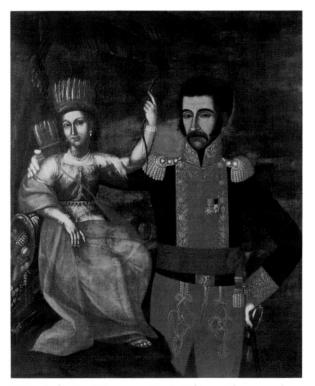

1.17 Pedro José Figueroa, *Simón Bolívar, Liberator and Father of the Nation*, 1819, oil on canvas, Quinta de Bolívar, Colombia.

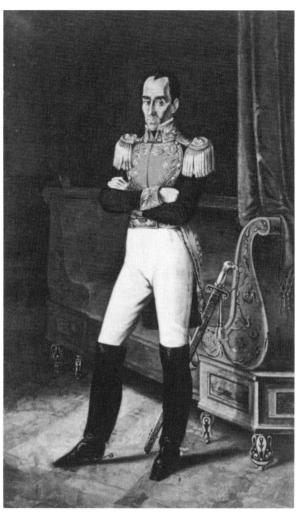

1.18 José Mariá Espinosa, Bolívar: Portrait of the Liberator, 1864, Palace of Miraflores, Caracas.

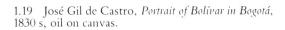

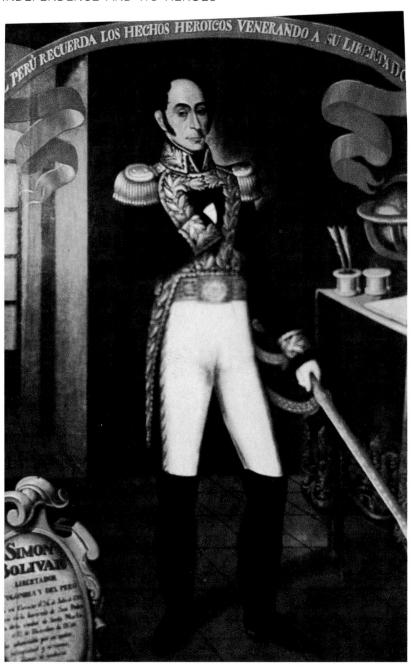

cism'. ¹⁸ His *Portrait of Simón Bolívar in Lima*, of 1825, was sent to Bolívar's sister in Caracas; its relative simplicity and directness pleased Bolívar [Pl. 1.21].

The production of the images relating to Independence could never be a neutral or objective matter, particularly in the climate of violence and discord that followed it:

. . . the interpretation of recent history was repeatedly a 'mirror of discords'. Faced with each version of the facts as it arose . . . the artists were called on to illustrate the thought of the historian or the political group to which they adhered. Thus the foregoing serves us as a basis for understanding the circumstances and the

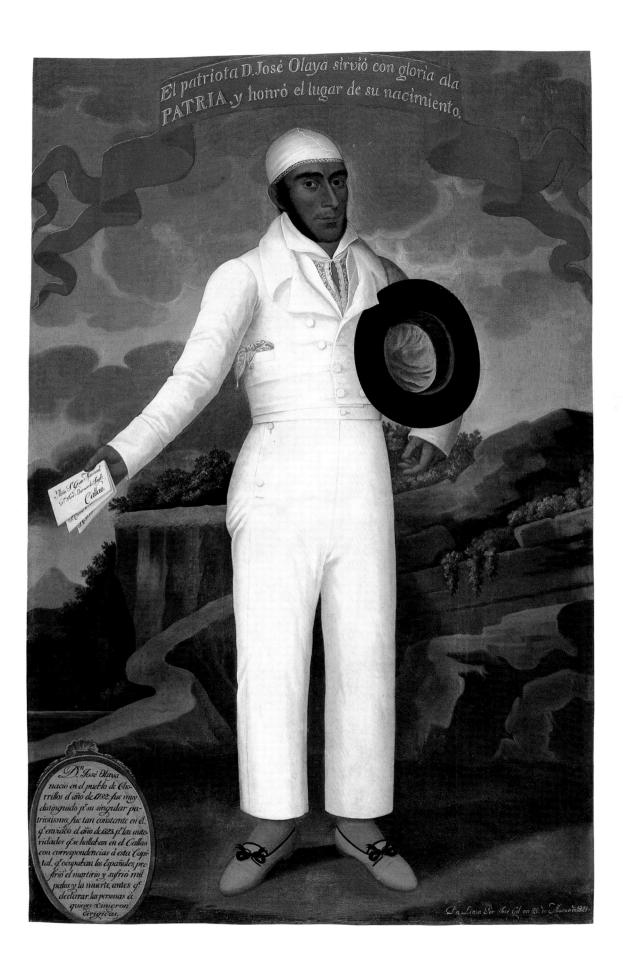

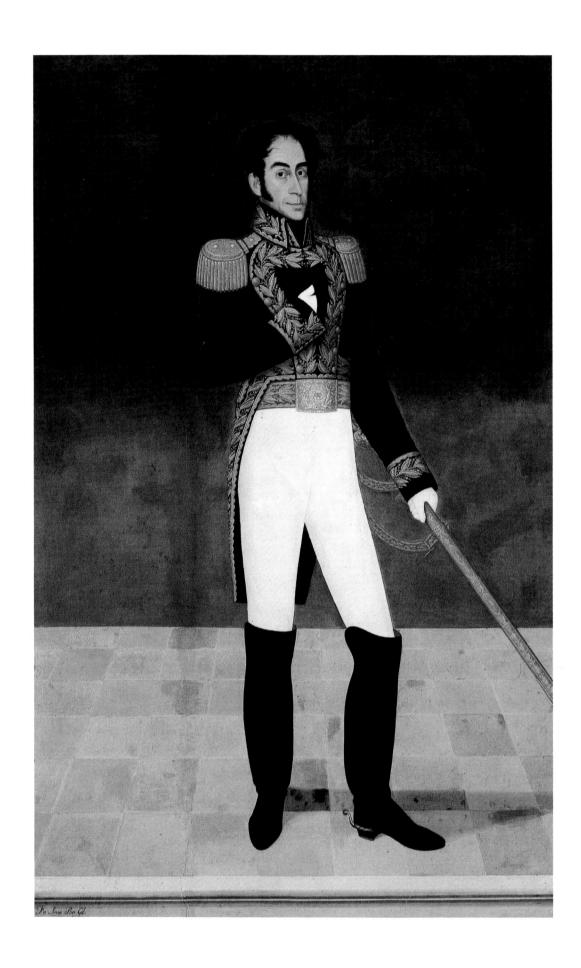

conjuncture in which the portraits of leading figures and the commemorative works bore witness to the various projects of nationhood. Linked with the emergence of conflicting political proposals (basically between a central and a federal system), the images not only took note of short-term changes in the political or military scene (memory), but also, through the recovery of certain antagonistic figures (Hidalgo v. Iturbide), traced the different ideological courses which the country was later to follow (the sense of history). Undoubtedly the decisive weight of the past, containing the genesis of the idea of nationhood, gave sanction to the deeds of the present and launched the ideals of the future. ¹⁹

The antagonism between different interests and ideals, between different models of the projected 'new nation' to follow Independence, represented in the passage quoted above by the phrase 'Hidalgo v. Iturbide', leads on to some of the issues raised earlier but now in the specific context of Mexico, and in particular the question, whose Independence was it?

Don Miguel Hidalgo, parish priest of Dolores, initiated the uprising against Spain on 16 September 1810, with the famous 'grito de Dolores': 'My children, will you be free? Will you make the effort to recover from the hated Spaniards the lands stolen from your forefathers three hundred years ago?'²⁰ His revolutionary programme had three main points: the abolition of slavery, the suppression of 'el pago de tributo', and the restoration of land to the Indians. He gathered massive popular support among the Indians and the rural poor, and shortly led an army of 100,000 men, with 95 cannon, and in addition controlled one of the few printing presses in Mexico. He issued two decrees from Guadalajara, on 5 and 6 December 1810, the first ordering the devolution of lands to the indigenous people, the second the abolition of slavery, payment of tribute and the 'papel sellado', signing himself 'Generalísimo de América'. 21 But almost none of the liberal creoles joined him; he was defeated, formally stripped of his priestly powers, and shot on 1 August 1811, although his movement was continued by supporters like Morelos.

When Independence came, it took a very different form, bringing neither the liberty nor the equality Hidalgo had fought for, and leaving the issue of land to explode again a hundred years later in the Mexican Revolution of 1910. It was finally achieved through an unlikely alliance of liberals and Freemasons, and conservative creoles appalled by the threat of reforms introduced by the new Spanish government in 1820, after the tyrannical Ferdinand VII had been forced to abdicate, 'to save traditional New Spain from radical Spain'. The creole Agustín de Iturbide entered Mexico City in triumph at the head of the army of the 'three guarantees' (union, religion, independence) in September 1821 [Pl. 1.23], and finally succeeded in being crowned emperor, having first appealed to Ferdinand VII to accept the crown. Although Iturbide's 'Plan de Iguala',

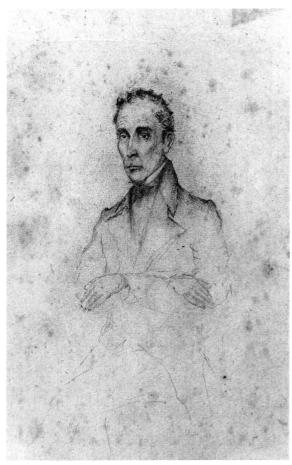

1.22 José María Espinosa, *Portrait of Bolívar*, pencil drawing from life, Collection Alfredo Boulton, Caracas.

1.21 José Gil de Castro, *Portrait of Simón Bolívar in Lima*, 1825, oil on canvas, 210×130 cm., Salón Elíptico del Congreso Nacional, Ministerio de Relaciones Interiores, Venezuela.

1.23 Anonymous, Agustín de Iturbide proclaimed Emperor of Mexico on the morning of 19 May 1822, 1822, watercolour on silk, 46×60 cm., Museo Nacional de Historia, Mexico City (INAH).

1.24 Juan O'Gorman, *Portrait of Miguel Hidalgo* (study for the mural in Chapultepec Castle), n.d., charcoal on paper, 99×73cm., Collection Kristina and Ernst Schennen, Bad Homburg.

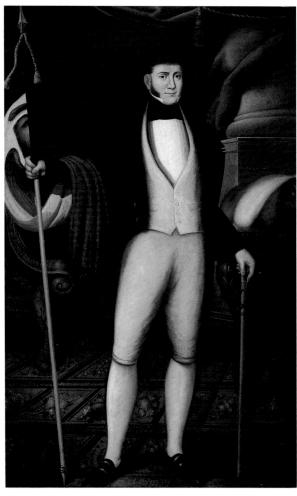

1.25 Anonymous, Portrait of the Liberator Agustín de Iturbide, 1822, oil on canvas, 198×125 cm., Museo Nacional de Arte, Mexico City (INBA).

1.26 Claudio Linati, 'Manuel Hidalgo', from *Costumes civils, militaires et réligieux du Mexique* (Brussels, 1828), The Board of Trustees of the Victoria and Albert Museum, London.

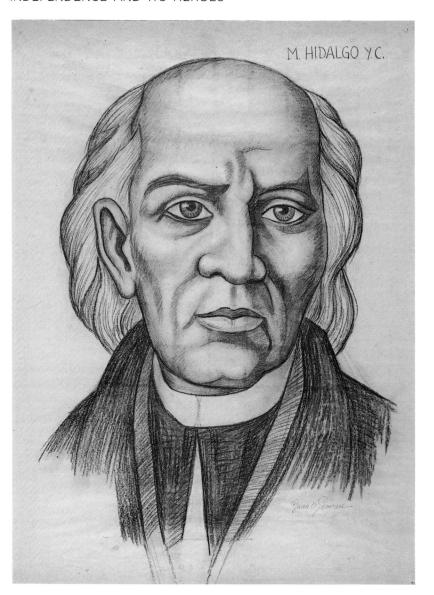

one of the most important statements of Mexican independence, proclaimed the ideal of equality of all 'ciudadanos idóneos' (suitable citizens), it was also traditionalist and reactionary, praising the achievements of the Spanish in America, condemning Hidalgo's disorderly insurrection and ignoring the pre-Spanish indigenous civilizations which were later to form such an important aspect of the ideology of Independence.

Iturbide (Agustín I) was celebrated during his reign in a series of anonymous, popular rather than academic scenes, and also in more academic portraits by José María Vázquez and José María Uriarte, which emphasize an imperial splendour. An interesting exception is the anonymous *Portrait of the Liberator Agustín de Iturbide* (1822) [Pl. 1.25], where he is dressed as a civilian citizen-liberator, with conflicting imperial connotations in the elaborate throne and draped column behind him. But Iturbide, executed in 1824, enjoyed little after-life in images, unlike Hidalgo. Of the priest Hidalgo, under-

Hidalgo.

Caré des Dalores. Dans son costume de guerre, proclamant l'indépendance du Méxique (l'usillé le 1º août 1811)
d'aprèsantableau original.

1.27 Anonymous, Pair of vases portraying Hidalgo and the Virgin of Guadalupe, n.d., glazed pottery, 40×27 cm. and 37.5×27 cm., Private Collection.

1.28 Anonymous, *Don José María Morelos*, n.d., figurine in wax, Museo Nacional de Historia, Mexico City (INAH).

standably few contemporary celebratory images survive; among them are a small wooden sculpture by Clemente Terrazas with inscriptions in Nahuatl, Latin and Spanish, showing a benevolent figure holding a decree, and a wax portrait of a type similar to this of Morelos [Pl. 1.28] made from life, probably by an Indian, on which the first popular image of him was based. This was the engraving by the Italian artist Claudio Linati. Linati, who visited Mexico after the fall of Iturbide, included a number of the early heroes of Independence in his *Costumes civils*, *militaires et réligieux du Mexique* (1828) [Pl. 1.26], and also, significantly, the Aztec emperor Moctezuma.

Linati shows Hidalgo as a vigorous, ruddy-faced, middle-aged man, a warrior-priest with a cross in one hand, staff in the other, sword in his belt, red sash, black cloak, scarf knotted round his neck and a jaunty hat with a feather. Quite different from this swash-buckling image was one produced later in the century by Santiago Rebull, the unfortunate Emperor Maximilian's court painter. Maximilian, unlike Iturbide, had liberal sympathies and admired Hidalgo, but had him depicted as a mild and venerable padre, and the white-haired, black-clad priest has dominated subsequent portrayals, including what is probably the most famous of all, by the muralist José Clemente Orozco [Pl. 1.29]. Orozco, who refused the black and white, good v. evil, version of Mexican history favoured

by Rivera, represents Hidalgo as a dynamic but troubled priest, fighting the oppression of the people, but at the same time tragically contributing to it.

The introduction to the Historia Documental de México II (1964) comments on the optimism of the creoles contrasted with the pessimism of the Indians, poor and oppressed, their own culture destroved by the Conquest, yet not assimilated to 'Mexico'. The radical language of reformers such as Morelos and others, with its refusal of racial difference, which echoed through the century, did not in the end help the Indians. 'In the middle of the nineteenth century, the territorial diminution of the country produced by the defeat of '47 and the political chaos were accompanied by the extremely violent manifestation of the evils stemming from the coexistence of two nations occupying a single territory: the mestizo and the creole on one side and the indigenous mosaic on the other.'22 Indigenous attempts to regain a degree of control were manifested in Mexico in three movements that shook the country during the dictatorship of Santa Anna: the Maya rebellion of the Caste War in Yucatán which began in 1847, the revolt of the Sierra Gorda, and the invasions of the so-called 'Indios bárbaros' in the north. The Maya almost succeeded in regaining control of Yucatán, and the extent to which they retained a native structure of organization parallel to the colonial, and subsequently Mexican, central governments is clear from the Book of Tizimin, which contains an unbroken written history of the Itzá from the seventh century AD well into the nineteenth century. Both culturally and economically, Independence was for the creoles, not the Indians.

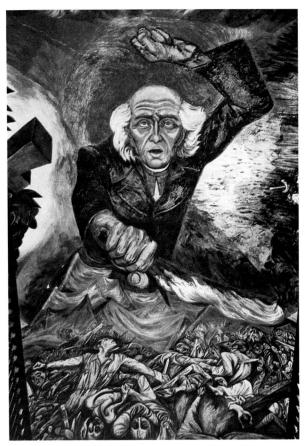

1.29 José Clemente Orozco, Manuel Hidalgo, 1937, fresco, Palacio de Gobierno, Guadalajara, Jalisco.

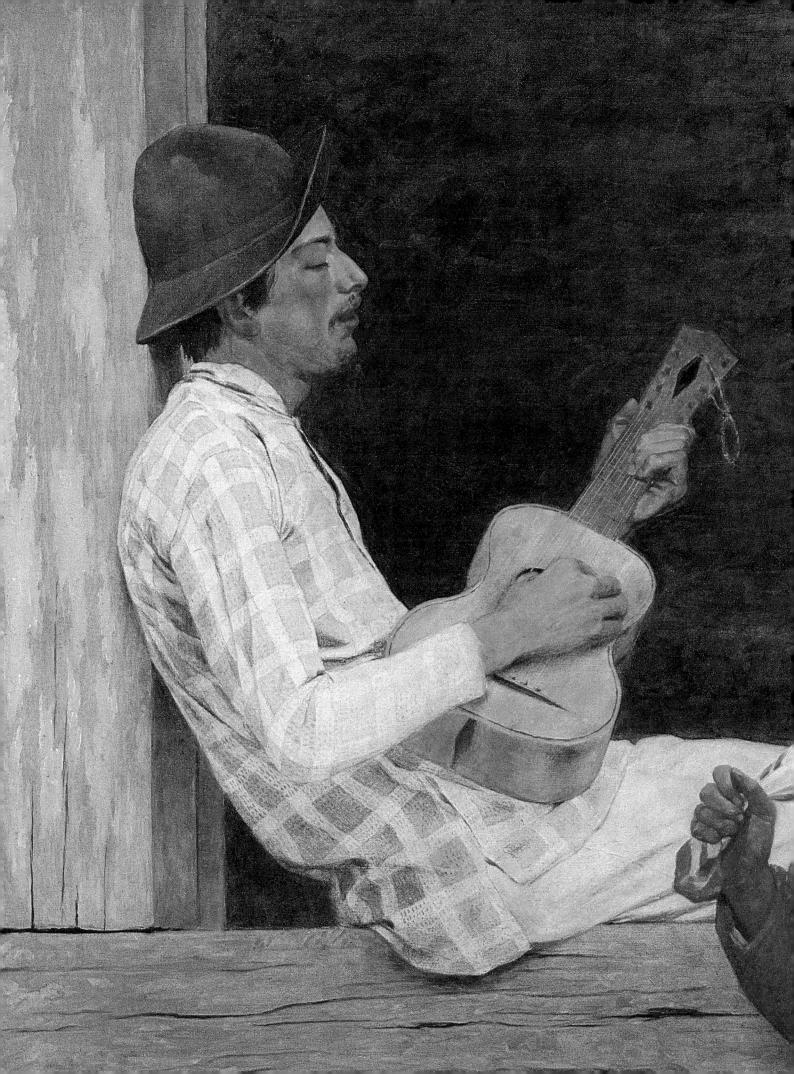

2 Academies and History Painting

THE ROYAL ACADEMY of San Carlos in Mexico City, founded in 1785, was the first academy of art in America, and the only one established under colonial rule. It was a great, if disconcerting, success, for the independence it acquired from its mother institution, the San Fernando Academy in Madrid, was regarded in Spain as a 'political error'. Indeed, Humboldt's description of the vigorous and productive democracy in the Academy suggests that it was not insignificant in fostering ideas that led eventually to Mexico's political independence.

Humboldt's account was recalled under sadly different circumstances in the 1830s by Frances Calderón de la Barca:

He tells us that every night, in these spacious halls, well illumined by Argand lamps, hundreds of young men were assembled, some sketching from plaster-casts, or from life, and others copying designs of furniture . . . and that here all classes, colours and races were mingled together; the Indian beside the white boy, and the son of the poorest mechanic beside that of the richest lord. Teaching was gratis, and not limited to landscape and figures, one of the principal objects being to propagate amongst the artists a general taste for elegance and beauty of form, and to enliven the national industry. Plaster-casts, to the amount of forty thousand dollars, were sent out by the king of Spain, and as they possess in the Academy various colossal statues of basalt and porphyry, it would have been curious, as the same learned traveller remarks, to have collected these monuments in the courtyard of the Academy, and compared the remains of Mexican sculpture, monuments of a semi-barbarous people, with the graceful creations of Greece and Rome.

. . . That the simple and noble taste which distinguishes the Mexican buildings, their perfection in the cutting and working of their stones . . . are owing to the progress they made in this very academy is no doubt the case. The remains of these beautiful but mutilated plaster-casts, the splendid engravings which still exist, would alone make it probable; but the present disorder, the abandoned state of the building, the non-existence of those excellent classes of sculpture and painting, and, above all, the low state of the fine arts in Mexico, at the present day, are amongst the sad proofs, if any were wanting, of the melancholy effects produced by civil war and unsettled government.²

The Academy was, like all others of its kind later established in

the New World, unquestioningly European in its aesthetic aims and practices, and Frances Calderón de la Barca's remarks about semibarbaric Aztec sculptures point to a common prejudice – although there was already debate in this area in the context of Enlightenment thought. The Jesuit Pedro José Márquez published two studies at the beginning of the century which argued that notions of beauty are relative, and that the great monuments of the indigenous past should be studied on an equal footing with those of Greece and Rome. The critic José Bernardo Couto, by contrast, a firm supporter of one of the most influential directors of the San Carlos Academy after its restoration by Santa Anna in 1843, Peregrín Clavé, rejected any claim that might be made for the works of the old indigenous world, which was not, he said, theirs; artists should look instead to those of Spanish America. ⁴

Academies were established usually as part of a programme of reform, to foster a newly independent country's intellectual and artistic life. In Brazil, the Academia Imperial de Belas Artes was founded in Rio de Janeiro, the capital of the newly independent Empire, in 1826, with the French painter J. B. Debret, who trained in David's studio, as director. The only other academy founded in the first flush of Independence, during the first half of the nineteenth century, was in Caracas, centre of Bolívar's Gran Colombia. Article 17 of the Ley Orgánica de Educación Pública de Colombia la Grande (18 March 1826) called for the establishment of special schools of drawing, theory and design of architecture, and of painting and sculpture. An Academy of Painting and Sculpture was finally opened in the mid-1830s. But many countries had to wait until the end of the century, or even the beginning of the twentieth, so that sometimes this most orthodox of art institutions coincided with the arrival of modern art. In Peru, the Academy was founded in 1919, the same year that José Sabogal returned from Europe with his new Fauvist-influenced indigenist style.

In Paraguay, which had been devastated by the war of the Triple Alliance (see, for instance, Juan Manuel Blanes' image of desolation, *Paraguay* [Pl. 2.2]) during the 1860s, the population of its capital Asunción reduced to 24,000, and artistic activity virtually ceased for decades. In 1895 the Instituto Paraguayo was founded, followed by the establishment of the Academia de Arte as a subsidiary, run by the newly arrived Italian artist Héctor Da Ponte.

Most of the directors and teachers in the academies were still imported from Europe, and even in countries where there was no official institution of this kind, and artists still trained in the large studios of established painters, Europe remained the Mecca, and the more fortunate received government grants to pursue their studies in Italy, Spain or France.

The founders of the academies of art in the new countries of America would have shared the ideas of the first president of the Royal Academy in London, Sir Joshua Reynolds, who argued that such institutions were intimately bound up with pragmatic commercial considerations (the general improvement of taste would

^{2.2} Juan Manuel Blanes, *Paraguay: Image of Your Desolate Country*, c. 1880, oil on canvas, 100×80 cm., Museo Nacional de Artes Plásticas, Montevideo.

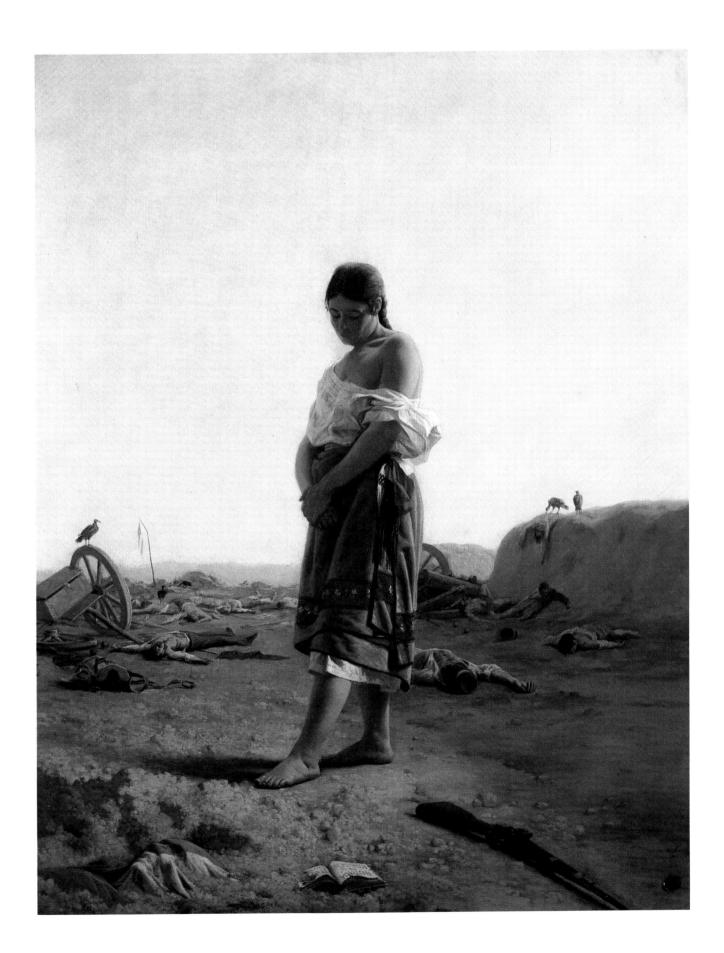

benefit manufacture), and with national pride; they were appropriate for the dignity of 'a great, a learned, a polite, and a commercial nation'. They also shared Reynolds's ideas about the classical tradition, and thereby reinforced generations of artists in their dependence on Europe. As a teaching institution, the academy's aims and principles were clearly laid out by Reynolds in the annual discourses he delivered to the students of the Academy from 1769 to 1790. The proper formation of the student lay in the copying of great examples of past art (antique sculpture, and masters like Raphael), and in drawing from life; he should pursue an ideal of beauty based on general rather than particular features, and should strive for the effect of 'noble simplicity and calm grandeur'.6 History painting came top in the hierarchy of art, above landscape and portraiture, and its subject matter should elevate and be as far as possible of universal interest: 'the great events of Greek and Roman fable and history . . . the capital subjects of scripture history'. With their emphasis on tradition, and on copying, such ideas were likely to inhibit individual responses to an American reality. They implied, too, the familiarity of the audience with the works that provided the models – to recognize a judicious borrowing here or there from Poussin, or from Raphael, a nice adaptation of Hercules, or the Venus de Milo, was an accomplishment comparable to the ability to recognize a quotation from Virgil or Horace. But even in Europe when Reynolds was writing, such assumptions of a common culture rooted in antiquity and the Renaissance were already fading; how much more difficult, then, to transplant this tradition into a society where few had any familiarity with its sources. This basic inappropriateness was compounded by the fact that the artistteachers imported to academies from Europe had themselves studied with neo-classical artists like Raphael Mengs, in whose work the 'great style' had already lapsed into routine and commonplace.8

Local conditions also proved problematic. The painting of the female nude, for instance, was in many places unacceptable. When Cordero's paintings of semi-draped nudes (*The Bather* [pl. 2.3], *The Death of Atala*), placed in tropical settings, were shown at a special exhibition in 1864, they shocked prudish Mexico. The Argentinian Pueyrredon's paintings of nudes were done in secret, and subsequently over-painted. In Venezuela, drawing from the nude female model was still forbidden in the Academy in 1904.

But there was one particular aspect of academic theory and practice that took deep root in the New World, and that was the painting of history. The energy in the treatment of the great subjects of both contemporary and ancient American history (the subjects were prolific), and in the use of traditional European themes to carry contemporary significance, combined with an increasingly unorthodox mixture of classicism and realism, give academic painting in the second half of the nineteenth century in Latin America an unusual interest [Pls 2.5,6].

2.3 Juan Cordero, *The Bather*, n.d., oil on canvas, 150×115 cm., Collection Banco Nacional de México s.n.c., Mexico City.

2.6 (facing page bottom) Padre Pedro Patiño Ixtolinque, *America*, 1830, marble, 200×90 cm., Museo Nacional de Arte, Mexico City (INBA).

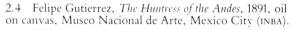

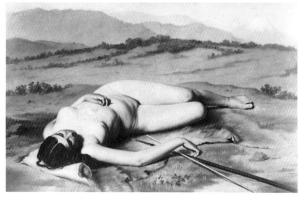

While many academic painters continued to pick their themes from Europe - Santiago Rebull painted a version of the death of the French Revolutionary martyr Marat, famously commemorated by David, while the 'Oath of Brutus' with its clear republican message, and the 'Death of Atala' were also favourites - by the 1850s subjects drawn from American history started to appear. In 1850, Juan Cordero painted Columbus Before the Catholic Monarchs [Pl. 2.7], the first work with an American theme to be seen by the Mexican public, when it was shown at the Academy exhibition of 1851. Cordero noted that no one had ever painted this subject before; Columbus is depicted demonstrating some of his 'finds' from the New World – a group of Indians dressed in skins, in deep shadow in the left corner, one of whom is actually a self-portrait. The setting of Columbus Before the Catholic Monarchs is faintly reminiscent of the gaudy imperial manner of David's Coronation of Napoleon, and the picture is considerably livelier than the stiff, awkward and stony classicism of the majority of Mexican academic painting of the 1850s. Other painters soon followed Cordero in choosing subjects from the 'discovery' of America, like Obregón's Inspiration of Christopher Columbus [Pl. 2.8]. In Brazil, at the same period, Victor Meireles painted the scene of the First Mass to be celebrated in the New World.

It wasn't unusual in Europe for history painting to have relevance in terms of contemporary ideologies; in Mexico during Maximilian's brief reign patriotic subjects were favoured as a means of legitimating and attempting to root his Empire: Santiago Rebull was in charge of painting a series of portraits of the heroes of Independence, including Hidalgo, Morelos and Iturbide. Following

2.5 Juan Manuel Blanes, Review of Rio Negro by General Roca and his Army, n.d., oil on canvas, 50.5×99.5 cm., Museo Municipal Juan Manuel Blanes, Montevideo.

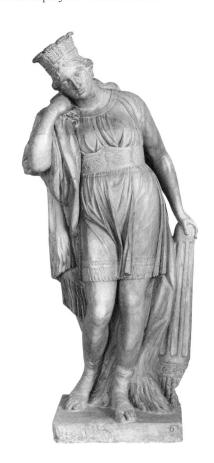

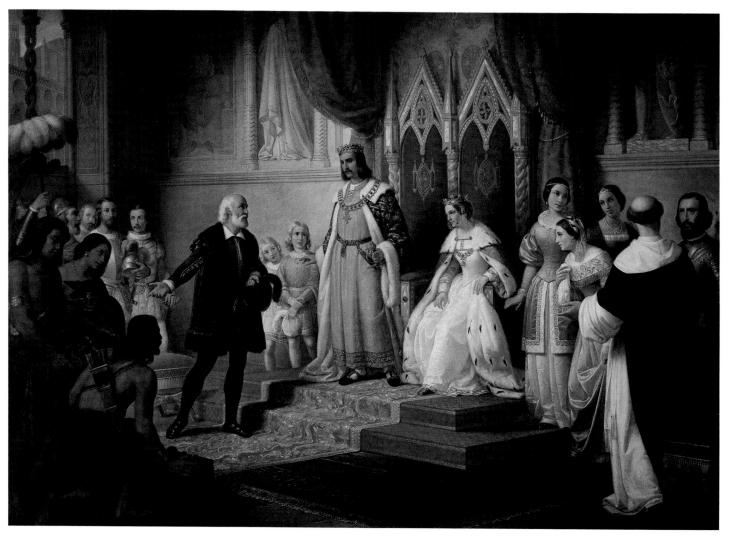

2.7 Juan Cordero, *Columbus Before the Catholic Monarchs*, 1850, oil on canvas, 173×244cm., Museo Nacional de Arte, Mexico City (INBA).

the restoration of the Republic in 1867, a number of large historical works portrayed events from the pre-Columbian past, like Rodrigo Gutiérrez' democratic *Tlaxcala Parliament* or Obregon's *Discovery of Pulque* [Pl. 2.9]. In the last quarter of the century, however, much more aggressive images from this history were chosen, which stressed the vicious and violent aspects of the Spanish Conquest and the three hundred years of colonial rule that followed, like Félix Parra's *Friar Bartolomé de las Casas* (1875) and *Episodes of the Conquest* (1877) [Pls 2.10,12]. National unity, a paramount concern, was increasingly seen as dependent upon a sense of identity, 'Mexicanidad', with strong historical roots. The years of colonial rule were regarded as a savage interruption of Mexican history, and a continuity with the pre-Conquest past was stressed.

So just as 'the Europeans revived Greece, the Middle Ages or the Germanic myths, the Mexican nationalists conjured Netzahual-coyotl, Moctezuma and Cuauhtémoc, asking them for inspiration and strength against [foreign] oppression'. Fear of further foreign intervention, after the war with the United States which resulted in 1848 in the annexation of Texas, and two French invasions, the

2.8 José María Obregón, *The Inspiration of Christopher Columbus*, 1856, oil on canvas, 147×106 cm., Museo Nacional de Arte, Mexico City (INBA).

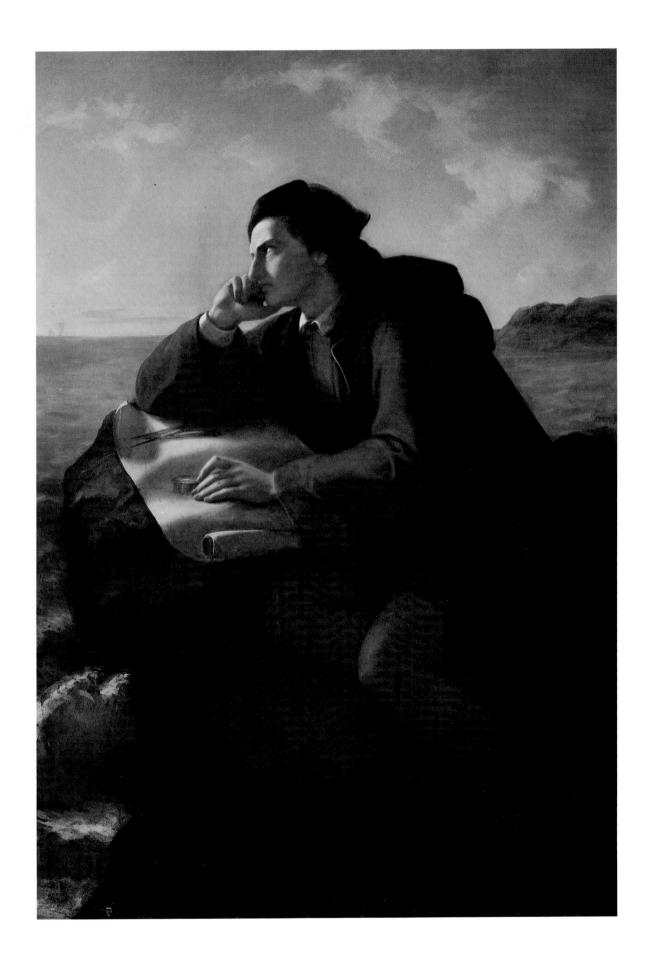

2.9 José María Obregón, *Discovery of Pulque*, n.d., oil on canvas, 76.5×102 cm., Collection Luis Felipe del Valle Prieto.

2.10 Félix Parra, *Episodes of the Conquest*, 1877, oil on canvas, 68.3×109.5 cm., Museo Nacional de Arte, Mexico City (INBA).

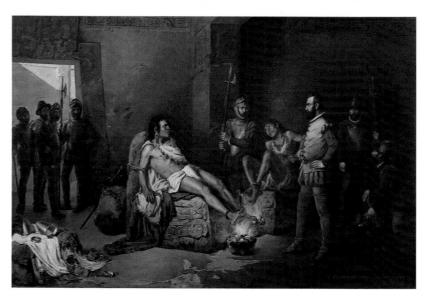

2.11 Leandro Izaguirre, *Torture of Cuauhtémoc*, 1893, oil on canvas, 295×456 cm., Museo Nacional de Arte, Mexico City (INBA).

second ending in the imposition of the Emperor Maximilian, was a major factor. A programme was initiated by the government of Porfirio Díaz to erect monuments in Mexico City of the nation's heroes; the most famous of those completed was the monument to Cuauhtémoc, finally unveiled in 1887, which had been realized by the sculptors Miguel Noreña, Gabriel Guerra and Epitacio Calvo, and the engineer Francisco Jiménez. Leandro Izaguirre's *Torture of Cuauhtémoc* [Pl. 2.11], a gigantic canvas, was painted for the Chicago World's Fair of 1893; the heroic figure of the last Aztec emperor, his clearly Indian profile confronting the harsh image of the Spanish invader, was the incarnation of national resistance. The fact that foreign capital was at this time busy exploiting Mexican natural resources probably exacerbated this spirit.

This politically significant 'historicist indigenism' coincided with the feeling, especially among liberals, for the need to 'rescue and preserve what was still left of the pre-Hispanic culture'. None of this had much to do with the actual plight of the Indians, many of whom were now living in worse conditions than ever before 11 and who were barely touched by the new Mexican pride, and the swift modernization of the country.

In countries where the manifest traces of the native civilizations were less evident than in Mexico, the heroes and events of Independence were kept in the forefront of public consciousness with a similar regard to the interests of national unity and identity. In Venezuela, the regime of Guzmán Blanco celebrated Bolívar's centenary in 1883 with a flood of paintings, sculpture, medals and books. 12 Arturo Michelena, who had worked in Paris in the mid '80s, and who favoured a light and realist style, painted Miranda in La Carraca (1896) [Pl. 2.13] and the Assassination of Sucre; Martín Tovar v Tovar covered the ceiling of the Salón Elíptico in the Palacio Federal in Caracas with a mural of the battle of Carabobo, as well as painting studies of the Act of Independence. In Peru, by contrast, subjects from Spanish history, the discovery of the New World, and episodes from the colonial period, like Ignacio Merino's The Hand of Charles V, The Painter Friar and his Critics, or Columbus Before the Government in Salamanca, were favoured. Víctor Meireles in Rio de Janeiro painted a vast canvas of the battle of Guaranapes, its subject taken from the Dutch invasions of Brazil in the seventeenth century.

The allegorical treatment both of ancient and recent history (as in Pedro Americo's *Concordia* or Blanes' *Paraguay*), and of philosophical and social ideas, was as popular as it was in Europe at the time. A notable instance of the latter was the mural Juan Cordero painted in 1874 in the staircase of the National Preparatory School in Mexico City; *The Triumph of Science and Work over Ignorance and Sloth* embodied the positivist philosophy of the School's director, Gabino Barreda, a student of Comte, whose Civic Oration of 1867 proposed that 'Mexico's regeneration could be achieved through the most prudent application of scientific knowledge . . . He ended his speech by coining a new slogan for the new Mexico: "Liberty, Order and Progress": . ¹³

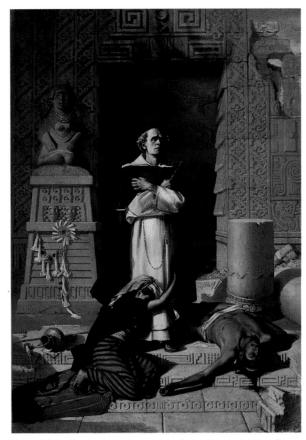

2.12 Félix Parra, Friar Bartolomé de las Casas, 1875, oil on canvas, Museo Nacional de Arte, Mexico City (INBA).

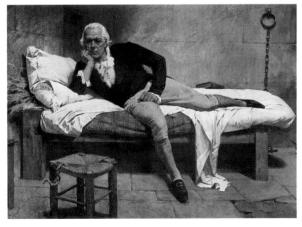

2.14 José Ferraz de Almeida Júnior, *The Violinist*, 1899, oil on canvas, 141×172 cm, Pinacoteca do Estado de São Paulo.

2.15 José María Jara, *The Wake*, 1889, oil on canvas, 178×134cm., Museo Nacional de Arte, Mexico City (INBA).

While the painting of history continued to dominate official art, genre scenes, influenced by the *costumbrismo*, which enjoyed a healthy life in popular art, also entered the repertoire of academic painters. José Correia de Lima was the first academic painter in Brazil, apart from Debret, to paint the black population (*Portrait of Simon the Sailor* [Pl. 2.17]). Almeida Júnior's *The Violinist* [Pl. 2.14] successfully turns his *costumbrista* subject into a realistic scene; elsewhere, though, a different kind of indigenism from the historial 'indigenist nationalism' of the Cuauhtémoc theme began to emerge. José María Jara's *The Wake* [Pl. 2.15] was exhibited under the title 'Burial of an Indigene' at the Paris World's Fair of 1889, where it 'answered the expectation of European taste for pictures that evoked the jealously preserved religious traditions among peasants, who could be imagined immune to the changes imposed by moder-

2.16 Francisco Laso, *The Indian Potter* (or *Dweller in the Cordillera*), 1855, oil on canvas, 135×86 cm., Municipalidad de Lima Metropolitana.

nity'. ¹⁴ This interpretation corresponds to other images like the Peruvian Francisco Laso's *The Indian Potter* [Pl. 2.16], (see chapter 9), who is as though rooted and immobilized in his old traditions, not just untouched but untouchable by modern life and 'progress'.

2.17 José Correia de Lima, *Portrait of Simon the Sailor*, c. 1855, oil on canvas, 92.8×72.5 cm., Museu Nacional de Belas Artes, Rio de Janeiro.

3

i. Traveller-Reporter Artists and the Empirical Tradition in Post-Independence Latin American Art

by Stanton L. Catlin

THE ART of modern Latin America, now close to two hundred years old, was born in the ferment of the European Enlightenment and out of contending, often contradictory forces within the Latin American Independence movements; it is at once a native and a Western phenomenon. Its beginnings brought separation from its Iberian colonial foster parents and from their orthodox precepts of Christian belief, and opened up wider realms of experience, in particular the then new-found commitment of Western society to the life of reason. Within a short time Latin American art became aware of the ancient sources of its Amerindian heritage as simply an extension of natural existence. When, in the first two decades of the present century, it joined forces with another phenomenon of this expanded world - the efforts of the European avant-garde precursors of international Modernism to rejuvenate Western art - it saw that movement as linked with its own indigenous elements, which it inevitably related to artistic values and form. Even now, the experience of individual artists and the physical circumstances of life on the American continents continue to set it apart, and to give Latin American art along with its particular self-contained character, a salient presence in the increasingly diverse, changing scene of world art.

The American territories under Spanish and Portuguese rule in the decades preceding Latin American Independence constituted four Spanish viceroyalties (New Spain, Nueva Granada, Peru and Rio de la Plata) and one Portuguese viceregal colony (Brazil). The art and architecture in each of the five areas reflected the dominant traditions and to some degree the trends current in the parent Peninsular metropolis. For example, French taste at the Bourbon court in Madrid was reflected in viceregal portraits done in mid-century

Santa Fé de Bogotá (Nueva Granada); Italian neo-classical style as received by Mengs, the German court painter to Carlos III, was carried to Mexico, to the San Carlos Academy, by the Valencians, de Tolsá and Jimeno y Planes; and the strict neo-classical style of the French followers of Jacques-Louis David became the model for instruction at the Academia Imperial de Belas Artes founded in Rio de Janeiro under the Le Breton Mission by the Portuguese ruler João VI. However, the influence on the artistic climate most widespread and most profoundly felt was unquestionably direct observation, experiment and rational analysis as the new basis of reality, brought into being by the European Enlightenment which began, before the French Revolution, the overall process of secularization in art.

Long before this, over the centuries following the Iberian discovery and gradual conquest of this immense part of the New World, the role of art had been to serve the Church in its evangelization of the indigenous populations. This included not only the teaching of Catholic religious doctrine and ritual but the hierarchical organization of state and civic life, and, through architecture, the shaping of the physical environment. Whatever the medium painting, sculpture, architecture, ornaments fashioned of gold, silver and composite materials - and whether the context was religious or secular, art's primary reason for being was devotional. As manifestations of the presence of God and of human allegiance to Him, in keeping with the faith of the reigning Peninsular powers, works of art everywhere symbolized and served as a guide to a supernatural, other-worldly view of life. Thus, while focusing thought and attention on a mystical essence of reality, art also provided future Ibero-American colonial generations with a common patrimony: artistic form in which existence found meaning as revealed through deity.

With the Council of Trent's redefinition in 1541 of art not as story-telling but as the symbolic interpretation of Catholicism, the propagation of the faith in the New World took up a new line: the nascent empiricism and individualism of the Italian High Renaissance were replaced by the universal authority and omnipotence of the Godhead as *given*. In the new lands of the Western hemisphere, 'unspoiled by civilization', this rigid doctrine for the next two-and-a-half centuries effectively channelled the creative energies of the secular community, as well as the religious orders, into supernatural frames of reference.

In Europe, however, the impetus brought by the Renaissance to the study of the tangible world, and the gradual recovery of information not as revealed but as *found* by observation and experiment, continued through the pursuit of knowledge for its own sake. From the time of Galileo's celestial observations in the sixteenth century, the scientific method as a means of determining principles governing the physical universe slowly gained recognition among the secular powers of Europe. The facts it yielded about the world beyond the known European horizons gradually came to the attention of the major seafaring nations and the subsequent

quest for reliable information, as a means of possession and trading for wealth, began in earnest in the eighteenth century. Taking pragmatic advantage of the new-found opportunities, these nations sent out maritime expeditions which combined geographical exploration with carefully planned efforts by artists objectively to record unknown forms of plant, animal and human life. Among the enlightened aristocracy the interest in nature itself often amounted to a passion, while the study of land masses, glaciers, coral reefs, harbours and archipelagos, most having military as well as economic importance, promised geopolitical advantage and, inevitably, strategic control by the powers sending out the vessels.

The longest and most far-reaching, although not the first, of

The longest and most far-reaching, although not the first, of these maritime ventures into little-known ocean spaces of the planet were the three voyages into the Pacific made between 1768 and 1776 by Captain James Cook for the Royal Society and the British Admiralty. To record his findings Cook took with him artists who could be counted upon to render natural phenomena objectively and in accurate detail, rather than in the idealizing classical manner advocated by the Royal Academy, then newly founded.

Theoretical and applied science made slow progress on the European continent, however, and the transmission of its methods and results to Latin America was impeded by the isolationist policies of the Peninsular regimes, with their defensive military strategies, centralized mercantile systems and the religious orthodoxy enforced by the Inquisition. It was only with the discovery of the unfamiliar beyond European experience, and with the harder necessity of accepting the existence and legitimacy of that experience, that both art and science came to interest themselves in questions of identity, in nature as well as in human beings, and that the descriptive function of art, tied to science as an aid to perception of the visible world and thus also to the understanding of nature, began gradually to emerge. The split between art as ideality and art as a means of defining the particular in nature began at that point to be narrowed, and new realities that could serve as a basis for creative invention fully to be appreciated.

The American career of the great Spanish physician and horticulturalist, José Celestino Mutis, a disciple of Carolus Linnaeus and founder of the Expedición Botánica of Nueva Granada (the viceroyalty that became Gran Colombia), prefigures the change of outlook that led to Independence in the Ibero-American world. Chartered by royal decree in 1784, the Expedición produced in its 33 years of existence more than 5,300 meticulously detailed studies of previously unknown species of flora of the Colombian highlands, rendered on folio sheets with unprecedented economy, accuracy and grace, for illustrations of this kind. The original drawings were preserved, but remained little known for nearly a century and a half, the Crown-supported Expedición having been shut down in the wake of Bolívar's campaign against the Spanish forces in northern South America. Recently the drawings have begun to be

Passiflora mollissima (H. B. K.) Bailey

Jard. Bot. Madrid: 2051

published through a collaboration of the Spanish and Colombian Academies of Science. Among artisans employed by the Expedición were Ecuadorean Indians trained in workshops of the Quito school of sulpture, famed for the purity of its religious sentiment. Under Mutis' direction, these recorders of living flower specimens invented new techniques for copying forms as they appeared to the eye. Materials and colours were made from local vegetables and minerals suited to the requirement for minutely detailed and accurately coloured renderings, to further the aim of truth to nature as found *in situ* [Pl. 3.2].

Because of the extraordinary range, accuracy and artistic quality of its record of newly-discovered North Andean natural phenomena, the Expedición Mutisiana (as it came to be known) helped Latin American art cross the threshold from serving ends that were exclusively other-worldly, towards a new goal, of identifying and becoming part of the world around it. It did this both through the subject matter it examined and the aesthetic example it set, and through the effect its activity had on the broader changes of the era. In that transitional period and in the same way the native sense of homeland and of individual self-awareness began to emerge and take shape as Latin American consciousness.

By the end of the eighteenth century a score of expeditions had been launched by competing European powers who, pursuing national self-interest, had begun to find in nature, directly examined, a source of reliable knowledge, and in the modernization of production and trade the surest way to material progress. This new orientation, known in Spanish history as the 'Ilustración' (and called by some in South America 'el despotismo ilustrado'), under the progress-minded Bourbon monarch, Carlos III, led to the opening of the Spanish American domains to free trade, and to other liberalizing reforms, as well as to scientific missions to New Spain, Cuba, Venezuela, Peru and Chile.¹

However, it was owing primarily to Count Alexander von Humboldt, the German pioneer traveller-explorer and natural scientist, in the first post-Independence decades of the nineteenth century, that the artistic threshold marked out by Celestino Mutis became the basis for a new, modern beginning for Latin American art. Humboldt (with his colleague, the young French botanist, Aimée Bonpland) was authorized by the Spanish crown to visit Cuba, traverse the North and Central Andes and Mexico (then Spain's namesake and most favoured extension of herself), to study the physical aspect of the land - the great rivers, mountains and volcanoes, and their vegetation - to gather plant specimens, data on the atmosphere and ocean currents, and to assess the general condition of Ibero-American society [Pl. 3.3]. The comprehensive first-hand report of their five-year journey (1799-1804), published serially over three decades and following as it did in the wake of the European Enlightenment's interest in science and primitive cultures, excited the European intelligentsia almost as a second discovery of a New World whose wonders had long been hidden by Spanish pro-

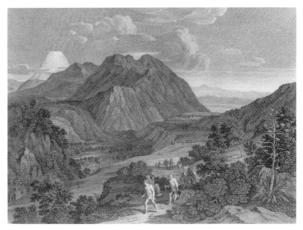

3.3 Alexander von Humboldt, 'Passage dans le Cordillère des Andes', *c.* 1814, from *Voyage de Humboldt et de Bonpland*, Paris: Schoell, 1814–34, Ibero-Amerikanisches Institut, Preussischer Kulturbesitz, Berlin.

3.2 Escobar y Villaroel, 'Passiflora Mollisima', watercolour, Pl. 37 from José Celestino Mutis y Bossio, Flora de la Real Expedición Botanica del Nuevo Reyno de Granada, Vol. 27: Passifloracases y Begoniaceas.

tectionist policy. By then the French Revolution had directed minds everywhere towards social change, the stirrings of intellectual and political freedom, and the crossing of new frontiers of knowledge, adventure and – inevitably – political and private fortune.

The immediate consequence of Humboldt's mission was an urge on the part of artists to follow in his footsteps. A handful of patrons, aficionados such as the Russian Consul-General in Rio de Janeiro, Baron Georg Langsdorff, were followed by stalwart individuals such as the Bavarian, Johann Moritz Rugendas, who moved with great strides from region to region, travelling long distances overland, then by sea. Others, members of ships' companies, spanned shorter stretches, from port to port. Still others, illustrators or draughtsmen with official state-sponsored expeditions, posted overland or went on global voyages; among them were the Frenchman Debret, in the Le Breton Mission to Brazil, and Conrad Martens, with Darwin and Fitzroy in HMS Beagle. The majority travelled alone (Emeric Essex Vidal in Argentina, Claudio Gay in Chile, Edward Mark in Colombia, Daniel Egerton in Mexico [Pls

3.4 Daniel Thomas Egerton, View of the Valley of Mexico, 1837, oil on canvas, Ministry of Public Buildings and Works, Mexico City.

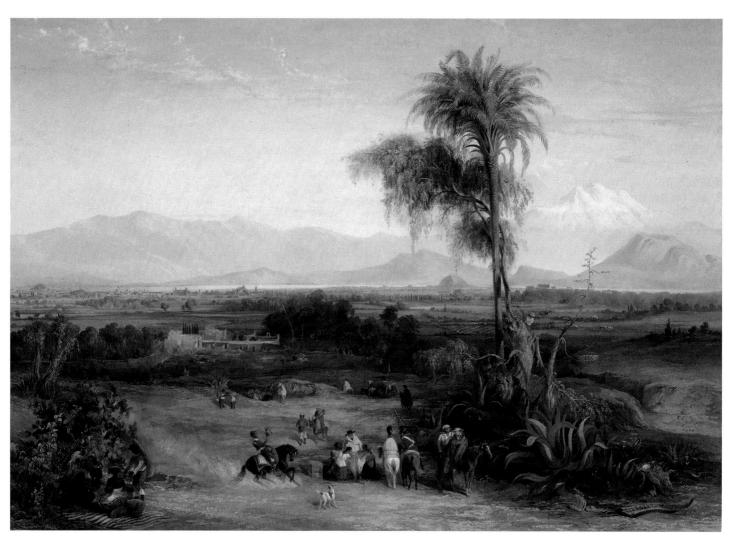

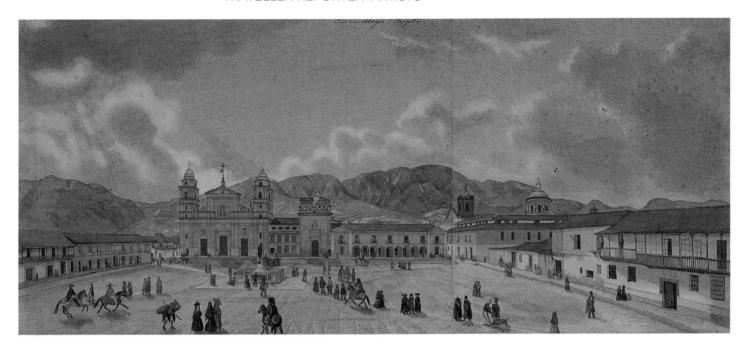

3.4,5,6]), or as a patron-artist team such as Stephens and Catherwood in the Yucatán. They moved between coastland and highland or jungle seeking the unfamiliar – aboriginal stone markings, ancient ruins, the different habitats and endless variety in tribal groups and mestizo peasant types, as well as forms of natural life that would strike the cultivated European eye as novel or characteristic of the freshness and mystery of the rediscovered Ibero-American world.²

As might have been expected, from the outset the reportorial activity of these travelling artists, whose purpose was to document natural phenomena, departed both in practice and in principle from the standards prevailing in the European academies of fine art. As Bernard Smith has shown in his book European Vision and the South Pacific 1768-1850 (1960), the European academies did not train artists to work from nature, seeking out its intrinsic characteristics, but to distill and refine its forms in search of 'ideality'. This did not suffice for Captain Cook and the Royal Society, who needed specific information on the forms of nature, whether it was the configuration of a coastline or harbour, the characteristics of an aboriginal tribe, or the flora and fauna of a tropical island. Thus a new norm for art came into being as part of the European Enlightenment's search for authenticity, or, in Professor Smith's word, 'typicality'. Its antecedents may perhaps be found in fine-art tradition, in, for example, seventeenth-century Netherlandish genre painting, as in the scenes making fun of peasant folkways and the lower classes called 'Bambocciate' that eventually led, in the Iberian and Latin American world, to what is still known condescendingly as 'costumbrismo'.

Among the first and most methodical of the early followers of Humboldt was Prinz Maximilian Wied, of Neuwied, a minor Rhineland principality. He began in 1815 by recording the natural

3.5 Edward Walhouse Mark, *Plaza Mayor, Bogotá*, 1846, watercolour on paper, 24.5×56.9cm., Biblioteca Luis Angel Arango, Bogotá.

3.6 Emeric Essex Vidal, *Estancia Foreman of the Artigas Epoch*, 1811-20, watercolour, Museo Historico y Archivo Municipal, Montevideo.

phenomena of Brazil's hinterland in a series of sketchbook diaries. He then followed Lewis and Clark's itinerary across the Louisiana Territory of the United States, accompanied this time by the Swiss artist Karl Bodmer, who produced a collection of lucid illustrations of the northern continent.

Possibly the most encyclopaedic of the early nineteenth-century European recorders of new life on the South American continent was Jean-Baptiste Debret, who worked in Brazil from 1816 to 1824 [Pls 3.7,8,9]. His Parisian training both at the Ecole des Beaux Arts and as an engineering student prepared him, after Napoleon's fall, for joining the Le Breton Mission: the group of French planners, artists and architects commissioned in 1816 by the Portuguese king, Joāo VI, to make over the city of Rio de Janeiro in French neoclassical fashion as a capital worthy of imperial status.

In Rio, Debret became court painter to the Braganza family and founder in 1826 of the Imperial Academy of Fine Arts, where he was professor of painting; he was also the official draughtsman-cataloguer of the imperial family's human subjects and its physical domain in the New World. Like a latter-day Diderot, he depicted visually the economic, architectural, ceremonial and ethnic aspects of life in the settled parts of Brazil as well as the nearer wilderness of the interior. The pre-Independence Portuguese ancien régime enlisted modern perspectives to promote both its own grandeur and its progressive outlook, a dichotomy which Debret better exemplifies than any of his traveller-reporter contemporaries. But his studies of the natural life of the land are more effective than his depictions of the formal grandeur of the court, done in neo-classical mode favoured for royal portraiture and ceremony and epitomized by the paintings of David.

Among the variety of subjects treated by traveller-reporter artists over their fifty years' activity, between 1810 and 1860, in all parts of Latin America from Mexico to Chile, as well as in the Caribbean, at least four principal categories can be distinguished: scientific, ecological, topological and social. (The latter, which took in an extremely wide range of customs and types of individuals observed in everyday activity, from region to region, is generally known in Spanish as costumbres, usos and tipos, or, again, costumbrismo.) Scientific subjects included newly discovered or unfamiliar phenomena in the plant and animal world; native inhabitants, coloured as well as indigenous (both exemplifying the Old World's wanted version of Rousseau's noble savage); and land forms showing the uniqueness of arboreal species as well as the prodigality of vegetation these last almost always connected with human activities typical of place. Under 'topological' may be grouped views of cities, village squares, port scenes and sites of geographical and military importance. The most varied and inclusive category, however, was the social, covering the activities and typical dress of every sort of inhabitant, from urban upper-class society to those of the barrios, from marketplace, military camp, cattle ranch, portside loading

3.7 Jean-Baptiste Debret, 'Guyanese Savages', from *Voyage pittoresque et historique au Brésil*, 1834-9, Vol. 1, The British Library Board.

dock to frontier forest and jungle. Foot-soldiers and horsemen, seemingly ever-present during the wars between blockading European naval powers, ambitious generals and rival caudillos were favourite subjects in the Rio de la Plata region. This category also included informal portraiture, which in many instances bordered on formal art, more or less following European models of the time.

Johann Moritz Rugendas, whose medieval ancestors had come from Catalonia but whose family had for generations been distinguished in the arts in Augsburg, probably best exemplifies the traveller-reporter tradition in both the Spanish- and Portuguese-speaking parts of Latin America during the post-Independence era. Rugendas travelled further, and over a longer period, than any of his contemporaries, and evolved the most expressively consistent style in the more than 5,000 paintings and drawings he produced between 1821 and 1847 in Mexico and South America. Sarmiento paired him with Humboldt in his often-quoted tribute: 'Humboldt with pen and Rugendas with brush are the two Europeans who have portrayed America most truthfully'.³

Rugendas first spent two years in Brazil (1821-3) depicting nature and the life of settlers and slaves in accurate and widely encompassing detail: the record of these years, published in *Voyage pittoresque dans le Brésil* (1835), is among the most sumptuous publications of the traveller-reporter era. Returning to Europe, Rugendas then spent eight years taking stock of his experience and career as an artist. He met Humboldt, who favoured him among his protégés as one who in his Brazilian work had set up models that would 'begin a new epoch in landscape painting'. During this time Rugendas seems also to have made contact with precursors of the Barbizon school of landscape painting, and allegedly he met Eugène Delacroix, whose work, following the latter's involvement with the cause of Greek independence, he apparently saw in Rome.

In 1830 the July Revolution revived freedom of thought in

3.8 Jean-Baptiste Debret, 'The Signal for Battle', from *Voyage pittoresque et historique au Brésil*, 1834-9, Vol. 1, The British Library Board.

3.9 Jean-Baptiste Debret, *Return of the Naturalist's Slaves*, c. 1820, watercolour, Private Collection.

France, and Romanticism emerged there, as in much of the rest of Europe, as the main counter-force to the classical style in officially approved art. Within a year of the Revolution Rugendas left on his second working journey to the New World, taking with him his experience of the young Barbizon avant-garde painters as well as Humboldt's advice: 'Avoid the temperate zones, Buenos Aires and Chile. . . . Go where the palm trees are abundant, the tree ferns, the cactus, snow-covered mountains and volcanoes, to the chain mountains of the Andes A great artist such as you must search for the monumental.'

Although he never abandoned Rugendas as a friend, Humboldt could 'not [then] have imagined how far his protégé would depart from this guidance'. Without avoiding volcanoes or the desolate passes of the cordillera, the arid spaces of the highlands or dense vegetation of the tropics, Rugendas turned from the precise depiction of typological specimens (albeit always in their natural context) such as he had produced in Brazil, and from the grandiose and prodigal aspects of nature, to the people and customs of the human settlements, shown against more generalized backgrounds of natural grandeur in which he emphasized the human rather than the monumental scale.

His fourteen years of travel and work took him this time to seven countries, from Mexico to Chile, from coastal lands to the remote interior, where he moved among the people at all levels of post-Independence society, recording the human scene in its daily ambience and natural phenomena in their geographical setting. He singled out many types of individuals and their occupations, and was often exposed to danger when protecting friends fleeing political arrest in Mexico, or while witnessing violent events such as *el malón*, a raid in which Indians destroyed white settlements and seized captives, in Argentina. Rugendas spent ten years in Chile, travelling between the cities and the high Andean passes of Peru, Bolivia and Argentina, virtually becoming a citizen of Santiago, whose intelligentsia were then, in the late 1830s, just beginning to sense and to express the cultural qualities of their nation.

Galasz and Ivelic in their history of Chilean painting from the colonial period up to 1981, isolate three areas of activity in Rugendas' work:

as historian – a chronicler who narrates events and describes the customs of an epoch, showing illustrious persons with distinguished records in the military, politics or society; as scientists – an explorer who extracts the elements characteristic of flora or fauna; as geographer – who favours geographical space in its natural plenitude, not yet transformed by the hand of man.⁷

In Argentina, where he worked in and around Buenos Aires for three months immediately after leaving Chile in 1845, Rugendas' subjects may be grouped under the same three categories: As historian – types of people, their habits and customs as ranchers, peons, soldiers, gauchos; hunting ostriches with *boleadoras*; private carriages and stevedore *carretas*; the Indian raid on a white settlement –

^{3.10} Johann Moritz Rugendas, *Study of Palm Trees*, c. 1831-4, oil sketch, Ibero-Amerikanisches Institut, Preussischer Kulturbesitz, Berlin.

3.11 Johann Moritz Rugendas, View in the Environs of Lima, 1843, oil on canvas, 34.7×45 cm.

the attack, the post in flames, demolished, the rape of a woman captive, the return of the captive. As scientist – depiction of human species such as tribal Indians (Patagonian) and of specific social types such as battalion sergeants and foot-soldiers (the dictator Rosas' ruffian *colorado* infantry). As geographer – mountain peaks, caves, hills, bridges, rocks, hovels, peninsulas, rivers, harbours, sunsets, panoramic city views.

From another angle, however, such an inventory – which could be repeated for many of the countries Rugendas visited on his second American journey – transcends its documentary function, serving as an early bridge between factual reporting and expressive art. In the first place the style does not radically change from country to country, or from one time to another – it is the manifestation of a consistent personal view, of how the artist observes his subjects, more than a literal record of what he has seen, however essential objective truth is to his scientific outlook and artistic mission. The personal quality or 'hand' in the execution of the work

becomes, in the light of Rugendas' contact in France with the work of Delacroix and the Barbizon landscapists, an extension of the proto-Romantic ideal then just beginning to declare its independence from the late neo-classic style favoured by the waning Bourbon Restoration. In not limiting himself to landscape, or isolating the mood and circumstances of a single place, the artist was showing his belief in the universality of the Romantic ideal by rendering the life of the whole South American continent, thereby enlarging the thematic repertory of art (as Delacroix was to do in 1831 by carrying it into North Africa), but also by pushing the creative frontier beyond conventional European, as well as American, horizons.

That Rugendas had a Latin American following is hard to prove. He had no known pupils, even in Chile in the decade he spent there. But he was a presence wherever he worked, and the image of him seated before an easel or standing before a subject in the drawing room of one of his many clients, undoubtedly encouraged others to try their hand at his *métier*. Perhaps this was especially true at the popular level, where self-taught depicters of street life such as the Peruvian mulatto, Pancho Fierro, and anonymous Indian and mestizo tradesfolk, were encouraged to describe their own ambience and their occupations as matters of impulse, following an ancient artisanal tradition. From this perspective, Rugendas must be seen as having influenced native Latin American art forms simply through propinquity, through others' observation of him or their study of his published work, and through word of mouth, both in Latin America and in European circles having Latin American affiliations. His *Voyage pittoresque dans le Brésil* was almost certainly known to the authors of the *Atlas* of Venezuela, the Italian Agustin Codazzi and his Venezuelan collaborator, Carmelo Fernández. Indeed it seems that after Rugendas' return to Europe the Romantic ideal was slow to take hold in Latin American art until the twentieth century, and then was fulfilled in forms of art other than representational.

Rugendas' predecessor in America, the Frenchman Debret, may have been even more prolific than his Bavarian contemporary in his many assignments as court painter. But although Debret's mission was confined to one country (however sufficient that country's variety, scale and uniqueness to one artist's fifteen-year commitment), and his work more diversified in style – as dictated by the different nature of his many tasks – than that of Rugendas, one can only draw a parallel between these two exemplary figures in the documentation of the early life of the Latin American world and its importance to its native artistic following.

In Argentina traveller-reporter artists, or 'costumbristas', as they have been vaguely known, dominated the post-Independence scene during the decades of the Rosas dictatorship (1833–52), becoming in effect a resident community, with second- and third-generation native-born followers. Each artist had his own ways of depicting

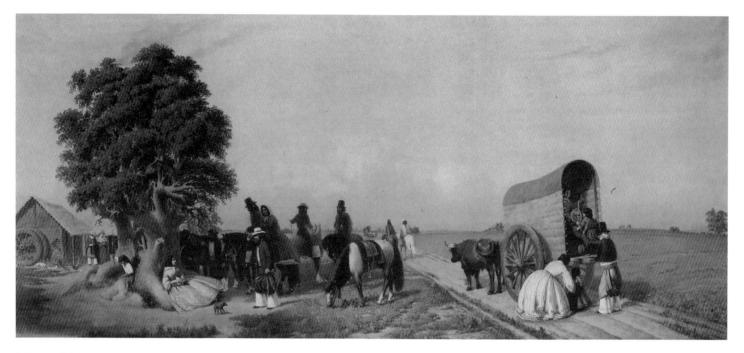

3.12 Prilidiano Pueyrredón, *A Rest in the Country*, c. 1860, oil on canvas, 76×166.5 cm., Museo Nacional de Bellas Artes, Buenos Aires.

both the picturesque and as often not-so-picturesque porteño life, with its grotesquely high-wheeled carretas, rough gaucho and soldier types, tent bazaars, its elegant indoor social life of theatre parties, female rivalries over dress and peineta, its country picnics, horse races and ostrich hunts, cattle round-ups and open corral abattoirs. The output of these artists, together with portraiture, both life-size and miniature, established an essentially representational and realistic norm of artistic practice, one that emphasized the particular, the typical and the natively characteristic, including the ironic and ridiculous. This mode of perception and expression continued in Argentina into the second half of the nineteenth century, influencing the quality of observation and new-found sense of home of native-born generations. It also laid the basis for a representational, socially aware tradition in art that anticipated, as did other Latin American work of this genre, the emergence in mid-to late-nineteenth-century Europe of strongly nationalist tendencies, as seen in the work, based on typical scenes from Spanish life, of Sorolla, Zuloaga, Zubiaurre and Fortuny.

From the precedent of this early down-to-life-as-it-is work, seen largely through the eyes of those newly arrived from Europe, came the first sharply differentiated examples of Argentine national art: the sensitively painted battle scenes and portraits of Carlos Morel, the inwardly reflective portraits of García del Molino, the panoramas by Cándido López of troop formations in the Paraguayan war, and the stately portraits and pampa landscapes of Prilidiano Pueyrredón [Pl. 3.12].

It happened that the first two of these important Argentine artists, Morel and García del Molino, were pupils of a Swiss painter, Josef Guth, who settled in Buenos Aires. Guth arrived from Paris in 1817, and within a year had established a drawing

academy in Buenos Aires; he was a widely respected professor of drawing in the University of Buenos Aires from 1822 to 1828. He became an Argentine citizen, and remained in the country until his death, in Entre Rios province, at an unknown date.

According to Alfredo Boulton's meticulously researched Historia de la Pintura en Venezuela – Epoca Nacional (1968), the earliest visiting recorders of the Venezuelan scene following Independence were British. They were visitors to or residents of Caracas or the near-by port of La Guaira, and nearly all were painters of portraits. Sir Robert Ker Porter, British Consul-General and Chargé d'Affaires at Caracas from 1826 to 1841, had trained as a portrait painter at the Royal Academy, and made carefully observed notebook sketches of the environs of Caracas with a late-eighteenth-century verve that pinpointed details of nature. It was the velvety neo-classic style of late-Georgian portraiture that prevailed, however, and in the small coterie of prominent persons, both natives and foreigners, cultivating international taste in the arts, it set a remarkably high, if conventionally British standard of taste, for its time and place. Indeed that style soon became part of Venezuelan tradition, modifying the patrician bearing of the mid- and late century portrait subjects of Tovar y Tovar and Herrera Toro. Yet there was a dichotomy in the portraiture of post-Independence Venezuela: the genteel neo-classicist manner of the early outsiders contrasts sharply with that of the formidable native portraitist, Juan Lovera, whose images of darkly clad founding fathers and eminent republican gentry have an almost New England puritan moralistic severity.

Between 1842 and 1846, after the eastern parts of Gran Colombia had split off to form the sovereign state of Venezuela, the versatile Prussian landscapist, Ferdinand Bellermann, toured that country as its first major traveller-reporter artist. Accompanied by his countryman, the naturalist Karl Moritz, Bellermann went from east to west painting in a vigorous style with rich impasto and spirited light and colour. Although his method of building compositions from dark to light to highlight, using an overall greenish-brown palette, places Bellermann's work in the late continental baroque tradition, as Boulton says, this artist captured for the first time the individuality of the Venezuelan landscape, opening native eyes, used to pastoral tranquillity, to its dynamic aspects [Pl. 3.13].

Within six years there arrived in Venezuela two artists from the island of St. Thomas, the Danish marine and landscape painter, Fritz Georg Melbye, and the twenty-two-year-old Camille Pissarro, whom Melbye found sketching in Charlotte Amalie and persuaded to leave home and his future in the family import-export business.

Together the two men spent two years drawing and painting the coastal and interior landscapes of Venezuela [Pl. 3.14]. Pissarro determined to become a full-time artist, and soon after his return to St. Thomas in 1854 he left permanently for France, later to become the 'patriarch of Impressionism'. Cézanne's comment, that Pissarro had the advantage over his fellow Impressionists through having

3.13 Ferdinand Bellermann, View of La Guaria, 1842-6, Collection Alfredo Boulton, Caracas.

3.14 Camille Pissarro, *View of La Guaria*, 1851, watercolour on paper, Private Collection.

3.15 Carmelo Fernández, frontispiece for Agustin Codazzi, *Atlas Físico y Político de la República de Venezuela*, Caracas, 1841, 27×32 cm., Map Division, Library of Congress, Washington, D.C.

learned to draw directly from nature, rather than having to unlearn the lessons of the academy, sums up the effect of his travelling with Melbye the towns and villages, plains and woodlands of midcentury Venezuela. It also points to the traveller-reporter tradition, in Latin America and elsewhere, as a proving ground for the empirical method as a means of activating the intuitive and expressive processes of art.

Despite Humboldt's journey and report, and his enthusiasm for the rugged montane grandeur of the North Andean region of Gran Colombia, especially that of the high equatorial stretch between Bogotá and Quito, few artists in the traveller-explorer-reporter category appeared in the region before the mid-nineteenth century. Because of Humboldt's report, however, before the end of the 1830s the vastness of the area as the unexplored part of a tripartite national domain became a challenge and a lure to naturalists and geographers as well to artists, native as well as from abroad.

With Independence, the need to know, in order to govern, as well as to comprehend objectively the newly freed native land led to the first major Latin American initiatives in systematic geographical exploration involving artists. The Comisión Corográfica of the 1850s in its organization followed, perhaps deliberately, the eighteenth-century precedent of the Expedición Botánica of Celestino Mutis. The organizer and leading figure of the Comisión, the Italian engineer-geographer Agustin Codazzi, belongs in the category of traveller-reporter. Under the direction of Codazzi - whose dedication to the mapping of vast areas of the South American mainland had already led to his and Fernández' enormously successful Atlas Físico y Político de la República de Venezuela (1841) [Pl. 3.15] - the Comisión Corográfica assembled a group of painters, writers, botanists and cartographers who took ten years (1850-9) to chart the physical, political and human geography of the republic of neighbouring Nueva Granada (later the United States of Colombia)

in each of its highland, coastal and tropical provinces; they left a visual record in some 200 perceptive watercolour drawings, many of the finest by Fernández [Pls 3.16,17]. Supported by the Colombian President of the time, José Hilario López (1849-53), the undertaking was a direct descendant of Humboldt's mission for the Spanish Crown some fifty years earlier. It was also a further application of the European Enlightenment's principles of empirical investigation and knowledge-gathering, now associated with rational control of its own affairs by an autonomous state, and carried out in part by local artists to gain an understanding of their native patrimony. Its legacy to Colombian art has been a wider appreciation of the physical setting of the territories and of their diverse populations, and finally a recognition of that setting as a subject for artistic interpretation. The natural riches of the country were given vigorous treatment in the 1940s and '50s in the mangles, condores, flores carnivoras, sortilegios, and similar themes of the Colombian modernist, Alejandro Obregón.

3.16 Carmelo Fernández, *Meztizo Farmers of Anis, Ocana Province, Colombia*, 1850-9, watercolour, Biblioteca Nacional de Colombia, Bogotá.

3.17 Carmelo Fernández, *Notables of the Capital*, *Santander Province*, *Colombia*, 1850-9, watercolour, Biblioteca Nacional de Colombia, Bogotá.

With the coming to Latin America of national academies of art (see Chapter 2) on the post-Revolutionary French model, neo-classicism became the approved standard in art and for the patronage of art by the creole upper classes, as well as the basis for instruction in art throughout both American continents. In the Antilles Spain provided the model for the San Alejandro Academy in Cuba, and England's Royal Academy for Haiti's beginning of art instruction during the monarchy of Henri Christophe. The San Carlos Academy in Mexico and the Le Breton Mission in Brazil – the latter with its offspring, the Escola Nacional de Belas Artes in Rio de Janeiro – set the example that was followed, under republican rule, by the academies founded in mid-century in Chile, Colombia, Venezuela, part of a continuing policy of state patronage of the arts following European royal tradition.

In Mexico, the forerunner of a national art was a state institution established in the late colonial period. The royal mint, La Moneda, where coins were designed and struck, soon became the Royal Academy of the Three Noble Arts of Painting, Sculpture and Architecture, and was so chartered in 1785. From the beginning, the curriculum of what was later called the San Carlos Academy followed neo-classical principles: students were taught to draw, first from casts then from life, over an exacting twelve-year course, comparable perhaps to present-day medical discipline. Pedro Patiño Ixtolinque, thought to have been a full-blooded Indian yet, under the notably equitable provisions obtaining under Spanish rule, eligible as well as qualified for the directorship of the Academy, assumed that position in 1825, after Independence; he had fought - as had some members of Colombia's Expedición Mutisiana – among the *guerrilleros* of the Independence movements. The Academy, however, bereft of royal support in the aftermath of revolution, was forced temporarily to close. Patiño, a former pupil of the exacting master sculptor and architect, Manuel de Tolsá, continued from his respected position to work on monuments to the heroes of Independence, in the classical style to which he was devoted. However, he introduced themes and symbols of the new Mexican nation, in a spirit and manner of working that reflected, within the neo-classical mode, the self-consciousness of pre-Hispanic identity, thereby sowing the seeds of the indigenism that was to become the focus of renascent Mexicanidad towards the end of the nineteenth century. Noreña's monument to Cuauhtémoc (1887) on the Paseo de la Reforma is still grandly in neo-classical guise.

Thus, following the models and the discipline of the officially sponsored San Carlos Academy, Greek and Roman art was the criterion of excellence in Mexico throughout the century; and this neo-classical standard applied as well in most other Latin American centres where state academies were established from the midcentury onwards. But the prevailing norm of style did not preclude variations in theme and expressive treatment among strongminded students and professors whose creative impulses rebelled against the imitation of imported models. Although instruction in

the Mexican academy during the long period from its eighteenthcentury inception to the end of the Díaz era kept well within the range of general academic practice, at periods of decline, as Charlot has shown, nationalistic inflections can be seen in the pose, features and mood of the prescribed antique subjects copied and in the frozen postures of live models. On the other hand, at periods when state support and outside control of curriculum and instruction (i.e., through appointment of European artists to the faculty) were at their highest, the need of artists to express values rooted in native experience built to explosive proportions. A reaction against the staffing of the original San Carlos Academy exclusively by Spanish academicians set in as early as the first decade of its founding. Then, with the present century's social revolution, came the student strike that closed the school between 1910 and 1913. It opened again when a new director general, Ramos Martínez, began out-of-door classes in the suburban surroundings of Santa Anita; there, on a wave of plein airism, in the lively popular surroundings glowing with colour and sunlight, the pall of gloomy neo-classical draughting rooms was lifted.

The rigour and tenacity of the Mexican academic tradition may at times have exceeded that of Brazil, Chile, Venezuela and the other countries paying homage to European artistic prototypes, after the Napoleonic era. But in all the countries where neo-classicism was instituted as an a priori means of artistic regeneration, to fill the void left by the nullification of exclusively other-worldly criteria of creativity, it was destined to confront, eventually, the consciousness of actuality in the minds of artists. Those brought up in surroundings defined empirically and, through Independence, progressively made their own, instituted a self-liberating process that continues today.

In the course of its history, as Charlot further points out, the Mexican academy acted essentially as a foil for and a charge to the impulse towards creative independence. Among the artists who were trained there, the strictures imposed, if not always the teaching that conveyed them, produced in the long run the grit and technical command needed for the success of the Mexican mural renaissance. This is affirmed by Orozco in his stout defence of his student years at the San Carlos Academy.

The effects of neo-classical discipline on nineteenth-century Latin American art in the many countries where that discipline, in the training of professional artists, including those abroad, was centred in state-supported academies have yet to be measured. One consequence may be that rationality in art was built permanently into the Latin American creative make-up. It put a brake on, if by no means a stop to, individual Romantic tendencies until the end of the century. And in the 1920s it re-emerged both in form and structure in countries as far apart as Mexico and Argentina, in movements as seemingly opposed as indigenism and constructivism.

All the same, the limitations imposed by neo-classicism on the free choice of themes and manner of treatment diverged more and

more acutely from the artists' own experience of their native environment. The traveller-reporter artists were building more autochthonous frames of reference in their recording of scientific, ecological and social reality. Their activity was especially telling in the first of these spheres, the archaeological record that was accumulating of ancient cities, monuments and artefacts, from the first amateur sketches of ancient statues in the Guatemalan and Honduran jungles to the expressively detailed lithographs by Frederick Catherwood of Maya sculpture and architecture [Pls 3.56-9] and the precision photographs of Desiré Charnay in the Yucatán. The work of these and others brought to native consciousness, through the medium of archaeological and popular publications, the millennial origins and the grand scale of native American civilizations. Thus new distinctions were drawn to counter artistic judgements that had made 'native' a synonym for inferiority and set external standards for cultural acceptance or exclusion.

The 'ecological' observations of traveller-reporters became a focus for appreciating a diversity in nature far greater than had been perceived before the Enlightenment; thus there was great interest in the sweeping panoramic landscapes of the Valley of Mexico by José María Velasco (whose first published work, in scientist-reporter style, was on the flora of Mexico City's environs); in the latenineteenth-century intimist landscapes of the Colombian highland savannah by González Camargo (in contrast to those of others who used this idyllic natural scene to convey essentially European, late-Romantic sentiment); in the humble surroundings to which the early-twentieth-century Venezuelan landscapists, Federico Brandt and Edmundo Monsanto, and their followers turned in their discovery of native values, as did also the Chilean impressionist painter of teeming country rosebushes and farmyard scenes, Juan Francisco González.

By their wide-ranging depiction of popular life in the country and city, the continuing customs of Indians, the fashions of the upper classes and their imitation by the fledgling middle class, the reporters on the social scene opened up the greatest number of possible subjects conducive to native and thus national aspirations. Reaching into all phases of Latin American life, their work stimulated the native would-be artist to pursue the same genre and soon led to the appearance of noteworthy artists and schools: the mulatto diarist of Limenian street life, Pancho Fierro, in Peru; J. G. Tatis and Torres Méndez, with their characterizations of city and country life in Colombia; the youthful itinerant artist Juan Cordero; the rich tradition of provincial portraiture, *retablo* and *pulquería* wall painting in Mexico which anticipated Hermenegildo Bustos' striking images; the vivid social tensions and contrasts of the Porfirian world of José Guadalupe Posada.

The cumulative effect of all the categories of traveller-reporter activity on the academic neo-classical tradition was first to divert, and finally to replace it. It was primarily in landscape painting, where compositions could be based on careful study of the Mexican

natural scene, that classical themes could be bypassed while keeping within permissible restraints of perspective, balance and colour. Epitomizing this approach are the Mexican landscapes of Velasco, which can be seen as a fulfilment of both classical and Romantic ideals of the late-nineteenth-century tradition in Western landscape painting, as well as a culmination, in this genre, of the empirical legacy of the traveller-reporter in the Western hemisphere.

The broader effect of that legacy for New World artists was, of course, to replace the ideal world of the neo-classical tradition with their own natural world, in all the phases and elements available to human perception, as a subject for their ordering and re-creation. That hundred-year process was a corollary of the gradual replacement in Latin America of the old forms of outside rule with a new social, ethical and political order having self-determination as its basis, both in society and in art.

A prominent art-historical view holds that the colonial style of art in Latin America survived into the late nineteenth century. ¹⁰ This, of course, does not preclude the theory that the intuitive and empirical processes of artistic invention which emerged at the start of the nineteenth century were brought about by Independence. The critical question, however, is what replaced the previously dominant styles, and what resources were available to later artists, especially when almost all elements of continuity had been removed by the establishment of a new philosophical attitude, comprehensively secular in its outlook. The traditional scholarly approach to such a question is to ponder the evidence of history, once a new style has emerged, and then go back to check on its evolution ex post facto. But for purposes of historiography an approach more in keeping with the empirical interest in process, stages of development, and based on a knowledge of sources, would be to consider stages of development as valid for artistic appraisal as the overall end result of evolution, thereby broadening the basis of critical enquiry into emergent areas of creative innovation. Indeed, if the many stages of Picasso's art had not been followed as they occurred, where, post mortem, would one start in reconstructing them and, indeed, what would one have if one did?

Such has been our purpose in reviewing some of the effects of the new universal attitude towards direct experience on the art of the New World: how the various models it brought were used as the basis for a new beginning over a much broader range of Western and indigenous traditions in art than had been true under colonial conditions – and how this process constitutes a clear beginning of the art of the modern world in the Latin American parts of the Western Hemisphere.

3

ii. Nature, Science and the Picturesque

In the decades following Independence, the number of foreign travellers to the new republics increased dramatically. The great curiosity in Europe about these lands that were virtually unknown—and to a large extent still unmapped—among scientists, and the lay public, and also in commerce and industry, led to a flood of books and sumptuously illustrated albums ranging from detailed studies of flora and fauna to picturesque scenes of the land and its inhabitants.¹

Although produced for Europe, these albums, as well as paintings and prints by the traveller-artists, quickly became known in America. The period in which they appeared, following Independence, was one of radical changes in the political and social consciousness of the new nations - a period of self-discovery as well as reform, of seeing the land and its opportunities with new eyes. Between the European-dominated 'high art' of the academies, and the relatively hidden traditions of popular art - the local and often anonymous artists in towns and villages who, during the colonial period, painted portraits, ex-votos and devotional images - arose an impetus to make images relevant to a new or newly perceived reality. The relationship between this impetus and the great wealth of information and of unaccustomed visual modes embodied in the work of the European scientist- and artist-travellers will be explored here through a series of visual encounters: 'una confrontación de miradas'.2 Because although it is true, for instance, that the development of landscape painting - for which there was little precedent within Latin America - owed much of its special character to the traveller-artists, and the 'costumbrismo' that entered the repertoire of many Latin American artists at the time was derived from the long-standing taste in European art for the exotic, it is none the less the case that it was not simply a matter of dependence. There is obviously a difference between the mobile traveller depicting the, to him or her, new and strange, and the resident artist for whom this is part of a continuum of familiarity. At the same time, this familiar world may reveal its potential for artistic investigation in response to a stranger's view, and in this area, the adaptation of European modes of depiction to local traditions and sensibilities, much remains to be explored.

The long history of European images of America goes back to the first moments of contact.³ The unexpected existence of another continent, interrupting the westward passage of the European merchants to the rich spice islands of the East, had had a profound effect

upon Europe's consciousness of itself in the world. Accounts of this new continent were to swing between emphasis on similarity to and on difference from Europe – but mostly on difference, sometimes to the extent of declaring America the offspring of a quite separate Creation. The idea that it was actually younger than the Old World was very common, and still lingers in the work of the greatest scientist-traveller, Alexander von Humboldt, at the beginning of the nineteenth century. The very terms 'discovery', 'New World', 'le nouveau continent', underline the euro-centric nature of descriptions of the lands which, for Europe, completed the globe, and also point to a certain concept of the passivity and immobility of those lands, waiting for the active, mobile Old World explorer.

Travellers' tales and images of these lands and of the people who lived there had gripped the imagination of the Old World and supplied it with myths to replace the old legend of lost Atlantis. The New World was a paradise on earth; a land stuffed with gold and silver mines; inhabited by cannibals, or by a race rivalling the ancient Greeks, or by the lost tribe of Israel. Those stories in particular which told of a people living in a pre-Adamic state of nakedness and innocence, without government or laws, fuelled some of the Old World's central preoccupations, especially with the concepts of nature and civilization, and freedom and slavery. One of its most potent myths, that of Utopia, was first named by Sir Thomas More who based his story of a harmonious and rational land on accounts of the New World.

While the Spanish colonies had remained virtually closed to foreign contact, the situation in Portuguese America had been somewhat different. During the Dutch occupation of large parts of Brazil between 1630 and 1654, the Dutch colonial governor, Count Maurits of Nassau, commissioned a number of artists and scientists, including Franz Post and Albert Eckhout, to record the natural history of the country. Post's landscapes are extremely unusual for the time among representations of America, in that they

3.19 Frans Post, *The Ox Cart*, 1638, oil on canvas, Musée du Louvre, Paris.

are neither purely topographical nor allegorical. He painted rural scenes, cultivated river valleys with boats and ox carts, to which he sometimes added, in close-up contrast at the edge, tropical trees, lianas and orchids. A painting like The Ox Cart [Pl. 3.19], in the Louvre, probably helped inspire the imaginary jungles of Le Douanier Rousseau. Eckhout painted still lifes of tropical fruit - guava, pineapple, peppers, etc. - on a large scale, holding a balance between botanical precision and a luscious sensuality not untypical of Dutch still-life painting of the period [Pl. 3.20]. Eckhout also painted careful studies of single figures [Pl. 3.21] of different ethnic groups - Brazilian Indians, blacks and mestizos - which are variations on the portrayals of trades and costumes in popular prints well known in Europe from the mid-sixteenth century. Eckhout's paintings of the inhabitants of Brazil had, it seems, little success in Europe,⁵ but they are important reminders of the long-standing links in European images of America between natural history, ethnography and 'costume' [Pl. 3.22].

Two other major scientific projects, immediate predecessors to Humboldt, were destined to remain unpublished until this century. In the early 1780s Alexandre Ferreira, who had studied Natural Philosophy at Coimbra University, was commissioned by the Portuguese government and Queen Maria I to 'study the economic possibilities of Nature's Three Kingdoms and the ways of life and habits of the population, especially the Indians'. The draughtsmen accompanying Ferreira were Joaquín José Codina and José Joaquín

3.20 Albert Eckhout, *Tropical Harvest*, 1640-3, oil on canvas, The National Museum of Denmark, Copenhagen.

3.21 Albert Eckhout, *Tarairiu Woman*, 1641, oil on canvas, The National Museum of Denmark, Copenhagen.

3.22 Zacharias Wagener, 'Mameluca', from *Livro dos Animals*, 1643-41, Cabinet of Prints and Drawings, Staatliche Kunstsammlungen, Dresden.

3.23 Leandro Joaquim, View of the Lake of Boqueirão and the Aqueduct of Santa Teresa, c. 1790, oil on canvas, 86×105 cm., Museu Nacional de Belas Artes, Rio de Janeiro.

Freire; the rich material they gathered (including quantities of what would later be termed 'ethnography': watercolours of circular Curuto Indian huts, Indians of Rio Branco or Tucuna, with masks, clothes, and face and body painting), which was to have had the title 'Viagem Filosofica', was stolen during Napoleon's ransacking of Portugal, and remained unedited and unpublished until the twentieth century. Similarly, the thousands of fine botanical drawings by Celestino Mutis and his followers in Bogotá (see chapter 3: I) were shipped back to Europe during the violent years of Independence, to be published finally in the 1950s.

Such material was potentially of great practical use to the hungry colonizing powers of Europe. The disinterested scientist and the invading exploiter had in common a need for accurate geographical and geological information, for the precise mapping of coasts and harbours, and for knowledge about the dispositions of the inhabitants and the possibilities of cultivation. It was probably in this context that Humboldt was granted a passport in 1799 by the Spanish king, Carlos IV, to travel freely in his American dominions, for Humboldt was trained as a geologist specializing in mines.

Humboldt was the greatest of the new kind of scientific explorer, bred of the Enlightenment, who, armed with a passion for accuracy and the new instruments with which to satisfy it, opened up a period of investigation which was often compared with the original discoveries of Columbus. Although Humboldt's five-year journey preceded Independence, he was associated with it both in Europe (where he met Bolívar) and in America, because of his liberal inclinations, and subsequently his name was invoked in the context of reform, and in scientific and cultural education programmes.

Humboldt shared his passion for nature with artists and poets of his age such as Goethe, Wordsworth, Constable and Turner, but

for him the passion was translated into a zeal to map, measure and record it. With his botanist collaborator, Bonpland, he travelled through the American continent on foot, by mule and boat, mapping and measuring as he went, collecting thousands of specimens, and sketching all the time. In the nearly thirty years it took, after his return, to compile and publish the 30 volumes of the Voyage de Humboldt et de Bonpland, close to 1,500 coloured and black and white plates were prepared, by artists working from his sketches and under his close supervision. There were seven volumes of botany, plus zoology and comparative anatomy, physical and geographical atlases, astronomy, political essays on New Spain (Mexico) and Cuba. The most popular volume of all was the Atlas pittoresque: Vues des Cordillères et monuments des peuples indigènes de l'Amérique. Fully aware that this volume was a 'mélange', Humboldt justified it on the grounds that an 'Atlas pittoresque' was in a different mode from the 'discours soutenu' of the more obviously scientific volumes, and variety here could be a positive feature.⁷

The Atlas includes the famous views of the volcanoes, including Chimborazo [Pl. 3.25], drawings of pre-Conquest ruins, Aztec and Peruvian sculpture, a remarkable dissertation on American picture-writing and calendar systems, and native myths, and linguistic ana-

3.25 Alexander von Humboldt, 'Chimborazo seen from the Tapia Plateau', from Voyage de Humboldt et de Bonpland, Première Partie; Relation Historique: Atlas pittoresque: 'Vues de Cordillères et monuments des peuples indigènes de l'Amérique', Paris, 1810, The British Library Board.

3.26 Alexander von Humboldt, 'Costumes drawn by Mexican Painters from the Time of Montezuma', from Voyage de Humboldt et de Bonpland, Première Partie; Relation Historique: Atlas pittoresque: 'Vues des Cordillères et monuments des peuples indigènes de l'Amérique', Paris, 1810, The British Library Board.

3.27 Alexander von Humboldt, 'Costumes of the Indians of Michoacan', from Voyage de Humboldt et de Bonpland, Première Partie; Relation Historique: Atlas pittoresque: 'Vues de Cordillères et monuments des peuples indigènes de l'Amérique', Paris, 1810, The British Library Board.

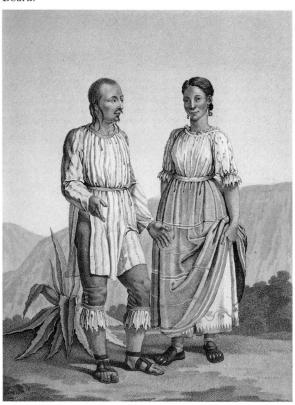

lyses with a table of languages comparing American with Tartar languages, proving that the former are as remote from one another as from Tartar. The cultural remains of the original inhabitants had, in Humboldt's view, historical as opposed to aesthetic value, but as such they would interest the 'philosophical study of man'; the land-scapes he describes as 'picturesque views of the most remarkable sites of the new continent'.

Humboldt's project, which laid the basis for the modern study of physical geography, and what we now call ecology, did of course stress accuracy of observation and measurement, but also the interlinkedness of the natural world and its structure, the plant in its context (the mapping of all the plants on Chimborazo at their correct heights, for instance), and of cultures within their physical setting. He ascribed the superiority of the civilizations of the Aztec and Inca to the fact that they were mountain peoples.

Although there is relatively little *costumbrismo* in the *Voyage*, Humboldt did sketch incidents from his travels, and the *Atlas* includes a small number of drawings of Indians from Michoacán in costume, which were in fact based on little wooden figurines he brought back to Germany [Pl. 3.26].⁸

Many of the albums that followed Humboldt's in the nineteenth century, while not attempting his universal coverage, still contain a mixture of the scientific and the picturesque. Ramón de la Sagra, director of the botanical gardens in Havana, published an Atlas physique, politique et naturelle de Cuba [Pl. 3.28], as well as an Histoire physique de l'Ile de Cuba in 12 volumes. Claudio Gay, who lived for twelve years in Chile, published 24 volumes of Historia Física y Política de Chile, with two volumes of an accompanying Atlas of lithographs (1854). One is devoted to fauna; the other, under the general title 'Historia de Chile', is not history in a conventional sense, but a mixed selection of plates of landscapes, cityscapes, pastimes, social gatherings, trades and costumes, ending with the customs of the Araucanian Indians. As with Humboldt, the plates were based on pictures by various artists. A number of lithographs in Gay are by Lehnert, based on Gay's own sketches, or on those of one of the most influential of all the traveller-artists, Rugendas. Gay used both landscapes and costume scenes by Rugendas, and his Costumes of Country People [Pl. 3.29] shows a group of gauchos. Such plates were probably a source for the Uruguayan artist Blanes, who painted a series of small-scale but highly finished oil paintings of pampas life. His moody and often solitary gauchos, however, are lifted out of their costumbrista context and given atmospheric titles like Aurora (dawn) and Crepúsculo (dusk), Amenecer (early morning) and Atardecer (evening) [Pls 3.31,32,33,34].

The three-volume album by the French artist Jean-Baptiste Debret (see Chapter 3:i), *Voyage pittoresque et historique au Brésil*, published between 1834 and 1839, is still valued in Brazil today as a source for its ethnographic and social information as opposed to artistic interest. Debret himself made all the watercolours and

TROGON temnurus. Cemm.
Valg. TOCORORO.

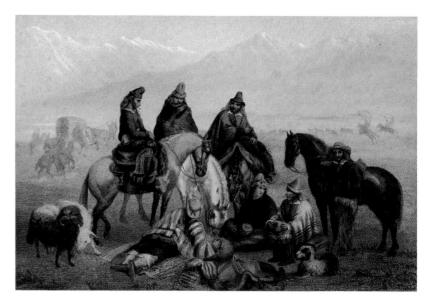

3.29 Claudio Gay, 'Costumes of Country People', *Atlas de la História Física y Política de Chile*, Paris, 1854, Vol. 2, The British Library Board.

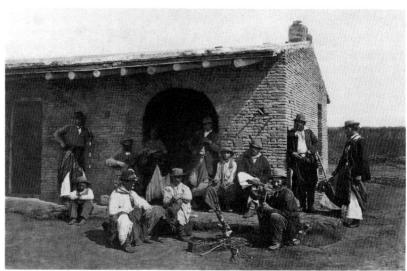

3.30 Benito Panunzi, *Argentinian Gauchos*, 1865, albumen print, 22×30.5 cm., Hoffenberg Collection.

drawings for the plates of the album. They provide a quite exceptional series of lively images of Brazilian society [Pls 3.35-40], unusually free of *costumbrista* stereotypes. Debret believed, like many of his contemporaries, that the Indians were at an earlier stage of development than 'civilized' European and creole society. 'Je me suis proposé de suivre dans cet ouvrage le plan que me trace la logique. C'est à dire, la marche progressive de la civilisation au Brésil. Dès lors j'ai du commencer par reproduire les tendences instinctives de l'indigène sauvage, et rechercher pas à pas ses progrès dans l'imitation de l'industrie du colon brésilien, héritier lui-même des traditions de sa mère-patrie.' These first contacts, Debret goes on, were brutally interrupted by the greed of the European sovereigns, which led to the betrayal of the Indians, appalling struggles, the temporary abandonment of attempts to subdue them and the introduction of slavery.

The first volume of Voyage pittoresque shows, in considerable

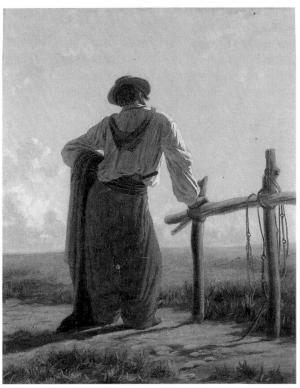

3.31 Juan Manuel Blanes, *Dawn*, n.d., oil on cardboard, 28×23 cm., Museo Municipal Juan Manuel Blanes, Montevideo.

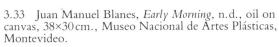

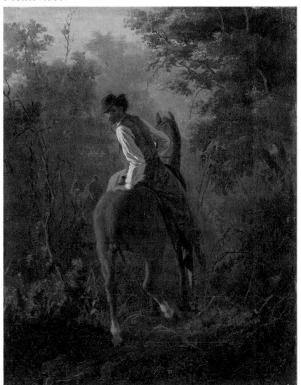

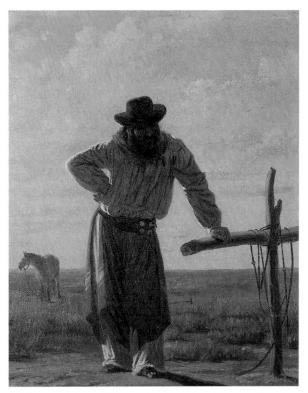

3.32 Juan Manuel Blanes, *Dusk*, n.d., oil on cardboard, 28×24cm., Museo Municipal Juan Manuel Blanes, Montevideo.

3.34 Juan Manuel Blanes, *Evening*, n.d., oil on canvas, 36×30 cm., Museo Nacional de Artes Plásticas, Montevideo.

3.35 Jean-Baptiste Debret, *Native Village in Cantagalo*, n.d., watercolour on paper, 19.9×26.9cm., Ministério da Cultura/FNPM/Museus Raymundo Ottoni de Castro Maya, Rio de Janeiro.

3.36 Jean-Baptiste Debret, *Hunt Presided by the Emperor of St-Esprit*, 1826, watercolour on paper, 15.5×21.2 cm., Ministério da Cultura/FNPM/Museus Raymundo Ottoni de Castro Maya, Rio de Janeiro.

3.37 Jean-Baptiste Debret, *Banha de cabellos bem cherosa*, 1827, watercolour on paper, 15.7×21.4cm., Ministério da Cultura/FNPM/Museus Raymundo Ottoni de Castro Maya, Rio de Janeiro.

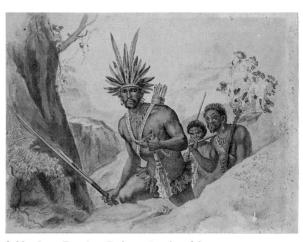

3.38 Jean-Baptiste Debret, *Leader of the Bororenas Setting off to Attack*, n.d., watercolour on paper, 24.3×32.8 cm., Ministério da Cultura/FNPM/Museus Raymundo Ottoni de Castro Maya, Rio de Janeiro.

detail, Indians like the Botacudos or the Coroados, presented in close conjunction with tropical fruits and vegetables, and the virgin forest, as though they are thought of as part of nature. Debret also depicts 'civilized' Indians, wearing European clothes, and often assisting bands of soldiers to capture the 'forest' Indians [Pl. 3.61]. These were the raiding parties known as 'bandeirantes', pushing far inland to seek slaves, but today honoured as pioneers. The habits and costumes of the urban dwellers, the creoles, are depicted with a sardonic eye.

The most popular albums, however, were those containing land-scape views and costumbrista scenes, and it was in those areas that the 'confrontación de miradas' between European and Latin American artists can best be examined. Joseph Skinner published The Present State of Peru in 1805, which included engravings of Indians in mythological European costume, as in The Minerva of Peru [Pls 3.41,42]. Daniel Thomas Egerton, one of the best of the English landscape painters to visit Latin America, produced Egerton's Views of Mexico in 1840. Typical of the accomplished amateur artist of the time was Emeric Essex Vidal, who was stationed as a young man on the Hyacinth (on the river Plate) in the role of paymaster, and drew and

3.41-2 Joseph Skinner, two plates from *The Present State of Peru*, London, 1805, Collection A. Burton-Garbett.

3.43 Jean-Baptiste Debret, *Garlic and Onion Seller*, 1826, watercolour on paper, 15.5×20.9cm., Ministério da Cultura/FNPM/Museus Raymundo Ottoni de Castro Maya, Rio de Janeiro.

3.44 Henry Chamberlain, Street Vendors, n.d., watercolour on paper, 15×22 cm., Museu de Arte de São

3.45 Daniel Thomas Egerton, *Travellers Crossing the Brook*, n.d., oil on canvas, 25×36 cm., Banco Nacional de México S.N.C., Mexico City.

painted watercolours of life in the new republic - gauchos, country races, streets and markets; 25 of these were reworked for publication in Picturesque Illustrations of Buenos Ayres and Montivideo of 1820. Augustus Earle, who was with Darwin in the Beagle in 1831, sketched scenes of life in Chile, Edward Walhouse Mark made watercolours in Colombia, and Chamberlain in Brazil. Claudio Linati, the Italian artist who introduced lithography into Mexico, provided costumbrista illustration for Lt. R. W. H. Hardy's Travels in the Interior of Mexico 1823-28, published in London in 1829. Linati's own Costumes civils, militaires et réligieux du Mexique, which was published in Brussels in 1828, is one of the most interesting and liveliest of the more specialized albums. In spite of its title, it is considerably more than a book of picturesque costumes of trades, professions and regions (though it contains these too), for it includes historical figures, each carefully commented on and chosen out of a clear commitment to Mexican ideals of independence and reform. The first plate depicts Montezuma, and Hidalgo [Pl. 1.26], Morelos and Fray Gregorio are all included.

The 'picturesque' views and scenes, in prints and in paintings, by the European travellers need to be understood in the context of European taste and thought of the time; the appreciation of landscape had become in Europe in the latter half of the eighteenth century one of the tools of cultivated taste, whether in terms of sketching, describing or simply looking at it. An increasing preference for the wild and remote was shared by artists, writers, and those who could afford to travel. (Crossing the Alps on the Grand Tour became an experience to be valued in its own right, rather than a necessary hazard before reaching civilization in Rome.) Informing these preferences were the ideas of Edmund Burke, and of William Gilpin. Burke's Philosophical Enquiry into . . . the Sublime and the Beautiful gave a new reading of the old aesthetic concept of the sublime that was to have a long-lasting influence. ¹⁰ He argued that our strongest emotion was fear (deriving from the instinct of self-preservation), and that therefore whatever had the power of overmastering us, and provoking sensations of awe and terror, aroused the strongest feelings of which we are capable, and could be described as 'sublime'. Burke drew his examples from literature and from nature, and the language he uses is constantly echoed in the description of awesome natural sights, like cataracts, storms, mountain crags in Romantic literature, and can be linked too to such paintings as de Loutherbourg's Avalanche in the Alps.

However, the qualities Burke named as contributing to the 'sub-lime' – vastness, darkness, obscurity – did not recommend themselves immediately as suitable for *visual* expression, and it is here that Gilpin's ideas, admittedly more limited theoretically, intervene. They had a widespread influence on artists, for he was concerned with specifically pictorial questions. Writing for professional artists and sensitive amateurs alike, he proposed in his *Three Essays on Picturesque Beauty; on Picturesque Travel; and on Sketching*

Landscape a series of rules for guidance in their approach to landscape, to help them select for pen or brush those aspects of strongest pictorial interest. He argued that broken contours and rough surfaces were to be preferred, aesthetically speaking, over the smooth and uniform. So, objects that were rough, rugged, ruined, broken, old and wild were to be preferred, as were prominent as opposed to harmonized and monotonous features in nature; these satisfied the twin demands of variety and being 'natural'. Wooded hillsides, mountain streams, cottages, ruined castles, gypsies, became the staple of 'picturesque taste'. The consequences of Gilpin's ideas for the artist were satirized by Rowlandson [Pl. 3.46].

Although attitudes to nature in terms of the picturesque were more clearly defined in England – too clearly defined, according to Wordsworth, who considered that the picturesque theorists discriminated presumptuously with regard to nature – the sense that nature should be sought in the wild and the untouched, that it was the opposite of civilization, was shared throughout Europe. Perceived in terms of a dialectic between nature and civilization, this taste for the wilder kinds of landscape can be seen as running parallel to the scientific passion for natural history.

This was the background from which so many of the travellerartists came, like Egerton and Rugendas, and which influenced their choice of subjects like volcanic craters and mountain crags and torrents, as well as the softer topographical views [Pls 3.45,47,48,49,50]. It also helps to account for the immense fascination with the ruined cities of the old Indian civilization, above all those of the Maya in the tropical forest regions.¹¹

The English artist Frederick Catherwood accompanied the writer John Stephens, from the United States, in his detailed exploration of the Maya regions. *Incidents of Travel in Yucatán* (1843) contained 120 engravings from 'Daguerreotype views and drawings taken on the spot by Mr Catherwood and . . . executed under his personal superintendence'. ¹² A superior mixture of archaeolog-

3.46 Thomas Rowlandson, *Dr Syntax in Search of the Picturesque*.

3.47 Agostinho José da Mota, *Factory at Barão de Capanema*, *c.* 1862, oil on cardboard, 35.2×52 cm., Museu Nacional de Belas Artes, Rio de Janeiro.

3.48 José Grijalva, *Workers on the Railway at Chiguacan*, 1907, oil on canvas, 72×93.5 cm., Museo de Arte Moderno, Casa de la Cultura Ecuatoriana, Quito.

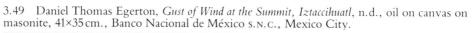

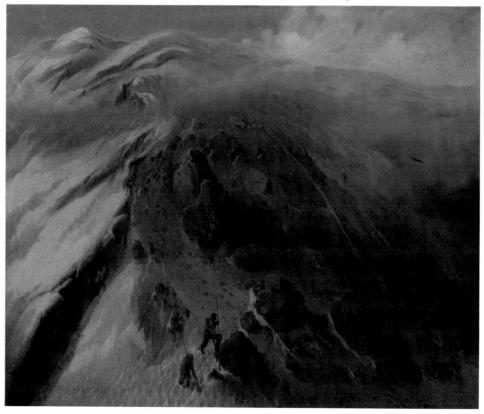

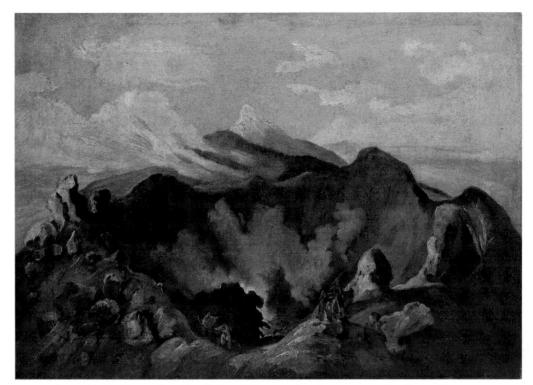

3.50 Johann Moritz Rugendas, *The Colima Volcano*, n.d., oil on canvas, 67×48 cm., Banco Nacional de México s.n.c., Mexico City.

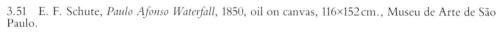

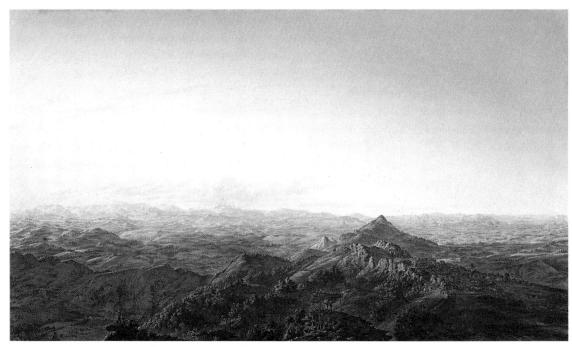

3.52 Nicolau Antonio Facchinetti, *São Tomé das Letras*, 1876, oil on panel, 56×93 cm., Museu Nacional de Belas Artes, Rio de Janeiro.

3.54 Rafael Troya, *Cotopaxi*, 1874, oil on canvas, 93×161 cm., Museo 'Guillermo Perez Chiriboga' del Banco Central del Ecuador.

3.55 Andrés de Santa Maria, The Gleaners, 1895, oil on linen, $80.5\times106.5\,\mathrm{cm.},$ Museo de Arte Moderno de Bogotá.

3.56-9 Frederick Catherwood, four plates from Views of Ancient Monuments in Central America, Chiapas and Yucatán, 1844, Royal Institute of British Architects, British Architectural Library, London.

ical report and travel tales, Stephens's book argued that the ruins had been built by the ancestors of those Maya who still lived in the area, a by no means widely accepted view at the time, and contributed to the accelerated interest in the Maya civilization during the nineteenth century.

Catherwood subsequently published a special volume of his Views of Ancient Monuments in Central America, Chiapas and Yucatán (1844), which included his drawing of the famous well at Bolonchén, still in use by the Maya at the time. Some of the plates in this book are concerned solely with the ruined cities and sculptures, in a Romantic rather than archaeological mode dominated by a nostalgia for vanished grandeur, but none the less still careful to render the details accurately [Pls 3.1,59]. Other plates, however, mix ruins with costumbrista scenes. Two plates [Pls 3.56,58] show a subtle difference in their portrayal of the local 'natives' - the women at the well draw water and are placed in the foreground; far less prominence is given to the group of Indian men in the other plate, who sit idly on the steps of the ruined house. Like Catherwood, Nebel mingled archaeological and costumbrista scenes; his Voyage pittoresque et archéologique dans la partie la plus intéressante du Mexique (1836) includes landscape scenes, as well as some of the most striking studies of picturesque costumes of different classes and from different areas in Mexico [Pls 3.62-9].

The European traveller came to America with the expectation of the remote and strange, and encountered a nature so much vaster and wilder than any he was familiar with, that the response was to exaggerate desolation and wilderness. Debret describes the European traveller 'stupéfait à l'aspect de chaos de destruction et de reproduction . . .' in the virgin forest of Brazil. The wild as he understood it was linked to a nature increasingly cornered and threatened by rapidly industrializing Europe, and never far from a more comfortable rural or pastoral scene. The pastoral, in a sense, did not exist in America (only among the Inca had there been any tradition of domestic animals), and the herding of cattle on the great open

3.60 Manuel de Araújo Porto Alegre, *Brazilian Forest*, 1853, sepia on paper, 54.5×82 cm., Museu Nacional de Belas Artes, Rio de Janeiro.

3.61 Jean-Baptiste Debret, 'Virgin Forest', from Fôrets Vièrges du Bresil, 1834-9, bound with Vol. 1. of Voyage pittoresque et historique au Brésil, 1834-9, The British Library Board.

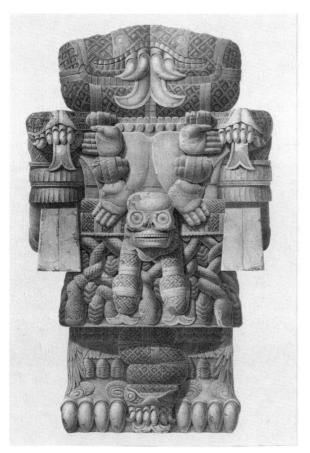

3.62-5 C. Nebel, four plates from Voyage pittoresque et archéologique dans la partie la plus intéressante du Mexique, Paris, 1836, The British Library Board.

3.66 C. Nebel, 'Indian charcoal-makers', from Voyage pittoresque et archéologique dans la partie la plus intéressante du Mexique, Paris, 1836, The British Library Board.

3.67 C. Nebel, 'Poblanas', from Voyage pittoresque et archéologique dans la partie la plus intéressante du Mexique, Paris, 1836, The British Library Board.

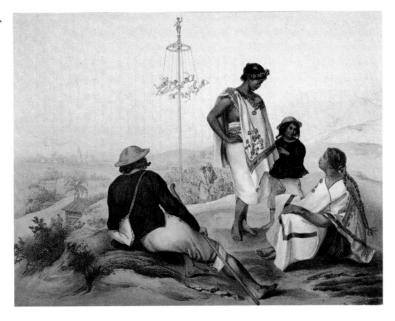

3.68 C. Nebel, 'Ranchers', from Voyage pittoresque et archéologique dans la partie la plus intéressante du Mexique, Paris, 1836, The British Library Board.

3.69 C. Nebel, 'Indians of the Sierra', from Voyage pittoresque et archéologique dans la partie la plus intéressante du Mexique, Paris, 1836, The British Library Board.

- 3.70 Pancho Fierro, *Doctor Valdez Busioni*, n.d., watercolour on paper, 23×18 cm., Museo de Arte de Lima.
- 3.71 Pancho Fierro, Marshall Castilla Walking over the Bridge, n.d., watercolour on paper, 23×18 cm., Museo de Arte de Lima.
- 3.72 Pancho Fierro, *Travelling Salesman*, n.d., watercolour on paper, 23×18 cm., Museo de Arte de Lima.
- 3.73 Pancho Fierro, *Friar Tomato*, n.d., watercolour on paper, 23×18 cm., Museo de Arte de Lima.

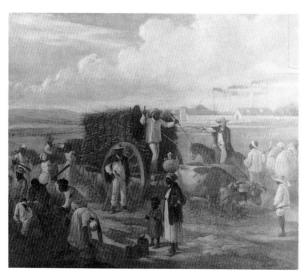

3.74 Víctor Patricio de Landaluze, *Sugar Cane Mill*, 1874, oil on canvas, 51×61 cm., Museo Nacional, Palacio de Bellas Artes, Havana.

pampas, as W. H. Hudson describes in Far Away and Long Ago, bears no relation to the enclosed farmlands of Europe. The terms in which the dialectic between nature and civilization was understood in Europe, then, and of which the picturesque was an aspect, did not correspond to the reality in America, and, while it was possible for the traveller to find scenes corresponding to his predispositions, these were heavily grounded in his European experience, and did not readily find an answering response from local artists. It was later in the century that American artists like Velasco developed a distinctive response to their own landscape.

The costumbrista side of the 'picturesque', on the other hand, the interest in costumes and customs, met a much more immediate response in Latin America and quickly fed into and was nourished by existing pictorial traditions and contemporary interests. The costumbrista works by European artists provided, in many respects, both models to be copied and an impetus to a new kind of social

3.76 Víctor Patricio de Landaluze, *A Little Devil*, n.d., oil on canvas, 35.5×26.5 cm., Museo Nacional, Palacio de Bellas Artes, Havana.

3.77 Víctor Patricio de Landaluze, *Soldier and Mulatto*, n.d., oil on canvas, 35.5×26.5 cm., Museo Nacional, Palacio de Bellas Artes, Havana.

observation, and directness of response to the world around them. The self-taught Pancho Fierro in Peru (see Chapter 3: I) made a series of watercolour sketches [Pls 3.70-3], not only of 'tipos' like the lottery seller and firework man, but also of characters of modern Lima who cannot be related to the *costumbrista* tradition. These hover on the edge of caricature; not infrequently the satirical printmakers contributing to the illustrated newspapers were also *costumbrista* painters.

The Cuban painter Víctor Patricio Landaluze, who was also director and chief caricaturist of the satirical illustrated review *Don Junípero*, painted colourful scenes of street and fiesta life, and also comic incidents of the French 'manners and morals' type [Pls 3.74,76,77]. The connection between traditions of caricature in these different countries of Latin America and *costumbrismo* is evident. The album of picturesque prints, for example, accompanying Claudio Gay's *Historia de Chile* (1854), includes two contrasting scenes of a 'tertulia' in 1790 and in 1840, in which the earlier includes a hint of caricature of provincial fashion. Numerous prints in Argentina in the 1830s satirize the more extreme fashions of the day – the gigantic tortoiseshell hair combs worn by society ladies were shown jammed in doorways and tangled in lovers' beards.

Torres Méndez, the Colombian artist, received no formal training, but became an apprentice in a printshop in 1824 at the age of fifteen. He produced some of the wittiest satires on contemporary society and politics, regularly contributing to *Los Matachines Illustrados*, which started in 1855. He was not only a caricaturist but an extremely skilled draughtsman from life; lithographs were made from his drawings, published as, for example, *Costumbres Neo-Granadinas*, some of which were printed in Paris. He was also a competent landscape and portrait painter; one of his last portraits was of Simón Bolívar for the centenary of his birth in 1883.

The representation of 'types' and local fiestas and processions in fact frequently entered the repertoire of local professional artists, as

3.78 Gusavo Lazarini, *Lady from Antigua*, 1941, watercolour on paper, 49.5×34cm., The Museum of Modern Art, New York; Inter-American Fund.

3.79 Ramón Salas, *Indian Mayor with Two Angels*, n.d., watercolour on paper, 15.2×11.5cm., Museo de Arte Moderno, Casa de la Cultura Ecuatoriana, Quito.

3.80 Ramón Salas, *Disfraces de Inocentes: Belermo, Mono y Baquero*, n.d., watercolour on paper, 16.5×13.5 cm., Museo de Arte Moderno, Casa de la Cultura Ecuatoriana, Ouito.

3.81 Ramón Salas, *Indian Waterseller from Quito*, n.d., watercolour on paper, 14.7×11.7cm., Museo de Arte Moderno, Casa de la Cultura Ecuatoriana, Quito.

3.82 Anon., 'Cafe de Escaurizà', from the *Historia Mulata*, 1862, tobacco label.

3.83 (right) Miguelzinho Dutra, *Human Type (José Veloso)*, 1843, watercolour on paper, 20.7×16.4cm., Museu Paulista da Universidade de São Paulo.

was the case with Torres Méndez. In Ecuador, Ramón Salas painted portraits and religious themes as well as a delightful series of watercolour figures [Pls 3.79,80,81], including the *Indian Mayor with Two* Angels and Indian Waterseller from Quito, the Indian watercarrier, carrying his burden in the traditional manner with a strap round his forehead. Joaquín Pinto, who, like Salas, was associated late in life with the newly formed School of Fine Arts in Quito, but who himself had been trained in an artist's studio, covers a wide range of subjects. He painted watercolour 'types', as well as folklore and local customs, and historical, mythological and religious themes [Pl. 3.85]. He was one of the first Ecuadorean artists to paint landscapes, too, specializing in mountain scenes, while his compatriot Rafael Troya concentrated more on tropical scenes [Pl. 3.54]. The Brazilian Miguelzinho Dutra painted, in a very naïve fashion, 'types' as well as portraits, and also architectural studies [Pls 3.83,84].

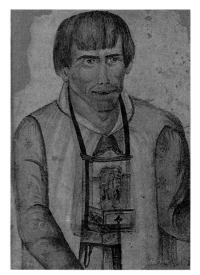

Besides *costumbrismo* in painting there were also figurines in wax and paper, often very finely made, which included a wide range of *costumbrista* types: the mounted *charro* and *charra*, priests, monks, Indians (semi-naked, usually, and with feather head-dresses), watercarriers, street vendors with their wares spread before them. Prototypes of the pottery, tin or paper figurines found today in many parts of Latin America, in part they owe their origin to wax figures of Christ of the colonial period.

The Mexican artist Arrieta was one of the most inventive of those painting 'picturesque' figure scenes [Pl. 3.90]. Trained in the Puebla Academy, his work bears comparison with seventeenth-century Dutch genre painting, especially the 'bodegón', or drinking scenes. It is interesting to compare him with, on the one hand, Pingret [Pls 3.89,91], and on the other Rugendas, both of whom worked in Mexico. Pingret, whose work has until recently been very little known, did a series of studies in oil on paper, notably of elaborately dressed charros and china poblanas. His technique is academic realism, although the figures are sometimes left on the sheet without a background, like specimens in a textbook, or single studies for an academic painting. Rugendas assembled his figures, often against a landscape background [Pl. 3.86], or in a street setting, and also painted much freer studies of local horsemen or crowds in Chapultepec Park. Arrieta is in many ways closest to Rugendas, in particular to the latter's street and market scenes, which he must have known. Rugendas' scenes remained, however, in spite of lively incidents and detail, frames for centrally placed costumbrista types. Arrieta integrates his figures more fully in their urban or interior setting; rather than remaining costumbrista specimens they become part of the life of the street or market, pulquería or fiesta [Pl. 3.90]. He arranges the scenes with considerable visual wit, and rather theatrical incidents.

Another Puebla artist, Manuel Serrano, painted domestic in-

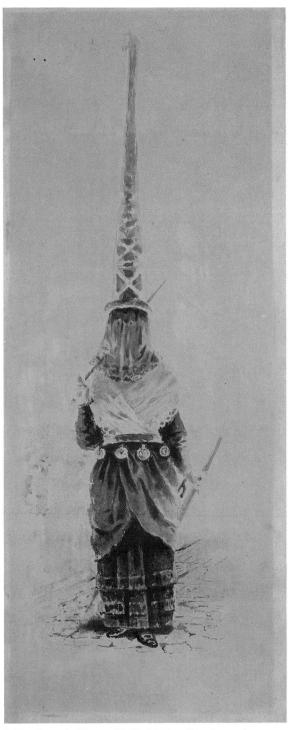

3.85 Joaquín Pinto, *All Souls' Day Disguise*, n.d., watercolour on paper, 32.5×13.2 cm., Museo Jacinto Jijón y Caamaño, Quito.

3.84 (facing page bottom right) Miguelzinho Dutra, *The Beggar (Pedinachão)*, n.d., watercolour on paper, 20×14cm., Museu Paulista da Universidade de São Paulo.

3.86 Johann Moritz Rugendas, Horseman with Two Rustics on the Road between Valparaiso and Santiago, 1843, oil on canvas, 61.5×89 cm., Baring Brothers & Co., Limited.

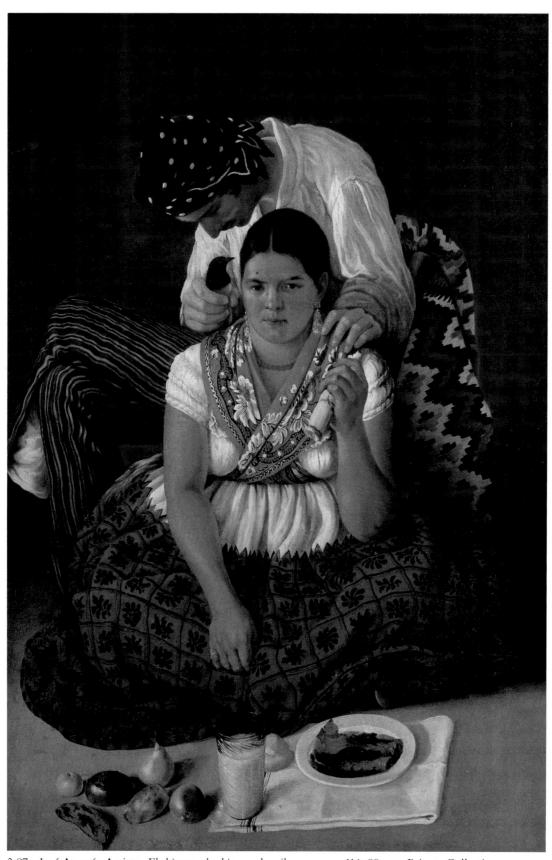

3.87 José Agustín Arrieta, El chinaco y la china, n.d., oil on canvas, 114×89 cm., Private Collection.

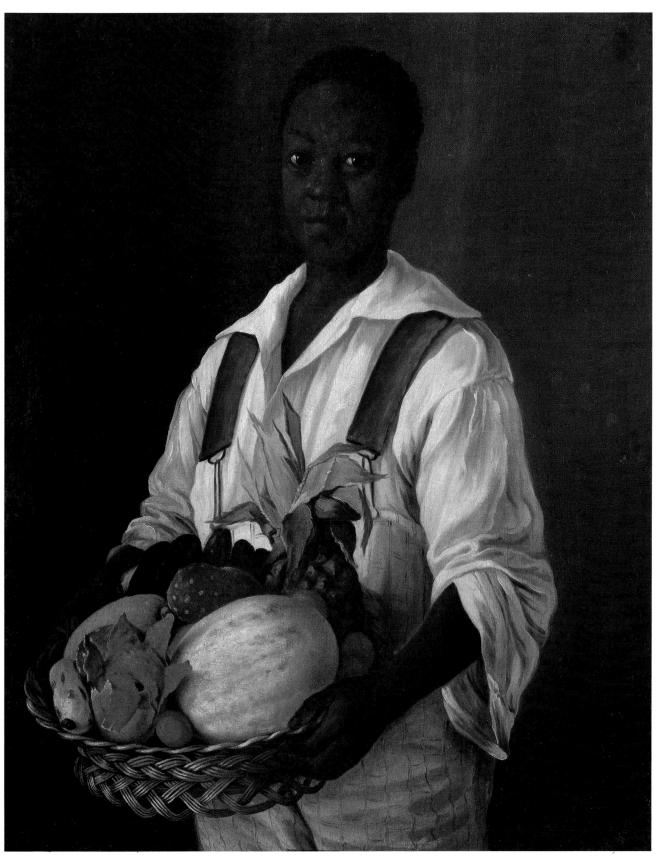

3.88 José Agustín Arrieta, *El costeño*, n.d., oil on canvas, 91×71 cm., Private Collection.

3.89 Edouardo Pingret, *Waterseller*, 1852, oil on canvas, 69×59cm., Museo Nacional de Historia, Mexico City (INAH).

3.89a Jesús Liébana de Ozumba, *Still Life with Basket and Fruit Bowl*, oil on canvas, 46.5×74cm., Collection Mariana Perez Amor.

3.90 José Agustín Arrieta,. *Market Scene: La Sorpresa*, 1850, oil on canvas, Museo Nacional de Historia, Mexico City (INAH).

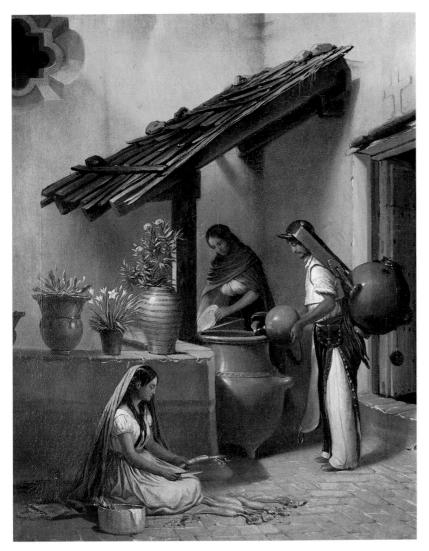

3.91 Edouardo Pingret, Waterseller, n.d., oil on canvas, 59×48 cm., Museo Nacional de Historia, Mexico City

canvas, 68×91cm., Collection Sr Jorge Larrea Ortega y Sra..

3.93 Hermenegildo Bustos, Still Life with Fruit and Frog, 1874, oil on canvas, 41×33.5 cm., Museo de la Alhondiga de Granaditas, Guonajuato (INBA).

teriors which, like Dutch genre pictures, lovingly depict food and cooking implements, together with scenes of human interest. His costumbrista scenes are sometimes given landscape settings and recall the studies Goya painted of popular and everyday life for tapestries. Serrano's works, like Arrieta's, are painted from the inside, as opposed to the European costumbrista gazing from the outside, at the exotic. They were painted for a Mexican, not a European, audience - for the 'rising new Mexican middle class'. 'In the provinces, obscure painters, unschooled amateurs or simple artisans, supplied a popular demand for family portraits, children's death-bed scenes or pictures of appetizing dishes to hang in the parlours and dining rooms of the local middle classes. They also painted ex-votos, signposts, furniture and walls.'13

Arrieta's paintings owe as much to these popular traditions as they do to costumbrismo. He also, like Apolinar Fonseca or Liébana, painted 'appetizing dishes', and still lifes of fruit, in a wonderful variety of presentations: on a sideboard, a table [Pl. 3.92], or piled on a market stall, in a tradition that continues today in the work, for

NATURE, SCIENCE AND THE PICTURESQUE

example, of Olga Costa. The self-taught painter Hermenegildo Bustos, from the village of Purisma de Rincón near Guanajuato, who sometimes signed the back of his portraits 'Yo . . . indio de este pueblo' (I, Indian of this village), painted his friends and neighbours, not idealized, as well as ex-votos, pictures of natural phenomena like comets and sheets with fruit and vegetables spread out, as in a natural history book. In *Still Life with Fruit and Frog* (1874) [Pl. 3.93] the fruits gape like mouths to show their soft interiors.

As Raymond Williams said, popular arts tend to preserve traditional forms, and certainly the portraits, death-bed scenes and exvotos of artists like José María Estrada, and many who remain anonymous [Pls 3.94-9], keep to traditions that stretch back into colonial times, although invested with a new vigour, as, in Mexico, stability began to return after the turbulent years of Independence,

3.94 Anonymous, ex-voto, 1885, oil on brass, 35×50 cm., Museo de Bellas Artes, Caracas.

3.95 Anonymous, ex-voto ('María Jacoba Gómez . . .'), n.d., oil on enamel, 36×25.7 cm., Museo Nacional de Arte, Mexico City (INBA).

HUN GRITOACLAME ALES DE VILLASECA QUELE MANDARAS

3.96 Anonymous, ex-voto ('Hallándose Ma. Gregoria Lozano muy grave . . .': 'Finding Ma. Gregoria Lozano very ill . . .'), n.d., oil on enamel, 17.8×25.5 cm., Museo Nacional de Arte, Mexico City (INBA).

3.97 Anonymous, ex-voto ('El día lunes 23 de abril año de 1742 . . .'), 1742, oil on canvas, 30.5×42 cm., Private Collection.

3.99 Anonymous, ex-voto ('Pueblo de Taxeria 30 de noviembre 1834 . . .'), 1834, oil on canvas, 38.5×30 cm., Private Collection.

3.98 Anonymous, *Esta es la Vida* (This is Life), n.d., oil on canvas, 77.2×119.3 cm., Museo Nacional de Arte, Mexico City (INBA).

3.103 Anonymous, Girl from Puebla, with Roses, n.d., oil on canvas, 87×65.5 cm., Museo Nacional de Arte, Mexico City (INBA).

3.100 Anonymous, *Jaguar*, n.d., oil on canvas, 62×83 cm., Private Collection.

3.101 Anonymous (attributed to Maestro Zuloaga), Portrait of the Couple Miguel Alfonso Villasana and Gregoria Nuñez Delgado de Villasana, c. 1850, oil on canvas, 70×84.5 cm., Galería de Arte Nacional, Caracas.

3.102 José María Estrada, *Portrait of Don Francisco Torres (The Dead Poet)*, 1846, oil on canvas, 44.8×33.2cm., Museo Nacional de Arte, Mexico City (INBA).

and the rising middle class provided a much expanded market. The demand for visual images was enormous in Mexico, and, while the landowners, especially under the regime of Porfirio Díaz in the last quarter of the nineteenth century, bought their art in Europe, everyone else patronized local artists. The anonymous *Girl from Puebla*, with Roses [Pl. 3.103] presents a very striking contrast with travellers' versions of the same subject. While the latter tend to the same range of 'naturalistic' poses that are oddly at variance with the anonymity otherwise of the figure, a type rather than a person, this painting has the stiff, frontal pose characteristic of more naïve

NATURE, SCIENCE AND THE PICTURESQUE

3.104 Christiano Junior, Cartes de visite, 1860s, Museu Historico Nacional, Rio de Janeiro.

3.105 Anonymous, Woman of Lima, n.d., photograph, Pinacoteca de Lima

3.106 Anonymous, *Woman of Lima*, n.d., photograph, Pinacoteca de Lima.

colonial portraits, and a fascination with the detail of costume and attribute, painted with the realistic deliberation of a *Douanier* Rousseau

The relationship between the European *costumbrista* artists and early photography in Latin America is an interesting one. The *cartes de visite*, for instance [Pl. 3.104], which were so popular early in the second half of the nineteenth century, often took their cue from the types, poses and costumes popular among the travellers. Both artists and photographers, for instance, were attracted by the unique costume worn by the women of Lima [Pls 3.105,106]. This consisted of a pleated skirt (*saya*) and black *manto* which 'completely covers the bust and most of the head, leaving only one eye uncovered'. The French socialist and feminist Flora Tristan described the fascinating effect of this almost complete disguise, and also the freedom it allowed: 'There is no place on earth where women are so

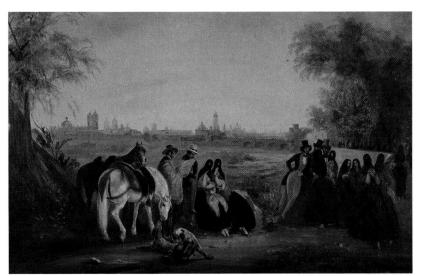

3.107 Johann Moritz Rugendas, View of Lima with Ladies and Gentlemen Strolling by the River Rimac, 1843, oil on canvas, 56×89.5 cm., Baring Bothers & Co., Limited.

3.108 Benito Panunzi, *Family of the Araucanian Chief*, 1865, albumen print, 12.5×19cm., Hoffenberg Collection.

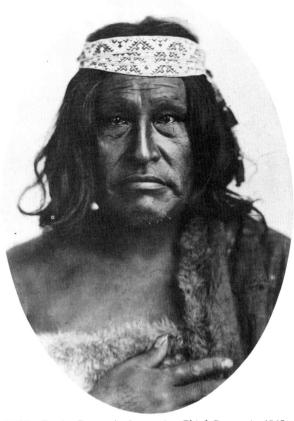

3.109 Benito Panunzi, *Araucanian Chief, Patagonia*, 1865, albumen print, 18×12.5 cm. (oval), Hoffenberg Collection.

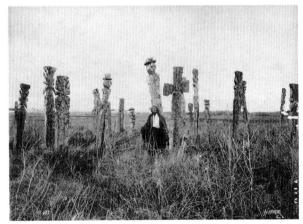

3.111 Heffer, Araucanian Indian Burial Ground, Chile, c. 1880, albumen print, 19×26.5 cm., Collection of the Chase Manhattan Bank.

3.112 Marc Ferrez, *Viaduct over São João River*, 1879, albumen print, 38×53.5 cm., Hoffenberg Collection.

3.113 Marc Ferrez, *Bridge over the Laguna River*, 1875, albumen print, 25.5×49.5 cm., Hoffenberg Collection.

3.114 Marc Ferrez, Emperor Dom Pedro II Dedicating Reservoir Named in His Honour, 1879, albumen print, 26.5×35.5 cm., Hoffenberg Collection.

free . . .'¹⁴ The 'Damas Limenas' ('Women of Lima') of Rugendas' painting View of Lima [Pl. 3.107] have direct parallels in photographs, as have scenes of the gauchos on the Argentinian pampas – parallels which point to the extent to which the 'documentary' art of photography constructed its subjects according to existing stereotypes. However, photography was at the same time open to reality in a way that picturesque scenes as such were not, and even emphasized its capacity to record people in conditions that did not enter the purview of the fine arts until the Mexican muralists, and the printmakers of the twentieth century. The anonymous photograph of the humiliation of an Indian girl [Pl. 3.115] or those of the Indian leader stripped of his dignity [Pl. 3.109], or the Araucanian defiant in the graveyard of his people [Pl. 3.111], offer a sombre counterpart to the painted picturesque.

3.115 Anonymous, *Indian Prisoner*, 1895, albumen print, 20×11.5 cm., Hoffenberg Collection.

4

José María Velasco

VELASCO'S landscapes dominate painting in Mexico in the last decades of the nineteenth century. A quality of freshness and naturalism in his paintings, and the careful observation and light handling of foreground detail, have suggested comparison with Corot, the Barbizon school, and, most aptly, with early Pissarro, but other features in his work distance him considerably from these artists. Most obvious of these was his love of the grand panorama, which involved an attitude to the landscape, and to nature, quite different from that of most Europeans of the time. For them, nature was to be 'truly seen in all its variety, its freshness', free of the tropes of classicism or Romanticism, the modest motif painted on the spot: trees, farmyard, village street, cornfield, river bank. Velasco had to find a means of representing a landscape so much vaster than Europe, and uncontainable within its contrasting modes of pastoral and untamed. He did so by drawing on two distinct earlier traditions of representing landscape, both of European origin, and his genius lay in adapting them to purely Mexican conditions [Pls 4.1-7,9,13,14,16].

These traditions were the classical landscape, originally created in the seventeenth century by Claude and Poussin, and the topographical scene of the European traveller-artists, which was infused (as was argued in chapter 3: II) with picturesque and Romantic attitudes. Each of these traditions was conditioned by a specifically European dialectic between nature and civilization, but was part of Velasco's formation as an artist. The classical landscape was brought to Mexico by the Italian artist Eugenio Landesio, who had

4.1 Detail of Pl. 4.5.

4.2 José María Velasco, *Mexican Landscape, Pico de Orizaba*, 1876, oil on canvas, 30.5×45 cm., Národní Muzeum, Prague.

4.3 José María Velasco, *Mexican Landscape with Cone of a Volcano*, 1887, oil on canvas, 76.6×107.8 cm., Národní Muzeum, Prague.

4.4 José María Velasco, *The Valley of Mexico*, 1899, oil on canvas, 15.2×23 cm., Národní Muzeum, Prague.

- 4.5 José María Velasco, *The Valley of Mexico from the Heights of Tacubaya*, 1894, oil on canvas, 47×62.3 cm., Museo Nacional de Arte, Mexico City (INBA).
- 4.6 José María Velasco, *Hacienda of Chimalpa*, 1893, oil on canvas, 104×159 cm., Museo Nacional de Arte, Mexico City (INBA).

trained in Rome and was imported in 1855 to teach landscape painting at the Academy of San Carlos. It depicted a nature that was, essentially, ideal, while the traveller-artists had started from the recording of a specific scene, and the scientific observation of flora and fauna – or alternatively, fuelled by the picturesque taste of Europe, had responded with awe to jungle and volcano. Velasco naturalized, rather than romanticized, the dramatic objects of this landscape; he painted rocks, tropical vegetation, volcanos, the massive candelabra cactus, individually, or combined with the sweeping vista. But his great subject was the Valley of Mexico itself, which lies some 7,000 feet up in the central highlands, ringed by volcanoes, above which tower the twin peaks of Popocatépetl and Iztaccíhuatl. Site of the capital city, it was the heart of the Aztec empire, and before that of the Toltec and Teotihuacán civilizations.

4.7 José María Velasco, *The Valley of Mexico*, 1875, oil on canvas, 35×48.8 cm., Národní Muzeum, Prague.

4.9 (facing page top) José María Velasco, View of the Valley of Mexico from the Hill of Santa Isabel, 1877, oil on canvas, 160.5×229.7 cm., Museo Nacional de Arte, Mexico City (INBA).

4.8 Eugenio Landesio, *The Valley of Mexico*, n.d., oil on canvas, Museo Nacional de Arte, Mexico City (INBA).

If we compare Velasco's Valley of Mexico of 1875 with his teacher Landesio's version of the same subject [Pls 4.7,8], it is possible to see how far Velasco used and transformed the structures of the classical landscape. Although considerably modified, the Claudian landscape was still the basis of Landesio's Mexican scenes. Claude had painted an ideal nature; although he sketched from life in the Roman Campagna, the whole picture was built up in the studio according to unvarying compositional principles. Framed by clumps of trees or a hill, the vistas from foreground to horizon were articulated in alternating bands of dark and light, set at slight angles to mask the transition from one to the next, often with a river winding through to help draw the eye into the distance [Pl. 4.10]. Arcadian nymphs and shepherds, or figures from classical mythology, introduced a poetic element and emphasized the ideal character of the scene, and the whole represented an image of a unified and ideal nature at harmony with man. The basic structure, and the harmonious display of the prospect, are still present in Landesio, although his figures suggest an actual rather than mythological or historical

4.10 Claude Lorraine, *The Marriage of Isaac and Rebecca (The Mill)*, 149×197 cm., oil on canvas, reproduced by courtesy of the Trustees, The National Gallery, London.

scene. Velasco pushed the changes much further, eliminating framing trees and hills, shifting the horizon line higher up the canvas, with the central vanishing point well below, rather than on, the horizon. This throws much greater emphasis on prominent and dramatic features in the foreground, which now seems to fall towards rather than away from the spectator, giving a slightly uneasy sense of extension rather than enclosure. Instead of the unifying golden or silver light of Claude (which in Landesio became a pinkish glow), Velasco's light is naturalistic. Like Constable, Velasco made studies of clouds, which he then used in his paintings for dramatic effect.

If we now go on to compare the 1875 Valley of Mexico with Velasco's most famous work, View of the Valley of Mexico [Pl. 4.9], of 1877, it is possible to see what has replaced the 'ideal' nature of the classical landscape, and also how Velasco succeeds in holding in balance the vista as a whole, and those wild and rugged features which resist the smoothing and unifying eye. The unremarkable picturesque figures in the foreground of The Valley of Mexico have vanished, to be replaced by an eagle, lower right, and a cactus. Although of course part of the natural scenery, these recall the myth of the founding of Tenochtitlán, the Aztec capital, on the site where Mexico City now stands. In 1325, the legend goes, the wandering Mexica people took the advice of their tribal god, Huitzilopochtli, and settled at the spot where an eagle, with a snake in its claws, alighted on a cactus. This image [Pls 4.11,12], whose tradition goes back to the pre-Hispanic screenfolds, became the emblem of Mexico. The significance of the causeway, too, which connects the winding road to the city and is so important structurally to the picture, would not have been lost on Velasco's audience. It was one of those constructed to link Tenochtitlán from its island to the shores of Lake Texcoco. (Today, Mexico City has spread to cover almost the whole area.)

The painting as a whole, then, relates clearly to the historicist nationalism, described in chapter 2, whereby Mexico's pre-Spanish past was invoked to strengthen the idea of Mexico as a nation. The structure and iconography of the painting take on a new meaning in this context. The foreground, rather than receding gently from the spectator, sweeps away unchecked on the left, suggesting a vastness to the land, but at the same time the dark, saurian mass of the hill points clearly to the city. The rocks, vegetation and craggy hillside are not set up as signs of a wilderness resistant to man and civilization, as they might have been by a picturesque traveller, nor are they subsumed as types of an ideal nature, but as characteristic of Mexico. Others of Velasco's paintings share the sense of Mexican history impressed on the landscape, like Netzahualcóyotl's Bath, the views of the pyramids at Teotihuacán, or The Savin of Popotla, but none have the subtle and allegorical grandeur of Mexico.

Velasco was a successful and much commented-on artist during his lifetime. In general the criticism was favourable, but there was one famous attack on him by the poet and critic Altamirano.

4.11 Anonymous, Eagle and Cactus, 1834, from a broadsheet in Papeles Varios, The British Library Board

4.12 Codex Mendoza, MS. Arch. Seld. A.1, fol. 2r, Bodleian Library, Oxford.

Velasco's conservatism and Catholicism were antipathetic to Altamirano, but this was not the basis for the accusations in the latter's 'Salón 1879-80, Impresiones de un Aficionado'. There Altamirano criticizes Velasco, firstly for being too concerned with locality and not enough with art, and secondly, for restricting himself to localities that were boring and repetitive: the dry, yellowish-brown hills of the Valley of Mexico, with its unvarying vegetation. Altamirano urged him to seek instead the majestic peaks of the high sierras, and the tropical lands with their velvety flora and picturesque Indian huts.² He also complained that Velasco's landscapes looked as if they were painted through a telescope, 'which is not natural'.³

It is possible that this criticism had some influence on Velasco, for he did paint some tropical scenes. But even in these he is often more centrally concerned with celebrating another crucial aspect of Mexico at the time: its modernization. *El Citlaltépetl* [Pl. 4.13] depicts one of the major engineering feats of the Mexico City–Veracruz railway, completed in 1872, and 'the most important economic development' of the period. Contemporary photographs record almost exactly the same scene. In *El Citlaltépetl* and in *Bridge at Metlac* [Pl. 4.14] Velasco has added exuberant tropical foliage, delicately painted and light against the dark ground: nature and

4.13 José María Velasco, *El Citlaltépetl*, 1879, oil on canvas, 105×160 cm., Museo Nacional de Arte, Mexico City (INBA).

4.14 José María Velasco, Bridge at Metlac, 1881, oil on canvas, whereabouts unknown.

4.15 Anonymous, photograph of the railway at the Metlac ravine, from Meyer and Sherman, *The Course of Mexican History*, p.406, The Humanities Research Centre, University of Texas at Austin.

technology in balance. In many of his vistas, like the *Lake Chalco* [Pl. 4.16], a distant plume of smoke marks the railway track.

When Velasco visited Paris for the Exposition Universelle of

1889, where 68 of his paintings were shown, he encountered Impressionism for the first time. Fascinated by the new technique, he painted while in France a few studies of trees and mountainscapes, thoroughly European in aspect, and in a new manner, with much looser dabs and strokes of paint. However, it would be hard to find any trace of this after his return to Mexico, and it was for other artists, like Clausell, to bring Impressionism to Mexico. Velasco continued to paint views of the Valley, which, though mostly on a smaller scale than the canvases of the 1870s, retain his characteristic combination of naturalism and grandeur.

For Velasco's European contemporaries, 'landscape painting' had ceased to figure in the academic hierarchy of genres. Different attitudes to the painting of nature had led to radical changes in painting itself. Velasco, however, remained an academic painter, within the context of Mexico (he even made copies of his own paintings). But he transformed the genre, manipulating the structures of the classical landscape to depict a nature whose reality was bound up with an idea of Mexico.

4.16 José María Velasco, *Mexican Landscape with Lake Chalco*, 1885, oil on canvas, 49×71.6 cm., Národní Muzeum, Prague.

5 Posada and the Popular Graphic Tradition

GRAPHIC ART, and in particular satirical and popular prints, has been an exceptionally strong and continuing tradition in Latin America. At least a part of this continuing strength is due to the work of the Mexican José Guadalupe Posada, and the Mexican muralists' admiration for it. Had it not been for their role in recovering it, this work might have been as ephemeral as the medium in which it was originally disseminated - the satirical illustrated newspapers and broadsheets produced in mass and widely distributed in the last century, with an afterlife only as items of archival interest for social and political historians. As it is, Posada's work fed into a mainstream of painting in Latin America, and also nourished generations of printmakers - notably the Taller de Gráfica Popular, founded in Mexico in 1937. The more recent curiosity about its context – the rich production of comic, satirical and picturesque prints all over Latin America in the second half of the nineteenth century - has served to underline rather than diminish his distinctive role.

There was in the last century considerable interaction between satirical newspapers and periodicals in Europe and in America. Charivari, founded in Paris in 1833, and Punch, or the London Charivari, founded in 1841, were internationally famous, and, reciprocally, the Mexican El Hijo del Ahuizote (1855-1903) and the Cuban Don Junípero (1862) became collectors' items. ² The same was true of La Orquesta (1861-77), a highly influential liberal periodical for which some of the best lithographers of the time, such as Constantino Escalante, worked. It is clear from his cartoons that Escalante knew the work of the French artist Grandville (Les Métamorphoses du jour, for instance), whose Les Fleurs animés was published in Mexico in 1849. The work of European caricaturists, especially the French, was available in places like the Litografía en la Calle de la Palma: 'This major lithographic workshop . . . no doubt had an extensive array of lithographic albums, illustrated books and periodicals to be used as models or inspiration.'3 Similar contacts are found elsewhere. In Cuba Don Junípero 'periódico satíricojocoso con abundancia de caricaturas', included cartoons from other periodicals, like Punch, as well as dramatic inventions of its own like the anonymous 'farewell to the old year' [Pl. 5.2].

The Italian artist Claudio Linati was one of the editors of a very early review, El Iris (1826), 'Periódico crítico y literario', whose in-

5.1 Detail of Pl. 5.22.

5.2 'Farewell 1863! . . .' *Don Junipero*, 4 January 1863, The British Library Board.

5.3 Don Simplicio, front page, 4 July 1846, The British Library Board.

5.4 Anonymous, 'Conspiración en esta capital' ('Conspiracy in this capital'), from a Mexican pamphlet, 1834, in *Papeles Varios*, No. 17, The British Library Board.

tention, as modestly stated in the first issue, was to offer agreeable entertainment rather than to seek literary glory. The periodical included biographical and literary essays, poems, reviews of theatre and music, but few illustrations, though Linati contributed to albums of prints in Mexico as well as producing his own *Costumes civils, militaires et réligieux du Mexique* (see chapter 3: ii).

But by far the strongest and most inventive tradition, as the popular illustrated newspaper got under way by the middle of the century, was social and political satire. The Mexican Don Simplicio ('periódico burlesco, crítico y filosófico'), founded in 1845, repeated the same satirical print on its title-page [Pl. 5.3], and had relatively few illustrations inside. But El Calavera, founded in 1847, 'periódico joco-serio, político y literario' as it announced on its title-page, put greater emphasis on its visual content. The skeleton (calavera) of the title is shown in caricature, in modern dress, as the moral-critical voice of the paper, with truth and justice on its side, exposing the government's lies or, in one characteristic metaphor, mourning the wrecked ship of state. This paper was one of the many precedents for Posada's famous calaveras. 4 The lithographs and engravings in El Calavera were by artists who mostly preserved their anonymity. This might well have been to avoid prosecution, for the editors of these satirical papers were constantly being arrested. In a manner reminiscent of the little political and Dada magazines in Weimar Germany after the First World War, titles changed and editors went in and out of jail. After 31 issues, the editors of El Calavera were arrested for 'fomenting disunion, inciting a revolution, lowering the prestige of the supreme magistrate, becoming involved in the private lives of public officials and making fun of these officials' physical defects'. Its successor in 1849, El Tío Nonillo, was published from the same address, though this time the editors remained anonymous. It continued in the same vein of invective, notably against the clergy and monarchists (see the 'comic-strip story' of the iniquitous Father Hypolite) [Pl. 5.5]. Inventive political metaphors appear in its caricatures, as in the lithograph of Sr. Tlachique, where the bat-winged barrel-bodied monarchist sucks the maguey plant, which, fascinatingly, is drawn in the style of an Aztec codex, and which stands for Mexico.

Satirical and political illustrated newspapers were also published in centres outside the capital. In Mérida, the more burlesque periodical *Don Bullebulle* lasted for one year in 1847. This 'periódico burlesco y de extravagancias', as it announced itself, contained satirical engravings by the artist Gabriel Vicente Gahona, who signed with the pseudonym 'Picheta' [Pl. 5.6]. He was a subject of interest later among the Mexican Surrealists, who published an article on him in *Dyn* in 1943. Posada was the chief lithographic artist for a weekly periodical, *El Jicote* (1871), in his home town of Aguascalientes. It ran to 11 issues before closing down, and it is possible that his political activities in connection with *El Jicote* prompted Posada's departure from Aguascalientes, with his employer, the printer Pedroza, to León, where a new workshop was opened. Posada's lithographs

for *El Jicote* show how familiar he was with the visual language of the caricaturists of Mexico City like Escalante.

In spite of the tight government censorship under Porfirio Díaz, ⁶ satirical illustrated periodicals, as well as the more irregular publications of the penny press, continued to flourish. In León, Posada enjoyed a high reputation as a lithographic artist; he taught lithography as well as fulfilling many commissions, some of them for topographical scenes, besides the normal typographic services ('... receipt forms, printed announcements, calling cards, cigar wrappers, prints, caricatures, etc.'). ⁷ In 1888 he moved to Mexico City, where, over the next 25 years, he contributed to over 50 different newspapers and pamphlets.

His first regular work in the capital was for *La Patria Ilustrada* (1886-90). His graphic manner and his wit are reminiscent of Escalante, but also possess distinctive characteristics. Unlike many cartoonists, he is also at home with more naturalistic, sympathetically

5.5 Anonymous, 'Chanzas de Cupido', from *El Tío Nonillo*, 30 October 1850, Yale University, Sterling Memorial Library, Latin American Collection.

5.6 Picheta (Gabriel Vincente Gahona), *The Clerk*, 1847, engraving, 7.5×6.4cm., Museo Nacional de la Estampa, Mexico City (INBA).

5.7 Manuel Manilla, *The Poisoning and The Jury*, n.d., zinc engraving, 8×14cm., Museo Nacional de Arte, Mexico City (INBA).

POSADA AND THE POPULAR GRAPHIC TRADITION

observed scenes and figures, while his satirical drawings are particularly energetic and vigorous. In the border of the cover of *La Patria Ilustrada*, the different classes of Mexican society, from the Indian with her child on her back to the socialite with fan and huge hat, are drawn with dignity and fluidity. Like many other cartoonists of the time, Posada contributed numerous political caricatures to different illustrated papers, satirizing governmental abuses and political intrigue, such as the fight for the vice-presidential chair in 1904. ⁸

Free-lance, in Mexico City, he continued to offer his services in lithography, but also 'as an engraver in metal, and wood, for every type of illustration for books and periodicals'. The adoption of other printing techniques was significant. Since lithography was relatively slow and expensive, and could not be printed simultaneously with type, Posada increasingly engraved in type metal, and then started to use a process of relief etching in zinc, which was extremely rapid and convenient. It was the latter technique that he tended to use, though not exclusively, from about 1900, and it is easy to distinguish from metal engraving, because the lines print black.

From about the beginning of the 1890s, there was an enormous increase in the number of very cheap illustrated papers and popular broadsides, and Posada undoubtedly helped shape the vigorous, simple and dramatic style that came to characterize their visual lan-

5.8 José Guadalupe Posada, Calavera de las Elecciones Presidenciales, 1919.

5.9 Manuel Manilla, Calavera de la Penitenciaria, Collection Arsacio Vanegas Arroyo, Mexico City.

5.11 José Guadalupe Posada, El Panteon de Zapata.

5.12 José Guadalupe Posada, *A Mishandled Death* – *Collision of a Trolley Car with a Hearse*, reprint, first published 1889-95, relief etching, 9.7×15.3cm., The Museum of Modern Art, New York; Larry Aldrich Fund.

5.13 José Guadalupe Posada, *Ballad of Macario Romero*, reprint, first published 1889-95, relief etching, 9.8×13.4cm., The Museum of Modern Art, New York; Larry Aldrich Fund.

5.14 José Guadalupe Posada, *The Arrival of the Body of Citizen General Manuel González to this Capital*, reprint, first published 1893, type-metal engraving, 11.6×19.7 cm., The Museum of Modern Art, New York; Larry Aldrich Fund.

POSADA AND THE POPULAR GRAPHIC TRADITION

guage. The majority of his work in this area was for the energetic publisher Antonio Vanegas Arroyo, who had also employed Manuel Manilla [Pl. 5.7]. Besides the staple of devotional images of the Virgin of Guadalupe and other virgins and saints [Pl. 5.16], produced on flimsy paper according to the calendar of pilgrimage and religious festival days, Vanegas Arroyo brought out broadsides and corridos of sensational items of news: train derailed, fire in the bullring, collision of tram and hearse [Pl. 5.12], mining disaster; woman who gave birth to three babies and four iguanas; or the man with the body of a pig, all illustrated by Posada in a particularly grotesque style. There were popular corridos on the capture and execution of the Robin Hood-style bandits (mopped up by Díaz but popularly celebrated as anti-government heroes) as well as on monstrous crimes and violent deaths [Pl. 5.13]. Posada made numerous prints of firing-squad executions, which Vanegas Arroyo would often use more than once, just inserting new names for the victims

[Pl. 5.15]. The famous pair of type-metal engravings of the anti-reelection demonstrations of 1892, showing government brutality against the defenceless crowd, were printed in Arroyo's *La Gaceta Callejera*, which came out when occasion demanded. Arroyo resurrected part of one of these prints after Posada's death, in connection with the *decena trágica* of February 1913.¹¹ Posada would sometimes, it appears, produce his drawings on the spot for Arroyo. The broadsides, *calaveras* and *corridos* would then be sold at street corners, to an audience which was largely illiterate.

Posada celebrated Arroyo himself in a *calavera* of about 1907 [Pl. 5.17], which listed in verse his wide range of publications:

Mil lecturas agradables mil cuentos maravillosos y versitos admirables

5.16 José Guadalupe Posada, Colloquy to Celebrate the Four Apparitions of the Virgin of Guadalupe, 36.1×26.8 cm., Museo Nacional de la Estampa, Mexico City (INBA).

5.15 José Guadalupe Posada, 'Today's Execution – Details', from *La Gaceta Callejera*, 39.5×29.5 cm., Museo Nacional de Arte, Mexico City (INBA).

POSADA AND THE POPULAR GRAPHIC TRADITION

Historias extravagantes oraciones fervorosas sucesos espeluznates y comedias muy hermosas.

[A thousand enjoyable articles and amazing narratives, admirable rhymes, extravagant stories, stirring speeches, hair-raising incidents and superb farces.]¹² Posada's covers for romantic novels and collections of popular songs are notably more conventional and refined – and dated: a buxom *fin de siècle* muse, for instance, against a fussy floral background. For the journal *El Popular*, in 1897, Posada made a spectacular series of pin-ups in which he succeeded in exploiting his photographic sources by dramatizing the dark tones, and made a special 'use of multiple line burin for backgrounds and a white line technique for defining the edges of dark areas against the light ground' [Pls 5.18,19].¹³

It was above all Posada's engravings and etchings for the broadsides and calaveras, and for the satirical press – papers like El Padre Padrilla (1908): 'founded to combat clerical corruption', as its masthead said, or El Diablito Rojo ('Of the people and for the people') of 1900–10, that spoke so forcibly to the muralists. For here he was chronicling the attitudes and events of the era, for a wide audience.

5.18 José Guadalupe Posada, 'Something rotten in the state of Denmark', from *El Popular*, 18 January 1897, University of Texas at Austin; Nettie Lee Benson Latin American Collection.

5.17 (facing page) José Guadalupe Posada, Calavera of the Popular Editor Antonio Vanegas Arroyo, Library of Congress, Prints and Photographs Division, Swann Collection, Washington, D.C.

5.19 El Popular, front page, 18 January 1897, University of Texas at Austin; Nettie Lee Benson Latin American Collection.

5.21 José Guadalupe Posada, 'The Great Pantheon of Lovers', from *La Gaceta Callejera*, 37.2×18.7 cm., Museo Nacional de Arte, Mexico City (INBA).

5.22 José Guadalupe Posada, *Calavera of the Cyclists*, reprint, first published 1889-95, type-metal engraving, 14.9×26.6 cm., The Museum of Modern Art, New York; Larry Aldrich Fund.

5.23 José Guadalupe Posada, *Bloody Encounter of the Federals and the Revolutionaries*, n.d., zinc engraving, 9×14.5 cm., Museo Nacional de la Estampa, Mexico City (INBA).

From the background of the intricate and fantastic wit of the nineteenth-century caricature Posada created a new kind of dramatic, condensed and simplified visual image. Sometimes he used devices similar to those of the earlier caricatures, such as disruptions of scale (later to be used in comic and satirical photomontages), as in The Metamorphosis of Madero, in which he comments on the sudden transition to power of the new President. He also transformed the traditional calavera figure, which had previously played a thousand roles, in a series of images directly relating to the Revolution. In one of the last prints he made for the Calavera Revuelta, he introduces a stick-figure calavera, helpless hordes trapped between fighting soldiers who could represent either civil war or foreign invasion. As well as this grim vision, though, Posada made several prints of images showing the human cost of the civil war [Pls 5.23,24]. More than once he made direct use of Casasola photographs of the Revolution; more interesting than any surface dependence, however, was the role he shared with photography in the construction of images of the Revolution, running parallel to one another: the Zapatista resting, the soldier's farewell, the woman soldier, the boy recruit, the firing squad.

For the muralists, seeking a way of engaging directly with revolutionary Mexico and creating a popular art, Posada offered a visual resource unlike any in the world of official art. The dictator Díaz had looked to Europe – importing a huge exhibition of European

POSADA AND THE POPULAR GRAPHIC TRADITION

5.24 José Guadalupe Posada, Streets of the City of Mexico, the Morning of 9 February 1913, n.d., zinc engraving, 11×8.5 cm., Museo Nacional de la Estampa, Mexico City (INBA).

5.25 José Guadalupe Posada, 'Mexican Independence celebrations . . .', 1892, 60.5×38.3 cm., Museo Nacional de Arte, Mexico City (INBA).

art as part of the elaborate celebrations planned for the centenary in 1910 of Hidalgo's initiation of the wars of Independence; the younger painters were experimenting with impressionist land-scape, and the academic painters struggled on with their history and allegory. But Posada, and other artists like him, had been making images of immediate relevance, showing political corruption and aspiration, the effects of the modernization of Mexico, and a society in conflict. Perhaps it was not Posada's intention to underline the political division of classes, in the contrast between the peons in their wide-brimmed hats and the upper classes with their top hats in the *Metamorphosis of Madero*, but it is easy to see how the muralists could use those images as such, and how far Posada could support their ambition to make an art for the people.

6

Modernism and the Search for Roots

THE RADICAL artistic developments that transformed the visual arts in Europe in the first decades of this century - Fauvism, Expressionism, Cubism, Dada, Purism, Constructivism - entered Latin America as part of a 'vigorous current of renovation' during the 1920s. These European movements did not, however, enter as intact or discrete styles, but were often adapted in individual, innovative and idiosyncratic ways by different artists. Almost all those who embraced Modernism did so from abroad. Some remained in Europe; some, like Barradas with his 'vibrationism', created a distinct modernist manner of their own [Pls 6.2,3,4,5], or, in the case of Rivera in relation to Cubism, and of Torres-García to Constructivism, themselves contributed at crucial moments to the development of these movements in Europe. The fact of being American, however, was registered in some form in the work of even the most convinced internationalists. Other artists returning to Latin America after a relatively brief period abroad set about creating in various ways specifically American forms of Modernism.

The relationship between radical art and revolutionary politics was perhaps an even more crucial issue in Latin America than it was in Europe at the time; and the response of writers, artists and intellectuals was marked by two events in particular: the Mexican Revolution and the Russian Revolution. The impact of the Mexican Revolution was immense, and the activities of the Mexican mural painters in interpreting and disseminating the ideals of the Revolution, in promoting the idea of an art for the people, and in helping to realize a cultural nationalism under revolutionary conditions were felt far beyond Mexico itself, and were important factors in contemporary cultural and artistic debates.

The different groups and movements which constituted the avant-garde announced themselves, as did their counterparts in Europe, through manifestos and reviews, exhibitions and lectures. Among the most significant of these reviews were *Klaxon* (1922) and the *Revista de Antropofagia* (1928) in São Paulo, *Actual* and *El Machete* (1924) in Mexico, *Martín Fierro* (1924) in Buenos Aires and *Amauta* (1926) in Peru. The debates in these reviews and the pronouncements of the manifestos (many of them translated here in the Appendix for the first time) reveal a number of crucial oppositions and areas of difference. While several movements maintained the principle of the organic unity of revolution in art and in politics (*El Machete*, as the voice of the Syndicate of Technical Workers,

6.1 Detail of Pl. 6.37.

6.2 Rafael Barradas, *Study*, 1911, oil on cardboard, 46×54cm., Museo Nacional de Artes Plásticas, Montevideo.

6.3 Rafael Barradas, *Composition*, 1917, watercolour on paper, 51×54cm., Museo Nacional de Artes Plásticas, Montevideo.

Painters and Sculptors, for instance, and *Amauta*), others insisted on artistic autonomy. There was a considerable range of opinion here, as there was in the debates on other central socio-cultural, literary and artistic issues. The break with the past, though rarely expressed quite as brutally as in Futurism or Dada, was usually affirmed in some form; sometimes this was accompanied by a more or less straightforward celebration of modernity, but more often a reassessment of tradition was involved, and a rejection of the colonial period and the Europeanized culture of the nineteenth century in favour of a deeper, Indian cultural tradition. (The attempt to identify with a native as opposed to a European present is examined in more detail in Chapter 9 on 'Indigenism'.) Nationalism as against internationalism, and the regional versus the central and cosmopolitan, in Brazil especially, were also central issues.

For most artists the initiation into modern art involved initially a complete rupture with their past and their training. Although Europe had long been the cultural Mecca for artists and writers, the contacts had largely remained within a conservative and academic tradition. There had been no movement in the visual arts between c. 1880 and 1910 to correspond to the literary revival baptized 'Modernismo' by its greatest activist, the Nicaraguan poet Rubén Darío. Darío, who lived in Chile, Argentina, Paris and Madrid, 'galvanized literary life', challenging traditionalists who wanted to keep to the purity of Spanish Castilian and to outdated literary values. ² He read 'contemporary French poets whose styles and rhythms he was to incorporate brilliantly into Spanish', and, with others of his generation, in looking to the Paris avant-garde, began to create the conditions for a Latin-American literary vanguard.

Impressionism and post-Impressionism, by contrast, had barely impinged on the visual arts. There were exceptions – the Mexican artist Clausell, for instance, who through his friend Dr Atl adopted Impressionism, the Colombian artist Andrés de Santa María, who developed a richly-coloured symbolist manner, and the exceptionally gifted Uruguayan painter Carlos Saez, who died in 1901 at the age of twenty-one. However, by the time Impressionism began to take root, artists were already coming in contact with more radical movements like Cubism and its variants, which provided them with a visual language they felt was better adapted to express the change in sensibility brought about by the rapidly modernizing and industrializing world. When Rivera returned to Mexico in 1921, already a post-Cubist painter and looking to a different form of visual expression, one adapted to a popular form of communication, he criticized the painters of the open-air academy at Coyoacán for still producing Impressionist pictures.³

The rupture for Latin American artists was greater than for, say, the cubists themselves, for, however radical Cubism was in the hands of Picasso and Braque, its relationship with previous art – especially with Cézanne – could easily be perceived. This avantgarde tradition stemming from Manet, and Cézanne, had no parallel in Latin America.

6.4 Rafael Barradas, *Gaucho*, 1927, oil on cardboard, 60×40 cm., Museo Nacional de Artes Plásticas, Monteyideo.

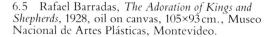

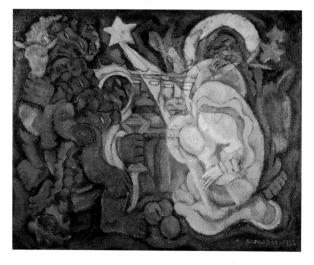

Diego Rivera encountered Cubism from a quite different direction, and indeed his serious interest in Cézanne dated from after his period as a Cubist. His claim to have gone to Europe to study with Cézanne, together with other myths about his development as a painter - that Posada was his real master, and that he had returned to Mexico to fight alongside the guerrillas in the Revolution, have turned out to be simply untrue. He spent the whole period of the Revolution in Europe, and Posada was not to enter his horizon until some years after his return to Mexico. Rivera travelled to Spain, on a scholarship from the governor of Veracruz in 1907, a precocious young painter who had had a successful career under the guidance of Velasco and Santiago Rebull at the San Carlos Academy, and looked set for a distinguished official career. In Madrid, Rivera began to move in avant-garde circles, having met the writer and critic Ramón Gómez de la Serna,4 but his painting still fluctuated between a costumbrista realism influenced by the Spanish painter Zuloaga, and Symbolism. He became absorbed in El Greco, and under the influence of a fellow Mexican, Zárraga, began mildly to accentuate the angular planes of his Toledo landscapes and picturesque subjects [Pl. 6.6]. By 1912 he was settled in Paris, among a group of Mexican painters that included Zárraga, Gerardo Murillo (Dr Atl) [Pl. 6.7], Adolfo and Emma Best Maugard, Jorge Enciso and Roberto Montenegro. Zárraga and Rivera were the most daring stylistically, but it was Rivera who committed himself fully to Cubism.

What is remarkable about Rivera's painting over the next three years was the way in which he moved through second-hand cubist manners – none the less impressive for that, especially in the can-

6.6 Diego Rivera, At the Fountain near Toledo, 1913, oil on canvas, 65×80 cm., Collection Señora Dolores Olmedo.

6.7 Dr Atl (Gerardo Murillo), *The Volcanos*, 1950, oil on masonite, 137×260 cm., Instituto Cultural Cabañas, Patrimonio de Jalisco, Guadalajara.

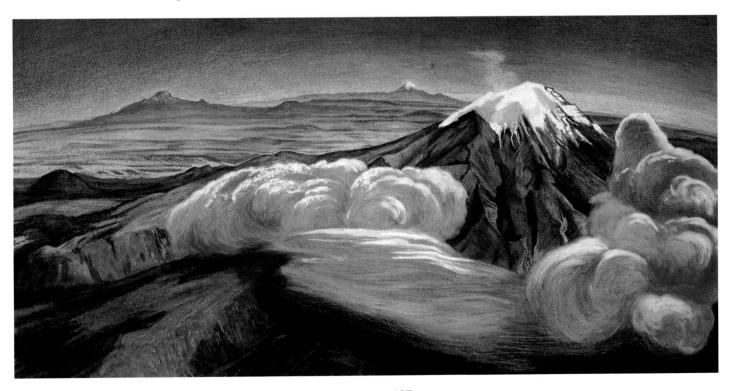

vases which show the influence of his neighbour Mondrian, and those based on the epic cubism of Gleizes or Delaunay [Pl. 6.9] - to the forefront of the 'movement'. He took an active part in theoretical debates, and after the outbreak of war in 1914, and the dispersal of the French Cubists, many to the Front, he, Picasso, Gris and Severini continued to explore and invent. In 1915 he painted an undoubted cubist masterpiece. 'I recall', he later said, 'that, at this time, I was working in order to bring into focus the inmost truth about myself. The clearest revelation came from a cubist canvas, The Zapatistas [sic], which I painted in 1916 [sic]. It showed a Mexican peasant hat hanging over a wooden box behind a rifle. Executed without any preliminary sketch in my Paris workshop, it is probably the most faithful expression of the Mexican mood that I have ever achieved.' Zapatista Landscape – The Guerilla [Pl. 6.8], like certain contemporary works by Picasso and Gris, sets a central image (still life) against a landscape, but rather than this being perceived framed through a window, it 'floats' in open space. The sky is doubled in an impossible deep blue reflection below the horizon; a mountain landscape with volcanic craters frames the hat above, while below, trees tip upside-down into the blue. Into the sophisticated cubist dialogue between representation and reality (the trompe-l'æil paper pinned to the canvas with a painted nail, devices like the negative-positive play of shapes derived from papiers collés, and the very recent introduction of decorative pointillism), Rivera introduces specifically Mexican objects - the hat and a brilliantly coloured serape. There seems no doubt that he was responding to recent news about the Revolution, brought by the new wave of Mexican refugees to Paris, and especially his friend Martín Luis Guzmán. Mexico was near to a state of anarchy and chaos;⁶ however, Rivera was perhaps moved by the vision of a Mexico aroused from its sleep, the land restored to the people. This was what the revolutionary leader Zapata, who had temporarily occupied Mexico City at the end of 1914, had promised in his 'Manifesto to the Mexicans' of August 1914.

Rivera rejected Cubism before his return to Mexico. In 1917 he embarked on a close study of Cézanne, having, like Picasso, previously begun to make a series of realistic still lifes and portraits. Unlike Picasso, however, who retained an alternative cubist style, Rivera abandoned Cubism completely by 1918, although his formidable capacity for spatial organization in the murals reveals his cubist training, and his first mural, *Creation* [Pl. 7.6], looks back directly to his earliest cubist pictures. 'In his Ingresque drawings, Rivera briefly digressed from a cubist to a truly modern representational style, where complicated spatial constructions are disguised by overt realism. It was a prelude to a tendency he was to display consistently while working out the rudiments of a modernist-based social realist mural style.'⁷

The emergence of the muralists in Mexico after 1921 was an important factor in the debates of the 1920s and '30s concerning art's en-

6.8 Diego Rivera, Zapatista Landscape – The Guerilla, 1915, Museo de Arte Moderno, Mexico City (INBA).

6.9 Diego Rivera, *Still Life with Bonbon*, 1915, oil on canvas, 92×73 cm., Collection Jacques and Natasha Gelman.

gagement in social and political issues. It was the idea of an art for the people, rather than the adoption of a 'social realist' style that, on the whole, mattered. Indeed, it would be incorrect to say that the creation of a 'social realist' style in any obvious sense was a central concern. There was considerable divergence, not to say opposition, among the mural painters, as is discussed in chapter 7, and Siqueiros especially pushed for the use of modern materials, experimental techniques and a dynamic expressionist style built partly on the principle of montage.

Amauta, edited by the writer José Mariátegui, who founded the Peruvian Socialist Party, was a review which explicitly linked the artistic and literary avant-garde to revolutionary politics. In the first editorial (Appendix, 6.7), he wrote: 'Amauta is not an open forum for all currents of opinion. We who founded the magazine do not conceive of culture and art as agnostic. We are militant and polemical. We make no concession whatsoever to the generally fallacious criteria of intellectual tolerance.' The review was opened to all 'vanguardistas, socialistas, revolucionarios' committed to change. Mariátegui laid out his position clearly in 'Art, Revolution and Decadence', published in the third issue (November 1926):

We cannot accept as new art, art which merely contributes new techniques. That would be flirting with the most fallacious of current illusions. No aesthetic can reduce art to a question of technique.

The revolutionary nature of contemporary schools or trends does not lie in the creation of a new technique. Nor does it lie in the destruction of an old technique. It lies in the rejection, dismissal and ridicule of the bourgeois absolute.⁸

Mariátegui expressed particular admiration for the French Surrealist leaders André Breton and Louis Aragon (both of whom that year had joined the French Communist Party), and especially for Breton's Les Pas perdus (1924), the collection of his Dada and post-Dada texts. While Amauta did not adhere to Surrealism itself, it admired the Surrealists' and Dadaists' attack on bourgeois values and artistic conventions, welcomed the contacts established between the Surrealist review La Révolution Surréaliste and the leftist review Clarté under Marcel Fourier, and anticipated the joint founding of a new review, to be called 'La Guerre civile' (never in the end to be realized). Within this broad avant-garde and leftist internationalism, however, Amauta was fairly eclectic. Its contributors included César Vallejo, José Vasconcelos (the Mexican philosopher and Minister of Education who founded the mural programme), Dr Atl, Bela Uitz (writing on 'Bourgeois Art and Proletarian Art') and the British playwright George Bernard Shaw on the definition of Socialism, and, among artists, the Argentinian Pettoruti, José Sabogal, who painted indigenist subjects in a broadly modernist style, and George Grosz, whose lecture 'Art and Bourgeois Society' was especially translated for Amauta. It maintained, as its Dada and Surrealist counterparts in Europe had done

just after the First World War, a broad network of contacts among the little avant-garde magazines. The first issue advertised *Renovación* (Lima), *Futurismo* (Marinetti, Rome), *Valoraciones* (La Plata) and *Der Sturm* (Berlin), and the second, *Martín Fierro* (Buenos Aires), *Alfar* (La Coruña), *Sagitario* (La Plata), *Poliedro* (Lima), *Revista de Oriente* (Buenos Aires), *El Estudiante* (Madrid) and *Repertorio Americana* (San José de Costa Rica).

At the same time, however, *Amauta* was specifically concerned with Peru: its title, a Quechua word meaning 'wise man' or 'teacher', 'expresses our adherence to the Indian race', and in 1927 *Amauta* began to include a supplement called 'Boletín de defensa indígena'. (Its involvement with *indigenismo* will be discussed in greater detail in Chapter 9.)

Martín Fierro, in Buenos Aires, on the other hand, elected for a cosmopolitan modernism, rejecting both the past and the 'absurd need to promote intellectual nationalism' (see Appendix, 6.5). Calling itself a 'periódico quincenal de arte y crítica libre', by contrast with the politically committed Amauta, it both asserted American independence and acknowledged the inevitability of European influence. 'Martín Fierro believes in the importance of the intellectual contribution of the Americas, after taking scissors to each and every umbilical cord. But extending the independence movement, begun in language by Rubén Darío, to all intellectual manifestations does not mean we have to give up or, even less, pretend we don't see the Swedish toothpaste, French towels and English soap we use every morning. . . . 'Martín Fierro, whose leading writer was Jorge Luis Borges, approached these issues with a certain amount of irony; its title was taken from the famous poem by José Fernández, an epic of the life and death of the individualist gaucho hero and loner Martín Fierro, with its roots in popular oral poetry, which became something like a national poem. Martín Fierro took freely from Dada and Futurism, and expressed its faith in a modern sensibility in terms virtually paraphrased from Marinetti's Founding and Manifesto of Futurism of 1909: 'Martín Fierro is . . . more at home in a modern transatlantic liner than a Renaissance palace and believes that a nice Hispano-Suiza is a much more perfect WORK OF ART than a Louis XV chair.'

An even more aggressive and eclectic modernism marked the manifesto in the first issue of *Actual* (1921), which described itself as 'Hoja de vanguardia'. Manuel Maples Arce's 'comprimido estridentista' (Appendix, 6.1) adopted a highly provocative Dada-Futurist tone, attacking bourgeois consumer society, its servile and corrupt political systems, and its culture of publicity and advertisements. Maples Arce demanded a synthesis of all contemporary 'isms', quoted directly from Marinetti's *Manifesto* ('A racing car is more beautiful than the Victory of Samothrace'), and appended a list of names including pretty well every contemporary artist and writer, including Dadaists, Cubists, Constructivists, as well as Rivera, Siqueiros, and several Russian intellectuals and artists. The *Estridentistas* combined an extreme vanguard position

6.10 Anita Malfatti, *The Yellow Man*, 1915-16, charcoal and pastel on paper, 61×45.5 cm., Museu de Arte Contemporânea da Universidade de São Paulo.

6.11 Vicente do Rêgo Monteiro, Légendes, croyances et talismans des Indiens de l'Amazonie, Paris, 1923, cover, Bibliothèque Nationale, Paris.

with political commitment, and 'hailed the Russian Revolution'. Maples Arce's poem 'Urbe' of 1924, dedicated to the workers of Mexico, declares

The lungs of Russia breathe in our direction the wind of social revolution. 9

El Machete, founded by the Syndicate of Technical Workers, Painters and Sculptors which became the official organ of the Mexican Communist Party ('Periódico obrero y campesino'), was closely linked to the mural movement, and contained many of the mural painters' first experiments with woodcuts.

The Brazilian 'modernists' were a specific group whose first public manifestation was the Semana de Arte Moderna (Modern Art Week) of 1922 in São Paulo, which included exhibitions, poetry readings, concerts and lectures. Graça Aranha spoke of the leading role taken by music and the visual arts: 'the music of Villa-Lobos, the sculpture of Brecheret, the painting of di Cavalcanti, Anita Malfatti, Vicente do Rêgo Monteiro, Zina Aita', as well as by the 'audacious' young poets. ¹⁰ Indeed, the first stirrings of Brazilian modernism really date back to an exhibition of Anita Malfatti's paintings in 1917, which provoked considerable hostility among public and critics [Pl. 6.10]. One long article, for instance, used it as the occasion to attack modern art as a whole, especially Cubism, affirming what its author saw as, by contrast, the 'unchanging values' of 'true' modern artists like Rodin, Frank Brangwyn and Paul Chabas.¹¹ Oswald de Andrade, a poet and leader of the modernist group, defended Malfatti as having challenged the 'photographic naturalism' then in fashion with audacious and daring canvases. Malfatti's work was in fact modernist in a very general and eclectic sense, combining an angular distortion of the figures with a free and rather Fauvist use of complementary colours. It is interesting that de Andrade and Aranha both emphasize audacity for itself, rather than any specific new aesthetic or style; and it does seem as if modernist styles were valued primarily for their capacity to shock, the more extravagantly the better.

In the same year as the Modern Art Week, the Futurist-style *Klaxon*, 'monthly review of modern art' (São Paulo), was founded (see Appendix, 6.2). It emphasized an international, industrialized context for art: 'A new scale . . . advertisements producing letters taller than towers. And new forms of industry, transport, aviation. Pylons. Petrol stations. Rails.'

Tarsila do Amaral, who became the artist most closely linked to the *modernista* group, took the view, significantly, that Cubism was a destructive movement, but one through which they had to pass. The writings and manifestos, while lacking the scepticism of Dada and the theoretical riches of Futurism, display a simultaneous sense of rupture and excitement in their staccato assertions of the modern world. Oswald de Andrade's manifesto 'Pau-Brasil Poetry' (see Appendix, 6.3), however, contains a new element. Without re-

jecting the internationalism of *Klaxon*, and while asserting clearly their lack of an aesthetic creed ('no formula for a contemporary expression of the world'), 'Pau-Brasil Poetry' turns back in a new way to Brazil, its mixed culture, the contrast of its tropical setting and modern industry, using the phrase 'the jungle and the school'. This marked an extraordinary change of consciousness in the group of wealthy, educated and highly Europeanized intellectuals, poets and artists who constituted the modernist group – a change not towards any simple version of nationalism, but towards a sense of the nature of colonization. This consciousness was 'pushed to its paroxysm in the "Anthropophagite Manifesto" by Oswald de Andrade of 1928 which exhorts us to devour our colonizer . . . in order to appro-

6.12 Tarsila do Amaral, *Anthropophagy*, 1929, oil on canvas, 126×142 cm., Fundação José e Paulina Nemirovsky.

6.13 Tarsila do Amaral, *Calm Sea II*, 1929, oil on canvas, 75×93 cm., Acervo Artístico-Cultural dos Palácios do Governo do Estado de São Paulo.

6.14 Tarsila do Amaral, *Black Woman*, 1923, oil on canvas, 100×80 cm., Museu de Arte Contemporânea da Universidade de São Paulo.

priate his virtues and powers and transform the taboo into a totem'. ¹² In this manifesto (Appendix, 6.4) de Andrade attempts to embrace the contradictions of their condition: modern/primitive, industry/indolence, centre/region, Europe/America. 'From the French Revolution to Romanticism, to the Bolshevik Revolution, to the surrealist revolution . . . we continue on our path. We were never catechized. We sustained ourselves by way of sleepy laws. We made Christ be born in Bahía. Or in Belém, in Pará. But we never let the concept of logic invade our midst.'

The 'Anthropophagite Manifesto' was published in the first issue of the *Revista de Antropofagia*, illustrated with a drawing by Tarsila of a naked figure with enormously enlarged foot, cactus and sun – an identical motif to that of her painting *Abaporu*, elaborated the following year in the painting *Anthropophagy* [Pl. 6.12]: Tarsila found the title in a dictionary of the Tupi–Guarani language: *Aba* meaning man, *poru*, who eats. Tarsila was settled in Paris in 1922–3, and the first traces of 'Pau–Brasil' themes occur then, when she was only just learning a basic analytical cubism. Beside the sober palette of her cubist pictures, the canvases in which some form of the 'jungle and school' idea appears have strong colours, and a simplified geometricized background which becomes, in the most remarkable of these works, *Black Woman* [Pl. 6.14], a completely abstract pattern. The seated woman and jungle plant of *Black Woman* already announce the *Abaporu/Anthropophagy* motif.

In Paris, Tarsila had studied with André Lhote, and frequented Léger's studio; her smooth, cylindrically-limbed figures and strong colours suggest that Léger was important for her, but her work remains idiosyncratic.

Through Léger she met the traveller-poet Blaise Cendrars, and a drawing of Black Woman was used on the cover of Cendrars's Feuilles de Route (1924). In 1924 she, Oswald de Andrade and Cendrars were back in São Paulo; there, Cendrars gave a talk on modern French poets¹³ and the group used it as the occasion to visit Minas Gerais and the country to the north which accelerated the 'rediscovery' of Brazil's colonial past, and popular culture, in the smaller towns and villages. In a burst of activity this year, Tarsila produced a group of particularly successful paintings, with Cendrars's presence perhaps providing an added impetus. The paintings of c. 1924 cluster round two contrasting themes - the city, and the apparently more country-like favelas, or slums. The former have the flat façades of modern buildings, and no perspective, although space is constructed by overlapping and diminution of scale, faintly anthropomorphic petrol pumps but no people, and use a mixture of quite strong colours and the pastel colours of Purism [Pl. 6.15]. The cityscapes, railways, etc. suggest a kind of industrial primitivism. The 'favelas', by contrast, are full of life people, animals, flags, vegetation, with intense oranges, reds and dark greens, still applied flat, and derived from the colours of Brazilian popular art.

Like Tarsila, Emilio di Cavalcanti painted local, picturesque scenes in a simplified, highly coloured style [Pl. 6.16].

6.15 Tarsila do Amaral, *Central Railway of Brazil*, 1924, oil on canvas, 142×126.8 cm., Museu de Arte Contemporânea da Universidade de São Paulo.

The Brazilian *modernistas* in the Twenties were an élite and privileged group, living a cosmopolitan life and travelling freely to Europe as well as in the provinces. A critic later remarked on the spectacle of Tarsila, returning from Paris with her Poiret dresses, to teach the people how to be Brazilian. However, although the group was not directly involved in the turbulent political events in Brazil in the Twenties, in the Thirties several became leftist sympathizers; Tarsila visited Moscow in 1931 and her work moved in the direction of social realism.

In opposition to this basically urban and cosmopolitan group of modernists, Gilberto Freyre agitated for a cultural, economic and social policy of regionalism, in his Programme of the Regionalist Centre of 1926. Recife and north-eastern Brazil have been flourishing centres of artistic activity, and popular art in Brazil has a wide regional base. ¹⁵

Two groups were founded in 1932 to support modern art in Brazil: SPAM, the Sociedade Pro-Arte Moderna, and CAM – the Clube dos Artes Modernos; the latter was founded by the artist and architect Flavio de Carvalho, in a spirit of opposition to the élitism of SPAM. In 1951 the first São Paulo Bienal established Brazil as an international centre for contemporary art.

For those artists who wished to adopt a modern idiom, Cubism was almost invariably the gateway. Pettoruti had travelled to Europe on a scholarship in 1913, first making contact with the Futurists, and then, in 1924, with Cubism. He remained on the whole heavily indebted to Picasso, but some of his most interesting work is a flat, hard-edged adaptation of Purism, which became on occasion highly abstract [Pl. 6.17].

Amelia Peláez was one of the younger and less radical artists who exhibited at the exhibition organized by the *Revista de Avance* in 1927, a review founded in Havana by the 'grupo minorista' which included Jorge Mañach, and the novelist Alejo Carpentier (Appendix, 6.10). They were admirers of the Mexican muralists, and of José Vasconcelos, as well as of the Spanish poet García Lorca. Peláez was, however, one of the artists who best understood Cubism and who subsequently used it in a highly original way.

Peláez left Havana for Paris at the end of the Twenties and stayed there for seven years, making a prolonged study of Cubism and in particular of Picasso's and Braque's synthetic cubism of 1912-13, in works using pencil and collage. In thus going for a cubism where construction, the building up of a surface of almost abstract elements in combination with objects, was more important than the analysis of form, Peláez showed a consistency of approach, even if overall her work in these years was highly eclectic, as her comment underlines: 'The artists who most interest me are, from France, Ingres, Seurat, Cézanne, Picasso, Braque and Matisse.' Beside the synthetic cubist collages, Peláez worked in a curvilinear style, as in Siesta (1936), in which a monumental Picasso-like figure lies in a landscape of heavily outlined, flattened organic shapes recalling

Léger's post-1920 canvases. In 1931 Peláez joined Léger's Académie Contemporaine, where she studied with Alexandra Exter. After her return to Cuba, she created a completely unique synthesis of the elements of her earlier work, in still lifes and interiors, brilliantly coloured tropical fruit and flowers, flat planes outlined by heavy black lines, inspired by the elaborate wrought-iron work of the balconies, gates and fanlights of late nineteenth-century Havana houses [Pl. 6.19]. 16

Pedro Figari was a unique and in certain respects an isolated figure. A lawyer with a distinguished public career, he began painting full-time in 1921 at the age of sixty. He was not, as he often said himself, interested in painting for its own sake – in the *métier* of painting, but rather seems to have considered himself as a guide to future generations of painters: 'my conviction has been to elevate our culture and make us love the American things that are so very much ours.'¹⁷

The Cuban novelist Alejo Carpentier described Figari's love for the American vernacular:

For Figari there is nothing more adorable in the whole world than those things that the ridiculous well-off and fancy people of our native country consider as 'failings', desolated as they are not to see the tropical cities turned into reproductions of Piccadilly. Colonial patios, local street bands, black fiestas, popular songs and dances, guitars, drums, bright colours, carnival teams, barbaric silks and percales; here are the themes that inspire him!¹⁸

The subjects of Figari's paintings are set 'some distance off in time and in space', as Borges said of his own collection of stories, *Dr Brodie's Report*. Many of these stories, like Figari's paintings, are set in the last decades of the nineteenth century, on the open pampas, with the wild and semi-literate gauchos as protagonists and the duel as the most characteristic action.

The open pampas had one landmark: the ombu tree, often the centre of Figari's painting [Pl. 6.22]. The naturalist W. H. Hudson, who lived on an estancia on the pampas as a boy in the last years of Rosas' dictatorship, described it thus:

The ombu is a very singular tree indeed . . . It belongs to the rare Phytolacca family, and has an immense girth – forty or fifty feet in some cases; at the same time the wood is so soft and spongy that it can be cut into with a knife, and is utterly unfit for firewood, for when cut up it refuses to dry, but simply rots away like a ripe watermelon. It also grows slowly, and its leaves which are large, glossy and deep green like laurel leaves, are poisonous; and because of its uselessness it will probably become extinct . . . but before other trees had been planted the antiquated and grandlooking ombu had its uses; it served as a gigantic landmark to the traveller on the great monotonous plains, and also afforded refreshing shade to man and horse in summer; while the native doctor or herbalist would sometimes pluck a leaf for a patient requiring a very violent remedy for his disorder. ¹⁹

6.18 René Portocarrero, *Little Devil No. 3*, 1962, oil on canvas, 50.5×45.5 cm., Museo Nacional, Palacio de Bellas Artes, Havana.

6.16 Emiliano di Cavalcanti, *Five Girls of Guaratinguetá*,1930, oil on canvas, 97×70 cm., Museu de Arte de São Paulo.

6.17 Emilio Pettoruti, *Argentinian Sun* or *Intimacy*, 1941, oil on canvas, 99.5×65 cm., Museo Nacional de Bellas Artes, Buenos Aires.

6.19 Amelia Peláez, *The White Cloth*, 1935, oil on canvas, 64×79cm., Museo Nacional, Palacio de Bellas Artes, Havana.

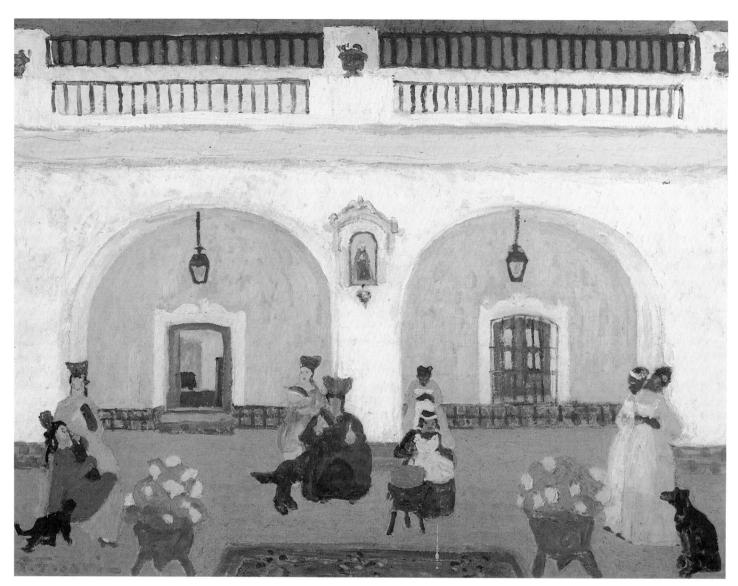

6.20 Pedro Figari, '*Dulce de Membrillo*', n.d., oil on cardboard, 60×81 cm., Museo Nacional de Artes Plásticas, Montevideo.

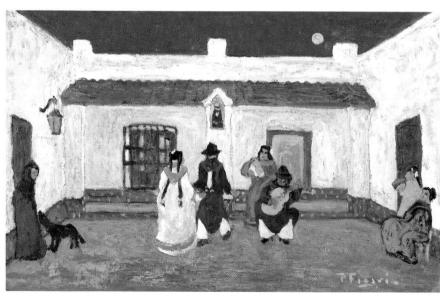

6.21 Pedro Figari, *Creole Dance*, c. 1925, oil on cardboard, 52.1×81.3 cm., The Museum of Modern Art, New York; Gift of the Honorable and Mrs Robert Woods Bliss.

The sense of a vanished or vanishing world also marks Figari's paintings of social gatherings and ritual events like funerals. He often painted contrasting scenes of 'candombe' and the more European 'pericón' and creole dances. 'Candombe' was the name given to the weekly gatherings of the black population of Uruguay (descendants of slaves escaped from the Brazilian plantations), and to a dance, ultimately of African origin. ²⁰ (The socio-religious activity in Brazil is known as 'candomblé'.) The dance took place on Sundays and on the chief Christian festivals, though the Afro-Latin celebration was 'essentially profane'. Figari painted the candombe many times, as in *African Nostalgia* [Pl. 6.23], as he remembered it from his childhood in the 1860s and '70s, during which period it had remained essentially unchanged. The energy and scale of the dancing and drumming figures in the candombe scenes contrast with the detached and acerbic observation of the stiff and pompous gatherings of the white creole world, with their chandeliers and framed

6.22 Pedro Figari, *Horses*, n.d., oil on board, 62×82cm., Private Collection, Buenos Aires.

portraits, and also with the scenes of country dances with girls and gauchos.

In 1930, in Paris, Figari published *Historia Kiria*, an account of a Utopian world, which was, as Utopias always are, a critique and satire on contemporary society, and especially that of the Rio de la Plata. The Kiria people did not know that there was any distinction of race, they did not know superstition, had no wars, and no sense of the tragic (life was not a vale of tears), preferred the useful to the decorative and laughed at the idea of art for art's sake.

Figari's passionate concern for the reform of legal, teaching and art institutions (in some respects his ideas parallel those of Ruskin, and William Morris), his preference for nature over civilization and the rational over the marvellous, help to explain his lack of interest in the more radical forms of modern art, although he was living and painting in Paris at the height of its artistic dominance. Although he owes a certain debt to the 'intimiste' manner of Bonnard and Vuillard, this connection has to be approached with care. Figari's man-

6.23 Pedro Figari, *African Nostalgia*, n.d., oil on cardboard, 80×60 cm., Museo Municipal Juan Manuel Blanes, Montevideo.

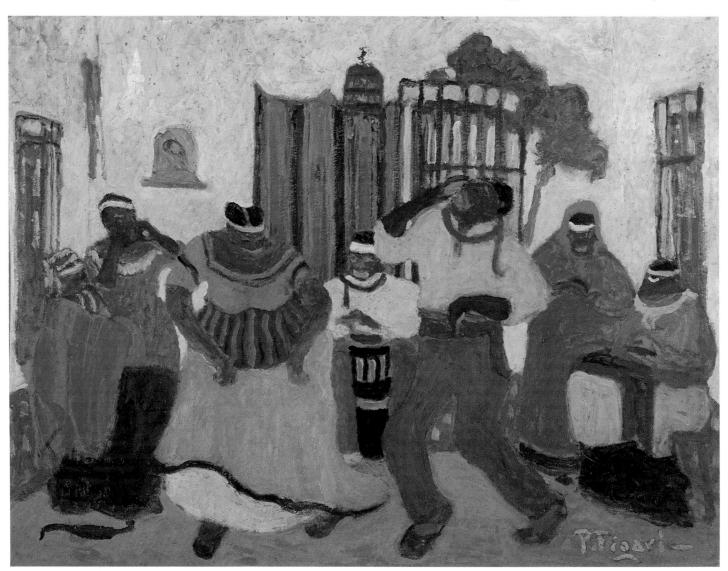

6.24 Pedro Figari, *The Bell for Prayer*, n.d., oil on cardboard, 69×99cm., Museo Nacional de Artes Plásticas, Montevideo.

ner is by comparison rough and rudimentary, he smudged paint to generalize features, but always restricted the decorative patterns which, in Vuillard, spread over the whole surface, to places where they would naturally occur – on cotton dresses, for instance [Pl. 6.24].

No one has explained more clearly the peculiar nature of memory in a country where investment in the new involves a total denial of the past than Borges. Of Figari, Borges wrote:

I spoke of the Argentine memory and I feel that a condition of modesty protects this subject and that to revel in it is treason. For in this house of America, the people of the world's nations have conspired to vanish into the new man or woman, who is not yet any one of us and whom we predict as being Argentine, so as to approach our hoped-for goal. It is conspiracy of an unusual kind: an extravagant adventure of breeds, not to survive but to be finally unknown: blood seeking the night. The creole is of the conspirators. The creole that shaped the entire nation has now chosen to be one of many. That there may be greater honours in this land, he has to forget honours. To remember them is almost

6.25 Xul Solar, 'Bri, país y gente', 1933, watercolour on cardboard, 40×56cm., Collection Marion and Jorge Helft, Buenos Aires.

Both Figari and the Argentinian Xul Solar (Alejandro Solari) adapted a European-derived style to a singular subject matter, but while Figari went for the vernacular, Solar was concerned with a more mystical and mysterious world. Solar returned to Buenos Aires after twelve years of absence in Europe. He was soon drawn into the 'Martín Fierro' group, contributed to the magazine (he translated for instance one of the Dadaists' favourite poets, Christian Morgenstern), and did drawings for Borges' books, such as *Idioma de los Argentinos* [Pls 6.25,26,27]. Solar not only painted his 'idea' pictures, in which he draws variously on the idiom of painters

like Klee and Malevich, and the German Expressionists, but invented two languages, 'neocreol', and 'pan lengua', ²² and studied astrology. It is not difficult, in fact, to imagine Solar as collaborator of Borges and also as a subject of the Borges of *Fictions*.

Solar's landscapes, which sometimes become cities of towers, sometimes vistas of mountains, relate both to Japanese painting and to the strange eroded land of Cappadocia in central Turkey [Pl. 6.28]. ²³ In one of the first versions of this landscape (1921), a watercolour made while he was still in Europe, the peaks with windows and doors carved in the rock are clearly based on the Cappadocia rocks. Solar later added ladders and archways, in metaphorical reference to transcendental experience, as in the painting that Borges owned, *Landscape* (1938), or *Deep Valley* (1944) [Pls 6.29,30].

Neither Xul Solar nor Figari formed a 'school', in spite of the fact that both enjoyed success in Buenos Aires; Joaquín Torres-García, however, although he had spent almost all his career outside his native country of Uruguay, living in Spain, France, and in the United States, was an active proselytizer after his return in 1933, and has had a lasting influence on the development of the constructivist tradition in America.

6.27 (left) Xul Solar, 'Los Quatro Plurentes', 1949, tempera on paper mounted on board and painted wood frame, 49.5×37.5 cm., Collection Felisa and Mario H. Gradowczyk, Buenos Aires.

6.28 Cappadocia, Turkey.

6.29 Xul Solar, *Deep Valley*, 1944, tempera on paper mounted on board, 35×50cm., Galería Kramer, Buenos Aires

6.30 Xul Solar, *Landscape*, 1938, watercolour on paper mounted on board, 31.7×37 cm., Private Collection, Buenos Aires.

6.26 Xul Solar, *Saint Dance*, 1925, watercolour on cardboard, 25×31 cm., Collection Marion and Jorge Helft, Buenos Aires.

Torres-García shared the convinced internationalism of the postwar generation of Constructivists: Moholy-Nagy, Mondrian, Richter, Vordemberge-Gildewart, Schwitters²⁴; but at the same time there was always a strong sense of place in his art. In his text 'Escuela del Sur' (1935, Appendix 6.11), this duality is clear. So he addresses Montevideo, whose

special character isn't found in the maté, or the poncho, or the songs; it's something more subtle, which permeates everything and has the same clarity, the same white light as the city. . . . And here we are, nexus of the swirling winds of these regions which disturb the mind and body on that particular bank of the great river, almost a peninsula, as if it wanted to spearhead the continent, to be in the vanguard. So, our geographical position seals our destiny.

But of course it was still inevitable that he should draw upon his own experience in Paris. In 1935 he founded the Asociación de Arte Constructivo, and the magazine *Círculo y Cuadrado* (1936-43), reviving the title of the movement 'Cercle et Carré' of which he had been a founder-member in Paris in 1930. Torres-García's impressive review, which contained contributions by and reproductions of the work of the leading international Constructivists, was highly influential in Latin America, and this, together with the revival of his *Taller* (teaching studio), and his writings and lectures, was instrumental in propagating his ideas.

In 1938 Torres-García erected Cosmic Monument [Pl. 6.31] - a freestanding 'wall' in a park in Montevideo outside the National Museum of Fine Arts. The stone grid contains many of the signs and symbols from his paintings: sun, anchor, ladder, clock and some of his own invention. Although his references to Native American civilizations – to what he called 'Indoamerica', and specifically to Andean theogony - increased in this period, it already existed in his Paris days, when he drew upon the pre-Inca civilization of Tihuanaco for both iconography and structure (there was a plaster cast of the Gateway of the Sun, at Trocadéro), and on the figureshapes and colours of Nazca pottery [Pls 6.32,33]. He was also fascinated by photographs of the massive Inca masonry in Cuzco, and the fortress of Sacsahuaman, and the heavy shadows cast by the bevelled edges of the giant stones in their irregular grids reappear in his black and white paintings. His 'masks', however, remained very generalized, using for instance universally recognizable symbols for male and female.

Although Torres-García had contacts with Mondrian, he did not

6.31 Joaquín Torres-García, Cosmic Monument, 1938, Parque Rodó, Montevideo.

6.32 Joaquín Torres-García, *Abstract Metaphysical Forms*, 1930, oil on canvas, 146×114 cm., Estate of the Artist, New York.

6.34 Joaquín Torres-García, *Pachamama*, c. 1942, oil on wood, 76.1×85.1cm., Collection Cecilia de Torres, New York

share his polemical attitude to abstraction. He did, however, share Mondrian's faith in the quality of equilibrium, as a balance between opposing forces: between, for Torres-García, reason and nature, life and abstraction. While the ex-Dadaist Hans Arp (like Mondrian, a member of 'Cercle et Carré') stressed the natural, irrational and organic over the human and measured, Torres-García sought a balance with reason. He traced the different modes of representation – naturalist versus the geometrical sign – back to primitive times, and looked for sources in both pre-historic Europe and in pre-Columbian art. ²⁶ The sign, he wrote, constitutes the Tradition of Abstract Man:

Any primitive culture progresses along that line. Its art, always geometric in expression, is a ritual, something sacred.

Such is the problem the artist today must face; this too is the wish revealed in modern artistic expression.

Raising the term 'structure' to a universal plane, we can determine that the sign is something natural, and so can grasp the essence of this point of incidence between the living and the abstract. And this would be the best explanation of what we understand by Constructive Art. ²⁷

However subsequently transformed, some initial engagement with an aspect of European modernism marks most of the works included in this section. The Venezuelan painter Armando Reverón, however, like Dr Atl and Figari, remained virtually untouched by the radical changes taking place in painting in the years immediately preceding the first world war. He was, rather, affected by the earlier rejection by the Impressionists of academic painting,

6.35 Armando Reverón, *Figure*, n.d., oil on canvas, 50×45 cm., Colección Sawas.

6.33 Joaquín Torres-García, *Constructive Art with Large Sun*, 1942, oil on cardboard, 75×48cm., Collection Augusto Torres, New York.

6.37 Armando Reverón, View of the Port of Guaira, n.d., oil and tempera on canvas, 65×81 cm., Colección Sawas.

6.36 Armando Reverón, *Macuto Beach*, *c.* 1934, oil and tempera on burlap, 96.7×108 cm., Private Collection.

returning from Europe in 1915 having definitively abandoned the academic style of his Fine Art training in Caracas; canvases of this time show him to have been a gifted colourist. Encouraged by the Circulo de Bellas Artes, (founded in 1912 in opposition to the restrictive approach of the Academia de Bellas Artes) – an organization which included artists and writers, and strongly influenced the new generation of Venezuelan artists – he devoted himself to painting from nature, and, above all, landscapes in the open air. In 1921 Reverón moved to Macuto, on the sea, where he lived for the rest of his life. Already in 1916 moving towards a monochromatic

use of blue, between about 1926 and 1932, he painted an extraordinary series of landscapes, of a startling originality [Pls 6.36,37]. The canvases are almost pure white, as though metaphors for pure light, uniting and transcending all the colours of the spectrum. These are often thinly painted, the canvas showing through as in later canvases in which colour begins to seep in again.

Reverón lived an increasingly isolated and eccentric life, suffering nervous crises, wild in appearance [Pl. 6.38], gathering the reputation of a hermit, his studio eventually becoming a stage peopled with dolls and 'toys'. Although he enjoyed patronage from the Caracas élite, and exhibited every year from 1940 at the Official Salon in Caracas, he lived an unconventional life, voluntarily excluded from society, living in isolation which, as with so many artists in Paris at the end of the last century living 'la vie de bohème', was symbolic of his condition as an artist. Reverón set a distance between himself and the world to which he had once belonged as great spiritually if not geographically as that Gauguin created by moving to Tahiti.

6.38 Armando Reverón, *Self-portrait with Dolls and Beard, c.* 1949, charcoal, chalk, crayon and pastel on paper on cardboard, 64.7×83.5 cm., Galería de Arte Nacional, Caracas.

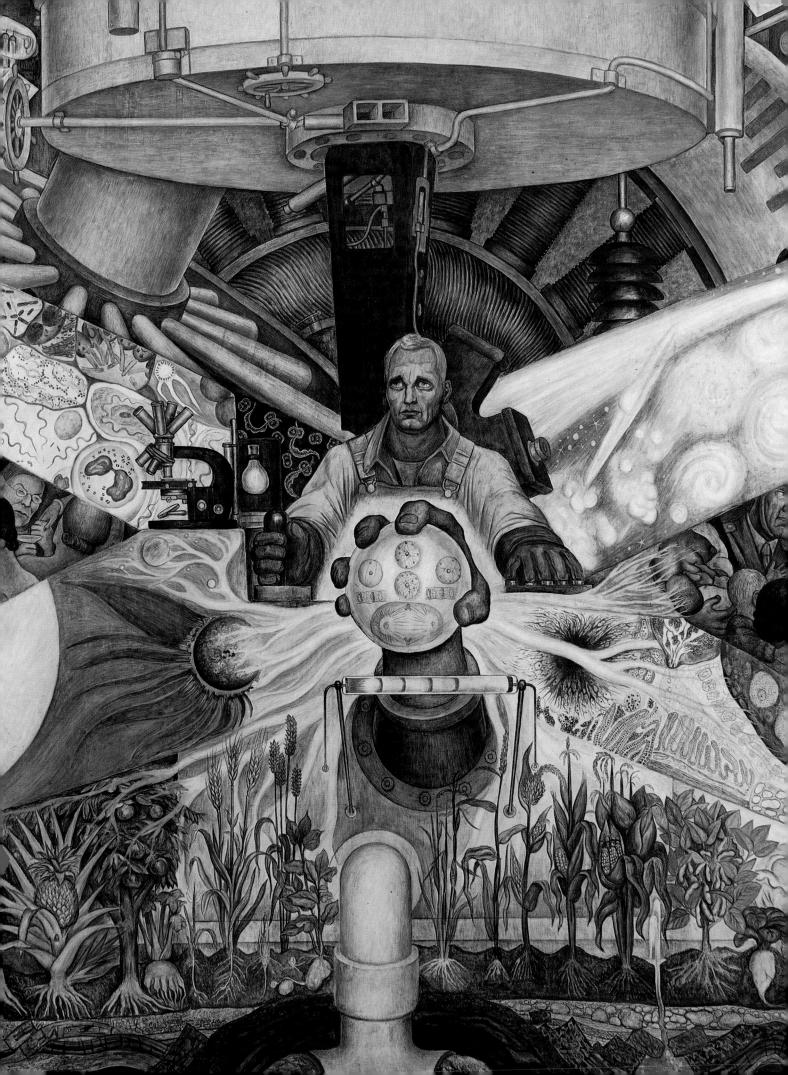

7 The Mexican Mural Movement

THE MEXICAN muralists produced the greatest public revolutionary art of this century, and their influence throughout Latin America – most recently in the wall paintings in Nicaragua – has been farreaching and continuous. There was a time, during the 1930s, when it was also felt in Britain, and in the USA, but since then they have rarely entered artistic discourse.¹

A major difficulty is that of adequately presenting the murals themselves, for although portable murals were produced, they cannot give a sense of the work in its setting. Murals were painted all over Mexico in different kinds of sites: graceful colonial churches and palaces, the patios of ministerial buildings, schools, town halls and museums, in positions ranging from dark and awkward staircases to the prominent façades of modern buildings.

The muralists were the most vigorous and creative of the cultural vanguard of revolutionary Mexico, with a powerful sense of the social value of their art. The violent revolt in 1910 against the regime of Porfirio Díaz had blazed on and off for ten years, during which time the President's chair in Mexico was often vacant. A cataclysmic event, never fully harnessed to any single programme or set of interests - though Zapata's struggle for agrarian reform in Morelos was and remained a fundamental issue - the Revolution brought a new consciousness to Mexico.² The inauguration of the former revolutionary leader Alvaro Obregón as President, in 1920, initiated a period of hope and optimism in which the mural movement was born. 'The Revolution revealed Mexico to us,' Octavio Paz said; 'Or better, it gave us eyes to see it. And it gave eyes to the painters. . . . '3 By contrast with the relatively halting response of novelists, the painters flooded the walls with torrents of images, in a variety of modes: realistic, allegorical, satirical, presenting the many faces of Mexican society, its aspirations and conflicts, history and cultures.

There were several reasons for the dominance of the visual arts and the cultural primacy of muralism. Most immediately, the philosopher and revolutionary José Vasconcelos, whom Obregón made president of the University and Minister of Education, was committed to a mural programme; what was unusual about it, though, compared with others launched under revolutionary conditions, was the absence of any direction concerning style or subject matter. Vasconcelos left his artists free to pick their themes, with unforeseen consequences. His visionary plan was rooted in a social theory indebted both to Pythagorean concepts and to the pos-

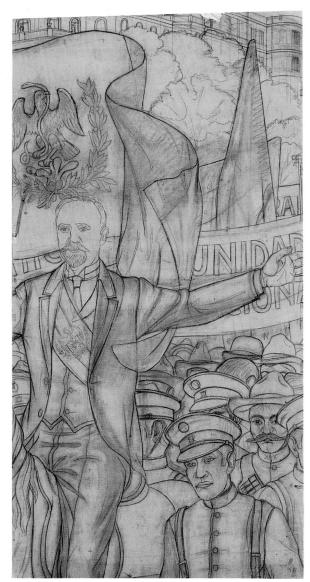

7.2 Juan O'Gorman, Francisco I. Madero (preliminary study for the mural in the Revolution Room of Chapultepec Castle), n.d., pencil on paper and canvas, one of five panels, 450×110 cm., Collection Vicky and Marcos Micha.

7.1 Diego Rivera, *Man, Controller of the Universe* (detail), 1934, fresco, Museo del Palacio de Bellas Artes, Mexico City (INBA).

THE MEXICAN MURAL MOVEMENT

7.3 Fernando Leal, *The Epic of Bolívar*: 'Bolívar as a Child', 'The Liberator', 'The Death of Bolívar', 1930, watercolour on paper, 52×47.5 cm. each, Collection Fernando Leal Audirac.

itivism of Comte; he held that society evolved through three stages, the most advanced of which was the aesthetic, which revolutionary Mexico should be about to enter. 'If Vasconcelos shared few of the views of the Painters' Syndicate with their collectivist aesthetic, he believed passionately that Mexicans could only be won over once their aesthetic sensibilities had been aroused.' Out of a conviction that in Mexico it was the visual sense that dominated, rather than the musical, he was the first enabler, releasing the walls of the newly reconstructed National Preparatory School (ENP, Escuela Nacional Preparatoria)⁵ to an extremely young and turbulent group of artists, whom he plucked from the art schools and studios, or, in the case of the more mature Rivera and Siqueiros, lured back from Europe.

Secondly, there was a long tradition of mural projects in Mexico. 6 Dr Atl (Gerardo Murillo), during his brief tenure as director of the School of Fine Arts in 1914, wrote: 'Architects, painters and sculptors should not work with an exhibition or a degree in view, but rather to make or decorate a building'. And, although most of the painters were less aware of them than of Italian frescoes. the walls of the pre-Conquest cities had been covered with murals.⁸ Rivera first saw examples when he accompanied Vasconcelos to the Yucatán in 1921, at Chichén-Itzá, in the Temple of the Jaguars. For practical purposes, though, any 'tradition' really existed only in theory, and the young painters' claims to be starting from scratch were not just rhetorical. Their training had made no provision for mural painting, and their stories of how they set out to teach themselves often reach levels of high comedy. There was an early battle between the followers of encaustic, 9 which Rivera used for his first mural Creation [Pl. 7.6], and true fresco, with the latter finally triumphant. Much was made in the press and by the artists of the rediscovery of ancient techniques in 1923, during the first phase of the painting of the Ministry of Education, but it seemed to come down to little more than dipping the brushes in a bucket of water containing nopal cactus leaves. Also perhaps to be taken into account, at least for those artists like Rivera and Siqueiros who had been in Europe, was the fact that several artists formerly of the Cubist milieu were also developing ambitions to paint on a large scale – for instance Delaunay, and, closer in terms of his populist orientation, Fernand Léger.

Thirdly, the Revolution sparked fresh research into the 'Indian problem', beneath which rumbled the great issue of whether 'Mexico' was one nation or two, the results of which placed considerable weight on the role of art. The archaeologist and anthropologist Manuel Gamio 'explained in his *Forjando Patria*, published in 1916, why art is no social interloper in the workings of a country where its uses are as widespread as those of bread'. So Jean Charlot wrote, going on to quote from *Forjando Patria*:

Divergent points of view in aesthetic matters contribute substantially to the pulling apart of Mexico's social classes. The Indian preserves and practices pre-Hispanic art. The middle class preserves and practices a European art qualified by the pre-Hispanic or Indian. The so-called aristocratic class claims its art to be pure European.

Leaving to the latter its dubious purism . . . let us observe both other classes. They are already split by ethnic and economic differences. The workings of time and an economic betterment of the native class will contribute to the ethnical fusion of the population, but cultural fusion will also prove a potent factor. . . . When native and middle class share one criterion where art is concerned, we shall be culturally redeemed, and national art, one of the solid bases of national consciousness, will have become a fact. ¹⁰

Such ideas, in bringing the visual arts to the fore, helped to establish the cultural and political framework by which muralism as a national art was established and promoted, but did not necessarily coincide with the muralists' own conception of their role, nor with the social message their art conveyed. In the passage quoted above it is notable that the Indians occupy the position the working class would in a Marxist model, but that model was not fully applicable, because of profound cultural difference between the two major social groupings, and because not all Indians are working class and not all the working class are Indians. Rather than aiming at the cultural fusion outlined above, the muralists demanded, at least in principle, the eradication of bourgeois art (easel painting), and pointed to the native Indian tradition as their model for the socialist ideal of an open, public art: 'a fighting educative art for all'.

In 1922 the 'Declaration of Social, Political and Aesthetic Principles' of the newly formed Syndicate of Technical Workers, Painters and Sculptors repudiated centuries of artistic dependence on Europe in favour of a native aesthetic:

THE MEXICAN MURAL MOVEMENT

The noble work of our race, down to its most insignificant spiritual and physical expressions, is native (and essentially Indian) in origin. With their admirable and extraordinary talent to create beauty, peculiar to themselves, the art of the Mexican people is the most wholesome spiritual expression in the world, and this tradition is our greatest treasure. Great because it belongs exclusively to the people and this is why our fundamental aesthetic goal must be to socialize artistic expression and wipe out bourgeois individualism. ¹¹

In practice, though, the differences between a native 'popular' art and the muralists' 'people's art' were not resolved.

The elements of this polemical national art were beginning to take shape on the walls, and they were very different indeed from the first murals commissioned by Vasconcelos. Those were genteel universalist allegories, conceived in 'the gentle aesthetic calm that preceded the impending plastic storm'. Roberto Montenegro, who was currently enjoying considerable success, together with Adolfo Best Maugard and Carlos Mérida, with paintings in the 'soft' picturesque nationalist style then in vogue, and who had also been involved with Dr Atl in the important exhibition of Folk Art in 1921, was commissioned to decorate the old convent church of San Pedro y San Pablo. He painted a Dance of the Hours, with twelve lightly draped ladies dancing round 'an armoured knight who leans against a Persian tree of life gay with giant blooms and chirping birds, on a gold background'. ¹³ The nave of the church was decorated by Xavier Guerrero (whose generous good sense and technical expertise was to be of great help to the new artists) with garlands of flowers. In a rather more dynamic, flamboyant spirit, Dr Atl worked in the patio on 'flaming depictions of Mexican scenery - tropical nights with a million coloured stars, blue surf under orange billowed clouds pounding against red rock', using his impermanent home-made 'Atl-colours'.

Diego Rivera disliked Dr Atl's work as much as he scorned the flat decorative arabesques of Montenegro; none the less, his first mural, *Creation*, which he started at the very end of 1921 in the auditorium of the ENP, was still in line with Vasconcelos' taste for vague allegories. Rivera's grand scheme brought together figures representing Mexican types dressed in picturesque costume [Pl. 7.6], and others representing the arts, and civic and theological virtues (justice, hope, faith, etc.), the whole topped by a symbol of 'The LIGHT ONE or PRIMAL ENERGY'. What concentrated critical attention on this mural by the already famous artist, recently returned from a successful career as a cubist painter in Paris, was its vigorous mix of cubist volumes and simplifications, and borrowings from quattrocento and Renaissance Italy, especially Giotto and Michelangelo.

Siqueiros, always a skilled and articulate polemicist, had already launched from Barcelona a blast against the flat archaic style of pic-

7.4 and 5 Diego Rivera, two sketches from the Tehuantepec Sketchbook, 1922, pencil on paper, 22.2×16.5 cm. each, Galería Arvil, Mexico.

turesque nationalist art. Always the most committed of the muralists to the modern world, both in terms of theme and technical practice, Siqueiros' 'A New Direction for a new generation of American painters and sculptors' called for a new, dynamic and constructive art: 'We must live our marvellous dynamic age!' His language is rooted in the modernist aesthetic of Cubism and Futurism, in which the Cubists' revaluation of 'primitive' art helped to confirm the new attitude to Mexico's native culture: 'We must absorb . . . the constructive vigour of their work, in which there is evident knowledge of the elements of nature', while avoiding 'the lamentable archaeological reconstructions (Indianism, primitivism, Americanism) which are so fashionable today and which are leading us into ephemeral stylizations.'15 Siqueiros emphasized 'the great primary masses: the cubes, cones, spheres, cylinders, pyramids which should be the scaffold of all plastic architecture. Let us impose the constructive spirit upon the purely decorative. . . . the fundamental basis of a work of art is the magnificant geometrical structure of form . . . ' - ideas which probably contributed to some of the most brilliant and uncompromising murals to come, such as Orozco's The Old Order (1926), Montenegro's The Feast of the Cross (1924) and Rivera's Sugar Factory (1923), where the 'geometric structure of form' slipped its cubist anchor and entered a magnificent synthesis with the real architecture.

7.6 Diego Rivera, *Creation*, 1922-3, encaustic and gold leaf, Anfiteatro Bolívar, National Preparatory School, Mexico City.

THE MEXICAN MURAL MOVEMENT

The mural movement was increasingly concentrated in the hands of 'Los Tres Grandes': Rivera, Orozco and Siqueiros. But in the early, heroic years between 1922 and 1924, the young artists commissioned by Vasconcelos to help decorate the walls of the ENP -Fernando Leal, Ramón Alva de la Canal, Fermín Revueltas, Jean Charlot, Emilio García Cahero – made important steps towards its consolidation. It was Revueltas, according to Charlot, who first used the 'hieratic white-clad Indian', which Rivera was to make so familiar, in his Devotion to the Virgin of Guadalupe. Leal broached a new, darker form of Indianism in his Feast at Chalma [Pl. 7.7], which took as its theme a recent incident in a Puebla village: '. . . During the course of a religious dance round the statue of the Virgin, the concussion caused the image to fall down in its glass case, leaving exposed a small figure carved in stone of the goddess of water, which had been hidden since time immemorial under the rich mantle of Our Lady.'16

Leal and Charlot had chosen to paint their murals on walls opposite one another, at the top of the main ENP staircase; although dark and awkward, there was the advantage that the 'diagonal thrust' of the wall was a complete contrast to the rectangular easel picture. Charlot, who had been assisting Rivera on *Creation*, began his own wall in April/May 1922 – in fresco as opposed to Leal's encaustic – on the subject of the *Massacre at the Templo Mayor*. A remarkable blend of Uccello and Léger, it was the first mural to treat the Conquest, and depicts robotic and faceless armoured Spaniards driving blood-red lances into defenceless Indian priests and people celebrating in their temple in Tenochtitlán.

7.7 Fernando Leal, *The Dancers of Chalma*, 1921, study for mural in the Ministry of Education, watercolour on paper, 52×91 cm., Collection Fernando Leal Audirac.

7.8 José Clemente Orozco, *Christ Destroying his Cross*, 1943, oil on canvas, 93×130 cm., Museo de Arte Alvar y Carmen T. de Carrillo Gil (INBA). A later version of the destroyed mural of 1924.

Another artist who should be mentioned in this context as 'the first artist who deserves to be called a painter for the people', is Francisco Goitia. ¹⁷ Like Siqueiros, Dr Atl and Orozco, he had been actively involved in the Revolution, with Pancho Villa's army, producing on the spot 'vivid, realistic paintings and drawings of the civil war'. Although he evaded the long arm of Vasconcelos, and failed to complete even the modest frescoes he had planned, his studies of the aftermath of battle, and of the poor, especially Indian women, mourning their dead, were undoubtedly a powerful support to the new painting [Pl. 9.11].

The culmination of this first phase of muralism were the fresco cycles by Orozco in the main courtyard of the ENP, and by Rivera on the ground floor of the Ministry of Education. Orozco was bitterly opposed to Rivera in terms of their attitudes to a nationalist art, Indianism, interpretations of Mexican history and the Revolution itself, and his murals, avoiding the clear-cut political and historical message of Rivera, can appear ambiguous. The earliest frescos, however, on the ground floor of the ENP, were, like Creation, universalist and allegorical. Of these, the relatively innocuous Maternity was the only one to survive; the more shocking Christ Destroying his Cross [Pl. 7.8] was among those so badly defaced by the hostile Preparatoria students that Orozco repainted them in 1926. Not at all ambiguous are the powerful and grotesque satires on the middle floor: The Reactionary Forces, Political Junkheap, Liberty and the False Leaders, etc., where Orozco's early career as a cartoonist is most evident. On the top floor a much quieter sequence, including The Mother's Farewell, The Grave-digger, and Return to the Battlefield, treats the hidden effect on families of the years of violence.

Rivera's murals for Vasconcelos' recently restored Ministry of Education were commenced in March 1923 amid considerable pub-

THE MEXICAN MURAL MOVEMENT

licity; Vasconcelos' pleased anticipation of a decoration of 'women in picturesque costumes typical of each of the States of the Republic' was not, however, to be realized [Pls. 7.4,5]. Rivera did complete the planned Mexican landscape up one staircase, which started at sea level with tropical vegetation, continued to the high plateau and culminated in the volcanoes. 18 But in the first courtyard, rather than the symbolic and decorative figures planned, he began to paint the daily life of the Mexican worker, from the Indian weaver, potter and farmer to the foundry, sugar refinery and mine, and, over the doors, Náhuatl poems and symbols of the Revolution. Three panels devoted to the theme of the redistribution of the land are set into the Court of the Fiestas, and these include the private rites and the street festivals of the Day of the Dead, and surviving pre-Columbian rituals (Deer Dance and Corn Harvest). 19 Set under the shadow of the arcade, the paintings vary from dark colours to a golden light that glows like corn [Pls 7.11,12].

As Rivera progressed round the courtyards, the work of the other painters commissioned to do panels was covered over – only two by Charlot (*Washerwoman* and *Loadbearers* [Cargadores]) and two by de la Cueva (*The Little Bull* and *Battle Dance* [Los Santiagos]) remain. In these two courts we already find a contrast between Rivera's delight in the modern industrial world, which was to find

7.9 Courtyard of the Ministry of Education, Mexico City.

7.10 First floor of the Ministry of Education, with murals by Rivera.

7.11 a and b Diego Rivera, *Day of the Dead – City Fiesta*, 1923–4, fresco, Ministry of Education, Mexico City.

7.12 Diego Rivera, Day of the Dead – The Offering, 1923–4, fresco, Ministry of Education, Mexico City.

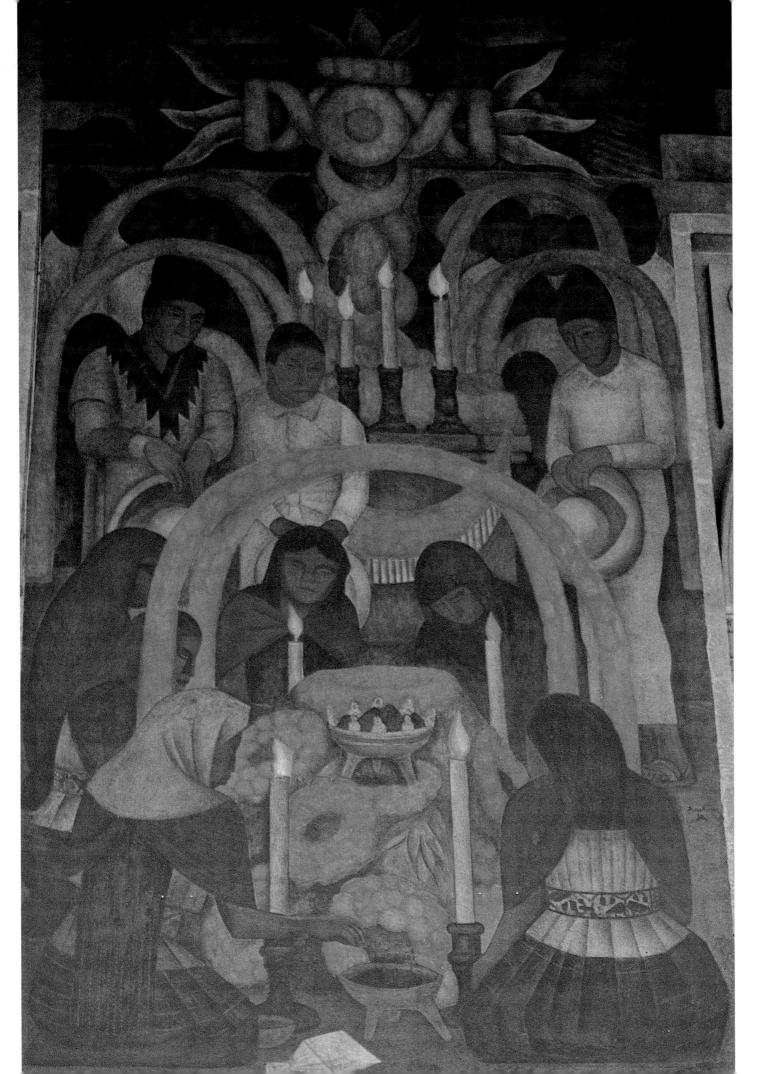

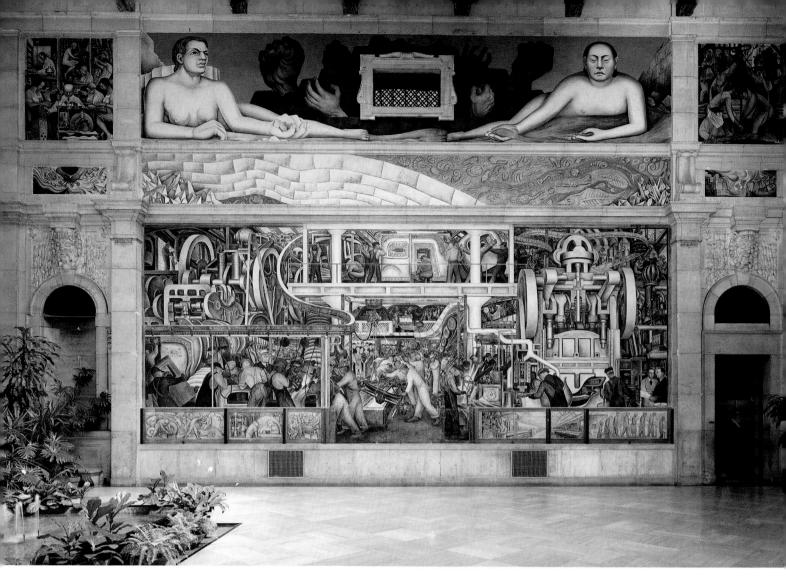

7.13 Diego Rivera, *Detroit Industry* (south wall), 1932-3, The Detroit Institute of Arts, Founders Society Purchase, Edsel B. Ford Fund and Gift of Edsel B. Ford.

its most spectacular literal expression in the *Detroit Industry* frescos of 1932-3 [Pl. 7.13], and powerful social criticism of the exploitation of the workers. Characteristic too is the contrast between industrial and rural Mexico; the latter, Rivera celebrates as vital and picturesque rather than backward and poverty-stricken. (A more Gamio-like presentation of the contrasts between a backward superstitious rural Mexico, and a modern industrial Mexico, in which natural resources are fully exploited, appear in a fresco by Juan O'Gorman entitled *Credit Transforms Mexico* [Pl. 7.15], painted for what is now the Banco International in Mexico City in the 1960s.) The manner in which Rivera moves from the representation of daily life in a simplified realism, to allegory and symbol, is partly possible because of the panel arrangement; later, he was to absorb these last elements into complex formal patterns of great precision, as in *Man at the Crossroads*. ²⁰

As Obregón neared the end of his four-year Presidential term, political troubles began to resurface. Hostility to the murals, particularly among the relatively conservative students of the ENP, led to 'direct action', and the regular casual defacements the painters had contended with became more serious damage, especially to Orozco's work. In 1924 Vasconcelos resigned, and, his protection

following pages
7.16 Diego Rivera, In the Trenches, 1928, fresco, Ministry of Education, Mexico City.

7.17 Diego Rivera, *Orgy – Night of the Rich*, 1926, fresco, Ministry of Education, Mexico City.

7.14 Juan O'Gorman, Mexico City, 1942, tempera on masonite, 66×122 cm., Museo de Arte Moderno, Mexico City (INBA).

7.15 a and b Juan O'Gorman, Credit Transforms Mexico, 1965, fresco, 2400×300 cm., Banco Internacional, Mexico City.

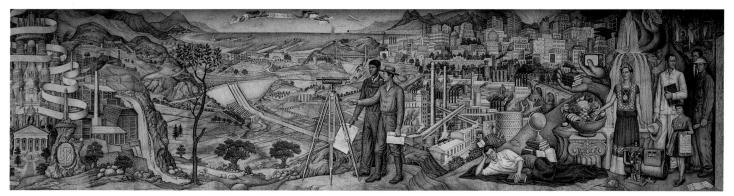

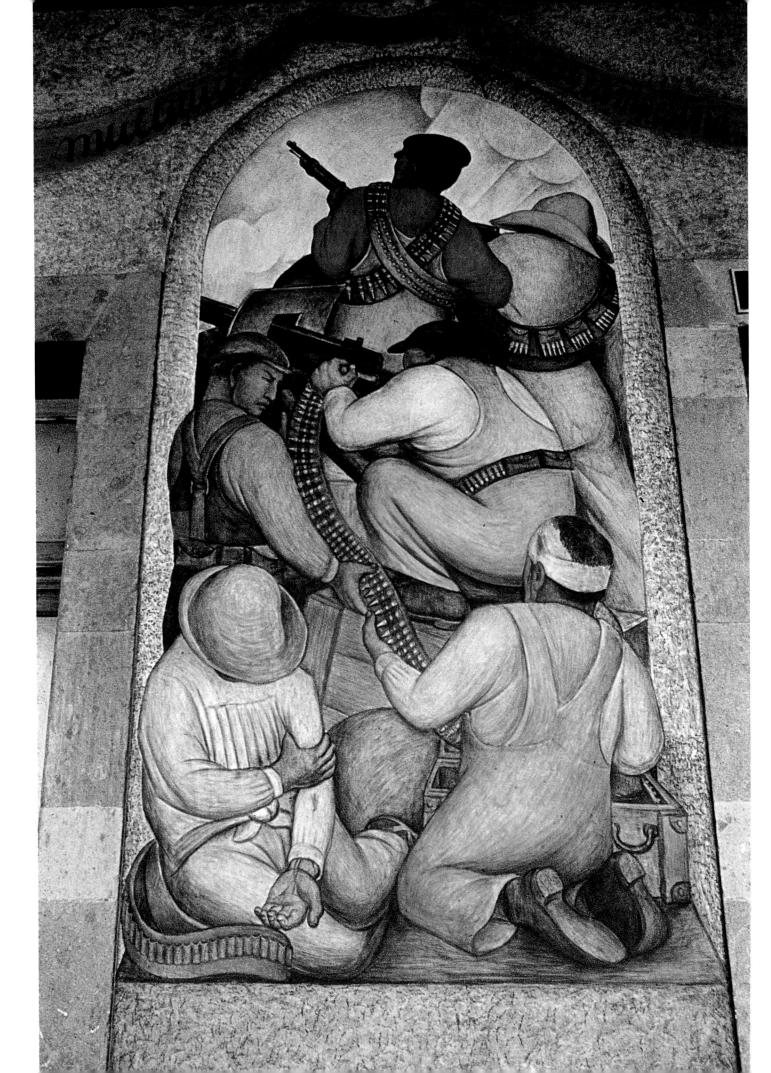

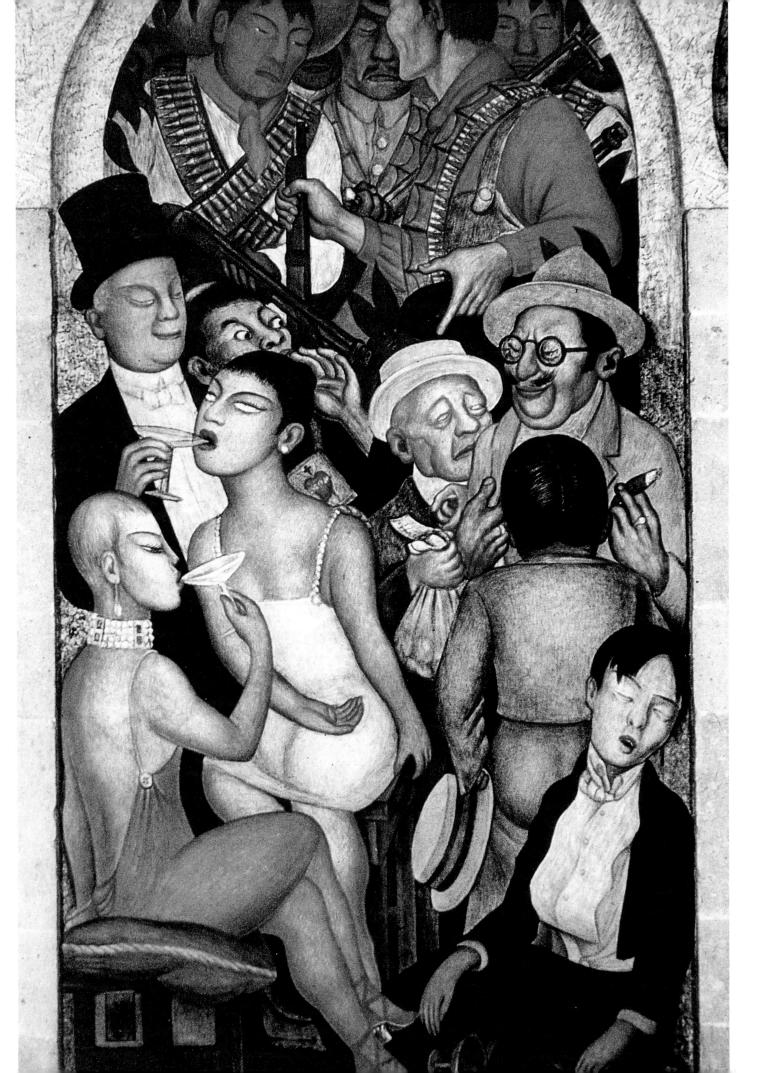

7.18, 19 and 20 Diego Rivera, *May Day Moscow*, 1928, three watercolours, 10.3×16cm. each, The Museum of Modern Art, New York; Gift of Abby Aldrich Rockefeller.

removed, the commissions were withdrawn, and the early phase of muralism was over. Most of the painters withdrew or dispersed, some to Guadalajara, where Siqueiros went to assist Amado de la Cueva on a commission from the governor, Zuno. Guadalajara was to continue its patronage to the muralists, and was the site of major later works by Orozco – in the University, the Palacio de Gobierno and the Hospicio Cabañas – including the great panel of the Independence hero, *Hidalgo* [Pl. 1.29].

Rivera, however, in the middle of the Ministry of Education murals, won over the new Minister, and for a while virtually had the field to himself in Mexico City. In 1926-7 he painted the chapel and part of the administration building at the National Agricultural School in Chapingo. The huge allegory of creative earth (The Liberated Earth with Natural Forces Controlled by Man) on the altar wall of the chapel is flanked with scenes relating to the Revolution, including the haunting image of the buried bodies of Zapata and Montaño: Blood of the Revolutionary Martyrs Fertilizing the Earth, as though in triumphant contradiction of the reactionary vow during the Revolution to 'exterminate the Zapatista seed so that it will not germinate again'. 21 In 1927 Rivera completed the murals on the top floor of the Ministry of Education; recently returned from Moscow [Pls 7.18,19,20], he introduced Russian revolutionary iconography: the red star, hammer and sickle, and in image after image stressed the revolutionary unity of worker, soldier and peasant, and classic oppositions between rich and poor [Pl. 7.21]. The whole cycle, though, was linked by a long red banner carrying the words of a corrido, or song of the agrarian revolution, of the kind Guerrero had used in his woodcut for the cover of El Machete in 1924 [Pl. 7.22]: 'The Earth belongs to those who work it.'

It is perhaps not surprising that these images of Mexico, which combine social criticism with a faith in progress, simultaneously with a celebration of Indian Mexico, should have found favour with succeeding governments. It could be argued that these murals keep the promises of the Revolution unavoidably and permanently in the people's consciousness, however slow and difficult the action may be to implement them. Octavio Paz analysed the situation with brutal clarity: 'These works that call themselves revolutionary, and that in the cases of Rivera and Siqueiros expound a simple and Manichean Marxism, were commissioned, sponsored and paid for by a government that was never Marxist and ceased being revolutionary . . . this painting helped to give it a progressive and revolutionary face.'²²

Orozco's work, however, is less easily assimilable. Forced to stop working on the National Preparatory School in 1924, he returned in 1926 to add a new set of frescos on the ground floor: The Rich Banquet While the Workers Quarrel, The Revolutionary Trinity, The Strike, The Trench and The Old Order. The first two depict a directionless and strife-torn society, the poor unable to unite against their oppressors. In The Revolutionary Trinity [Pls 7.23,25], one of the causes for this is suggested: the two kneeling victims

7.21 Second floor of the Ministry of Education, with murals by Rivera.

7.22 Xavier Guerrero, 'The Parceling of the Land', from El Machete, 1924, woodcut.

7.25 (above) José Clemente Orozco, *The Revolutionary Trinity*, 1923-4, first version of the mural, destroyed.

7.23 (top left) José Clemente Orozco, *The Revolutionary Trinity*, 1926-7, fresco, National Preparatory School, Mexico City.

7.24 (top right) José Clemente Orozco, *The Trench*, 1926-7, fresco, National Preparatory School, Mexico City.

7.26 (right) José Clemente Orozco, *The Trench*, 1923-4, pencil on paper, 55×46cm., Instituto Cultural Cabañas, Guadalajara (INBA).

7.27 David Alfáro Siqueiros, *Zapata*, 1966, pyroxylin on masonite, 122×91cm., Museo de Arte Alvar y Carmen T. de Carrillo Gil, Mexico City (INBA).

(their original identities as engineer and worker altered into a generalized reference to farmer and worker) are forced apart by a revolutionary soldier blinded by his ill-fitting red liberty hat. It has been suggested that 'the soldier embodies the pseudo-revolutionary state powers', ²³ and certainly later murals, like *Hidalgo*, are also critiques of the failures and betrayals of the Revolution. The reference to Christian iconography in The Revolutionary Trinity is counterposed in The Rich Banquet . . . by reference to the iconography of class. Christian iconography is evoked in a visually more explicit way in The Trench, where the central soldier lies spread-eagled as though on a cross [Pls 7.24,26]. Rivera used a similar Christian metaphor to portray suffering in The Exit from the Mine; neither artist uses it in the interests of Christian devotion. Both were fiercely anti-clerical. It is difficult for us in secular Europe to understand such apparent contradictions, which have to be perceived in the context of a country where the Church is seen officially as an enemy, but where at the same time the great mass of the people are

7.28 José Clemente Orozco, *The Franciscan*, 1930, lithograph, 31.3×26.4cm., The Museum of Modern Art, New York; Inter-American Fund.

7.29 José Clemente Orozco, *Prometheus*, 1930, tempera on masonite, 61.2×81 cm., Museo de Arte Moderno, Mexico City (INBA). A version of the mural painted the same year for Pomona College, California.

7.30 David Alfáro Siqueiros, *Ethnography*, 1939, enamel on composition board, 122.2×82.2cm., The Museum of Modern Art, New York; Abby Aldrich Rockefeller Fund.

devout Catholics. The Zapatistas, for instance, rode to battle under the banner of the Virgin of Guadalupe [Pl. 7.27].

Orozco was opposed to what he saw as the confusion between painting and folk art in the nationalism of his fellow painters. 'Painting in its higher form and painting as a minor folk art differ essentially in this: the former has invariable universal traditions from which no one can separate himself . . . the latter has purely local traditions.' He abjured 'the painting of Indian sandals and dirty cotton pants, and naturally I wish with all my heart that those who use them will discard them and become civilized'. He rejected the idea of painting as propaganda: 'A painting should not be a commentary but the thing itself; not a reflection but light itself; not an interpretation but a thing to be interpreted.' Later, in an open letter of 1944, Siqueiros warned him that his 'ideological expression [would] lose its clarity'. But Orozco refused to commit himself to

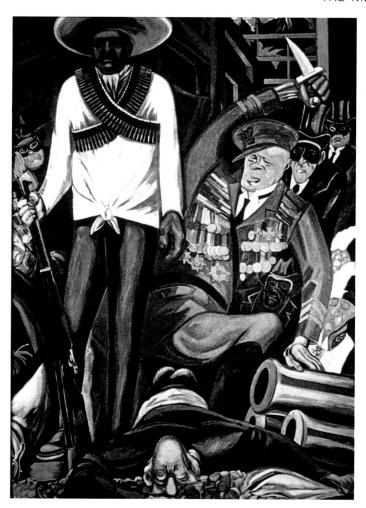

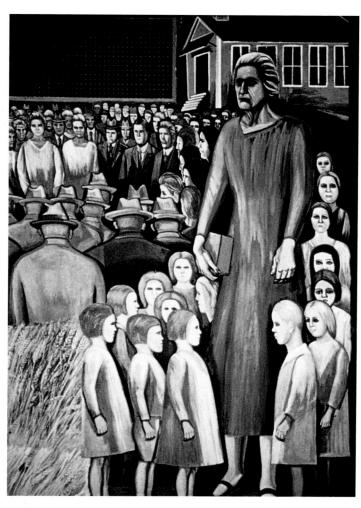

7.31 José Clemente Orozco, *Hispanoamerica*, 1932-4, fresco, Dartmouth College, New Hampshire, U.S.A.

7.32 José Clemente Orozco, *Angloamerica*, 1932-4, fresco, Dartmouth College, New Hampshire, U.S.A.

an ideology. His painting sets up an internal dialectic between the power and the dangers of the traditional icons and political myths of the Revolution, in which he too once had 'exuberant faith'.

An interesting comparison can be made between the treatment of history in Orozco's Dartmouth College murals and that in Rivera's huge mural frieze in the National Palace in Mexico City. In the Baker Library at Dartmouth, Orozco painted the evolution of civilization in America, and its modern industrial condition. At the time, he said, 'The American continental races are now becoming aware of their own personality as it emerges from two cultural currents, the indigenous and the European [Pls 7.31,32]. The great American myth of Quetzalcoatl [Pls 7.33,34] is a living one, embracing both elements and pointing clearly by its prophetic nature, to the responsibility shared equally by the two Americas of creating an authentic American civilization. 26 Both painters treat the history of America as a progression, but Orozco then turns the modern era back, satirically, as a grotesque mirror image of the past: at Dartmouth, his Modern Human Sacrifice and Modern Migration of the Spirit are faced at the far end by Ancient Human Sacrifice and Ancient Migration. Eisenstein, calling on Orozco to 'replace the beard of the mythical Quetzalcoatl with that of the combative

7.33 José Clemente Orozco, *Head of Quetzalcoatl*, c. 1932-4, crayon on tracing paper, 81.7×61 cm., The Museum of Modern Art, New York; Gift of Clemente Orozco.

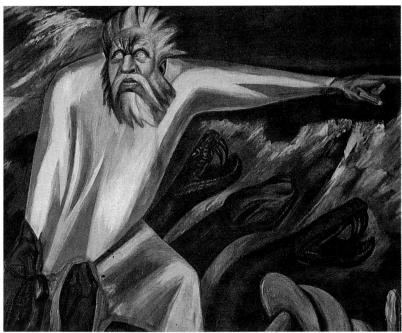

7.34 José Clemente Orozco, *The Expulsion of Quetzalcoatl* (detail), 1932-4, fresco, Dartmouth College, New Hampshire, U.S.A.

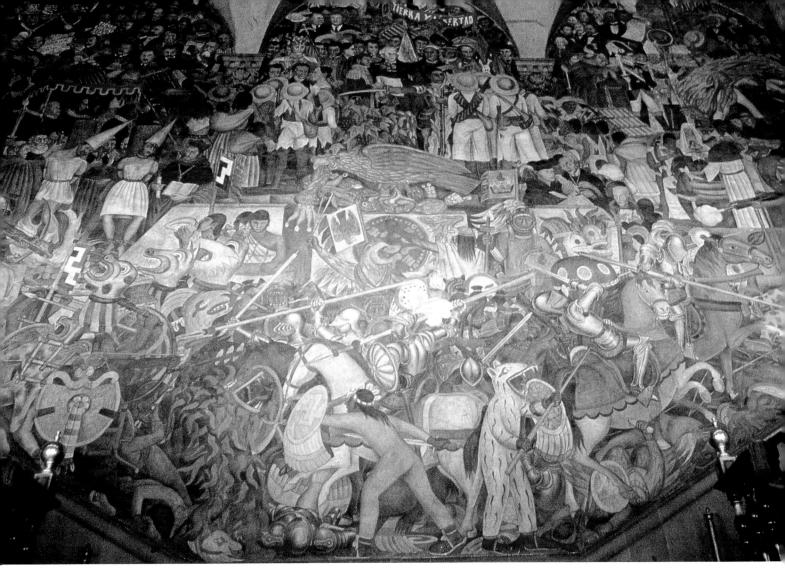

7.35 Diego Rivera, The History of Mexico: From the Conquest to the Future, 1929-30, frescos, Palacio Nacional, Mexico City (INBA).

7.36 Codex Vindobonensis, Nationalbibliothek, Vienna.

7.37 Diego Rivera, The Huastec Civilization, 1950, fresco, Palacio Nacional, Mexico City (INBA).

Marx', felt apprehension about the surroundings. 'The bookish spirit of sleeping consciences passes without questioning among this poetry of nightmares and horrors, caught in the frames of the bookshelves.'

The broad strokes and expressionist energy of Orozco contrast strongly with Rivera's smoothly painted, crammed and intricate narrative surface. The National Palace *History of Mexico* [Pl. 7.35] winds from the eagle-cactus symbol of Tenochtitlán in the lower centre, through scenes of the Conquest, episodes of the colonial period, the wars of Independence and foreign invasions of the nineteenth century, to the final mural on the left-hand wall, completed in 1935, which depicts 'Exploited Mexican People, Roots of Social Evil, Repression of Strikers, Armed Uprising in downtown Mexico City', and culminates in the figure of Karl Marx, framed by a 'scientific' sun, pointing to a future where the abolition of class and private property ensures peace, progress and prosperity for all.

Rivera derived the organizational structure for this giant panorama from the snake-like narrative boustrophedon form of the pre-Conquest screenfold, the picture-writing in which the Toltec, Mixtec and Aztec recorded their history and ritual. He was the only one of 'los tres grandes' to continue to seek a solution to the issue of 'art for the people' in truly indigenist terms, not just in reproducing

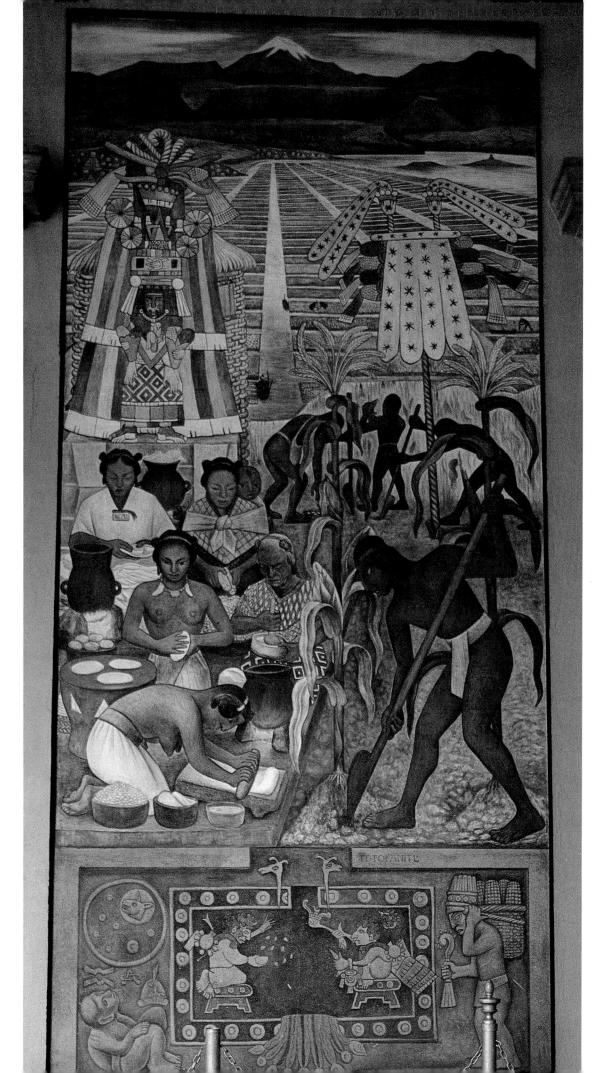

THE MEXICAN MURAL MOVEMENT

7.38 Diego Rivera, The History of Medicine in Mexico: The People's Demand for Better Health (detail), 1953, fresco, Hospital de la Raza, Mexico City.

images of the pre-Columbian past, which he first did with the painting of the statue of Xochipilli among the plants on the Ministry of Education staircase, and continued in the idealized scenes of the pre-Conquest civilizations in the National Palace corridors (1942-51), but in attempting to understand and use in a creative way pre-Columbian structures and iconography. His illustrations to the Maya book the *Popol Vuh* [Pls 9.16,17], and the Hospital de la Raza mural *The History of Medicine in Mexico: The People's Demand for Better Health* (1953) [Pl. 7.38], reveal his deep interest in the scientific and ritual thought of the Indian civilizations, and his increasing use of a dualistic structure (the sun and moon governing the two sections in the *History of Medicine*) probably derives from the same source.

Of all the muralists, Siqueiros is by far the most difficult to reproduce with any success. This is a consequence of his style, technique, and chosen working spaces. These he selected, or altered, or had built, to enable him to activate the entire wall area to create a total painting environment. For instance his large mural for the Hospital de la Raza occupies without break the curved walls and oval ceiling. He used industrial paints and a spray gun, and experimented with photography, using for example a projector to distend

David Alfáro Siqueiros, Don Porfirio and his Courtesans, 1957, fresco, Museo Nacional de Historia, Mexico City (INAH).

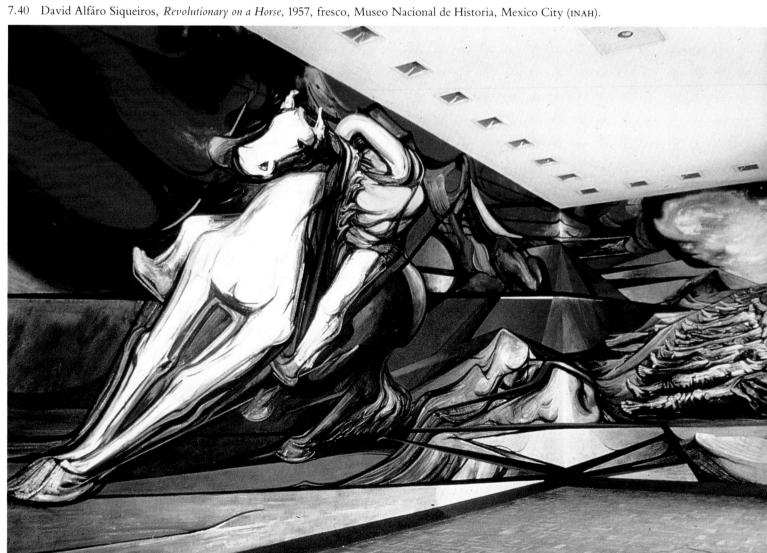

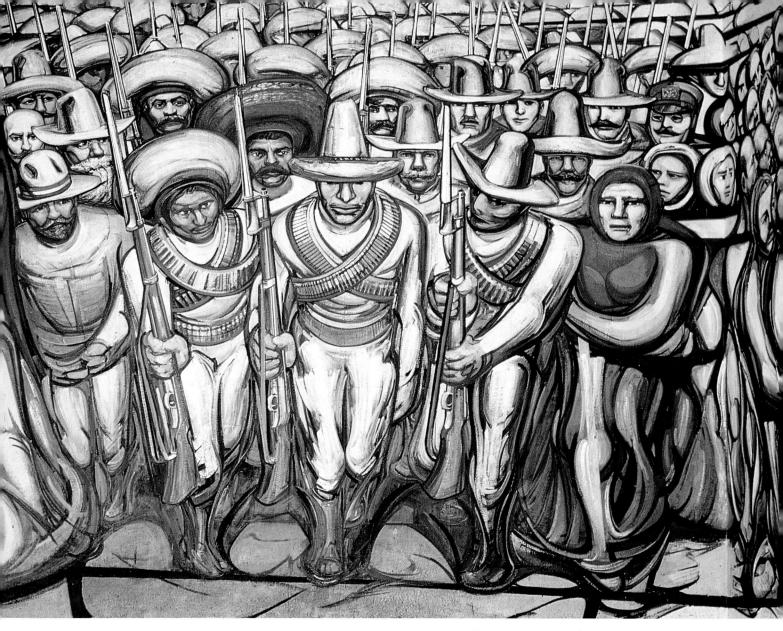

7.41 David Alfáro Siqueiros, *The People in Arms*, 1957, fresco, Museo Nacional de Historia, Mexico City (INAH).

images on the wall, as he explained in his important text *How to Paint a Mural*.

Unlike Orozco and Rivera, Siqueiros relatively rarely utilized themes from Mexican history, being more absorbed in the class struggle of contemporary Mexico. The 'poster-mural' Portrait of the Bourgeoisie (originally called 'Portrait of Fascism') was the 'first to utilize contemporary photographs to depict a political theme, here the Spanish Civil War and its aftermath'. This mural has a complex relationship with the radical administration of Lázaro Cárdenas and with Siqueiros' own experiences fighting for the Republican government in the Spanish Civil War.²⁷ The first time he addressed the Revolution directly in a mural was at Chapultepec Castle, in a room with specially constructed walls with jutting, curved wings. The Revolution Against the Dictatorship of Porfirio Díaz is a triumphant meld of wit and satire in its portrayal of the decadent court of Díaz, and a moving depiction of key moments of revolt leading to the Revolution, 'full of actual portraits taken from photographs of revolutionary heroes Placed as it is in a site of popular recreation, it is, in principle, in daily, didactic use [Pls 7.39,40,41].

THE MEXICAN MURAL MOVEMENT

Siqueiros also developed a theme based on the Spanish invasion of Mexico, 'Cuauhtémoc against the myth', in which the last Aztec emperor, who had sought, unlike his uncle Moctezuma, to defend his people against the Spanish, refusing to succumb to fatalistic myths which identified Cortés with the returning god Quetzalcoatl, becomes the symbol of resistance against colonial/capitalist exploitation.

Public and historical emphasis has always, understandably, been on the murals themselves, but all the artists also painted easel pictures which frequently repeat themes and subjects of the murals.

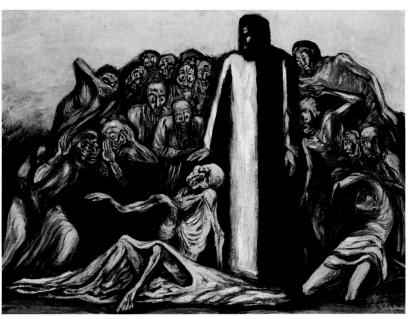

7.43 José Clemente Orozco, *Metaphysical Landscape*, 1948, pyroxylin on masonite, 215×122 cm., Instituto Cultural Cabanas, Guadalajara (INBA).

7.42 José Clemente Orozco, *Cabbages*, 1944, oil on canvas, 100×120 cm., Museo de Arte Alvar y Carmen T. de Carrillo Gil, Mexico City (INBA).

7.44 José Clemente Orozco, *Resurrection of Lazarus*, 1943, mixed media on canvas, 52×74 cm., Museo de Arte Moderno, Mexico City (INBA).

7.45 David Alfáro Siqueiros, Feminine Torso, n.d. pyroxylin on masonite, 114×93cm., Museo de Arte Alvar y Carmen T. de Carrillo Gil, Mexico City (INBA). Study for the torso of the central figure in *The New Democracy*, 1944-5, Museo del Palacio de Bellas Artes.

7.46 David Alfáro Siqueiros, *Three Calabashes*, 1946, pyroxylin on masonite, Museo de Arte Alvar y Carmen T. de Carrillo Gil, Mexico City (INBA).

THE MEXICAN MURAL MOVEMENT

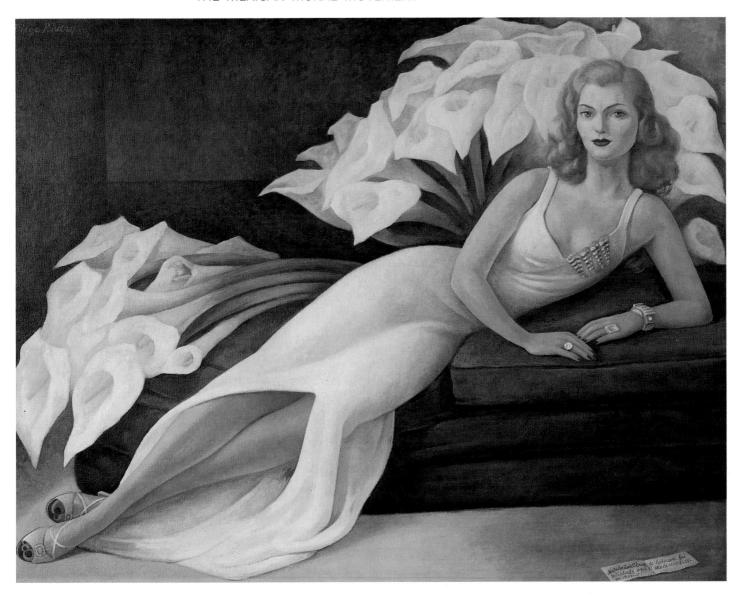

The vicissitudes of patronage often made it necessary for them to accept private commissions for murals, and for portraits. Orozco's easel paintings also allow him to portray single scenes which he would have felt inappropriate for mural art, or abstract metaphysical images like *Metaphysical Landscape* of 1948 [Pl. 7.43]. On the smaller scale of the easel painting, too, Siqueiros produced concentrated dynamic images which do not fall into the trap which his murals occasionally do of pictorial confusion and exaggeration [Pls 7.45,46]. Rivera's easel pictures encompassed society portraits, and also images which, although closely related to fragments of his murals, undoubtedly stand on their own [Pl. 7.47].

7.47 Diego Rivera, *Natasha Gelman*, 1943, oil on canvas, 155.5×120 cm., Collection Jacques and Natasha Gelman.

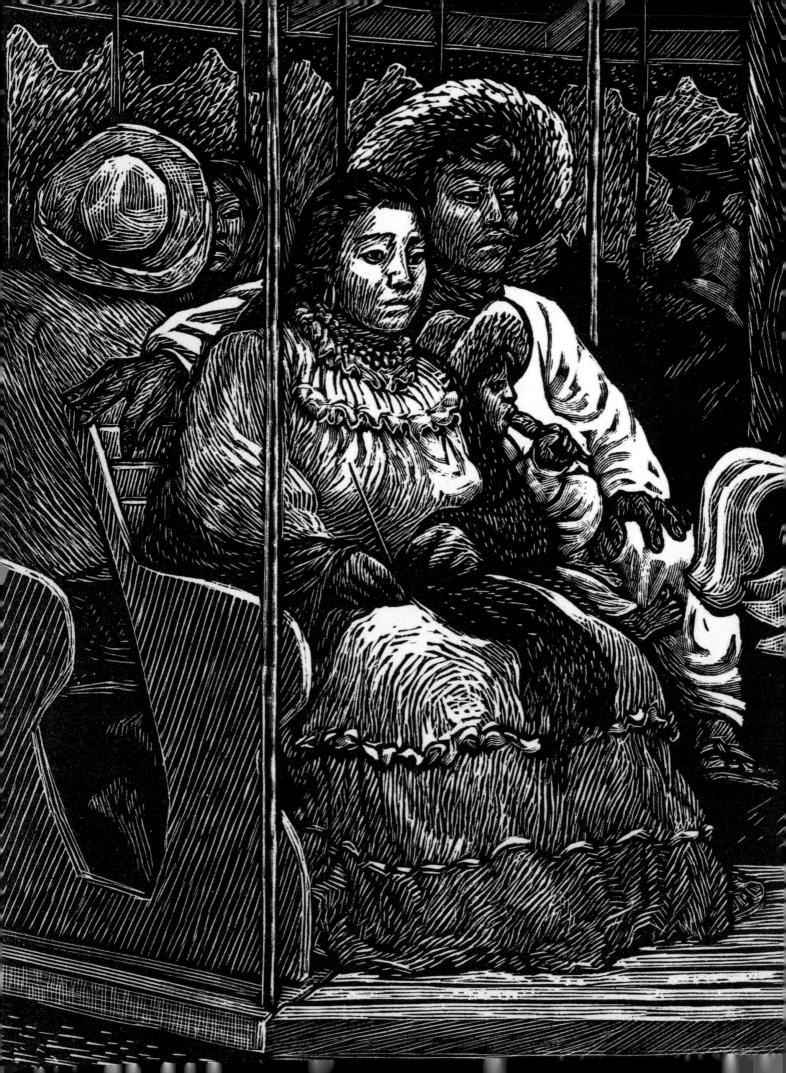

8

The *Taller de Gráfica Popular*

THE TALLER de Gráfica Popular (People's Graphics Workshop) was founded in 1937 by Leopoldo Méndez, Luis Arenal and Pablo O'Higgins. Its 'Declaration of Principles' (see Appendix, 8.1), which remained its only formal statement, announced it as 'a collective work centre for functional production'. It not only provided printmaking facilities but also guidance for artists not trained in graphic techniques.

Leopoldo Méndez had been director of the Plastic Arts division of the Liga de Escritores y Artistas Revolucionarios (League of Revolutionary Writers and Artists, LEAR), which was founded in 1933, but disagreements led to his breaking away to found the Taller de Gráfica Popular, and the League dissolved the same year. He, Arenal and O'Higgins had all been active contributors to LEAR's magazine *Frente a Frente*. However, it is notable that *Frente a Frente* included photographs and photo-montages in the John Heartfield and Russian Constructivist tradition – the fourth issue, for instance, contained among others Gustav Klutsis' photomontage, *The USSR is the shock brigade of the world's proletariat*, while the Taller de Gráfica Popular concentrated on prints – lino-cuts and woodcuts, as well as lithographs. There was a sense among the

8.1 Detail of Pl. 8.9

8.2 Leopoldo Méndez, *Homage to Posada*, 1956, engraving in linoleum, 36.2×78.5 cm., Collection José Sánchez Aguilar.

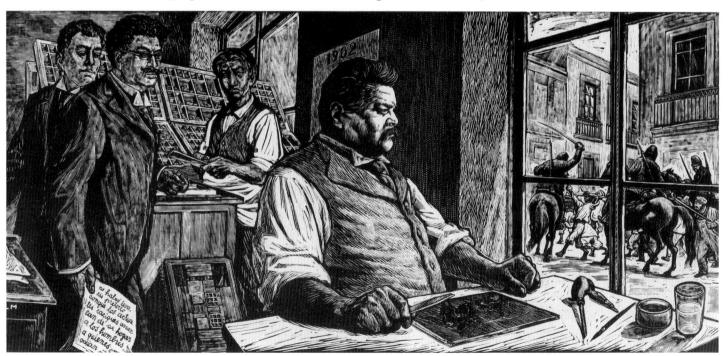

THE TALLER DE GRÁFICA POPULAR

artists that this was part of a particularly Mexican tradition, going back to the nineteenth century, with Posada, above all, acknowledged as the forebear: Méndez made a *Homage to Posada* in 1956 [Pl. 8.2]. Printmaking was an appropriately public, popular medium for the politically and socially concerned artists.

Jean Charlot, who had arrived from France in 1921, and who met Fernando Leal at the open-air school of painting in Coyoacán, was, it appears, responsible for the introduction of woodcuts to artists who were also involved in the mural renaissance [Pls 8.3,4,5]; bringing with him admiration for the popular coloured 'Images d' Epinal', and probably a knowledge of German expressionist prints, ¹ it was also Charlot who directed attention to the street prints of Vanegas Arroyo, and led the revival of Posada's work. In 1924 the Syndicate of Technical Workers, Painters and Sculptors financed 'a large-format sheet stamped with bold black, white and

8.3 José Clemente Orozco, *Mexican Pueblo*, 1930, lithograph, 27.7×38.8cm., The Museum of Modern Art, New York; Gift of Abby Aldrich Rockefeller.

- 8.4 José Clemente Orozco, *Mexican Soldiers*, 1929, lithograph, 28.3×45.7cm., The Museum of Modern Art, New York; Gift of Abby Aldrich Rockefeller.
- 8.5 David Alfáro Siqueiros, *The Storm* or *Latin America*, n.d., lithograph, 30×22.8 cm., sheet 49.5×32.6 cm., Archer M. Huntington Art Gallery, The University of Texas at Austin; Gift of Thomas Cranfill, 1966.

8.8 (facing page top) Isidoro Ocampo, Fascism, 5th Lecture: Spanish Fascism, 1938, lithograph and letterpress, printed in colour, 32.1×45.7 cm., The Museum of Modern Art, New York; Inter-American Fund.

8.6 Pablo O'Higgins, *Brickmaker*, c. 1940, lithograph, 35.5×29 cm., sheet, 44.5×38 cm., Museum of Modern Art of Latin America, Organization of American States.

8.7 Pablo O'Higgins, *The Market, c.* 1940, lithograph, 29×36 cm., sheet 38×44.5 cm., Museum of Modern Art of Latin America, Organization of American States.

THE TALLER DE GRÁFICA POPULAR

red woodcuts': El Machete. Siqueiros, Orozco, Guerrero and others produced El Machete's illustrations.

Only because they wanted to put across a message did the muralists turn engravers. They were awkward at their new craft. The desire to enunciate clearly, the strong mural style regardless of scale, the authentic primitivism of engravings carved with a pocket knife, rich in art and short on skill, the unequal pressure on inked blocks hardly level with the type and the resulting coarse printing, even the tone blocks that smudge with red the design – all combine to make an effective impact.³

At the end of 1924 the Communist Party took over *El Machete*, trimmed its size and dropped the woodcuts in favour of half-tone illustrations. In the same year Charlot, Méndez, Revueltas, Guerrero, Máximo Pacheco and Alva de la Canal produced prints and drawings for the first *Estridentista* exhibition (see chapter 6), Charlot illustrated Maples Arce's poem *Urbe*, and Díaz de León did the first lino-cut prints in Mexico. The '30-30' artists' group (see Appendix, 7.4) continued to promote printmaking, and in 1935 the LEAR founded a workshop/school for mural painting and graphics. It was the Taller de Gráfica Popular, however, that provided the most active and long-lived collective centre for printmaking, and stamped its mark so strongly on the medium that artists from the modernist tradition of the New York School felt inhibited from using it.

Visiting galleries with Franz Kline around 1955, I asked him how he felt about making prints, perhaps lithographs, thinking that his vivid white and black image could be perfectly suited to the velvety inks and papers of the medium.

'No', he said, 'printmaking concerns social attitudes, you know – politics and a public . . .'

'Politics?'

'Yes, like the Mexicans in the 1930s; printing, multiplying, educating; I can't think about it; I'm involved in the private image' . . . ⁴

The first headquarters of the Taller de Gráfica Popular was set up in three rooms, with exhibition, workshop and machine space. Their first lithographic press, apparently, was inscribed 'Paris 1871', and was believed to have served the Paris Commune. Around Méndez, Arenal and O'Higgins [Pls 8.6,7] gathered a group of artists including Ignacio Aguirre, Raúl Anguiano, Ángel Bracho, Jesús Escobedo, Everardo Ramírez, Antonio Pujol, Alfredo Zalce and Isidoro Ocampo. Numbers grew, and continued to remain at between twelve and fifteen until the Fifties.

The Presidency of Lázaro Cárdenas, who instituted a programme of radical reforms between 1934 and 1940, was particularly favourable to them; besides the continuing mural programme, the printmakers, working in the more pugnacious, ephemeral and easily distributable medium, supported Cárdenas' programme,

THE TALLER DE GRÁFICA POPULAR

with posters and broadsheets on the expropriation of foreignowned oil companies, as well as a major poster campaign attacking fascism [Pl. 8.8]. (In 1942 Mexico entered the Second World War on the Allied side.) After the war they became actively involved in the literacy campaigns established by the government in 1944.

But beside the frequently satirical and grotesque posters, the Taller de Gráfica Popular produced numerous portfolios of lithographs and woodcuts exposing the exploitation of the poor, attacking the abuses of peasant rights, and the continuing 'latifundio' land-ownership system [Pl. 8.10]. These powerful single images provide a counterpoint to the murals, which often, on their huge scale, treated Mexican society in generalized or allegorical terms.

Méndez defended persistent criticism of their use of woodcut and lino-cut, on the grounds of practical necessity, because they were cheap. Lino-cuts in particular were cheap and flexible: large-scale prints could easily be replaced, unlike the precious lithographic stone or wood blocks. Linoleum was also an extremely effective

8.9 Leopoldo Méndez, *The Merry-go-round*, n.d., linoleum cut on paper, 30.5×41.9 cm., sheet 50×64 cm., Archer M. Huntington Art Gallery, The University of Texas at Austin, University Purchase, 1966.

8.10 Alberto Beltrán, *Song of the Miners' Parade*, n.d., linoleum cut on paper, 17.8×13 cm.; sheet 36.2×28.5 cm., Archer M. Huntington Art Gallery, The University of Texas at Austin; Gift of Thomas Cranfill, 1972.

8.11 Newton Cavalcanti, *Christ, c.* 1945, woodcut on Japanese paper, 28.1×18.9 cm., Museu Nacional de Belas Artes, Rio de Janeiro.

8.12 Leopoldo Méndez, *The Serpent*, from Juan de la Cabada, *Melodic Incidents of the Irrational World*, 1945 wood engraving on paper, 13.2×13.5 cm., The Museum of Modern Art, New York; Inter-American Fund.

8.13 Ángel Bracho, *The Bridge of Nonoalco* or *The Bridge and the Pedlar*, 1944, lithograph, 46.5×58.4cm.; sheet 49.5×64.8cm., Archer M. Huntington Art Gallery, The University of Texas at Austin; Gift of M.K. Hage Jr., 1970

8.14 Anonymous, *Cordeles* (pamphlets with woodcuts), c. 1970, pamphlets and leather suitcase, Museu de Folclóre Edison Carneiro, Instituto Nacional do Folclore/Fundação Nacional de Arte, Rio de Janeiro.

medium, which they exploited to the full, working over the whole surface with sharp strokes to create a multitude of tones and textures, the lively and varied patterns of the marks offering greater scope for imaginative invention than the relatively sober and conventional lithograph [Pl. 8.9].

The Taller de Gráfica Popular produced several portfolios devoted to Indian life in Mexico: Bracho's *Rito de la Tribu Huichol*, for instance, and Zalce's *Estampas de Yucatán*[Pls 8.13,15,17].⁶ Méndez' illustrations to Juan de la Cabada's *Incidentes Melódicos del Mundo Irracional* [Pl. 8.12] are wood engravings which present myths and rituals, mingled with fantasy. One of the most important of the Taller de Gráfica Popular publications, which contained 85 linocuts by a number of Taller de Gráfica Popular artists, came out in 1947: *Estampas de la Revolución Mexicana*.

The Taller de Gráfica Popular, as well as Mexican muralism, had a considerable impact in other countries in America and Europe during the Thirties. Contacts were established with the WPA/FAP (Works Progress Administration/Federal Art Project) in the USA, and the direct influence of the Taller was felt in Czechoslovakia, Italy, Brazil, Ecuador and Guatemala.⁷

In 1946, the Taller de Gráfica Popular published a portfolio of prints by the Ecuadorean artist Galo Galecio, who had studied engraving and fresco paintings in Mexico [Pl. 8.18]. In Brazil, the most significant development was the founding of two engraving

THE TALLER DE GRÁFICA POPULAR

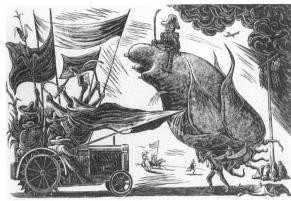

8.16 José Chávez Morado, *The Skirmish*, 1945, wood engraving on paper, 26.8×42.1cm., The Museum of Modern Art, New York; Inter-American Fund.

8.17 Alfredo Zalce, *Untitled, c.* 1940, lithograph, 28×35 cm.; sheet 38.5×44.5 cm., Museum of Modern Art of Latin America, Organization of American States.

clubs, both of popular leftist persuasion [Pl. 8.20]. The Clube de Gravura de Porto-Alegre was started in 1950, by Carlos Scliar and Vasco Prado [Pl. 8.19], who met Leopoldo Méndez, and in 1951 the Clube de Gravura de Baje. In 1952 a volume entitled Gravuras Gauchas was published. Nourished by the Brazilian popular traditon of the Cordeles, cheaply printed sheets or pamphlets of popular verses or stories with woodcuts on the cover [Pl. 8.14], as well as by the Mexican example, the engraving clubs attracted a wide range of artists, but were relatively short-lived, though printmaking on an individual basis has continued to flourish [Pl. 8.11].

8.18 Galo Galecio, Burial of the Black Girl, n.d., woodcut

HOMENAGEM DO CLUBE DE GRAVURA AO

IV CONGRESSO BRASILEIRO DE ESCRITORES

DE 25/430 DE SETEMBRO 195

PORTO ALEGRE

In Uruguay, Carlos González was a solitary, self-taught printmaker. Although he produced his best woodcuts between 1935 and 1945, it is not clear how much contact he had with the Mexicans. He worked in a simple powerful style, carving the wood with a knife, with the emphasis on clear strong lines and patches of white and black, with large-scale figures often set in a frame which contains little narrative scenes, drawing here more on a folk manner than on the social realism of the Mexican printmakers [Pl. 8.22]. González rejected the urban and Europeanized culture of Montevideo for a rural and regional world. In The Duel [Pl. 8.21], the central image is of two peasants - perhaps brothers, they are dressed so alike - about to fight, but separated by a third figure, who, although the peacemaker, seems to concentrate in himself the violence of the scene. Round the edge are images of the history of America: at the bottom, a missionary is paired with an armed knight killing Indians, while on the two crucifixes in the corners hang Indians of the river Plate, who were virtually wiped out during the nineteenth century,

8.20 Henrique Oswald *Inflation*, 1944–50, aquatint, etching and drawing point, 23.1×31.8cm.; sheet 28.8×36.7cm., Museu de Arte Contemporânea da Universidade de São Paulo.

8.19 Vasco Prado, *Tribute to the Engravers Club at the Brazilian Writers' Congress*, 25-30 September 1951, woodcut on newsprint, 47.5×33 cm., Museu Nacional de Belas Artes, Rio de Janeiro.

having fought with particular bitterness against the European settlers. Possibly it was the sense of isolation that led González to abandon his work, which he always intended to have a didactic function: 'The task I undertook – doing research into our national reality – should have been a co-operative effort undertaken by us all; instead, the trends in fashion in my time went against my language.'⁸

- 8.22 Carlos González, *Death of Martín Aquino*, 1943, woodcut on paper, 39×48 cm., Museo Nacional de Artes Plásticas, Montevideo.
- 8.24 Lasar Segall, *Third Class*, 1928, drypoint on paper, 28×32.5 cm.; sheet, 38.5×56.5 cm., Museu Lasar Segall, São Paulo.

8.23 Lasar Segall, Woman from the 'Mangue' with Persiennes, 1942, woodcut on Japanese paper, 15.5×8.5 cm.; sheet 46×30.5 cm., Museu Lasar Segall, São Paulo.

8.21 Carlos González, *The Duel*, n.d., woodcut on paper, 50×39 cm., Museo Nacional de Artes Plásticas, Montevideo.

9

Indigenism and Social Realism

SIQUEIROS' Peasant Mother (1929), Diego Rivera's Flower Day (1925) and José Sabogal's The Indian Mayor of Chincheros: Varayoc (1925) [Pls 9.2,3,4], all belong to the broad current of indigenismo, which gained momentum during the Twenties and Thirties, in the wake of the Mexican Revolution, and which was manifested in the 'rediscovery' and revaluation of native cultures and traditions, as well as in the use of Indian themes in literature and the visual arts, which are often articulated in terms of social protest.

These three paintings, however, present three distinct attitudes to their Indian subjects, attitudes which are partly, but not fully, conditioned by the official and unofficial 'indigenist' policies operative in Mexico and Peru respectively.

Siqueiros' *Peasant Mother*, while depicting an Indian woman and her child, does not emphasize the ethnic, but rather the woman's social condition as poor and exploited. Rivera's *Flower Day*, on the other hand, is more of a solemn celebration of contemporary native/mestizo life, while Sabogal's painting, depicting an Andean village leader, emphasizes connections with the pre-Spanish rulers of Peru, the Inca, through the traditional silver-bound staff of office he holds, and his proud and independent stance.

Diego Rivera's Flower Day – a theme which he repeated in later versions – is a reprise of part of the fresco in the Ministry of Education (1923–4), Good Friday at Santa Anita Canal, with the lily seller now seen from the front, and the Indian women kneeling before him in the posture of stone representations of the Aztec deity Chalchihuitlicue. It is one of the most spectacular of the images in which Rivera expressed his fascination with Indian/mestizo way of life – a fascination which dates back to his first visit to the Maya region of Yucatán in 1921, and was strengthened by a visit the following year to Tehuantepec.

Flower Day is dark in tone, compared with the chalkier and more delicate colours of the mural, and it is massive rather than picturesque, its interlocked, precisely structured and almost geometrical forms recalling the architectural cubism of 1915-16. This emphasizes its static and hieratic, as opposed to decorative, character. The flower-seller bends under his flowers towards the women, tree-like, but also cross-like, evoking both shaman and Christ. The women's faces are generalized and simplified, with flat profiles, though the curving arm of the woman on the left recalls Picasso's substantial neo-classical figures. In Flower Seller with Lilies [Pl. 9.5]

9.1 Detail of Pl. 9.10.

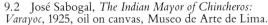

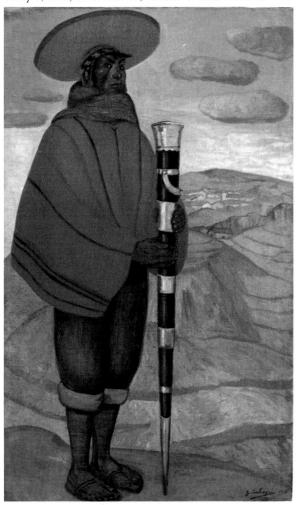

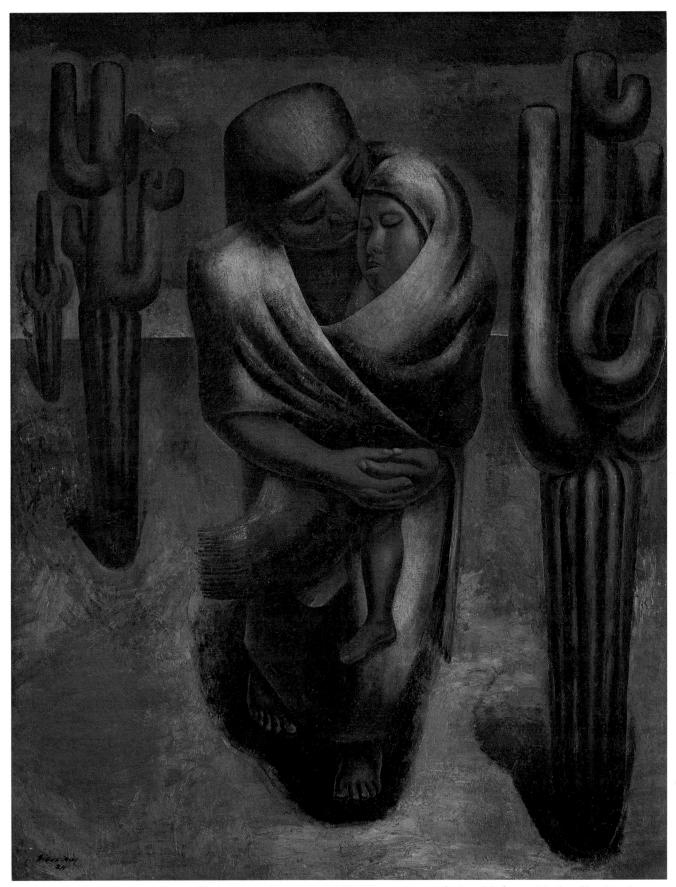

9.3 David Alfáro Siqueiros, Peasant Mother, 1929, oil on canvas, 220×177 cm., Museo de Arte Moderno, Mexico City (INBA).

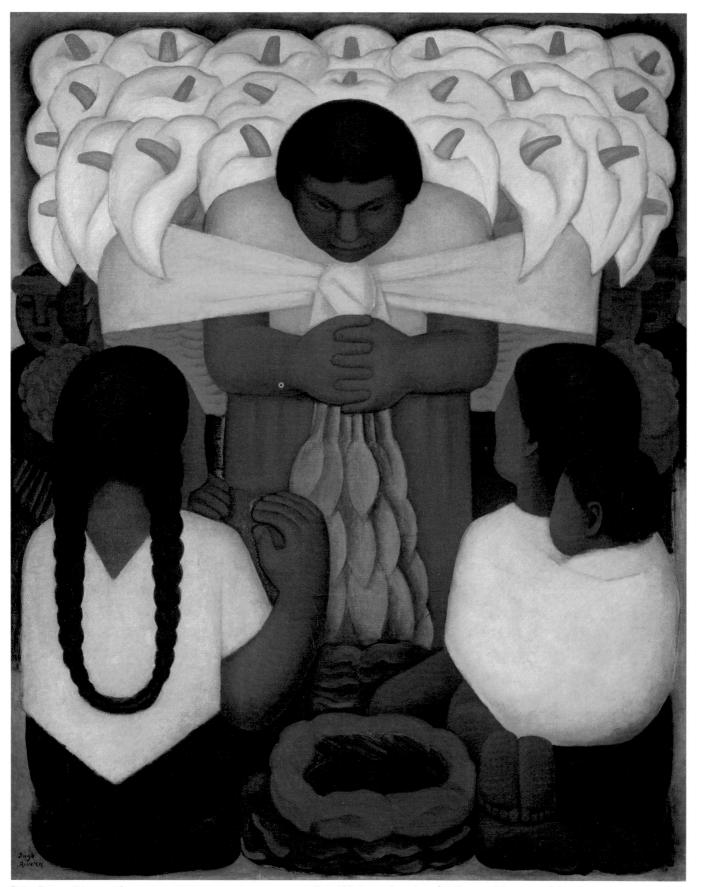

9.4 Diego Rivera, Flower Day, 1925, encaustic on canvas 147.4×120.6cm., Los Angeles County Museum of Art; L.A. County Funds.

the great mass of lilies almost hides the male figure behind. Rivera possibly knew Aztec poems, like the following love song, where flowers are also a metaphor for poetry itself:

I've come to offer you songs, flowers to make your head spin. Oh, another kind of flower and you know it in your heart.

I came to bring them to you I carry them to your house on my back,

uprooted flowers I'm bent double with the weight of them for you.²

Certainly Rivera must have had a sense of the deep antiquity within the Mexican tradition of the image of the flower bearer.

Indigenismo, in Mexico, as 'the official attitude of praising and fostering native values', has taken several forms: notably the teaching in school and universities of pre-Columbian history and literature, and the excavation and restoration of major pre-Columbian cities like Teotihuacán, or Chichén-Itzá, culminating in the founding of the great Museum of Anthropology in Mexico City in 1964. It has become a major bulwark in the maintenance of a sense of pride in the national heritage and the idea of common roots for the nation in the Indian past. It has also been recognized that the mestizo majority as well as the Indian groups preserve much of native origin in their daily life: food, medicine, ritual, history and language.

But, as León-Portilla wrote in 1975, 'Unfortunately, the official praise of the Indian heritage has not always translated itself into coherent forms of action which would really make possible the development of the native communities. It is perplexing indeed that only a few effective steps have been taken to put an end to the abuses of which, for centuries, the Indians have remained the principal victims.'

A major influence on the new interest in the Indians, their past and the long history of that past before the Conquest had been Manuel Gamio, whose *Forjando Patria* (1916) was mentioned in chapter 7 in connection with ideas of national identity within the mural movement. Gamio, like Franz Boas, rejected the theory of inferior and superior races that had dominated American social science to account for the persistence of 'these two great social groupings', Spanish and Indians, living side by side in the same territory; '. . . the one, numerically inferior, presents an advanced and efficient civilization, the other, numerically the larger, displays a backward civilization.'⁴

Gamio undertook two major projects: an ethnographic survey of the population of the Valley of Teotihuacán, and the excavation and

^{9.5} Diego Rivera, *Flower Seller with Lilies*, 1943, oil on masonite, 150×119 cm., Collection Jacques and Natasha Gelman.

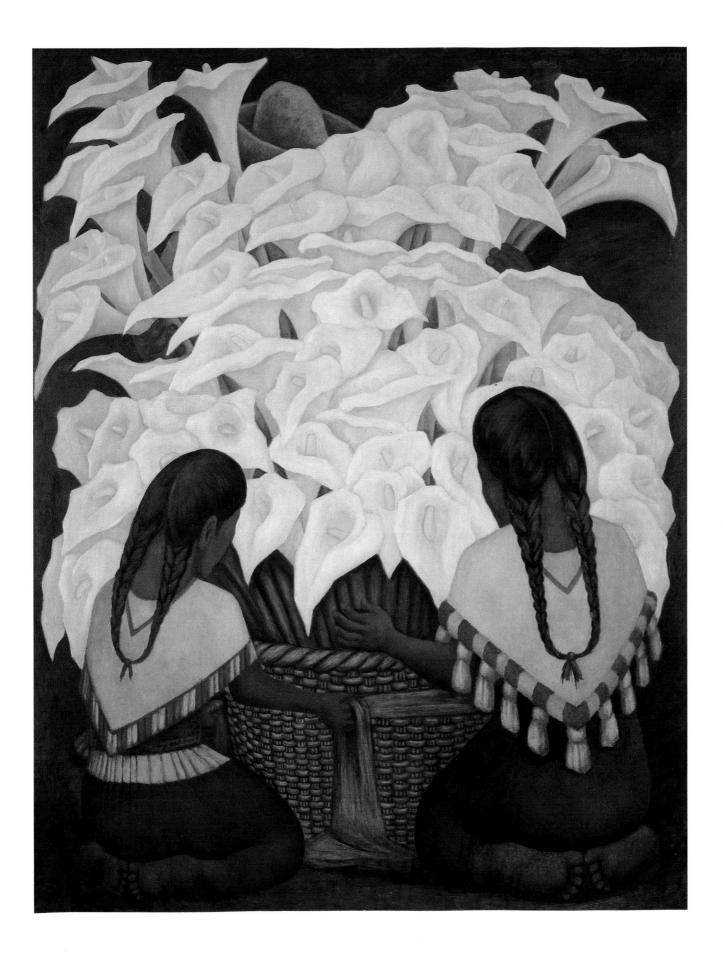

restoration of the great pre-Conquest city of Teotihuacán, the beginning of whose florescence dates back to the time of Christ. The restoration of the vast pyramids, murals and sculpture from Teotihuacán brought the achievements of the early Mexican civilizations to the forefront of public consciousness, now eager to claim them as part of the 'Mexican heritage'. The ethnographic survey revealed that about 60 per cent of the population of the Valley was in fact Indian, the rest mostly mestizo. Gamio blamed the misery and backwardness in which most of them lived on poverty, poor diet and lack of education, and advocated land reform and the return of communal land holdings. Ninety per cent of the cultivable land, he found, was owned by a tiny fraction of the population (seven absentee landlords). There had, undeniably, been a disastrous decay of Indian civilizations, systematically suppressed by the Spanish, since the Conquest, but Gamio found that conditions had worsened considerably since Independence, particularly during the reforms of the 1850s, and under the dictatorship of Díaz. Although he recognized a continuation of the 'native cultures' of Anáhuac, he acknowledged aesthetic value only in their products, actively encouraging the production of 'folk' crafts: textiles, pottery, metal work and lacquer.

Gamio's conclusion was that in their own interests and in that of Mexico the Indians should be assimilated into the modern Mexican nation:

The extension and intensity that folk-loric life exhibits in the great majority of the population eloquently demonstrates the cultural backwardness in which that population vegetates. This archaic life, which moves from artifice to illusion and superstition, is curious, attractive and original. But in all senses it would be preferable for the population to be incorporated into contemporary civilization of advanced, modern ideas.⁷

This 'liberal-progressive' conclusion was to influence official indigenist policies for years to come, in the practice known as induced assimilation, although all too often the socio-economic basis of Gamio's argument was forgotten in subsequent discussions of the so-called 'Indian problem'.

Another tendency inherent in indigenism was to merge all Indian peoples together as one 'other' nation. Whereas in Peru and other Andean countries the Inca had in the years immediately preceding the Conquest introduced Quechua as a common language to the different groups and imposed thereby a measure of unity, in Mexico there were many different groups with different languages. In the Valley of Mexico, for instance, both Otomí and Náhuatl are spoken, and the Maya speak languages that are mutually incomprehensible.

For the supporters of assimilation this was seen as a further obstacle. Eugenio Maldonado, for instance, in 'The Indian Problem' (1938) identified this as the first problem, and went on to elaborate on what he saw as the second problem, 'the reorientation of their

mental processes. Little has been accomplished along this line, above all because it implies a previous knowledge of the Indian mind and up to this date the various institutions which have undertaken to investigate the Indians' psychological processes have stumbled on two fundamental obstacles: insufficiency of staff devoted to such studies and the vastness of the population to be studied.'8 Such implicitly neo-colonial attitudes have been fought vigorously by Indian nations like the Yaqui, who finally won the right to selfdetermination, and by authorities like León-Portilla who recognized the economic and material basis of the social divisions, 'confinement to impoverished and often waterless lands; the frequent uncertainty of their titles of possession; the isolation of their communities; the absence of the more elementary public services; and the non-operating character of certain socio-political structures which have been imposed on them. To these may be added other injuries to their morale . . . '9

Rivera's love of the 'curious, attractive and original' in the life of the Indians [Pl. 9.6], to use Gamio's phrase, was not modulated by any concern for the official policies of assimilation; indeed only Orozco seems to have agreed with Gamio's conclusion. Rivera tended to treat injustice towards the Indian in terms of an historical rather than a contemporary context, emphasizing in the National Palace murals in particular the brutality of the Spanish Conquest, and depicting in the Ministry of Education murals the positive efforts of the Mexican Revolution in redistribution of land and improvements in education, while simultaneously celebrating the picturesque aspects of Indian culture.

The Revolution had transformed the consciousness of the country, but the changes and improvements in conditions were slow. Siqueiros' *Peasant Mother* was painted in the context of what was understood as a continuing revolution. A manifesto in *El Machete*, signed by Siqueiros as General Secretary of the Syndicate of Mexican Technical Workers, Painters and Sculptors, had, following the rebellion late in 1923 of military-backed conservative forces, warned against the new and threatening power of the bourgeoisie 'who will seize the land and well being of your brothers with the very same weapons with which the Revolution had guaranteed them that land'.

Peasant Mother and its companion picture Proletarian Mother [Pl. 9.7] were painted in the consciousness that Mexico was still in a vulnerable transitional state, that the old order had not been fully defeated and that the worker and peasant were still exploited and needed to defend themselves and claim the promised reforms: 'You, the peasant on the land, fertilize the soil so that the fruit it bears is swallowed by the greed of profiteers and politicians, while you starve; . . . you, the worker in the city, keep the factories going, weave the cloth, and create with your own hands modern comforts to service prostitutes and drones while your bones shiver with cold. . . .'10 Siqueiros does not restrict his strongly worded

9.6 Diego Rivera, *Day of the Dead in the Country*, 1925, charcoal, chalk and pencil on paper, 46.4×30cm., The Museum of Modern Art, New York; Given anonymously.

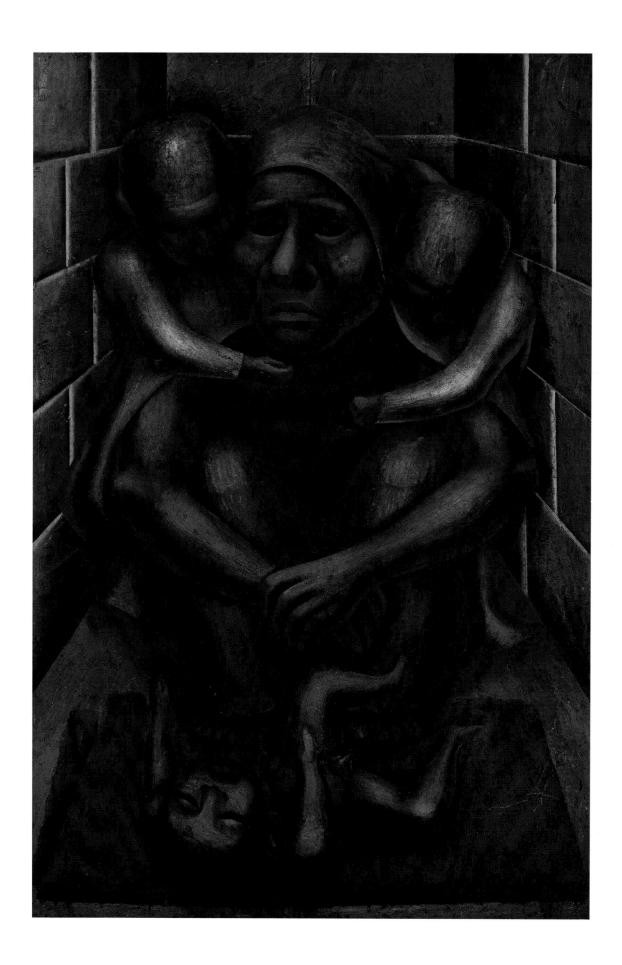

manifesto to social and political issues, however, but extends it to culture as an organic part of these: '. . . victory for the working classes will bring with it a unanimous flowering of ethnic art, cosmologically and historically transcendant in the life of our race, comparable to that of our wonderful autochthonous civilizations'. But he distinguishes this from the 'criollo and bourgeois approval (which is all-corrupting) of popular music, painting and literature; the reign of the "picturesque"'.

What the relationship might be between the 'flowering of ethnic art', and the muralists themselves is not clear. Certainly Siqueiros saw his role as that of creating a propaganda art for the people. Unlike Rivera, Goitia or Francisco Leal, Siqueiros himself rarely painted Indians, but when he did, it was clearly in the context of social protest.

In Peru, where Sabogal painted his *Indian Mayor*, the situation was different, for although the condition of many of the Indians was no less desperate than in Mexico, there had been no social and political upheaval like the Mexican Revolution, and movements of reform or protest were much more circumscribed. 'Ten years after the popular Mexican uprising, the fullest and most intense social struggle in Peru was limited, geographically, to the capital, and in terms of objective, to achieve state recognition of the eight-hour working day. '11 President Leguia's strong dictatorship lasted from 1919 until 1930, but during this period new political parties were founded: APRA (Alianza Popular Revolucionaria Americana) and Mariátegui's Peruvian Socialist Party. Although Mariátegui founded his party on Marxist lines, it took as its model not European socialism but the Peruvian Indian commune, or ayllu, which was based on pre-Conquest Inca social structures. Both writers and artists in Peru were closely involved with Mariátegui and shared his ideas, contributing to his vanguard review Amauta [Pl. 9.8] (see Chapter 6).

Sabogal dominated indigenist painting in Peru during the Twenties and Thirties, and his painting more than any other 'incarnates the contradictions inherent in this movement'. 12 A further comparison would be useful at this point, between Sabogal and the nineteenth-century Peruvian artist Francisco Laso. Laso was the first academic artist in republican Peru to turn his attention to the local inhabitants. He travelled, between 1850 and 1853, through the Andes, where he made numerous sketches from life of local scenes and events, and of figures [Pl. 9.9]. The final paintings, however, were done in the studio, with the aid, too, of photographs. In paintings like Rest in the Mountains and The Indian Potter [Pl. 2.16], the figures are presented as highly dignified and static. There is little connection between Laso's painting and the picturesque costumbrista scenes of traveller-artists, and his treatment of his subjects runs counter to the attitude of the middle- and upper-class urban élite (creoles and some mestizos) which assumed the inferiority of the Indian. His emphasis on the individual character of the faces, as opposed to the undifferentiated mass, is quite singular, even if the effect of the smoothly academic style is to idealize and romanticize.

9.8 Amauta, September 1926, cover.

- 9.7 David Alfáro Siqueiros, *Proletarian Mother*, 1930, Museo de Arte Moderno, Mexico City (INBA).
- 9.9 Francisco Laso, *Rest in the Mountains*, 1859, oil on canvas, 138×147 cm., Banco Central de Reserva del Peru, Lima.

The potter must surely be a portrait (though unnamed), but at the same time the shaded face shifts attention away from the man and on to the costume and the pre-Columbian pot, his occupational attribute.

The potter holds a Moche pot, though precisely what this signifies is unclear. In the mind of the viewer, though, a connection must be made between the Indian and the ancient Moche civilization (c. 500 Ad). He seems, in other words, independent, owing nothing to the Spanish colonial settlers. In Laso's Rest in the Mountains, too, a Moche pot rests beside a magnificently cloaked figure, with his strange hat – perhaps this, and the potter's equally strange costume, were intended as authentic dress. A contradictory sense of timelessness and great antiquity emerges, not unlike that of European orientalist painters (it is interesting that in Paris Laso worked in the studio of the academic orientalist Delaroche).

Although there are no obvious social connotations in Laso's scenes, he does at the same time seem to resist too great a romanticization of the Andean Indian world, and his own activities as political reformer confirm that his interest was not just that of an observer of the picturesque.

Even if Laso's dignified, noble and hieratic Indians obscured the conditions of exploitation in many Andean communities, they still challenged the bourgeois stereotype of the Indian as inferior. A strong tradition was subsequently to grow presenting the Indians as Inca – in other words presenting a past grandeur in the context of a nation that needed to assert its unity. Mirko Lauer suggests that one should speak of a 'Tahuantinsuyuism' as well as of 'indigenism' in painting and literature. He is strongly critical of this tendency: 'It was art of academic formalism which exploited the gold and the feathers, and which reproduced the hierarchical structure of its own society in an historical setting; its final achievement was to make the undernourished muscular, the poor rich, the ragged luxurious, and to create in the public mind a divide between the past and the present of the Andean people.'¹³

Sabogal's Indian is caught between these worlds - he is both of the present and of the past; perhaps an ideal figure, and yet one which is in many ways close to the Indians in the novels of Sabogal's contemporaries among Peruvian writers, such as Arguedas and Cirio Alegría. Rosendo Maqui, the village leader in Cirio Alegría's Broad and Alien is the World (1927), is a wise leader who guides his people and settles their disputes, and who lives in harmony with the natural world. But, unversed in the unscrupulous practices of the invaders (now the creole landowners), he fails to defend his village, is cheated by the law, and the novel ends with the landowner supported by an army moving to force the Indians off their land. In this novel, which admittedly reads rather like a tract, Alegría fictionalizes the then current practice of landowners, who annexed the Indians' land and forced them to work it in the condition of serfs (gamonalismo). Mariátegui argued, in 'The Indian Question' (Appendix, 9.1), that its root cause was this feudal system of land

tenure: 'A socialist critique examines and clarifies the problem because it looks for its roots in the Peruvian economy rather than in its administrative, legal or religious institutions, or in the plurality of its racial composition, or in cultural or moral terms. The Indian problem stems from our economy. It is rooted in the system of land ownership. '14 The Indians and the laws formulated for their protection were in fact powerless against the great landowners. 'Land individually or collectively owned by Indians has by now been largely expropriated', and, Mariátegui goes on, 'The assumption that the Indian question is an ethnic one is fostered by the most antiquated collection of imperialist ideas. The concept of racial inferiority served the white West's programme of conquest and expansion. To expect the emancipation of our indigenous peoples through the active hybridization of aboriginals and white immigrants is a piece of anti-sociological naïveté, conceivable only in the simple mind of an importer of merino sheep . . .' It is over the question of land that the Indian's struggle has continued, not only in Peru but throughout Latin America.

Sabogal's Indian figure appeals to 'Inca-ism', but at the same time the fact that he stands before a real Andes landscape, with a village, rather than in the blank portrait space of Laso's potter, links this Incaism to the land problem, if obliquely. Sabogal contributed to Mariátegui's magazine Amauta, but he was more concerned with cultural than social issues. His version of indigenism sought to shape cultural unity in Peru through the encouragement of popular art; he wrote articles about popular ceramics, carvings, and the carved wooden beakers (Kero) which remained unchanged in material and shape since Inca times [Introduction Pl. 4]. At the same time he eschewed the academicism then in favour for the heightened colour, emphatic outline and broad brush-strokes of Fauvism. After teaching at the School of Fine Arts from 1920, he was in 1932 appointed director;¹⁵ under his guidance there grew up what was virtually a school of indigenist painting in Peru, including Julia Codesido, Camino Brent, Camilo Blas, Cota Carvallo, Jorge Segura, and the self-taught Mario Urteaga [Pl. 9.10]. Indigenismo was, however, a derogatory term, used, as Sabogal said, with malice; 'The term "indigenism" applied to Peruvians like Sabogal is a racist nickname and a reflection of cultural discomfort. It is a reaction against those artists and cultivated intellectuals, without quotation marks, who do not distance themselves from the people and the land. It is a protest against them for not perceiving the people and the land as a spectacle or as a mere thematic construct.'16 In 1943 Sabogal was forced to resign the directorship, and, although continuing to paint, devoted much time to the rescue and encouragement of popular arts, on the verge, in many places, of extinction.

The relationship between indigenism and 'popular' arts should briefly be raised, for there is no doubt that in the most general terms the treatment of Indian themes in painting and in literature was accompanied by a revival of interest in popular and traditional 'arts

9.10 Mario Urteaga, *Burial of an Illustrious Man*, 1936, oil on canvas, 58.4×82.5 cm., The Museum of Modern Art, New York; Inter-American Fund.

and crafts' – but in a selective way. In Mexico, popular art was officially welcomed as 'mestizo', as guaranteeing and strengthening the purposed unity of the Mexican nation¹⁷ and in a sense proposing an interchange at the level of the cultural assimilation of Indian groups in Mexico, which was actively pursued from the Twenties. Similar revivals of folk art took place all over Latin America (see Introduction).

Indigenism in Mexico covers a multiplicity of different and even opposing attitudes. The syndicate, as we saw, placed great faith in native art, but warned against the bourgeois taste for popular art. The notion of indigenous art itself as 'popular' was certainly appealed to in terms of the muralists' rejection of easel painting and the individualist aesthetic of the bourgeoisie. Rivera surrounded himself with pre-Columbian and contemporary Indian art and artefacts, and objects of mestizo popular culture. His collection included Aztec, Maya, Zapotec and Mixtec sculpture and ceramics, and for this he built the special museum, the Anahuacalli; in his studio he kept an extraordinary collection of objects of ancient and recent origin. The walls and ceiling were hung with papier mâché

9.11 Francisco Goitia, *Way to the Tomb*, 1936, tempera on canvas, 119×91 cm., Private Collection.

9.12 Jesús Guerrero Galván, *I and My Future*, 1951, oil on canvas, 55.5×70.5 cm., Collection Pascual Gutiérrez Roldán.

9.13 Xavier Guerrero, *Two Mothers*, 1945, black crayon on orange-red paper, 55.6×39.1cm., The Museum of Modern Art, New York; Inter-American Fund.

9.14 Roberto Montenegro, *Maya Women*, 1926, oil on canvas, 80×69.8 cm., The Museum of Modern Art, New York; Gift of Nelson A. Rockefeller, 1941.

9.16 Diego Rivera, 'The Mansions of Xibalba', watercolour, Pl.XV from *Popol Vuh*, Museo Casa Diego Rivera, Guanajuato (INBA).

9.17 Diego Rivera, 'The hero twins are summoned by bat messengers to play the ball game with the lords of the underworld', watercolour, Pl.IX from *Popol Vuh*, Museo Casa Diego Rivera, Guanajuato (INBA).

and wire skeletons (calaveras), there were huge Judas figures from street festivals, fine Guerrero masks, models of jaguars and other pre-Conquest deities, painted bowls, etc. [Pl. 9.18]. Yet it could be argued that his art never really assimilated this - unlike Frida Kahlo's, whose paintings in many senses absorbed the popular form of the retablo and actually became it, Rivera's remains at the level of aesthetic and intellectual admiration. On the walls of the National Palace in Mexico City he conjured a Utopian golden age in the scenes of pre-Columbian civilization. Yet Rivera perhaps was the painter most respectful of and most seriously immersed in the ideas, the cosmology, medicine, literature and art of the original inhabitants of America; in the series of watercolour illustrations he made. for example, for the Popol Vuh, the great Quiché Maya account of the creation of the world and of man [Pls 9.16,17], he attempted to stay close to pre-Columbian artistic sources. He looks, for instance, to the native screenfold books, although he did not necessarily rely exclusively on Maya sources like the Dresden Codex [Pl. 9.20], drawing as much on Toltec pictographs, like the Laud screenfold [Pl. 9.19].

But at the same time he could be accused of generalizing the contemporary Indians he depicts, as in *Flower Day*, of rendering them as little more than tokens – without individual character. More actively engaged, perhaps, with the problems and contradictions

9.18 The studio of Diego Rivero.

9.19 Page from the Laud Codex, Bodleian Library, Oxford.

- 9.20 Illustrations from the Dresden Codex, Sachsische Landesbibliothek, Dresden.
- 9.23 (facing page top right) Marcello Pogolotti, *Capitalism*, n.d., oil on canvas, 92.5×73 cm., Museo Nacional, Palacio de Bellas Artes, Havana.

inherent in indigenism were members of the Taller de Gráfica Popular, who went to consult León-Portilla in the late 1950s not only about Mexican history, but about the Náhuatl communities in Mexico. ¹⁸ Their prints and engravings represent in many ways a closer and more informed involvement with the issues raised by 'indigenism'.

Siqueiros' refusal to separate indigenism from social protest is found elsewhere in Latin America – in Ecuador, for instance, where Egas, Guayasamín and Eduardo Kingman all produced works critical of social conditions [Pls 9.21,22]. They often portrayed tragic figures, frequently women in mourning, which relate quite closely to the expressionist work of Käthe Kollwitz. Guayasamín tended to concentrate on urban subjects, as in *The Strike*, while Kingman, in the large painting *Los Guandos* whose oppressed figures are

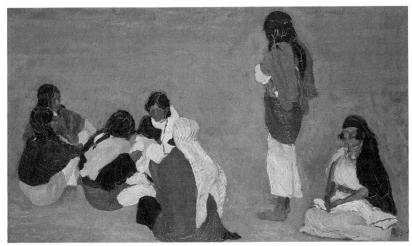

9.21 Camilo Egas, *Indians*, 1926, oil on canvas, 42×70 cm., Museo de Arte Moderno, Casa de la Cultura Ecuatoriana, Quito.

9.22 Oswaldo Guayasamín, *The Strike*, 1940, oil on canvas, 141×210 cm., Fundación Guayasamín, Quito.

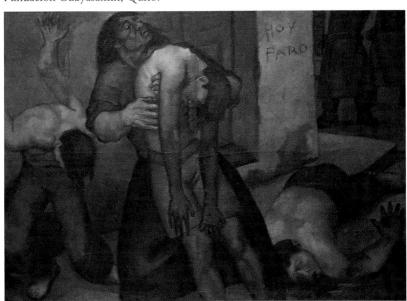

9.24 (below) Eugênio de Proença Sigaud, *Accident at Work*, 1944, 132×95cm., Museu Nacional de Belas Artes, Rio de Janeiro.

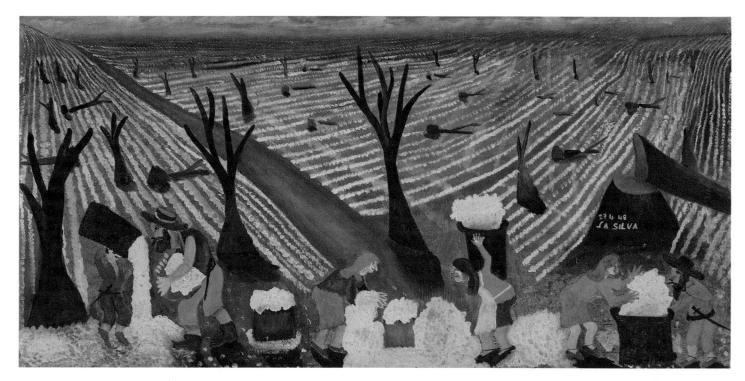

- 9.25 José Antônio da Silva, *The Cotton Harvest*, 1948, oil on canvas, 50×101 cm., Museu de Arte de São Paulo.
- 9.26 José Antônio da Silva, *Repousa* (*Fazenda*), 1955, oil on canvas, 70×99.8 cm., Museu de Arte Contemporânea da Universidade de São Paulo.
- 9.27 José Antônio da Silva, *Enchanted Waterfall*, 1957, oil on canvas, 25×49.5 cm., Collection João Marino, São Paulo. The widespread success of self-taught naïve artists all over Latin America, like José Antônio da Silva, runs parallel to the success of 'popular' art.
- 9.28 José Antônio da Silva, *Sugar Factory*, 1948, oil on canvas, 50×100 cm., Collection João Marino, São Paulo.

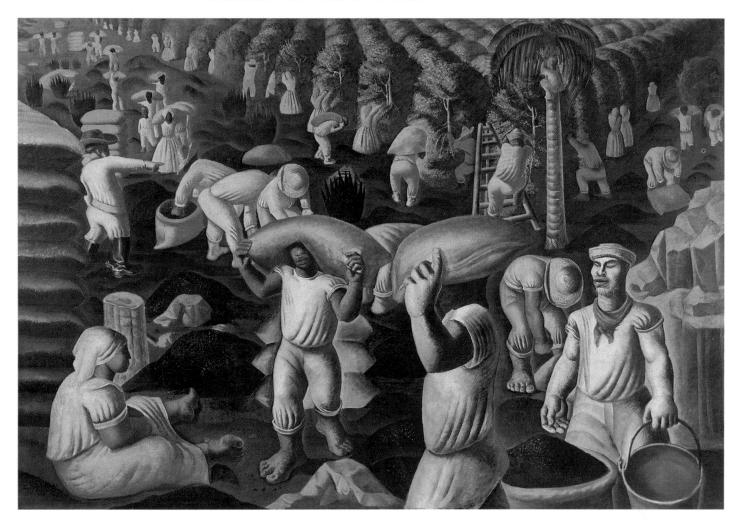

crammed into the lower edge of the canvas, expressed great anger at the condition of peasant serfdom.

Throughout Latin America during the 1930s there was a similar movement among groups of artists towards art with a social theme. Lasar Segall, himself an immigrant, coming from a background of German Expressionism, treated the theme of immigration in paintings and engravings; among his most striking and original works, though, are the engravings he made of the street life of Rio de Janeiro, its cafés, prostitutes and sailors [Pls 8.23,24].

Cándido Portinari was involved in both mural and easel painting. He painted murals for the Ministry of Education in Rio de Janeiro, and in 1941 a *Discovery of the New World* for the Library of Congress in Washington, D.C. During the '30s, he based a number of canvases on coffee plantation workers and miners, which range from the depiction of whole scenes, as in *Coffee* [Pl. 9.29], which won a prize at the Carnegie Institute in the USA in 1935, to studies of individual figures, which are conceived as paintings of types rather than portraits, as in *The Mestizo*.

9.29 Cándido Portinari, *Coffee*, 1935, oil on canvas, 131×195.3 cm., Museu Nacional de Belas Artes, Rio de Janeiro.

10 Private Worlds and Public Myths

'Under the pretence of civilization and progress, we have managed to banish from the mind everything that rightly or wrongly may be called superstition or fancy.' In this way André Breton concluded his attack on the 'reign of logic' in the first Surrealist Manifesto, preparatory to arguing that, following the discoveries of Freud, the 'imagination is perhaps on the point of reasserting itself, of reclaiming its rights. If the depths of our mind contains within it strange forces capable of augmenting those on the surface or of waging a victorious battle against them, there is every reason to seize them . . . '1 These 'strange forces' are no less 'real' than those that govern our more workaday conscious life, and it was for this reason, rather than because of any fantasy per se in them, that the Surrealists put such faith in dreams, and in all other expressions of the human experience and imagination which are not conditioned by the narrow confines of logic. 'Fear, the attraction of the unusual, chance, the taste for things extravagant. . . . There are fairy tales to be written for adults, fairy tales still almost raw.'2

The Surrealists understood the 'freedom of the imagination' in terms of the Romantic tradition, which distinguished between the imagination and fantasy, the former remaining essentially linked to reality, the latter over riding it. In the face of the disbelief of their critics, the Surrealists held to the necessary relation between art and life - Surrealism 'plunges its roots in life'. They did not, in other words, subscribe to the idea of art for art's sake, to the selfreferential artistic tradition of Europe. It is true that in speaking up for the rights of the imagination Surrealism sometimes stated its case in ways that laid the movement open to an identification with the fantastic; the theatrical academicism of some later surrealist art has strengthened this identification and worked to undermine its true position. Reality was always an essential term in the surrealist equation, however, and it was never Surrealism's intention to seal off the imagination from that reality, desire from action, the unconscious from the conscious, the marvellous from the everyday world, dream from waking life.

But the rationalism of Europeans, Gabriel García Márquez remarked,

prevents them seeing that reality isn't limited to the price of tomatoes and eggs. Everyday life in Latin America proves that reality is full of the most extraordinary things. To make this point I usually cite the case of the American explorer . . . who

10.1 Detail of Pl. 10.45.

10.3 Rufino Tamayo, *Woman in Grey*, 1959, oil on canvas, 195×129.5 cm., Solomon R. Guggenheim Museum, New York.

10.2 Rufino Tamayo, *Girl Attacked by a Strange Bird*, 1947, oil on canvas, 177.8×127.3 cm., The Museum of Modern Art, New York; Gift of Mr and Mrs Charles Zadok, 1955.

made an incredible journey through the Amazon jungle at the end of the last century and saw, among other things, a river with boiling water, and a place where the sound of the human voice brought on torrential rain. In Comodoro Rivadivia, in the extreme south of Argentina, winds from the South Pole swept a whole circus away and the next day fishermen caught the bodies of lions and giraffes in their nets . . . ³

In Latin America, the Surrealists came to feel, the imagination possessed a vitality, and art and poetry a meaning, lacking in the constricted civilization of the West. 'In Mexico', Breton wrote, '. . . artistic creation is not adulterated as it is here.' Art there was not cut off from its roots in the world of magic, and popular art was very much alive and its value recognized by artists. And not only was the ethnographic reality of indigenous life strongly present in the continent still, with its myth and ritual, cosmologies and cosmogonies embodied in painted pots, in weavings, in carvings and in the masks collected by the Surrealists, but a belief in magic was present at all levels of society: 'a world of omens, premonitions, cures and superstitions that is authentically ours, truly Latin American'.⁵

This chapter is therefore predominantly concerned with the currents in Latin American art that seemed to the Surrealists to possess those qualities in which they yearned to recognize their own ideas. It is concerned both with the private worlds of the imagination and with wider networks of belief such as the *santería* or voodoo of the African Caribbean and of Brazil. It also includes the work of artists who chose to settle in Latin America, among them Remedios Varo, whose husband the surrealist poet Benjamin Péret spent many years in Mexico, Wolfgang Paalen and Leonora Carrington; and of Latin American artists who joined the Surrealist movement, most notably Wifredo Lam and Roberto Matta Echaurren. The intention is to present, rather than homogeneity, elements of contrast and comparison.

Surrealism's interest in and experience of Latin America was initially concentrated in Mexico, which Breton visited in 1938. In his introduction to the work of Frida Kahlo, he wrote:

There is a country . . . where creation has been prodigal with undulations of the ground and species of plant life, and has surpassed itself with its range of seasons and cloud architectures; where, for a whole century now, the word INDEPENDENCE has continued to crackle beneath a blacksmith's giant bellows, sending up incomparable sparks into the sky. I had long been impatient to go there, to put to the test the idea I had formulated of the kind of art our own era demanded, an art that would deliberately sacrifice the external model to the internal model, that would resolutely give perception precedence over representation. 6

PRIVATE WORLDS AND PUBLIC MYTHS

The rejection of the 'external model', and the Surrealists' opposition to the 'desire to subordinate painting to social action' tended to turn their attention away from the most famous Mexican artists of the time, the first generation of muralists. Breton wrote approvingly of Rufino Tamayo's own comments on his disillusionment with muralism and with a nationalism (to which Surrealism was always resistant) which had led the muralists 'to neglect the true problems of plasticity and degenerate into the picturesque'. Breton saw Tamayo's work as governed by two necessities: on the one hand, the 'need to reopen the lines of communication which painting, as a universal language, should be providing between the continents', and on the other 'to extract the essence of eternal Mexico'. He praises Tamayo's free morphology, which has nothing to do with distortion for expressionist ends, but rather with a lyrical imagination by which a child can assume the dimensions of its mother's heart, and which uses the rich colours of pre-Columbian codices. [Pls 10.2,3]

However, Breton also recognized that much of the muralists' work had little to do with social realism in the sense in which it was understood in Europe, and that there were strong connections, above all in the frescos of Diego Rivera, with popular art. In his 'Souvenir du Mexique', he addressed Rivera:

you have the advantage over all of us of participating in that popular tradition which to my knowledge remains alive only in your country. That innate sense of poetry and of art as they should be, as they must be made by all, for all, and whose lost secret we desperately seek in Europe - one only has to see you caress a tarascan idol, or smile, with that grave, matchless smile, at the extraordinary arrangement of a market display, to know that it can never let you down. It is clear that you are linked by millennial roots to the spiritual resources of that earth which is to you, as it is to me, the dearest in the world. . . . it is that which plastically allows you to find your measure in any kind of subject, and to treat history as the ancient anatomists treated man. In your gigantic ever-open atlas on the inner walls of the buildings of Mexico City, of Cuernavaca, of Chapingo, I've been able to follow with the wondering eyes of childhood the concrete progression of man in time . . .

Mexican popular art featured strongly among the works illustrating 'Souvenir du Mexique': the anonymous painting *Esta es la Vida* [Pl. 3.98], a Posada print of Zapata, photographs by the Belgian Surrealist Raoul Ubac of Day of the Dead objects – a sugar skull, a clay *calavera*. There were also photographs by Manuel Alvarez Bravo [Pls 10.4-13], whom Breton valued highly, and whose 'very great art', in Breton's words, touches the opposite poles of life and death and in some sense reconciles them – as, for Breton, Mexico itself did: the marguerites blooming on an Indian grave, the perfectly balanced construction of the photograph of the coffin maker's, *Ladder of Ladders* [Pl. 10.4], where all the coffins are

10.4 Manuel Alvarez Bravo, Ladder of Ladders, 1931, silver gelatin print, 25.5×20 cm., Collection Manuel Alvarez Bravo.

10.5 Manuel Alvarez Bravo, *Chalma Cross*, 1942, silver gelatin print, image 24×17.3 cm., The Minneapolis Institute of Arts; Gift of Martin Sklar.

10.7 Manuel Alvarez Bravo, *Public Thirst*, 1934, silver gelatin print, 25.5×20 cm., The Board of Trustees of the Victoria and Albert Museum, London.

10.6 Manuel Alvarez Bravo, *The Over-prudent Washerwomen*, 1932, silver gelatin print, 25.5×20 cm., Collection Manuel Alvarez Bravo.

10.8 Manuel Alvarez Bravo, *The Dancers'*Daughter, 1933-4, silver gelatin print, 25.5×20 cm.,
Collection Manuel Alvarez Bravo.

10.9 Manuel Alvarez Bravo, *'Parábola Optica'*, 1940(?), silver gelatin print, 25.5×20 cm., The Board of Trustees of the Victoria and Albert Museum, London.

10.10 Manuel Alvarez Bravo, *Wooden Horse*, silver gelatin print, 25.5×20 cm., Collection Manuel Alvarez Bravo.

10.11 Manuel Alvarez Bravo, *The Dreamer*, 1931, silver gelatin print, 20×25.5 cm., Collection Manuel Alvarez Bravo.

10.12 Manuel Alvarez Bravo, *Mannequins Laughing*, 1930, silver gelatin print, 20×25.5 cm., Collection Manuel Alvarez Bravo.

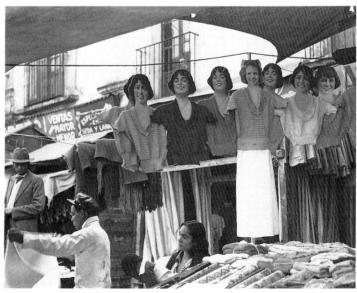

those of children; the photograph of the dead striker in Tehuantepec [Pl. 10.13], lying above the centre of the image rather than below our gaze, blood like gleaming ritual paint on his face.

For art thus to be able to present the problems of social injustice (infant mortality rising to 75 per cent) and violence, without losing its special visual quality – to use the 'imagination as an instrument to create reality', 9 rather than replace it, was what made its condition in Mexico unique.

Neither Alvarez Bravo, nor Frida Kahlo, the artists whose work Breton most admired in Mexico, thought of themselves as Surrealists; there is no doubt, however, that their recognition by Surrealism added a dimension to that movement that was quite new. Both were prominently included in the Exposición Internacional del Surrealismo, which took place at the Galería de Arte Mexicano in January and February 1940. The exhibition was organized by Wolfgang Paalen, who had moved to Mexico in 1939, with the collaboration of Breton and the Peruvian poet César Moro. The cover of

10.13 Manuel Alvarez Bravo, *Striking Worker Murdered*, 1934, silver gelatin print, 20×25.5 cm., The Board of Trustees of the Victoria and Albert Museum, London.

A CONTRACTOR

10.14 Diego Rivera, *Landscape with Cacti*, 1931, oil on canvas, 125.5×150 cm., Collection Jacques and Natasha Gelman.

10.15 Carlos Mérida, Variations on the Theme of Love (Variation 2, Ecstasy of a Virgin), 1939, gouache and pencil on paper, 47×57.2cm., Mary Anne Martin/Fine Art, New York

10.16 Guillermo Meza, *Polyphemus*, 1941, pen and ink on paper, 50.2×65.5 cm., The Museum of Modern Art, New York; Inter-American Fund.

PRIVATE WORLDS AND PUBLIC MYTHS

the catalogue was a photograph by Alvarez Bravo, and a wide selection of works by surrealist artists was brought together, although transport difficulties because of the war reduced the number of sculptures available by Arp, Giacometti, Moore, Picasso and Ernst. Included in the general catalogue, which did not distinguish the artists' country of origin, were Kahlo (who showed two recent paintings, the large The Two Fridas and the now lost Wounded Table), Rivera, Matta, César Moro and Alvarez Bravo. In a separate section, however, was a group of 'Painters of Mexico', including some of those whom Breton had mentioned favourably after his 1938 visit, but who were presumably not considered part of the movement: Agustín Lazo, Manuel Rodriguez Lozano, Carlos Mérida, Guillermo Meza, Moreno Villa, Roberto Montenegro, Antonio Ruiz and Xavier Villarútia [Pls 10.15-20]. Also in the exhibition were examples of ancient Mexican art, in the form of Colima pottery, and dance masks from Guerrero and Guadalajara, all from Rivera's own collection. Fewer 'objets surréalistes' were included than the organizers would have wished, but these did include Paalen's Genius of the Species.

It is not surprising that Kahlo's painting made an impact on those

10.18 Agustín Lazo, *Interrupted Execution*, n.d., ink and watercolour on paper, 24×35 cm., Collection Mariana Perez Amor.

10.17 Carlos Mérida, *Plastic Invention on the Theme of Love*, 1939, cassein and watercolour on paper, 74.7×55.3 cm., The Art Institute of Chicago, Gift of Katharine Kuh, 1955.

10.19 Agustín Lazo, Reclining Woman in a Landscape, n.d., collage on paper, $22.2\times30\,\mathrm{cm}$., Collection Luis Felipe del Valle Prieto.

10.20 Antonio Ruiz, *The Dream of Malinche*, 1939, oil on canvas, $30\times40\,\mathrm{cm}$., Collection Mariana Perez Amor.

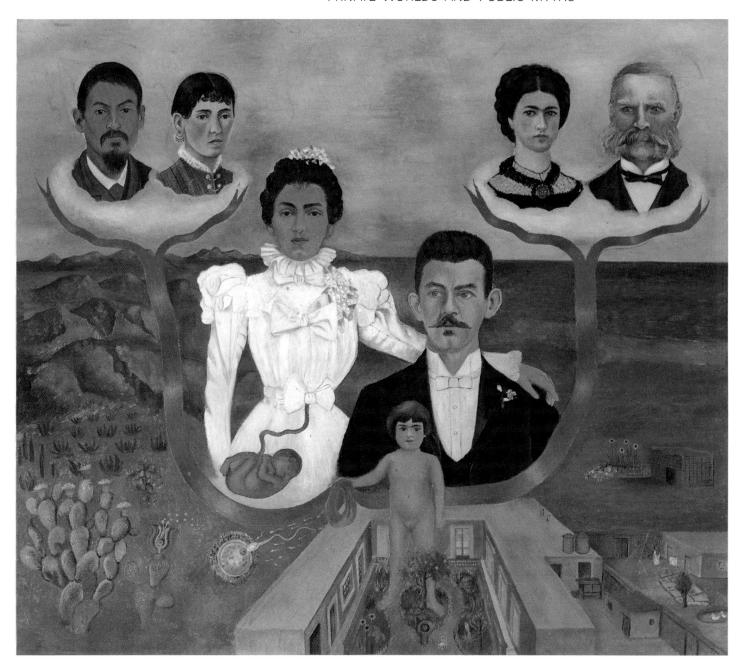

10.21 Frida Kahlo, *My Grandparents, My Parents and I (Family Tree)*, 1936, oil and tempera on metal panel, 30.7×34.5 cm., The Museum of Modern Art, New York; Gift of Allan Roos, M.D., and B. Mathieu Roos, 1976.

10.22 Frida Kahlo, *Self-portrait with Cropped Hair*, 1940, oil on canvas, 40×27.9cm., The Museum of Modern Art, New York; Gift of Edgar Kaufmann, Jr., 1943.

Europeans who saw it, rooted as it is in Mexico, but at the same time opening out imaginatively into a wider signification, poised 'at the point of intersection between the political (philosophical) line and the artistic line'. 'My surprise and joy', Breton wrote of Kahlo, 'was unbounded when I discovered, on my arrival in Mexico, that her work has blossomed forth, in her latest paintings, into pure surreality, despite the fact that it had been conceived without any prior knowledge whatsoever of the ideas motivating the activities of my friends and myself' [Pls 10.21-25].

Kahlo's painting was consciously rooted in the *retablo*, or ex-voto – the simple rudimentary image, with an inscription below giving details of the miraculous event in which a particular virgin or saint

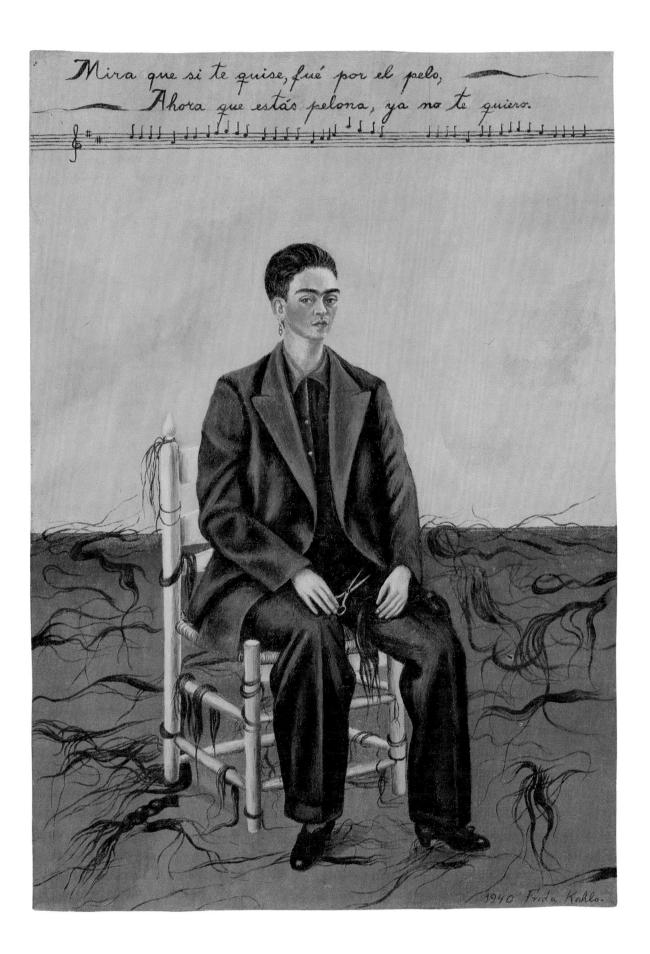

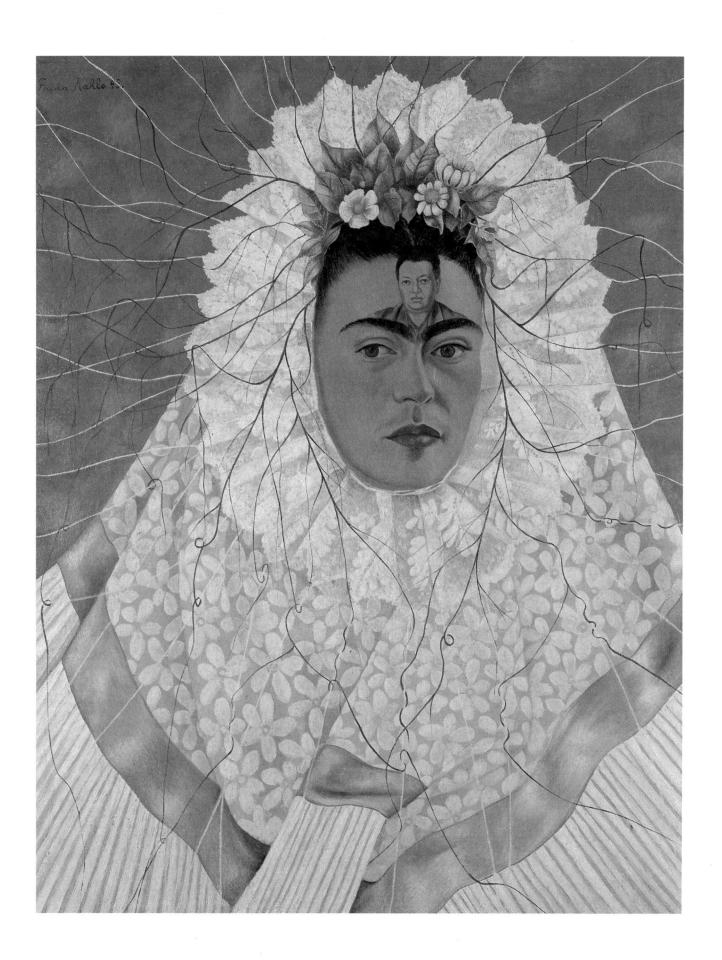

had interceded. The walls of the stairwells in Kahlo's house in Coyoacán are covered with such little paintings, usually anonymous. Kahlo, however, subverts the *retablo*'s function; in works like *My Birth*, or *The Suicide of Dorothy Hale*, it is the absence of miraculous intervention that is presented. In *My Birth*, the space normally reserved for an inscription, the panel at the bottom, is left blank, and in place of the normal devotional image, on the wall behind the bed is the Mater Dolorosa, the Virgin of Sorrows. This is one of the paintings in which Kahlo refers most directly to her own disastrous experience. Injured in an accident when she was eighteen, and unable to bear children though constantly wishing to, she was always in pain and underwent innumerable operations. The *retablo* is both a private act and a commonly shared tradition, and Kahlo's frequent adoption of the form points to the situation of her art on the borderline between public and private worlds.

Kahlo's subject was, more often than not, herself. Self-portraits show her dressed in a variety of beautiful Tehuantepec costumes, wearing her extraordinary jewellery, with tropical fruit or flowers, or with a pet monkey, on display. In one fine pencil self-portrait, her heavy dark brows are also a bird – a transformation that directly echoes the snake-surrounded eyes of the Aztec rain deity Tlaloc. Sometimes she depicts herself as a child, as in *My Grandparents, My Parents and I* [Pl. 10.21], in which her own mestizo origins are examined. The self-portraits probe the question of identity, personal, cultural and political. In the *Self-Portrait with Portrait of Doctor Farrill* [Pl. 10.24], she shows herself disabled, in her wheel-chair, with the dominating image of her male doctor, just finished, and painted as it were with her own blood – the palette is of veins rather than pigments. It is with metaphors of this kind that Kahlo touches the surrealist concept of the poetic image.

The 'drop of cruelty and humour' Breton spoke of as characteristic of her work is clear in the Self-Portrait of 1932, which contains an ironic commentary on the issues of identity. Kahlo was at this time in the USA with her husband, Diego Rivera, who, having completed the mural An Allegory of California for the Pacific Stock Exchange, was starting his major commission for the Detroit Institute of Arts, the Detroit Industry panels revelling in the might of modern machinery [Pl. 7.13]. In her tiny picture, Kahlo paints herself as a pretty mechanical doll, on a little motorized pedestal, casually holding the Mexican flag in one hand and a cigarette in the other. Behind her are two equally forbidding landscapes - Mexico, with its ancient idols and mythologies, and the United States with its regimented factories belching smoke. Rich and complex as this picture is, at one level it is an extremely witty exchange with Rivera, and a commentary on his allegorical style and his favourite themes.

In the late Thirties, the Surrealists increasingly turned their attention to magic and 'primitive' religion, and here their experiences in Latin America were of special value. The first Surrealist exhibition

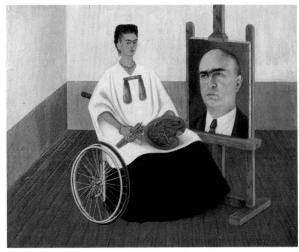

10.24 Frida Kahlo, Self-Portrait with Portrait of Doctor Farill, 1951, oil on masonite, 41.5×50 cm., Galería Arvil, Mexico.

10.23 (facing page) Frida Kahlo, *Diego on my Mind*, 1943, oil on canvas, 96.5×81 cm., Collection Jacques and Natasha Gelman.

10.24a Frida Kahlo Self-Portrait, 1932, Private Collection.

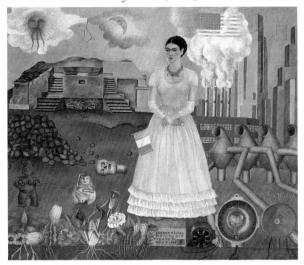

10.25 Frida Kahlo, *The Fruits of the Earth*, 1938, oil on masonite, 40×60 cm., Collection Banco Nacional de México, s.n.c., Mexico City.

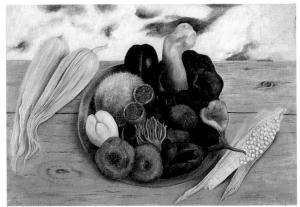

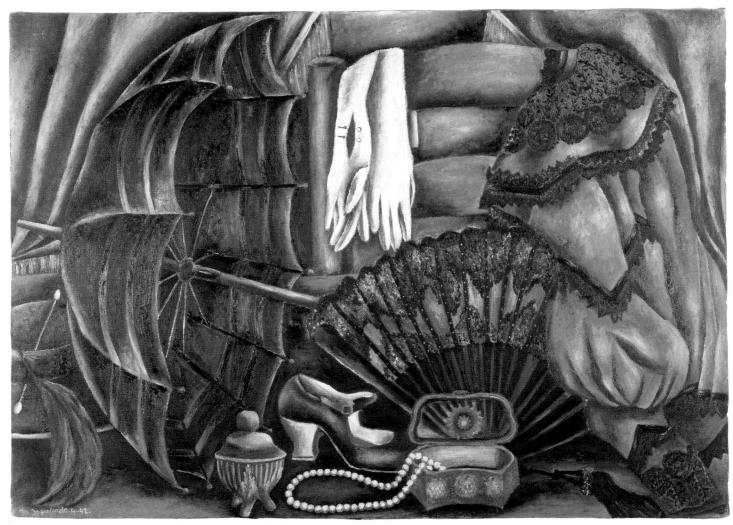

10.26 María Izquierdo, *Adornments, c.* 1941, oil on canvas, 70×100 cm., Collection Banco Nacional de México, s.n.c., Mexico City.

10.27 Hector Hyppolite working on Agoué and his Consort, Jason Seley Archives, Cornell University.

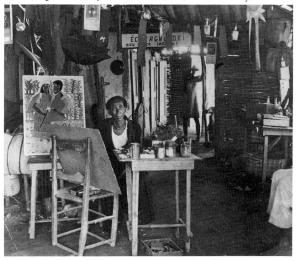

in Paris after the war, in 1947, included a 'room of superstition', and a series of 'altars'. The first plate in the catalogue of this exhibition was a painting by the Haitian Hector Hyppolite (*Papa Lauco*).

Breton had visited Haiti on his way back to France from the USA in 1945. He gave a series of lectures in December, the first of which, at the Rex Cinema, had 'an overwhelming effect on the disaffected youth 12 In Port-au-Prince, Breton came across the paintings of Hyppolite at the Art Centre, run by the American de Witt Peters, who kept an open studio for artists and hung their work, which was already finding a market in the States. The virtues of the Centre, Breton considered, 'in terms of the encouragement and support it offered to potential artists far outweighed the rather tiresome commercial aspect.' Hyppolite's paintings, in Breton's view, surpassed the others on display, because, raw and unschooled as they were, they had the 'stamp of total authenticity . . . the only ones to convey the unmistakable impression that the artist who had created them had an important message to communicate, that he was the guardian of a secret' [Pls 10.27,28].

While studying Hyppolite's development, Breton learned that he had been initiated as a voodoo priest, and wrote that his paintings

PRIVATE WORLDS AND PUBLIC MYTHS

were the first record of actual voodoo ceremonies and divinities (which Breton, through his friend Pierre Mabille, had attended). Hitherto, colour prints of Christian saints had served the devotees of this syncretic religion, 'for the excellent reason that Erzalie Freda Dahomey, the goddess of love, is at present adored by the faithful under the guise of St. Anthony of Padua; Ogoun Ferraille, the god of War under the guise of St. James the Greater because the latter is often represented in popular art, wearing a sword . . .'. ¹⁴ In his Ogoun Ferraille, Hyppolite includes the divinity himself, the paraphernalia that accompanies his ritual, and the geometric signs and symbols that are drawn on a wall or sprinkled on the ground with flour or sand, and are possibly of Caribbean Indian origin [Pl 10.31]. The inclusion of playing cards in this particular representation of Ogoun Ferraille relates to the fact that he intended it in this instance as a 'magical card', and Breton notes the similarity of Ogoun Ferraille to the juggler in the Tarot pack.

Many Haitian artists following Hyppolite have pursued the

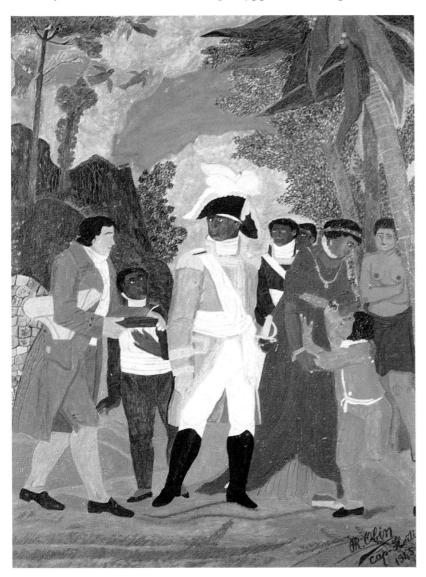

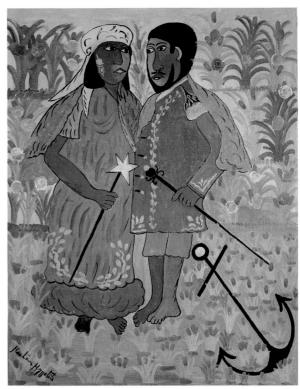

10.28 Hector Hyppolite, *Agoué and his Consort*, 1945-8, oil on board, 62×77cm., Collection Maurice C. and Patricia L. Thompson.

10.29 Philomé Obin, Toussaint l'Ouverture Receives the Letter from the First Consul, 1945, oil on masonite, 56.2×43.4 cm., Museo de Bellas Artes, Caracas.

10.30 Rigaud Benoit, *The Interrupted Marriage*, 1966, oil on masonite, 65×57 cm., Collection Selden Rodman.

PRIVATE WORLDS AND PUBLIC MYTHS

10.31 Voodoo Altar, Museo Nacional de Guanabacoa, Cuba.

10.32 Georges Liautaud, *Siren*, 1952, forged and cut iron, 80×72×21.5 cm., Museo de Bellas Artes, Caracas.

10.33 Wilson Bigaud, Sacrifice of the Cock, 1954, oil on masonite, 46×62 cm., Collection Selden Rodman.

imagery and the practice of voodoo, although others like Rigaud Benoit and Philomé Obin have also developed social and historical themes – as in Obin's canvas depicting the Caribbean's first Independence leader, *Toussaint l'Ouverture* [Pls 10.29,30]. Although the commercial success of the Art Centre's operation meant that many of the artists had access to materials (Hyppolite, in desperate material circumstances, had used a kind of enamel paint on cardboard beer crates, torn up and patched together), others still work with cast-off materials. Murat Brierre, for instance, flattened old petrol drums and cut out his shapes using the simplest tools, and Georges Liautaud combined iron and ready-made objects to construct his totems and mythological creatures [Pl. 10.32].

The cults in Haiti, Cuba and Brazil have the same divinities, though they have different names, and these are mainly of African origin. While some versions of the cult in Cuba stress in their iconography their African roots, others, in the elaborate altar constructions in homes, assemble masses of different objects – cloth, Catholic images, cheap glass, souvenirs and toys, often with surprising iconographical associations with the particular divinity. Each deity has his or her own colour, metal, and animal and vegetable associations, and the objects in the decorative arrangements are laid out according to a principle of lateral symmetry – an organizational principle that is often evident in the work of otherwise very different artists in Cuba, like Manuel Mendive and Ruperto Matamoros [10.31, 35].

At the time of Breton's visit to Haiti, an exhibition of the Cuban artist Wifredo Lam opened in Port-au-Prince. When Hyppolite was asked his opinion of it, he suggested deferentially that it was 'Chinese magic' as opposed to 'African magic'. Although Lam had, on his return to Cuba in 1941, after a long stay in Paris, become immersed in the world of *santería*, he remained first and foremost a painter and not an initiate, and this was the difference, probably,

10.34 Wifredo Lam, *Figure on Green Ground*, 1943, oil on paper, 106.5×83.5 cm., Museo Nacional, Palacio de Bellas Artes, Havana.

10.35 Manuel Mendive, *Obba*, 1967, plaka on canvas on wood, 66×78 cm., Museo Nacional, Palacio de Bellas Artes, Havana.

10.36 Wifredo Lam, *Moths and Candles*, 1946, pencil, pen and ink on paper, 51×62.1 cm., The Museum of Modern Art, New York; David Rockefeller Latin American Fund.

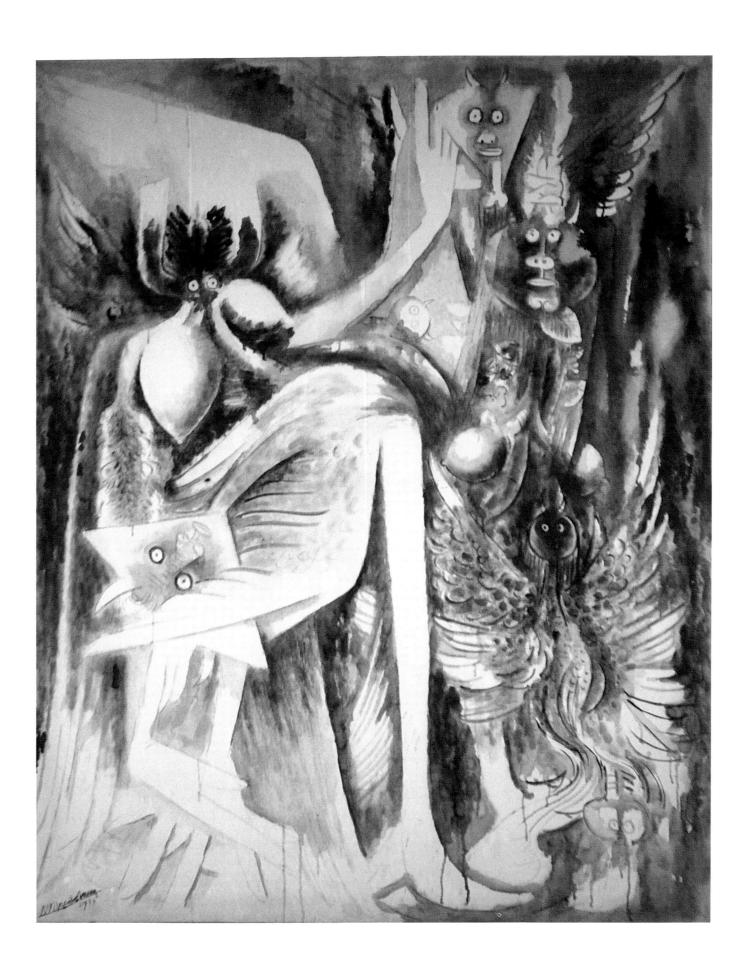

that Hyppolite was indicating. Although Lam did occasionally paint specific deities like Ogoun Ferraille, horned and with an iron horseshoe as head, or the 1944 *Altar for Eleggua* ('Loa Carrefour' in Haiti), his figures are more often more generalized: horned or masked, set within a tropical world, with titles like *The Dream, The Idol* [Pl. 10.37] or *Secret Ritual*.

Lam had quickly become involved with Surrealist circles in Paris, and Picasso had a special interest in him, perhaps feeling that Lam was closer to those secret worlds of primitive religion than he himself could be. 'The modern eye', wrote Breton, '. . . aware at last of the incomparable resources of the primitive vision, has fallen so in love with it that it would wish to achieve the impossible and wed it.' Lam, like Picasso, took the primitive vision as inspiration, but at the same time, to the extent that he was a sophisticated artist, remained outside it.

Both Lam and Roberto Matta Echaurren had early left their native countries for Paris, and became associated with Surrealism there just before the Second World War. Whereas Lam subsequently returned and sought to root his identity as a painter in the Cubo-African culture, Matta has consistently refused to be identified in any sense as a 'Latin American' painter. Indeed it was with a horror of the unresolvable problem of identity that he left Chile as a very young man. A series of brilliant oil paintings done during the years of his first association with the Surrealists explore visual metaphors for the mental landscape, hinting at different surfaces and levels of reality, and at the same time resorting in new ways to the surrealist practice of automatism [Pls 10.39, 40]. Matta is also one of the few surrealist artists to confront political themes directly, though always on his own terms and with no concession to 'predatory ideologies' or to social realism, in the lithographs Per Il Chile (For Chile), for instance, or the wonderful satirical paintings of Eisenhower and the Cold War.

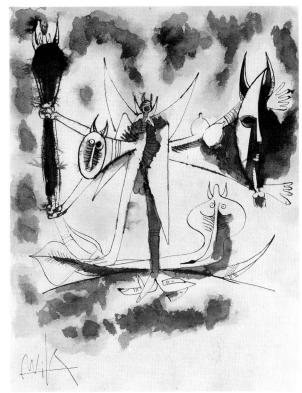

10.38 Wifredo Lam, *Untitled*, 1946, pen and ink, ink wash and traces of pencil on paper, 31.4×24.1cm., The Museum of Modern Art, New York; The Joan and Lester Avnet Collection.

10.37 (facing page) Wifredo Lam, *The Idol*, 1944, oil on canvas, 158×127 cm., Colección Villanueva, Caracas.

10.39 Roberto Matta Echaurren, *Joan of Arc*, 1942, crayon and pencil on paper, 59.1×73.9 cm., The Museum of Modern Art, New York; The James Thrall Soby Bequest.

10.40 Roberto Matta Echaurren, *Condors and Carrion*, 1941, crayon and pencil on paper, 58.4×73.7cm., The Museum of Modern Art, New York; Inter-American Fund.

10.41 Roberto Matta Echaurren, *Invasion of the Night*, 1941, oil on canvas, 96.5×152.7 cm., San Francisco Museum of Modern Art; Bequest of Jacqueline Onslow Ford.

10.42 Leonora Carrington, *The House Opposite, c.* 1947, oil on pastel, 33×83 cm., Tragopan Corporation Limited (The Edward James Collection), by permission of the Trustees of the Edward James Foundation.

10.43 Tilsa Tsuchiya *Myth of Dreams*, 1976, oil on canvas, 69×104 cm., Collection Francisco Moreyra G.S.

10.44 Leonora Carrington, *Who art thou, White face*?, 1959, oil on canvas, 70×100 cm., Private Collection.

In Latin America, surrealist activities were pursued both by local groups and by refugees from Europe, such as Paalen, Alice Rahon, Péret, Remedios Varo and Leonora Carrington, many of whom at different times settled in Mexico [Pls 10.42,44,45]. In 1942 Paalen founded the review Dyn, which was both a focus for and critical of Surrealism. It contained an exhilarating mixture of art, poetry, philosophy and ethnography, in the best tradition of the Surrealist reviews, and produced a special Amer-Indian number (December 1943) with contributions from leading Mexican specialists like Alfonso Caso and Miguel Covarrubias. In the same period the important review Cuadernos Americanos was founded, which had special sections devoted to Americanist research and to modern art. In 1944 Cuadernos Americanos published Juan Larrea's study 'El Surrealismo entre viejo y nuevo mundo' (Surrealism between the Old World and the New). Relating his argument to the much-debated issue of identity Larrea maintained that in the New World Surrealism's dream would be realized in the form of a 'universal poetic Realism'.

Surrealist periodicals and books had been fairly widely disseminated since the late Twenties, and the ideas of the group were taken up in various ways by both writers and artists – though in the case of the latter, on the level of individual interests rather than commitment to the movement as a whole. It has been in literature and poetry that Surrealism's influence has been most far-reaching. In Chile the review *Mandrágora* was founded in 1938 by three poets, Braulio Arenas, Enrique Gómez-Correa and Jorge Cáceres. ¹⁷

Mandrágora ran for seven issues, though its public life continued until *c.* 1952, and included a Surrealist exhibition in 1948, and a long-running feud with the poet Pablo Neruda. ¹⁸ Vicente Huidobro, who had many contacts among the avant-garde and the Surrealists in France and Spain, ¹⁹ contributed to *Mandrágora*, although the editors distinguished clearly between themselves and Huido-

10.46 Graciela Aranis-Brignoni, *Like the Sand in my Veins, Like the Black in my Mouth*, 1934, photocollage, 23.7×16.8 cm., Schweizerische Stiftung für die Photographie.

10.45 (facing page) Remedios Varo, *Useless Science* or *The Alchemist*, 1958, oil on masonite, 142×52 cm., Private Collection.

10.47 Huillca (Antonio Huillca Huallpa), *Corpus Christi*, 1982, oil, 104×142 cm., Collection Luis Rivera Davalos.

10.48 Batlle Planas, *The Message*, Museo Nacional de Bellas Artes, Buenos Aires.

bro, who in their view remained a rationalist/modernist. They brought out a single issue of a *Boletín Surrealiste*, and also maintained contact with the surrealist César Moro in Peru, and with Aldo Pellegrini in Argentina; the latter published the Surrealist-oriented review *Qué* in 1926, and was especially active as an anthologizer and disseminator of surrealist writings.

The Argentinian painter Roberto Aizenberg's relationship with Surrealism is particularly interesting, and follows a very individual path. He was partly influenced by the ideas of his teacher Batlle Planas, who was familiar with surrealist concepts of automatism [Pl. 10.48]. ²⁰ For Aizenberg, automatism became a way of 'evading the interference of local considerations'; ²¹ – a kind of 'ideal abstraction' of the self, as Breton once described it, but not necessarily involving any Freudian dimension of exploring the unconscious. Both Picasso and de Chirico were important for Aizenberg, while some of his images of tiny figures in a deep landscape recall Dalí. The recurring theme of the tower, while clearly linked to de Chirico, and to sexual symbolism, is also symbolic of culture and tradi-

tion – a tower of Babel, for instance, or the tower with a brick base and its head in the clouds [Pls 10.49, 51, 52]. Aizenberg's work tends towards order rather than disorder, and holds a delicate balance between an almost geometrical abstraction and symbolism. The freedom from the conventional divisions and categories which operate in European modernism, characteristic of Aizenberg's work, has produced some of the continent's richest art.

10.49 Roberto Aizenberg, *Figures or Persons in a Landscape*, 1953, oil on canvas mounted on board, 31×24cm., Collection Felisa and Mario H. Gradowczyk, Buenos Aires.

10.51 Roberto Aizenberg, *Tower*, October 1950, oil on canvas, 40×30 cm., Collection Roberto Aizenberg.

10.52 Roberto Aizenberg, *Tower*, 1978, oil on canvas, 93×57 cm., Collection Matilde Herrera.

10.50 Angel Acosta León, *The Colander*, 1961, oil on masonite, 123×94.5 cm., Museo Nacional, Palacio de Bellas Artes, Havana.

11

Arte Madí/Arte Concreto-Invención

One of the most active and inventive periods in the history of non-figurative or 'concrete' art in Latin America began with the publication of the review *Arturo* in Buenos Aires in the summer of 1944. Although it only ran to one issue, it brought together the artists and poets who were shortly to form the movement 'MADI' (or 'Madi') and the 'Arte Concreto-Invención Asociación'. *Arturo* described itself as a 'review of abstract arts', and was edited by Arden Quin, Rhod Rothfuss, Gyula Kosice and the Argentinian poet Edgard Bayley. It included reproductions of works by Tomás Maldonado, Rhod Rothfuss, Vieira da Silva, Augusto Torres, Lidy Prati Maldonado, Torres-García, Kandinsky and Mondrian. *Arturo*'s editorial announcement, 'Afirmaciones' (see Appendix, 11.1) announced its commitment to abstract art, 'pure imagery, free from determinism or justification', and attacked, in rather eccentric terms, Surrealism.

Torres-García, then living in Montevideo, contributed a text to *Arturo*, 'concerning a future literary creation', and a poem. He was an important source of encouragement and inspiration for the younger artists, both in Uruguay and Buenos Aires: he welcomed them to his studio, showed them reproductions of the work of the European avant-garde, and urged them to develop their personal voice; his weekly lectures on the radio were widely listened to. In the same year, the Taller Torres-García made an important series of murals for the Hospital of Saint Bois, later tragically destroyed by fire. His text in *Arturo*, as relevant to visual as to literary creation, proposed in general terms a move to structure which could easily be interpreted as a move to abstraction:

Now we are less interested in the thing than in the structure where it is situated. The house, the sun, the tree we can see now live there in another way: like stones in a wall. We are more interested in the wall we have built, in the construction, than in the things and events we were pursuing. And so we realize that what belongs to us and originality both are on that construction's side. It is no longer the things but the rhythm where they are now that is the essentiality of poetic creation.²

Although different currents are present in the visual material in *Arturo*, with two extremes represented by Maldonado on the one hand and Rothfuss on the other, all share a basic commitment to non-figuration. Maldonado's cover [Pl. 11.2] has the appearance of an aggressive automatic drawing, a violent swirl of lines with just visible Torres-García-like signs. The vignette on the title-page was

11.1 Detail of Pl.11.12.

11.2 Cover of Arturo, 1944

ARTE MADÍ/ARTE CONCRETO-INVENCIÓN

also by Maldonado, but this time strongly recalls the biomorphic abstraction of Hans Arp's woodcuts and reliefs. Rothfuss' highly original text 'The Frame: A Problem of Contemporary Art' (see Appendix 11.2), on the other hand, locates itself more within a cubist/constructivist tradition. Rothfuss, who taught drawing in Montevideo, and had become aware of Cubism and Picasso through Pettoruti, had, it seems, held an exhibition in 1942 of cubist paintings with irregular edges, which Arden Quin baptized 'cubisme decoupé'.³

In 'The Frame', Rothfuss presented, in rather elliptical terms, an argument for the abolition of the conventional rectangular frame, which he associated with a naturalist tradition of the picture as window. Rothfuss outlines a progression from Cézanne through Cubism, to Constructivism, in which the move to abstraction is identified with the search for greater reality:

Cubism was succinctly defined by Guillaume Apollinaire in 'Le Temps' of 14 October 1914, when he referred to the 'geometric aspect of those paintings where the artist wanted to restore, with a great purity, the essence of reality'. And it was that desire to [express] the reality of things which made painting more and more abstract, passing through Futurism and culminating most recently in Cubism, Non-Objectivism, Neo-Plasticism, and also in its most abstract form, Constructivism. And now, just when the artist seems to be furthest from nature, Vicente Huidobro has said: 'Man has never been closer to nature than the present, when he no longer tries to imitate it superficially but, like nature itself, imitates it in the depths of its constructivist laws, in the realization of a whole. . . .'.

Although Rothfuss might not have known Gleizes' and Metzinger's *Cubism*, which stated that a painting 'carries within itself its *raison d'être*', ⁴ he reached a similar conclusion, but with more radical results, by arguing that geometrical forms like circles, ellipses or polygons, put in an oblong frame, 'dominate the composition', and by implication, by remaining discrete elements, are in conflict with the base shape of the picture, preventing it from becoming a whole: 'A painting with a regular frame suggests a continuity of theme, which disappears only when the frame is rigorously structured according to the painting's composition. That means the edge of the canvas plays an active role in the work of art. A role it must always have. A painting should begin and end with itself. Without continuity.'

Rothfuss' ideas were shared by the artists who formed the 'Arte-Concreto Invención' movement the following year, 1945, and in the photographs of the two exhibitions held that year in private houses – they found it impossible to get exhibition space in the galleries, and, it is said, resorted to hanging their work in the street – the walls are covered with irregularly shaped canvases, whose edges are determined by the lines of the composition. A torrent of invention had been let loose: in some works the frame itself became

11.3 Gyula Kosice, 'Royi' Articulated Sculpture, 1944, wood, Private Collection, Buenos Aires.

the composition, while the idea of movement was introduced in a variety of ways. Wall-pieces in wood and metal had movable parts, and free-standing constructions could be taken to pieces and reassembled, or shifted into different configurations, as in Kosice's *Royi* [Pl. 11.3].

The first exhibition took place at Dr Pichon Rivière's house on 8 October, and the invitation stated: 'Concrete-elementary Theory, resolutions, music, painting, sculpture and poems. Ramón Melgar, Juan C. Paz, Rhod Rothfuss, Estéban Eitler, Gyula Kosice, Valdo Wellington and Arden Quin.'

The second exhibition, again with the title 'Arte concreto invención', was in the photographer Grete Stern's house on 2 December, and included music and 'elementarist dances'. Although they appear in the photograph, Raúl Lozza and Alfredo Hlito did not exhibit. Following disagreements among the artists, Maldonado, who had not participated in this exhibition, formed the 'Asociación Arte concreto-invención', which Alfredo Hlito, Manuel Espinosa, Enio Iommi, Claudio Girola, Raúl and Rembrandt van Dyck Lozza, Oscar Nuñez and Jorge Souza also joined. This group held its first exhibition at the Peuser exhibition room in March 1946, and the same year brought out two issues of a bulletin.

The original group, including Kosice, Rothfuss, Quin, Martin Blaszko, Diyi Laañ and Eitler, now took the name 'Madí', to distinguish itself clearly from Maldonado's 'Arte concreto-invención'. The origins of this term are as much in dispute as those of 'Dada'. The 'Madí Manifesto' (Appendix, 11.3) says that the term 'Concrete' was dropped because it still retained the static elements of the old art; this might suggest that the name evolved from 'Movimiento de Arte de Invención'. Others have held that the letters MA/DI stand for MArxisme or MAtérialisme DIalectique, or that

11.4 Diyi Laañ, *Painted Frame*, 1946, enamel on wood, 72×40 cm., Collection G. Kosice.

the name is basically a nonsense vocable, like Dada. Three exhibitions were held during 1946; the first, which launched the movement, took place at the French Institute in August. The third exhibition, in November 1946 at the Bohemian Club in Buenos Aires, was advertised in the following terms: 'Madí has invented the trimmed and irregular frame, breaking for ever with the taboo of the pictorial "Frame"; it invented painting and sculpture with movement, articulated universal and linear; it created Plural and Ludic Plastic art.'

Obviously, the two groups initially had a great deal in common; to begin with, both had taken the term 'Arte Concreto', which clearly signalled their adherence to the broad alliance of non-figurative artists within the European avant-garde who rejected the term 'abstract', because it implied abstracting *from* a given reality in the way Cubism, say, did, and adopted instead the term 'concrete'. The first full public use of the term had been in the title of the review *Art Concret* founded by Theo van Doesburg in 1930. The manifesto on its front page declared:

- 1. Art is universal.
- 2. The work of art must be entirely conceived and formed by the mind before its execution. It must receive nothing from nature's given forms, or from sensuality, or sentimentality.

We wish to exclude lyricism, dramaticism, symbolism, etc.

3. The picture must be constructed from purely plastic elements, that is, planes and colours. A pictorial element has no other meaning than 'itself' and thus the picture has no other meaning than 'itself'...⁸

Although this group was short-lived, Max Bill and Hans Arp later picked up the term. In 1936 Bill wrote, 'We call concrete art the works of art created according to a technique and laws entirely their own. . . without intervention of any process of abstraction. Concrete art. . . is an expression of the human spirit'. And in March 1944 Max Bill organized the exhibition Konkrete Kunst at the Kunsthalle in Basel; the catalogue contained a version of Arp's vivid account of the practice of the concrete artist, who aims for a 'direct' as opposed to 'illusionistic' art: 'We don't want to copy nature. We don't want to reproduce, we want to produce. We want to produce like a plant that produces a fruit, and not to reproduce. We want to produce directly and not by way of any intermediary. Since this art doesn't have the slightest trace of abstraction, we name it: concrete art.'10 Arp goes on to mention not only Kandinsky and Delaunay, but also Duchamp, Man Ray and Miró (among others), and the resistance to orthodox divisions among the modernist tendencies (Abstraction/Surrealism) demonstrated by Arp was echoed in the Madí group's free manipulation of sources.

Arturo had proclaimed: 'INVENT: to find or discover through ingenious thinking or mediation or mere chance something new or unknown./ To find out, imagine, create his work the poet or the

11.5 Juan N. Mele, *Cut Out Frame 11*, 1946, oil on wood, 71×46 cm., Collection of the Artist.

11.6 Photograph of Realités Nouvelles installation, Paris, 1948.

11.8 Juan Bay, Shaped Painting Madí, 1947, enamel on hardboard, 78×57 cm., Collection G. Kosice.

11.7 Diyi Laañ, Articulated Madí Painting, 1946, enamel on wood, 72×40 cm., Collection G. Kosice.

artist/... INVENTION AGAINST AUTOMATISM'. Both Madí and the Arte Concreto-Invención Associaión laid stress on invention: Kosice published a pamphlet entitled *Invención*, in 1945, and Raúl Lozza gave a lecture in 1946 at the third exhibition of the Arte concreto-invención group on 'The inventive as concrete reality in art', while the 'Inventionist Manifesto' was published in the first issue of the Association's bulletin (August 1946, see Appendix, 11.4)

The two groups also shared the aim of incorporating music and poetry, but Madí went further in this direction, and, as the Madí Manifesto signed by Kosice indicates, extended its ideas also to theatre, dance and architecture.

The Madí group also began to emphasize the movement and articulation of its constructions, dropping, as we saw, the term 'concrete', and explored numerous ways of undermining or subverting the conventional, static easel painting or sculpture. Its combination of aggression and playfulness recalls Dada, and especially the little magazines of the early Twenties in which Dadaist and Constructivist artists mingled side by side: Arp, Moholy-Nagy, Schwitters, El Lissitsky, Picabia, Richter, and so on. In this respect, it is worth noting that the relations between Dada and Constructivism were not simply those of polarized opposites. For instance, Arp, one of the leading Zurich Dadaists, and van Doesburg, theoretician of Neo-Plasticism, collaborated in the late Twenties, and van Doesburg, first propagator of 'concrete art', literally incarnated the apparently opposed spirits of Dada and Constructivism: not only did he edit the international Constructivist review De Stijl, but also, under his Dada persona 'I. K. Bonset', the neo-dada review Mécano (1922-3), and wrote dada poetry. While there were, of course, profound differences between many of these artists in terms of their attitudes to nature, technology, man and the machine, their work often looked, in reproduction in the magazines, quite similar. They shared a radical rejection of past art, the refusal of representation and the abandonment of the figure, the search for new forms and experiments with new materials, the blurring of traditional distinctions between painting and sculpture.

With complete freedom, the Madí artists used a broad spectrum of avant-garde European art – Dada, Russian constructivism, Mondrian, and so on – as a springboard for invention. Variations on the shaped and irregular canvas, and on the frame as structure in its own right, continued. Arden Quin made a series of canvases which he called *Cosmopolis*, not only with shaped edges, but sometimes also a curved surface, as well as articulated wall-constructions [Pls 11.9–11].

The introduction of movement led to a proliferation of formal inventions. Kosice, in whose work the impulse to de-materialize the static or solid – introducing space, light, water, movement – has been most pronounced, made sculptures out of neon lights, probably the first artist to do so[Pl. 11.12]. Biedma, Laañ, Kosice and Arden Quin, among others, made sculpture with movable parts, which variously call to mind the transformable toys of Torres-

11.9 and 10 (above) Arden Quin, Coplanal (two positions), lacquer on wood, 60×60 cm., Collection of the Artist.

11.11 (top right) Arden Quin, *Niory*, 1948, oil on board, 90×65 cm., Collection of the Artist.

11.12 Gyula Kosice, *Madí Aluminium Structure No. 3*, 1946, neon gas, light, 56×41×18 cm., Collection of the Artist.

García, Russian Constructivism, Futurism and Arp's dada objects – the early wood reliefs like *Eggboard*, or *Clock*, in which the idea of movement is humorously but not literally present [Pl. 11.13, 14]. ¹² But it would be a mistake to imply any great dependency or derivation, for the Madí works remain unique and quite original. The articulation of the idea of play with structural inventiveness is one of the most striking characteristics of these artists' work.

Sandú Darié, a Romanian artist settled in Cuba, made increasingly complicated versions of his 'Pintura transformable Madí', strips of painted wood nailed together which could be formed into an almost infinite variety of configurations. Darié had exhibited in New York and at the Venice Biennale, and was invited by Kosice to send work to the Madí group in Buenos Aires, though he never went there himself. The American critic Clement Greenberg recognized the spirit of invention in Darié's work, but sought to draw it into a more orthodox modernist project: writing to Darié in 1950, he said, '. . . the reproductions in the catalogue struck me by the originality they evidenced. Not as realizations, but as promises, the

11.13 Hans Arp, *Clock*, painted wood relief, 65×58, 1924, Fondation Arp, Clamart.

11.14 Joaquín Torres-García, Two Men, 1920, painted wood, 11 pieces, Estate of the Artist, New York.

ARTE MADÍ/ARTE CONCRETO-INVENCIÓN

beginning of something in the form of bas-relief constructions that will be a real expansion of the medium. . .'13

In Cuba, Darié has continued to invent: chairs that fold up and can become pictures on the wall; moving and kinetic sculptures, using the simplest forms of light and energy, a 'primitive technology', he says, as a form of challenge to the industrialized consumer world.¹⁴

A sense of play was central to the Madí group's inventiveness. The presence of the ludic, and the capacity for movement led to a kind of continuing irresolution, a permanent sense of possibilities. The Arte concreto-invención artists pursued a more rigorously formal direction, initially with a strong affinity to Mondrian, and later moving close to Max Bill and Vantongerloo.

Maldonado met Max Bill in 1948 on a visit to Europe, and subsequently was invited by Bill to teach with him at Ulm. ¹⁵ Maldonado had explained in 1946 the evolution of the ideas of the Arte concreto-invención group, from the point of adopting the cut-out frame, and the shaped canvas:

We noticed then that the 'cut-out frame or picture', as we had called it, gave the frame a spatial quality; we could not remain indifferent to the fact that we were, in this way, opening the gates and that space penetrated into the picture and participated as a more aesthetically belligerent element. At the same time, we repeated Nicholson's and Domela's experiences: we materialized figures, we turned them into forms (Maldonado, Prati, Raúl Lozza, Antonio Caraduje). But at this point we found ourselves looking for a tri-dimensional solution to the bi-dimensional problem: we were repeating the same mistake. . .and we made a stop. . . . We resumed in depth the study of the problem concerning the 'cut-out frame or picture'. We started by giving more importance to the penetrating space than to the picture itself (Molenberg, Raúl Lozza, Nuñez).

The destruction of the picture plane as a still potentially illusionistic space, led to a new problem. As Hlito wrote in a later essay:

The walls to which those paintings were fixed immediately assumed the optical function that the canvas had fulfilled before, so that the background reappeared again. These objects participated both in painting and sculpture, but without coming to have a coherence of their own. This experience, which some of us gave up because we considered it unsatisfactory, at least served to prove that the requirement for a plane could not be taken beyond certain limits without placing painting in a blind alley.¹⁷

ARTE MADÍ/ARTE CONCRETO-INVENCIÓN

In 1947 Raúl Lozza had separated from the Arte Concreto-Invención Asociación and formed a new movement, 'Perceptism'; he sought a solution to the problem of the dispersed planes and the wall by placing his dynamically shaped coloured planes on a background large enough to form a 'field', but in a sense he now returned the problem back to the fixed picture surface.

11.15 Enio Iommi, Construction, 1946, aluminium, bronze and wood, $40\times40\times56$ cm., Collection of the Artist.

12

A Radical Leap

by Guy Brett

When describing the concrete-optical-kinetic art movements of the 1950s and 1960s it is tempting to use an analogy with science, not only because most of the artists were interested in and knowledgeable about science, the relation of science to philosophy, and often expressed themselves (verbally) in scientific phraseology, but because these did seem to be genuinely international movements. Radical innovations were made in different parts of the globe; travel, exchange, seemed to take place relatively independently of the commercial/bureaucratic/institutional culture-machine of the Western powers; there was a common feeling of working at the forefront of modernity.

Without completely abandoning the scientific analogy (as a corrective to localization, folklorization, and therefore subordination of Latin American art¹), I would like to delve deeper into the works considered in this chapter, both as 'international' (a radical leap in the practice and theory of art) and as 'Latin American' (i.e., not the same as European or North American art). To do this soon reveals tensions and complex relationships which upset many of the categories and labels which have been handed down to us.

To begin with – the comings and goings of the artists themselves. Mira Schendel was born in Zurich, grew up in Italy and went to São Paulo as an adult. Lucio Fontana was born in Rosario de Santa Fe, Argentina, spent significant periods there or in Buenos Aires but most of his life in Italy. Alejandro Otero, Jesús Rafael Soto, Carlos Cruz-Diez, Sergio Camargo and Lygia Clark have all spent important periods of their life in Paris, and Hélio Oiticica in London and New York. Lygia Pape, however, has rarely left Brazil. Mathias Goeritz arrived in Mexico in 1949 from Germany and Spain, and has at times faced a certain Mexican xenophobia.

Secondly, any grouping of artists which merely follows the labels and -isms provided by art history misses what was really innovatory in this period. Abstract art, constructivism, concrete, neo-concrete, informal art, kinetic, optical, process art: the artists grouped here touch all of these movements at certain points without entirely belonging to any of them, because in a sense all these labels describe the search for something which was 'in the air' but could not at the time be named – a *new space*. The feeling that this new space represented something volatile and dynamic, a turning-point and not a system or doctrine, is confirmed by the fact that these artists, whose work was quite closely related in the '50s and '60s, later moved in directions so different that these divergencies

12.2 Jornal do Brasil – Suplemento Dominical, 24 August 1958, illustrating the sculptor Amilcar de Castro's design for the cover of a book of concrete poetry by Ferreira Gullar

12.1 (facing page) Detail of Pl. 12.52.

12.3 Lygia Clark, 1958, Rio de Janeiro.

12.4 Alexander Calder's ceiling of 'acoustic clouds' for the Aula Magna auditorium, Central University of Venezuela, Caracas, designed by the architect Carlos Raúl Villanueva, 1952.

12.5 Carlos Raúl Villanueva, 1948. Photo by Alfredo Boulton.

themselves raise profound questions about the development of art. This discussion concentrates on that historical moment of relationship and only hints at the artists' later development.

A third complexity is these Latin American artists' relationship to the metropolitan art centres, especially to Paris. This can't be described as one of provincial imitation of the latest fashion, since the artists they sought out were not fashionable in the Europe of the 1950s. Otero and Soto made special trips to Holland to see Mondrian's work. 'At that time [1950] no one in France was talking about Mondrian, still less might one see any of his work', Otero said.² Camargo visited Brancusi. Many Latin Americans called on Vantongerloo - then working on his prism-objects, wire 'nucleuses' and 'atomic' drawings - at a time when Vantongerloo was completely ignored in France and was living in Paris in poverty. (Fontana, being somewhat older, had conducted his own highly individual dialogue with Futurism and abstract art in the Italy of the 1930s, before making his first theoretical approaches to Spazialismo in Buenos Aires in the mid '40s.) In other words, these young artists took from Europe what corresponded to their own needs.

And not only by going to Europe themselves. Le Corbusier made lecture tours in Argentina, Uruguay and Brazil in 1929 and 1936 (he arrived the second time by zeppelin!). Joseph Albers, Max Bill and Alexander Calder were invited to Brazil in the 1950s. The second São Paulo Bienal (1953) was one of the most comprehensive exhibitions of modern Western art ever mounted (a room of 51 Picassos, including *Guernica*, a room of Klee, of de Stijl and Mon-

drian, a room of Italian Futurists, Constructivism, Americans such as Calder and de Kooning, and so on). During the late '50s the Rio newspaper *Jornal do Brasil* published a Sunday supplement which surveyed the whole modern movement from Cézanne to Pollock and from Mallarmé to the Beats. Its pages were often designed by artists. In Venezuela, the architect Carlos Raúl Villanueva invited artists like Léger, Arp, Laurens, Calder and Vasarely to design work for the new University City of Caracas (1948–57), alongside young and then unknown Venezuelans like Otero and Soto [Pls. 12.4–7]. By dint of his friendship with artists, Villanueva built up one of the finest collections of experimental art in the world, a collection which subtly combined the geometric with the surreal strands in abstraction (e.g., Wifredo Lam and Calder with Moholy-Nagy and Vantongerloo).

These interchanges bear on a fourth complexity: that of locating this work within a Latin American history and a Latin American space. The term 'Latin American' is itself obviously a gigantic simplification in the face of such obvious differences of nation, class, cultural tradition, and of levels of wealth and poverty. Nevertheless, many writers and speakers have proposed in one form or another a Latin American 'subject' faced by overwhelming contradictions: between experiences on the one hand of the immensity and richness of nature (itself a source of wonder and of fear), and on the other hand of its waste and destruction by corrupt administrations (in league with foreign interests, which have been continuously engaged in robbing the continent for more than 400 years), a 'subject' caught in a cycle between economic booms and busts, between civilian and military rule, between socialist experiments and right-wing tyrannies ('Devastating experiences', as a Chilean writer has put it, 'where the greatest hope is mixed with the greatest terror'3).

It was in a moment of such high optimism, and of desire for the modern, that the concrete and kinetic movements were born. While Europe was immersed in the war and its aftermath some Latin American economies were booming (partly from supplying war materials). In Argentina, Perón had shaken the rule of the landowning aristocracy (though without seriously weakening their power) and released the energy of the growing numbers of industrial workers. Brazil and Venezuela were urbanizing intensively, and the modern architecture movement flourished with the demand for many public works. Soto has described the immense aspiration of the Latin Americans to take on and surpass modern art. ⁴ They had an almost explosive eagerness both to enjoy the new freedoms of form and to ask the fundamental questions which arose from the discoveries of the pre-war avant-garde. It seemed natural to couch their work in universal, almost cosmological, terms. Geometry provided a synthesizing key, rather in the manner of Mondrian's 'plus-minus' (Lygia Pape's recasting of the creation myth as a concrete/kinetic book [Book of Creation, 1959] is a characteristic expression of this). But lying behind such universalizing

12.6 Alejandro Otero on the staircase of the Engineering School, Central University of Venezuela, 1956; in the background: polychrome walls by Otero.

A RADICAL LEAP

12.7 J. R. Soto with Spiral, Paris 1955.

advanced research questions of the time (often, defining what those questions were). They inherited the language of geometric abstraction (exemplified by Mondrian), which marked the most complete break with traditional representation, and they inherited Dada (exemplified by Duchamp and his ready-mades), which gave the freedom to posit any object as a 'sign', and which engaged the institutions of the art world in continual critical questioning.⁵ In a sense a common starting-point for all their work was the adoption and then the interrogation of geometry and its rationale of order (geometry here means not simply 'lines and squares' on the picture's surface, but the surface itself as a two-dimensional plane creating a fictive space isolated from the surrounding 'real' space). So a fertile tension arises between a geometric order, with its values of lucidity and modernity, and an invitation to chaos, disorder, flux, organicity, the random, the void - which begins to create a new kind of space. Artists of Latin American origin were not of course the only ones involved in this search, but they played a very significant part in it. It was an international dialogue of different origins, experiences and aspirations.⁶

abstractions there are two legacies in some way irreducibly connected with Latin American history; a sense of the vastness of nature and the precariousness of human existence, which are here welcomed as the springboard of new perceptions, and a social and political consciousness, related at this period, in the tradition of constructivism, to the environment, to architecture and to the participation of the spectator, but interpreted in profoundly different

To go back again to the scientific analogy, we can see a number of Latin American artists in the '50s and '60s working with the most

Lucio Fontana

Much of Lucio Fontana's work playfully 'makes light' of the categories of painting and sculpture, showing up the protocols which separate, and therefore limit them. For example, Spatial Concept [Pl 12.9] the metal sheet erupting with two holes: is it simultaneously a painting and a sculpture? between painting and sculpture? or neither painting nor sculpture? The ceramic objects made at the same time as the early Spatial Concepts are substantial volumes made up of what might be tumultuous brushwork. Fontana's works have an unmistakable feeling of a cosmic energy brought about by his poetic collision between 'matter' and the traditional formats and supports of art; the surface as matter, space as matter, colour as matter - and matter as energy. Already in the 1930s, Fontana had made a witty series of sculptures in which the geometric lines and plane take on a plant-like look. Throughout the White Manifesto (Appendix, 12.1), written in Argentina in 1946, which was Fontana's first announcement of Spazialismo, there are references to the need for 'an art springing from materialism (not from ideas) which in a sense generates itself in accordance with natural forces'. Premonitions of 'action painting', of the Yves Klein void,

12.8 Lucio Fontana, *Spatial Concept* (C 52 P 7), 1952, mixed media on canvas, 49×64 cm., Fondazione Lucio Fontana, Milan.

12.9 Lucio Fontana, Spatial Concept (50 B 9), 1950, iron, 74.5×64 cm., Fondazione Lucio Fontana, Milan.

12.10 Alejandro Otero, *Coloured Lines on White Ground*, 1950, oil on canvas, 130×89 cm., Collection Oscar Ascanio.

12.11 Alejandro Otero, *Coloured Lines on White Ground*, 1950, oil on canvas, 130×97 cm., Collection Alfredo Boulton.

12.12 (facing page left) Alejandro Otero, *Colourhythm 28*, 1957, ducotone on wood, 200×44 cm., Colección Sawas.

12.13 (facing page centre) Alejandro Otero, *Colourhythm* 39, 1959, ducotone on wood, 200×53 cm., Collection Maruja Delfino.

12.14 (facing page right) Alejandro Otero, *Colourhythm 40*, 1959, ducotone on wood, 200.4×58.7cm., Fundación Anala y Armando Planchart.

and of the coming diversity of 'kinetic' proposals can all be felt in Fontana's formulations: 'The "representation of known forms" is out of date . . . The aesthetics of organic motion substitute for the aesthetic weakness of congealed forms . . . We are taking the very energy of matter and its need to exist and develop' (*Manifesto Blanco*, 1946). 7

Alejandro Otero

The outstanding Venezuelan art of this period is certainly closer to painting than sculpture (however defined), and makes its leap towards a new space out of a tradition of great optical refinement (traceable in Venezuelan art from colonial painting, through Reverón, to the present). In the late '40s, Alejandro Otero had already aroused violent controversy in Venezuela with his *Coffeepots* (painted in Paris), in which he worked through the influence of Picasso. But at the moment he broke with Picasso and became aware of Mondrian's work, he produced a series of canvases which Soto and others still acknowledge as of great importance: the *Coloured Lines* [Pls 12.10,11]. 'A few gently slanting lines of colour floating on a white surface'; the description belies the drama in-

12.15 Jesús Rafael Soto, *Spiral with Red*, 1955, plexiglass, wood and enamel, 53×53×26.4cm., Colección Villanueva, Caracas.

12.16 Jesús Rafael Soto, White Points on Black Points, 1954, plexiglass, wood and enamel, 100×100 cm., Colección Villanueva, Caracas.

12.17 Jesús Rafael Soto, Kinetic Structure of Geometric Elements, 1955, wood, paint and plexiglass, 74.5×74.5× 30.8 cm., Colección Villanueva, Caracas.

12.18 Jesús Rafael Soto, *Silver Light*, 1956, wood and plaka, 100×100×34 cm., Colección Villanueva, Caracas.

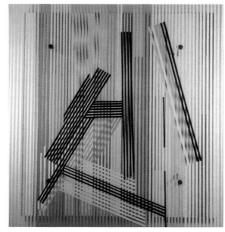

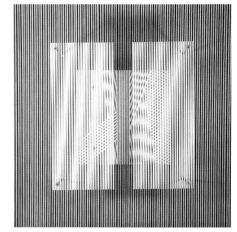

volved, a drama of orientation: 'Putting that red line there was like walking to Patagonia it's a space where there is practically no top, no bottom, no right, no left, certainly no horizon line. . . '8 These 'slightly inclined lines' are also the armature of Otero's *Colourhythms* [Pls 12.12-14] (1955-60), one of the most remarkable serial works (75 panels in all) in abstract art. Painted with the industrial technique of airbrush and duco, their dynamism is due to their emphasis on 'rhythm' rather than 'form', produced by a sustained ambiguity between figure and ground. Our perceptual habits themselves are disturbed, or set in motion, but without the behavioural rigidity of much later 'optical' art. As the series develops (unplanned and improvisationally, according to Otero) it is not hard to see a transposition of tropical light and shadow, of colour and vegetation in the geometric elements.

Jesús Soto

The audacity and freshness of Jesús Soto's early works is undoubtedly partly due to an application of the conceptual freedom of the Duchampian ready-made to purely pictorial problems (Soto produced his first *Superimpositions* after seeing Duchamp's motorized spiral [*Rotary Demi-Sphere*, 1925] at the *Mouvement* show at the Denise René Gallery, Paris, in 1955.) Soto had already reduced his means to elements of no compositional interest (dots, rectangles, etc.), and the device of superimposition enabled him to create a space *between* the elements, fluid, unstable, both 'pictorial' and 'physical' at the same time. When he hung a metal rod in front of a lined screen, the optical interference of these two elements released

12.19 Jesús Rafael Soto, First Vibration, 1957, hardboard and metal, 50×50cm., Collection of the Artist.

12.20 Jesús Rafael Soto, *Five Large Rods*, 1964, wood and metal, 173×92×16cm., Fundación Museo de Arte Moderno 'Jesús Soto', Ciudad Bolívar.

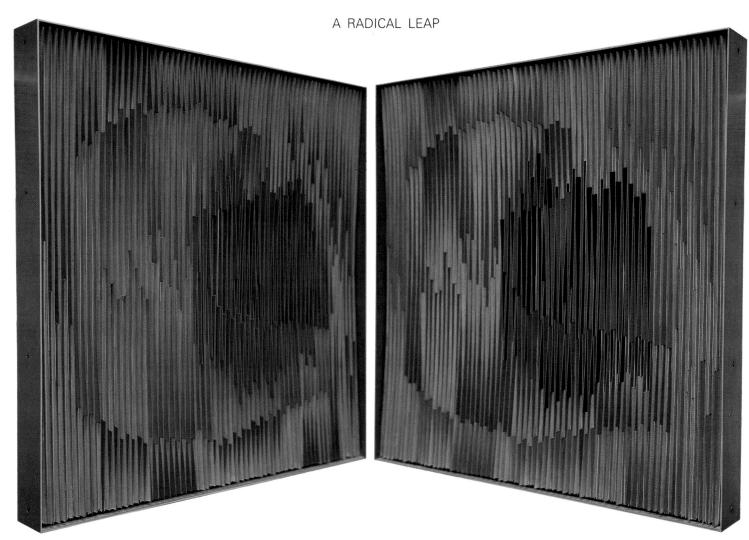

12.21,22 Carlos Cruz-Diez, *Physichromy No. 48*, Paris 1961, (two views), wood, cardboard and acrylic, 60×60 cm., Collection of the Artist.
12.23 Carlos Cruz-Diez, *Physichromy No. 6*, Caracas

12.23 Carlos Cruz-Diez, *Physichromy No. 6*, Caracas 1960, wood, cardboard and acrylic, 50×50 cm., Collection of the Artist.

a third – the vibration – which is real though it has no material existence. The rod is not exactly *dissolved* into vibrations, for then it would be absorbed into another medium and would disappear altogether. The vibrations take the shape of the solid rod, tracing its movement in pulses. But the situation is so finely balanced it could equally be that the solid rod is the trace of the energy pulses, which 'really' constitute the rod, and everything else we see as solid, stable objects in the world. Early Sotos are ironic objects: 'constructions' which are impossibly impractical and fragile as part of the everyday world but which, hung on a wall as paintings, become an expression of freedom and play. They are metaphors of age-old problems: the relation of real and illusory, of chaos and order: at the same time they suggest a new equilibrium beyond a static geometric order.

CARLOS CRUZ-DIEZ

Somewhat later a third Venezuelan, Carlos Cruz-Diez, embarked on series of perceptual experiments. His *Physichromies* [Pls 12.21-24] were specifically concerned with colour. The strips, vanes and louvres of colour, some opaque, some transparent, at right-angles to the surface, constitute a device whereby colours mix and interfere with one another, not by juxtaposition or layering, but in the

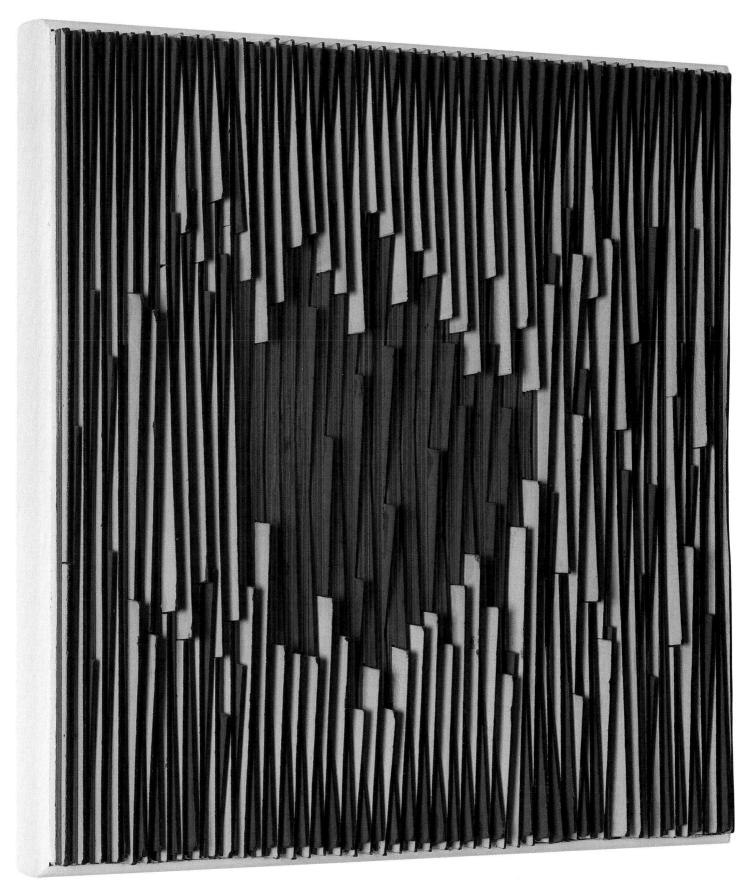

12.24 Carlos Cruz-Diez, *Physichromy No. 42*, 1961, hardboard and cardboard, 31×31 cm., Collection Jesús Rafael Soto.

12.25 Lygia Clark, *Linear Egg*, 1958, nitro-cellulose paint on wood, 33cm (diam.), Collection David Medalla, London

12.26 Lygia Clark, *Relief painting with Yellow Square*, 1957, 75×75 cm., Collection Jean Boghici.

A RADICAL LEAP

spectator's vision. This mixing depends on variable factors such as the angle of the light or of the spectator's eye, etc. Again the effect is to create an ambiguous space, a 'climate' of colour.

Lygia Clark

If Venezuelan art of this period makes its innovations by 'specializing' in the visual sense, the work of some Brazilians (especially the artists of Rio de Janeiro) does almost the opposite: de-emphasizes the visual sense in favour of the ensemble of senses, in fact of the whole body, conceived in terms of its 'plenitude'. It would be interesting to trace in more detail than is possible here the tensions and perturbations introduced into the geometric order as the work of these artists develops. Lygia Clark, Hélio Oiticica and Lygia Pape were all members of the Neo-Concrete group (1959) which broke away from the more strictly Bauhausian Brazilian constructivism, which followed the principles of the Swiss-German Max Bill, to reintroduce the 'subjective' and 'organic' dimensions (though still within strict non-representationality, as a guarantee of absolute modernity). But one has the feeling that this was where they had of necessity to begin. Lygia Clark's early paintings (e.g. Unities, Linear Egg [Pl. 12.25]) are simultaneously the most rigorous statements of the exclusion of representational devices from the picture surface, and of opening up this space to the world 'outside the frame'. The next phase of her geometric work - the Cocoons - explicitly suggests by its interior space (as well as by its title) some organicity, dormant life, discoverable within rational geometry. 'I began with geometry, but I was always looking for an organic space where one could enter the painting', 9 a desire which now she realized by opening up this abstract language to the direct participation of the spectator in her Bichos (Animals), 1960 [Pls 12.27,29]:

The Bicho has his own and well-defined cluster of movements which react to the promptings of the spectator. He is not made of isolated static forms which can be manipulated at random, as in a game: no, his parts are functionally related to each other, as if he were a living organism; and the movements of these parts are interlinked. ¹⁰

Lygia Clark produced *Bichos* of many different shapes and sizes, as well as the slightly later *Trepantes* (Climbing Grubs) [Pl. 12.28] and *Borrachas* (Rubber Grubs, 1964) [Pls 12.30-2] which are nonrigid, non-precious, and for which any part of the environment, any support, is as good as any other. But while appreciating the marvellous range of sensibility within the geometric schema, we can see that this is only a transitional, provisional phase. From Lygia Clark's extraordinary later development and body experiments, culminating in her *Therapy*, whose implications are only gradually becoming known and understood (and which cannot be properly experienced in a conventional exhibition setting), we know that the important thing is the dialogue, the object as 'relational'. The early geometry, like the later airbags, elastic bands and stones, are only vehicles by means of which the 'spectators' can let their own poetics flower.

12.27 Lygia Clark, *Machine Animal (Bicho)*, 1962, aluminium, 55×65 cm., Collection Fulvia and Adolpho Leirner, São Paulo.

12.28 Lygia Clark, *Trepante 3*, 1965, inox and wood, 33×50cm., Collection Fulvia and Adolpho Leirner, São Paulo.

12.29 Lygia Clark, *Bicho 'The Inside is Outside'*, 1964, stainless steel, 38×44×55 cm., Collection Sonia Lins.

12.30 Lygia Clark, *Rubber Grub*, 1964 (remade by artist 1986), rubber, $142\times43\,\mathrm{cm}$., Museu de Arte Moderna do Rio de Janeiro; donated by the artist.

12.31 Lygia Clark, *Rubber Grub*, 1964 (remade by artist 1986), rubber, 110×50.2 cm., Museu de Arte Moderna do Rio de Janeiro; donated by the artist.

12.32 Lygia Clark, *Rubber Grub*, 1964 (remade by artist 1986), rubber, 144×44cm., Museu de Arte Moderna do Rio de Janeiro; donated by the artist.

12.33 Hélio Oiticica, White Crossing Red – Metaschema, 1958, oil on canvas, 51×60 cm., Collection Fulvia and Adolpho Leirner, São Paulo.

12.34 Hélio Oiticica, *Box Bolide 9*, 1964, painted wood, painted glass, pigment, 50×34×50.5 cm., Projeto Hélio Oiticica, Rio de Janeiro.

12.35 Hélio Oiticica, *Spatial Relief (Red), c.* 1960, painted wood, 62.7×148.5×8.5 cm., Projeto Hélio Oiticica, Rio de Janeiro.

12.36 Hélio Oiticica, *Nucleus 1, c.* 1960, painted wood, mirror, 1: 52×37×37 cm.; 2: 52×60×35.3 cm.; 3: 52×36.5×37 cm.; 4: 52×51.5×36.3 cm.; 5: 52×36.5×36.5 cm.; mirror 110×110 cm., Projeto Hélio Oiticica, Rio de Janeiro.

12.37 Hélio Oiticica, *Spatial Relief (Yellow)*, c. 1960, painted wood, 98×121×20 cm., Projeto Hélio Oiticica, Rio de Janeiro.

HÉLIO OITICICA

Hélio Oiticica began like Lygia Clark with the surface and geometry. In his *Metaschemas* (1959) the forms animate the surface and edges of the canvas. But his planes soon became the agents of an environmental art: at first reliefs suspended in space (1959-60) and then a series of 'Nucleic Penetrables' (1960), which one could enter and be surrounded in an ambience of colour of an intense hedonistic beauty. Colour began to change here from a purely optical to a bodily sensation, by means of the demarcation of the space surrounding one by painted geometric planes. Next, Oiticica presented colour in quite a different form. His *Bólides* (Fireballs, Nuclei or Flaming Meteors) [Pls 12.34,38,39] are objects which contain colour as a mass (of pigment, earth, dust, liquid, cloth) and isolate it

from the global field as a kind of energy centre to which the psyche and body of the spectator immediately feels attracted, 'like a fire', as Oiticica once described it. *Bólides* later became for Oiticica a generic class of containers: a box, bag, bottle, basin, can, cabin, sack, nest, bed, and so on – full of a substance or waiting to be entered by the spectator. They are a way of focusing perceptions and desires across a whole range of phenomena, both natural and cultural, both communal and personal (for example in his participatory *Parangolé* (Capes), his *Eden*, a 'mind-settlement', set up for the first and only time and London's Whitechapel Gallery in 1969, and his later installations).

LYGIA PAPE

Lygia Pape's *Book of Creation* [Pls 12.41-51] is one of the expressions most characteristic of Brazil's Neo-Concrete movement. A recasting of the creation story and early human discoveries in lucid geometric metaphors, it is also a set of manipulable models for the viewer to exercise his/her own creativity. A kind of sub-text linking abstraction with the body, and *vivências* (or 'lived thought') – with what the poet Haroldo de Campos has called, 'this special character, this Brazilian communication, so characteristic, this *marca tropicalista*' – is beautifully brought out in Mauricio Cirné's and Lygia Pape's photos of pages of the Book deposited around Rio: on the beach, on car-bonnets, on a rounded rock as bodies dive

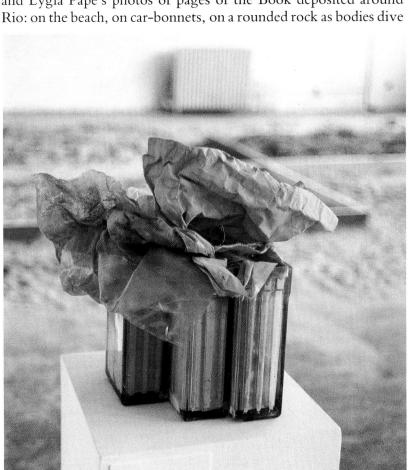

12.38 Hélio Oiticica, *Box Bolide*, 1964, painted wood, glass, 52×44×55.3 cm., Projeto Hélio Oiticica, Rio de Janeiro.

12.39 Hélio Oiticica, *Glass Bolide 3*, 1964, glass, plastic, canvas, pigment, 46×28×23 cm., Projeto Hélio Oiticica, Rio de Janeiro.

12.40 Mosquito of Mangueira wearing Oiticica's Cape 6 (Parangolé 10), 1965, and dancing with Glass Bolide 5 ('Hommage to Mondrian'), 1964.

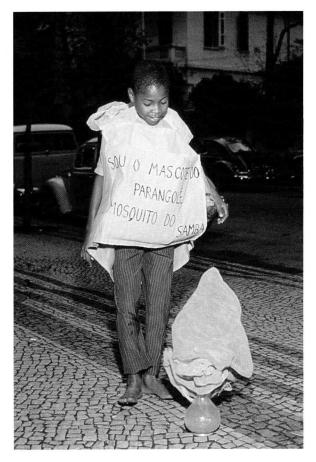

12.41 light

Lygia Pape, pages from the *Book of Creation*, 1959, painted card, 30×30×15 cm., Collection of the Artist.

12.42 discovery of fire

into the sea. . . . Like Lygia Clark and Hélio Oiticica, Pape took participation further. In 1968, for example, she invited people to put their heads through holes cut in an enormous $(98' \times 98')$ white sheet $(O\ Divisor)$ [Pl. 12.68], which separated heads from bodies, and whose mathematical order was once again displaced by people's movements and speech within this ocean of cotton.

Sergio Camargo

The process suggested here, of a sort of derangement of European constructivism by Latin American artists (though not as an end in itself: constructivism was adopted as a starting-point for their own concerns) – this process could hardly be more lucidly and succinctly expressed than in Sergio Camargo's work. On the one hand so linked to the constructivist tradition – in its use of system, of simple, uniform volumetric elements, of the white monochrome, and so on – on the other hand taking precisely that logic of the system to a point of imponderability, of the unknown and the perturbing, of what the critic Ronaldo Brito calls 'the madness of order' Camargo's work is in perpetual tension between these two experiences. In his long series of reliefs and sculptures he goes back again and again to the same constructive paradigm – a cylinder or

12.43 in the beginning all was water – then the water receded

12.45 receded

12.46 humans

12.47 began

12.48 to measure time

12.49 man was nomad and hunter – in the forest.

12.50 man is gregarious and sows the soil

12.52 Sergio Camargo, Large Relief No. 3/39/69, 1964, wood, 200×100cm., Collection Anna Mathilde Penteado Millan, São Paulo.

12.53 Sergio Camargo, Large Relief No. 5/39/104, 1966, wood, 200×100 cm., Collection of the Artist.

12.54 Sergio Camargo, *Large Split Relief No. 34/4/74*, 1964-5, wood, 212×92 cm., The Trustees of the Tate Gallery, London.

12.55 Mira Schendel, *Drawing*, 1964, ink on Japanese paper, 50.5×26.5 cm., Collection Guy Brett, London.

cube and the ways it may be cut and combined – and the more he explores it, the more he articulates all its possibilities, the more he undermines its status as a paradigm, as 'law', making us question the sort of stability and finality we invest in paradigms. The most subtle thing, perhaps, is that Camargo does not investigate this paradox in an ideal conceptual realm but in *light*, in the changing light of the everyday world with its incalculable complexity of nuance [Pls 12.52–54].

MIRA SCHENDEL

Mira Schendel produced a remarkable series of graphic works during the 1960s whose existence is practically unknown outside Brazil. Done by a method of transferring marks and scratches made on an inked glass to extremely thin and fragile Japanese paper, they astonished, then, by their bareness: 'I would say the line, often, just stimulates the void. I doubt whether stimulate is right. Something like that. At any rate what matters is the void, actively the void. . . . The void is not the vicarious symbol of non-being.' ¹³

In some ways analogous to Fontana's 'hole', the blank paper in Mira Schendel's work is the scene of disorientation, of indeterminacy – and of freedom: of possibility rather than necessity. The line

12.56 Mira Schendel, *Drawing*, 1964, ink on Japanese paper, 50.5×26.5 cm., Collection Guy Brett, London.

12.57 Mira Schendel, *Droguinhas* ("little scraps, nothings"), 1964-5, knotted Japanese paper, left 28 cm, right (detail): 90×90 cm (approx), Collection Guy Brett, London.

acts upon this void in different ways: as a boundary, as an energizing coil, or by littering or herding across it a 'cosmic dust of words. 14 The acceptance of the blank/void sheet of paper brings to mind the Zen-inspired principles of Chinese painting, which imply, as Bertolt Brecht noted, that the artist 'has gladly renounced the idea of completely dominating the spectator, whose illusion can never be total'. 15 In 1964 Schendel extended this idea with wonderful irony into the domain of 'sculpture'. Her *Droguinhas* (Nothings) [Pl. 12.57] are actually made from rolled up and knotted sheets of the same Japanese paper. With their nucleic structure they have an aura of intense energy while remaining soft, fragile, ephemeral 'little nothings' in comparison to heroic monumental sculpture. These 'sculptures', which can be displayed in any way one chooses, are a proposition from the 1960s which remains extremely fresh, interweaving notions of energy, matter and language by hinting at the etymology common to tissue, textile and text.

Mathias Goeritz

In Mexico the situation was rather different from Brazil, Venezuela and Argentina, since Mexico had experienced a revolution whose forces had become institutionalized. This revolution had been given its image by the unique enterprise of the mural movement, and therefore the national and official status of this art made the introduction of abstraction, for example, very difficult in Mexico. Mathias Goeritz came from Germany with new ideas, organizational energy and a polemical personality. He found himself resented – by Diego Rivera and David Alfaro Siqueiros, among others: '. . . A faker without the slightest talent or preparation for being an artist, which he professes to be', they wrote (in a joint open letter to the president of Mexico's National University). ¹⁶ Goeritz's is certainly a strange and unruly body of work: ranging from ex-

12.59 Mathias Goeritz, *Plastic Poem*, 1953, concrete poem in wrought iron at entrance to museum.

Mathias Goeritz, *El Eco*, experimental museum, Mexico City, 1953. Goeritz was given complete freedom by his client, Daniel Mont, to design and run the building.

12.60 Mathias Goeritz, maquette for The Serpent, 1953.

pressionism to geometric abstraction, from religious art to a protominimalism, from architecture to contrete poetry. He pioneered the introduction of visual education in Mexico and is highly regarded as a teacher, as well as founding galleries, museums and artists' groups. Goeritz created in Mexico in the '50s and '60s architecture-sculptures of an awesome gigantism which anticipated some of the work of the later North American minimalists, as well as presaging artists' 'installations'. The Museum of the Echo (Mexico City, inaugurated 1953) [Pls 12.59-62] was a synthesis of his work as artist, architect, teacher, catalyst and writer. Passing the non-figurative Plastic Poem at the entrance, you entered a series of 'neo-concrete' spaces (asymetrical and with virtually no rightangles) to arrive at a walled courtyard filled with a single sculpture. The huge Serpent was itself a conjunction of modernist 'drawing in space' with pre-Colombian pyramid and serpent forms. It was intended too as a set for the performance of the Walter Nicks dance group, with choreography by Luis Buñuel, which Goeritz organized, among other experimental events, during the Museum's short life. In this early challenge to the institutional

12.61 Mathias Goeritz, facade of *El Eco*, 1953. The tower, in the artist's words, 'was painted yellow to be incorporated – like a sunbeam – into the whole, which was painted only in grey and white'.

12.62 Mathias Goeritz, *The Serpent*, 1953, steel sculpture in the courtyard of *El Eco*.

cristal

cristal

fome

cristal

cristal

fome de forma

cristal

cristal

forma de fome

cristal

cristal

forma

12.63 Haroldo de Campos, 1958. Cristal = crystal, fome = hunger, forma = form, de = of. 'An essay in cystallography. The metaphorical hunger of form and form as a kind of hunger. Crystal as the ideogram of the process'.

12.64 Signals, Newsbulletin of Signals, London, edited by David Medalla. May-July 1965: special issue on Lygia Clark.

12.65 (facing page) Mathias Goeritz, *The Five Towers*, 1957-8, concrete, Satellite City, Mexico City.

museum, one art form was echoed in another, and the past echoed in the present.

* * *

We have been describing here a phenomenon of the avant-garde, with its complex relationships between 'universal' research questions and regional histories and cultures, between 'international' communications/rapports and 'local' circles (both of which, as at all the most creative periods of experiment, have brought painters, sculptors, musicians, poets, scientists, philosophers, architects, film-makers, together). The work of these Latin American artists has much in common with that of certain artists living in Europe (which is only a way of putting it, since with their travels and changes of domicile they often had direct contact); with, for example, Yves Klein's and Piero Manzoni's concepts of the void and of a 'living art', with the meta-machines of Jean Tinguely, provocative and liberating, or with David Medalla, whose Bubble Machines (1964-), inspired by the movement of clouds, are a daring statement of the same 'new space' and order/disorder paradox. Medalla also, with Paul Keeler at Signals London (1964-66), gave the first major European retrospective exhibitions to Camargo, Lygia Clark, Otero, Soto and Cruz-Diez [Pl. 12.64].

Within Brazil, for example, the radical leap in the visual arts was closely paralleled in literature by the Concrete Poetry movement (in fact, a dividing line can hardly be drawn between them). The Neo-Concrete Manifesto (Appendix, 12.3) was written by a poet, Ferreira Gullar, while in São Paulo the Noigandres Group (Haroldo de Campos, Augusto de Campos and Décio Pignatari) have formed what amounts to a multi-disciplinary movement in itself. Their poetic production, which broke with traditional syntax and structure by applying to alphabetic language the technique of the ideogram ('poetic crystallography' as Haroldo de Campos called it at the time) was interwoven with a prodigious work of literary theory, of translation (especially by Haroldo de Campos), and of cross-fertilization with the other arts, with music and visual arts in Augusto de Campos' case, and with architecture/design in Décio Pignatari's work. The Brazilian concrete poets often secrete in their spare ideograms a harsh social comment [Pl. 12.63].

The relationship with architecture among these artists is much more striking than it is among artists in Europe and North America in the same period [Pls 12.65-7]. The permutations and inflections of this relationship are suggestive and fascinating. For example, Fontana, whose spatial language is so clearly related to the gestural (in his case, to the dynamism of the baroque gesture) has been continually interested in environmental space. In the early '50s he collaborated several times with architects on designs which, revealingly, gravitated towards the ceiling: punctured ceilings, ceilings with indirect lighting, neon arabesques hanging in space, and so on. Mathias Goeritz has collaborated with several of Mexico's leading architects; in fact it was they who defended him against the attacks

12.66 Lucio Fontana, ceiling for the cinema of the Breda pavillion at the 31st Milan Fair, 1953.

12.67 Carlos Cruz-Diez, painting in the turbine inspection area of the new hydroelectric complex at Guri, Venezuela, 1987.

of the muralists and the press. The uniquely close collaboration between Villanueva and his artist friends in University City, Caracas, is well known (Otero's colour-grading of the outside surfaces of the Architecture Faculty vies with Calder's ceiling in the Aula Magna as the most imaginative artist/architect collaboration in the University). For his part, Sergio Camargo has designed several beautiful sculpture walls for buildings in Brazil.

'Architecture' enters in quite another sense into the work of Lygia Clark and Hélio Oiticica. Into their early geometric work quite overtly – Oiticica designed an imaginary domestic-poetic architecture with close connections to Gaston Bachelard's ideas of the 'poetics of space', and Clark's *Bichos*, matchbox constructions, and *Abrigos Poéticos* (Poetic Shelters), can be read in terms of architectural ideas. Later, the *Beds, Tents, Cabins* and *Nests* of Oiticica's environmental experiments [Pl. 12.70], his 'mind-settlements' (partly influenced by Amazonian Indian *tabas* – communal houses, campuses and village settlements) invoke architecture as part of a proposal for new ways of living, new ways of behaviour: 'To in-

habit is to communicate' was one of his slogans. Later too, Lygia Clark experimented with the notion that people would make architectural spaces out of their own bodies – using elastic bands, plastic and gestures of arms and legs [Pl. 12.69]. This was part of her 'return' of certain basic human cultural forms to the living body, to its most intimate sensations and memories. She called this series of works L'Homme, Support vivant d'une architecture biologique et cellulaire

In fact the relationship of art with the 'social', which the link with architecture implies among other things, could hardly have taken more different courses as these artists moved away from the common area they had shared in the '50s and '60s. In Venezuela, after the collaboration with Villanueva which was carried out, according to his socialist-humanist principles, very much in the public sector, the commissions for Soto, Otero and Cruz-Diez increased dramatically in both the public and the private sectors: art works for plazas,

12.68 Lygia Pape, *O Divisor*, 98×98 foot cloth cut with head holes for the participation of the public, Rio de Janeiro, 1968.

12.69 Lygia Clark, *Mandala*, 1969. Part of her series *L'homme support vivant d'une architecture biologique et cellulaire* (also know as *Collective Body*). People are linked together in a web of elastic bands attached to their wrists or ankles. The movement of one affects all the others.

bridges, theatres, corporate headquarters, hydro-electric projects, hotel lobbies. This can be explained by several factors: the revenue from Venezuela's oil, the presence of active patrons like Alfredo Boulton and Hans Neumann in the upper reaches of Venezuelan economic and political power, an identification of these artists' 'abstract' work with national pride. It is hard to think of any European country which has given commissions to artists on the scale of Venezuela. Otero's *Solar Tower* and Cruz-Diez's turbine paintings at the new Guri Dam must be among the most ambitious applications of art to an industrial installation seen anywhere in recent times. But was something sacrificed in the process? Did the artists accept a social role which compromised their original discoveries, making the insubstantial substantial, the disturbing sign of a possible freedom into the decorative harmonization of a disjointed environment?¹⁷

In Brazil, two different kinds of trajectory can be seen, which may be described in terms of a distinction between 'closed' and 'open' work. The 'closed' work is represented by Camargo and Schendel: artists, in other words, who accept the prevailing view of the artist as the creator of autonomous objects for the spectator to contemplate, within the given institutional venues - the gallery and museum - but who, within those limits, continue to make discoveries and to challenge and disturb with their artistic languages. With the practitioners of 'open' work, like Clark, Oiticica and Pape, it is exactly those limits which are questioned. 'Participation' had clearly been intended to change the received myth of the artist as the sole creator, by bringing forward ideas which have no life or meaning without the spectators' active intervention. These artists felt sympathetic and close to the youth revolt and counter-cultural movement of the later '60s and early '70s, a very widespread expression of desire, which Oiticica at the time perceptively summed up as 'the re-taking of confidence by the individual in his/her intuitions and most precious ambitions'. ¹⁸ In this search for a new definition of the 'public' (both in terms of 'people' and of 'site') Clark moved inward, towards the most intimate interior world, and Oiticica outward, towards the external world. Does such work need to turn everyone into artists to escape the eventual absorption into the commercial, museum, and academic context which it violently rejects? Between these different courses the viewer/reader will draw his or her own conclusions. These questions of the relationship of art to society cannot be answered by artists alone.

12.70 Hélio Oiticica, *Babylonests*, installed at the exhibition *Information*, Museum of Modern Art, New York, 1970. Oiticica realized several versions of his 'Nests', or 'non-repressive leisure place', a cellular structure to be inhabited and transformed by the public.

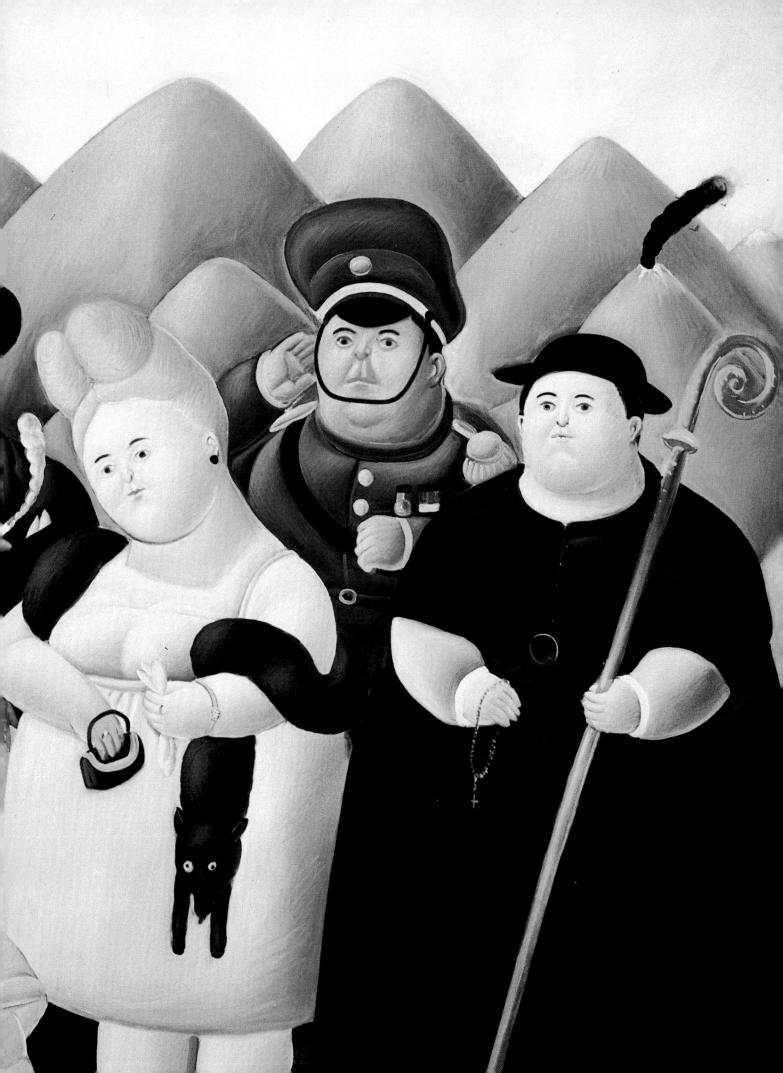

13

History and Identity

Torres-García once reversed the map of South America so that the South Pole was at the top, and the Equator at the bottom. 'Our north', he said, 'is the south.' Thus with the map upside down, 'we have a true idea of our position, not how the rest of the world would like it' [Pl. 13.2]. This effectively signalled the will to an independent identity, a reorientation graphically rupturing the traditional dependence on the geographical north. Torres-García's ironic geography proposed a new cultural myth. The construction of a new cultural identity, which some artists have seen more as a recuperation of an ancient one, remains in Latin America a pressing issue, subject for debate and dispute and spur to experiment.

In his review of the first Latin American Biennial, in Havana in 1984, which brought together 2,200 works by 835 Latin American artists, Luis Camnitzer wrote, 'It may well be that the established means in art will prove unsuited for the building of a new culture. Perhaps the mere act of taking a paintbrush in one's hand - no matter how one uses it – condemns one to producing colonial art.'2 Behind this apparently outrageous charge are several serious points. Firstly, painting has been so dominated by 'the North' that artists elsewhere feel necessarily controlled by both its styles and its institutions. The nagging fear of provincialism may haunt any artist remote from the metropolitan centres who lacks both community and audience in his or her own country. Secondly, oil painting on canvas had been introduced to America by the European colonizers, and until Independence was almost exclusively in the service of colonial ideologies. Thirdly, native and popular arts in Latin America had traditionally used other mediums, and this has offered a great range of resources to artists concerned with establishing a new language for art, which often in Latin America involves a challenge to the boundaries between high and popular art. With many Latin American artists, in fact, there has been a rejection of the traditional medium of oil painting parallel to the position taken by Dada and Constructivist artists at the time of the First World War. But in Latin America this rejection, and the choice of the material process of artistic production, bear a much greater weight of cultural significance and orientation.

Collage and assemblage, the always potentially subversive incorporation of real objects and materials, have been used to expose the structural relationship between 'Third World' poverty and 'First World' technology. What Antonio Berni calls the 'mirage of technology' is presented as the juxtaposition of two worlds in *Juanito Laguna and the Astronauts*. 'Any attempt,' Berni wrote, 'on the

13.1 Detail of Pl.13.11.

13.2 Joaquín Torres-García, *The North is the South*. Estate of the Artist, New York.

ESCUELA DEL SUR

PUBLICACION DEL TALLER

TORRES - GARCIA

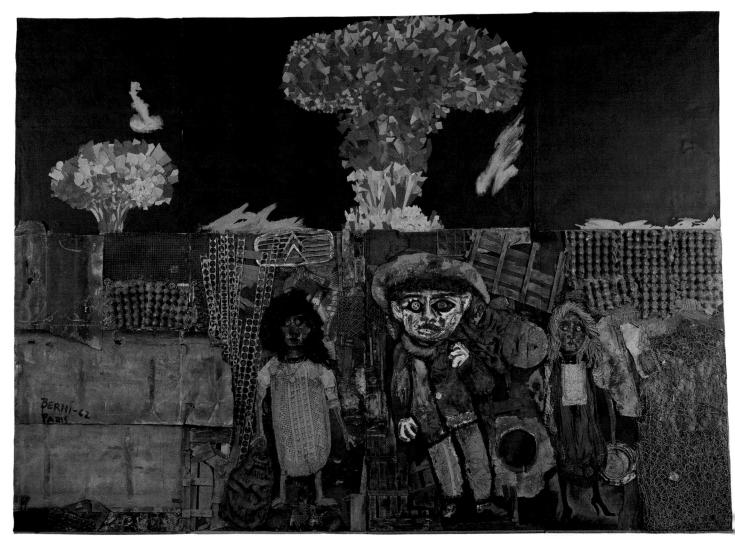

13.3 Antonio Berni, *The World Promised to Juanito Laguna*, 1962, collage on corrugated cardboard, 300×400 cm., Galería de Arte Ruth Benzacar.

13.4,5 Wifredo Díaz Valdéz, Wheel (two views), 1984, wood, 43×140×66cm. open, Museo Nacional de Artes Plásticas, Montevideo.

part of developing countries . . . to construct an independent science and industry is impeded and obstructed by the inexorable exploitation by powerful countries of poor countries. This is the phenomenon before us: the greater the technology of the first, the greater the exploitation, poverty and backwardness of the second.'³

Berni developed a deliberate poverty of means as a way of engaging more closely with what had already been his subject since his return to Argentina from Europe in 1934: the lives of the disposessed and the migrant workers. The World Promised to Juanito Laguna [Pl. 13.3] was one of the earliest in a cycle of collages which takes as protagonist a boy who is the archetype of the dispossesed, of those who live on the margins of all great cities, but at extremes of poverty and misery in the shanty towns of South America. Berni usually located Juanito in Buenos Aires or Rio de Janeiro. He described his sudden recognition of the literal potential of the use of discarded materials: 'One cold, cloudy night, while passing through the miserable city of Juanito a radical change in my vision of reality and its interpretation occurred . . . I had just discovered, in the unpaved streets and the waste ground, scattered, abandoned materials which composed the authentic surroundings of Juanito Laguna - old wood, empty bottles, iron, cardboard boxes, metal sheets, etc., which were the elements used for the construction of shacks in misery city. '4 The material conveys multiple associations, though; what is junk and discardable packaging for the rich is shelter and the habitual surroundings of the poor, but it is also capable of transformation, for Juanito constructs toys and kites out of the rubbish, just as Berni himself constructs his art. A second cycle of collages similarly takes a named character as opposed to an anonymous victim - a prostitute called Ramona. Her world is quite different from Juanito's, and the materials Berni uses - cheap and bright fabrics and tinsel - reflect its instability and ephemerality.

The distinction between 'readymade', found and natural objects in the meticulously crafted wooden constructions by Wifredo Díaz Valdéz is not so much blurred as deliberately tested, as part of his challenge to technology. Taking, it might be, a wheel, a rolling pin, or simply a log, Díaz Valdéz carves/dissects them, so that, while remaining in one piece, their identity evaporates. The logs that are treated in this way, with usually an axe or a saw left embedded in them, contain a literal reference to the continuing destruction of the Brazilian rain forest. The deconstructed wheel also contains within itself a reference to the ancient refusal of the pre-Columbian civilizations to develop, technologically, the wheel. [Pls. 13.4,5]

To return to the point Camnitzer raised about the 'compromised' character of painting: some artists have made of this negative condition a positive virtue. There is, for instance, a defiant relish in the way the Mexican artist Alberto Gironella paints his paraphrases of Velázquez, El Greco or Goya, reminiscent of the way his friend Luis Buñuel treated the imagery of Catholicism in his films. In accepting the fact that he belongs to a mestizo culture ('my painting is mestizo: that's the problem. Pure Mexican doesn't exist, it's a

13.6 GTO (Geraldo Teles de Oliveira), *Totem*, 1968, wood, 185×95×36 cm., Collection Jacques van de Beuque, Rio de Janeiro.

13.7 GTO (Geraldo Teles de Oliveira), *Roda Viva*, 1968, wood, 108×85×42 cm., Collection Jacques van de Beuque, Rio de Janeiro.

HISTORY AND IDENTITY

13.8 Alberto Gironella, *The Black Queen*, 1961, mixed media on canvas, Private Collection.

mixture of all races, of all indigenous ethnic groups with Spaniards who in their turn arrived jumbled up . . . '5'), Gironella confronts colonialism and its legacy. Octavio Paz, using Michel Leiris' phrase 'painting considered as a bullfight', suggests that Gironella fights his seventeenth-century sources. 'His critique is indistinguishable from devotion and devotion from vengeful fury. The treatment he inflicts on works like *Queen Mariana*, *Las Meninas*, *The Burial of Count Orgaz* or Valdés Leal's *Vanitas* goes beyond critique: it is a kind of liturgy of torture.'6

Herein, perhaps, lies the difference between Gironella's paraphrases of Velázquez and those of the many European painters who have recently paraphrased or quoted old masters – above all, that conundrum *Las Meninas*. Gironella partially adopts and exaggerates the manner of painting of the originals: 'within contemporary structures, the brush-stroke somewhat brutal, arrogant in the jargon of the seventeenth or eighteenth century. They abound in the late works of Velázquez, Goya, El Greco'. Gironella, like his fellow Mexican Carlos Fuentes, was fascinated by the dark and hidden history and legend of the Spanish court – the necrophilia of Carlos II, bewitched by his mother Mariana for instance. Fuentes' novel *Terra Nostra* similarly re-makes Spanish history and weaves it into themes of Apocolypse and Utopia. *The Black Queen* [Pl. 13.8] is one of many versions by Gironella of Velázquez' *Queen Mariana* [Pl. 13.9], some of which reduce her to a bestial spectre.

Sometimes Gironella combines his periphrases of the broad, gestural style with real objects. These 'peinture-objets' of the '60s can be seen in the context of the surrealist object, and were shown at the eleventh International Surrealist Exhibition, L'Écart absolu, in Paris in 1965. However, his incorporated ready-made materials usually take their meaning from Spain, as in the Reina de los Jugos, with its literal reference to the 'colonial yoke'. 'I incorporate extra-artistic objects, or ones that appear so, but they are within the spirit and iconographic tradition of Spain'. His frequent incorporation of objects like bottle tops, labels and sardine tins, even, recently, of sausages, refers to the bodegón, or cheap eating house. In the following passage Gironella links his use of alimentary leftovers to Spain, playing on the double sense of the word escatológico (scatological or eschatological):

Spanish painting has neither the grandiloquence of Italian art nor the serene intimacy of Dutch art. On the contrary it is made of . . . women who smell of sweat and garlic, Dulcinea. On the other hand, there is a whole *escatológico* side, well expressed by Bartolomé Murillo when he said to Valdés Leal: 'to look at your pictures one has to hold one's nose'. This painting worlds after death is, in a way, the product of the disillusionment of the conquest and plunder. It is a manner of sublimation, many Spaniards begin to doubt their discoveries and all they got from them. I repeat, with my own forms I recuperate those meanings. . . . ⁸

Gironella, and the Mexican artist José Luis Cuevas were members of a loose group that gathered during 1952-3 in a spirit of rebellion against the muralists' dominance through official political art – a resistence assisted by an artist from a different – constructivist – background, Mathias Goeritz (see Chapter 12). The relish and arrogance in Gironella's handling of paint also relate to the Neo-Figurative movement that began in 1961 in Argentina, which included the artists Deira, de la Vega, Noe, and Macció and to the expressionist painting of Jacobo Borges. Like Gironella, Borges has also 'reworked' other artists' work – notably David's *Coronation of Napoleon*, but more often uses the setting of a spectacle to treat the violence and degradation of the human [Pl. 13.10].

The attitude to colonialism in the generation of artists that succeeded the muralists has often involved an ambivalence. A growing tendency to resist the Mexican muralists' didacticism and openly tendentious art has led to a more ambiguous treatment of history and of myth – which none the less remains on several levels and in several forms a central theme – and to the frequent use of quotation from and paraphrase of European art.

Fernando Botero frequently refers to Spanish Golden Age painting, but has also re-worked French neo-classical artists like David, in this way bringing into play not only the style associated with the ideals of the Enlightenment and thus of Independence, but also the imported academic manner which effectively imposed a new colonialism in art. These 'models' combined with naïve traditions of colonial portraiture to form the smooth but overblown manner in which he treats the figures in his paintings.

The sense of a society heir to traditions belonging to another world, too remote in time and space any longer to have a clear identity, a legacy of colonialism, is shared by Botero and his fellow Colombian García Márquez, in for example the novel *One Hundred*

13.9 Diego Velázquez, Mariana of Austria, 1652, oil on canvas, Museo del Prado, Madrid.

13.10 Jacobo Borges, Everyone to the Revels (from the Song to Death), 1962, oil on canvas, 160.5×205 cm., Galería de Arte Nacional, Caracas.

13.11 Fernando Botero, *The Presidential Family*, 1967, oil on canvas, 203.5×196.2cm., The Museum of Modern Art, New York; Gift of Warren D. Benedek, 1967.

13.12 Fernando Botero, *Our Lady of Fatima*, 1963, oil on canvas, 182×177 cm., Museo de Arte Moderno de Bogotá.

13.13 Juan Camilo Uribe, Declaration of Love to Venezuela, 1976, collage, 80×80 cm., Museo de Arte Moderno de Bogotá.

Years of Solitude. A more extreme example is that of Vargas Llosa's The War of the End of the World, in which an ideal community is set up in the far backlands of Brazil in the late nineteenth century, by a band of thieves, murderers and holy men and women; led by the 'Counsellor', they maintain their loyalty to a long-dead king in resistance to the Republic. This fantastic story was in fact true; photographs exist of the dead counsellor, slain after government troops finally stormed the rebel town.

The 'magic realism' of García Márquez's novels, representative both of the omen-filled world of remote villages and a metaphor for an incredible reality, has echoes in such works by Botero as the levitating priest. The miracles that inspire cults are also a subject for him: the Our Lady of Fatima [Pl. 13.12] - in the same broad early painterly style as his Mona Lisa, a comparable cult of the art world, perhaps - is the vision which appeared to three shepherdesses at Fatima in Portugal, now a pilgrimage centre. Using the very different medium of collage, the Colombian J. C. Uribe refers, in Declaration of Love to Venezuela [Pl. 13.13], to two popular cults that constitute a contemporary mythology in parts of South America: the Christ of the Sacred Heart, in whose name the President rededicates the cathedral in Bogotá every year, and José Gregorio Hernández, a Venezuelan doctor who lived early in the century, who is now the object of a strong popular cult and in whose name miraculous cures are still performed. The cheap coloured lithographs of the Christ are so arranged that they form the shape not only of a heart, but also of lips. The obvious irony of the pop treatment by Uribe, which goes straight back to Dada, is common in much of Latin America, and can be highly provocative in the more devout countries.

Botero's work reveals a particular fascination with 'types' representing on the one hand the Church, on the other the army and government officials [Pl. 13.11]: the last two united in the figure of the dictator – the one myth, García Márquez once remarked, that Latin America has given the world.

The treatment of history and myth is also a central concern of José Gamarra, who works with a full consciousness of the fact that painting itself comes from Europe. He began to paint the American landscape only after moving to Paris, and it functions for him as a sign—the only way, he commented, of marking South America unmistakably as his subject was to paint it as jungle, which is how most foreigners think of Latin America. The deep tropical rain forest acts as a setting for historical, mythological or legendary figures and revolutionary heroes like the Nicaraguan Sandino, and sometimes for narrative fragments from a recent or more distant past. In *Five Centuries Later* [Pl. 13.15] there are four figures, glimpsed at one side of a dramatically forked forest scene: two are Europeans, dressed in the style of the sixteenth century, with two Indians as load bearers, one just visible through a wedge between trees. The title argues that the invasion continues, that the original

13.14 Leon Ferrari, *Re-reading of the Bible*, 1986–7 (detail), 14 collages/photomontages on cardboard, 2 panels, each 105×75 cm. with 7 collages each, Collection of the Artist, São Paulo.

13.15 José Gamarra, Five Centuries Later, 1986, oil on canvas, 150×150 cm., Collection Spencer and Myrna Partrich, Bloomfield Hills, Michigan.

13.16-19 Francisco Toledo, Four prints from the Guchachi portfolio (Iguana), 1976, etching and aquatint with printed colours, 2/9: 39.5×39.1 cm., sheet 76×56 cm.; 5/9: 29.5×19.7 cm., sheet 75.8×56.5 cm.; 7/9: 54.2×39 cm., sheet 76×56.2 cm.; 8/9: 31.5×19.8 cm., sheet 76×56 cm., Archer M. Huntington Art Gallery, The University of Texas at Austin, Gift of Eleanor Freed, 1986.

13.20 Francisco Toledo, *The Death*, gouache on paper, 22.5×32 cm., Collection Solomon Laiter, gift of the artist.

13.21 Claudio Bravo, *The Skull*, 1973, conté crayon, 90×70.8 cm., The Museum of Modern Art, New York; Gift of Gloria Kirby Madrid.

13.22 Oswaldo Viteri, We Are Wayfarers of the Night and Pain, 1979, collage on wood, 160×160 cm., Collection of the Artist.

HISTORY AND IDENTITY

intrusion and exploitation go on, above all precisely in the Amazon region where felling, burning and flooding of forests threaten those who hitherto were relatively unaffected by the Conquest.

Gamarra's landscapes are also, however, created in the awareness of the way in which South American nature has been the 'other' for European travellers. His virgin forest is also that of Humboldt and Debret's lush and awesome prints, or of Eckhout's Brazilian scenes. At the same time, of course, Gamarra distances himself from the traveller's viewpoint, criticizing it through his use of history and myth. In common with many artists in Latin America, Gamarra is turning increasingly to the representation of pre-Columbian and native myths. ¹¹

Francisco Toledo, an Indian from the Oaxacan valley, takes as his subject the fauna of Mexico, and of America as a whole, and brings together the contrasting modes of natural history and of myth, frequently making veiled reference to native legends. He not only paints, but uses other materials like terracotta. Among his most imaginative works is the extraordinarily elaborate set of prints [Pls 13.16-19] in which he treats a 'history' of the lizard.

It is neither chance, nor a reflection of international high taste, that some of the most powerful visual images and structures in Latin America are being made at the intersection of environmental and popular art. Such intersections take place at crucial points on the defining line of cultural identity.

13.23 Apolinar, *Untitled (Apolinar's Library*), 1977, mixed media (coins, spangles and objects on painted wood), 40.5×72.5 cm. open, Collection Patricia Phelps de Cisneros.

13.24 Oswaldo Viteri, 'Throw the Spear Through the Window, Wound my Breast, but not my Soul', 1986, collage on wood, 160×160 cm., Collection of the Artist, Quito.

13.25 Oswaldo Viteri, 'Mestizaje', 1987, collage on wood, 122×122 cm., Collection of the Artist, Quito.

13.26 Oswaldo Viteri, Eye of Light, 1987, collage on wood, 160×160 cm., Collection of the Artist, Quito.

Found, or specially made, materials and objects made by local communities have been incorporated by artists into their work in an attempt to draw upon or draw in those other cultures. Oswaldo Viteri, who originally trained as an anthropologist, gathers the brightly coloured little fabric dolls made by villagers in Ecuador and makes metaphorical compositions with them, as in *Eye of Light* [Pl. 13.26]. He also, in his sparely constructed collages, may allude

13.27 Santiago Cardenas Arroyo, *Blackboard with Frame*, 1983, oil on linen, 97×147 cm., Galería Garcés Velásquez.

in material or colour to the pre-Columbian past, and to colonial vestments; the title 'Mestizaje' [Pl. 13.25] is the most direct reference to the cross-cultural currents in his work – which is, of course, as with the work of many of the younger generation of Cuban artists, wholly at home at the same time on the international stage. 12

The notion of *mestizaje* has become central to artistic resistance to colonialism. There is no particular aesthetic attached to it, for it is not a prescriptive notion, but one that opens out on to new languages that can function in the context of Latin America, 'a mixed culture that is bursting through the cracks of dictatorship and colonialism throughout Latin America'.¹³

The Cuban writer Gerardo Mosquera has argued that this *mestizaje*, which may involve an incorporation of black and of Indian culture, is different in kind from the primitivism of 'affinity' presented in the last section of the 1984 exhibition, *Primitivism in Twentieth Century Art*, at the Museum of Modern Art in New York, as well as from the passion of early twentieth-century artists like Picasso, Derain, Brancusi or Kirchner for 'primitive' art. The vagueness of the idea of 'affinity', and the fact that the latter 'incorporated designs and methods stemming from "primitive" art although ignoring its meaning', ¹⁴ disqualify these as useful models

13.28 Mestre Didi, 'Omo-Osanyin', 1977, dried palm ribs, leather, shells, beads, 193 cm. high, Hoffenberg Collection.

HISTORY AND IDENTITY

for today's Latin American artist, who has the advantage over them of understanding that art from the inside rather than regarding it from the outside. In Latin America is found the 'very natural presence of mythological forms of thought, alive and integrated with the 'Western' pragmatic reality that corresponds to modern life'. Mosquero tells the story of the university professor who taught materialistic dialectics and who was simultaneously a practicing 'santero' and performed his magical work 'so that the orishas would help him in his studies . . .' For Latin American artists, this Cuban writer wishes to suggest, both the Western and the primitive are part of his or her own culture – they are 'thus the tertium quid between the West and the non-West' [Pl. 13.28].

However, aspects of Mosquera's argument reveal rather than solve the dilemmas at the heart of *mestizaje*. Many of the artists involved are 'informed primitives', ¹⁶ 'artists well documented in anthropology, history, archaeology, etc.' This is especially so in the case of those artists looking to native cultures past and present, rather than those within the Afro-Caribbean world. For while some artists are also *santeros*, for most, knowledge, expert and sympathetic as it may be, is still gained from the outside. And these artists, of course, make 'Western' art, in the sense of its being an activity independent of magical aims, or religious, ceremonial or any other aims we would today call extra-artistic.

But it is here, perhaps, that some answer lies to the threat felt by some critics and artists in relation to the success of native and popular art, and to their suspicion of the hunger for the 'authentic' that haunts the West's notions of the 'primitive' and renders questionable the appeal to origins. 'It is hard to shake off the essentialism that reduces the Latin American condition to images of primitivism. The mythologization of the native, and the phantasm of origins which feeds the metaphysics behind the discourse on Latin America, are effectively responsible for the archaic attitude that prevents any serious discussion internationally of the Latin American condition.'17 The problem for the artist in Latin America of, on the one hand, resisting marginalization and entering an international artistic discourse without losing a sense of his or her own identity, and on the other of avoiding the further marginalization of native cultures within Latin America is a serious one. What should perhaps be recognized is not the absence of a single 'solution' but the presence of manifold ways of stating the problem within art.

Notes

Introduction

- Jorge Luis Borges, Figari, Editorial Alfa, Buenos Aires, 1930.
- Ethnies, Summer/Autumn 1986 vol. 2, no. 4-5, p. 29.

Angel Kalenberg 'interview' . . . 1988.

Jean Franco, The Modern Culture of Latin America: Society and the Artist, London, 1970, p. 11.

See for instance the anthology, Textos Sobre Arte Popular, Mexico, 1982, which included texts dating from the twenties to the eighties, by among others Dr Atl, Manuel Gamio, Miguel Covarrubias and Miguel León-

Plinio Apulevo Mendoza in conversation with Gabriel García Márquez, The

Fragrance of Guava, Verso, 1982, 51.

See Valerie Fraser, An Architecture of Conquest, Cambridge University Press (forthcoming).

Chapter 1

- William Bullock, quoted in Justino Fernández, El Arte del siglo XIX en México (Mexico City, 1983), 15.
- Jean Franco, The Modern Culture of Latin America: Society and the Artist (London, 1970), 13.
- Estimates of the proportion of the population that was 'Indian' vary, as indeed they still do; of the hundreds of different languages spoken through the continent, five or six main language groups have now been identified.

Gloria in Excelsis: The virgin and angels in viceregal painting of Peru and Bolivia,

Center for Inter-American Relations, N.Y., 1986

- José Martí, 'Bolívar', in The America of José Martí: Selected Writings (New York, 1953), 156.
- Teresa Gisbert, Iconografía y Mitos Indígenas en el Arte (La Paz, 1980), 179.

Martí, 'Our America', op. cit., 144.

Franco, op. cit., 12.

Augusto Mijares, The Liberator (Caracas, 1983), 25.

Martí, 145

- Maria Graham, Journal of a Resident in Chile and Brazil 1823 (London, 1824), Appendix III.
- Gisbert, 209. Ibid., 175.
- Ibid., 169.
 - For further information on Bolivarian iconography, see Alfredo Boulton, Los Retratos de Bolívar (Caracas, 1964), El rostro de Bolívar (Caracas, 1982), and El Arquetipo iconográfico de Bolívar (Caracas, 1984); Simón Bolívar: Bicentenario de su Nacimiento 1783-1983 (catalogue), Galería de Arte Nacional y Museo de Bellas Artes, Caracas, 24 July - 2 Oct 1983; the magazine series Bolívar el Libertador: su vida, obra y pensamiento, ed. José Rivas (Bogotá, 1981).
- See Hugh Honour, The New Golden Land: European Images of America from the Discoveries to the Present Time (New York, 1975), Pilar Moreno de Angel, 'Los Indígenas en la iconografía bolivariana', Lámpara (Bogotá), XXVI: 106 (Mar 1988) and Peter Hulme 'Polytropic Man; tropes of sexuality and mobility in early colonial discourse' Europe and its Others ed. F. Barker et al., Essex Sociology of literature conference, 1984, vol. 2, 17.
- An interpretation proposed by Marta Traba; see Lámpara, op. cit.

Luis Eduardo Wuffarden, 'Gil de Castro, Retratista sin Rostro', in José Gil de Castro (catalogue), Banco Continental, Lima, Apr-May 1988

Jaime Cuadriello, 'De la Conmemoración nacional a la dispersión del Classicismo' Museo Nacional de Arte, Salas de la Colección Permanente (Mexico City, n.d.), Sala 4

George Pendle, A History of Latin America (London, 1971), 93.

Ernesto de la Torre Villar, Moisés González Navarro and Stanley Ross, Historia Documental de México II (Mexico City, 1964), 48. Hidalgo was also influenced by Enlightenment philosophy, and by the radical reformist ideas of the Jesuits, who were expelled from Mexico in 1767, restored in 1816, and again suppressed in 1821. His Disertación sobre el verdadero método de Estudiar Teología Escolástica in 1784 had already incurred the Church's disapproval before the insurrection. After his excommunication, he was brought before the Gran Tribunal of the Inquisition, and condemned to the humiliating formal degradation of being stripped of his vestments before being executed. Moisés González Navarro, 'La Era de Santa Anna', in ibid., 163.

Chapter 2

J. Fernández, El Arte del Siglo XIX en México, 2. The Academy of San Fernando had been founded in 1752, followed by five others in major towns in Spain. The Royal Academy in London was founded in 1769. For a detailed account of the Academy in Mexico, see Jean Charlot, Mexican Art and the Academy of San Carlos 1785-1915 (Austin, Texas), 1962.

Frances Calderón de la Barca, Life in Mexico (London, 1954, first pub. 1843),

Pedro José Marquez, S. J., Discurso Sobre lo Bello en General (Madrid, 1801) and Due Antichi Monumenti di Architettura Messicana (Xochicalco y Papantla) (Rome, 1804). See Fernández, 8.

See Fernández, 130.

Sir Joshua Reynolds, Discourses on Art (London, 1969), 19.

Johann Joachim Winckelmann, Thoughts on the Imitation of Greek Works in Painting and Sculpture (1755).

Reynolds, op. cit., 55 (Discourse 4).

Reynolds criticized in Mengs 'a certain routine of practice . : .' ibid., 218 (Discourse 14).

Josefina García Quintana, Cuauhtémoc en el siglo XIX (Mexico City, 1977), 18.

Ibid., 16.

The law of 'desamortización de bienes de manos muertas', issued in 1856, was primarily intended to strip the ecclesiastical authorities of their immense landholdings, which were to be put up for sale at public auction. However, it had consequences for the ancient communal landholding system of the Indian villages, many of which were forced to sell land, which was then usually bought by the hacienda owners, the Indians themselves not having the money to purchase them. Many Indians therefore found themselves without money or land, and became peon labour on the great estates.

See Guzmán Blanco y el Centenario del Libertador 1883 (catalogue), Consejo

Municipal del Distrito Federal, Caracas, 1983.

Michael C. Meyer and William L. Sherman, The Course of Mexican History

(New York, 1979), 428.

Fausto Ramírez, 'Apogeo del Nacionalismo Académico: El arte entre 1877 y 1900', Museo Nacional de Arte, Salas 11-14.

Chapter 3:i

For the Spanish and Latin American 'Ilustración' as part of the general European Enlightenment, see Jean Sarrailh, L'Espagne éclairée de la seconde moitié du $XVIII^e$ siècle (1954), tr. as La España ilustrada de la segunda mitad del siglo XVIII(Mexico City, 1957), and Arthur P. Whitaker, ed., Latin America and the Enlightenment (Ithaca, N.Y., 1967).

In preparing his Brazilian notes and sketches for European publication, Maximilian Wied zu Neuwied's sister and brother modified them to suit the 'tastes of the age', which preferred to see in America 'dreamy examples of

Rousseau's "noble savage"

Bonifacio de Carril, Mauricio Rugendas (Buenos Aires, 1966), 15. Source: Gertrud Reichert, Johann Moritz Rugendas Ein Deutscher Maler in Ibero-Amerika (1952); see also 2nd expanded edn, (1959).

Ibid., 18, as quoted from Reichert.

Ibid.

Ibid. See Gaspar Galasz and Milan Ivelic, La pintura en Chile desde la Colonia hasta 1981 (Valparaiso, 1981), 52-3, also Rüdiger Joppien and Bernard Smith, The Art of Captain Cook's Voyages, vol. III, pt. 2 (New Haven, Conn., and London, 1988), 151.

Galasz and Ivelic, op. cit., 49-52.

Alfredo Boulton, Historia de la Pintura en Venezuela, II: Epoca Nacional (Caracas, 1968), 127.

See J. Charlot, Mexican Art and the Academy of San Carlos, 71-2.

Studies in Ancient American and European Art: The Collected Essays of George Kubler, ed. T. Reese (New Haven, Conn., and London, 1985), 76.

Chapter 3:ii

These often multi-volume publications sometimes included special 'Atlases', which contained not only maps, but also pictorial and historical scenes (cf. the two volumes of Gay's Atlas de la Historia física y política de Chile; Humboldt published a special Atlas pittoresque to accompany the Voyage).

The title of an exhibition organized in Bogotá by the artist Beatriz Gonzales juxtaposing the work of Colombian artist Torres Mendes with the European Mark. See also S. Catlin and T. Greider, *The Art of Latin America since Independence* (New Haven, Conn., 1966), where this subject was raised. Professor Catlin's essay (ch. 3:I) in this Volume addresses the theme of the travellerartists in terms of its more general philosophical and aesthetic background.

³ See H. Honour, The New Golden Land.

⁴ Ibid., 48.

⁵ Ibid., 83.

Humboldt attacked slavery in Cuba, 'The greatest of all the evils that have afflicted humanity', Voyage de Humboldt et de Bonpland, Pt. 1: Relation histo-

rique, vol. 3 (Paris, 1825), 447.

The *Voyage* as a whole is curiously disorderly: Humboldt's friend Arago is said to have commented, 'Humboldt, you don't really know how to write a book. You write endlessly but what comes out of it is not a book. It's a portrait without a frame.' (Douglas Botting, *Humboldt and the Cosmos* (London, 1973), 211.)

Humboldt notes that the Spanish monk Ríos, who transcribed the pre-Conquest book (Vaticanus 3738), paid attention to the costumes rather than the contours of the figures, and thereby rendered them more European in

proportion.

J. B. Debret, Voyage pittoresque et historique au Brésil, ou séjour d'un artiste français au Brésil, 1816-1831 (Paris, 1834-9), vol. II, Introduction.

Edmund Burke A Philosophical Enquiry into the Origin of Our Ideas of the Sub-

lime and the Beautiful (London, 1757)

- The construction of stereotyped 'Maya' and 'Aztec' civilizations, the one humanist, the other brutal and bloodthirsty, in the works of the nineteenth-century travellers and archaeologists is discussed in Oriana Baddeley, 'The Cacaxtla Murals: The Problems They Raise for Mesoamerican Art History' (unpub. Ph.D. thesis, Univ. of Essex, 1984).
- John Stephens, Incidents of Travel in Yucatán (New York, 1843), Preface.
 Miguel Covarrubias, 'Modern Art', in Twenty Centuries of Mexican Art (catalogue), Museum of Modern Art, New York, 1940, p. 137.

Flora Tristan, Peregrinations of a Pariah (London, 1986; first pub. 1838), 269.

Chapter 4

- Eugène Boudin, note of 1856, quoted in John Rewald, The History of Impressionism (New York, 1973), 38.
- J. Fernández, El Arte del siglo XIX en México, 92.

Javier Pérez de Solazar y Solana, Velasco y sus contemporáneos (Mexico City, 1982), 94.

M. C. Meyer and W. L. Sherman, The Course of Mexican History, 405. In 1860 Mexico had ε. 150 miles of railway track, compared with over 30,000 in the USA. The Mexico City-Veracruz railway was begun in 1837; although completed under Juárez, it was under the dictatorship of Porfirio Díaz that the greatest expansion took place. In many ways Velasco's celebration of the Mexican landscape can be understood in terms of the pride in the country's progress, and in the consolidation of the idea of being a nation that accompanied the stability of the period, the double-edged 'Paz Porfiriana', Porfirio's peace.

Chapter 5

- Orozco described watching the printmaker in his workshop when he was a student. Orozco's early career as a cartoonist naturally kept him close to Posada. Jean Charlot discovered Posada from the penny broadsheets still on sale while he was working on Rivera's mural in the ENP in 1921, and was the first to publish an article on him in 1925. Rivera also knew his prints early on, though Charlot doubts his story of watching him at work. See Jean Charlot, 'Posada and His Successors', in *Posada's Mexico*, ed. Ron Tyler (Fort Worth, Tex. and Washington, D.C., 1979).
- See Joyce Waddell Bailey's highly informative essay, 'The Penny Press', in

Posada's Mexico, op. cit., 85-121.

³ Ibid., 92

There are numerous accounts of the origin and popular importance of the calavera, or skeleton figure, in Mexico, and of its European and/or Aztec sources: see for instance the exhibition catalogue Day of the Dead (Fort Worth, 1986); Rafael Carillo, Posada and Mexican Engraving (Mexico City, 1980); Posada's Mexico, op. cit. Most also mention Fray Joaquín Bolaños, La portentosa vida de la muerte (The Prodigious Life of Death), published in Mexico in 1792, with 18 engravings.

Waddell Bailey, op. cit., 90.

Of Diaz was elected to the Presidency for the second time in 1884, where, having changed the rules about re-election, he remained until 1911.

Waddell Bailey, 100.

Díaz played off the two contenders for the post of Vice-President, the popular and brilliant General Reyes and his regime's wizard financier, Limantour. Jealous of both, he finally gave the prize to Ramón Corrales, the most unpopular man in Mexico, who had brutally suppressed the Yaqui Indians, wiping out villages and sending the Yaqui into virtual slavery on the plantation in the Yucatán. His argument was, correctly, that no one would want to plot against him, Díaz, with the risk of Corrales as successor. This political situation and its intrigues were a gift to the cartoonists.

This advertisement appeared in El Fandango in 1892.

'Engraving on type metal (a lead alloy) with a many-pointed burin that leaves furrows which print white after the block is inked': R. Badeceus and Stanley Appelbaum, *Posada's Popular Mexican Prints* (New York, 1972). This was the technique used by one of Posada's predecessors, Manuel Manilla; with zinc etching, the artist draws directly on to a zinc plate, using a special pen and greasy ink. After being dipped in acid, the pen lines stand out in relief and print black. The result is like a very concentrated drawing.

Posada died in January 1913. The 'decena trágica (ten tragic days)' of violence in Mexico City followed the military coup against Madero; on 21 February

Madero and his Vice President were murdered.

Advertisements by Posada for Arroyo's shop offered a wonderful variety of products, including that year's songs, greeting cards, horoscopes, cookery books, comic stories for children, and other books and newspapers.

Waddell Bailey. 110.

Chapter 6

Dates given are those of the founding of each review.

J. Franco, *The Modern Culture of Latin America*, 25. The artist or poet in Darío's work was often the outsider whose bohemian way of life and values

challenged the materialism of the bourgeoisie.

Ramos Martínez, elected director of the Academy of San Carlos by a soviet of teachers and students in 1920, set up 'open air' schools for students to paint from nature. At the unveiling of Rivera's *Creation*, the so-called 'cubist decoration in the Preparatoria' (El Universal, 10 Mar 1923), Maples Arce, the fiery leader of the 'Estridentistas', spoke for one and a half hours, reviling 'the partisans of the impressionist style, going so far as to assert that the National School of Fine Arts was a Brothel of Pictorial art' (Jean Charlot, *The Mexican Mural Renaissance 1920-25* [New Haven, Conn., 1963], 145).

⁴ Ramón Gómez de la Serna was a leader of Madrid intellectual and literary life; he wrote about the visual arts: a collection of witty short essays on contemporary art movements, *Ismos*..., which referred to Mexico, was

published in Madrid in 1931.

Ramón Favela, *Diego Rivera: The Cubist Years* (catalogue), Phoenix (Ariz.) Art Museum, 1984, 108. *Zapatista Landscape – The Guerilla* was bought by Rivera's wartime Paris dealer Léonce Rosenberg, and after they quarrelled in 1918 over the issue of stylistic freedom, lay in his stock until the 1930s. Favela points out that Alfonso Reyes' *Visión de Anáhuac* (Madrid, 1915), published the year Rivera painted *Zapatista Landscape*, had described the Mexican central highland valleys as existing in 'the most transparent region of the air' (p. 104). Anáhuac was the Náhuatl term for Mexico.

Gutiérrez had set up his government in Nuevo León, Carranza in Veracruz, Pancho Villa in Chihuahua, while Obregón occupied the capital and the Zapatistas had their own candidate for President. The bloodiest battle of the Revolution, Celaya, fought in April 1916 between Obregón and Pancho

Villa, left 4,000 Villistas dead.

Favela, op. cit., 145.

⁸ José Carlos Mariátegui, 'Arte, Decadencia y Revolución', Amauta (Lima), no. 3 (Nov 1926); see Appendix 6.8.

See Franco, 156.

- Graca Aranha, inaugural lecture for the Modern Art week, at the Municipal Theatre of São Paulo, 15 Feb 1922, reprinted in Modernidade: art brasilien du 20e siècle (catalogue), Musée d'art moderne de la ville de Paris, 10 Dec 1987-14 Feb 1988, 71.
- Montiero Lobato, O Estado de São Paulo (evening edition), 20 Dec 1917, in ibid., 62-4.
- Aracy Amaral, 'Le Modernisme: entre la rénovation formelle et la découverte du Brésil', in ibid., 162.
- He chose poets with a strong Dada/Surrealist inclination, including Lautréamont, Rimbaud, Aragon, Cravan and Picabia.
- Guilherme de Almeida, in Aracy Amaral, Tarsila, sua obra e sui tempo (São Paulo, 1986), 99. Tarsila owned a fine Delaunay Eiffel Tower of 1910-11.

- G. Freyre, 'Manifest regionalist', in *Modernidade*, op. cit., 86. See *Amelia Peláez 1896-1968: A Retrospective* (catalogue), Cuban Museum of Arts and Culture, Miami, Fla., 1988.
- Quoted in Marianne Manley, 'Intimate Recollections of the River Plate', Pedro Figari (catalogue), Center of Inter-American Relations, New York,
- Alejo Carpentier, 'Pedro Figari y el Clasicismo Latinoamericano' (1928) in Seis Maestros de la pintura Uruguaya (catalogue), Museo Nacional de Bellas Artes, Buenos Aires, 1987, 72.

W. H. Hudson, Far Away and Long Ago: A Childhood in Argentina (1918; repr.

London, 1985), 4-5.

- See Alicia Haber, 'Vernacular Culture in Uruguayan Art: An Analysis of the Documentary Function of the Works of Pedro Figari, Carlos González and Luis Solari', Occasional Papers Series, Latin American and Caribbean Center, Florida International University (Miami, Fla., 1982).
- Jorge Luis Borges, 'Figari' (Buenos Aires, 1930) in Seis maestros de la pintura Urugaya, op. cit., 73.
- See Mario Gradowczyk, Xul Solar (catalogue), Galería Kramer, Buenos Aires, 1988.

Ibid., p.11, fig. 6.

- The magazine Cercle et carré, edited by Michel Seuphor, was the focal point for a wide grouping of constructive artists; the Cercle et carré exhibition of 1930 was described as 'the first international exhibition of modern art'.
- J. Torres-García, 'La Escuela del Sur', 1935, author's transl.; see Appendix 6. See Margit Rowell, 'Order and Symbol: the European and American Sources of Torres-García's Constructivism', in Torres-García: Grid-patternsign (catalogue), Arts Council of Great Britain, London, 1985-6.
- Torres-García, La Tradición de Hombre Abstracto (Doctrina Constructiva) (Montevideo, 1938), n.p. Translation, T. Ades.

Chapter 7

- The major general sources in English are Charlot, The Mexican Mural Renaissance; Antonio Rodríguez, A History of Mexican Mural Painting (London, 1969); Emily Edwards, Painted Walls of Mexico (Austin, Tex., 1966). See also Alistair Hennessy's excellent review article, 'Artists, Intellectuals and Revolution', Journal of Latin American Studies, 3: 1 (May 1971), pp. 71-88.
- See John Womack, Zapata and the Mexican Revolution (London, 1972).
- Octavio Paz, 'Social Realism in Mexico: The Murals of Rivera, Orozco and Siqueiros', Artscanada, Dec/Jan 1979/80, p. 56.
- Hennessy, op. cit., p. 73. For a detailed study of Vasconcelos and his intellectual circles, see Nicola Coleby, 'Vasconcelos y el Ateneo de Juventud', unpublished thesis, UNAM, Mexico.

The National Preparatory School in Mexico City was an élite state post-

secondary school for sixteen- to eighteen-year-olds.

Mural painting had been advocated in different contexts in nineteenthcentury Mexico. The critic Couto, in his Diálogo sobre la historia de la pintura, traced 'the cradle of our civilization' to the convent of San Francisco, with its religious mural paintings. Mural painting was seen as a possible way of revitalizing the arts; both Clavé, director of the Academy 1846-68, and Cordero produced mural paintings for churches, but Cordero also painted, in a progressive as opposed to a conservative context, a mural entitled Science and Industry in the staircase of the National Preparatory School in 1874.

Charlot, op. cit., 69.

Rodríguez, op. cit., starts his history of Mexican murals with the pre-Conquest period. The fact that the majority of the walls of major buildings in pre-Columbian cities were painted, inside and out, has only gradually

- become apparent. The Bonampak murals were discovered in 1946, those at Cacaxtla in 1975.
- See Charlot, op. cit., 139-41. Xavier Guerrero, Carlos Mérida, Charlot and Amado de la Cueva assisted Rivera, grinding the pigments by hand, 'priming . . . the wall with hot resin at the moment of painting', and immediately applying a blow torch to vitrify the pigment. In true fresco, the paint is applied to wet plaster, so that it dries in with it.

Charlot, op. cit., 68.

David Alfaro Siqueiros, Art and Revolution (London, 1975), 20. See also Appendix 7.2

Charlot, op. cit., 84.

Ibid., 99. This mural was finished in August 1923.

- For Rivera's detailed breakdown of the scheme, see Bertram D. Wolfe, The Fabulous Life of Diego Rivera (London, 1968), 135-9.
- Siqueiros, op. cit., 20, see Appendix, 7.1 for another version of this text. Charlot, 168. The incident was told to Leal by his brother; Anita Brenner
- based her famous book on Mexico, Idols Behind Altars (1929), on it. Siqueiros, 'José Clemente Orozco, the formal precursor of our painting', in op. cit., 59. A note from Goitia to the then Secretary of Public Instruction and Fine Arts suggested that some 'fresco painting . . . will begin to cover the walls of churches, of hospitals and public buildings, with creations in which the characteristics both of our country and of our time will be embodied'.

Charlot, op. cit., 78-9.

- Ibid., 254. See the invaluable 'Mural Census' by Stanton Catlin, in Diego Rivera: A Retrospective (catalogue), Detroit Institute of Arts, 1986, for a complete list of each mural scheme.
- 'Man at the Crossroads, with hope and high vision to the choosing of a new and better future', 1933. This mural for the Rockefeller Center, New York, was half finished when, in May 1933, it was destroyed after Rivera refused to remove a portrait of Lenin. See Catlin, op. cit., p. 295. A version was made in 1934 for the Palace of Fine Arts in Mexico City with the title Man, Controller of the Universe.

Womack, op. cit., 244.

Paz, op. cit.

- Olav Munzberg and Michael Nungesser, 'The Preparatory School Murals 1923-1926: Between Allegory, Caricature and Historical Depiction', Orozco! (catalogue), Museum of Modern Art, Oxford, 1980, p. 25
- Orozco, 'Notes on the Early Frescoes at the National Preparatory School' (1923), in ibid., 34.
- Siqueiros, 'José Clemente Orozco . . .', op. cit., 64. This text was originally published as a 'Letter to Orozco on visiting an exhibition of his paintings, drawings and engravings at the National School which opened on September 25 and will run until October 5th', in Hoy, 7 Dec 1944.

Quoted in !Orozco!, op. cit., 55.

Laurence Hurlburt, 'David Alfáro Siqueiros' Portrait of the Bourgeoisie', Artform, Feb 1977, from which the above quotation is taken, p.39.

Rodríguez, op. cit., 409.

Chapter 8

See Judith Keller, El Taller de Gráfica Popular (catalogue), Archer M. Huntington Art Gallery, Univ. of Texas at Austin, 1985, 17.

J. Charlot, The Mexican Mural Renaissance, 248.

Ibid.

Thomas Hess, 1972, quoted in Keller, op. cit., 9.

- See extract from 'Diario de Leopoldo Méndez', 1948, in 50 años Taller de Gráfica Popular: 1937-1987 (catalogue), Museo de Palacio de Bellas Artes, Museo Nacional de la Estampa, and Galería José María Velasco, Mexico City, 1987,
- In the late Fifties, Taller de Gráfica Popular artists like O'Higgins and Beltrán were in close contact with Miguel León-Portilla, the greatest authority on Náhuatl Indian civilization past and present, author of La Filosofía Náhuatl, and consulted him for information (conversation with León-Portilla, Nov
- Numerous exhibitions of Taller de Gráfica Popular artists, both individual and collective, took place in Mexico and abroad.
- Haber, 'Vernacular Culture in Uruguayan Art', op. cit., p. 15.

Chapter 9

Later paintings include Flower Sellers (1943), and Sellers of Arum Lilies (1943); both show two Indian women seated before their baskets of lilies, with a male figure behind. Flower Seller (1942) and Nude with Arum Lilies (1944) both show single female figures.

Flower and Song: Aztec Poems, tr. Edward Kissam and Michael Schmidt

(London, 1977), 44 (no. 33).

Miguel León-Portilla, 'Aztecs and Navajos: A Reflection on the Right of Not Being Engulfed' (occasional paper, the Weatherhead Foundation, New York, 1975), 10-11.

Quoted by David Brading in his illuminating article, 'Manuel Gamio and Official Indigenism in Mexico', Bulletin of Latin American Research 7 (1988),

no. 1, p. 84.

This inaugurated, as David Brading put it, a distinctively Mexican 'craft industry, financed by the Mexican state and justified by the joint aim of recuperating national glory and attracting mass tourism. In Mexico archaeology has always been governed as much by political and practical rationale as by academic criteria', op. cit., p. 78. Gamio's Guide for Visiting the Archaeolog-

ical City of Teotihuacán (1922) was also published in English.

A measure of protection of the native farmers' land rights persisted until the mid-nineteenth century, but the Reform Laws, 'which in most aspects were beneficial, in those relating to territorial possession wrought irreparable damage, for, in dividing the communal lands there was no obstacle for the great landowners to . . . acquire them . . . '(Manuel Gamio, La Población del Valle de Teotihuacán [1922], xiv). Gamio also notes that the excellent intentions of the 1917 Constitution in redistributing land could not be efficiently implemented, and that the worst obstacles had been met in regions near the capital, and round the state capitals.

Gamio, quoted by Brading, 84.

Eugenio Maldonado, 'The Indian Problem', Mexican Art and Life, no. 4 (Oct

León-Portilla, op. cit., 12.

D. A. Siqueiros et al., 'Manifiesto del Sindicato de obreros, tecnicos, pintores y escultores de Mexico': 'A la raza indigena . . .', El Machete, Mexico City, 1923 (Author's translation). See Appendix 7.2, an expanded version of the 'Declaration of Social, Political and Aesthetic Principles' is translated in Siqueiros' Art and Revolution (op. cit., 1975), no. 4, pp. 24-5.

Jorge Falcón, quoted in Mirko Lauer, Introduccion a la Pintura Peruana del Siglo

XX (Lima, 1976), 104.

Ibid., 98. 13 Ibid., 100.

> José Carlos Mariátegui, 'El Problema del Indio', 7 Ensayos de la Realidad Peruana (Lima, 1928). Mariátegui's review Amauta began to publish a Boletín de defensa indigena in 1927; Amauta no. 6 (1927) included an article on Sabogal's painting Varayoc de Chincheros, and an article by Valcancel, 'El Problema in-

As director Sabogal was very influential in turning the attention of artists and students to Peru. He also had close contacts with Mexico, and put on an important exhibition of Mexican art. He was active in support of the Spanish government during the Civil War against the fascist rebels; in 1938 he was a founder member of the Asociación de Escritores, Artistas e Intelectuales del Peru. In 1943 he resigned his post as director of the School of Fine Arts in protest at government interference. See Jorge Falcón, Jose Sabogal (1888-1956) (Lima, 1986).

Falcón, in Lauer, op. cit., 103.

See, for example, Dr Atl, Las Artes Populares en Mexico (1921), and Antología de Textos sobre Arte Popular (Mexico City, 1982).

Conversation with author, Nov 1988.

Chapter 10

- André Breton, Manifeste du Surréalisme (Paris, 1924), in Manifestos of Surrealism, tr. Richard Feaver and Helen R. Lane (Ann Arbor, Mich., 1969), 10.
- Ibid., 16.
- Gabriel García Márquez in conversation with Plinio Apuleyo Mendoza, The Fragrance of Guava (London, 1982), 35.
- A. Breton, 'Souvenir du Mexique', Minotaure, 12/13 (May 1939), 41.

García Márquez, op. cit., 59.

A. Breton, 'Frida Kahlo de Rivera' (1938), in Surrealism and Painting (New York, 1972), 141.

- Breton, 'Rufino Tamayo' (1950), in ibid., 233.
- Breton, 'Souvenir du Mexique', op. cit., 41.

Garciá Márquez, op. cit.

Breton, 'Frida Kahlo de Rivera', op. cit., 141.

On his way to New York in 1941, having left Europe as a refugee, Breton had stopped at another French-speaking Caribbean island, Martinique, where by chance he had come across the review Tropique, and the work of the black poet Aimé Césaire, henceforth to be one of Surrealism's foremost poets. Césaire gave a series of lectures in Haiti in 1945 at the same time as Breton.

J. Michael Dash, Literature and Ideology in Haiti 1915-1961 (London, 1981), 158-9. The effect of Breton's 1945 lectures was so great that the reactionary Haitian leader, Elie Lescot, thought it was the Surrealist who had engineered the revolt that overthrew him early the next year; Lescot is said to have exclaimed a few days later, 'Quant á ce monsieur Breton, il ne parlera plus!' This was, as Breton said, the only occasion on which Surrealism could be said to have been effectively involved in a revolution. Breton met Leon Trotsky in Mexico when both were guests of Rivera and Kahlo (though in different houses); he said in a later interview (Entretiens 1913-1952 [1952], 188) that although in their many conversations he, Rivera and Kahlo had tried their hardest not to irritate Trotsky, 'we couldn't avoid presenting to him, as a group, an "artistic" complexion which was necessarily strange to him'. None the less, Trotsky and Breton together drew up a manifesto (signed by Rivera on behalf of Trotsky) announcing FIARI, the Fédération Internationale d'Art Révolutionnaire Indépendant, the rather detached and general tone of which is very unlike most of Breton's writing.

Breton, 'Hector Hyppolite' (1947), Surrealism and Painting, 308.

Ibid., 311

These signs and symbols stand for individual names of palaros, priests and also for cosmological ideas. I am indebted to the curators at the Museo Nacional de Guanabocoa, Cuba, for information relating to Santería and voodoo cults.

Breton, 'Wifredo Lam' (1941), Surrealism and Painting, 169.

- Jorge Cáceres, to the Surrealists' surprise, was also leading dancer of the Santiago Ballet.
- See Stefan Bacin, Antología de la poesía Surrealista Latinoamericana (Valparaiso, 1981).
- Huidobro collaborated with the Dada and Surrealist poet/sculptor Hans Arp on three short stories, Trois Nouvelles exemplaires (1931).

I am indebted to Elisa Vargas for information about Batlle Planas. She is researching a Ph.D. on Surrealism in Argentina.

Conversation with the author, Buenos Aires, October 1986.

Chapter 11

- See Gyula Kosice, Arte Madí (Buenos Aires, 1982); Nelly Perrazzo, El Arte concreto en la Argentina en la década del 40 (Buenos Aires, 1983); Jorge B. Rivera, Madí y la Vanguardia Argentina (Buenos Aires, 1976). An interesting open letter from César Paternosto, 'Pioneros ignorados', Arte en Colombia, no. 33 (May 1987), criticized the Contrasts of Form exhibition at the Museum of Moden Art, New York, for ignoring the South American constructivist/ concrete artists.
- Quoted in Perazzo, op. cit., p. 58. Precursors in Argentina in the field of abstraction included Juan del Prete, and Pettoruti; although the latter was rarely purely abstract. In his Futurist-inspired paintings and drawings, his intention was rather to express speed and dynamism.

Conversation with author, Paris, Oct 1988.

- A. Gleizes and J. Metzinger, Cubism (1912), in R. Herbert, Modern Artists on Art (New York, 1964), 5.
- Whether Maldonado and his group split before or after the private exhibition at Grete Stern's house in the autumn of 1945 is a matter of disagreement.
- Arden Quin, one of the original and most influential members, older than the others, has been interested in Marxism since the 1930s. He has spoken of his commitment to dialectical materialism, which informs his text in Arturo.

The constructivist Max Burchartz had first used the term 'concrete' in an artistic context. Antonio Berni apparently had a copy of Art Concret, which he showed to Maldonado.

Translated in Stephen Bann, The Tradition of Constructivism (London, 1974), 193. The manifesto was signed by Carlsmund, van Doesburg, Hélion, Tut-

tundjian and Wantz. Max Bill, quoted in Perazzo, op. cit., 24-5. Hans Arp, 'Concrete Art', preface to Konkrete Kunst (catalogue), Kunsthalle, Basel, Mar-Apr 1944. This was an extract from an article first published in English as 'Abstract Art, Concrete Art', in Peggy Guggenheim, Art of This Century (catalogue), New York, 1942, but probably written earlier.

Lucio Fontana, who was in Buenos Aires at this time, maintained a genial interest in the young MADI and concrete artists, and had his students publish his 'White Manifesto' (Appendix, 12.1) in 1946. On his return to Europe, he too

began to work in neon.

The role of the Futurist manifestos should be mentioned here: Arden Quin has spoken of his admiration for them as a continual source of new ideas, especially Boccioni's 'Manifesto of Futurist Sculpture'. (Conversation with Arden Quin, Paris, Oct 1988.)

C. Greenberg, letter to Sandú Darié (coll. the artist, Havana).

¹⁴ Conversation with Sandú Darié, Havana, May 1988.

Bill intended to resume the Bauhaus tradition at Ulm. Maldonado remained a professor there until 1967.

T. Maldonado, in Revista Arte Concreto Invención (Buenos Aires) no. 1 (1946),

tr. in Perazzo, op. cit., 88.

Alfredo Hlito, 'El tema del Espacio en la pintura Actual', Nueva Visión (Buenos Aires) no. 8 (1955), tr. in ibid., 89.

Chapter 12

Ido not mean by this to deny the great and continuing significance of popular expression on the Latin American continent.

Quoted in José Balza, Alejandro Otero (Milan, 1977), 48.

José Joaquin Brunner, 'Cultura y Sociedad en Chile', in Chile Vive (catalogue), Circulo de Bellas Artes, Madrid, 1987.

Jésus Soto, in conversation with the author, Caracas, May 1988.

- This description is not so true of Fontana, who was most conscious of the Futurist legacy, or of Camargo, at one time a student of Fontana's in Buenos Aires, who felt closer to Brancusi than to constructive or concrete artists.
- There are more artists of significance than it is possible to discuss here: indeed the 'neo-concrete' movements in Latin America deserve an exhibition to themselves.

Fontana's 'Manifiesto Blanco' is translated in the Appendix, 12.1.

- 8 Alejandro Otero, interview with Rachel Adler, in Alejandro Otero, A Retrospective Exhibition (catalogue), University of Texas at Austin, 1975, p.18.
- Lygia Clark, quoted in Lucia Rito, 'Sensação em dose dupla', Veja (Rio de Janeiro), Dec 1986, p.34.
- Lygia Clark, 'Writings', in Signals Newsbulletin (London), April-May 1965, pp.2-3.
- Haroldo de Campos, interview with Lenora de Barros, Lygia Clark e Hélio Oiticica (Rio de Janeiro, 1986), 54.
- Ronaldo Brito, 'A Ordem e a Loucura da Ordem', preface to Sergio Camargo (catalogue), Museu de Arte Moderna do Rio de Janeiro, 1975.

- Mira Schendel, letter to the author, 24 Nov 1965.
- The phrase is Haroldo de Campos', from an (?) unpublished poem written in homage to Mira Schendel, Apr 1966.
- Bertolt Brecht, 'Sur la Peinture Chinoise', in Sur le Réalisme (Paris, 1970), 68-9.

Ouoted in Olivia Zuñiga, Mathias Goeritz, (Mexico City, 1963).

To build the Guri Dam, two communities of Pemon Indians were forcibly removed from their land and relocated in new villages built by the government, an experience which has left them far from happy. Brazil has recently seen Indian protests against hydro-electric projects in the Amazon, saying they 'do not benefit local people, only business interests.'

Hélio Oiticica, Aspiro ao Grande Labirinto (Rio de Janeiro, 1986), 79.

Chapter 13

J. Torres-García, 'La Escuela del Sur' (1935); see Appendix 6.11.

Luis Camnitzer, 'Report from Havana: The first Biennial of Latin American Art', Art in America, Dec 1984, 41.

³ Antonio Berni: Obra pictórica 1922-81, Museo Nacional de Bellas Artes, Buenos Aires, Argentina, 1984, 24.

4 Ibid

⁵ Lelia Driben, 'Alberto Gironella' (interview with the artist), Mexico en el Arte, no. 11 (Dec 1985), p.18 (author's trans.).

Octavio Paz, 'Los obvisiones de Alberto Gironella', Los Privilegios de la Vista (Mexico City, 1987), 441.

L. Driben/Gironella, op. cit., 23.

Ibid., 27.

I am grateful to Val Fraser for providing this information.

10 Conversation with author, Paris, Nov 1988.

Gamarra, Francisco Toledo and the Nicaraguan painter Armando Morales are working together on a film inspired by Eduardo Galliano's anthology of the myths of Latin America, Mémoires du Feu.

The conditions for artists in Cuba are exceptionally favourable; it is the only country in Latin America where training begins seriously, and free, at secondary-school level. A generation of extraordinarily articulate and inventive artists is now gaining international recognition.

Lucy Lippard, 'Made in the USA: Art from Cuba', Art in America, Apr 1986,

. 35

Gerardo Mosquera, Introduction, New Art from Cuba (catalogue), Amelia Walham Gallery, Old Westbury, L.I., N.Y., 1968, 1-3.

¹⁵ Ibid.

- ⁶ The term is Luis Camnitzer's.
- Nelly Richard, 'The problematic of Latin American Art', Margins and Institutions: Art in Chile since 1973 (Art & Text, special issue no. 21), Melbourne, 1986.

Appendix: Manifestos

Manifestos are grouped and numbered according to the chapters to which they relate, and within chapters are in chronological order.

6.1
Actual: Avant-Garde Newspaper
A Strident Prescription penned by Manuel Maples Arce

Subversive illuminations by Renée Dunan, F. T. Marinetti, Guillermo de Torre, Lasso de la Vega, Salvat Papasseit, etc., together with a few more peripheral crystallizations.

```
S
Death to Father Hidalgo*
U
Down with San Rafael†
C
and San Lázaro ---
C
Corner ---
E
No bill-sticking
S
S
```

In the name of the contemporary Mexican avant-garde, and in genuine horror at the notices and signs plastered on the doors of chemists and dispensaries subsidized by law at the behest of a cartulary system for the last twenty gushing centuries, I affirm my position at the explosive apex of my unique modernity, as definite as it is eminently revolutionary. The whole off-centre world contemplates its navel with spherical surprise and wringing of hands while I categorically demand (with no further exceptions for 'players' diametrically exploded in phonographic fires with strangulated cries) with rebellious and emphatic 'stridentism' in self-defence against the textual blows of the latest intellective plebiscites, 'Death to Father Hidalgo, Down with San Rafael and San Lázaro, Corner, No bill-sticking'.

I. My madness has not been reckoned with. Truth never occurs outside our own selves. Life is but a system open to the rains that fall at intervals. From this standpoint our superlative literature insists upon honouring telephones whose perfumed conversations are articulated along electronic wires. Aesthetic truth is merely an uncoercible emotional state unravelling on a baseless plane of integrating equivalences. Things have no con-

ceivable intrinsic value and their poetic parallels only flourish in an inner dimension, their relationships and co-ordinations are more defined and emotionally evocative than a dis-established reality, as you can see from the fragments of one of my forthcoming new latitudinal poematics: 'Those Electric Roses. . .' (Cosmópolis, 34). As Albert Birot says, to produce a work of art, it is essential to create and not to copy. 'We seek truth not in the reality of appearances but in the reality of thought.' At this particular moment, we are attending the performance of ourselves. In our illuminated panoramas circumscribed by spherical modernist skies, all must be in transcendental harmony. I believe, with Epstein, that we should not imitate nature but study its laws and do as nature does.

II. Every artistic technique fulfills a spiritual function at a given moment. When expressionist formats are awkward or inadequate ways of transmitting our personal emotions – their sole and elementary aesthetic function – we need to turn off the electricity and pull out the plug, even against all the reactionary forces and upstart opinions of official critics. A rheumatic chest-protector has burnt out, but this is no reason for me to stop the game. Whose turn is it next? Now the dice are thrown by Cipriano Max Jacob, a sensationalist act when one considers such a circumspect journalist.

While Blaise Cendrars, always keeping his balance transcendentally, intentionally mistaken, does not know whether what he sees is a starry sky or a drop of water under the microscope.

III. 'A racing car is more beautiful than the Victory of Samoth-race'. I add my positive passion for the typewriter and superabundant love of the literature of the classified ads to this enthusiastic statement by the Italian Futurist Marinetti, hailed by Lucini, Buzzi, Cavacchioli and the rest. I have found deeper and greater emotion in an arbitrary but thought-provoking newspaper clipping than in all the pseudo-lyrical barrel-organs or melodic sweetmeats freely peddled to young ladies, and insultingly recited to audiences of spasmodic fox-trotting deb-

utantes and members of the bourgeoisie pre-ocupied with their mistresses and safe-deposit boxes. As indeed my spiritual brother Guillermo de Torre so courageously proclaimed in his Egoist Manifesto, read at the first Ultraist explosion in Paris, without puncturing all those poematizations (*sic*) so enthusiastically applauded in literary circles where only the pasteboard imitations of literapods are admitted.

IV. All Stridentist propaganda must praise the modern beauty of the machine. It is there in the gymnastic bridges tautly stretched over ravines on muscles of steel, in the smoke from factory chimneys, the Cubist emotions evoked by great transatlantic liners with their smoking red and black funnels horoscopically anchored - according to Ruiz Huidobro [cf. Appendix, 6.6] - at their teeming congested quaysides, the reign of great throbbing industrial cities, the blue shirts of the workers exploding at such an emotional and moving moment, all the beauty of this century so forcefully prophesied by Emile Verhaeren, so sincerely loved by Nicolas Beauduin, and so completely understood and dignified by every avant-garde artist. Finally, trams have been ransomed from the taunts of the prosaic (prestigiously valued by a pot-bellied bourgeoisie and their marriageable daughters throughout years of successive backwardness and intransigent melancholy), and from among chronological archives.

V. To the electric chair with Chopin! This is my hygienically cleansing vow. Anti-selenegraphic Futurists have already demanded the assassination of moonlight in block capitals, and the Spanish Ultraists, via their spokesman Rafael Cansinos Assens, have transcribed the end of the dry leaves shaken about in subversive newspapers and leaflets. Similarly, it is a matter of the utmost telegraphic urgency to harness radical and effective methods. To the electric chair with Chopin! MMA (trademark) is a magic product: it does away with all the germs of a putrified literature in twenty-four hours and is harmless, even pleasant, to use. Shake well before using. I insist. Let us perpetrate our crime on the night-long melancholy of the 'Nocturnes', and simultaneously proclaim the aristocracy of petrol. The blue discharge of car exhausts, scented with a dynamic modernity, has exactly the same emotional value as the beloved talents of our 'exquisite' modernists.

VI. Provincials iron tram tickets of former times into their wallets. Where is the Hotel Iturbide? Every dyspeptic newspaper is gorged with photographs of Maria Conesa‡ beaming off the front page, and there is always someone who dares be totally taken aback by the architectural shock of the National Theatre. Yet no one so far has shown any susceptibility at all to the subliminal emotions of the roadside, patchworked with wonderful billboards and geometric posters. Planes of pure colour: blue, yellow, red. With 80 horsepower and a half-cup of petrol we literally gobbled up the whole length of the Avenida Juarez. I mentally do an unforeseen elliptical turn to avoid the

statue of Carlos IV. Car accessories, Haynes spare parts, wheels, batteries and generators, chassis, spare tyres, horns, spark plugs, oil, petrol. I've made a mistake: Moctezuma de Orizaba is the best beer in Mexico, Buen Tono cigars are of course smoked, etc. A perpendicular brick has crashed through the schematic scaffolding. Everything shudders. My sensations are magnified. The penultimate façade collapses on top of me.

VII. As of now, no more creationism, Dadaism, paroxysm, Synthesism, Imaginism, Suprematism, Expressionism, Cubism, Orphism, etc. No more -isms, however theoretical or practical. Let us formulate a quintessential synthesis to strip away all tendencies that flourished on the highest planes of luminescent and modern exaltation. Not through syncretism – a false desire for reconciliation – but through a rigorous aesthetic conviction and sense of spiritual urgency. It is not a question of prismal techniques, fundamentally anti-seismic, being mistakenly distilled in the glasses of fraternal etiquette, but of inherently organic tendencies, easily adapted with reciprocity, that illuminate our marvellous desire to maximize internal emotions and sensory perceptions in multi-spirited and multi-faceted forms, resolving the equations posed by modern technical problems in all their sinuous complexity.

VIII. Man is not a systematically balanced clockwork mechanism. Genuine emotion is a form of supreme arbitrariness and specific chaos. The whole world is conducted like an amateur band. Ideas are killed off while a single aspect of the emotions, rather than their original three dimensions, is presented, with mock excuses on grounds of clarity and simplicity, overlooking the fact that at any panoramic moment emotions will surface, not only for elemental and conscious reasons but also because of a strong binary impulse of internal propulsion, clumsily susceptible to external worlds yet, in contrast, prodigiously responsive to the roto-translatory projections emanating from the ideal plane of aesthetic truth that Apollinaire called the 'golden section'. From this, one can derive a fuller interpretation of electrically-charged personal emotions due to the positive elements of recent technological developments, since these crystallize a unanimous and unifying aspect of life. Ideas often run off the rails. They never follow on continuously, one after another, but are simultaneous and intermittent. (ii. Profond aujourd'hui. Cendrars. Cosmópolis, 33). They dioramically fill the canvas, superimposing themselves in disciplined convergence at the apex of introspective instant.

IX. And who raised the question of sincerity? Just a moment, ladies and gentlemen, while we shovel on more coal. Every eye is blinded by aluminium flashes, and this absent-minded young lady strolls superficially across the lateral advertisements. Here we have a demonstrative graph. Intermittent conversations surface in the domestic drawing room and a friend begins to play the piano. The electric chrysanthemum sheds its petals in mercurial snows. And that isn't all. Neighbours burn petrol instead

of incense. Ministerial idiocies are promulgated through the gutter press. My abstracted fingers dissolve in smoke. Now, I ask, who of us is the most sincere? Those of us who refuse to admit strange influences, but who purify and crystallize ourselves through the kinaesthetic filter of personal emotions, or all those ideochlorotic and diernefist 'artists' whose only concern is to ingratiate themselves with the amorphous crowd of a scanty audience, an audience of dictatorial and retrograde officious idiots, photophobic academics, and blacklegging art dealers?

X. Let us become more cosmopolitan. We can no longer stick to the traditional chapters of national art. News is sent by telegraph to the top of skyscrapers, those wonderful skyscrapers everyone detests, dromedary clouds floating above them, and electric lifts moving within their muscular webbing. The forty-eighth floor. One, two, three, four, etc. Here we are. And trains devour the kilometres along the parallel bars of the open-air gymnasium. Steam evaporating into absence. Everything approaches and recedes with the motion of the moment. The environment is transformed and its influence modifies everything around it. Racial traits and characteristics begin to be erased from cultural and genetic profiles, through rigorous processes of selection, whilst the psychological unity of the century flowers under the sun of today's meridian. The only possible boundaries in art are the uncrossable ones of our own alienated emotions.

XI. Impose aesthetic limits. Create art from one's own innate abilities nurtured within one's own environment. Not reincorporate old values but create anew. Destroy all those erroneous modern theories rendered false by dint of being interpretations, such as those derived from impressionist (Post-Impressionism) and luminist dead-ends (Divisionism, Vibrationism, Pointillism, etc.). In painting, suppress all the mental suggestion and false literariness so lauded by our critical buffoons. Establish limits, not according to Lessing's interpretative parallels, but on the level of transcendence and equivalence. As Reverdy says, a new art demands a new syntaxis. In this context, Braque's saying is apposite: 'A painter thinks in colours, hence the need for a new syntax of colours.'

XII. No more retrospection. No more futurism. Everyone silent, open-mouthed, miraculously illuminated by the vertigious light of the present; like a sentinel witness to the prodigiousness of unmistakable emotion, unique and electronically sensitized to the upwardly-moving 'I', vertical on the point of the meridional moment, forever renewed yet forever the same. Let us honour the avant-garde. Walter Bonrad Arensberg has already praised positive 'stridentism' by announcing that his poems have a life span of only six hours. Let us love our unparalleled century. Does the public really not have the intellectual capacity to penetrate the phenomenon of our formidable aesthetic movement? All right then. They can stand in the doorway or take themselves off to a music hall. Our egotism is now supreme, our confidence unswerving.

XIII. My gramophone-listening clientele of the infinitely foolish, and the bilious critics eaten away by the lacerating wounds of a pestilential and tortured old-fashioned literature, are of particular delight to me. These retrograde academics, specialists in obfuscation and every variety of esoteric anadroids, are highly praised by our stinking authoritarian intellectual environment. Naturally they purport to circumscribe my heavenly horizons with their useless delimitations, petty rages, and ridiculous vainglorious operattas. Yet such an audience merely encounters the electrifying hermeticism of my negative subversive laughter, in my radically extreme inner conviction, uncircumscribed isolation, and glorious intransigence. What possible spiritual relationship or ideological affinity could there be between a gentleman who puts on evening dress to wash dishes and the music of Erik Satie? With one golden Stridentist word, I can convey the maxims of Dada, created from nothing to counteract the 'official nothings of books, exhibitions and plays'. This synthesis is a radical force set against the solid conservatism of an agglomeration of bookworn bookworms.

XIV. Success to the new generation of Mexican poets, painters and sculptors which has not been corrupted by the easy money of government sinecures, which still stands aloof from the pathetic praise of official critics and the applause of a brutish and concupiscent public! Success to all those who have not resorted to licking the plates at Enrique González Martínez' culinary banquets, to fabricating art out of the stylicide of their intellectual menstruations. Success to those who are magnificently sincere, who have not vanished into the lamentable efflorescences of our nationalistic environment alongside the stench made by the pulque-brewers and the leftovers of fried food. To each and every one we wish success in the name of the contemporary Mexican modernist avant-garde. That they may come and do battle alongside us in the devilish ranks of the 'découvert' where, I believe with Lasso de la Vega, 'we have come a long way from the spirituality of the beast. Like Zarathustra, we have shed our burdens and shaken off prejudice. Our great laughter is great laughter. We are engraving, here and now, new tablets of stone.' And finally, I demand the head of the scholastic nightingales responsible for turning poetry into a repsonian cancan, mounted on the bars of a chair, plucked bare after the downpour in the idyllic pigpens of a bourgeois Sunday. Logic is a mistake and the right to wholeness a monstrous joke. The intelcesteticide Renée Dunan interrupts me. But Salvat-Papasseit, tumbling from his swing, reads this announcement on the screen: spit on the cretins' bald heads, and while the rest of the world spins off axis, contemplating itself with spherical astonishment, wringing its hands, I, in my glorious isolation, am illuminated by the marvellous incandescence of my electrically-charged nerves.

Directory of the Avant-Garde: Rafael Cansinos Assens. Ramón Gómez de la Serna. Rafael Lasso de la Vega. Guillermo de Torre. Jorge Luis Borges. Cleotilde Luisi. Vicente Ruiz Huidobro. Gerardo Diego. Eugenio Montes. Pedro Garfias. Lucía Sánchez Saornil. J. Rivas Panedas. Ernesto López Parra. Juan Larrea. Joaquín de la Escosura. José de Ciria y Escalante. César A. Comet. Isac del Vando Villar. Adriano Del Valle. Juan Las. Mauricio Bacarisse. Rogelio Buendía. Vicente Risco. Pedro Raida. Antonio Espina. Adolfo Salazar. Miguel Romero Martínez. Ciriquiain Caitarro. Antonio M. Cubero. Joaquín Edwards. Pedro Iglesias. Joaquín de Aroca. León Felipe. Eliodoro Puche. Priewto Romero. Correa Calderón. Francisco Vighi. Hugo Mayo. Bartolomé Galíndez. Juan Ramón Jiménez. Ramón del Valle Inclán. José Ortega y Gasset. Alfonso Reyes. José Juan Tablada. Diego M. Rivera. D. Alfaro Siqueiros. Mario de Zayas. José D. Frías. Fermín Revueltas. Silvestre Revueltas. P. Echeverría. At. J. Torres García. Rafael P. Barradas. J. Salvat. Papasseit. José María Yenoy. Jean Epstein. Jean Richard Bloch. Pierre Brune. Marie Blanchard. Corneau. Ferrey. Fournier. Riou. Mme. Ghy Lohem. Marie Laurencin. Dunozer de Segonzac. Honniger. Goerges Auric. Ozenfat. Alberto Gleizes. Pierre Reverdy. Juan Gris. Nicolás Beauduin. William Speth. Jean Paulhan. Guillermo Apollinaire. Cypien. Max. Jacob. Jorge Braque. Survage. Coris. Tristst Tzara. Francisco Picabia. Jorge Ribemont. Dessaigne. Renée Dunan. Archipenko. Soupault. Bretón. Paul Elouard. Marcel Duchamp. Frankel. Sernen. Erik Satie. Elie Faure. Pablo Picasso. Walter Bonrad Arensberg. Celine Arnauld. Walter Pach. Bruce. Morgan Roussel. Marc Chagall. Herr Baader. Max Ernst. Christian Schaad. Lipchitz. Ortíz de Zárate. Correia d'Araujo. Jacobsen. Schkold. Adam Fischer. Mme. Fischer. Peer Kroogh. Alf Rolfsen. Jeauneiet. Piet Mondrian. Torstenson. Mme. Alika. Ostrom. Geline.

Salto. Weber. Wuster. Kokodika. Kandisnsky. Steremberg (Com. de B. A. de Moscou). Mme. Lunacharsky. Erhenbourg. Taline. Konchalowsky. Machkoff. Mme. Ekster. Wlle Monate. Marewna. Larionow. Gondiarowa. Belova. Sontine. Daiibler. Doesburg. Raynal. Zahn. Derain. Walterowua Sur Mueklen. Jean Cocteau. Pierre Albert. Birot. Metsinger. Jean Charlot. Maurice Reynal. Pieux. F. T. Marinetti. G. P. Lucinni. Paolo Buzzi. A. Palazzeschi. Enrique Cavacchioli. Libero Altomare. Luciano Folgore. E. Cardile. G. Carrieri. E. Mansella Fontini. Auro d'Alba. Mario Betuda. Armando Mazza. M. Boccioni. C. D. Carrá. G. Severini. Balilla Psratella. Cangiullo. Corra. Mariano. Boccini. Fessy. Setimelli. Carli. Ochsé. Linati. Tina Rosa. Saint-Point. Divoire. Martini. Moretti. Pirandello. Tozzi. Evola. Ardengo. Sarcinio. Tovolato. Daubler. Doesburg. Broglio. Utrillo. Fabri. Vatrignat. Liege. Norah Borges. Savory. Gimmi. Van Gogh. Grunewald. Derain. Cauconnet. Boussingautl. Marquet. Gernez. Fobeen. Delaunay. Kurk. Scchwiters. Heyniche. Klem. Zirner. Gino. Galli. Bottai. Cioccatto. George Bellows. Giorgio de Chirico. Modigliani. Cantarelli. Soficci. Carena, etcétera,

*One of the heroes of Mexican independence [Ed.]. †Adjacent districts in Mexico City [Ed.]. ‡Wife of the former dictator Porfirio Díaz.

Revista Actual (Mexico City), no. 1 December 1921 (Poster mounted on walls)

6.2 *KLAXON*: Monthly Review of Modern Art

Statement of Intent

The battle was actually joined in the pages of the *Jornal de Comercio* and the *Correo Paulistano* at the beginning of 1921. The result: 'Modern Art Week', a kind of International Conference of Versailles. Like it, the Week had a *raison d'être*. Like it, it brought neither triumph nor disaster. Like it, it bore unripened fruit. Mistakes were shouted from the rooftops. Unacceptable ideas were disseminated. We need to reflect. We need to clarify. We need to construct. That is the reason for KLAXON.

KLAXON will never complain that it is not understood in Brazil. Brazil must make an effort to understand KLAXON.

Aesthetic outlook

KLAXON knows that life exists. And, in the footsteps of Pascal, its objective is the present, now, today. KLAXON is not concerned with being new, it wants to be modern. That is the first law of novelty.

KLAXON knows that humanity exists. That is why it is internationalist. But that would not prevent KLAXON and its

Brazilian contributors from dying for the integrity of Brazil.

KLAXON knows that nature exists. But it also knows that the lyric sense which produces works of art is a lens which transforms and even deforms nature.

KLAXON knows that progress exists. That is why, without rejecting the past, it is always moving forward, ever forward. The bell tower of Saint Mark's was a work of art. It should have been preserved. It was destroyed. Reconstructing it was a sentimental and expensive mistake; it does not meet contemporary needs.

KLAXON knows that the laboratory exists. It wants scientific laws for art; laws based primarily on the advance in experimental psychology. Down with artistic prejudices! Freedom! But a freedom governed by observation.

KLAXON knows that cinematography exists. Pearl White is preferable to Sarah Bernhardt. Sarah is tragedy, sentimental and technical romanticism. Pearl is reason, learning, sport, speed, joy, life.

Sarah Bernhardt = 19th century. Pearl White = 20th century.

MANIFESTOS

Film is the most representative artistic creation of our age. We must learn from it.

KLAXON is not exclusivist. Nevertheless, it will never print the bad unpublished work of good authors just because they are dead.

KLAXON is not Futurist.

KLAXON is Klaxist.

Announcement

KLAXON is primarily concerned with art. But it wants to represent our age from 1920 onwards. So it is polymorphous, omnipresent, enquiring, comic, irritating, contradictory, in demand, insulted, happy.

KLAXON seeks: it will find. KLAXON knocks: the door will open. KLAXON does not destroy bell towers. But it will not rebuild ones that are destroyed. It will use the space for solid, hygienic, arrogant buildings of reinforced concrete.

KLAXON has a collective soul and a constructive impetus. But just as each engineer uses materials best suited to him, KLAXON's contributors will each be responsible for their own ideas.

Problem

The nineteenth century – Romanticism, Ivory Tower, Symbolism. Then the international fireworks of 1914. For almost 130 years humanity has been killing time. We are right to rebel. We want to bring gaiety. Farce and burlesque do not disgust us, just as they did not disgust Dante, Shakespeare or Cervantes. Soaked, chilled, rheumatized by a tradition of artistic tears, we have made a decision. Surgery. Extract the tear ducts. It is the age of 8 batutas, the Jazz Band, Chicharrão, Charlie Chaplin, Mutt and Jeff. The Age of Construction. The Age of KLAXON.

Editorial Board

Revista Klaxon (São Paulo), no. 1 15 May 1922

6.3 Pau-Brasil Poetry Manifesto

Poetry exists in facts. The shacks of saffron and ochre among the greens of the hillside favelas, under cabraline blue, are aesthetic facts.

The Carnival in Rio is the religious outpouring of our race. Pau-Brasil. Wagner yields to the samba schools of Botafogo. Barbaric, but ours. Rich ethnic mix. Richness of vegetation. Minerals. Casserole of vatapá. Gold and dance.

The whole history of *Tordesillas* (the pioneers)* and the commercial history of Brazil. The learned side, the scholarly side, the famous authors side. Stirring stuff. Rui Barbosa, a top hat in Senegambia. Everything turns to richness. The richness of the dances, and stock phrases. Black women in the Jockey Club. Odalisques in Catumbí. Obscure speech.

The learned side. Fate of the first white colonizer, the political master of the virgin jungle. The graduate. We can't stop being learned. Doctors. Country of anonymous pain, anonymous doctors. The Empire was like that. We are all erudite. We have forgotten the plumed sparrow hawk.

We don't export poetry. Poetry is hidden in the malicious creepers of knowledge. In the lianas of university nostalgia.

But learning exploded. Men who knew everything were distorted like blown-up balloons. They popped.

Back to specialization. Philosophers studying philosophy, critics being critics, housewives staying in the kitchen.

Poetry for poets. The joy of discovery for the ignorant.

Everything was turned on its head, everything invaded: intellectualized theatre and the struggle on stage between the moral and the immoral. The thesis must be decided in a war of sociologists, men of law, fat and golden like Corpus Juris.

The theatre is agile, born of acrobats. Agile and illogical. The novel is agile, born of invention. Poetry is agile. Pau-Brasil poetry. Agile and candid. Like a child.

A suggestion from Blaise Cendrars: stoke your engines, you're ready to go. A black turns the handle of the rotating platform you're standing on. The slightest hitch will send you off in the opposite direction to your destiny.

Down with bureaucracy, the erudite practice of life. Engineers instead of jurists, lost like Chinamen in the genealogy of ideas.

Language free of archaisms, free of erudition. Natural and neological. The millionfold contribution of error. How we speak. How we are.

Battles are not waged in the land of academia. There are only uniforms. The Futurists and the others.

One lone battle – the battle for the way forward. Let us distinguish: Imported poetry. And Pau-Brasil Poetry, for export.

The five learned parts of the world went through a period of aesthetic democratization. Naturalism became institutionalized. Copying. Paintings of sheep had to be of pure wool, or they were no good. The oral dictionary of the School of Fine Arts defined interpretation as 'reproducing exactly as it is...'. Pyroengraving arrived. Every other nice young girl wanted to be an

artist. Then came the camera. And with all the privileges of long hair, dandruff and the mysterious genius of the inverted eye, the artist-photographer.

In music, the piano invaded bare rooms with calendars on the wall. Every other girl wanted to be a pianist. The advent of the pianola and the grand piano. The pianola. Slav irony composed for the pianola. Stravinsky.

Statuary was left behind. Processions came out of the factories brand new.

The only thing not invented was a poem-writing machine. The Parnassian poet already existed.

Then the revolution indicated that art was becoming élitist again. And the élites began by undoing. Two phases. First, distortion through Impressionism, fragmentation, voluntary chaos. From Cézanne to Mallarmé, Rodin and Debussy to the present day. Second, lyricism, the presentation in the temple, materials, constructive innocence.

Opportunist Brazil. Learned Brazil. And the coincidence of Brazil's first construction with the general reconstruction movement. Pau-Brasil Poetry.

In this age of miracles, laws stem from the very dynamic rotation of destructive elements.

Synthesis

Balance

Finished bodywork

Invention

Surprise

A new perspective

A new scale

Any natural effort in this direction will be good. Pau-Brasil Poetry.

Work against naturalist detail, by synthesis; against romantic softness, by geometric balance and finished technique; against copying, by inventiveness and surprise.

A new perspective.

The other, that of Paolo Uccello, was the very height of Naturalism. It was an optical illusion. Far-away objects did get smaller. It was a law of appearances. Then came the reaction against appearances. Reaction against copies. Replace the visual, natural perspective with another kind of perspective: emotional, intellectual, ironic, naïve.

A new scale.

The other, that of a world catalogued by words in books and babes in arms. The advertisement producing letters taller than towers. And new forms of industry, transport, aviation. Ports and airports. Pylons. Petrol stations. Rails. Laboratories and technical workshops. Voices and clicking cables, and airwaves and flashing lights. Stars made familiar by photo negatives. The equivalent in art of physical surprise.

React against the invasive subject, far removed from the objective.

Intellectual theatre was a monstrous compromise. The novel of ideas, a mishmash. Historical painting, an aberration. Eloquent sculpture, a meaningless fear.

Our age heralds the return of pure meaning.

A painting is made of lines and colours. Sculpture is volumes under light.

Pau-Brasil Poetry is a Sunday dining room, with birds singing in the tiny jungle of their cages, a thin man composing a waltz for flute and Mary-Jane reading the paper. Our whole present is in the newspapers.

There is no formula for a contemporary expression of the world. Look with unblinkered eyes.

We have a dual heritage – the jungle and the school. Our credulous mestizo race, then geometry, algebra and chemistry after the baby's bottle and herbal tea. 'Go to sleep my baby or the bogeyman will get you', mixed with equations.

A vision which is present in windmills, electric turbines, industry, factories, and the Stock Exchange, but which keeps one eye on the National Museum. Pau-Brasil.

Lift shafts, skyscraper cubes, and the compensating laziness of the sun. Devotions. Carnival. Intimate energy. The songbird. Hospitality, somewhat sensual, loving. The nostalgia of medicine men and military airfields. Pau-Brasil.

The work of the Futurist generation has been Cyclopic. Adjust the imperial clock of Brazilian literature.

Once this stage is past, the problem is different. To be true to one's region and time.

The state of innocence replacing the state of grace which can be spiritual.

Native authenticity to redress the balance of academic influence.

Reaction against the indigestibility of knowledge. The best of our lyric tradition. The best of what we are today.

Brazilians of our time, or nothing. The strictly necessary of chemistry, mechanics, economics, ballistics. All digested. No cultural forum. Practical. Experimental. Poets. No bookish reminiscences. No comparisons. No etymological research. No ontology.

Wild, naïve, picturesque, and tender. Readers of newspapers. Pau-Brasil. Jungle and school. National Museum. Cooking, minerals and dance. Vegetation. Pau-Brasil.

OSWALD DE ANDRADE

*The Treaty of 1493 whereby the Pope allotted Africa and Brazil to Portugal, and the rest of South America to Spain [Ed.]

Correio da Manha, Rio de Janeiro 18 March 1924

6.4

Anthropophagite Manifesto

Only anthropophagy unites us. Socially. Economically. Philosophically.

The world's only law. The disguised expression of all individualisms, of all collectivisms. Of all religions. Of all peace treaties

Tupy or not tupy, that is the question.

Down with all catechisms. And down with the mother of the

The only things that interest me are those that are not mine. The laws of men. The laws of the anthropophagites.

We are tired of all the dramatic suspicious Catholic husbands. Freud put an end to the enigma of woman and to other frights of printed psychology.

Truth was reviled by clothing, that waterproofing separating the interior from the exterior world. The reaction against the dressed man. The American cinema will inform you.

Children of the sun, the mother of mortals. Found and loved ferociously, with all the hypocrisy of nostalgia, by the immigrants, slaves and tourists. In the country of the giant snake.

It was because we never had grammar books, nor collections of old vegetables. And we never knew what urban, suburban, frontiers and continents were. We were a lazy spot on the map of Brazil.

A participating consciousness, a religious rhythm.

Down with all the importers of the canned conscience. The palpable existence of life. The pre-logical mentality for M. Lévy-Bruhl to study.

We want the Carahiba revolution. Bigger than the French Revolution. The unification of all successful rebellions led by man. Without us, Europe would not even have its meagre Declaration of the Rights of Man. The golden age proclaimed by America. The golden age and all the girls.

Descent. Contact with Carahiban Brazil. Où Villeganhon print terre [sic]. Montaigne. Natural man. Rousseau. From the French Revolution to Romanticism, to the Bolshevik Revolution, to the Surrealist revolution and the technical barbarity of Keyserling. We continue on our path.

We were never catechized. We sustained ourselves by way of sleepy laws. We made Christ be born in Bahia. Or in Belém, in Pará

But we never let the concept of logic invade our midst.

Down with Father Vieira. He contracted our first debt, so as to get his commission. The illiterate king told him: write it down on paper but without too many fine words. And so the loan was made. An assessment on Brazilian sugar. Vieira left the money in Portugal and left us with the fine words.

The spirit refused to conceive of the idea of spirit without body. Anthropomorphism. The need for an anthropophagical vaccine. We are for balance. Down with the religions of the meridian. And foreign inquisitions.

We can only pay heed to an oracular world.

Justice became a code of vengeance and Science was transformed into magic. Anthropophagy. The permanent transformation of taboo into totem.

Down with the reversible world and objective ideas. Transformed into corpses. The curtailment of dynamic thought. The individual as victim of the system. The source of classic injustices. Of romantic injustices. And the forgetting of interior conquests.

Routes. Routes. Routes. Routes. Routes.

The Carahiban instinct.

The life and death of hypotheses. From the equation – me as part of the Cosmos – to the axiom – the Cosmos as part of me. Subsistence. Knowledge. Anthropophagy.

Down with the vegetable élites. In communication with the earth.

We were never catechized. Instead we invented the Carnival. The Indian dressed as a Senator of the Empire. Pretending to be Pitt. Or appearing in Alencar's operas, full of good Portuguese feelings.

We already had communism. We already had surrealist language. The golden age. Catiti Catiti Imara Natiá Notiá Imara Ipeiú.

Magic and life. We had the relation and the distribution of physical goods, moral goods and the goods of dignity. And we knew how to transpose mystery and death with the help of grammatical forms.

I asked a man what Law was. He told me it was the guarantee to exercise the possible. That man was called Gibberish. I swallowed him.

Determinism does not exist only where there is mystery. But what has this got to do with us?

Down with the stories of men, that begin at Cape Finistère. The undated uncountersigned world. No Napoleon. No Caesar.

The determining of progress by catalogues and television sets. They are only machines. And the blood transfusors.

Down with the antagonical sublimations. Brought in caravels.

Down with the truth of missionary peoples, defined by the sagacity of a cannibal, the Viscount of Cairú: – A lie repeated many times.

But they who came were not crusaders. They were fugitives from a civilization that we are devouring, because we are strong and vengeful just like Jaboty.

If God is the conscience of the Universe Uncreated, Guaracy is the mother of living beings. Jacy is the mother of all plants.

We did not speculate. But we had the power to guess. We had Politics which is the science of distribution. And a planetary social system.

The migrations. The flight from tedious states. Down with urban sclerosis. Down with the Conservatoires and tedious speculation.

From William James to Voronoff. The transfiguration of

tabool in totem. Anthropophagy.

The pater familias and the creation of the Moral of the Stork: real ignorance of things + lack of imagination + sentiment of authority towards the curious progeny.

It is necessary to start with a profound atheism in order to arrive at the idea of God. But the Carahiba did not need one. Because they had Guaracy.

The created object reacts like the Fallen Angel. After, Moses wanders. What has this got to do with us?

Before the Portuguese discovered Brazil, Brazil had discovered happiness.

Down with the Indian candleholder. The Indian son of Mary, godson of Catherine de Medici and son-in-law of Sir Antonio de Mariz.

Happiness is the proof of the pudding.

In the matriarchy of Pindorama.

Down with the Memory, source of custom. Personal experience renewed.

We are concretists. Ideas take hold, react, burn people in public squares. We must suppress ideas and other paralyses. Along the routes. Believe in signs, believe in the instruments and the stars.

Down with Goethe, the mother of the Gracchi, and the court of João VI.

Happiness is the proof of the pudding.

The *lucta* between what one would call the Uncreated and the Creature illustrated by the permanent contradiction between man and his taboo. The daily love and the capitalist *modus vivendi*. Anthropophagy. Absorption of the sacred enemy. In order to transform him into totem. The human adventure. The

mundane finality. However, only the purest of élites managed to become anthropophagous in the flesh and thus ascended to the highest sense of life, avoiding all the evils identified by Freud, catechist evils. What happens is not a sublimation of sexual instincts. It's the thermometric scale of the anthropophagous instinct. Moving from carnal to wilful and creating friendship. Affective, love. Speculative, science. Deviation and transference. And then vilification. The low anthropophagousness in the sins of the catechism – envy, usury, calumny, murder. Plague of the so-called cultured Christianized peoples, it is against it that we are acting. Anthropophagi.

Down with Anchieta singing the eleven thousand virgins of the sky in the land of Iracema – the patriarch João Ramalho, founder of São Paulo.

Our independence has not yet been proclaimed. A typical phrase of João VI: – My son, put this crown on your head before some adventurer puts it on his! We expelled the dynasty. We must expell the spirit of Bragança, the laws and the snuff of Maria da Fonte.

Down with social reality, dressed and oppressive, registered by Freud – reality without complexes, without madness, without prostitution and without the prisons of the matriarchy of Pindorama.

OSWALD DE ANDRADE

Piratininga, The year 374 after the swallowing of the Bishop of Sardinia

Revista de Antropofagia (São Paulo), no. 1 May 1928

6.5 'Martín Fierro' Manifesto

Faced with the elephantine impermeability of the 'honourable public';

Faced with the funereal solemnity of historians and academics who mummify everything they touch;

Faced with the formulas which inspire the lucubrations of our 'greatest' minds, and the fondness for Anachronism and Mimeticism:

Faced with the absurd need to promote intellectual nationalism which inflates the false values that pop like balloons at the first pinprick;

Faced with the inability to look at life without scaling library shelves;

And faced, above all, with the terrible fear of being mistaken which paralyses the creative impulses of a young generation which is more moth-eaten than any retired bureaucrat;

Martín Fierro feels that it is imperative to make its position clear,

and calls upon all those capable of recognizing that there is now a NEW sensibility and a NEW understanding in the air which, if we are true to ourselves, offer us unexpected horizons and new means and forms of expression.

Martín Fierro accepts the consequences and the responsibilities of adopting a position. Its very health depends on it. Mindful of our history, anatomy and latitude, we consult the barometer and the calendar before going out into the street to live our lives with nerves and minds of today.

Martín Fierro believes that 'everything is new under the sun' if looked at through modern eyes and expressed in contemporary accents.

Martín Fierro is, therefore, more at home in a modern transatlantic liner than a Renaissance palace and believes that a nice Hispano-Suiza is a much more perfect WORK OF ART than a Louis XV chair.

MANIFESTOS

Martín Fierro sees architectonic possibilities in an 'Innovation' suitcase, a lesson in synthesis in a 'marconigramo', intellectual organization in a 'rotary press', but does not object to having, like all the best families, a photo album to leaf through from time to time to discover a likeness to an ancestor. . . or laugh at his collar and tie.

Martín Fierro believes in the importance of the intellectual contribution of the Americas, after taking a scissors to each and every umbilical cord. But extending the independence movement, begun in language by Rubén Darío, to all intellectual manifestations does not mean we have to give up or, even less, pretend that we don't see the Swedish toothpaste, French towels and English soap we use every morning; far from it.

Martín Fierro has faith in our phonetics, our view of things, our fashions, our ear for things, and our ability to digest and assimilate.

Martín Fierro, artist, is constantly rubbing his eyes to wipe away the cobwebs which habit and custom keep forming. Offer each new love a new virginity, and may the excesses of each new day be different from those of yesterday and tomorrow! This, for

him, is the true sanctity of the creator! There are so few saints! *Martín Fierro*, critic, knows that you cannot compare a train to an apple. The fact that everyone does compare a train to an apple and some choose the train, others the apple, confirms his suspicion that there are many more 'blacks' around than is apparent. A black is someone who shouts 'Stupendous!' and thinks he has said it all. A black is someone who needs to be dazzled with glitter and isn't satisfied until he is dazzled. A black is someone who holds his hands out flat like a pair of scales, weighs everything, and judges everything by its weight. There are so many blacks!

Martín Fierro only values those blacks and whites who are really black or white, and who do not have the slightest intention of changing colour.

Do you support *Martín Fierro*! Contribute to *Martín Fierro*! Subscribe to *Martín Fierro*!

Martín Fierro (Buenos Aires), no. 4 15 May 1924

6.6 Pure Creation An essay on aesthetics

The enthusiasm for art in our time and the conflict between the diverse individual and collective conceptions which stem from this enthusiasm, have made aesthetic questions fashionable again, just as they were in the days of Hegel and Schleiermacher.

We must, however, exact greater clarity and precision than in those days because the metaphysical language of the eighteenthand early nineteenth-century professors of aesthetics has no meaning for us now.

Therefore we must leave metaphysics as far behind as possible and gravitate towards scientific philosophy.

Let us begin by studying the different stages, the diverse aspects of art.

These stages can be reduced to three, and for greater clarity, I have outlined my plan as follows:

Lower than average Art (Reproductive Art)
Art in harmony with its environment (Adaptive Art)
Higher than average Art (Creative Art)

Each part of this outline marks a period in the history of art and involves a second outline, also in three parts, which sets out the evolution of each of those periods:

Predominance of intelligence over sensitivity Harmony between sensitivity and intelligence Predominance of sensitivity over intelligence

If we analyse the first element of the first outline – Reproductive Art, that is – we see that the first steps towards its

'exteriorization' are provided by intelligence, which seeks and experiments. It is a question of reproducing nature, and reason tries to do it in the most economical and simple way the artist is capable of.

Everything superfluous is left aside. In this period, new problems have to be resolved every day and the intelligence has to work with such zeal that sensitivity is relegated to second place.

But then comes the second period: the main problems have been solved and everything superfluous and unnecessary to the creation of the work has been carefully jettisoned. Sensitivity now takes its place beside intelligence, varnishes the work with a warmth which makes it less dry and injects more life than in the first period. This second period marks the height of an art.

The generations of artists which follow have learned this art like a recipe, they are used to it and can do it from memory. They have forgotten, however, the laws which originally constituted it and provide its very essence. They see only its external and superficial side; in short, its appearance. They create their work from pure sensitivity, we might even say mechanically, because habit turns it from a conscious act into an unconscious one. Here begins the third period: decadence.

I have to add that various schools are involved in each of these stages. In the Reproductive Art stage, we have Egyptian, Chinese, Greek and primitive art, Renaissance art, classic art, Romantic art, etc. The whole history of art is full of examples to testify to it.

In these diverse stages, there are obviously artists in whom one faculty dominates the other, but in the main they follow the path I have set out here.

Every serious school which marks an era must necessarily begin with a period of investigation in which the intelligence directs the artist's work. This first period can originate in sensitivity and intuition; that is, a series of unconscious inputs. Always starting from the basis that everything passes through the senses first. But this only occurs at the moment of gestation, which is prior to the production of the work itself, like its first impulse. It probes in the dark, but when it comes out into the light, when it is exteriorized, the intelligence goes to work.

Believing that intuition is part of sensitivity is a common error. For Kant, there can be no intellectual intuition in it. On the other hand, Schelling says that only intellectual intuition can catch the relationship of basic unity which exists between the real and the ideal.

Intuition is a priori knowledge and only enters the work as impulse; it is prior to realization and only in rare cases does it remain there during the course of it.

In any case, intuition is not found closer to sensitivity but stems from a rapid understanding between the heart and the brain, like an electric spark which suddenly illuminates the darkest depths of a receptacle.

In a conference I gave in the Buenos Aires Atheneum, in July 1916, I said that the whole history of art is merely the history of the evolution of Man-Reflection towards Man-God; that when we study this evolution we see clearly the natural tendency of art to move further and further away from pre-existent reality and seek its own truth, leaving behind everything superfluous, every impediment to its perfect realization. And I added that all this is as visible to the observer as the evolution of the *Paloplotherium* through the *Anquitherium* to the horse is in geology.

This idea of the artist as absolute creator, the Artist-God, was suggested to me by an old South American Indian poet (Aimara) who said: 'The poet is a god; don't sing to the rain, poet, make it rain.' Despite the fact that the author of these lines made the mistake of confusing poets with magicians, and believing that in order to create, the artist must change the rules of the world, when what he has to do is create his own world, parallel and independent of nature.

The idea that the truth of art and the truth of life are separate from scientific and intellectual truth was no doubt thought of a long time ago, but no one put it as precisely and showed it as clearly as Schleiermacher when he said, at the beginning of the last century, that 'poetry does not seek truth, or rather it seeks a truth which has nothing in common with objective truth. Art and poetry only express the truth of a single consciousness'.

It is important to note this difference between life's truth and art's truth; one precedes the artist, the other comes afterwards, produced by him.

Confusing the two truths is the main source of error in aesthetic judgement.

This point is important because the period beginning now will be eminently creative. Man is shaking off his yoke, rebelling against nature as Lucifer rebelled against God, despite the fact that it is only an outward rebellion, because man has never been closer to nature than at present when he no longer seeks to imitate it superficially but, like nature itself, imitates it in all the depths of its constructivist laws, in the realization of a whole, within the mechanism of the production of new forms.

We see straight away how man, the product of nature, follows the same order and laws as nature in his own independent creation.

It is not a question of imitating nature but doing as nature does, not imitating its exteriorizations but its exteriorizing power.

Since man belongs to nature and cannot escape it, he should obtain from it the essence of its creations. We will have to consider, therefore, the relationship between the objective world and the ego, the subjective world of the artist.

The artist receives his motifs and elements from the objective world, he transforms them and combines them and gives them back to the objective world as something new. This aesthetic phenomenon is as free and independent as any other phenomenon of the external world – a plant, a bird, a star, or a fruit – and like them its *raison d'être* is within itself and it has the same rights and independence.

The study of the diverse elements which the phenomena of the objective world offer the artist, selecting some, rejecting others, according to the work he wants to create, is what forms the System.

Hence, the system of Adaptive Art is different from that of Reproductive Art, because the artist belonging to the former takes different elements from nature than the imitative artist. The same goes for the artist in the Creative period.

So the system is the bridge by which the elements of the objective world pass to the ego or subjective world.

The study of the means of expression by which the selected elements reach the objective world, constitutes the Technique.

Therefore, the technique is the bridge between the subjective world and the objective world created by the artist.

Objective world which offers the artist diverse elements

System

Subjective world

Technique

Return to the objective world in the form of something new created by the artist

This 'something new' created by the artist is precisely what interests us, and the study of it, together with the study of its genesis, constitutes the aesthetic or theory of art.

The perfect harmony between System and Technique is what makes Style, and the result of the predominance of one of these factors over the other is Manner.

We can say, then, that an artist has style when the methods he uses to realize his work are in perfect harmony with the elements he chose from the objective world.

When an artist has good technique but does not know how to choose his elements perfectly or, on the contrary, when the elements he uses are suited to his work but his technique leaves something to be desired, that artist will never have a style, only a manner.

We will not bother about those whose system has no rapport at all with their technique. They do not enter into a serious study of art, although they are the majority, keep journalists happy, and are the toast of phoney art-lovers' salons.

Before I end this article, I want to make one point clear: almost all modern intellectuals want to deny the artist his right to create, and even artists themselves seem to be afraid of the word.

For years I have been fighting for art of pure creation, it has been a real obsession running through all my work. In my book *Pasando y Pasando*, published in January 1914, I said that the poet must be interested in 'the creative act and not in the act of crystallization'.

It is those very scientists who deny the artist the right to create who should, more than anyone, be granting it to him.

Does not the art of mechanics also humanize nature and result

6.7

Amauta

Editorial

This magazine does not represent an intellectual group. It represents a movement, a spirit. For some time now there has been an increasingly vigorous and determined trend towards new ideas in Peru. Those responsible for this new spirit are called the avant-garde, socialists, revolutionaries, etc. History has not as yet baptized them definitively. Although certain divergences of form, certain psychological differences, do exist, these young spirits stress, over and above what divides them, the thing which unites them: their desire to create a new Peru within a new world. Understanding and co-operation among the most dynamic of them is progressing apace. The intellectual and spiritual movement is gradually becoming organic. With the

in creation?

And if the mechanic is conceded the right to create, why deny it to the artist?

When someone says a car has 20 horsepower, no one can see 20 horses. Man has created an equivalent but we don't see them. He has done the same as nature.

Man, in this case, has created something without imitating nature superficially but by obeying its internal laws. And it is curious to see how man has followed the same order as nature in his creations, not only in the constructive mechanism but also in the chronology.

Man begins by seeing, then he listens, then he talks, and finally he thinks. In creating, man followed the order which was imposed on him. First he invented photography, which consists of a mechanical optical nerve. Then the telephone, which is a mechanical aural nerve. Then the gramophone which is made up of mechanical vocal chords. And finally the cinema, which is mechanical thought.

And not only in this, but in all human creations, an artificial selection parallel to natural selection has been produced, still obeying the same laws of adaptation to the environment.

We find this in a work of art just as we do in mechanical things and in each human production.

That is why I said at a conference on Aesthetics in 1916 that a work of art 'is a new cosmic reality which the artist adds to nature and it should have, like the stars, its own atmosphere and a centripetal and a centrifugal force. Forces which give it a perfect equilibibrium and take it out of the productive centre'.

The time has come to draw artists' attention to pure creation. It is talked about a lot, but nobody does it.

VICENTE HUIDOBRO

From Vicente Huidibro, *Obras* (First published 1925)

publication of Amauta, it is entering a decisive stage.

Amauta has gone through a normal gestation process. It did not suddenly appear because I decided it should. I returned from Europe determined to start a magazine. Painful personal vicissitudes prevented me from doing so, however. But the time was not spent in vain. My efforts found an echo in other intellectuals and artists who think and feel as I do. Two years ago this magazine would have been a somewhat personal venture. Now it is the voice of a movement, and a generation.

What the contributors to *Amauta* aim to do first is to understand each other better. Working together on the magazine will forge a certain solidarity. As it slowly attracts other good

people, it will also dissuage the various waverers and faint hearts who flirt with avant-gardeism but disappear as soon as any sacrifice is demanded. *Amauta* will sift through the avant-garde, militants and sympathizers, and separate the wheat from the chaff. It will polarize and concentrate, or at least accelerate the process.

There is no need to state expressly that *Amauta* is not an open forum for all currents of opinion. We who founded the magazine do not conceive of culture and art as agnostic. We are militant and polemical. We make no concession whatsoever to the generally fallacious criteria of intellectual tolerance. For us, there are good ideas and bad ideas. In the introduction to my book *La Escena contemporánea* (The Contemporary Scene), I wrote that I am a man of one affiliation and one faith. I can say the same for this magazine. It rejects whatever is contrary to its ideology, or indeed anything that pretends no ideology at all.

Neither is there a need for solemn words to introduce *Amauta*. I want rhetoric banned from the magazine. Programmes seem absolutely pointless to me. Peru is a country of postures and labels. Let us have content, something with spirit, for a change. *Amauta* does not need a programme; it needs only a destiny, an objective.

6.8 Art, Revolution, and Decadence

It is important to dispel with the utmost speed a misleading idea which is confusing some young artists. We must correct certain hasty definitions, and establish that not all new art is revolutionary, nor is it really new. Two spirits co-exist in the world at present, that of revolution and that of decadence. Only the former confers on a poem or painting the title new art.

We cannot accept as new, art which merely contributes a new technique.

That would be flirting with the most fallacious of current illusions. No aesthetic can reduce art to a question of technique. New technique must also correspond to a new spirit. If not, the only things to change are the trappings, the setting. And a revolution in art is not satisfied with formal achievements.

Distinguishing between the two contemporary categories of artists is not easy. Decadence and revolution; just as the two coexist in the same world, so they co-exist within the same individual. The artist's conscience is the arena for the struggle between the two spirits. This struggle is sometimes, almost always, beyond the comprehension of the artist himself. But one of the two spirits ultimately prevails. The other remains strangled in the arena.

The decadence of capitalist civilization is reflected in the atomization and dissolute nature of its art. In this crisis, art has above all lost its essential unity. Each of its principles, each of its elements, has asserted its autonomy. Secession is the most natural conclusion. Schools proliferate *ad infinitum* because no centrifugal forces exist.

But this anarchy, in which the spirit of bourgeois art dies,

The title will probably bother some people. This is because labels are so important in Peru. In this case, the strict meaning of the word is not important. The title expresses our adherence to the Indian race, it merely reflects our allegiance to Incaism. But the word takes on a specific new meaning with this magazine. We will create it anew.

The aim of the magazine is to raise, elucidate and understand Peruvian problems from a doctrinal and scientific perspective. We will, however, always look at Peru in a world-wide context. We will examine all the important new movements in politics, philosophy, art, literature and science. The human race is our domain. The magazine will link the new men of Peru firstly with the new men of the Americas, and then with the new men of the world.

I have no more to add. It takes very little perception to realize that a historic magazine is being born in Peru.

José Carlos Mariátegui

Amauta (Lima), no. 1 1926

irreparably fragmented and broken, heralds a new order. It is the transition from dusk to dawn. In this crisis, the elements of a future art emerge separately. Cubism, Dadaism, Expressionism, etc., signal a crisis and herald a reconstruction at the same time. No single movement provides a formula, but all contribute (an element, a value, a principle) to its development.

The revolutionary nature of contemporary schools or trends does not lie in the creation of a new technique. Nor does it lie in the destruction of the old. It lies in the rejection, dismissal and ridicule of the bourgeois absolute. Art is always nourished, consciously or unconsciously – it's not important – by the absolute of its age. The contemporary artist's soul is, in the majority of cases, empty. The literature of decadence is literature with no absolute. But man can take no more than a few steps like that. He cannot march forward without a faith, because having no faith means having no goal. And marching without a goal is standing still. The artist who declares himself most exasperatedly sceptical and nihilistic is, generally, the one who most desperately needs a myth.

The Russian Futurists have embraced Communism, the Italian Futurists have embraced Fascism. Is there any better historical proof that artists cannot avoid political polarization? Massimo Bontempelli says that in 1920 he felt almost Communist and in 1923, the year of the march to Rome, he felt almost Fascist. Now he feels totally Fascist. Many people have made fun of Bontempelli for that confession. I defend him; I think he is sincere. The empty soul of poor Bontempelli has to accept the Myth which Mussolini lays on his altar. (The Italian avant-garde

is convinced that Fascism is the Revolution.)

César Vallejo writes that, while Haya de La Torre thinks the *Divine Comedy* and *Don Quijote* have political undercurrents, Vicente Huidobro maintains that art is independent of politics. The causes and motives behind this assertion are so old-fashioned and invalid that I wouldn't ascribe it to an Ultraist poet, assuming Ultraist poets are capable of discussing politics, economics and religion. If, for Huidobro, politics is exclusively what goes on in the Palais Bourbon, we can clearly endow his art with all the autonomy he wishes. But the fact is that politics, for those of us who, as Unamuno says, see it as a religion, is the very fabric of history. In classical periods, or periods of supreme order, politics may merely be administration and trappings; in romantic periods and regimes in crisis, however, politics occupies the foreground.

This is evident in the conduct of Louis Aragon, André Breton and their fellow artists of the Surrealist Revolution – the best minds of the French avant-garde – as they march towards Communism. Drieu La Rochelle, so close to this state of mind when he wrote 'Mesure de la France,' and 'Plainte contre l' Inconnu', could not follow them. But since he could not escape politics either, he declared himself vaguely Fascist and clearly reactionary.

In the Hispanic world, Ortega y basset is responsible for part of this misleading idea about new art. Since he could not distinguish between schools or trends, he could not distinguish, at least in modern art, between revolutionary elements and decadent elements. The author of *The Dehumanization of Art* did not define new art. Instead, he took as features of a revolution those which are typical of decadence. This led him to state, among other things, that 'new inspiration is always, unfailingly, cos-

6.9 1927 Exhibition of New Art

The editors and contributors of the magazine 1927 are the main promoters of and participants in this first group exhibition of New Art. We wish, therefore, expressly to identify ourselves as the sponsors of this event. Hence the exhibition, the first of its kind in Havana, will bear the name 1927. Two of our five editors have been, and still are, almost entirely responsible for heralding this new aesthetic. It is not surprising, therefore, that our magazine is sponsoring the forthcoming exhibition and will be closely involved with it.

As the sponsors of this first group exhibition of New Art in Cuba, to 1927 falls the honour of introducing a new generation of artists determined to link our art with the important events of our time without abandoning its essential Cubanism. These artists are: Eduardo Abela, Rafael Blanco, Gabriel Castaño, Carlos Enríquez, Víctor Manuel García, Antonio Gattorno, José

mic'. His symptomological framework is, in general, correct; but his diagnosis is incomplete and mistaken.

Method is not enough. Technique is not enough. Despite his images and his modernity, Paul Morand is a product of decadence. A sense of dissoluteness pervades his literature. After flirting with Dadaism for a while, Jean Cocteau now gives us 'Rappel à l'ordre.'

It is important to clarify this matter, to dispel the very last misconceptions. The task is not easy. Many points are difficult to reconcile. Glimpses of decadence are frequently seen in the avant-garde even when, overcoming the subjectivism which sometimes infects it, they want to achieve truly revolutionary goals. Hidalgo, thinking of Lenin, says in a multi-dimensional poem, that the 'Salome breasts' and 'tomboy hairstyle' are the first steps towards the socialization of women. This should not surprise us. There are poets who think that the jazz band is a herald of the revolution.

Fortunately there are artists in the world, like Bernard Shaw, who are capable of understanding that 'art cannot be great unless it provides an iconography for a living religion, but it cannot be completely objectionable either except when it imitates the iconography of a religion which has become superstition.' This path seems to be the one taken by various new artists in French and other literature. The future will mock the naïve stupidity with which some critics of their time called them 'new' and even 'revolutionary'.

José Carlos Mariátegui

Lima, 3 November 1926

Hurtado de Mendoza, Luis López Méndez, Ramón Loy, Alice Neel, Rebeca Peink de Rosado Avila, Marcelo Pogolotti, Lorenzo Romero Arciaga, Alberto Sabas, José Segura, and Aida M. Yunkers. Proof that we have overcome any local 'isms' is seen in the participation of Peink de Rosado, López Méndez, Neel and Yunkers.

This group exhibition is not intended, either by 1927 or its artists, to define or single out any particular trend or style of painting. This, we think, would still be very premature. We wish only to bring together the work of young artists stimulated by a sense of anxiety, enquiry, a search for new horizons, as long as it is a genuine position and not some false simulation. It is not simply a question of enlisting forces, but of a much-needed revision of values that will enable us to move forward. Martí Casanovas, Francisco Ichaso, Jorge Mañach, Juan Marinello, and Luis G. Wangüemert will give lectures in conjunction with

the event.

1927 Revista de Avance (Havana), no. 3 15 April 1927

6.10

Manifesto of the Grupo Minorista

In response to a certain statement by a local journalist and essayist, Señor Lamar Schweyer, to the effect that the Grupo Minorista (Minority Group) does not exist, the undersigned, who consider themselves to be members of the said group, feel obliged to correct, once and for all, the misconception under which certain people, among them Señor Lamar Schweyer, are labouring.

What is the Grupo Minorista, how was it born, what is it, who belongs to it?

Some years ago, on 18 March 1923 to be precise, a small number of intellectuals (artists, journalists, lawyers) happened to be present at the Academy of Sciences and joined in an act of protest and censure against the then Minister of Justice who was also present, thereby manifesting the general public's repudiation of the government's famous purchase of the Convent of Santa Clara contrary to the wishes of the majority of the population.

That action set a destructive, apolitical pattern of behaviour for young people who wanted to participate honourably in civic life, and provided Cuban intellectuals with a formula for social sanction and revolutionary activity.

This nucleus of protesters used to meet regularly to assess material and books for a proposed anthology of modern Cuban poetry, so a link was forged between artistic collaboration and civic, even legal, responsibility.

From there, they tried to organize and expand the group, and proposed the creation of the so-called 'Falange of Cuban Action'. This form of organization did not prove effective, but almost all its adherents, together with a broader spectrum of dedicated sympathizers, joined the ranks of the association known as the 'Veterans and Patriots', which was planning an armed movement against administrative corruption and government incompetence.

What was this symptomatic of? Why these frequent spontaneous gatherings of usually the same people, almost all young, almost all connected with the arts? Why did the group's conversation revolve around mocking false values, jingoistic wheeler-dealers, monumental incompetents, official 'geniuses'? Why did they criticize ignorance of Cuba's problems, the government's subjugation to foreign demands, electoral farce, and the sheep-like passivity of the average citizen?

It all went to show that there was a left-wing intellectual group in Cuba, not a statutorily constituted body but an increasingly important group of people with identical ideals, a product of its environment, a historical factor inevitably determined by the social function which it would fulfill.

The fact that some members of the group met for lunch in a restaurant every Saturday explains why friends who were not actually comrades sat with them, and that is how the confusion arose which mistook the so-called Minority Group for an accidental heterogeneous gathering with no particular timetable or special activity of its own.

The Minority Group is a group without rules, it has no president, secretary, monthly membership fee, in fact, no symbols of any kind. But this is precisely the most viable type of organization for a group of intellectuals. What has failed in so many places in the past is the regimentation of analogous groups in which the imposition of a single criterion is all-important. The Minority Group does not have the drawbacks of a formal, external and adjectival structure.

As the experience of other countries has shown, there is an undeniably new ideology and a shift leftwards in such groups. The Minority Group knows that it is a group of intellectual workers (men of letters, painters, musicians, sculptors, etc.). Its name, given it by one of its adherents, refers to its small number of effective members, but it is actually a majority group because it is the spokesman, platform, and index for the majority of the population. It is only really a minority as far as its artistic criteria are concerned.

In the course of the year, the group has interpreted and reflected Cuban public opinion by protesting against the invasion of Nicaragua, Washington's policy on Mexico, the ransacking by police of both the University and the house of Enrique José Varona. The fact that people who are not members of the nucleus sometimes appear at our demonstrations and sign our manifestos in no way detracts from the group's unity of being and purpose.

Collectively or individually, our nucleus has fought and is still fighting:

For the revision of false and outmoded values;

For popular art and, in general, new art in all its diverse forms; For the introduction and dissemination in Cuba of the latest artistic and scientific doctrines, theory and praxis;

For educational reform. Against the corrupt system of University appointments. For University autonomy;

For Cuban economic independence. Against Yankee imperialism. Against political dictatorships throughout the world, in the Americas, in Cuba;

Against the excesses of our pseudo-democracy. Against electoral farce. For the people's effective participation in government;

MANIFESTOS

For improved conditions for the farmer, the peasant, and the worker in Cuba;

For the friendship and unity of Latin American nations. Rubén Martínez Villena, José A. Fernández de Castro, Jorge Mañach, José Z. Tallet, Juan Marinello, Enrique Serpa, Agustín Acosta, Emilio Roig de Leuchsenring, María Villar Buceta, Mariblanca Sabas Alomá, Antonio Gattorno, José Hurtado de Mendoza, Otto Bluhme, Alejo Carpentier, Orosmán Viamontes, Juan Antigua, Arturo Alfonso Roselló, Juan José Sicre, Diego Bonilla, Conrado W. Massaguer, Eduardo Abela, Luis López Méndez, Armando Maribona, Guillermo Martínez Márquez, José Manuel Acosta, A. T. Quílez, F. de Ibarzábal, L. G. Wangüemert, Juan Luis Martín, Félix Lizaso, Francisco Ichaso, Martín Casanová, Luis A. Baralt y Felipe Pichardo Moya.

Havana, 7 May 1927

6.11 The Southern School

There should be a great Art School in our country. I say without any hesitation; *here in our country*. And I have my reasons for making this statement.

I have said Southern School because in fact *our north is the South*. We shouldn't have a north, except to contrast with our South.

So let us turn the map upside down, and *voilà*, that is our real position, not how the rest of the world sees it. The tip of America, from here on, extending upwards, insistently indicates the South, our north. At the same time, our compass points relentlessly to the South, to our pole. Boats, when they leave here, *go downwards not upwards*, as they used to, to go north. Because the north is now down there. And facing our South, the east is on our left.

That correction was necessary. So, now we know where we are.

Moreover, our city, where we live, is unlike any other: *Montevideo is unique*. It has such a profoundly distinct character that it is unmistakable. You notice it as soon as you see the Cerro, then again in the port, and most of all in the Plaza Independencia and the Plaza Matriz. What a shame a few blemishes disfigure it!

The houses in Uruguay make us very much aware of where we are. Especially the low ones, contrasting as they do with the wide streets. This gives an abundance of light you don't find in other places. Moreover, it is white light (I'd call it luminous light without fear of pleonasm), and its angle is also unique, it could be perfectly regulated. And remember how elongated the doors and windows of the houses are, this gives them such distinctively characteristic proportions.

The composition of the air is also peculiar to us: it corrodes the walls and covers them with a sort of greenish slime. This comes undoubtedly from our great river which can be seen from most Montevideo streets. It is so incredibly wide that it seems like a sea, and this confuses us because we think it is a sea, but have to remember it is only a river; our great river Plate, also unique. And as we all know, many of the streets drop sharply down to the river, continually rising and falling with terrifying steepness, and that is another distinguishing feature of our city.

So, if we look carefully, we discover the intimate nature of everything. Because Montevideo people aren't like people from

other cities either. They are as distinct as the city itself. The people probably don't realize this, or that the type of people they are is quite different from other countries. Not that there is a uniform type, on the contrary, they are very heterogeneous; so their distinct physiognomy doesn't come from the component varieties but from a particular *expression* they have which gives them their character. We have the real European type, then the mixture of Indian and black, and the almost pure black. This is what, on the whole, gives our people a distinct physiognomy.

If we move on to what we could call expression, gestures, vocabulary, mentality, way of seeing things, etc., we find something which is also very markedly our own. You only have to listen to them to know how idiosyncratic they are. And, strangely enough, it's not in the tango or slang expressions that we encounter this idiosyncrasy. It would be like looking in the smart shops and stores, or in modern architecture, in the places where our character actually gets lost. So much so that the city which is unique and typical in so many neighbourhoods is much less so in the new modernized areas. This does not mean we should not modernize or change, because we have to, but why not do it in keeping with our distinct character - a very fine nuance but one which we should clearly identify so that it enters people's consciousness. The problem is that by accentuating certain modalities and expressions we believe to be very much our own, we create an artificial character, loathsome because it is anodyne. We see this all over the place. For example, what has football got to do with us? If we ask what this game contributes to our country, the answer is zero. But let's leave that delicate subject alone.

In certain parts of Montevideo, you wouldn't believe you were really here, because of all the imported things you see. Some will say: isn't that what modern life is about? I say: not at all, it is foreign trade and industries invading our shores. And there are areas where this invasion has not succeeded, despite the fact that they trade and traffic in things needed for modern living too. That comes from the people who live there, they are more rooted in their native soil, less frivolous, less consumers of frivolities. That street, with that elongated door and fan window, that tree (not a plane tree), and that bar or little shop, and those men and women, could only be in Montevideo. But I repeat, its

character is everywhere. So, that elegant young lady, with Europeanized pretensions of being French or English, is actually Uruguayan, whether she likes it or not, and if she doesn't, that's too bad. This distinct character isn't found in the *maté*, or the poncho, or the songs; it is something more subtle, which permeates everything and has the same clarity, the same white light, as the city. And the people are as unique as the city itself, with its ten letters in a row, neither rising nor falling, all the same, disquieting because they are inexpressive: MONTEVIDEO. Of course, even its name is unique.

And here we are, nexus of the region's swirling winds which disturb the mind and body on this particular bank of the great river, almost a peninsula, as if it wanted to *spearhead the continent*, to be the vanguard. So, our geographical position seals our destiny. In this we are consistent.

So I say, careful not to step out of line! And I add: we can do everything (now I'm talking about essence, what we could call telluric, what gives everything its own particular character), so we must not exchange what is ours for what is foreign (that is unforgivable snobbishness), we should assimilate foreign things instead. I believe the age of colonialism and imports is over (now I'm talking primarily about what we call culture), so away with anyone who speaks, in literary terms, a language other than our own natural language (I don't say criollo), be they writers, painters, or composers! If they didn't learn the lesson of Europe when they should have, too bad for them, because the moment has passed. But if they think typical music is better, they're wrong; it is worse, even more unbearable. And anyway, that is passé too. Didn't they realize?

Our reality is different today. It is forged by people with their eyes open, people who are up to date, who love life, and are moulded by it. And who are, therefore, *Uruguayans of today*.

And that is what I was leading up to: Uruguayan women of today, Uruguayan men of today. That is, our own special version of things today. I don't say European, I simply mean whatever has come our way. And those who go for 'retrospective typicality' are just as paralysing and retarding as those who go for 'the European'. Because art today is more genuine than that, it lifts the spirits of a people who no longer live in the past or the future, but in the present. Twentieth-century Uruguayans stamping their own personality, constructing.

Yes, constructing everything. And if initially they were in somewhat of a hurry because of the novelty, now they are constructing more positively, at a slower and surer pace.

They will have to rethink many things, and go back and make some adjustments.

The point is, Uruguayans of today must say: we must find a positively original style of our own. Positive because it is simple and natural, not the work of dreamers or apprentices, but of conscious men working in a clearly realist way. Those men will now say: Down with simulation! Down with theatre! Down with meaningless art, art with neither logic nor reason! The time for rehearsals is over! Because today we want definite, concrete things. In a word, we want to construct with art (which means

with knowledge) and with our own materials. Because we are adults now.

Things are moving faster than we thought. The stage has already changed without our realizing it, the rhythm is speeded up now. And we, fortunately, are in time with it.

Yes, things are on the move. Our time is not a time for renewal but, for the reasons I've given, a time for construction. And even the man who still does not realize it, is working towards it.

Throughout the world, two factors provide the axis around which all the others rotate; the *political factor*, and the *economic*, *industrial and commercial factor*. So, if we compare how things are in Uruguay today, with what they used to be, we find an enormous difference. And that difference is what gives us a different angle on things, it is what creates a different mentality; *the Uruguayan of today*.

We will explain briefly what that difference is. It's like this: *local* concerns become *national* concerns without, of course, ever losing sight of the former. This is what gives them a new character. And that's why I said before that things are on the move.

This gives a new perspective, much greater than we imagined. A man leaves his small patch behind and goes out into the wide world.

And the artist, what must he do, what *does* he do? He must do the same; remembering the things around him, he must turn outwards to the world. In this way, his surroundings will take on a new character, a broader concept, a larger scale, limitless space. He will work within a huge framework. And this will provide him, not only with a new vision, but also with new subjects he would never ever have thought of. Also, he will realize he has to raise his standards. He will now be working alongside artists from other countries. He has to be on their level.

The Uruguayan of today is *changing in the ways we mentioned*. And so must the artist, be he musician, painter, poet, architect or writer. What doesn't change is left behind. Like something old, something which no longer has any influence, and is done and undone every day.

The artist who goes down to the docks today (and not for the purely picturesque), greets the great transatlantic liner, looks at the cranes, at the goods piled up, and watches the men working. . .he no longer even notices the picturesque quality of the sun and its reflection in the water. He sees the enormous smoke stack, the ladders, the ropes, the winches, the ventilators, and the huge bulk of the ship. He sees the sheds, the letters, the numbers, other signals, and the train going past. He sees it all as something ideal, because he is looking at *forms and their architecture*, *not things*.

What does all this mean? That the romantic age of the picturesque has gone, and that we are now in the Doric age of the form. And there is now no knowing what country we are in, because without realizing it everything is universal. And that's why it is more important than ever to be truly Uruguayan. A twentieth-century Uruguayan. Well, from there to constructing is only a small step, and he will take that step. He will construct with form and tone.

Only then will he *paint*. And he'll realize that what he did before was literature. And then he'll look at his work; it is universal, but also Uruguayan. Let's leave that for the moment and go on to something else.

We said at the beginning that we need to create a great Art School here. Not because of the way it's organized, or the luxurious facilities, or the means at its disposal, and a thousand other things, but for a real, effective, vigorous life which responds to an equally very real need.

Necessity has always been the spur in art, as in everything. And here I use the word 'art' in its *highest* sense; to construct well, to follow the rules properly.

And that *need*, when applied to an art form (in this case, the visual arts), takes on a *decorative meaning*, as it has throughout the ages and in all countries. But here, decorative would not be mere decoration, it would definitely be *socially functional art*. That means an *authentically based art – real*.

Not naturalist art (which is always subjective, based on personality and fleeting emotion), but art which is steadfastly *linked to the city*: commenting on or praising its life, emphasizing it, exhibiting it, and even guiding it perhaps.

If I said *decorative*, it was only to make things clearer, because in fact that kind of art is *monumental* art, *plane-ist* and *two-dimensional*, *schematic* and *synthetic*; art of grand rhythms and closely linked to architecture.

So, if we are to arrive at a *truth*, it will be an *absolute truth*, not a partial unilateral truth, because our own genuine style will always show through, so the *art of today* will necessarily be linked to the *art of yesterday*.

That, to my mind, would be the function of the Southern School which we want to create on this eastern shore of the

7.1 Three Appeals for a Modern Direction To the New Generation of American Painters and Sculptors

1. Detrimental influences and new trends

Our work is, in the main, extemporaneous. It develops erratically and produces next to nothing of lasting value to match the vitality of our great racial characteristics. Isolated from the new important trends, which to our detriment we receive with hostility and prejudice, we adopt only those decadent influences from Europe which poison our youth and prevent us from seeing fundamental values: the anaemia of Aubrey Beardsley; the preciosity of Aman Jean; the ill-fated archaism of Ignacio Zuloaga; Anglada Camarassa's fireworks and the sculptured confections of Bistolfi, Queralt, Benlliure, etc.; all that marketable art nouveau, dangerously camouflaged as art, which sells so splendidly here (especially if it is imported from Spain).

From the early nineteenth century onwards, Spanish art has shown a marked decadence. Recent group shows in Madrid,

River Plate.

If we paint some aspect of the city, a street, a park, etc., a bit of beach or a corner of the port, and make the work as realistic as possible, we won't have achieved much in terms of the intense life of the city, with its thousand diverse intellectual, moral, artistic and industrial mechanisms, and the contradictory elements inherent in that life; and beyond that, in terms of the *idea* we have of their importance. Because *that* can never be conveyed by such *fragmentary* means, and our concept of the city even less so. That is where the *raison d'être* of a schematic, *symbolic* art lies. Art which when devoid of naturalist, imitative and descriptive aspects, corresponds beautifully to today's spirit of synthesis. It can give us all that, in new rhythms, symbolically; the river Plate, the vibration of the factory or the streets, the character of its people, its geographic position, its hopes, its marvellous light, its games and its art; in fact, everything.

With that aim in mind, then, and conscious of the magnitude of such art, either on a small canvas or a mural, I insist that this kind of art must enter into the rhythms – not only into the fixed eternal plastic laws, but also into the system of proportions whereby through measure you achieve unity, i.e. harmony. So, every artist (in visual arts or music), independently yet united with others by the laws of harmony, should give Uruguayan art a unity which, at the moment, it does not but should, like all great art throughout history everywhere, should have. That is: a Style. This, of course, demands a true understanding of the problems of art, and the superior level we should by now have reached.

Joaquín Torres-García Uruguay, February 1935

which represented the very latest in contemporary Spanish art, make one's heart sink: traditional literary art; theatrical art in the folkloric *zarzuela* manner, a disease which we through racial affinity have caught. And yet many years ago, three Spaniards of genius, Spaniards of their time – Sunyer, Picasso and Juan Gris – avidly embraced Cézanne and obeyed the husky voice of Renoir.

Fortunately a new group of painters and sculptors is emerging in Spain who feel restless, want to experiment and investigate, and free themselves from the enormous weight of their great traditions and become more universal. Most of this group are from Catalonia.

We extend a rational welcome to every source of spiritual renewal born of Paul Cézanne: the invigorating substance of Impressionism; the purifying reductionism of Cubism in its diverse ramifications; the new emotive forces of *Futurism* (but not that which naïvely tries to crush the previous invulnerable process); the absolutely new *reappraisal* of 'classic voices' (Dada is still developing); truths which all flow into the main stream, the multiple psychological aspects of which we will easily find within ourselves; preparatory theories endowed with fundamental elements which have brought true plasticity back to painting and sculpture, enriching it with new admirable elements.

An essential part of strengthening our art is bringing back lost values into painting and sculpture and, at the same time, endowing them with new values! Like the classical masters, let us make our work conform to the inviooilable laws of aesthetic balance and become as skilled craftsmen as they were. Let us look to the old masters for their constructive base, their great sincerity, but let us not use archaic 'motifs' which for us would be exotic. Let us live our marvellous dynamic age! Let us love the modern machine which provokes unexpected plastic emotions, the contemporary aspects of our daily lives, thelife of our cities under construction, the sober practical engineering of our modern buildings, devoid of architectural complications (immense towers of iron and cement stuck in the ground), comfortable furniture and utensils (plastic materials of the first order). Let us dress our human invulnerability in modern clothing; 'new subjects', 'new aspects'. And let us, first and foremost, be firmly convinced that, despite periods of natural transitory decadence, the art of the future must be forever higher.

2. Prevalence of the constructive spirit over the decorative or analytical

We draw silhouettes in pretty colours. When we sculpt we concentrate on superficial arabesques and forget the concept of important primary shapes – cubes, cones, spheres, cylinders, pyramids – which should provide the skeleton of all artistic architecture. Let us, the painters, impose the constructive spirit on the merely decorative. Colour and line are expressive elements of a secondary order; the fundamental essence, the basis of the work of art, is the magnificent geometrical structure of form – the concept, inner workings, and architectural materialization of form and perspective – which, by imposing 'limits', creates the depth and atmosphere of 'volumes in space'. Whether our view be dynamic or static, let us first and foremost construct. Let us mould and build on our own personal emotional reactions to nature, with a scrupulous regard for the truth.

Let us be specific and unambiguous about the organic 'quality'

7.2 El Machete: Newspaper of the Workers and Peasants Manifesto of the Union of Mexican Workers, Technicians, Painters and Sculptors

To the Indian race humiliated for centuries; to soldiers made executioners by the praetorians; to workers and peasants

of the plastic 'elements' we work with; *creating* matter which is solid or fragile, rough or soft, opaque or transparent, etc., and determining its weight.

Understanding the wonderful human resources in 'black art', or 'primitive art' in general, has given the visual arts a clarity and depth lost four centuries ago along the dark path of error. Let us, for our part, go back to the work of the ancient inhabitants of our valleys, the Indian painters and sculptors (Mayas, Aztecs, Incas, etc.). Our climatic proximity to them will help us assimilate the constructive vitality of their work. They demonstrate a fundamental knowledge of nature which can serve as a point of departure for us. Let us absorb their synthetic energy, but avoid those lamentable archaeological reconstructions ('Indianism', 'Primitivism', 'Americanism') which are so in vogue here today but which are only short-lived fashions.

Our framework must be firm but, if necessary, we can use caricature in order to humanize. The theories of 'painting light' ('Luminism', 'Pointillism', 'Divisionism'), that is, which simply copy or interpret luminosity analytically, lack any strong creative ideal, art's only real objectivity. They are discarded puerile theories which we have welcomed with frenzy in the Americas recently, sickly branches of the tree of 'Impressionism' pruned by Paul Cézanne, the restorer of the essential art form. We must turn 'Impressionism' into something which endures like museum art.

3. Let us abandon literary motifs. Let us devote ourselves to pure

Let us reject theories anchored in the relativity of 'national art'. We must become universal! Our own racial and regional physiognomy will always show through in our work.

Our Free Schools are *open-air academies* (as dangerous as the official academies in which at least we learn about the classic masters); in them we have commercially oriented teachers and a type of criticism which stifles the individuality of aspiring artists.

Let us close our ears to the critical dictates of our poets. They produce beautiful pieces of literature totally divorced from the real value we seek in our work.

David Alfaro Siqueiros

Vida Americana (Barcelona, Spain), May 1921 (First and only number of this magazine)

scourged by the greed of the rich; to intellectuals uncorrupted by the bourgeoisie.

COMRADES

The military coup of Enrique Estrada and Guadalupe Sánchez (the Mexican peasants' and workers' greatest enemies) has been of transcendental importance in precipitating and clarifying the situation in our country. This, aside from minor details of a purely political nature, is as follows:

On the one hand the social revolution, ideologically more coherent than ever, and on the other the armed bourgeoisie. Soldiers of the people, peasants, and armed workers defending their rights, against soldiers of the people, press-ganged by deceit or force by the politico-military leaders in the pay of the bourgeoisie.

On their side, the exploiters of the people in concubinage with traitors who sell the blood of soldiers who fought in the Revolution.

On our side, those who cry out for an end to an old cruel order – an order in which you, the peasants on the land, fertilize the soil so that the fruit it bears be swallowed by greedy profiteers and politicians while you starve; in which you, the workers in the city, man the factories, weave the cloth, and produce with your own hands modern comforts to service prostitutes and drones while your bones shiver with cold; in which you, the Indian soldier, in an heroic selfless act, leave the land you till and give your life to fight the poverty your race has endured for centuries only for a Sánchez or an Estrada to waste the generous gift of your blood by favouring the bourgeois leeches who strip your children of their happiness and rob you of your land.

Not only are our people (especially our Indians) the source of all that is noble toil, all that is virtue, but also, every manifestation of the physical and spiritual existence of our race as an ethnic force springs from them. So does the extraordinary and marvellous ability to create beauty. The art of the Mexican people is the most important and vital spiritual manifestation in the world today, and its Indian traditions lie at its very heart. It is great precisely because it is of the people and therefore collective. That is why our primary aesthetic aim is to propagate works of art which will help destroy all traces of bourgeois individualism. We reject so-called Salon painting and all the ultra-intellectual salon art of the aristocracy and exalt the manifestation of monumental art because they are useful. We believe that any work of art which is alien or contrary to popular taste is bourgeois and should disappear because it perverts the aesthetic of our race. This perversion is already almost complete in the cities.

We believe that while our society is in a transitional stage between the destruction of an old order and the introduction of a new order, the creators of beauty must turn their work into clear ideological propaganda for the people, and make art, which at present is mere individualist masturbation, something of beauty, education, and purpose for everyone.

We are all too aware that the advent of a bourgeois government

in Mexico will mean the natural decline of our race's popular indigenous aesthetic, at present found only in the lower classes but which was, however, beginning to penetrate and purify intellectual circles. We will fight to prevent this happening. Because we are sure that victory for the working classes will bring a harmonious flowering of ethnic art, of cosmogonical and historical significance to our race, comparable to that of our wonderful ancient autochthonous civilizations. We will fight tirelessly to bring this about.

Victory for La Huerta, Estrada, and Sánchez will be, aesthetically and socially, a victory for typists' taste; criollo and bourgeois approval (which is all-corrupting) of popular music, painting and literature, the reign of the 'picturesque', the American 'kewpie doll', and the official introduction of 'l'amore e come zucchero'. Love is like sugar.

The counter-revolution in Mexico will, as a result, prolong the pain of the people and crush their admirable spirit.

The members of the Painters' and Sculptors' Union have in the past supported the candidacy of General Plutarco Elias Calles because we believed that his revolutionary fervour, more than any other, would guarantee a government which would improve the conditions of the productive classes in Mexico. We reiterate this support in the light of the latest politico-military events and put ourselves at the service of his cause, the cause of the people, to use as it sees fit.

We now appeal to revolutionary intellectuals in Mexico to forget their proverbial centuries-old sentimentality and languor and join us in the social, aesthetic and educational struggle we are waging.

In the name of the blood shed by our people during ten years of revolution, with the threat of a reactionary barracks revolt hanging over us, we urgently appeal to all revolutionary peasants, workers and soldiers in Mexico to understand the vital importance of the impending battle and, laying aside tactical differences, form a united front to combat the common enemy.

We appeal to ordinary soldiers who, unaware of what is happening or deceived by their traitorous officers, are about to shed the blood of their brothers of race and class. Remember that the bourgeoisie will use the self-same weapons with which the Revolution guaranteed your brothers' land and livelihood to now seize them.

For the proletariat of the world:

Secretary-General, David Alfaro Siqueiros Committee member, Diego Rivera Committee member, Xavier Guerrero Fermín Revueltas, José Clemente Orozco, Ramón Alva Guadarrama, Germán Cueto, Carlos Mérida

El Machete (Mexico City) 1923

7.3 Appeal to the Proletariat

How do we combat the bourgeois press? By subscribing (to El Machete), and making sure your comrades do too; by sending small donations that do not involve too great a financial sacrifice; by advertising the proletarian press in whatever way you can; by sticking our newspaper on walls; by sending information about the situation of the proletariat in different regions; by taking collections and holding fund-raising events, etc.

El Machete includes work by over thirty draughtsmen and engravers, all Mexico's revolutionary writers, and experts on social issues. It only needs the effective help of all the workers in Mexico to be produced on a more substantial and regular basis.

Workers of our land, the continuation of our publication rests with you! It would be criminal if we failed to counteract the disastrous influence of the bourgeois press through the sound efforts of a proletarian press!

The Union of Painters and Sculptors will continue the struggle in *El Machete*.

No one can deny that the satirical cartoon, or the visual arts

themselves, are powerful weapons of social change. We members of the Union of Painters and Sculptors who have been rejected by the reactionaries within the public adminstration sector, and are still being excluded by Jesuitical intrigues, will be contributing to *El Machete*. We will exchange the walls of public buildings for the columns of this revolutionary newspaper.

We want to support the Mexican proletariat in its struggle against the bourgeoisie. No sacrifice or effort will prove too great. We will devote our efforts specifically to combating the bourgeois press which has succeeded in turning many men of good faith in the present government against our revolutionary projects.

Workers of the world unite!

DAVID ALFARO SIQUIEROS Secretary-General of the Painters' and Sculptors' Union

Handbill published by *El Machete* (Mexico City) Sunday, 10 August 1924

7.4 Protest of Independent Artists '30-30'

The incident involving students at the National School of Fine Arts and teachers and workers at the Free School of Painting was something that was bound to happen.

Any change of government provokes a general kerfuffle among those who are prepared to flatter individuals and institutions and substitute noise for ability, in the hope of getting a bite of the next cherry.

A constant phenomenon of the revolutionary regeneration of Mexico is the scramble for public office by opportunist elements intrinsically alien to the Revolution. What is a revolutionary artist in Mexico? One who, by taking an active part in the people's struggle for their rights, puts his art at the service of this movement. What kind of artistic production qualifies as participation in the struggle of the masses?

That which aesthetically frees public taste from the colonial tradition dominating popular ideology, and which, furthermore, addresses the masses directly, encouraging them in their struggle and serving their organizations through the dialectical representation of the new social order to which the people aspire.

Even a good ex-combatant in the Revolution who paints pictues in the sterile colonial academic aesthetic, is a counter-revolutionary in artistic terms. And a public official, however lofty his position, and regardless of his positive political record, is also a counter-revolutionary, a real reactionary, if he defends any ideological and aesthetic expression that contradicts the

people's revolutionary progress. Since the Revolution's objective is to regenerate our economy and our culture in the interests of the productive masses, our art, like any revolution, is not possible without a revolutionary theory. Therefore, anyone who tries to hold back, or worse still, obstruct the ideological and aesthetic development of a mass consciousness, is a traitor to the Revolution.

The entire world now recognizes the artistic achievements of Mexico's productive masses, synthesized by revolutionary artists' leaders.

The fact that in Mexico there is freedom to paint, freedom to sculpt, has been praised in every language of the civilized world. From time immemorial, the visual arts have been the Mexican people's greatest artistic expression.

Amid the attacks of reactionary fanatics throughout the world on the Mexican government's justifiable anti-clerical actions, voices have been raised in recognition of our country's intrinsic vitality and its right to occupy a privileged place among the nations who, through the work of revolutionary artists, form part of humanity's vanguard.

Let us protest, therefore, at the sloths' attempts to attack the workers. Let us protest at the opportunists who, clinging to the remnants of a bourgeois academic machinery, seek to deceive the public, the press and government officials, with phoney movements of pseudo-academic democracy, like the one being promoted at present by Señor Fernández Urbina, academic

MANIFESTOS

sculptor par excellence. We ask, no, we demand, that the members of the state bureaucracy remain true to their calling, that is, not betray the Revolution by allying themselves with that most dangerous of groups, the ideological reactionaries, whose destruction is of the utmost urgency.

Despite the efforts made over the past seven years to regenerate and revitalize the National School of Fine Arts, it remains a hotbed of counter-revolutionary activity, of which José de León Toral is a product. The real School of Fine Arts are the Free Schools of Painting and Sculpture, and the School of Architecture.

Of the San Carlos building, only the architecture workshops and other buildings should remain as a splendid museum for the art of the Mexican people. There is nowhere at present a place where either Mexicans or foreigners can see a collection of this work.

We need to create an organism linking the Open Air Art School, the School of Sculpture and Carving, the School of Architecture, and the already excellent technical colleges. In this way, without spending a single penny, the government can make a positive effective contribution to the creation of the social order: the Central School of Art and Science of the Arts.

The money wasted on maintaining the lamentable, gangrenous establishment of San Carlos should be used, without further ado, to create art schools all over the country along the lines of the Open Air Art School, and Sculpture and Carving

8.1
Declaration of Principles
of the People's Graphics Workshop [T.G.P]

Article 1

The People's Graphics Workshop [Taller de Gráfica Popular] is a collective work centre for functional promotion, and for studying different branches of engraving and painting and different methods of reproduction.

Article 2

The T.G.P. will strive to ensure that its work helps the Mexican people defend and enrich their national culture. This can be achieved only if Mexico is an independent country in a peaceful world.

Article 3

The T.G.P. believes that, in order to serve the people, art must reflect the social reality of the times and have unity of content

School. Within a year, maybe even six months, a splendid concentration of production will prove our demands absolutely incontrovertible. Recent proof of the above is the verdict of an admiring world on our artistic achievements in Mexico City alone.

Our demands must be met immediately.

Diego Rivera, Alfredo Ramos Martínez, Guillermo Ruiz, J. Manuel Anaya, Juana García de la Cadena, Manuel Maples Arce, Martí Casanovas, Rosario Cabrera, Luis Martínez, Fernando Leal, Ramón Alva de la Canal, Germán List Arzubide, Luis Islas García, Gabriel Fernández Ledesma, David Alfaro Siqueiros, Ignacio Millán, B. Rivas Cid, Enrique A. Ugarte, Bulmaro Guzmán, Gabriel Fernández, Francisco Dosamentes, Rafael Vera de Córdova, Francisco Díaz de León, Tamigi Kita-gawa, Fermín Revueltas, Francisco Plata, Cristina García de la Cadena, Margarita Torres, Erasto Cortés, Fermín Martínez, Antonio Silva, Ramón Cano, Víctor Tesorero, Carolina Smith, Manuel Villarreal, Ezequiel Negrete, Roberto Velázquez, Abelardo Ramírez, Gonzalo de la Paz Pérez, Rosendo Soto, Gonzalo Tello y Leopoldo Méndez

Mexico City, 7 November 1928

Produced as a poster with an engraving by Gabriel Fernández Ledesma

and form. By applying this principle, the T.G.P. will strive to raise the artistic standards of its members, in the belief that art can only truly serve the people if it is of the very highest plastic quality.

Article 4

The T.G.P. will co-operate professionally with other cultural workshops and institutions, workers' organizations, and progressive movements and institutions in general.

Article 5

The T.G.P. will defend freedom of expression and artists' professional interests.

Mexico City, 1937

9.1 The Indian Question A new appraisal

Any thesis dealing with the Indian question which does not see it as a socio-economic problem is no more than a sterile theoretical exercise – at times merely verbal – and deserves to be entirely discredited. This includes those construed in good faith. In fact, they have only obscured or distorted the real issues. A socialist critique examines and clarifies the problem because it looks for its roots in the Peruvian economy rather than in its administrative, legal or religious institutions, or in its racial quality or plurality or in its cultural or moral conditions. The indigenous problem stems from our economy. It is rooted in the system of land ownership. Any attempt to resolve the problem through administrative or police methods, or even education and good works, is only tinkering with the problem while the feudal gamonales still exist.

This form of land tenure (gamonalismo*) inevitably invalidates any law or ordinance made for the protection of our indigenous people. The estate owner, the latifundista, is effectively a feudal lord. The written law of the land is impotent against an authority sanctioned by custom and habit. The law prohibits unpaid labour, yet unpaid and even forced labour persists on large estates. Judges, prefects, police officers, teachers, and tax-collectors, are all harnessed to the feudalism of the major land-owners. The law is powerless in the face of the gamonales. Should an official persist in trying to apply the law, he will inevitably be sacrified and abandoned by central government over which gamonalismo is supremely influential. Whether or not this supremacy is enacted directly or through the will of parliament, the outcome remains the same.

Hence, this new look at the Indian question concerns itself less with beneficent legislation than with the effects of the system of land ownership. The study by Dr José E. Encinas in 1918, 'Towards Protective Legislation for Indigenous Peoples', started a trend which has become more and more entrenched since then. The very nature of his study meant the Dr Encinas could not devise any kind of socio-economic programme. His proposals, aimed at protecting Indian property, were limited to legal objectives. Dr Encinas sketches out a system of Indian 'homesteading' and recommends the distribution of state and Church lands. He makes absolutely no mention of expropriating the large estates of the gamonales. Yet his entire thesis is marked by repeated criticism of the effects of large-scale landholding. The system is totally condemned by this survey which, in some way, anticipates our present socio-economic critique of the Indian question.

This critique refutes and dismisses the various theses which address the question from one or other of the following unilateral and exclusive criteria: administrative, legal, ethnic, moral, educational, ecclesiastical.

The oldest and most obvious blind alley is to reduce the

question of the protection of the Indians to a merely administrative matter. Ever since the days of Spanish colonial legislation, wise and long-winded ordinances, elaborated after painstaking investigations, have proved totally fruitless. And since Independence, the fecundity of Peruvian governments has spawned a prolific quantity of decrees, laws and provisos meant to protect the Indian from exploitation and extortion. But the *gamonal* of today, like the feudal lords of the past, has little to fear from administrative theory. He knows its practice to be different.

The individualistic nature of legislation in Peru has unquestionably favoured the absorption of Indian lands into the big estates. In this respect, the position of the Indian was viewed more realistically by Spanish law. But legal reform has no more practical value than administrative reform when faced with a feudalism whose economic structure remains intact. The expropriation of land individually or collectively owned by Indians is now almost complete. The experience of other countries emerging from feudalism demonstrates how liberal legislation cannot operate without the break-up of the fiefdoms.

The assumption that the Indian question is an ethnic one is fostered by the most antiquated collection of imperialist ideas. The concept of racial inferiority served the white West's programme of conquest and expansion. To expect the emancipation of our indigenous peoples through the active hybridization of aboriginals and white immigrants is a piece of anti-sociological naïveté, conceivable only in the simple mind of an importer of merino sheep. Asians, to whom our native Indians are in no way inferior, have admirably assimilated the dynamism and creativity of Western culture, without transfusions of European blood. The degeneration of the Peruvian Indian is a cheap fabrication on the part of pettifogging lawyers who act for the feudal lords.

The tendency to couch the Indian question in terms of a moral dilemma embodies the liberal, humanitarian, illuminist, nineteenth century notion which inspired the 'League of the Rights of Man' in Western political circles. The anti-slavery societies and committees in Europe, which denounced the crimes of colonialism to so little effect, are born of this tendency, which always placed an exaggerated faith in appealing to a civilized morality. González Prada was obviously influenced by it when he wrote that the 'condition of the Indian can improve in two ways: either the hearts of our educators will be moved to the extent that they recognize the rights of oppressed peoples, or the spirit of the oppressed will become sufficiently virile to punish the oppressors'. The Pro-Indigenous Association (1909-17) encapsulated this hope above, all, although its real achievements on behalf of the Indians lay in the concrete, immediate aims laid down by its leaders, which in turn owed much to the practical, characteristically Saxon, idealism of Dora Meyer. The result can

MANIFESTOS

be seen fully in Peru and throughout the world. Humanitarian preaching failed to stop, or even hamper European imperialism, or improve its methods. The anti-imperialist struggle now relies on solidarity, and on the strength of the emancipation movements of the colonized masses. This attitude governs anti-imperialist activities in Europe today. Among its adherents are liberal thinkers like Albert Einstein and Romain Rolland, and it can, therefore, in no way be considered purely socialist in outlook.

For centuries religion has dealt with reason and morality most energetically, or at least with the greatest authority. This crusade only achieved, however, wisely inspired laws and edicts. The lot of the Indians did not change substantially as a result. González Prada, who as we know did not regard these matters from a purely personal or sectarian socialist point of view, sought an explanation for this failure in the economic roots of the question: 'it could not have happened any other way: exploitation was officially sanctioned, iniquities were perpetrated in the name of humanity or injustices were carried out equitably. In order to eliminate abuses, it would have been necessary to abolish tithes and tied labour, in other words, change the whole colonial system. Without the sweated labour of American Indians the chests of the Spanish treasury would soon have been empty'. On the whole, religious sermons tended to meet with more possibilities of success than liberal ones. The former appealed to exalted and dominant Spanish Catholicism whereas the latter tried to influence exiguous formalistic Peruvian liberal-

Today, however, a religious solution is undoubtedly the most obsolete and anti-historical of all. Its proponents no longer even bother, as did their distant (oh, so distant) forebears, to obtain a new Declaration of Indian Rights backed by sufficient authority and guarantees. Instead they charge their missionaries with mediating between the Indian and the land owner. If the Church could not achieve this task in a medieval framework when its spiritual and intellectual capacity was measured by monks of the calibre of Las Casas, what chance has it of doing so today? Fundamentalist missionaries have taken over in this respect from the Catholic priests in whose cloisters declining numbers of the faithful gather.

11.1 Arturo What Arturo stands for

Free acceptance of the so-called art schools fails to break the mould of the old guard of contemplative artists.

It is a mistake to believe that schools founded on doctrines and definitions (precise definitions are by their immutability of little real use) will survive indefinitely.

The most recent contributions of the Surrealists and their spokesmen eliminate any possibility of destroying this sub-

The notion that the Indian question is a problem of education does not even withstand the narrow and closed criteria of pedagogical analysis. Education today, more than ever, takes social and economic factors into account. The modern educator is perfectly well aware that education is not a simple matter of schooling and teaching methods. The socio-economic climate unavoidably conditions the teacher. Gamonalismo is fundamentally opposed to the education of the Indian: its very existence depends on perpetuating ignorance and alcoholism among Indians. Modern schooling - assuming it were feasible to extend it to the rural school-age population given existing conditions is incompatible with feudal land ownership. The mechanism of servitude would totally counteract the efforts of the school even if by some miracle, inconceivable in Peru today, it did manage to conserve a purely educational mission within a feudal environment. Even the most efficient and ambitious educational system could not work those miracles. Both school and teachers are irremediably condemned to the inhumanities engendered by a feudal environment, completely at odds with the most elementary progressive or evolutionist ideas. When this truth is half understood, a saving formula can be found in boarding schools for Indians. But the blatant inadequacy of this formula is revealed as soon as one thinks of the insignificant percentage of the Indian school population that can be accommodated in these schools.

The educational solution propounded by so many in perfectly good faith is officially discounted now. The educators are, I repeat, the least able of all to divorce themselves from socioeconomic realities. So, at present there is nothing more than a vague informal suggestion for which no body or doctrine is responsible.

The new appraisal rests on looking at the Indian problem as a question of land ownership.

*Gamonalismo, the Peruvian version of landholding through large estates whose labourers are exploited by feudal-style lords. [Ed.]

José Carlos Mariátegui

7 Ensayos de la Realidad Peruana (7 Essays on Contemporary Peru) (Lima, 1928)

ordination while their spongy exclusivity sops up all new artistic expression.

The Surrealist school explains: there exists a balance of differentiating forces that, in the process of crystallizing dream images, turns them into 'technique'. As far as its pictorial periphery is concerned, the latent content of thought is split by the juxtaposition; this automatically endows it with a dependency

value. F. Delanglade, for example, with his psychoanalytical mind, reproduces dreams in their primitive format.

But this pure oneirism will lead to even greater idiocy, given that its sole source will be a constant systematic escapism which, when analysed, will become a closed intimacy, the fossilization of the personality. Hence it is restricted (in its pure form) almost exclusively to pictorial art.

The rest is simple, painting becomes parasitic upon therapy and the study of psychoanalysis.

The result: the conscious and the unconscious, with a considerable unifying element, undermine the unconcomitant need for a wild liberation and the value of the image for its own sake.

Arturo stands for pure imagery, free from determinism or justification.

If distance is suppressed, Art will be only tension and pure image, aesthetic vibration.

This does not modify the vision of continuity, immersion and displacement. Only material conditions determine the course of evolution in every age.

If death were real, there would be no beginning. And every

attempt to endow it with vital significance is decadence and decomposition.

If abstraction affords less emotional communication between human beings, it cannot be used to justify a form of cowardice and inadequacy.²

To verify invention and exploration, let a certain degree of illegality and autonomy enter the process.

Man is not bound to finish on Earth.

Abstract art, as part of a global whole, will guarantee a multidimensional harmony, without the need for psychological adaptation.

¹For example, the value of a painting by Dalí resides in the objects and their symbolic meaning, regardless of the plethora of stupefying description.

²Ignorance and the fear of losing oneself prevent many people from expressing themselves fully. This gives rise to a sensation of 'gooseflesh' in any attempt to make contact with the unconscious.

Revista Arturo (Buenos Aires) 1944

11.2
The Frame
A problem of contemporary art

Inspired by the 1779 [sic] Bourgeois Revolution in France, a strong naturalist current dominates the arts, especially painting which was for many years relegated to the status of a camera.

For painting slowly to return to its former, long-forgotten laws, it took a Cézanne, with his highly pictorial conception of art, to say: 'I have discovered that the sun is something you can't reproduce, you can only represent it'; and a Gauguin to write: 'Primitive art is born of the spirit and expands nature. So-called refined art is born of sensuality and serves nature. Nature is the servant of the former and master of the latter. Making it the servant, adopted by the artist, debases it. That is how we fell into the abominable trap of naturalism which began with Pericles' Greece. . .'.¹ This was confirmed in 1907² with the advent of Cubism, where once again the laws of proportion, colour, composition, and everything related to technique recovered their rightful place in the creation of the painting.

Cubism was succinctly defined by Guillaume Apollinaire in *Le Temps* of 14 October 1914, when he referred to the 'geometric aspect of those paintings where the artists wanted to restore, with a great purity, the essence of reality'. And it was that desire to express the reality of things which made painting more and more abstract, passing through Futurism and culminating most recently in Cubism, Non-Objectivism, Neo-Plasticism, and also in its most abstract form, Constructivism. And now, just when the artist seems to be furthest from nature, as Vicente Huidobro said, 'Man has never been closer to nature than at present when he no longer seeks to imitate it superficially but, to act

like nature itself, imitating it in all the depths of its constructivist laws, in the realization of a whole, within the mechanism of the production of new forms.'

But, while the problem of pure artistic creation was solved, the solution itself (through a rigid dialectical principle) created another problem, less obvious in Neo-Plasticism and Constructivism, because of its orthogonal composition, than in Cubism and Non-Objectivism: the problem of the frame.

Cubism and Non-Objectivism created the problem of the rectangular frame because their compositions were based sometimes on rhythms of oblique lines, sometimes on triangular or polygonal figures. It impeded the visual development of the theme. The painting was inevitably reduced to a fragment.

This was soon recognized. And the paintings demonstrate the solutions that were sought. For example, Man Ray, Léger, Braque, and nearer home, the autumnal Cubist Pettoruti, among others, composed some of their work in circles, ellipses or polygons, which they put in the oblong frame. But that was not a solution either, because it is precisely the regularity, the uninterrupted symmetric outline of those figures, which dominates the composition.

That is why most of these paintings followed that concept from naturalist paintings of the window, giving us a part of the subject but not all of it. A painting with a regular frame suggests a continuity of theme, which disappears only when the frame is rigorously structured according to the painting's composition.

That means the edge of the canvas plays an active role in the

RHOD ROTHFUSS

work of art. A role it must always have. A painting should begin and end with itself. Without continuity.

¹Paul Gauguin, 'Notes éparses'. ²Guillaume Janneau in 'Art Cubiste'. Revista Arturo (Buenos Aires), no. 1 1944

11.3 Madí Manifesto

Madí art can be identified by the organization of elements peculiar to each art in its continuum. It contains presence, movable dynamic arrangement, development of the theme itself, lucidity and plurality as absolute values, and is, therefore, free from interference by the phenomena of expression, representation and meaning.

Madí *drawing* is an arrangement of dots and lines on a surface. Madí *painting*, colour and two-dimensionality. Uneven and irregular frame, flat surface, and curved or concave surface. Articulated surfaces with lineal, rotating and changing movement.

Madí sculpture, three-dimensional, no colour. Total form and solid shapes with contour, articulated, rotating, changing movement, etc.

Madí architecture, environment and mobile movable forms.

Madí music, recording of sounds in the golden section.

Madí *poetry*, invented proposition, concepts and images which are untranslatable by means other than language. Pure conceptual happening.

Madí theatre, movable scenery, invented dialogue.

Madí *novel and short story*, characters and events outside specific time and space, or in totally invented time and space.

Madí dance, body and movements circumscribed within a restricted space, without music.

In highly industrialized countries, the old bourgeois realism has almost completely disappeared, naturalism is being defended very half-heartedly and is beating a retreat.

It is at this point that abstraction, essentially expressive and romantic, takes its place. Figurative schools of art, from Cubism to Surrealism, are caught up in this order. Those schools responded to the ideological needs of the time and their achievements are invaluable contributions to the solution of problems of contemporary culture. Nevertheless, their historic moment is past. Their insistence on 'exterior' themes is a return to naturalism, rather than to the true constructivist spirit which has spread through all countries and cultures, and is seen for example in Expressionism, Surrealism, Constructivism, etc.

With Concrete Art – which in fact is a younger branch of that same abstract spirit – began the great period of non-figurative art, in which the artist, using the element and its respective continuum, creates the work in all its purity, without hybridization and objects without essence. But Concrete Art lacked uni-

versality and organization. It developed deep irreconcilable contradictions. The great voids and taboos of 'old' art were preserved, in painting, sculpture, poetry respectively, superimposition, rectangular frame, lack of visual theme, the static interaction between volume and environment, nosological and graphically translatable propositions and images. The result was that, with an organic theory and disciplinarian practice, Concrete Art could not seriously combat the intuitive movements, like Surrealism, which have won over the universe. And so, despite adverse conditions, came the triumph of instinctive impulses over reflection, intuition over consciousness; the revelation of the unconscious over cold analysis, the artist's thorough and rigorous study *vis-à-vis* the laws of the object to be constructed; the symbolic, the hermetic, and the magic over reality; the metaphysical over experience.

Evident in the theory and knowledge of art is subjective, idealist, and reactionary description.

To sum up, pre-Madí art:

A scholastic, idealist historicism

An irrational concept

An academic technique

A false, static and unilateral composition

A work lacking in essential utility

A consciousness paralysed by insoluble contradictions; impervious to the permanent renovation in technique and style

Madí stands against all this. It confirms man's constant allabsorbing desire to invent and construct objects within absolute eternal human values, in his struggle to construct a new classless society, which liberates energy, masters time and space in all senses, and dominates matter to the limit. Without basic descriptions of its total organization, it is impossible to construct the object or bring it into the continuity of creation. So the concept of invention is defined in the field of technique and the concept creation as a totally defined essence.

For Madí-ism, invention is an internal, superable 'method', and creation is an unchangeable totality. Madí, therefore, INVENTS AND CREATES.

Gyula Kosice Buenos Aires, 1946

11.4 Inventionist Manifesto¹

The artistic age of representational fiction is coming to an end. Man is becoming less and less sensitive to illusory images. That is, he is becoming progressively more integrated in the world. The old phantasmagoria no longer meets the aesthetic needs of the new man, brought up in a society that demands his total, unreserved commitment.

The prehistory of the human spirit is thus closed.

Scientific aesthetics will replace the age-old speculative, idealistic aesthetics. Deliberations on the nature of 'the beautiful' are now meaningless. The metaphysics of 'the beautiful' have died of exhaustion. The physics of beauty is relevant now.

There is nothing esoteric in art: those who claim to be 'experts' are frauds.

Representational art shows static, abstractly restrained 'realities'. And all representational art has in fact been abstract. Non-representational aesthetic experiences were called 'abstract' only because of an idealistic misunderstanding. In fact, through these experiences, consciously or not, we have moved in the opposite direction from abstraction. The results, which have exalted the concrete values of painting, are irrefutable evidence of this. The battle waged for so-called abstract art is actually the battle for concrete invention.

Representational art tends to muffle man's cognitive energy, distract him from his own power.

The raw material of representational art has always been illusion.

Illusion of space.

Illusion of expression.

Illusion of reality.

Illusion of movement.

A formidable mirage from which man has always returned disappointed and weakened.

Concrete art, on the other hand, exalts Being, because it practises it.

12.1

White Manifesto

We are Continuing the Evolution of Art

Art is passing through a latent period. A force exists which man is unable to express. We shall express it in a literal form in this manifesto.

It is for this reason that we are asking all the men of science throughout the world, who are conscious of the fact that art is a vital necessity for the human race, to orient a part of their research towards the discovery of the luminous and malleable substances and the sound-producing instruments which will make possible the development of tetradimensional art.

Art of action, it generates the will to act.

A poem or a painting must not justify inaction but, on the contrary, must help man act within his society. We Concrete artists do not avoid conflict. We are in every conflict. In the front line.

Art must no longer reinforce differences. Art must serve the world's new sense of communion. We practice the technique of joy.

Only outmoded techniques feed off gloom, resentment and secrecy.

Up with inventive jubilation. Down with the ill-omened moths of Existentialism or Romanticism.

'Down with the second-rate poets and their tiny wounds or insignificant intimate dramas. Down with all élite art. Up with collective art.

'Kill the Optical,' say the Surrealists, the last Mohicans of representation. 'Exalt the Optical,' we say.

The key to everything: surround people with real things not with ghosts.

Concrete art makes people relate directly to real things not to fabrications.

For a specific aesthetics, a specific technique. Aesthetic function versus 'good taste'. White function.

Don't Search or Find: Invent.

Edgar Bayley, Antonio Caraduje, Simón Contreras, Manuel O. Espinosa, Alfredo Hlito, Enio Iommi, Obdulio Landi, Raúl Lozza, R. V. D. Lozza, Tomás Maldonado, Alberto Molemberg, Primaldo Mónaco, Oscar Nuñez, Lidy Prati, Jorge Souza, Matilde Werbin.

¹Manifesto published to mark our first exhibition, held in the Salon Peuser, Buenos Aires, March 1946.

Revista Arte Concreto – Invención (Buenos Aires), no. 1 1 August 1946

We will place at the disposal of the research workers the necessary documents.

Ideas cannot be challenged. They are to be found in the form of germs in society, and thinkers and artists express them.

Everything springs up for reasons of necessity and is valuable for its epoch.

Throughout history the transformations in the material ways of life have controlled the psychic state of man.

The system which has controlled civilization from its very origins is being transformed.

In the place of this system there is being progressively substituted another which is completely the contrary in its essence and in all of its forms. All the conditions of life of the individual and of society will be transformed. Each man will live on the basis of an integral organization of work.

The inordinate discoveries of science gravitate upon the new organization of life.

The discovery of new physical forces, the mastery of matter and space gradually impose on man conditions which have never existed heretofore in history. The application of these discoveries to all the forms of life produces a modification in the nature of man.

The psychic structure of man becomes different.

We are living in the era of mechanics.

Already painted cardboard and the plaster figure no longer make sense.

An analytic process has been produced for each art right from the very instant that the known forms of art were discovered, and this process has continued throughout the various historical epochs.

All the possibilities have been examined thoroughly and developed; everything that could be expressed has been expressed.

The same subjects have found expression in music, in architecture and in poetry.

Man apportions his energies amongst the various possible manifestations according to the exigencies of knowing and understanding.

Idealism has been employed whenever it was not possible to explain existence in concrete forms.

The mechanisms of nature have been ignored. The processes of the intelligence were known. Everything depended on the very possibilities of the intelligence. Knowledge consisted of confused speculations which only very rarely succeeded in attaining the status of truths.

Plastic art consisted of ideal representations of known forms, of images that were rendered ideally real. The spectator imagined one object after the other; he imagined the muscles and the clothes represented.

Today experimental knowledge replaces imagined knowledge. We are aware of a world that exists and which is explained by itself and cannot be modified by our ideas.

We are in need of an art whose value is contained within itself; an art uninfluenced by any idea we may have regarding it.

The materialism which is firmly established in the consciousness of everyone demands an art which has its own values and which is alien to those representations that today have become mere farces. The men of this century, moulded by this materialism, have become insensible to the representation of known forms and to the narration of constantly repeated experiences. Abstraction has been conceived as the result of progressive deformation

This new state of affairs no longer corresponds, however, to the exigencies of contemporary man. A change is demanded in the very essence and in the form. It is further demanded that painting, sculpture, poetry and music be superseded. An art is needed which is more coherent with the exigencies of the new spirit.

The fundamental conditions of modern art were clearly noted at the beginning of the thirteenth century, when space began to be depicted. The great masters, who subsequently made their appearance, gave impulse to this tendency. Space is depicted with ever-increasing amplitude in the following centuries. The baroque artists gave proof of this fact in this sense: they depicted space with a grandeur that has never been surpassed and they added the concept of time to the plastic arts. The figures seem to abandon the surface in order to continue their depicted movements in space. This conception was the consequence of the idea of existence which had been formed in man. The physics of the epoch for the first time was explaining nature with dynamics as its spokesman. It was established, as a principle for the understanding of the universe, that movement is an immanent condition of matter.

Having arrived at this point of evolution, the necessity of movement was so great that it could no longer be represented by the plastic arts. The evolution continued, therefore, in music. Painting and sculpture entered into the period of neo-classicism, which became the morass of the history of art. Having conquered time, the necessity of motion fully manifested itself. The progressive liberation from principles has produced an everincreasing dynamism (Bach, Mozart, Beethoven). Art continues to progress in the sense of motion. Music maintained its impulse for two centuries, and impressionism evolved contemporaneously in the plastic arts.

Since then the evolution of man has been a march towards motion evolving in time and space. The elements in painting which limit the impression of dynamism are suppressed.

The impressionists sacrificed delineation and composition. A few elements were eliminated by futurism, whilst others lost their importance and remained subordinate to sensation. Futurism adopted motion as its sole principle and its sole aim. The cubists denied that their painting was dynamic; the essence of cubism is the vision of nature in movement.

When music and the plastic arts united their development in impressionism, music based itself on the elements of plastic art while painting seemed to dissolve in an atmosphere of sound. In the majority of Rodin's works we notice that the volumes seem to move about in the same environment as that of sounds. Rodin's conception is essentially dynamic and very often arrives at the point of exasperating the sense of motion. Recently has there not been an intuition of the 'form of sound' (Schoenberg) or of the superposition or correlation of 'sonorous planes' (Scriabin)? There is also a resemblance between the forms of Stravinsky and cubist planimetry. Modern art finds itself now in a situation of transition that imposes a rupture with previous art, with the aim of opening the road to new conceptions. This state, seen as a synthesis, is in fact a passage from the static to the dynamic. But art, confined within the limits of the transition, is not able to

detach itself entirely from the heredity of the Renaissance. The same materials have been employed and brought under control in order to express, however, a completely transformed sensibility. The ancient elements were employed in a completely contrary sense. But the opposing forces are now in mourning. The known is disregarded; the future is the past. It is for this reason that the number of tendencies multiplies; they are supported by opposing values and they apparently pursue different objectives. We accept this experience and project it towards a clearly visible future.

Whether they are conscious or unconscious of this research, modern artists are unable to arrive at this point. They lack the necessary technical means to give motion to their bodies; they can only give them motion in an illusory fashion by depicting them with the conventional methods.

It is in this way that the need arises for new materials and techniques which will permit us to realize the desired ends. This circumstance, together with mechanical developments, produced the cinema; and its triumph is further testimony of the direction taken by the spirit as regards dynamism.

Man is saturated with pictorial and sculptural forms; his own experiences and his enervating repetitions are testimony that those arts remain congealed in values which are inconsistent with our civilization and which offer no possibilities for development in the future.

The tranquil path has disappeared. The concept of speed is a constant in the life of man.

The artistic era of paralytic colours and forms has come to an end. Man becomes more and more insensible to congealed images without a sense of vitality. The ancient immobile images no longer satisfy the new man formed by the necessity of action and by the cohabitation with mechanics, which impose on him a constant dynamism. The aesthetics of organic motion replace the aesthetic weaknesses of congealed forms.

In invoking this transformation, which has taken place in the nature of man, and the psychic and moral changes of all human relations and activities, we are abandoning the use of known forms of art and we are initiating the development of an art based on the unity of time and space.

The new art takes its elements from nature.

Existence, nature and matter are a perfect unity developing in time and space.

Change is the essential condition of existence.

Motion, evolution and development are the basic conditions of matter. The latter exists in motion and in no other fashion. Its development is eternal. Colour and sound are found in nature bound to matter.

Matter, colour and sound in motion are the phenomena whose simultaneous development is an integral part of the new art.

Colour, in the form of volume, develops in space by adopting successive forms. Sound is produced by instruments still unknown. Today's instruments no longer meet the need for great

sonority nor do they produce the sensations of required amplitude.

The construction of voluminous forms which become transformed by means of the use of plastic and mobile substances.

Placed in space they assume synchronized forms and complete the dynamic images. The matter in motion manifests its total and eternal existence by developing in time and space and by adopting the different stages of its existence in its changes.

We conceive man in his continuing meetings with nature as being in need of clinging to her in order to recover once again the exercise of her original values. We are asking for a total comprehension of the primary values of existence; that is why we are establishing in art the substantial values of nature.

We are offering the substance and not the accidents. We shall never depict either man or the other animals or the other forms.

The latter are the manifestations of nature which change in time and disappear according to the succession of phenomena.

Their physical and psychical conditions are subject to matter and its evolution. And we are applying ourselves to matter and its evolution, which are the generating sources of existence.

We are taking the very energy of matter and its need to exist and develop.

We are asking for an art free from all aesthetic artifices. We are putting into practice that which man has within himself that is natural and true. We reject the aesthetic falseness invented by speculative art.

We are placed within nature as art has never been before in its entire history.

Our love of nature spurns us to copy it. The sentiment of beauty that is offered to us by the form of a plant or a bird, or the sexual sentiment aroused in us by the body of a woman, are developed and worked over by each man according to his sensibilities. We reject the particular emotions which are aroused in us by predetermined forms. Our intention is to unite the entire life of a man in a synthesis which, linked to the function of his natural conditions, constitutes a true manifestation of his being.

We proclaim the first artistic experiences as a principle. The prehistoric men, who for the first time heard a sound produced by the blows delivered on an empty object, were naturally subjugated by its rhythmic combinations. Spurred on by the power of suggestion of rhythm, they continued to dance to the point of intoxication. Sensation was everything with primitive man: sensation in the face of misunderstood nature, musical sensations, rhythmic sensations. It is our intention to develop this original condition of man.

The subconscious – that magnificent receptacle which stores all the images received by the intellect – adopts the essence and the form of the images and conserves the notions which thus form the nature of man. But not only does it function in this way: whilst transforming the objective world, that which the subconscious assimilates is also transformed, and thus modifications are produced in the way man is conceived.

The adaptation to the new conditions of life of the historical heritage received from the epochs which preceded civilization is

MANIFFSTOS

carried out thanks to this function of the subconscious. The latter moulds the individual, integrates him and transforms him. It gives him the orders it receives from the world and that the individual adopts. All artistic conceptions are due to the functioning of the subconscious.

Plastic art develops on the basis of forms drawn from nature. The manifestations of the subconscious adapt themselves fully to those forms thanks to the idealist conception of existence.

The materialistic consciousness – in other words, the necessity of clearly selecting tangibles – demands that the forms of art be created directly by the individual, after having suppressed the adaptation to natural forms.

An art based on the forms created by the subconscious and equilibrated by the reason constitutes a veritable expression of being and a synthesis of the historical moment.

The position of the rationalistic artists is false. In their efforts to superimpose reason and deny the function of the subconscious, they only succeed in rendering their presence less visible. We have noticed this faculty and function in all their works.

Reason does not create. And in the creation of forms its function is subordinated to the function of the subconscious.

In all activities man acts as the result of the functioning of the totality of his faculties. The free development of the latter is a fundamental condition of creation and interpretation of the new art. The analysis and the synthesis, meditation and spontaneity, construction and sensation are the values which contribute to the integration of the new art in a functional unity. And its development through experience is the only path which leads to a complete manifestation of the human being.

12.2 Pilot-Plan for Concrete Poetry

Concrete poetry: product of a critical evolution of forms. Closing the historical cycle of verse (as a formal rhythmic unit), concrete poetry's starting-point is the understanding of graphic space as a structural agent. Qualified space: temporal-spatial structure instead of mere linear-temporal development. Thus the importance of the idea of the ideogram, from its general meaning of spatial or visual syntax to its specific meaning (Fenollosa/Pound) of composition based on the direct juxtaposition of elements – analogical, non logical-discursive. 'Il faut que notre intelligence s'habitue à comprendre synthético-idéo graphiquement au lieu de analytico-discursivement' (Apollinaire). Eisenstein: ideogram and construction.

Precursors: Mallarmé (Un Coup de dés, 1897): the first qualitative leap: 'subdivisions prismatiques de l'idée'; space ('blancs') and typographical resources as substantive elements of the composition. Pound (The Cantos): ideogrammatic method. Joyce (Ulysses and Finnegans Wake): word-ideogram; organic interpenetration of time and space. Cummings: the atomization of words, physiognomical typography; expressionist valuing of space. Apollinaire (Calligrammes): as a vision rather than a real-

Society suppresses the separation of its forces and integrates them into one single force. Modern science is based on the progressive unification of its elements.

Humanity integrates its values and its knowledge. It is a movement implanted in history by many centuries of development.

An integral art rises from the new state of consciousness; it is an art in accordance with which the human being functions and manifests itself as an entity.

Thousands of years having passed in artistic-analytical development, the moment of synthesis arrives. In the beginning the separation was necessary. Today it constitutes a disintegration of the conceived unity.

We conceive of this synthesis as an addition of physical elements: colour, sound, movement, time, space, integrating a physical-psychical unity. Colour (the element of space), sound (the element of time) and motion (that develops in time and space) are the fundamental forms of the new art which comprehends the four dimensions of existence, time and space.

The new art demands the functioning of all the energies of man in creation and interpretation. The Being manifests itself integrally, with the plenitude of its vitality.

> Lucio Fontana Buenos Aires, 1946

Translated in *Devenir de Fontana* (Turin, 1962))

ization. Futurism, Dadaism: contributions to the life of the problem. In Brazil: Oswald de Andrade (1890-1954): 'em comprimidos, minutos de poesia'. João Cabral de Melo Neto (b.1920 – the engineer and the psychology of the most anti-ode composition): direct language, economy and functional architecture of verse.

Concrete poetry: the tension of word-things in space-time. Dynamic structure: multiplicity of concomitant movements. In music as well – by definition, an art of tempo – space intervenes (Webern and his followers, Boulez and Stockhausen; concrete and electronic music); in the visual arts – spatial, by definition – time intervenes (Mondrian and the Boogie-Woogie series; Max Bill; Albers and perceptive ambivalence; concrete art, in general.)

Ideogram: an appeal to non-verbal communication. The concrete poem communicates its own structure: structure-content. The concrete poem is an object in and for itself, not an interpreter of exterior objects and/or more or less subjective sensations. Its material: the word (sound, visual form, semantic charge). Its problem: the functions-relationships of this material. Factors of

proximity and similarity, psychology of the gestalt. Rhythm: relational energy. The concrete poem, through the use of the phonetic system (digits) and an analogical syntax, creates a specific linguistic zone – 'verbivocovisual' – that draws on the advantages of non-verbal communication, without abdicating the virtualities of the word. With the concrete poem occurs the phenomenon of meta-communication: coincidence and simultaneousness of verbal and non-verbal communication, that is, the communication of forms. Of a content-structure, not the usual communication of messages.

Concrete poetry aims at the least common multiple of language. Thus its tendency for substantification and verbification: 'the concrete mode of speech' (Sapir). Thus its affinities with the so-called 'isolating languages' (Chinese): 'the less exterior grammar the Chinese language has, the more inherent interior grammar it has' (Humboldt via Cassirer). The Chinese language is an example of a purely relational syntax based exclusively on word order (see Fenollosa, Sapir and Cassirer).

We call the conflict of content-and-form in search of identification, isomorphism. Parallel to content-and-form isomorphism, space-time isomorphism develops and generates movement. Isomorphism, in a first moment of concrete poetic

pragmatics, tends to physiognomy, to a movement imitating reality (motion); the organic form and the phenomenology of the composition predominate. In a more advanced stage, isomorphism tends to be pure structural movement; in this phase, the geometric form and the mathematics of composition predominate (sensitive rationalism).

Turning its back on any dispute about 'absolutes', concrete poetry remains in the magnetic field of the perennial relative, the microchronometry of chance. Control, cybernetics, the poem as a self-regulating mechanism: 'feedback'. The quickest communication (an implicit problem of functionality and structure) gives a positive value to the poem and guides its very rendering.

Concrete poetry: an integral responsibility *vis-à-vis* language. Total realism. In opposition to a poetry of subjective and hedonistic expression. Create exact problems and solve them through sensitive language. A general art of the word. The product-poem: useful object.

Augusto de Campos Décio Pignatari Haroldo de Campos

Revista Noigandres (Rio de Janeiro), no. 4 1959

12.3 Peo-concrete Manifesto

We use the term 'neo-concrete' to differentiate ourselves from those committed to non-figurative 'geometric' art (neo-plasticism, constructivism, suprematism, the school of Ulm) and particularly the kind of concrete art that is influenced by a dangerously acute rationalism. In the light of their artistic experience, the painters, sculptors, engravers and writers participating in this first Neo-concrete Exhibition came to the conclusion that it was necessary to evaluate the theoretical principles on which concrete art has been founded, none of which offers a rationale for the expressive potential they feel their art contains.

Born as Cubism, in a reaction to the pictorial language of the Impressionists, it was natural that geometric art should adopt theoretical positions diametrically opposed to the technical and allusive features of the painting of the time. Advances in physics and mechanics widened the horizons of objective thought and led those responsible for deepening this artistic revolution to an ever-increasing rationalization of the processes and purposes of painting. Mechanical notions of constructing works of art invaded the language of painters and sculptors, generating, in turn, equally extremist reactions of a reactionary nature such as the magical, irrational realism of Dada and Surrealism.

However, there is no doubt that, despite the consecration of the objectivity of science and the precision of mechanics, true artists – like, for example, Mondrian and Pevsner – overcame the limits imposed by theory in the daily struggle to express themselves artistically. But the work of these artists has always been interpreted with reference to theoretic principles which their work, in fact, denied. We propose that neo-plasticism, constructivism and the other similar movements should be reevaluated with reference to their power of expression rather than to the theories on which they based their art.

If we want to understand Mondrian's art by examining his theories, we would have to conclude one of two things. Either we believe that it is possible for art to be part and parcel of everyday life – and Mondrian's work takes the first steps in this direction – or we conclude that such a thing is impossible, in which case his work fails in its aims. Either the vertical and the horizontal planes really are the fundamental rhythms of the universe and the work of Mondrian is the application of that universal principle, or the principle is flawed and his work is founded on an illusion. Nevertheless, the work of Mondrian exists, alive and fertile, in spite of such theoretical contradictions. There would be no point in seeing Mondrian as the destroyer of surface, the plane and line, if we do not perceive the new space which his art creates.

The same can be said of Vantongerloo and Pevsner. It does not matter what mathematical equations are at the root of a piece of sculpture or of a painting by Vantongerloo. It is only when someone sees the work of art, that its rhythms and colours have meaning. The fact that Pevsner used figures of descriptive geometry as his starting-points is without interest alongside the new space that his sculptures gave birth to and the cosmic-

organic expression which his works reveal. To establish the relationships between artistic objects and scientific instruments and between the intuition of the artist and the objective thought of the physicist and the engineer might have a specific cultural interest. But, from the aesthetic point of view, the interesting thing about art is that it transcends such considerations and creates and reveals a universe of existential significance.

Malevich, because he recognized the primacy of 'pure sensibility in art', spared his theoretical definitions the limitations of rationalism and mechanicism, and gave his painting a transcendental dimension that makes him very relevant today. But Malevich paid dearly for the courage he showed in simultaneously opposing figurativism and mechanicist abstraction. To this day, certain rationalist theoreticians have considered him to be an ingenuous person who never understood properly the true meaning of the new plasticism. . .

In fact, Malevich's 'geometric' painting already expresses a lack of satisfaction, a will to transcend the rational and the sensory, that today manifests itself irrepressibly.

Neo-concrete art, born out of the need to express the complex reality of modern humanity inside the structural language of a new plasticity, denies the validity of scientific and positivist attitudes in art and raises the question of expression, incorporating the new 'verbal' dimensions created by constructivist neo-figurative art. Rationalism robs art of its autonomy and substitutes the unique qualities of art for notions of scientific objectivity: thus the concepts of form, space, time and structure – which in the language of the arts have an existential, emotional and affective significance – are confused with the theoretical approach of those who want to make a science of art.

In the name of prejudices that philosophers today denounce (M. Merleau-Ponty, E. Cassirer, S. Langer) – and that are no longer upheld in any intellectual field beginning with modern biology, which now has gone beyond Pavlovian mechanicism – the concrete rationalists still think of human beings as machines and seek to limit art to the expression of this theoretical reality.

We do not conceive of a work of art as a 'machine' or as an 'object', but as a 'quasi-corpus' (quasi-body), that is to say, something which amounts to more than the sum of its constituent elements; something which analysis may break down into various elements but which can only be understood phenomenologically. We believe that a work of art represents more than the material from which it is made and not because of any extra-terrestrial quality it might have: it represents more because it transcends mechanical relationships (sought for by the Gestalt) to become something tacitly significant (Merleau-Ponty), something new and unique. If we needed a simile for a work of art, we would not find one, therefore, either in the machine or in any objectively perceived object, but in living beings, as Langer and V. Weidlé have said. However, such a comparison would still not be able adequately to express the specific reality of the aesthetic organism.

That is because a work of art does not just occupy a particular place in objective space, but transcends it to become something new that the objective notions of time, space, form, structure, colour, etc. are not sufficient in themselves to explain. The difficulty of using precise terminology to express a world that is not so easily described by such notions did not stop art critics from indiscriminately using words which betray the complexity of works of art. Science and technology had a big influence here, to the extent that today, roles are inverted and certain artists, confused by this terminology, try to use objective notions as a creative method in their art.

Inevitably, artists such as these only get as far as illustrating ideas a *priori*, because their starting-point already closely proscribes the result. The concrete rationalist artist denies the creativity of intuition and thinks of himself as an objective body in objective space. Artist and spectator are only required to be stimulated or to react; the artist speaks to the eye as an instrument and not to the eye as a human organ capable of interaction with the world; the artist speaks to the eye-machine and not to the eye-body.

It is because a work of art transcends mechanical space that, in it, the notions of cause and effect lose any validity. The notions of time, space, form, colour are so integrated - by the very fact that they did not exist beforehand, as notions, as art - that it is impossible to say art could be broken down into its constituent parts. Neo-concrete art affirms the absolute integration of those elements, believes that the 'geometric' vocabulary that it uses can express complex human realities as proved by many of the works of Mondrian, Malevitch, Pevsner, Gabo, Sofie Tauber-Arp, et al. Even though these artists at times confused the concept of form-mechanics with that of form-expression, we must make clear that, in the language of art, the so-called geometric forms lose the objective character of geometry and turn into vehicles for the imagination. The Gestalt, given that it is a causal psychology, is also insufficient to allow us to understand a phenomenon which dissolves space and form as causally determined realities and creates a new time and spatialization of the artistic creation. By spatialization, we mean that the work of art continuously makes itself present, in a dynamic reaction with the impulse that generated it and of which it is already the origin. And if such a reaction leads us back to the starting-point, it is because neo-concrete art aims to rekindle the creativity of that beginning. *Neo-concrete* art lays the foundations for a new expressive space.

This position is equally valid for neo-concrete poetry, which denounces the same mechanical objectivism of painting. The rationalist neo-concrete poets also had as their ideal the imitation of machines. For them also, space and time are nothing more than exterior relationships between word-objects. Well, if this were so, the page becomes graphic space and the word one element contained in this space. As in painting, the visual is reduced to the optical and the poem goes no further than its graphic dimensions. Neo-concrete poetry rejects such spurious ideas and, faithful to the nature of language itself, affirms the poem as a temporal being. The complex nature and significance of words becomes apparent in time and not in space. A page of a neo-concrete poem is the spatialization of verbal time: it is a pause, a

silence, time. Obviously, it is not a question of harking back to the concept of time held by those writing discursive poetry. In the latter, language flows in one continuum while, in neoconcrete poetry, language extends itself in time. So, contrary to rationalist concretism, which takes the word as an object and transforms it into a mere optical signal, neo-concrete poetry gives it back its power of 'expression', that is to say, it presents reality in a human way. In neo-concrete poetry, language does not trickle away, it is enduring.

Meanwhile, neo-concrete prose opens a new field of expression, recovers the flowing qualities of language, overcomes its syntactical uncertainties and gives a new amplified meaning to certain solutions wrongly understood to be poetry. This is how, in painting as in poetry, in prose as in sculpture and engraving,

13.1 Interiorism, Neo-Humanism, New Expressionism

Figurative art has now returned with a vengeance as an international movement. Its expressive content is a reaction to more than fifteen years of a terrible artistic and human void engendered by uncommitted painting and sculpture, 'non-figurative' painting and sculpture. Art which denies the existence of man cannot survive in this age of profound preoccupation with man's destiny.

'Isms' serve only as labels or symbols to identify artistic trends. The term 'Interiorist' does not in itself mean any more than 'Futurist' or 'Expressionist'. It is a convenient term for referring to art which is committed to the human condition; fig-

neo-concrete art reaffirms the independence of artistic creativity in the face of objective knowledge (science) and practical knowledge (ethics, politics, industry etc.).

The participants in this first Neo-concrete Exhibition are not part of a 'group'. They are not linked to each other by dogmatic principles. The evident affinity of the research they have been involved in in various fields brought them together and to this exhibition. Their commitment is firstly to their own particular experience and they will be together for as long as the deep affinity that brought them together exists.

Ferreira Gullar

Jornal do Brasil (Rio de Janeiro) 22 March 1959

urative art, but not the supra-nationalist literary descriptivism which characterizes so-called social realism; art which seeks images of truth meaningful for our contemporaries; art which seeks to communicate on the broadest possible level and believes there are ways of achieving this without compromising the integrity of what it has to say.

Arnold Belkin

Nueva Presencia (Mexico City), no. 2 September 1961

Biographies

by Rosemary O'Neill

Roberto Aizenberg (b. 1928, Entre Ríos, Argentina)

Born into a well-established family of Russian immigrants; initially studied architecture, then painting (1950-3) under the Argentine surrealist Juan Batlle Planes. First solo exhibition, of drawings and collages, Galería Galatea, Buenos Aires, 1958. Six one-person exhibitions, including *En Memoria de Juan Batlle Planes* (drawings) (1966), before being given his first retrospective exhibition, Instituto di Tella, Buenos Aires, 1969, at which he showed 50 paintings and some 200 drawings. Numerous group exhibitions, chiefly in Buenos Aires; included in VII São Paulo Bienal (1963). First European exhibition, Hanover Gallery, London, 1972. Prizes and awards: Automobile Club of Argentina; Acquarone Prize, 1962; first prize for painting, Instituto de Tella, 1963; Cassandra Foundation Prize, Chicago, 1970. 1977 moved to Paris, 1981 to Tarquinia, Italy. Now lives and works in Buenos Aires.

Manuel Alvarez Bravo (b. 1902, Mexico City)

Father and grandfather both painted and practiced photography. Studied accounting and worked in Treasury Department, 1915-18; at San Carlos Academy, 1918, studied art and music. Interest in photography developed while working for Power and Transportation Department; in 1923 met the German photographer Hugo Brehme, and following year purchased his first camera, a Century Master 25. Through the muralist Pablo O'Higgins met Tina Modotti, 1927, and through her, in 1929, Diego Rivera and Frances Toor, editor of Mexican Folkways. Taught, San Carlos Academy, 1929-30, under Rivera's directorship, and photographed work of the muralists for Mexican Folkways. First one-person exhibition, Galería Posada, Mexico City, 1932. Met Henri Cartier-Bresson, Mexico, 1934, and exhibited with him, Palacio de Bellas Artes, 1935. Participated in Surrealist exhibitions, Mexico and Paris, after meeting André Breton, 1938. Employed, 1943-59, Sindicato de Trabajadores de la Producción Cinematográfica de México; worked as cameraman on Sergei Eisenstein's film Que Viva México (1930-31). and with directors Luis Buñuel and John Ford; made his own film, Tehuantepec, 1934. In 1959, co-founded El Fondo Editorial de la Plástica Mexicana, for the publication of Mexican art. From 1980, organized and directed Museum of Mexican Photography, inaugurated 1986. Solo exhibitions in U.S.A. and Mexico, as well as in Paris (1980) and London, and exhibited internationally in group shows. Appointed member of Academy of Arts of Mexico, 1980.

Tarsila do Amaral (b. 1886 Capivari, São Paulo, Brazil – d. 1973, São Paulo)

Daughter of wealthy São Paulo rancher, first travelled to Europe with the family early 1900's. Studied in Barcelona before return to Brazil, 1906. First studied sculpture, 1916; turned to painting, 1917, under instruction of Pedro Alexandrino and later of J. Fischer Epons. Settled in Paris, 1920; studied at Académie Julien; first exhibited, Salon des Artistes Français, 1922. In Brazil that year, associated with 'Grupo des Cinco'. Again in Europe, 1923, travelled to Spain and Portugal; continued studies in Paris at Academy of André Lhote, and with Albert Gleizes; frequented studio of Fernand Léger and became friend of poet

Blaise Cendrars. In Brazil, 1924, associated with modernist group. 'Antropofágica' compositions, based on idea of cultural cannibalism painted in 1928; the same year her companion Oswald de Andrade founded Brazilian avant-garde journal, Revista de Antropofágia. Held her first solo exhibition, Galérie Percier, Paris, 1926; exhibited the antropofágica work O Aboropu in second one-person show in Paris, 1928. In 1931, exhibited at Museum of Modern Western Art, Moscow, which acquired her work O Pescador. Turned in 1930s and 1940s to social realism. Major retrospective, Museum of Modern Art, São Paulo, 1950. Her paintings featured at VII São Paulo Bienal, 1963; in 1969 Tarsila-50 Años de Pintura shown at Museum of Modern Art, Rio de Janeiro, and Museum of Contemporary Art, São Paulo.

Apolinar (b. 1928, Guatere, State of Miranda, Venezuela)
Pablo Livinally Santaella, called Apolinar, did not begin to work as an artist until 1965. Self-taught, his series of books 'Biblioteca de Apolinar', highly imaginative book-objects, quickly gained him recognition.

nar', highly imaginative book-objects, quickly gained him recognition. Has exhibited in group shows of Venezuelan popular painters, including 1977 *Creadores al Margen*, Museum of Contemporary Art, Caracas.

Manuel de Araújo Porto Alegre (b. 1806, Rio Pardo, Brazil – d. 1879, Lisbon, Portugal)

Began education with stepfather at age five; attended primary school, Rio de Janeiro; displayed strong interest in drawing and natural sciences. In 1827 began to study painting at Imperial Academy of Fine Arts with Jean-Baptiste Debret, also with Grandjean de Montigny and João Joaquim Alão; took courses in architecture and sculpture, and studied philosophy, physiology and anatomy at Escola Militar. Won prizes for painting, sculpture and architecture in first public exhibition, Imperial Academy. Accompanied Debret to France, 1831, with subsidy from leading Brazilian public figures; studied painting at École des Beaux Arts under Baron Gros. Additional subsidy enabled him to study in Italy; travelled to England, Holland and Belgium. Returned to Rio de Janeiro, 1837; professor of historical painting, Imperial Academy, before transfer to Escola Militar as professor of drawing. Returned to Academy as director, 1854-7, when initiated reforms in curriculum and teaching methods. Set aside painting to devote himself to writing of poetry, art history and criticism; in later career as diplomat, served as Brazilian ambassador to Prussia 1859-67, after which moved to Portugal. Title of Baron conferred on him, 1874, by Emperor Dom Pedro II.

José Agustín Arrieta (b. 1802, Santa Ana Chiautempan, Tlaxcala, Mexico – d. 1874, Puebla, Mexico)

From a family of humble means, moved to Puebla to attend Academy of Fine Arts, where awarded a prize, 1818. Trained in academic tradition as student of Lorenzo Zendejas and Manuel López Guerrero; exhibited San Carlos Academy, Mexico City, 1850, with painting of an episode from the *Aeneid*, and 1865, with a portrait. Known as 'the painter of the people', excelled in *costumbrista* paintings and in still lifes. Exhibited

Academy of Fine Arts, Puebla, 1855; also painted religious subjects and retablos. Buried in Panteón de San Antonio, Puebla.

Dr Atl, see Murillo, Gerardo

Rafael Barradas (b. 1890, Montevideo – d. 1929, Montevideo)

Rafael Pérez Barradas, son of the painter Antonio Pérez Barradas, began to paint as a youth. Brief career in journalism and as an illustrator; founded periodical *El Monigote*. To Europe 1912; after travel in France, Italy and Switzerland, settled in Spain where he joined circle that included Joaquín Torres-García and Ignacio Zuloaga. Initially drawn to Italian Futurism, later devised his own form of expression, 'vibracionismo', and styles he called 'clownism' and 'mystic' painting. In Spain contributed illustrations to journals and books, and designed scenography for Teatro de Arte, Madrid; series of drawings and watercolours included *Estampones de Montevideo*. Returned to Montevideo 1928, in failing health, and died shortly thereafter.

Juan Bay (b. 1892, Trenque Lauquén, Argentina)

Born in a province of Buenos Aires, moved to Milan, Italy, 1908. Studied painting and drawing until 1914; exhibited in the *Free Exhibition of Art* organized by the Futurists, Milan, 1911; included in group exhibitions in Italy until 1920. In Argentina, 1925–9. Again in Milan, was an active member of 'Grupo del Milione'; wrote art criticism for European and Argentine periodicals. Invited to exhibit with the Futurists in the 1942 Venice Biennale and at the 1943 Cuadrienal de Roma. Returned to Argentina, 1949, and joined 'Movimiento Madí, with whose artists he exhibited at Buenos Aires galleries and in the *Exposición en Resistencia*, and in Paris at the Denise René Gallery (1954–8). Included in the exhibition *50 años de Pintura Argentina* (1951), Librería Viscontea, Buenos Aires, 1957, and the First Exhibition of Modern Art at the Museum of Modern Art, Buenos Aires (1960); retrospective.

Alberto Beltrán (b. 1923, Mexico City)

Studied applied arts, Free School of Art and Advertising, and print-making at San Carlos Academy, Mexico City. Book designer and illustrator as well as graphic artist; member of Taller de Gráfica Popular. Worked in literacy campaigns during 1940s, and accompanied anthropological missions. Illustrated texts such as Ricardo Pozas' *Juan Pérez Jalote, Biografía de un indígena tzotzil* (1948); specialized in woodcuts, linocuts and lithographs. Contributed political cartoons to weekly *El Día Dominguero*; founded, edited and illustrated satirical political magazines *Ahí va el Golpe* and *El Coyote emplumado*; for a short time assistant director, newspaper *El Día.* Director, School of Fine Arts, University of Veracruz, 1965-6. Has exhibited internationally in group shows; received National Award for Graphics, 1956, and Premio Nacional del Periodismo for his cartoons, 1976.

Luis Benedit (b. 1937, Buenos Aires)

Degree in architecture from the University of Buenos Aires, 1963. Became interested in painting after travel to Peru and Chile, 1960; painted with industrial enamels, 1961-7, subjects including animals, architecture, fantastic landscapes and mechanical figures. Further study of architecture in Spain, 1964-5, and in Italy, in 1967, of landscape architecture with Francesco Fariello, and industrial design. In Buenos Aires showed paintings of animals, with the live subject displayed within a frame. Created his first animal habitat for an exhibition, Materials: New Forms of Expression, National Museum of Fine Arts, Buenos Aires, 1968; solo exhibition, Galería Rubbers, the same year. Represented Argentina in the 1970 Venice Biennale with Biotron, a transparent structure containing a beehive with 4,000 bees having access to both a simulated and a natural environment. Created Invisible Labyrinth, 1971, and in 1972 installed Fitotron, a simulated growth environment for plants, at the Museum of Modern Art, New York. Numerous solo and group exhibitions in Europe and Buenos Aires, including Luis Ferdinando Benedit: Projects and Labyrinths, Whitechapel Art Gallery, London, 1975. Exhibits regularly at the São Paulo Bienal, where in 1987 showed series of drawings of Columbus' Discovery of the New World.

Rigaud Benoit (b. 1911, Port-au-Prince, Haiti – d. 1986, Haiti) Worked as musician, shoemaker and taxi driver; as protégé of Hector Hyppolite, began to decorate china and ceramic cups; invited to join Centre d'Art, 1946. First major primitive painter to emerge from Centre, depicted everyday life of Haiti, including folklore and voodoo; often used magnifying glass to render minute detail. Under direction of De Witt Peters, worked with others on egg tempera murals for Holy Trinity Cathedral, Port-au-Prince. Major solo exhibition, Centre d'Art, 1969, on occasion of Centre's 25th anniversary.

Antonio Berni (b. 1905, Rosario, Argentina – d. 1981, Buenos Aires) Son of an Italian immigrant tailor; employed in a glass workshop while studying drawing and painting at the Catalonian Centre in Rosario. In 1925 awarded a scholarship to study abroad; travelled in Europe before settling in Paris where he attended André Lhote's school and the Grande Chaumière under Othon Freisz and formed close friendship with Spilimbergo. In 1929 met Louis Aragon, read Freud and moved in Surrealist circles. On his return to Rosario in 1930, he initially continued to work in Surrealist manner. In 1931 joined the Communist Party briefly; founded the group 'Nuevo Realismo' and now saw his work within the current of narrative social realism. In 1933 he helped Siqueiros on Plastic Exercise, an experimental mural commissioned by the publisher Botana in his private house near Buenos Aires. Taught at the National School of Fine Arts, Buenos Aires, 1936-46. First prize for painting, International Exposition, Paris, 1937. In 1941, selected by the National Commission of Culture to study pre-Columbian and post-colonial American art, travelled the Pacific coast from Peru to the north-western United States, producing a series of paintings of Indian life. First used collage in 1959, and in 1960 began his series of collage-constructions on the life of Juanito Laguna; in 1963 he began another on Ramona Montiel as well as producing sculpture. Grand Award for Etching, Venice Biennale, 1962, for his collection Juanito Laguna. Retrospective exhibitions in Santiago, Chile, 1964; Trenton, N.J. (Trenton Museum), 1966; Mexico City, 1967; Rio de Janeiro, 1968; Paris (Musée d'Art Moderne de la Ville de Paris), 1970; Caracas (Museo de Bellas Artes) 1977; Mar del Plata (Museo de Arte Contemporáneo) 1980. 1981 painted murals on theme of the Apocalypse.

Henrique Carlos Bichalho Oswald (b. 1918, Rio de Janeiro – d. 1965, Rio de Janeiro)

Son of painter and printmaker Carlos Oswald, attended School of Arts and Trades where father was on the faculty. Enrolled National School of Fine Arts; awarded silver medal in drawing, 1947, and gold medal in printmaking, 1948. Instrumental, 1940s, in forming School of Fine Arts, Recife. In Bahia, 1952, documented country and indigenous types. In Paris, 1958, frequented studio of printmaker Johnny Friedlaender. On return to Brazil, 1959, moved to Salvador and became head of printmaking, University of Bahia. Included in São Paulo Bienal, 1951-63.

Wilson Bigaud (b. 1931, Port-au-Prince, Haiti)

Born into a poor family; received first art training from his neighbour, Hector Hyppolite; at age fifteen became Hyppolite's apprentice and joined Centre d'Art. *Marriage Feast of Cana*, mural in egg tempera for transept of Holy Trinity Cathedral, Port-au-Prince, commissioned at age twenty-two. His *Earthly Paradise* first painting by a Haitian to be included in Carnegie International Exhibition (1952). Work of 1950s included carnival scenes such as *Mr and Mrs Pig* (1957) and religious paintings as in altarpiece for Eglise Episcopal, Leogone. In 1960s suffered a series of breakdowns; continued to paint, 1970s themes often reflecting his illness.

Juan Manuel Blanes (b. 1830, Montevideo – d. 1901, Pisa, Italy) Son of an Andalusian father and an Argentine mother; left school at age eleven, yet taught himself to draw, and displayed artistic talent noted by the master Juan Cabral. Parents separated, and he moved to Cerrito to work as typographer for newspaper El Defensor de la Independencia Americana and help support his mother and sister. In period 1844-53 began to paint and to make colour drawings; moved in 1855 to Salto, where he taught painting at College of the Humanities and painted a portrait of General Justo José de Urquiza; other paintings of the General's residence and his military victories followed. Travelled to Buenos Aires, 1857, where he painted An Episode of Yellow Fever in Buenos Aires (acquired by Uruguayan government for the National Museum when it was exhibited in 1871). Returned to Montevideo, 1859, and received government subsidy to study in Europe. In Florence from 1860, studying under noted history and portrait painter Antonio Ciseri. First shipment of his works back to Uruguay lost in shipwreck off Montevideo, 1862. Returned to South America, 1863, and produced many paintings on historical themes and portraits of military heroes. In 1873, exhibited two works on Chilean history at the Exposición de Santiago. Returned to Italy, 1879-80, when he painted La Paraguaya and El Ultimo Paraguayo, works for which he received a gold medal when they were shown in Buenos Aires in 1882 Continental Exhibition. In Montevideo, decorated Rotunda of the Cementerio Central; his painting El Gauchito issued on stamps 1895, 1896 and 1897. Continued to paint historical allegories, including what is now called La Revista de Río Negro (1891). On a final return to Italy, settled in Pisa, 1898, where he died of bronchial pneumonia; remains returned to Uruguay and interred in the Panteón Nacional. A major commemorative exhibition held in 1941 in Teatro Solís and at Museo Nacional de Bellas Artes, Buenos Aires.

Jacobo Borges (b. 1931, Caracas)

Born to a poor family in a small rural community outside Caracas; education limited to primary school. Attended Cristobal Rojas School of Fine and Applied Arts, Caracas, 1949-51, while working for an advertising firm and drawing comic strips. Visited the reclusive artist Armando Reverón at Macuto, at this time, and met Alejo Carpentier, the Cuban writer in exile. In 1952, awarded a scholarship by Metro-Goldwyn-Mayer in connection with the film An American in Paris, went to Paris where he joined the Young Painters Group and evolved, experimentally, an expressionist style. Returning to Caracas in 1956, held first solo exhibition at Lauro Gallery and Museo de Bellas Artes awarded an honourable mention, 1957, at São Paulo Bienal. Associated with Round Table Group and Whale Group Co-operative, an alternative exhibition space; in 1965 ceased to paint and worked on designs for a staging of Carlos Muniz' The Inkwell, and with film-makers, 1966-8, on an audio-visual production, Images of Caracas. In 1971 returned to painting; in 1976, an exhibition of 48 of his works from 1968-76, entitled Magic of a Realist Critic, shown in Mexico City and Caracas. Wrote and illustrated The Mountain and Its Era (1979). Major retrospective exhibitions Staatliche Kunsthalle, Berlin, 1987 and Museo de Arte Contemporáneo, Caracas, 1988.

Fernando Botero (b. 1932, Medellín, Colombia)

Began his career in 1948 working as an illustrator for Sunday literary supplement of *El Colombiano*, Medellín newspaper, where he published articles on Picasso and Dalí, 1949. Baccalaureate from Liceo de Antioquia Medellín, 1950; moved to Bogotá. First one-person exhibition Galería de Arte Foto-Estudio Leo Matiz, Bogotá, 1951; another the following year. To Europe, 1952; enrolled Real Academia de Bellas Artes de San Fernando, Madrid, and frequented Prado to study and copy Goya and Velásquez. In Florence, 1953, studied fresco painting, Academia San Marco, attended lectures by Roberto Longhi. Returned to Bogotá, 1955; after cool reception of work exhibited Biblioteca Nacional, moved to Mexico City, 1956, and later to New York. Work

included in Gulf-Caribbean exhibition, Museum of Fine Arts, Houston, Texas, 1956, and in 1957 first solo exhibition in USA, at Pan-American Union, Washington, D.C. Returned to Bogotá as professor of painting, Escuela de Bellas Artes, Universidad Nacional, 1958-60. Moved to New York, 1960-73. Received award for Colombian section, Guggenheim International, 1960. His Mona Lisa at Age 12 (1961) purchased by Museum of Modern Art, New York; solo exhibitions New York, Baden Baden, Hanover, Paris and Madrid. In Paris in 1970s, turned to sculpture, exhibited at Paris art fair (FIAC) 1977; painting again from 1978, in studio once occupied by Académie Julien. Major retrospectives of his work in Germany (1970) and Kunsthalle, Frankfurt (1987), Colombia (1973), the Netherlands (1975) and the United States (1979-80). On occasion of retrospective at Museo de Arte Contemporáneo, Caracas, 1976, awarded Venezuelan order Andres Bello; Cruz de Boyaca from Colombian government of Antioquia for services to his native country.

Angel Bracho (b. 1911, Mexico City)

Studied San Carlos Academy, Mexico City 1928. Associated with artists working under direct influence of Diego Rivera; 1933, collaborated on fresco, Abelardo Rodríguez Market, Mexico City. Joined LEAR and founder member of Taller de Gráfica Popular 1937.

Claudio Bravo (b. 1936, Valparaiso, Chile)

Eldest of seven children of wealthy landowner and cattle rancher; mother an amateur artist. At Jesuit school, San Ignacio, 1945-55; studied with local artist, Miguel Venegas Cienfuentes. In mid-1950s, assistant to professor of architectural drawing, Catholic University, Santiago; wrote poetry, danced professionally, active in the theatre. In Concepción, joined followers of poet Luis Oyarzún. First one-person exhibition, of oils and drawings in red chalk, Salon 13, Santiago, 1954-5. To Europe, 1961; settled in Madrid. Success as society portrait painter led to invitation to Philippines, where he did portrait of Imelda Marcos and exhibited, Luz Gallery, Manila, 1968. In late 1960s began series of paintings of wrapped packages inspired by art of Antoní Tàpies and Mark Rothko; in 1970s worked on stone paintings influenced by study of Zen, on still lifes in Spanish Baroque tradition, and on scenes of local life in Tangier, Morocco, where he now lives. Has exhibited internationally in more than 20 shows; participated in Documenta 5, Kassel, 1972, and Carnegie International Exhibition, 1983.

Roberto Burle Marx (b. 1909, São Paulo, Brazil)

In Germany, 1928, attending art classes at Berlin Academy, frequented Dahlem Botanical Gardens; developed interest in plants and their ecology. Enrolled 1930 National Academy of Arts, Rio de Janeiro; studied with Cândido Portinari. Encouraged by the architect Lucio Costa, completed first landscape project 1933. Director of Parks, Recife, 1935-7, where he designed Casa Forte water gardens and Benfica cactus gardens. Assisted Portinari in execution of tiled murals, Ministry of Education, Rio, 1937. After 1937 worked privately as landscape architect; numerous projects over last fifty years include Odette Montiero Garden, Petrópolis, near Rio, and 5 km. mosaic pavement at Copacabana Beach. Discovered and cultivated numerous indigenous plants now bearing his name. Also an accomplished painter and jewellery designer; exhibited widely; retrospective exhibitions of his landscape designs and paintings, Museum of Modern Art, São Paulo, 1952; Pan-American Union, Washington, D.C., 1954; Institute of Contemporary Arts, London, and Stedelijk Museum, Amsterdam, 1956. First Prize for Landscape Architecture São Paulo Bienal, 1953; Fine Arts Medal, American Institute of Architects, 1965. Awarded honorary doctorates, Royal College of Art, London, and Royal Academy of Arts, The Hague, both 1982.

Hermenegildo Bustos (b. 1832, Purisma del Rincón, near León, Guanajuato, Mexico – d. 1907, Purisma del Rincón)

Studied for only six months with painter Herrera, who taught him little, used him mostly as a servant. Produced religious sculpture and mural programmes for his native parish; designed masks for religious festivals, painted *retablos*, and hundreds of small portraits, usually in oil on tin, of friends and neighbours. Interested in astronomy, left painted records of comets and eclipses. Designed coat he wore in 1891 *Self-Portrait*. His portraits first collected by writer Francisco Orozco Muñoz, of Guanajuato; home of later collector, Dr Aceves Barajas of Francisco del Rincón, became Bustos Museum. Work exhibited, Museo Nacional de Arte, Mexico City, 1951, and subsequently in Paris and Stockholm (1952), London (1953) and Tokyo (1955); focus of 1956 'First Week of Culture in Guanajuato' sponsored by Instituto Nacional de Bellas Artes.

Sergio Camargo (b. 1930, Rio de Janeiro)

Began to study art at age sixteen, Altamira Academy, Buenos Aires, with Emilio Pettoruti and Lucio Fontana. In Paris, 1948, studied philosophy at the Sorbonne, began to make sculpture; visited Brancusi's studio, met Arp and Vantongerloo. Returned to Brazil, 1953; in 1954, visited China; exhibited sculpture at National Salon of Modern Art, Rio, the same year. Again in Paris, made his first wood reliefs; received International Sculpture Prize, Paris Biennale, 1963; one-person exhibitions, Signals Gallery, London, and São Paulo Bienal, 1964; in group shows of kinetic art, including 1964 Mouvement II exhibition, Denise René Gallery, Paris. In 1965 began work on sculptural wall for Oscar Niemeyer's Foreign Ministry building, Brasilia. Named 'Best National Sculptor', São Paulo Bienal, 1965; represented Brazil at Venice Biennale, 1966. Began to carve geometrical volumes in Carrara marble. Settled in Rio, 1974. 'Best Annual Sculpture Exhibition' award, Associação Paulista de Criticos de Arte, São Paulo, 1977. Since 1980, solo exhibitions Museums of Modern Art, São Paulo and Rio; represented in Venice Biennale, 1982.

Santiago Cárdenas (b. 1937, Bogotá)

Santiago Cárdenas Arroyo. Received BFA degree, Rhode Island School of Design, 1960; travelled in Europe 1960-2. At School of Fine Arts, Yale University, studied under Alex Katz, Neil Welliver, Al Held and Jack Tworkov, received MFA degree 1964. In Colombia, taught at several universities before appointed director, School of Fine Arts, National University of Colombia, Bogotá, 1972. First exhibited painting in Colombia 1963 at Asociación de Arquitectos Javerianos, Bogotá; solo exhibitions, Luis Angel Arrango Library, Bogotá, 1968, 1970, 1974. Center for Inter-American Relations, New York, 1973, and elsewhere. Chosen to represent Colombia, XIV São Paulo Bienal, 1977; has received numerous awards for his paintings, drawings and scenographic designs.

Leonora Carrington (b. 1917, Lancashire, England)

Second of four children of wealthy English textile manufacturer, Harold Wilde Carrington, and his Irish wife, née Moorhead; strict Catholic upbringing, educated at (and expelled from) convent schools in Essex and at Ascot, and at finishing schools in Florence and Paris, before being presented at court, 1934. First student to enrol at Amédée Ozenfant Academy, London, 1936. To Paris with Max Ernst, 1937, and lived with him at Saint-Martin d'Ardèche; exhibited with Surrealists, Galerie Beaux Arts, Paris, 1938. With outbreak of war and Ernst's internment, 1939, fled to Spain and later Portugal; sailed for New York with Mexican diplomat Renato Leduc and other refugees. Arrived Mexico, 1942, and became Mexican citizen; in 1946, married Hungarian photographer Emerico Weisz. First solo exhibition, Pierre Matisse Gallery, New York, 1948. Work included in international Surrealist exhibitions, d'Arcy Galleries, New York, 1961, and Galérie d'Oeil, Paris, 1966, and in Au Coeur du Surréalisme, Cologne, 1971. Wall painting dedicated to State of Chiapas, commissioned 1963 by Museum of Anthropology, Mexico City, led to study of Chamula Indians, their herbal medicine and ritual magic. Along with output of paintings and drawings, published fiction, poetry, drama and essays. Retrospective exhibitions, Center for Inter-American Relations, New York, 1976; Brewster Gallery, New York, 1988.

Flavio de Rezende Carvalho (b. 1899, Rio de Janeiro – d. 1973, Rio de Janeiro)

Born of well-to-do parents, educated American School, São Paulo, and in Paris and London; degree in engineering, University of Durham. In Brazil after 1922, worked as engineer, entered designs in architectural competitions for public buildings; met Le Corbusier, 1929. Interested in psychology, studied and copied art of the insane, late 1920s. In the 1930s turned to painting and sculpture, and began to exhibit at national salon of Fine Arts; awarded a prize for Monumento do Soldado Constitutionalista, 1932, year he co-founded, with Emiliano di Cavalcanti and others, the Clube dos Artistas Modernos. First solo exhibition, São Paulo, 1934, closed by police and reopened only after a court battle. In 1935 coorganized association of Modernists, 'Quarteirao'. Active in the theatre, later in film, as art and dance critic, author and lecturer. Painting represented in 1st and 2nd Salão de Maio, São Paulo, 1937, 1938. Many portraits of celebrated figures in the arts, such as Pablo Neruda, and figure studies of women; A Série Trágica, drawings of his mother on her deathbed, completed 1947. Presided over fine arts commission, García Lorca Cultural Centre performance. In 1958, participated in exploration of upper Amazon basin organized by Department of Indian Protection. Continued to show painting; represented in Venice Biennale, 1938, and in São Paulo Bienal throughout the 1950s. Solo exhibition, São Paulo Bienal, 1963, in 1967 awarded First Prize among Brazilian artists. Retrospective São Paulo Bienal, 1983.

José Gil de Castro (1785, Lima – d. 1841, Lima)

Known as 'El Mulato Gil'; first portrait painter of the heroes of Independence. Early artistic training unknown, though may have been apprenticed to some colonial master in Lima. Accompanied Bernardo O'Higgins on campaign for Chilean independence, 1814–22; expertise in engineering and map-making won him rank of captain in Engineering Corps. Chilean government made him member of Legion of Merit, and in Santiago he painted society portraits as well as those of heroes O'Higgins and San Martín. Returned to Peru via Argentina, 1822; numerous portraits of Simón Bolívar, 1823–5. His paintings of heroes, with their rigid, linear forms, frontal poses, and fascination with military regalia, are distinguished by visual accuracy and frequent use of texts and cartouches.

Frederick Catherwood (b. 1799, England – d. 1854, England)

Began career as an architect in London. In 1831, joined expedition under Robert Haig as archaeological draughtsman, exploring Nile valley, Palestine and Arabia. In London 1836, met North American archaeologist John Lloyd Stephens; in 1839 joined Stephens as artist and companion on expedition to study and document ruins of Mexico and Central America, resulting in accurate descriptions of 44 sites, many reported for first time. Used camera lucida, and on second trip to the Yucatán, early daguerreotype camera, to achieve precise detail in drawings of architecture and decoration of Mayan structures. With Stephens, published works on Mayan culture including *Incidents of Travel in Central America* and *Chiapas and Yucatán* (both 1841) and *Incidents of Travel in Yucatán* (1843); volume of his own lithographs, *Views of Ancient Monuments in Central America, Chiapas and Yucatán*, (1844).

Emiliano di Cavalcanti (b. 1897, Rio de Janeiro – d. 1976, Rio de Janeiro)

Initially considered a career in law; turned to art after success of first exhibition of caricatures, Librairie O Livro, São Paulo, 1917. Coorganizer of the Semana de Arte Moderno (Modern Art Week), São Paulo, 1922, where he exhibited with leading modernist painters Anita

BIOGRAPHIES

Malfatti and Tarsila do Amaral. In Europe 1923-5 was particularly influenced by Picasso's neo-classical paintings. Exhibited Brazil, National Salon of Fine Arts, 1931. Returned to Europe, 1938-40. Retrospective exhibition, Architecture Institute, São Paulo, 1948. Awarded prize for Best National Painter. São Paulo Bienal, 1953; represented in Venice Biennale, 1956; gold medal at 11th International exhibition of Fine Arts, Mexico City, 1960. Retrospectives, Museum of Modern Art, São Paulo, 1971, MAC University of São Paulo 1985. Included in 1984-5 exhibition, *Tradição e Ruptura*, sponsored by the Bienal Foundation, São Paulo.

Newton Cavalcanti (b. 1930, Bom Conselho, Pernambuco, Brazil) Left his native Pernambuco in 1952 for Rio de Janeiro, where he frequented the studio of Raimudo Cela. Studied wood engraving with Oswaldo Goeldi; entered National School of Fine Arts, 1954. From 1960, taught printmaking under Goeldi's direction at Educational Centre of Niterói. First solo exhibition, National School of Fine Arts, 1958. Since then, in addition to solo gallery exhibitions, has shown at Museum of Modern Art, Belo Horizonte (1959), Italian Institute of Culture, Rio (1963), Brazilian Ministry of Education and Culture (1973). Numerous awards for his graphic work; has also illustrated books, and worked in film.

Henry Chamberlain (b. 1796, England – d. 1844, Bermuda)

The son of Sir Henry Chamberlain, British Consul in Rio de Janeiro and chief negotiator with Brazil in the period 1815-29, who himself spent time in Rio, 1819-20, as an officer in the Royal Navy. An amateur artist, produced drawings, watercolours and oils of landscape, customs and architectural features of Rio de Janeiro whose richness of detail provides an important document of the period. On his return to London, published in 1822 an album of colour aquatints, *Views and Costumes of the City and Neighbourhood of Rio de Janeiro, Brazil, from Drawings taken by Lieutenant Chamberlain, Royal Artillery, During the Years 1819 and 1820, with Descriptive Explanations.*

José Chávez Morado (b. 1909, Siloa, Guanajuato, Mexico)

Studied at Chouinard Art Institute, Los Angeles, and at Central School of Plastic Arts, Mexico City; at San Carlos Academy, 1933, studied wood engraving with Francisco Díaz de León and lithography with Emilio Amero. Appointed to department of elementary education, Ministry of Public Education, 1933; with Siqueiros, associate director, Centro de Arte Realista. In 1940, appointed director, fine arts section, Ministry of Education; professor of lithography, Escuela de Artes del Libro, 1945-7. Member of LEAR; founding member of Taller de Gráfica Popular. Murals painted in Jalapa, Veracruz, San Miguel Allende and in the Alhondiga, Guanajuato; bronze reliefs on theme mestizaje for 'umbrella' column, courtyard of Museum of Anthropology, Mexico City.

Lygia Clark (b. 1920, Belo Horizonte, Brazil – d. 1988, Rio de Janeiro) Began art instruction, 1947, with landscape architect Roberto Burle Marx. In Paris studied for two years, from 1950, with Fernand Léger, Dobrinsky and Arpad Szènes. First solo exhibition, Institut Endoplastique, Paris, 1952; the same year awarded Premio Federico Schmidt, selected as 'artistic revelation of the year' in exhibition sponsored by Brazilian Ministry of Education. In later 1950's, turned from abstract painting to sculpture, making first reliefs with surfaces constructed as if of folded paper, then articulated works in metal; series of the latter made after 1959 she called 'Animals', with a second series begun in mid-1960's called 'Goings'. In 1959 co-founded Brazilian Neo-Concrete group. Awarded Acquisition Prize, São Paulo, Bienal, 1957; Guggenheim International Award, 1958, 1960; International Prize, Instituto de Tella, Buenos Aires, 1962. Solo exhibition of her articulated sculpture, abstract reliefs and architectural projects, Signals Gallery, London, 1964; work included in group exhibitions, 2nd Pilot Show of

Kinetic Work, Signals, London, and Mouvement II, Denise René Gallery, Paris, both also 1964. Represented Brazil in Venice Biennale, 1960, 1962, 1968. A practising psychologist, Clark used the articulated works she created in her practice, and wrote texts on spectator participation in their manipulation.

Juan Cordero (b. 1824, Teziutlán, Puebla, Mexico – d. 1884, Popotlal, Mexico)

Son of a Spanish trader and his Mexican wife; attended San Carlos Academy, studied with Miguel Mata; briefly travelled as mercero (pedlar) to fairs to earn money to go to Europe. To Rome, 1844, to study at Academy of St. Luke; appointment as attaché to Legation of the Holy See provided means for continued study; paintings sent back to Academy included Moisés en Raphidín and an Annunciation (both 1847). First major painting, Columbus before the Catholic Monarchs, exhibited at third San Carlos Academy exhibition, 1851. Returned to Mexico, 1853. Conflict with Academy over his refusal to serve as subdirector of painting under Spaniard Pelegrín Clavé, exacerbated by political repercussions from portraits he painted of dictator Santa Anna and wife. Murals for Church of Santa Teresa, 1857, and for Church of San Fernando, 1859, painted in tempera, anticipated technical practice of modern muralists. Travelled outside the capital, especially in the Yucatán, to execute portrait commissions. Last mural for National Preparatory School, The Triumph of Science and Work over Ignorance and Sloth, completed 1874 (destroyed 1900); work again exhibited at Academy, 1875, after departure of Clavé. Commemorative exhibitions of his work, Palace of Fine Arts, Mexico City, 1945 and 1973.

José Correia de Lima (b. 1814, Rio de Janeiro – d. 1857, Rio de Janeiro) Studied history painting at Imperial Academy of Fine Arts, Rio de Janeiro, from 1827 under Jean-Baptiste Debret. Two drawings shown in architecture section of first exhibition at Imperial Academy, 1830. Appointed professor, and in 1837 acting head of history painting at Academy; on return from Europe in 1849; became head. Participated in numerous exhibitions at Imperial Academy, receiving distinction 1840; in 1841 honoured with robes of Order of Christ for submission of three portraits and historical painting *A Magnanimidade de Vieira*. As outstanding disciple of Debret, work included in *Retrospective Exhibition of Painting in Brazil*, National Museum of Fine Arts, Rio de Janeiro, 1949.

Carlos Cruz-Diez (b. 1923, Caracas)

Degree in art education and manual arts from School of Plastic and Applied Arts, Caracas, where he studied 1940-5. Publications designer, Creole Petroleum Corporation, 1944-5; art director, McCann Erickson Advertising Agency, Caracas, 1946-51, with brief period in New York, 1947. Illustrator for daily El Nacional; taught history of applied arts at school he had attended, 1953-5. In Barcelona 1955, with two brief visits to Paris, began study of kinetic properties of colour which led to his series 'Physichromies'. In Caracas again, 1957, opened studio of art and industrial design; designer of publications, Venezuelan Ministry of Education; from 1958, taught in School of Arts, also layout and design in School of Journalism, Central University of Venezuela, until his move to Paris in 1960. Exhibited regularly in international exhibitions including The Responsive Eye (New York, 1965) and Soundings Two (London, 1965). Grand Prize, Córdoba Bienal, 1966; International Painting Prize, São Paulo Bienal, 1967. Considering kinetic art an important contribution to architecture, has created works integrating the two forms, as in Transchromies for Phelps Tower Gates, Caracas, 1967, and public projects such as Chromosaturation pour un lieu public (Paris, 1967), and 'chromatic environments' for Guri Dam powerhouse (1980s).

Sandú Darié (b. 1908, Romania)

Left Romania to study law at University of Paris; during 1930s contributed satirical cartoons to magazines. Volunteered for French army

1939, served until fall of Paris, 1940. To Cuba, where became naturalized citizen. First non-objective works painted 1946; exhibited Havana 1949. Invited by Gyula Kosice to join international MADÍ movement. Solo exhibitions 1949 at Carlbach Gallery, New York; Lyceum, Havana, 1950, under auspices of Cuban Director of Culture and Ministry of Education; included in 1954 Lyceum exhibition, *Homage a José Martí*. Represented in exhibition commemorating MADÍ art, Museum of Modern Art, Buenos Aires, 1961. Served on admissions jury, Cuba's *Salon 70* exhibition. Lives and works in Havana.

Jean-Baptiste Debret (b. 1768, Paris – d. 1848, Paris)

Cousin of Jacques-Louis David, whom as a youth he accompanied to Rome. Enrolled Académie Royale, 1875; at onset of French Revolution abandoned painting for civil engineering, though still taught drawing, École Polytechnique, and in 1798 won award at the Salon. By 1806, painting large-scale canvases exalting Napoleonic era; at fall of Empire, decided to leave France. In 1816, joined LeBreton Mission, invited by Portuguese monarch João IV to Brazil to foster education of young Brazilian artists and develop the arts there. Appointed professor of historical painting, Rio de Janeiro, 1820, and became court painter to Brazilian royal family. Instrumental in organizing Académia Imperial de Belas Artes; notable students included Manuel de Araújo Porto Alegre and José Correia de Lima. Organized first public exhibition of art, Academia, 1829, and a second, 1830; painted scenery for João Theatre. Returned to Paris after 15 years in Brazil; his Voyage pittoresque et historique au Brésil, illustrated with lithographs documenting landscape and inhabitants of Brazil, published 1836-9. In recognition of the work, made a member of Instituto Historico e Geográfico Brasileiro, 1839. Also executed many portraits and historical paintings such as Retrato de D. João IV and Aclamação de D. Pedro I reflecting neo-classical style on the model of David.

Mestre Didi (b. 1917, Salvador, Bahia, Brazil)

Born Deoscoredes dos Santos, a fifth-generation direct descendant of Yoruba royal family of Benin, West Africa, whose ancestors brought first religious society of Xangô Alfonjá to Bahia; the artist, known as Master Didi, is a practising high priest of the Eguns, only group in America to perpetuate Yoruba cult of ancestors. Began making sculpture as an adolescent, utilizing wood, cement, stone, leather, cowrie shells and beads to create objects synthesizing African and Brazilian cultures. Has exhibited widely in Africa, Europe, U.S.A. and South America. In 1967 undertook UNESCO project to study connection between Brazil and West Africa in ritual and ritual art. As cultural historian, continues oral tradition of Afro-Brazilian stories and songs, preserving them in written form. Founder and curator of Bahian section of Museum of Modern and Popular Arts, Salvador. Author of a Yoruba-Portuguese dictionary. Solo exhibition, Schomberg Center for Research in Black Culture, New York, 1986.

Dos Santos, Deoscoredes, see Didi, Mestre

Augusto Rodrigues Duarte (b. 1848, Nespereira, Portugal – d. 1888, Rio de Janeiro)

Resident in Rio de Janeiro from his youth; studied at Imperial Academy of Fine Arts from 1866 under Victor Meireles, awarded gold medal 1869. In Paris from 1874, enrolled Ecole des Beaux Arts under academic painter Jean-Léon Gérôme. Painted historical themes, genre scenes and landscapes; exhibited in Salon of 1877, and at Universal Exposition of 1878 showed his noted work *Funeral of Atala*. Exhibited at Imperial Academy, Rio de Janeiro, in 1879, receiving gold medal, and in 1884 being honoured with title Knight of the Imperial Order of Roses. Work included in *Retrospective Exhibition of Painting in Brazil*, Museu Nacional de Belas Artes, Rio de Janeiro, 1949.

Miguelzinho Dutra (b. 1810, Itu, São Paulo, Brazil – d. 1875, Piracicaba, São Paulo)

Miguel Arcanjo Benício da Assunçao Dutra, known as Miguelzinho, musician, writer and architect as well as self-taught artist; painted numerous watercolours, 1835-55, portraying people, customs and landscapes of provincial Itu and Piracicaba. Worked with Friar Jesuíno de Monte Carmelo on decoration of churches, São Paulo and Itu. Drawings and watercolours in collections of Museum of Itu and Paulista Museum.

Roberto Matta Echaurren (b. 1911, Santiago, Chile)

Attended French Jesuit College of the Sacred Heart; degree in architecture, Catholic University, Santiago, 1931. In merchant marine, 1933, travelled to Europe. Assistant in office of Le Corbusier, Paris, 1933-4; in 1936 to the Soviet Union, and to Finland where met Alvar Aalto. Work on Spanish Pavilion, International Exhibition, Paris, 1937. Through García Lorca and Dalí, met André Breton; joined Surrealists 1938; first oil paintings ('inscapes') completed that year in Brittany. To New York on outbreak of war, 1939; first exhibition, with Pavel Tchelichew, Julian Levy Gallery, New York, 1940; to Mexico that summer with Robert Motherwell. Exhibited Pierre Matisse Gallery, New York, 1942-8. In 1942 illustrated Breton's Prolegomena to a Third Manifesto of Surrealism; expelled from Surrealist group, 1947. In Rome 1950-4; resided Paris thereafter until 1969. Visited Cuba, 1960s, to work with art students; presided at Cultural Congress, Havana, 1968. Travel since 1970 to Africa and Central and South America; resides currently in Rome, Paris and London. Retrospective exhibitions, Museum of Modern Art, New York, 1957; National Gallery, Berlin, 1970; Pompidou Centre, Paris, 1985.

Camilo Egas (b. 1899, Quito - d. 1962, New York City)

Camilo Alejandro Egas Silva; spent his youth in San Blas barrio; attended College of San Gabriel y Mejia. Enrolled Academy of Arts, Quito, 1905; studied with Paul Bar, Víctor Puiz and others. First award, 1909, in national competition celebrating anniversary of Ecuadorean independence; won prize in first Mariano Aguilera competition, Quito, 1913. To Europe, to study at Academy in Rome, 1918, on government grant; second grant to study at San Fernando Academy, Madrid, 1919. In Paris, studied at Colorrossi Academy, 1922; met Picasso. In charge of Ecuadorean art, Exposition des Arts Décoratives; exhibited in Salon des Indépendants and Salon d'Automne, 1924-5; paintings of Ecuadorean Indians shown Galérie Carmine, Paris, 1925. In Quito, 1926, appointed professor at Normal de Quito and art director of National Theatre. Painted indigenist subjects, often from social and political viewpoint. In 1927 moved to New York; taught in painting department, New School for Social Research, 1929; director of department from 1935 until his death. Influenced by Mexican muralists; friendship with José Clemente Orozco from 1931. Mural Festival for New School, 1932; collaborated on mural project for Ecuadorean Pavilion, New York World's Fair, 1938. Contact with Surrealists in New York, 1940s; work influenced by them shown at Acquavella Gallery, New York, 1946. Exhibited New York, Caracas and Quito in 1950s. In 1962 received award for artistic merit from American Academy of Arts and Letters; honorary doctorate in fine arts, New School for Social Research, 1962.

Daniel Thomas Egerton (b. ? 1800, England – d. 1842, Tacubaya, Mexico)

Landscape artist, founding member of Society of British Artists, exhibited in London 1824-9. In Mexico, 1829-36, in search of the picturesque, made drawings and watercolours of Valley of Mexico, five landscapes of views of Popocatepetl, exhibited 1836-40. Published portfolio of colour lithographs, *Vistas de México* (1839-40). Returned to Mexico, 1840, settling at Tacubaya where he painted the large oil, *Valley of Mexico*, and where he and his wife were murdered in 1842.

José María Espinosa (1796, Bogotá, Colombia - 1883, Bogotá)

Espinosa was born to a distinguished creole Bogotá family. Studied painting with Pablo Antonio García, but education was interrupted by the revolution of July 1810. He took an active role in the army until victory was declared in 1819 and recorded incidents of his service under General Antonio Narino from 1813-16 in his *Memorias de un Abandero*. Espinosa was taken prisoner on a southern campaign and held in San Augustín. Made humorous caricatures of fellow prisoners; inspired by the beauty of the southern scenery, he painted landscapes in addition to recording battle scenes in which he participated.

After independence, returned to Bogotá and dedicated himself to painting scenes of the revolutionary war, and portraits of heroes of independence, including the liberator, Simón Bolívar. Prominent in social and political life of the new republic.

A history painter, portraitist, miniaturist and caricaturist, Espinosa's work represents the transition from art of the colonial period to that of independence. His style was carried on by his sons and his noted disciples José Manuel Groot and Luís García Hevia.

José María Estrada (b. ?1810, Guadalajara, Mexico – d. 1865, Guadalajara)

A student of José María Uriarte, miniature painter and director of painting, Academy of Fine Arts, state of Jalisco, Estrada favoured portraiture. Never left his native city, but painted many distinctive portraits of people from all classes in Jalisco, such as those of Don José María de Villaseñor and Doña María Tomasa García Aguirre; also painted historical scenes and allegories on moral or religious themes.

Nicola Antonio Facchinetti (b. 1824, Treviso, Italy – d. 1900, Rio de Janeiro)

Completed art training in Italy before emigrating (possibly for political reasons) to Brazil, 1849. Portraits include some of Brazilian imperial family, but known primarily as landscape painter of scenes near Rio de Janeiro. Work included in retrospective exhibition of Brazilian painting, National Museum of Fine Arts, Rio, 1948, and in *Brazilian Landscape Painting before 1900*, São Paulo Bienal, 1953.

Gabriel Fernández Ledesma (b. 1900, Aguascalientes, Mexico – d. 1983, Mexico City)

From a family of intellectuals, received first impetus towards a career in art watching local potters decorating ceramics. After attending School of Fine Arts, Mexico City, commissioned 1920 by Minister of Education, José Vasconcelos, to make tiles for former convent of SS Pedro y Pablo, for which he revived 'Puebla Talavera' designs. With Roberto Montenegro, decorated Mexican Pavilion for 1921 Centenary Exposition in Rio de Janeiro. From 1926, editor of government-sponsored art magazine Forma, to which he contributed articles. Director of Centro Popular de Pintura, San Antonio Abad, 1928-32; in this period, travelled to France and Spain, prepared portfolio Fifteen Woodcuts, printed in Madrid. With Díaz de León, founded and co-directed arts exhibition space, Ministry of Education, 1931. Designed theatre sets and costumes; studies on indigenous arts of Mexico include Juguetes Mexicanos (1929). In 1942 awarded a Guggenheim Fellowship for research into death customs in pre-Hispanic, colonial and modern Mexico, and his paintings often relate to indigenous themes.

Leon Ferrari (b. 1920, Buenos Aires)

Began to sculpt, using stainless steel wire, while living in Italy, 1952. In 1962 began a series of drawings; collaborated on a book of poems and drawings. *Escrito en el Aire* (Milan, 1964). Included in the exhibition *Schrift und Bild*, Stedelijk Museum, Amsterdam, 1963; solo exhibitions Buenos Aires 1960-64; awarded the Premio di Tella, Buenos Aires, 1965. In the 1960's, participated in such exhibitions as *Homenaje a Vietnam* (1966) and *Homenaje a Latinamerica* (1967), and was active with the artists' groups 'Tucumán Arde' and the 'South Cone' of Santiago,

Chile. Settled in São Paulo, 1976, and returned to the fabrication of steel sculpture; created a series of sound sculptures, and worked with photocopies, heliographic copies, video and other media. Books include *Hombres* (1984) and *La Basílica* (1985). Work on religious theme includes a series of Hell (1984); his *Biblia Ilustrada*, verses from the Scriptures illustrated with collage, exhibited at Franklin Furnace, New York; 1987, and at the Latin American Space, Paris, 1988.

José Ferraz de Almeida Júnior (b. 1850, Itu, Brazil – d. 1899, Piracicaba)

From a poor country family, sent 1869 to study, School of Fine Arts, Rio de Janeiro. Pupil of Julio Le Chevrel and Víctor Meireles, awarded gold medal on completion of courses. Encounter with Dom Pedro II in Itu resulted in grant for European study. In Paris, 1876–82; study at Ecole des Beaux Arts under Alexandre Cabanel. Visited other European capitals before return to Brazil. Worked at Itu, except for brief visit to Paris, 1897; murdered 1899 while painting at his easel.

Marc Ferrez (b. 1843, Rio de Janeiro – d. 1923, Rio de Janeiro)

Son of Zéphérin Ferrez who came to Brazil in 1816 as member of French LeBreton Mission; Marc Ferrez taken to Paris at age seven, on death of his parents, where remained under care of sculptor Alpheé Dubois; probably returned to Rio de Janeiro 1859. Apprentice in paper and lithography shop of George Leuzinger; influenced by Franz Keller, German engineer and botanist in charge of Leuzinger's photography section, devoted himself to photography. Opened his own studio, 1865; photographed festivities attending return of Dom Pedro II from Europe. After fire destroyed studio, 1873, acquired new equipment, including panoramic camera, in Paris. Joined expedition of Charles Frederick Hartt of Cornell University to north-eastern Brazil, 1875; some 200 photographs from this important scientific mission exhibited, Ministry of Agriculture, Rio, 1877. In 1870s and early 1880s, perfected technique of panoramic photography, developing camera capable of recording 190-degree vista. His panoramic photographs awarded gold medal at Centennial Exhibition, Philadelphia, 1876, as at exhibitions in Paris (1878), Rio de Janeiro (1879) and St. Louis (1904); won Grand Prize, Brazilian exhibition of 1881 and medals at Buenos Aires (1882) and Amsterdam (1883); in 1885 made Knight of Brazilian Order of the Rose. Exhibited International Exhibition, Paris, 1889. In 1880s and 1890s, documented construction of Minas and Rio railroads; also photographed slave labour on coffee plantations and workers panning gold; produced some 1500 negatives documenting construction of Avenida Central, Rio, completed 1906. His studio one of first to manufacture 'ferroprussiate' postcards; in 1912 introduced Lumière autochromes, establishing collection of three-dimensional colour plates of Brazilian landscapes. Obtained rights to Lumière cinematographic projection system and in 1907 opened Pathé Cinema in Rio.

Pancho Fierro (b. 1810, Lima – d. 1879, Lima)

A mulatto of humble origins, self-taught, began career as artist by making maps and painting mural decorations as well as series of coats of arms of Peruvian cities. Emerged as one of Peru's foremost *costumbrista* painters, capturing in small-scale anecdotal watercolours and drawings (he had no interest in medium of oil) the spontaneity of nineteenth-century popular life and providing a valuable historical record of his time and place.

Pedro Figari (b. 1861, Montevideo – d. 1938, Montevideo)

Born of Italian parents, in 1886 began professional career as a lawyer and public defender; defence of murderer in 1895-9 trial earned him title of 'American Zola'. Elected to Chamber of Deputies 1896 and appointed vice-president 1904. Founded newspaper *El Diario*; published articles on poetry, education, law and aesthetics. Appointed director, School of Fine Arts and Crafts, Montevideo, 1915; initiated radical reforms in artistic and educational practices, resistance to which led to his re-

signation, 1917. Early work as a painter influenced by teaching of Italian artist Godofredo Sommavilla, known for genre scenes and portraits; but exposure to works of Bonnard and Vuillard in collection of Uruguayan artist Milo Beretta enabled him to break with academic tradition. Seriously embarked on career as a painter 1921, when moved to Buenos Aires and held first one-person exhibition, Muller Gallery. In 1924 helped to found Amigos del Arte, dedicated to defence of modern art. Successful solo exhibition, Galerie Druot, Paris, 1923; two years later moved to Paris, to remain for nine years. Published *Arte Estética, Ideal* (1912; Paris, 1926), *El Arquitecto* (1928) and *Historia Kiria* (1929). In 1930, awarded first prize (gold medal) for painting, Exposición Iberoamericana de Sevilla. Returned to Montevideo, 1933, where he continued to paint and exhibit until his death.

Pedro José Figueroa (b. 1780, Bogotá – d. 1838, Bogotá)

Descendant of a well-known family of seventeenth-century Colombian painters; studied with noted Peruvian painter, Pablo Antonio García (1744-1814). Overseer of completion of church of Las Nieves, Bogotá; painted a *Holy Trinity* for Cathedral of Bogotá, as well as portraits of archbishops for Cathedral museum. Notable for portraits of Simón Bolívar, completing no less than ten likenesses of the Liberator 1819-22. Founded an atelier for his numerous disciples, among them his sons José Celestino and José Miguel y Santos.

Lucio Fontana (b. 1899, Rosario de Santa Fé, Argentina – d. 1968, Varese, Italy)

Son of Milanese sculptor, Luigi Fontana; grandson of director of painting and sculpture workshop. Left Argentina with his father, 1905; attended school for master builders, Carlo Catteneo Technical Institute, Milan, 1914-15. Military service, World War I; enrolled Brera Academy, Milan, 1920. Returned to Rosario de Santa Fé, 1922; worked in father's commercial studio before opening his own sculpture studio, 1924. Again enrolled Brera Academy, Milan, 1928, in sculpture course under Italian symbolist Adolfo Wildt; diploma in sculpture, 1930. First one-person exhibition, Galleria del Milione, Milan, 1930; represented in Venice Biennale and 1st Florence International Exhibition same year. By 1931, executing terra-cotta reliefs and engraved tablets in coloured cement. In Paris, met Miró, Tzara, Brancusi, Venturi, joined Parisian group 'Abstraction-Création', 1935. Began working in ceramics at Albisola factory of futurist artist Guiseppe Mazzotti. Exhibited ceramic sculptures made at Sèvres factory, Galérie Jeanne Bucher-Mybor, Paris; executed sculpture for Italian Pavilion, International Exhibition, Paris, both 1937.

In Argentina from 1939, did mainly figurative work. In 1946, helped to organize Academia d'Altimira art school, Buenos Aires, contact with group Madí; 'Manifesto Blanco' issued that year. Four 'spatialist' manifestos issued, Milan, 1948-51. In 1949, created his first Buchi, punctured canvases; designed a spatial environment, Galleria del Naviglio, Milan. First collaboration with architect Baldessari, on a 200-m. neon tubing environment for 1951 Milan Triennale. First prize in competition for 5th portal, Milan Cathedral, 1952. Experiments with Buchi as filters for projection of light and movement from television emissions; 'Manifesto de movimento spaziale per la televisione' issued 1952. Series of Pietra, incorporating fragments of Murano glass; brief association with Milanese 'Grupo nucleare'. Completed first Tagli (Cuts),1952, year of retrospective at Venice Biennale. Exhibited internationally and in numerous solo shows, 1950s and 1960s. Series of concetti spaziali of copper, dedicated to New York City, shown at Martha Jackson Gallery, New York, 1961. Grand Prize for Sculpture, Venice Biennale, 1966.

A. Frisch (Active c. 1865 in the Amazon region of Brazil)

A. Frisch is known for his photographs of the aborigines who inhabited areas along the Amazon River. Depicted as noble savages, Frisch sometimes emphasized the sculptural quality of these figures by opaquing

the backgrounds of his negatives. He exhibited his work at the Paris International exhibition in 1867 when anthropological photography was in its early stages. Frisch was not a permanent resident of Brazil. The Leuzinger studio was given the rights to sell his prints in Brazil.

Gabriel Vicente Gahona (Picheta) (b. 1828, Mérida, Yucatán, Mexico – d. 1899, Mérida)

Studied briefly at Columbia University, New York. Awarded a Mexican government grant to study in Italy for four years, but after a short time returned to Mérida, aged nineteen. That year, 1847, cofounded *Don Bullebulle*, a 'periódico burlesco y de extravagancias', which he illustrated throughout the year with 86 woodcuts signed 'Picheta'. An extraordinary popular graphic artist, his critical and satirical work bears a relation to that of the great nineteenth-century Parisian printmakers such as Daumier, Guy, Doré and others. Wish after 1847 to found an academy in Mérida never realized, but he did establish a lithography studio in 1851. Appointed a directing member, Yucatán Museum, 1866; taught drawing at Instituto Literario del Estado. Elected president council of Mérida 1880.

Galo Galecio (b. 1912, Vinces, Los Ríos, Ecuador)

Studied art, School of Fine Arts, Guayaquil; in 1944 received grant from Ministry of Education to continue studies in Mexico. There, studied printmaking at Taller de Gráfica Popular as well as fresco painting. Painted several murals in Quito and Tulcán, including monumental series *La Historia de Ecuador* in which he collaborated with Oswaldo Guayasamín. Numerous awards for his graphic work include 'Badalona' award at III Bienal Hispanoamericana de Arte, Barcelona, 1955, and award for printmaking at Mariano Aguilera exhibition, Quito, 1957 and 1964. Appointed professor of printmaking, School of Fine Arts, Quito.

José Gamarra (b. 1934, Tacuarombo, Uruguay)

Studied painting and engraving, School of Fine Arts, Montevideo, 1952-9; travelled through South America and to Cuba after 1953. To Rio de Janeiro, 1959, on Brazilian government scholarship. Assumed teaching position, São Paulo, at Armando Alvarez Penteado Foundation. Awarded Tercer Prize, 1st Bienal of Córdoba, 1962; in 1963, included in Biennal of Young Artists, Paris. Settled in Arcueil, France, 1963, but travels extensively in Europe, the USA and South America. Represented Uruguay in 1964 Venice Biennale. Has moved away from abstraction towards painting of jungle landscapes, settings for historical incidents and myths. In 1967 co-founded the 'Automat' group and began a study of animation.

Epifanio Garay (b. 1849, Bogotá, - d. 1903, Villeta, Colombia) Born in the modest household of Narcisco Garay, portrait painter and cabinet maker. First art lessons from father, before studying with José Manuel Groot, as well as at the Academia de Música. In 1865, Garay sang the lead with an Italian opera company in productions such as La Traviata as well as Spanish musical comedies. Continued to paint; 1871 exhibited at 'Aniversario de la Independencia', receiving honourable mention for the painting Dolor. 1871-3, toured as singer with Compañía de Zarzuela; 1874 to Musical Academy of New York. 1880, returned to Bogotá, appointed director of Académia Gutiérrez. 1882, received government grant to study in Paris; enrolled at Academie Julien, where tutors included Bouguereau, Boulanger, Ferrier and Bonnat. His grant cancelled in 1885 due to civil war in Colombia, so he returned to singing. On tour, he visited museums in Italy and England, and made copies of European masters. Back in Colombia, disillusioned with the reception of his work, turned briefly to agriculture and cattle ranching before establishing a school of painting at Cartegena. 1894-8, acting director of the School of Fine Arts in Bogotá; officially appointed in 1898, a year before the academy closed with the onset of the 1899 revolution. Notable for his portraits of presidents, generals and influential women from the Santa Fé area of Bogotá.

Claudio Gay (b. 1800, Draguignan, France – d. 1873, France) Draughtsman and botanist whose travels and botanical study in Chile, 1843–51, under government auspices, resulted in the *Historia física y política de Chile* (24 vols., 1844–54); accompanying *Atlas* contained 289 lithographs depicting plant life, zoological and human specimens and landscapes, based on his own drawings and watercolours and those of other artists, notably Johann Moritz Rugendas. Gay contributed botanical studies of South America to European scientific journals. Monograph on his work by Diego Barros Arana published in Chile, 1876.

Claudio Girola (b. 1923, Rosario, Argentina)

Parents Italian, father a sculptor and carver. Studied Manuel Belgrano School of Fine Arts, Buenos Aires; left 1943. Founding member with Iommi, Hlito and Maldonado of 'Arte Concreto-Invencíon', 1945; in group show, Galería Peuser, 1946. To Europe, 1949; in Paris, met Vantongerloo; solo exhibition, Librería Salto, Milan, and showed with Milanese 'Gruppo MAC'. In Buenos Aires, 1952, exhibited with 'Artistas Modernos de Argentina' at Galería Viau, and in 1953 at Galería Krayd. Member, Institute of Art, University of Valparaiso, Chile, 1952; exhibited Catholic University of Valparaiso. Moved to Valparaiso, 1957; retrospective, National Museum of Fine Arts, Santiago, Chile, 1961. Included in 1960 exhibition, 50 Años de Arte Argentino, National Museum of Fine Arts, Buenos Aires; received that Museum's Braque Prize, 1963. Represented in Venice Biennale, 1962, and Amsterdam Biennale, 1970; solo exhibitions, Buenos Aires, at Galería Rubbers, 1970, 1972, 1977, Galería Carmen Waugh, 1974 and Galería del Retiro 1983-85. Collaborated on journal, Revue de Poésie (Paris).

Alberto Gironella (b. 1929, Mexico City)

Born of a Catalan father and a mother from the Yucatán; studied Spanish literature, National Autonomous University (UNAM), Mexico City, early 1950's, wrote poetry and a novel (unpublished) before returning to painting, 1952. Exhibited that year at Galería Prisse, Mexico City, with José Luis Cuevas and others turning away from established political art of the Mexican School towards more personal expression and greater interest in international painting styles. To New York, 1959, where Velázquez portrait of Queen Mariana, in Metropolitan Museum, inspired series of his paintings and constructions, exhibited Galería Juan Martín, Mexico City, 1963. Visited Paris and Madrid, 1961, met André Breton; associated with group 'Phases', organized by Edouard Jaguer, with which he exhibited, University of Paris, 1963. On return to Mexico, 1962, associated with Salvador Elizondo's publication S. NOB in attempt to revive Parisian Surrealism of 1920s and 1930s. Has exhibited regularly since 1952, including solo exhibitions, Pan American Union, Washington, D.C., 1959, and Palacio de Bellas Artes, Mexico City, 1972; numerous international group exhibitions, including surrealist L'Ecart Absolu Paris, 1965; work included in São Paulo Bienal, 1961, and Salon de Mai, Paris, 1964, 1966. Illustrated with lithographs Carlos Fuentes' Terra Nostra (1975). Lives and works in Mexico.

Mathias Goeritz (b. 1915, Danzig, Germany)

Mathias Goeritz attended the School of Arts and Crafts of Berlin-Charlottenburg from 1932; Ph.D. in the history of art from the Friedrich-Wilhems Universitaet. While in Berlin, Goeritz associated with the artists Paul Klee and Hans Arp. He fled Germany in 1941 settling in Spanish Morocco then returning to Spain. 1948 moved to Santillana del Mer where established 'School of Altamira' and artistic brotherhood called 'The New Prehistorics'. 1949 to Mexico on the invitation of the Mexican architect Ignacio Diaz Morales, to join faculty of School of Architecture, University of Guadalajara. Goeritz introduced the idea of 'emotional architecture' with the El Eco Experimental Museum in Mexico City in 1952. This controversial work provoked criticism from Rivera and Siqueiros, for introducing decadent European aesthetic. Goeritz continued to teach; 1954 appointed director of Visual Design at

the National School of Architecture. 1957, organized a new art school at the Ibero-American University and headed the Department of Industrial Design; in same year, commissioned by architect Luis Barragán to design the entry to Satellite City, in north of capital: Goeritz designed five triangular concrete pylons 123–190 feet in height. For the 1968 Olympics in Mexico, Goeritz designed another series of concrete towers for the Sports Palace.

As a theorist, he was interested in synthesizing arts and urban planning as a means of elevating the spiritual level of urban society. He served as the editor of the art section of *Arquitectura-Mexico* from 1958-1975; was elected to the Akademie der Kunst, Berlin, (1974) and made Honorary Fellow of the Royal Academy of the Hague (1975); member of the 'Sculptural Space Center' team at the Universidad Nacional Autónoma de Mexico, 1979.

Francisco Goitia (b. 1886, Zacatecas, Mexico – d. 1969, Xochimilco. Mexico)

Born in a rural area, son of a farm labourer; after a few years' schooling, worked on a hacienda. Began to study painting, aged sixteen, at Academy of Fine Arts, Mexico City, working meanwhile as an etching printer. Student of Germó Gedovius, who in 1904 sent him to Europe on government stipend; travelled in Italy before becoming pupil of Francisco Gali in Barcelona. Returned to Mexico City, 1912, to join staff of General Angela in support of Revolution; drew and painted grim scenes of effects of war. In 1918 invited by Manuel Gamio to join archaeological survey in San Juan Teotihuacán; study of indigenous art and culture inspired his future art. Work exhibited, Carnegie Institute, Pittsburgh,in conjunction with lectures by Gamio; moved to Xochimilco with government commission to study indigenous people. His masterpiece, *Tata Jesucristo*, painted after brief visit to Oaxaca, 1927. Collection of his sketches, notes and watercolours at Ministry of Education, Mexico City.

Carlos González (b. 1905, Melo, district of Cierro Largo, Uruguay) A self-taught artist, began to make prints 1938; devoted himself to wood engraving, taking his themes from life of *campesinos*. Known from his painterly approach to printmaking, by contrast with draughtsmanlike quality of later generation of Uruguayan printmakers. Exhibited at National Salon of Fine Arts, receiving silver medal 1942, gold medal 1943 for *Muerte de Martín Aquino*, and Grand Prize gold medal 1944 for *Lobizón*. Work shown internationally in Riverside Museum Exhibition, New York, 1941, and International Exhibition of Contemporary Prints, Paris, 1949. Published an album of 32 prints before his retirement from printmaking in 1944. Work exhibited at IV Bienal Americana de Grabado in Santiago, 1970, where he was credited with invention of Uruguayan printmaking.

'GTO', see Oliveira, Geraldo Teles de

Oswaldo Guayasamín (b. 1919, Quito, Ecuador)

Eldest of ten children of Indian-mestizo family. Studied at National School of Fine Arts, Quito, under Pedro León Donaso, 1933-40; first solo exhibition, 1940. Works purchased by Nelson Rockefeller, through whose influence he visited museums in USA under auspices of U.S. State Department; exhibited major cities of USA. In Mexico, 1943, studied fresco painting with José Clemente Orozco. Travelled to Peru, Chile, Argentina and Bolivia as cultural attaché, Ecuadorean government; work exhibited capital cities of these countries. In 1948 completed first fresco, El Incario y la Conquista, for Casa de Cultura of Ecuador, Quito. More than 100 works exhibited, under title Huacayñan (House of Tears), Museum of Fine Arts, Caracas, 1952. Awarded Grand Prize for Painting, III Spanish Bienale; first prize for painting in South America, IV São Paulo Bienal. Exhibited Pan-American Union, Washington, D.C., 1955, 1958. Series of 250 paintings, La Edad de la Ira (Age of Anger), inspired by political prisoners. Has also fashioned

jewellery on pre-Columbian motifs, and carved figures in Ecuadorean tradition of immortalizing the dead. Lives and works in Quito, where his house is also museum of his own work and of his collection of pre-Columbian art.

Jesús Guerrero Galván (b. 1910, Guadalajara, Mexico – d. 1973, Cuernavaca, Mexico)

Of Indian descent. First studied with painters of open-air school, Guadalajara, then at School of Fine Arts, San Antonio, Texas. In 1922, returned to Guadalajara and continued to study art in painting shop of José Vizcarra. In Mexico City, from 1925 employed as teacher in primary schools. Painted murals at primary schools, Portales, and at University of New Mexico, where he taught in 1942. Oil paintings often recall childhood memories, as in *Children* (1939). Published lithographs; illustrated book on Quetzalcoatl, (1947), by Ermikio Abreu Gómez.

Xavier Guerrero (b. 1896, San Pedro de las Colonias, Coahuila, Mexico – d. 1974 Mexico)

Of Aztec descent, son of a master house painter whose profession, and work as a union organizer, formed Guerrero's view of painting as communal activity. Family settled in Guadalajara, 1911, after some years in Chihuahua; Guerrero served from 1912 as soldier in Revolution. In Mexico City, 1921, became technical adviser to Roberto Montenegro on mural for former chapel of SS Pedro y Pablo, himself painting sections of cupola and the architectural features. Worked with Diego Rivera from 1922, on murals for Bolívar Amphitheatre, National Preparatory School, and subsequently those at Ministry of Education, 1923. A founding member of Union of Technical Workers, Painters and Sculptors, 1922, and with Siqueiros of newspaper El Machete; also founding member of LEAR. In 1922, to U.S.A. accompanying an exhibition of folk art to Los Angeles. Assisted Rivera on murals at National Agricultural School, Chapingo, 1924. To Europe and the Soviet Union, 1929, remaining abroad for nearly a decade and returning to Mexico City only briefly before accompanying Siqueiros to Chile. In Chile, painted some 400 metres of mural decorations at Escuela México, Chillán, donated by Mexican government after 1939 earthquake; other murals in Chile include Hippodrome in Santiago, and series for a workers' recreation centre. In 1941, awarded prize in an industrial design competition, Museum of Modern Art, New York. First solo exhibition in New York at Knoedler Gallery, 1947. Continued to paint murals in 1950s, in Mexico City at Benito Juárez House of Pensions and in Cuernavaca and Guadalajara.

Alexander von Humboldt (b. 1769, Berlin, Germany – d. 1859, Berlin)

Friedrich Wilhelm Heinrich Alexander von Humboldt, the son of a Prussian nobleman. He attended the universities of Frankfurt-an-der-Oder, Göttingern and the Mining Academy of Freiberg. In 1780, he travelled with George Foster, a former companion on Captain Cook's second voyage, which roused his interest in the tropics. He became a mine assessor in the district of Bayreuth in 1792 and also conducted research in various scientific fields.

A substantial inheritance in 1796 enabled him to pursue his scientific studies and exploration. Humboldt sailed from Spain in 1799 for Venezuela with French botanist Aimé Bonpland. They explored the course of the Orinoco and Rio Negro Rivers to study animals, plants, geology and astronomy in the savannas and rain forests. Sailed to Cuba, December 1800, to study plantation economy and the slave labour trade, a practice which offended his liberal beliefs. From Cuba, sailed to Colombia in 1801 then to Ecuador where he attempted to climb Mount Chimborazo. He then explored the Andes in Peru and surveyed the headwaters of the Amazon. To Mexico in 1803; for a period of a year, studied the pre-Colombian antiquities and economic resources of the country. During these travels, he made numerous drawings of the

people, customs and landscapes of the Americas. In 1804, he left for Philadelphia visiting Thomas Jefferson and the artist/naturalist Charles Wilson Peale. He returned to Europe in 1804 settling finally in Paris in 1808. He continued to study the scientific discoveries which resulted from his travels in the Americas and he published c. 30 volumes including Relation historique de voyage aux régions équinoxiales du nonveau continent.

Humboldt served on diplomatic missions for Fredrich William III of Prussia and in 1827, he accepted a position in the court of Berlin where he lectured on geography and astronomy. These lectures provided the materials for the study of his last 30 years, *Kosmos*, his conception of the earth and universe published between 1845–62.

Hector Hyppolite (b. 1894, St. Marc, Haiti – d. 1948, Port-au-Prince) Born into a family of voodoo priests or *houngans*, became a priest himself but performed ceremonies occasionally. At age twelve, apprenticed to a shoemaker; began copying decalcomanias from waterfront storefronts on to postcards for sale to American Marines. During World War I, travelled to Cuba, then to New York and to French Equatorial Africa. In Haiti again, 1920, settled in St. Marc as house painter and sometime *houngan*. Encouraged by De Witt Peters of the Centre d'Art, moved in 1945 to Port-au-Prince and began, at age fifty-six, to devote himself to painting. Works purchased by André Breton on 1946 visit to Haiti, shown in Paris at 1947 UNESCO exhibition, won international attention. Painting career cut short by heart attack the following year.

Enio Iommi (b. 1926, Rosario, Argentina)

Son of an Italian sculptor with whom he first studied art; moved to Buenos Aires, 1926. Founding member of 'Arte Concreto-Invención', 1945. Major exhibitions, Argentina, 1950s, including Orientaciones actuales de la Escultura, Galería Krayd, Buenos Aires, 1953. Invited to exhibit at Ministry of Education. Valparaiso, Chile. Gold medal, 1958 Brussels International Exposition. Showed in First Exhibition of Modern Art, Museum of Modern Art, Buenos Aires, 1960, and represented Argentina in first exhibition of Art Concret, Kunsthalle, Zurich, the same year. Exhibited in São Paulo Bienal, 1961, Venice Biennale, 1964, and 1st Nuremberg Biennale, 1969; retrospective, National Museum of Fine Arts, Buenos Aires, 1963. Represented in three exhibitions organized by Instituto de Tella, Buenos Aires: New Art of Argentina (1964); Argentina Around the World (1965); Mas allá de la Geometría (1967). Invited to Italy by Italian government, 1968. Travelled to Switzerland, France, England and USA; solo exhibitions at Contemporary Sculpture Centres, Tokyo and Osaka, 1987.

Leandro Izaguirre (b. 1867, Mexico City – d. 1941, Mexico City) Studied at San Carlos Academy from 1884, under Rebull, Pina and Velasco. In 1893 painted *The Torture of Cuauhtémoc*, a large-scale work exhibited in Mexico City and Philadelphia which represents the culmination of indigenous historical themes in academic painting. Utilized photography to study details of nature, a method until then little known. In Europe 1902–6 working on a commission to copy 22 paintings in European collections; on his return became, and remained until his death, professor at the Academy, where he taught Rivera and Orozco

María Izquierdo (b. 1902, San Juan de los Lagos, Mexico – d. 1955, Mexico City)

1923 family moved to Mexico City; 1928 joined School of Painting and Sculpture, working under Gedovius, but disliking academicism abandoned her studies, preferring to remain 'auto-didact'. For the next four years lived and worked with Rufino Tamayo. First exhibition 1929 Galería de Arte Moderno, Mexico City. 1930 exhibited at Art Centre in New York, and included in *Mexican Arts* at the Metropolitan Museum. 1935 organized group of women artists in making of posters: travelling exhibition 'Revolutionary posters of female section of Artes Plásticas, Departamiento de Bellas Artes'. 1936 Antonin Artaud published en-

BIOGRAPHIES

thusiastic account of her work in *Excélsior* (Mexico City). 1940 included in *Twenty Centuries of Mexican Art* (Museum of Modern Art, New York). Among most unusual of her paintings are still lifes set in landscapes; she also developed circus themes and painted portraits and interiors. Exhibited widely, and wrote as well as painted.

José María Jara (b. 1866, Orizaba, Veracruz, Mexico – d. 1939, Morelia, Mexico)

Studied San Carlos Academy, 1881-9, on grant from governor of state of Veracruz. Professor of drawing and painting, Colegio de San Nicolás, Morelia, for 44 years; printmakers Manuel Iturbide and Salvador Martínez Baez among his pupils. *El Velorio* most notable of his works, in which costumbrista themes realized within academic tradition.

Leandro Joaquim (b. c. 1738, Rio de Janeiro – d. c. 1798, Rio de Janeiro)

Follower of João de Sousa; active in eighteenth-century Rio de Janeiro as painter, architect and stage designer. Noted for panels, *Incendio do Recolhimento do Parto* and *Reconstrução do Recolhimento do Parto*, church of Our Lady of Parto, Rio, and for six panels painted for pavilion, Passeio Publica, built by Master Valentim; also for portraits such as that of Luis de Vasconcellos e Sousa, and for work as stage designer for Teatro de Manuel Luis.

Frida Kahlo (b. 1907, Coyoacán, Mexico, - d. 1954, Coyoacán)

Father, a German Jew of Austro-Hungarian descent, an artist-photographer; mestiza mother a devout Catholic. Politically active from age of thirteen; leader of anarchist group 'Los Cachuchas' while student at National Preparatory School, 1923. Health affected by polio, 1916, and left a permanent semi-invalid by injuries suffered in a street accident, 1925, when preparing to enter medical school. Studied drawing briefly with printmaker Fernando Fernández; began to paint portraits of herself and others during extended convalescence. In 1928, met Tina Modotti and joined Mexican Communist Party. Married Diego Rivera, 1929; with him to U.S.A., 1930-4, when he carried out mural projects in San Francisco, Detroit and New York. In Mexico, 1936, met Leon Trotsky, assassinated 1940 while living in her house in Coyoacán. Met André Breton, Mexico, 1938; through his efforts and later those of Marcel Duchamp, her work shown 1938 at Julien Levy Gallery, New York, and in 1939 and 1940 at Pierre Colle Gallery, Paris. Appointed professor of painting, 1943, at 'La Esmeralda', Education Ministry's School of Fine Arts, Coyoacán, and with her students painted mural in pulquería La Rosita. Active as anti-fascist during World War II and as anti-imperialist thereafter. Leg amputated, 1953, and died the following year; her house in Coyoacán now the Museo Frida Kahlo.

Gyula Kosice (b. 1924, Kosice, Hungary)

Left Hungary with his parents at age four; now an Argentine citizen. Studied drawing and sculpture at the Free Academy in Buenos Aires. In 1944, co-founded the review Arturo, succeeded after disagreements within the group by the publication Invención. Exhibited with colleagues in Arte Concreto-Invención, at Dr. Pichon-Rivière's house, Buenos Aires, 1946; the same year co-founded the movement Madí and authored its manifesto. First Madí group exhibition, French Institute, Buenos Aires, 1946; founded and directed its magazine, Arte Madí Universal, published 1947-54 (8 issues). In his own work began to use plexiglas and to experiment with neon and fluorescent tubing. First solo exhibition, Pacífico Gallery, Buenos Aires, 1947; three works exhibited in the Madí room, Salon des Réalités Nouvelles, Paris (1948). Settled in Paris, 1957, where he created his first hydraulic sculpture; issued the manifesto 'The Architecture of Water-Hydrosculpture'. Conceived the design for the Argentine Pavilion, 1964 Venice Biennale. Awarded International Sculpture Prize, Instituto di Tella, Buenos Aires, 1962; retrospective, One Hundred Works of Kosice, a Precursor, Instituto di Tella, 1968. Has published poems, essays, and a series of interviews with artists, as well as *Hydrokinetic Art* (1968) and *Arte Madí* (1982). Commissioned 1988 to make sculpture for Seoul Olympic Games.

Divi Laañ (b. 1927, Buenos Aires)

Studied briefly at University of Buenos Aires; left to devote herself to writing. Madí movement 1946; included in group's first exhibition, French Institute, Buenos Aires, and in Madí work representing Argentina in Salon des Réalités Nouvelles, Paris, 1948. Collaborated on review *Arte Madí Universal*; represented in 1961 exhibition commemorating Madí work, Museum of Modern Art, Buenos Aires.

Wifredo Lam (b. 1902, Sagua la Grande, Cuba – d. 1982, Paris) Youngest of nine children in a family of Chinese, African and European descent. In Havana after 1916, attended school of Fine Arts 1918-20, exhibited in Salon of Association of Painters and Sculptors of Havana, 1920-3. In Spain 1923-38, attended classes at studio of Fernández Alvarez de Sotomayer, curator of Prado, and at Free Academy of the Alhambra. In Paris, 1938, through the sculptor Manolo met Picasso, with whom he exhibited at Perls Gallery, New York, 1939. Met André Breton and Benjamin Péret, became associated with Surrealists; joined them in Marseilles, 1940, where he illustrated Breton's Fata Morgana. With other refugee intellectuals, fled Europe 1941; arrived in Havana 1942 after a stay in Martinique and St. Thomas. His The Jungle, inspired by black culture and tropical vegetation of Cuba, exhibited Pierre Matisse Gallery, New York, 1943. In Haiti with Breton, 1945, became interested in voodoo and mesmerism. Returned to Europe via New York, 1946; settled in Paris, 1952. In 1960s, established as an international figure, received several awards including Guggenheim International Award, 1964-5. Organized Salon de Mai, Havana, 1967, and participated in Havana Cultural Congress. Retrospective exhibitions Amsterdam, Paris, Havana and Brussels.

Víctor Patricio de Landaluze (b. 1828, Bilbao, Spain – d. 1889, Guanabacoa, Cuba)

Spanish painter, draughtsman and caricaturist, settled in Havana mid-1850s. Made drawings for Los Cubanos pintados por si mismo (1852); contributed political caricatures to La Charanga, El Muro Muza, Juan Paloma and other satirical weekly papers published by Juan Martinez Villegas in support of Cuban independence movement. In 1862, founded satirical periodical Don Junipero. As costumbrista painter of indigenous peoples of Cuba, notable for such works as Dia de Reyes and La Mulata Adelantada. Illustrated Antonio Bachiller y Morales' Typos y Costumbres de la Isla de Cuba (1882); the album Cuba Pintoresca published 1881. Solo exhibition of his work, Lyceum, Havana, 1941; included in exhibition of nineteenth-century Cuban works from collection of Museo Nacional, Havana, at the Prado, Madrid, 1983.

Eduardo Laplante (b. 1818, ? France – d. ? Cuba)

Painter, draughtsman and lithographer, arrived Cuba 1848. Settled Havana, visited interior and major cities. Series of lithographs, Los Ingenios (1857), recording scenes in sugar-refining areas; La Isla de Cuba Pintoresca, after drawings by Leonardo Barañano, published 1856. With Víctor Patricio de Landaluze, made series of prints for Gran Baile en el Navío Reina Isabel II el 11 de abril (1858). Notable also for oil paintings such as Trinidad (1878). Included in exhibition of nineteenth-century works from collection of Museo Nacional, Havana, at the Prado, Madrid, 1983.

Francisco Laso (b. 1823, Tacna, Peru – d. 1869, San Mateo, Peru) Third of five children, moved to Lima as a youth. On completion of secondary school, entered Academy of Painting and Drawing to study under its then director, the Quiteño artist Javier Cortés. On death of Cortés, became a student of Ignacio Merino, a follower of Delaroche; assistant to Merino when latter became director of Academy. To Europe, 1842, to study with Delaroche and, shortly, with Gleyre in

Paris; visited Rome and Venice: works of Titian and Veronese became important influences. On return to Peru, 1847, visited Cuzco and Puno in search of Peruvian subject matter. Again in Paris, in Gleyre's studio in 1853, painted his notable *El Indio Alfarero*, which attracted critical attention there. Political events forced his return to Peru in 1856; commissioned to paint the four Evangelists for Lima Cathedral. To Europe for third and last time, 1863–6, after which took active part in Peruvian politics, representing Lima in Constitutional Assembly; devoted himself to political writing and to satire and moralizing works, yet continued to paint, his celebrated *St. Rose of Lima* completed 1866. Joined the Red Cross as a volunteer, 1868, to help fight epidemic of yellow fever, which caused his death the following year.

Gustavo Lazarini (b. 1918, Montevideo)

Employed as detective on Montivideo police force, received some instruction in painting from commercial artist, Maggioli. Known principally for his watercolour portraits.

Agustín Lazo (b. 1898, Mexico City – d. 1971, Mexico City)

After attending National Preparatory School, prepared to follow father in a career in architecture; studied for one year at School of Architecture, Mexico City, before entering National School of Fine Arts, 1917, as student of Alfredo Ramos Martínez. Along with Rufino Tamayo, Julio Castellanos and Gabriel Fernández Ledesma, studied drawing under Saturnino Herrán. To Europe, 1922, where remained for a decade, in Paris attending the Grande Chaumière and theatrical school of Charles Dullin. Returning to Mexico, 1932, created scenery for Teatro de Orientación, division of Ministry of Public Education, and pursued career in stage design with National University theatre, while continuing to paint in a style influenced by European masters he admired.

Fernando Leal (b. 1900, Aguascalientes, Mexico – d. 1964, Mexico City)

Studied painting, National School of Fine Arts, Mexico City, until 1920; then attended Open Air Painting School, Coyoacán, under Alfredo Ramos Martínez. Appointed director of that School after his first exhibition, and remained on its faculty for seven years. First mural, The Dancers of Chalma, executed in encaustic, National Preparatory School, 1922. With Jean Charlot, devoted himself to woodcuts, exhibited in a group show of work by 25 artists, 1929. Founding member of the group '30-30', which published a review in opposition to academic ideology in art. One of the first to utilize indigenous themes as subject for largescale murals, completed over next three decades several murals, of which that for the Bolívar Amphiteatre (in ENP) (1930-3) is notable for its depiction of scenes from the life of Simón Bolívar. In 1952, appointed government director of culture; instituted a campaign for artists' rights, 1959. Left incomplete at his death a book on life at the San Carlos Academy. Retrospective exhibition Palacio de Bellas Artes, Mexico, 1973.

Angel Acosta León (b. 1930, La Ceiba Marianao, Cuba – d. 1964, Cuba)

Worked as a bus driver in Havana before studying painting and sculpture, Escuela San Alejandro, Havana. Received awards, Círculo de Bellas Artes exhibitions, 1958-9; first solo exhibition, Lyceum, Havana, 1959. Also in 1959, included in São Paulo Bienal, and awarded acquisition prize, Salón Nacional, Havana. Exhibited, Segunda Bienal Interamericana de México, where his painting *Carruje* received prize. Settled in Paris, 1960, on travel grant from Cuban National Institute of Tourism; work shown in exhibition *Ecole de Paris*, Charpentier Gallery, 1963; solo exhibition, Galerie D'Eendt, Amsterdam, same year. Returned to Havana, 1964; died by suicide. Work included posthumously in group exhibitions of Cuban painting, Madrid (1978), New York (1981), and in *Ten Cuban Artists in Paris*, Cuban Museum of Arts and Culture, Havana, 1985.

George Leuzinger (b. Switzerland, active in Rio de Janeiro, Brazil, 1840-1870)

By 1840, George Leuzinger was the proprietor of a well-known lithography studio in Rio de Janeiro; c. 1861, he established a photography department in his firm. He began to publish images of panoramic views, stereoscopic prints and photographs of local people and their customs, probably purchased mainly by travellers. c. 1865, he issued a catalogue titled 'Oficina Fotográfica de G. Leuzinger . . . 337 Fotografías Diversas' which included vistas of Rio de Janeiro, Neteroi, Petrópolis and Teresópolis. A publisher and retailer of photographs rather than a photographer, he nonetheless exhibited photographs at the Academia Imperial de Belas Artes, and the Paris International Exhibition of 1867. The photographer Marc Ferrez learned photography at the 'Casa Leuzinger' from the German Franz Keller, who had established photography there.

Georges Liautaud (b. 1899, Croix des Boquets, Haiti)

Family background included both professionals and peasants; received an above-average education. Interested in mechanics, worked as repairman on sugar railroad, spending some years in Dominican Republic. In blacksmith shop in his native village, made branding irons, agricultural implements and cemetery crosses based on *vevés*, floor tracings used to invoke voodoo gods. Encouraged by De Witt Peters of Centre d'Art, began in 1950s to produce two-dimensional sculpture from flattened oil drums. Siren, part woman part fish, a favourite subject derived from voodoo religion. Work generally small in scale, but *Devil-Man-Woman* in collection of Musée d'Art Haitien is life-size. Followers include Murat Brierre and school of Haitian artists working in cut-out sheet metal.

Claudio Linati (b. 1790, Parma, Italy – d. 1832, Tampico, Mexico) Well educated, the son of a count; showed early talent for drawing. At seventeen, joined the Parma Society of Engravers, where first exhibited his work; soon turned to lithography. In Paris, 1809, studied art, frequented studio of David. Joined Napoleon's forces, 1810 imprisoned in Hungary; on release, travelled to Spain. Returning to Parma, 1818, cofounded Secret Society of the Sublime Perfect Master, to resist tyranny. Political pressure led to departure for Mexico; arrived Veracruz 1825 with fellow Italian Gaspar Franchini. Established workshop of lithography where assistants he trained included José Gracida of Oaxaca and Ignacio Serrano. In 1826, with Italian Fiorenzo Galli and Cuban poet José María de Heredia, published liberal political journal El Iris, which included lithographs. Briefly in New York, then moved to Brussels, 1827-9, where published his Costumes civiles, militaires y religieux du Mexique (1828), with 48 coloured lithographs and accompanying text. Returned to Mexico, 1829, and again in 1830 to Tampico, where he fell ill and died.

Raúl Lozza (b. 1911, Alberti, Buenos Aires) First studied painting with his father; first exhibition 1928. Contributed drawings to newspapers and magazines from 1932. Co-founder of group 'Contrapunto', 1943. In 1946, co-founded 'Asociación Arte Concreto-Invención', to promote non-figurative art in Argentina; exhibited with this group, lectured, and edited its review. Formed independent movement, 'Perceptism', 1947 (its theoretical basis expounded in Raúl Lozza y el Perceptivismo (1948), by Abraham Haber). First solo exhibition of perceptivist paintings, Buenos Aires, 1949, when 'Perceptivist Manifesto' issued. With Haber, published seven issues of 'theoretical and polemical' review Perceptismo, 1950-53; also published theoretical studies on form and colour, integration of painting and architecture. Exhibits regularly in Buenos Aires.

Anita Malfatti (b. 1889, São Paulo, Brazil – d. 1964, São Paulo) Daughter of an Italian engineer; mother of German descent; studied at Mackenzie College, São Paulo, 1904-6. To Germany 1910, to study at Imperial Academy of Fine Arts, Berlin, and with Fritz Burger; in 1913 studied with the Expressionist artist Lovis Corinth. Returned to Brazil on the outbreak of World War I. In 1915 to New York; worked at Art Students' League under Yasuo Kuniyoshi and Morris Kantor, and in 1915-16 under Homer Boss of the 'Fifteen Group' at Independent School of Art; met Marcel Duchamp, Jean Crotti, Isadora Duncan and Diaghilev; began to produce illustrations for Vogue, Vanity Fair and other publications. Returned to Brazil, 1916; solo exhibition, Líbero Badaró, São Paulo, provoked scandal, 1917. In 1922, with Tarsila do Amaral, Lasar Segall, Emiliano di Cavalcanti participated in the Semana de Arte Moderno, (Modern Art Week) São Paulo. Member of the 'Grupo dos Cinco', founded 1922. To Paris, 1922, and to Italy, 1927; returned to Brazil, 1928. During the 1930's exhibited in the Salão Paulista de Belas Artes, 1934-6, and in solo exhibitions, São Paulo and Rio de Janeiro. In 1940, became president of the Sindicato dos Artistas Plásticos, in which she remained active throughout the 1940's. Retrospective of her work, Museum of Art, São Paulo, 1949; participated in exhibition commemorating the Semana de Arte Moderna, Museum of Modern Art, São Paulo, 1952. Retrospective exhibitions, VII São Paulo Bienal, 1963; Museum of Contemporary Art, University of São Paulo, 1977.

Manuel Manilla (b. 1830, Mexico City – d. 1895, Mexico City) Worked as master draughtsman and printmaker for Vanegas Arroyo publishing house, Mexico City, from 1882, illustrating *corridos* and *calaveras*; as well as popular songs and games. First to use lead zinc plate for engraving; his technical expertise and style influenced José Guadalupe Posada, later employed by same publishing house. Produced some 1,500 prints (not all identified despite his strong personal style) in years with Vanegas Arroyo. Retired in 1892, died of typhus three years later. Exhibition of his work organized by Fernando Gamboa for Museo Nacional de Arte, Mexico City, 1951.

Matta, see Echaurren, Roberto Matta

Juan Mele (b. 1923, Buenos Aires)

Attended National School of Fine Arts, Buenos Aires, where appointed professor of drawing, 1945. In 1946 joined 'Asociación Arte Concreto-Invención', participated in group's exhibitions. To Europe to study on a French government grant; attended Ecole du Louvre, 1948, and studied privately with Vantongerloo and Sonia Delaunay; included in 1948 Salon des Réalités Nouvelles, and exhibited 1949 at Maison de l'Amérique Latine, Paris. On return to Argentina, included in *Annual Exhibition of Artists under Thirty* and *Curuzú-Cuatiá* annual exhibition, both 1952; included in II São Paulo Bienal, 1953. Exhibits regularly in Buenos Aires; has taught art and art history, and published critical articles in numerous reviews. Recent one-man exhibitions include Cayman Gallery, New York (1978), Arch Gallery, New York (1983, 1985), Museo de Arte Moderno, Buenos Aires (1987), Centoira Gallery, Buenos Aires (1988).

Leopoldo Méndez (b. 1902, Mexico City – d. 1969, Mexico City) Studied San Carlos Academy 1917-20. Worked in California briefly, after which co-founded centre for painting, Chimalixtac, where experimented with new methods of teaching fine arts. In 1925, joined 'Estridentista' group of Manual Maples Arce (see Appendix 6.1); active member of LEAR, 1933-7; contributed caricatures to newspaper El Machete. Founder member of Taller de Gráfica Popular, director of workshop policies. As director of Fine Arts Section, Ministry of Education, from 1932, participated in pedagogical programmes, rural Mexico. Awarded Guggenheim Fellowship, 1940; travel to Eastern and Western Europe. Awarded National Prize for achievements in graphic arts by Mexican government, 1946. Collaborated with Alfredo Zalce, Fernando Gamboa and Pablo O'Higgins on frescos for Taller Gráfico de la Nación, in 1946 with O'Higgins executed a jointed fresco for Social Security Maternity Hospital No. 1, Mexico City. In 1946 left

PCM and founded Grupo Insurgente José Carlos Mariátegui. From late 40s made engravings for films, including *La rebelión de los Colgados*, (1954) based on B. Traven's novel. Numerous collective exhibitions including 'Homenaje a J. Martí' (1961).

Manuel Mendive (b. 1944, Havana)

Graduated, 1963, San Alejandro Academy, Havana. During 1960s, carved and painted on wood interpretations of lives of saints and *loas* (pantheon of voodoo gods); also worked with oil and pastel on paper, and made designs for dance performances. Work influenced by *Santeria*, incorporates performance and masks. Awarded Adam Montparnasse prize for painting exhibited, Salon de Mai, Paris, 1968, and third prize, Salón Nacional de Artes Plásticas, Havana, same year; national prize at International Festival of Painting, Cagnes-sur-mer, France, 1970. Solo exhibitions, Havana, 1964 and 1980. Included in group shows of Cuban painting, Madrid (1978) and New York (1981). Represented Cuba at Venice Biennale, 1988.

Carlos Mérida (b. 1891, Quetzaltenango, Guatemala – d. 1984, Mexico City)

Of Maya-Quiché descent. In Guatemala City, 1908, met the artist Carlos Valenti; with Valenti to Europe at age seventeen. Studied with Van Dongen and Anglada Camarasa; met Picasso, Modigliani and others of Paris school. Visited Belgium, Holland and Spain. Returned to Guatemala City, 1914, where initiated, with sculptor Yela Gunther, pro-Indian movement in attempt to find an authentic 'American art'. To Mexico, 1919; Guatemalan paintings exhibited Academy of Fine Arts, Mexico City, 1920. 1922, assisted Diego Rivera on first mural for National Preparatory School; joined Union of Technical Workers, Painters and Sculptors; his own first mural painted at Children's Library, Ministry of Education. From 1925 contributed to Frances Toor's review Mexican Folkways, which helped spread interest in Mexican popular art. First exhibition in New York, 1926. To Europe, 1927; friendship with Klee and Miró. Exhibited, Gallery Des Quatre Chemins, Paris; published coloured lithographs, Images of Guatemala with introduction by André Salmon. Returned to Mexico, 1929; became more abstract under influence of Surrealism, 1930-7. Exhibited in International Surrealist exhibition, Mexico City, 1940. 1944 friendship with Breton and European Surrealists in New York. After 1950 turned to architectural art, relief murals for President Juárez housing estate, Mexico City, 1952, mosaic for Municipal Palace, Guatemala City, 1956 and mosaic mural La Confluencia de las Civilizaciones en América in San Antonio, Texas, 1968. Last mosaic mural in Mexico City completed

Guillermo Meza (b. 1917, Ixtapalapa, Mexico)

Of Tlaxcalan Indian descent; left school at fourteen to become apprentice in father's tailor shop. Attended Workers' Night School in Ixtapalapa until 1937, when his teacher, Santos Balmori, took him to Morelia as his assistant. In Mexico City, 1938, employed at Merced Market, began to retouch photographs; Diego Rivera, after seeing his drawings, sent him to Inés Amor of Galería de Arte Moderno, who sponsored him and gave him first solo exhibition, 1940. His 'expressionist-surrealist' paintings, on themes often drawn from Indian mythology, associated with work of such artists as Frida Kahlo and Agustín Lazo; he also treated political themes.

Roberto Montenegro (b. 1887, Guadalajara, Mexico – d. 1968, Mexico City)

Grandson of José Guadalupe Montenegro, who devoted his fortune to liberal causes, and a cousin of Amado Nervo, co-publisher of *La Revista Moderna de México* (1898-1911). Began to study painting, 1903, with Félix Bernardelli in Guadalajara. In Mexico City the following year, briefly studied architecture at San Carlos Academy but returned to painting, under Antonio Fabrés; later studied with Ruelas, Gedovius

and Izaguirre. Fellow student of Diego Rivera, Angel Zárraga and Francisco Goitia. In 1905 awarded a scholarship for study abroad; in Madrid worked in the studio of painter Baroja, and then studied in Paris from 1907. Associated with Picasso, Juan Gris, Cocteau and others; contributed drawings to Le Témoin, 1907. At the outbreak of war, in 1914 with Anglada Camarasa, moved to Palma de Mallorca, where remained until 1919; in this period illustrated La Lámpara de Aladino and published a book on Nijinsky (1919). Returning to Mexico, held first exhibition, and organized first Exhibition of Popular Arts, Mexico City, 1921. Active in mural movement, commissioned by Minister of Education, José Vasconcelos, to paint frescos, with Dr Atl, at exconvent of SS Pedro v Pablo; his mural masterpiece Fiesta de la Santa Cruz, for main staircase, completed 1924. Published Mexican Masks (1926) and Pintura Mexicana 1800-1860 (1933). Work in stage design in 1930s included collaboration with Marc Chagall on ballet Aleko and with Antonio Leal on Lenormand's The Simoon. In 1934 appointed director, Museum of Popular Arts of Palace of Fine Arts; selected section on popular arts for exhibition, Twenty Centuries of Mexican Art, Museum of Modern Art, New York, 1940. In 1946 founded Museum of Popular Arts in Toluca; published Retablos de México (1951). Continued to publish his writings and drawings throughout 1950s and 1960s; completed two mosaics in Guadalajara. Work shown internationally in more than 200 solo exhibitions; retrospective exhibition of fifty years of his artistic life, Museo del Palacio de Bellas Artes, Mexico City, 1965.

Agostihno José da Mota (b. 1821, Rio de Janeiro, Brazil – d. 1878, Rio de Janeiro)

Began to study art 1837, Imperial Academy of Fine Arts, Rio de Janeiro. In 1850, was first Brazilian artist to be awarded a scholarship for European study. In Rome, studying under the French artist Benouville, awarded a gold medal for works exhibited at Esposçães Gerais de Belas Artes, Rio de Janeiro, 1952. Participating later in same exhibition, received the honours Cavaleiro da Ordem Imperial da Rosa (1868) and Ordem de Christo (1871). Professor of drawing, Academy of Fine Arts, Rio, 1859; in 1860 succeeded Augusto Miller in chair of landscape painting, occupied until his death. Best known for still lifes of Brazilian fruits and flowers, also painted landscapes of environs of Rio.

Gerardo Murillo (Dr Atl) (b. 1875, Guadalajara, Mexico – d. 1964, Mexico City)

First studied painting, in Guadalajara, with Felipe Castro, then (1896) in Mexico City. To Europe 1897; doctoral degree in philosophy and law, Rome, 1898. Visited Universal Exhibition, Paris, 1900, and travelled in Spain, Germany, England and Russia; in France, came under the spell of Impressionism. In 1902, adopted the name Atl, from the Náhuatl word meaning 'water'. Returned from abroad, 1903; organized exhibitions of Mexican art in San Pedro Tlaquepaque and at the Jardín de San Francisco, Guadalajara; began teaching at San Carlos Academy, Mexico City, where students included Rivera, Siqueiros and Orozco. In 1910, organized exhibition of independent Mexican artists, as counter-attack on the exhibition of European art imported by Porfirio Díaz to commemmorate Independence. Founded Centro Artístico, association of artists who plan murals for the National Preparatory School; for which he proposed innovative techniques. 1911 returned to Europe after outbreak of the Mexican Revolution, to study volcanology; exhibited his landscapes and published reviews Action d'Art and La Révolution au Mexique. Returning to Mexico, 1913, joined forces of Carranza; appointed chief of propaganda, issued from Orizaba Acción Mundial and other publications; in 1914-15 published the Carranzista newspaper La Vanguardia, whose staff included Siqueiros, Goitia and Orozco. Organized in 1914 first revolutionary labour union in Mexico, La Casa del Obrero Mundial. In 1920, named director of Mexican government Department of Fine Arts; began series of murals at Church of SS Pedro y Pablo; published Artes Populares de México (1921). During 1920s and 1930s, continued to study and paint volcanoes; on finding of new crater, Paricutín, 1943, moved to near-by village to document discovery, producing 130 drawings and 11 paintings of the event: dreamed of a utopian cultural centre to be established in crater of an extinct volcano near Puebla. His body buried in the Rotunda of Illustrious Men, Mexico City.

Carl Nebel (b. ?, 1800, Germany – d. 1865, Frankfurt, Germany) First journeyed to Mexico, 1829, to study Aztec and Mayan archaelogical monuments; returned to Europe, 1834, and published his *Voyage pittoresque et archéologique dans la partie la plus intéressante du Méxique* (Paris, 1836), with 50 lithographs. Present at principal battles of Mexican-American War (1845-7); his *The War Between the United States and Mexico, Illustrated* (Philadelphia, 1851) include *Battle of Buena Vista, Bombardment of Veracruz* and *Capture of Monterey*.

Philomé Obin (b.1892, Cap Haitien, Haiti - d. ? 1984 Haiti)

One of seven children of a tailor, painted his first work in 1908, encouraged by local drawing teacher, Berthold. Worked as a barber, then as trader in coffee beans, before becoming clerk in city's finance department, 1914–23. Commissioned by Masonic Lodge, Limonade, to paint heraldic panels, 1937, 1943; other semi-religious works for Masons: two murals for Holy Trinity Cathedral, Port-au-Prince. His *Arrival of President Roosevelt at Cap Haitien* (1944) sent to De Witt Peters of Centre d'Art, Port-au-Prince, led to opening in Cap Haitien of branch of the Centre ('Branche Capoise') which Obin directed. As patriarch of northern school of Haitian painting, influenced members of his family (notably his brother Sénèque Obin) and subsequent generation of painters.

José María Obregón (b. 1832, Mexico City – d. 1902, Mexico City) Studied at the Academy of San Carlos under its influencial director Pelegrín Clavé, who had been brought to Mexico in 1846. Clavé had studied in Rome with Overbeck, and his late classical manner was strong influence on Obregón and his generation. Obregón painted scenes from biblical history such as *Hagar and Ishmael in the Desert*, but is best known for subjects chosen from the Ancient history of pre-Spanish Mexico, like *The Discovery of Pulque*, thereby constributing to the nationalist indigenism so prevalent in late nineteenth century Mexican art.

Isidoro Ocampo (b. 1910, Veracruz, Mexico)

Four years' study of painting, etching and lithography, from 1928, San Carlos Academy, Mexico City. Joined staff of *Cultura* publishers, where he worked six years as book illustrator. In 1936, appointed professor of drawing, painting and printmaking, Instituto Nacional de Bellas Artes (National Institute of Fine Arts). One of founders of Taller de Gráfica Popular, 1937. Most prolific output of lithographs and etchings at two periods, 1959 and 1970; also created masks and papier mâché dolls, Judas figures and toy carts, inspired by folk art. Exhibited in Mexico, U.S.A. and Europe after 1939; work included in *Twenty Centuries of Mexican Art*, Museum of Modern Art, New York, 1940. Represented in more than 150 exhibitions, including Festival of Mexican Culture, Havana, and Society of Mexican Printmakers exhibition, Tokyo, both 1950. Solo exhibition, Institute of Fine Arts, Mexico City, 1964; retrospective, Palacio de Bellas Artes, Mexico City, 1973.

Juan O'Gorman (b. 1905, Coyoacán, Mexico – d. 1982, Mexico City) From a mixed Irish-Mexican background, father a mining engineer and later portrait painter and mother born in Mexico of Irish parents. Attended primary school in Guanajuato and later National Preparatory School in Mexico City, where met Diego Rivera, then at work on his mural *Creation*. After six months at medical school, O'Gorman enrolled at the National University, 1922, to study architecture, graduating in 1927. During 1920s a proponent of Le Corbusier's functionalist architecture; in 1929 built an International Style house and studio for Rivera at San Angel. Joined faculty of Polytechnic Institute, 1932; re-

sponsible for building of 28 new schools for Ministry of Public Instruction, 1932-5. Left government post, 1935, and began to paint seriously. Controversial commission for murals at Mexico City airport, 1938. In 1940s painted landscapes, influenced by Velasco, on whom he published an article in 1943, and portraits; solo exhibition, Palacio de Bellas Artes, 1950. In 1950s renounced functionalism, became advocate of organic architecture of Frank Lloyd Wright. Interest in mosaics as architectural element led to design for University of Mexico Library, begun in 1950, with ten-storey tower covered with mosaic coloured stones from all over Mexico. His own house at San Angel, drawing on Wright's organic ideas and covered with mosaics, begun in 1956. 1960-61 painted fresco Retablo de la Independencia for Chapultepec Castle. Death by suicide, 1982.

Pablo O'Higgins (b. 1904, Salt Lake City, Utah, U.S.A. – d. 1983, Mexico City)

1922 attended art school, San Diego, California. With Miguel Foncerrada to Guaymas, Mexico, 1924; learning of Rivera's murals at National Preparatory School, wrote to the artist and was invited by him to Mexico City. Instructed by Rivera, worked with him, 1925-7, on Ministry of Education and National School of Agriculture, Chapingo; 1927 joined Mexican Communist party; participated in cultural missions to rural districts for Ministry of Public Education. Paintings exhibited John Levy Gallery, New York, 1931. Visited Soviet Union, 1932, on grant from Russian Academy of Art. First mural, at Emiliano Zapata School, Mexico City, designed by Juan O'Gorman, 1933. Major fresco series, La Explotación del Campesino y del Obrero, for Abelardo Rodríguez Market, Mexico City, 1934. Founding member of LEAR (Liga de escritores y artistas revolucionarios) with Leopoldo Méndez, organized its Fine Arts Section, 1933-4. Collaborated in 1937 with Méndez, Alfredo Zalce and Fernando Gamboa on fresco murals at national printshop, Taller Gráfico de la Nación; co-founded Taller de Gráfica Popular, 1937. Murals at Ship Scalers, Union Hall, Seattle, Washington (1945), Longshoreman's Union, Honolulu, Hawaii (1947), and Municipal Palace, Veracruz (1958-9), reflect his social concerns. Represented Mexico at 1962 Latin American Congress of Graphic Arts, Cuba. In 1960s painted mural of pre-Hispanic period at National Museum of Anthropology, Mexico City. Solo exhibitions, Salón de la Plástica Mexicana, 1963 and 1966; retrospective of his work, Palacio de Bellas Artes, Mexico City, 1971.

Hélio Oiticica (b. 1937, Rio de Janeiro – d. 1980, Rio de Janeiro) Studied first with painter Ivan Serpa, founder of Frenete Group and associated with Neo-Concrete artists, at Museum of Modern Art, Rio de Janeiro, from 1954. Joined Frenete Group, 1955, and exhibited 1959-61 in group shows of Neo-concrete work, Rio, São Paulo and Zurich. His Parangoles (capes), spatial sculptures created through movement of the spectator, first presented, Museum of Modern Art, Rio, 1965. Studied samba, movement of which provided a source for sensory experiences he sought, and by 1965 had advanced to passista (lead dancer). At Galerie G4, Rio, in 1966, exhibited Nuclei, a coloured labyrinth of screens, and Bolides, fireballs made of commonplace substances. In retrospective at Whitechapel Gallery, London, 1969, exhibited Penetrables, in which tactile materials used to create an environment. Work included in ParisBiennale, 1967; contributed to 1970 exhibition, Information, Museum of Modern Art, New York. Resided in Rio de Janeiro except for brief stays in New York in 1970s. Since his death, work exhibited in Tradição y Ruptura, Fundação Bienal de São Paulo, 1984-5; IX Salon of Fine Arts, Rio de Janeiro, 1986; Og Faço é Mú sica, Galeria São Paulo, 1986.

Josée Clemente Orozco (b. 1883, Ciudad Guzmán, Jalisco, Mexico – d. 1949, Mexico City)

Of middle-class origins; in Guadalajara until 1890, when family moved to Mexico City. As a youth, frequented studio of José Guadalupe

Posada to watch engraving of popular broadsheets. From 1897, attended School of Agriculture, San Jacinto, and National Preparatory School, considering career in architecture. Studied painting full-time, 1906-14, San Carlos Academy, under Dr Atl. In 1911, took part in students' strike at Academy resulting in dismissal of director; joined Dr Atl's group 'Centro Artístico', agitating for wall space for paintings in public buildings. Began working as cartoonist for anti-Madero newspapers El Imparcial and El Hijo del Ahuizote. Series of watercolours, The House of Tears, begun 1912. Moved to Orizaba, state of Veracruz, 1915, to work on Carranzista newspaper, La Vanguardia, edited by Dr Atl. First exhibition, Librario Biblios, 1916. Visited San Francisco and New York, 1917. In Mexico from 1920, given first mural commission, National Preparatory School, by José Vasconcelos, Minister of Education. While living in New York, 1927-34, carried out mural projects at New School for Social Research, New York and at Claremont College, California (both 1930), and at Dartmouth College, in New Hampshire (1932); first trip to Europe, 1932, when visited major museums in Italy, France, England, and Spain. Returned to Mexico, 1934, to paint mural Catharsis in Palacio de Bellas Artes, and murals in Guadalajara in Chamber of Deputies, Hospicio Cabañas, University and Government Palace (1935-9). Represented Revolutionary Writers and Artists League at Congress of American Artists, New York, 1936. Autobiographical articles published in newspaper Excélsior, 1942. Work of 1940s included portraits and series of anti-clerical and anti-military paintings as well as murals, notably Juárez, the Clergy and the Imperialists in Chapultepec Castle (1948). Awarded national Prize for murals in Church of the Hospital of Jesus, 1946; major retrospective the following year in Palacio de Bellas Artes, Mexico City.

Alejandro Otero (b. 1921, El Manteco, State of Bolívar, Venezuela) Father a rubber worker who died 1923, when family moved to Upata, and in 1930 to Ciudad Bolívar. Began to study agriculture, 1938, at Maracay, State of Araguay. Took courses in painting, sculpture, stained glass and art education, School of Fine and Applied Arts, Caracas, 1939-45; taught painting and stained glass from 1943; on graduation, awarded government grant to travel to France. Series of 40 still lifes completed 1946-8 exhibited at Pan American Union, Washington, D.C., 1948, and at Museo de Bellas Artes, Caracas, 1949. In Paris, 1949-52, collaborated on publication Revista Los Disidents, attacking Venezuelan artistic conservatism; to Holland to see work of Mondrian. Taught, Caracas, Cristobal Rojas School of Fine Arts from 1952. With architect Villanueva and artists Calder, Vasarely, Arp, Léger and Soto, collaborated on design of University City, Caracas. Named coordinator, Museo de Bellas Artes; active in reforming programme, Escuela de Bellas Artes. In Paris, 1960, created series of assemblages and collages influenced by neo-Dadaism. Vice-president, Instituto Nacional de Cultura de Bellas Artes, Caracas, 1964-6. Solo exhibition, Venice Biennale, 1966. Series of large outdoor works, Estructuras Spatiales, begun 1967 and erected Maracay (1968), Bogotá (1975), Washington, D.C. and Mexico City (1975), Milan (1977) and Guri Dam, Venezuela (1987). At Center for Advanced Visual Studies, Massachusetts Institute of Technology, on Guggenheim Foundation Fellowship, 1971-2.

Wolfang Paalen (b. 1905, Vienna – d. 1959, Taxco, Mexico) Encouraged by his father to devote himself to art after early display of visual artistic aptitude, 1916; with his parents to Paris, 1920. Studied in Italy and in Berlin from 1922; in 1925 included in Berliner Secession exhibition on recommendation of critic Meier-Graefe. Painting impressionist landscapes, 1925-7; in Paris, 1926; study at Hans Hofmann atelier, Munich, 1927; at Cassis, 1928. Exhibited Paris, 1929, in Salon des Surindépendants. Introduced by Swiss sculptor Serge Brignoni to Oceanic art; visited caves at Altamira, 1933, and began works of his 'Cycladic period', based on pre-archaic Greek sculpture. From 1932 exhibited with 'Abstraction-Création' group in Paris and Switzerland. Met Max Ernst, Roland Penrose and Paul Eluard; first exhibited

with Surrealists, in London and at Museum of Modern Art, New York, 1936; solo exhibition of his work, Galérie Pierre, Paris, same year. In 1937 contributed to surrealist automatist techniques with his 'fumages' or smoke paintings; beginning of 'Totemic period', as in Totem Landscape of My Childhood. Participated 1938 in International Surrealist Exhibition, Galérie des Beaux Arts, Paris; one-person exhibition, Guggenheim-Jeune Gallery, London, 1939. Illustrated pamphlet for 1937 production of Alfred Jarry, Ubu enchainé, and Lautréamont's Oeuvres complètes (1938). Left Europe, 1939, for New York, going on to Alaska and west coast of Canada to study totemic landscape of Haida and Tlinget Indians. To Mexico late in 1939 on invitation of Frida Kahlo. With André Breton and Peruvian poet César Moro, organized International Surrealist Exhibition, Galería de Arte Mexicano, Mexico City, 1940; solo exhibition of his own work same year at Julien Levy Gallery, New York. Introduced to pre-Columbian art through friendships with Diego Rivera and Miguel Covarrubias. In 1942, with Covarrubias, founded publication Dyn; published his 'Farewell to Surrealism' in first issue. Writings for Dyn collected in Form and Sense (1945); illustrated books by Alice Rahon-Paalen and César Moro. One-person exhibitions at Peggy Guggenheim's Art of This Century, New York, 1945, and San Francisco Museum of Art, 1948. Reconciled with Breton, 1950. Returned to Europe, 1950-4; paintings of 'Telluric period' (1953) and 'Floral period' (1958). Died by suicide, 1959. Posthumous exhibitions, Mexico City, Museum of Modern Art, 1967, and Museo Carrillo Gil, 1979.

Benito Panunzi (b. 1835, ?, Italy – d. 1886, ?, Italy)

First worked as assistant to Felice Beato, who photographed in China and India, and documented Crimean War (1855-6). Panunzi arrived in Buenos Aires, 1865, opening a photographic studio and advertising his landscapes and cityscapes in local newspapers; also did portrait photography. Photographed gauchos and carriage workers; travelled to province of Pampa to photograph landscape and local inhabitants. Covered war in Paraguay, 1866; in southern Argentine region of Capilla del Señor, photographed landscape, local sheepherders and cowboys. His series of photographs of rural Argentinian inhabitants published in an album after his return to Italy, 1870.

Lygia Pape (b. 1929, Nova Friburgo, Rio de Janeiro)

Member of Frente Group, founded 1954, which espoused importance of geometry and abstraction over the recreation of nature; exhibited with group, 1954-6, beginning with first group exhibition, Galerie IBEU, Rio de Janeiro. Participated in first national exhibition of Concrete Art, Rio 1956-7; awarded second prize for printmaking. With Lygia Clark, the poet Reynaldo Jardim and others, signed 'Manifesto Concreto' of Ferreira Gullar which accompanied exhibition. Primarily a printmaker, has explored dynamics and diversfication of geometric images in series of wood engravings such as 'tecelares'. In 1958-9, collaborated with choreographer Gilberto Mota and Reynaldo Jardim on a neo-concrete ballet; published her *Book of Creation* (1959). Included in International Exhibition of Concrete Art, Zurich, 1960, and in 1967 exhibition, *Nova Objectividade Brasileira*. Has also worked in Brazilian film industry.

Félix Parra (b. 1845, Morelia, Mexico – d. 1919, Mexico City) Studied at San Carlos Academy, 1864-7, under Clavé, Rebull and de Pina. Painted historical themes, including Galileo in the School at Padua demonstrating the new astronomical theories, and his most famous canvas, the huge and theatrical Fray Bartolomé de las Casas (1876). Although much criticized, this sympathetic depiction of the Spanish friar who defended the Indians against the abuses of his countrymen fed into the indigenist nationalism of the period. A Scene from the Conquest was exhibited Mexico City 1877. In 1878, to Europe for five years; on return to Mexico City, became professor at the Academy. Decorated Sala de Cabildos del Ayuntamiento, 1890; painting for College of Guadalupe, 1897.

Amelia Peláez (b. 1897, Yaguajay, Cuba – d. 1968, Havana)

Amelia Pelaez del Casal; one of nine children of a country doctor and his wife, sister of poet Julian del Casal. First instruction in painting at age fifteen with Magdalena Peñarredonda. Moved to Havana, 1915; enrolled 1916 San Alejandro Academy, also studied with realist painter Leopoldo Romanach. In New York, 1924, studied at Art Students' League with George C. Bridgman. Study in Paris, 1927-34, on Cuban government scholarship; attended classes Grande Chaumière, in history of art at Ecole des Beaux Arts and Ecole du Louvre, and in 1930 in set design and colour theory at Académie Moderne with Russian artist Alexandra Exter. Travelled to Madrid to study Velázquez at Prado, and to see Gothic architecture in Belgium, Holland, Czechoslovakia and Germany. First solo exhibition in Europe, Zak Gallery, Paris, 1933. Returned to Havana, 1934; one-person exhibition of European work, Lyceum Society, Havana, 1935; received prize at National Salon of Art, Havana, same year. Fresco programmes for school buildings Santa Clara and Havana, 1935-6. Stay in California, 1940. Taught drawing, Havana; travelled to Mexico 1946, and to Scandinavia 1949. Worked in ceramics, 1950-3; mural for National Accounting Office, fresco for Esso Building, Havana, 1957. Book illustration included Léon-Paul Fargue, Sept Poèmes, poems of Luis Amado Blanco and Julian del Casal; work for magazines Havana and Paris, including Art

Picheta, see Gahona, Gabriel Vicente

Edouard Henri Théophile Pingret (b. 1788, St. Quentin (Aisne), France – d. 1875, St. Quentin)

Student of David and Regnault, known for genre and historical paintings and portraits; exhibited in Salon, Paris, 1810-69, received silver medal, 1824 and 1831; Chevalier, Légion d'Honneur, 1839. Active in Mexico in mid-century, painted oils of *costumbrista* subjects; exhibited paintings such as *The Water Vendor*, San Carlos Academy, 1852. His paintings on Mexican themes now in Museo Nacional de Historia, Chapultepec Park, Mexico City.

Joaquín Pinto (b. 1842, Quito - d. 1906, Quito)

Father Portuguese, mother Ecuadorean; family reduced to poverty on death of father. Joaquín Pinto displayed talent for art at an early age; studied for one year with master Ramón Vargas, later with series of artists, among them Raphael Vanegas, Andrés Acosta, Tomás Comacho and Nicolás Cabrera; watercolour study with Juan Manosalvas, trained in Rome, whose studio became gathering place for young Quito artists. Unable to obtain a grant for study in Europe, Pinto remained in Ecuador throughout his life. Excelled in languages, mastering French, English, German, Hebrew, Greek and Latin; lectured on history of art; studied mathematics and sciences. Director, Academy of Painting and Drawing, Cuenca, 1903-4; founding member of new National School of Fine Arts, Quito, 1904. In last years of life, dedicated himself to painting, notably of *costumbrista* scenes, as well as landscapes, religious subjects, and portraits.

Camille Pissarro (b. 1831, St. Thomas, Antilles – d. 1903, Paris) Son of French merchant selling European products in Dutch Antilles. Sent to France at age twelve to complete his education preparatory to entering father's business; in care of artist Savary, who taught him drawing. Work of Corot and Delacroix an important early influence; returned to St. Thomas 1852, having decided to abandon career as merchant for art. Met young marine painter, Antoine Melbye, 1853, and went to Caracas where he completed his first known works; on Savary's advice, made numerous drawings of tropical plants as well as scenes from Venezuelan life. Returned to St. Thomas and in 1855 left for Europe, settling in Paris. Several works based on memories of the Antilles, among them *Négresse portant une cruche*, and of Venezuela, as in *Place aux environs de Caracas* (both 1856). In 1870's became leading figure in French Impressionist movement.

353

Marcelo Pogolotti (b. 1902, Havana, Cuba)

Studied at the Art Students League in New York, U.S.A. and in Havana. Participated in Exposición de Arte Nuevo, Havana, 1927. First one-man show Galerie Carrefour, Paris 1938. Painted social and political subjects comparable to those of Mexican muralists. Most famous work, *Paisaje Cubano* (1933) attacked imperialist exploitation of Cuba. In 1937 he went blind; wrote several books including *El Camino de Arte* (Cuba 1985). Retrospective Museo Nacional de Bellas Artes Havana, 1986.

Cândido Portinari (b. 1903, Brodowski, Brazil – d. 1962, Rio de Janeiro)

Born on Santa Rosa coffee plantation, second of twelve children of Italian immigrant parents. After assisting itinerant artists redecorating local church, decided on career as a painter; left home at fifteen to study at National School of Fine Arts, Rio de Janeiro, until 1921. In 1928 awarded European fellowship for portrait of poet Olegario Mariano: studied Old Masters, France, Italy, Spain and England. In Rio de Janeiro, 1932, introduced by painter Foujita, became fashionable as portraitist of diplomatic community. Genre paintings of Brazilian life, controversial second prize awarded Coffee, Carnegie International Exhibition, 1935. On faculty of University of the Federal District, Rio, 1936-9. Frescos depicting regional occupations of Brazil commissioned for Ministry of Education, Rio. Submitted panels for Brazilian Pavilion, New York World's Fair, both 1938. In 1942, completed mural for Hispanic Foundation, Library of Congress, Washington, D.C., and War and Peace for United Nations, New York, 1953. Comprehensive exhibition of more than 200 works, Ministry of Education, Rio, 1939. Solo exhibition, Galérie Charpentier, Paris, 1946; participated in Venice Biennale, 1950, and exhibited intrernationally 1950s. Guggenheim National Award, 1957. Returned to Brazil, 1961.

René Portocarrero (b. 1912, Cerro, Cuba – d. 1986, Cuba)

Born in colonial quarter of Havana; between ages of eleven and fourteen, attended classes Academia de Villate y San Alejandro. Began to teach, 1938, Eduardo Abela Studio of Painting and Sculpture; appointed art teacher, Havana Prison, 1940. Influence of Spanish-Cuban baroque evident in works like *Interior* (1943); elements of fantasy related to Afro-Cuban tradition seen in *Small Devil* (1962). Awarded International Prize at São Paulo Bienal, 1963, where he showed more than 50 works; solo exhibitions include 1945 show at Julien Levy Gallery, New York, and 1965 exhibition at Museum of Modern Art, Mexico City. Also worked in ceramics, and made frescos, graphic illustrations and set designs.

José Guadalupe Posada (b. 1852, Aguascalientes, Mexico – d. 1913, Mexico City)

From a peasant family, worked as a child with his father in the fields and with an uncle in a pottery; briefly attended drawing academy under Antonio Varela. In 1870s, worked as apprentice lithographer in printshop of Trinidad Pedrozo, producing advertisements, posters and cards, and contributed satirical illustrations to Pedrozo's weekly newspaper, El Jicote. Followed Pedrozo when latter forced to move, for political reasons, to León, Guanajuato; taught lithography, 1884, in Escuela de Instrucción Secundaria, León; published lithographs in religiouseducation journal La Educación. In Mexico City, 1888, opened first shop, printing and illustrating newspaper La Patria Ilustrada. In 1889 joined Antonio Vanegas Arroyo publishing house, on whose engraving staff he remained until his death. Introduced technique of etching on zinc, 1895, used for greater part of his prolific output of an estimated 20,000 engravings. Illustrated corridos of Oaxacan poet S. Suárez; with Vanegas Arroyo made popular the calaveras, satirizing the living in terms of the dead. Along with much ephemeral work for the penny press, produced illustrations for more than 50 newspapers, among them the anti-Díaz El Hijo del Ahuizote, of political and social relevance.

Despite wide popular circulation of his work, died poor; buried by civil authorities in Cemetery of Dolores.

Vasco Prado (b. 1914, Rio Grande do Sul, Brazil)

Self-taught until 1947, when grant from French government enabled him to study in Paris, in ateliers of Fernand Léger and Etienne Hadju and at Ecole des Beaux Arts. In Brazil, 1950, co-founded Clube de Gravura, group advocating social realism, in Porto Alegre. Work, depicting customs and traditions of gauchos and herdsmen of Rio Grande do Sul prairies, exhibited Salões da Associação de Artes Plasticas 'Francisco Lisboa', 1954-60, receiving award for sculpture, 1957, and printmaking, 1960. First prize in competition for monument to Villa Lobos, 1962; acquisition prize in exhibition *Arte Riograndese do passodo e presentem* 1960; second prize for sculpture, Salon of Belo Horizonte, 1965. Solo exhibition of sculpture, Galería de Arte, São Paulo, 1965.

Arden Quin (b. 1913, Rivera, Uruguay)

Carmelo Arden Quin; attended primary and secondary schools taught by Catholic order Maristas; in 1932 began to study painting and history of art under Catalan writer and painter Emilio Sans. Met Joaquín Torres-García, 1935; in 1938 to Buenos Aires to study philosophy and law. Collaborated with group of vanguard writers and painters on review Sinesia, and in 1942 with poets Gedo Iommi and Edgard Bayley co-founded bi-monthly El Universitario. Following year, with Bayley, Gyula Kosice, Tomás Maldonado and Lidy Pratí, formed group 'Arturo' and served on editorial board of its review, later foundermember of 'Arte Concreto-Invención', and Madí movement which succeeded it; influential in creation of Madí ideas; collaborated on performances held in conjunction with Madí exhibition, French Institute, Buenos Aires, 1946, after which broke with Kosice and Madí group. In Paris, exhibited Salon des Réalités Nouvelles, 1949-56. In Buenos Aires 1956, co-founded Association of New Art with Aldo Pelligrini and others. Exhibited collages and cut-outs, 1956-71. Retrospectives of his work, Galerie de la Salle, Saint-Paul de Vence, France, 1978, Galerie Franka Berndt, Paris, 1988. Lives and works near Paris.

Alice Rahon-Paalen (b. 1916, Brittany, France – d. 1987, Mexico City)

Daughter of an academic painter; educated in Paris, began painting at seventeen in impressionist manner. In 1933, married the painter Wolfgang Paalen. Associated with Surrealists, 1930s; experimented with automatic drawing. Settled in Mexico, 1939. Paintings influenced by prehistoric and primitive art, often using unusual surface textures (sand, cement, marble mixed with colour ground). First one-person exhibition, Galería de Arte Mexicano, Mexico City, 1944; exhibited New York at Peggy Guggenheim's Art of This Century (1945), Nierendorf Gallery (1946) and Willard Gallery (1948-51). Contributed poetry and prose to Dyn, journal published in Mexico by Wolfgang Paalen early 1940s; published three volumes of poems $M\hat{e}me$ la terre (illustrated Yves Tanguy), Salier Couche (Joan Miró) and Noire animal (Wolfgang Paalen).

Vincente do Rego Monteiro (b. 1899, Recife, Brazil – d. 1970, Recife) Son of a businessman, mother a professor; in 1911 decided to become a painter. In Paris studied intermittently Académie Julien; exhibited painting and sculpture 1913 Salon des Indépendants; worked with Diaghilev's Ballets Russes. Returned to Brazil, 1914; in Rio de Janeiro, sculpted bust of Rui Barbosa, and maquette for monument to heroes of 1817 revolution. In Recife, 1918, worked on series of drawings inspired by dancer Pavlova, and conceived a ballet on indigenous legends of Brazil. Met modernists Anita Malfatti, Emiliano de Cavalcanti, Victor Brecheret. Drawings and watercolours on indigenous themes exhibited 1920, Livraria Moderna, São Paulo; his oil Negro Head among works shown in 1922 Semana de Arte Moderna, São Paulo. In Paris 1922–30,

associated with Léonce Rosenberg's Galérie de l'effort Moderne; showed in Salon des Indepéndants through 1920s; solo exhibitions, Galérie Fabre 1925, Galerie Bernheim-Jeune 1928. In 1930, included in first exhibition of Latin American Artists, organized by Joaquín Torres-García at Galérie Zack, Paris. Associated with review Montparnasse, directed by poet and critic Geo-Charles; with Geo-Charles in Brazil 1930, organized L'Ecole de Paris, first major international exhibition shown in Recife, São Paulo and Rio. During 1930s, co-directed Catholic review Fronteiras; produced documentary film on Pernambuco (Recife). Commissioned 1937 to decorate Brazilian chapel in Vatican Pavilion, International Exhibition, Paris. Founded the review Renovação, 1939, dedicated to popular education. In 1940s and 1950s, devoted more time to poetry; collaborated on First Wall of Poetry, 1948 Salon de Mai, Paris. Major exhibition of paintings and drawings, Museum of Art, São Paulo; retrospective, Museum of Contemporary Art, University of São Paulo, 1971.

Armando Reverón (b. 1889, Caracas - d. 1954, Caracas)

Only child of distinguished creole family. Raised by foster family, Valencia; health permanently impaired by typhoid contracted in childhood. First art lessons from maternal uncle, Ricardo Montilla, who had studied in New York. Enrolled, Academy of Fine Arts, Caracas, 1908; sent down for participating in strike over curriculum and awarding of scholarships, but reinstated, graduated with distinction, 1911. Awarded stipend by city of Caracas; to Spain to join painter Rafael Monasterios in Barcelona; enrolled Academy of San Fernando, Madrid, 1912-13; visit to Paris, 1914. In Caracas, 1915, joined 'Circle of Fine Arts', group of young painters committed to theory and practice of Impressionism. Decisive influence was Russian painter Nicolas Ferdinandov, who organized exhibition of Reverón's and Monasterios' works, Academy of Fine Arts, 1919, and encouraged Reverón to build a house at Macuto to which he retired, 1920. Period of near-monochrome white works, 1925-32, followed by so-called 'sepia period'; concentration on nude female figure, 1936-9, and fabrication of life-size dolls, succeeded 1940s by renewed interest in landscape, still in sepia. Work exhibited Paris 1933, at Galerie Katia Granoff; awarded first prize, list Official Salon of Venezuela, 1940; exhibited Caracas, at Taller Libre de Arte, 1949, and Venezuelan-American Center, 1950. Entered Sanatoria San Jorge, Caracas, 1953, where he died the next year. Retrospective held posthumously at Museo de Bellas Artes, Caracas, 1955; exhibition organized by Creole Petroleum Corporation at Museum of Contemporary Art, Boston, 1956, and 25th anniversary of his death commemorated by retrospective, Caracas Museo de Bellas Artes, 1979.

Diego Rivera (b. 1886, Guanajuato, Mexico - d. 1957, Mexico City) José Diego María Rivera; parents politically liberal; both teachers, mother later a midwife. Studied art San Carlos Academy, 1896-1905, under Félix Parra, José María Velasco and Santiago Rebull. Exhibited 1906 with pro-modernist group 'Savia Moderna'. To Europe, 1907, on government scholarship. In Spain, studied with Eduardo Chicharro y Agüera, copied master works in Prado; formed friendship with Ramón Gómez de la Serna. Studied with academic painter Victor-Octave Guillonet, Paris, 1909. Successful exhibition Mexico City 1911 financed return to Paris, where rejoined Mexican artists Angel Zárraga, Dr Atl, Roberto Montenegro and Adolfo Best-Maugard. Influenced by Mondrian; produced some 200 works in cubist period (1913-17); one person exhibition in Paris, Berthe Weill Gallery, 1914. Associated with Parisian avant-garde including Léger, Delaunay, Chagall, Modigliani, Picasso and Puteaux Cubists; discussions with Russian émigré artists at weekly meetings chez Matisse. Exhibited New York, 1916, Marius de Zayas Gallery; included in group exhibition. Les Constructeurs, organized by art historian Elie Faure, who became life-long friend. Visited Italy,

On return to Mexico, 1921, appointed to arts-related government post by José Vasconcelos, Minister of Education. Began mural *Creation*, National Preparatory School, 1922; co-founded Union of Technical Workers, Painters and Sculptors, and its organ, El Machete. Murals at Ministry of Education, 1922-6; in chapel, National School of Agriculture, Chapingo, 1926-7. Visit to Soviet Union, 1927, and work with 'October' group of Moscow artists; membership in Communist Party of Mexico, 1927-9. Appointed director San Carlos Academy, 1929, but resigned the next year in dispute over curriculum changes. Mural projects National Palace, Mexico City, and Cortes Palace, Cuernavaca. To U.S.A., 1930; mural at new Stock Exchange, San Francisco; retrospective exhibitions, California Palace of Legion of Honor, 1930, and Museum of Modern Art, New York, 1931. Murals for Detroit Institute of Arts, 1932; controversy over mural, RCA building, New York, for its inclusion of portrait of Lenin; mural destroyed, but later re-created for Palacio de Bellas Artes, Mexico City. No public wall commissions, Mexico, 1937-42; painting genre scenes, notably some depicting Day of the Dead, and portraits. Intercession on behalf of Leon Trotsky, who arrived in Mexico, 1937; visit of André Breton the next year, resulting in publication, 1938, of 'Manifesto: For an Independent Revolutionary Art', written by Trotsky and signed by Rivera and Breton.

Mural, San Francisco City College, 1942; began construction of pyramid-shaped 'residence-tomb', Anahuacalli, eventually to house pre-Columbian collection. Appointed to Colegio Nacional representing fine arts, 1943, and to faculty of 'La Esmeralda' (Escuela Nacional de Pintura y Escultura). In 1947, with Orozco and Siqueiros, formed Commission of Mural Paintings, as arm of Instituto Nacional de Bellas Artes. Major retrospective, Palacio de Bellas Artes, Mexico City, 1949; awarded National Prize in art by Mexican government, 1950. Last mural commission, Hospital de la Raza, 1953. To Soviet Union, 1955, at invitation of Fine Arts Academy, Moscow; also visited East Germany and Poland. Death from heart failure, San Angel, 1957; accorded official honours, Palacio de Bellas Artes, and buried in Rotunda of Illustrious Men, Mexico City. His art willed to Mexican nation.

Johann Moritz Rugendas (b. 1802, Augsburg, Germany – d. 1858, Weilheim, Germany)

Born into a family of artists; first trained under his father, Johann Lorenz Rugendas, director of Augsburg Academy of Art, known for his paintings of Napoleonic battle scenes. Attended Munich Academy where studied with Lorenz von Quaglio; painted mountain landscapes of Bavaria. In 1821, joined as artist an expedition into the interior of Brazil, organized by Baron Georg Heinrich von Langsdorff, Russian Consul-General in Rio de Janeiro. Broke with the Baron and went off to paint alone the landscape, people, animals and plants of Minas Gerais, Matto Grosso, Espíritu Santo and Bahía. In Paris 1823, met and formed lifelong friendship with Alexander von Humboldt; settling in Paris 1826, made the acquaintance of artists Gros, Vernet and Delacroix. His Voyage pittoresque au Brésil, with 100 lithographs taken from more than 500 drawings and paintings made in Brazil, published in four parts, 1827-35. Returned to America with Humboldt's encouragement, 1831; numerous drawings and watercolours made in Mexico, where visited Teotihuacán, Xochimilco and Cuernavaca and states of Morelia and Acapulco. Departed under adverse political conditions, 1833, for Chile, where he remained for 12 years, with visits to Argentina (1837-8) and to Peru and Bolivia (1842-4), drawing and painting the landscape and indigenous peoples. Left Chile 1845 for Montevideo and Buenos Aires; in Rio de Janeiro, 1847, became acquainted with Brazilian emperor Dom Pedro II, who acquired some of his works. In Europe, attempted without success to publish his work in Paris; returned to Bavaria to become court painter to Maximilian II.

Antonio Ruiz (b. 1897, Mexico City – d. 1964, Mexico City) In youth displayed inclination towards art and mechanical construction. Studied painting at National School of Fine Arts, Mexico City. In California, 1926-9, developed interest in scenography working on movie sets for Universal Studios. Returning to Mexico, devoted himself to painting the Mexican people and popular scenes, characterized by their intimate scale and rich colour, and tending increasingly towards the fantastic. Aspects of the surreal and the political combined in such works as *El Orador* (1939), shown in International Surrealist Exhibition, Galería de Arte Mexicano, Mexico City, 1940. Interest in set design continued, and particularly in children's theatre, promoted in course of cultural missions, sponsored by Mexican government, to outlying states. Also worked in Mexican film industry.

Ramón de la Sagra (b. 1798, Coruña, Spain – d. 1871, Coruña.) Studied agriculture in Madrid until 1820. Appointed director, Jardín Botánico de la Habana, 1822. Reached Havana 1823; studied plant life and agricultural potential of the island, and experimented in botany and agriculture in a new division of the botanical garden, 'Institución agrónoma', sponsored by Spanish government, 1829. While in Cuba, wrote series of scientific works and maintained contact with scholars internationally. His *Historia económica, política y estadística de la Isla de Cuba* (1831) identified numerous collections of flora, fauna and mineral-rich sites on island and included sociological studies of inhabitants. In 1835, de la Sagra returned to Paris, where published *Histoire physique, politique et naturelle de l'isle de Cuba* (1842–57), of which several volumes were devoted to botanical studies. An economist and social reformer, he also wrote theoretical tracts on economic and social issues influenced by the French socialist Pierre Proud'hon.

Antonio Salas (b. 1795, Quito – d. 1860, Quito)

A disciple of the colonial artists Bernardo Rodríguez and Manuel Samaniego, like them painted religious themes, including La Muerte de San José and La Negación de San Pedro in Cathedral of Quito. After Independence, portrayed heroes and military leaders, including Simón Bolívar, depicted in 1822 as virile liberator. Returned in 1838 to religious works, painting for Augustinian Order scenes from life of the Virgin. Progenitor of large family of artists including Ramón; son Rafael Salas became important landscape and genre painter of nineteenth-century Ecuador.

Ramón Salas (b.c. 1815 Quito, Ecuador – d. 1880, Quito) Born into famous Salas family of artists: son of Antonio (d. 1858), who had the major studio/workshop in Quito, and half-brother of Rafael, (d. 1906), one of first professors at Academy of Fine Arts in Quito. Ramón was particularly responsive to nineteenth-century taste for costumbrismo; his small watercolours depict scenes and characters of social and religious interest, often humourously.

Santaella, Pablo Livinally, see Apolinar

Andrés de Santa María (b. 1860, Bogotá – d. 1945, Brussels, Belgium) At age two, taken to London where Santa María-Hurtado family remained until 1869; then lived in Paris and Brussels for next 24 years. Studied at Ecole des Beaux Arts, Paris, from 1882, also in ateliers of Fernando Humberto, Enrique Gervex, Ignacio Zuloaga, and Eugene Prince of Sweden, and in Spain with Santiago Rusiñol. First exhibited Paris 1887 with inclusion of his work Seine Laundresses in Salon des Artistes Français and Salon des Tuileries. To Bogotá, 1893; in 1899, appointed juror for exhibition Academy of Fine Arts, a post he refused; returned to France the same year. In Bogotá again from 1904, appointed director of School of Fine Arts; founded Professional School of Industrial and Fine Arts, with curriculum including silversmithing, ceramics, and wood and stone sculpture. His own work, at this time inspired by Degas and the Impressionists, shown at Academy of Fine Arts, 1904; Teatro Colón, Bogotá, 1906; and in Exposicion del Centenario, 1910. Returned to Europe, 1911, to take up permanent residence in Brussels. Paintings of 1914-27, utilizing more colourful palette reminiscent of Van Gogh, exhibited in Paris, Brussels and Bogotá; work of late 1920s more expressionistic, using dark rich colours and dramatic chiaroscuro. Named academic correspondent, Academy of San Fernando, Madrid, 1930. Retrospective exhibitions, 1930s, in Bogotá at Colombian Academy of Fine Arts (1931), Palace of Fine Arts, Brussels (1936) and New Burlington Gallery, London (1937). Posthumous exhibition of 126 works held 1971, Museum of Modern Art, Bogotá.

Mira Schendel (b. 1919, Zurich, Switzerland – d. 1988 Saõ Paulo) Raised in Italy, moved in 1949 to São Paulo, Brazil. Began to paint, with encouragement from artist Sergio Camargo. Represented Brazil in II; Biennial of American Art, Córdoba, Argentina, 1964, in São Paulo Bienal 1963-76 and 1981, and in Venice Biennale 1968. Solo exhibitions of paintings, drawings and graphic work Museum of Modern Art, São Paulo, 1964; Signals Gallery, London, 1965; Brazilian-American Cultural Institute, Washington, D.C., 1971. Represented throughout 1970s in Panorama de Arte Actual Brasileira, Museum of Modern Art, São Paulo. First prize, Salón de Arte Moderno de El Salvador, 1953; acquisition prizes, Salon of Modern Art, São Paulo, 1963, and São Paulo Bienal, 1967.

E. F. Schute (b. in Austria, active in Brazil during the mid-19th century)

Little is known about the life of this artist who at mid-century painted the famous waterfalls of Paulo Alfonso in Northeast Brazil. His romantic conception of this landscape emphasizes the sublime character of nature in contrast to the fragility of man.

Lasar Segall (b. 1891, Vilna, Russia - d. 1957, São Paulo, Brazil) Born in a Jewish ghetto, son of a Torah scribe; at fifteen went to Berlin. Studied at Imperial Academy of Fine Arts until 1910; won Liebermann Prize that year in first exhibition, with the 'Freie Sezession'. To Dresden, 1910; attended Meisterschüle (art academy). Made the acquaintance of Otto Dix and George Grosz, joined Expressionist movement 1911-12. In Holland, 1912, painted series of works in old persons' asylum. First trip to Brazil, 1912; solo exhibitions São Paulo and Campinas, 1913, considered first modern exhibitions in Brazil. Returned 1914 to Dresden, where interned as a Russian citizen and exiled for two years to Meissen. Active in Expressionist movement, in 1919 co-founded with Otto Dix and others 'Dresden-Secession Group'. One-person exhibitions, Folkwang Museum, Hagen, 1920; Chames Gallery, Frankfurton-Main, 1921; Hall of Engravings, Leipzig Museum, 1923. To Brazil, 1923, acquired Brazilian citizenship. Works of 1923-6 on Brazilian themes exhibited Dresden, Stuttgart and Berlin. To Europe 1928, in Paris until 1932. On return to Brazil co-founded São Paulo Society of Modern Art. Paintings of Brazilian landscape done at Campos de Jordão, 1935; series on theme of suffering (Concentration Camp, War, Exodus, Ship of Emigrants), 1936-50. Represented Brazil at 1938 International Congress of Independent Arts, Paris; one-person exhibition, Renou et Colle Gallery, Paris, at that time. Exhibited 1940s New York and Rio de Janeiro; major retrospective, Museum of Art, São Paulo, 1951, and his work given special exhibition space, I and II São Paulo Bienal, 1951 and 1953. Memorial exhibition of 200 of his works, IV São Paulo Bienale, 1957, and posthumous exhibitions sponsored by Brazilian Ministry of Foreign Affairs in Venice, Paris, Barcelona, Amsterdam and Nuremberg. The Lasar Segall Museum in the artist's house officially inaugurated 1970.

Eugenio de Proença Sigaud (b. 1889, Santo Antonio de Carangola, Rio de Janeiro – d. 1979, Rio de Janeiro)

From 1921, studied drawing with Modesto Brocos at National School of Fine Arts, Rio de Janeiro; member of Núcleo Bernardelli, group of artists paying hommage to professors Rodolfo and Henrique Bernardelli of National School by maintaining rigorous dedication to technique. Also trained as an engineer and architect. Participated in Salão de Primavera, 1923; exhibited National Salon of Fine Arts from 1924. Travelled abroad, visiting Rome and Paris; returned to Brazil, 1934. In-

terested in mural painting from 1935. Work depicts social problems in classically realistic style. Bronze medal, National Salon of Fine Arts, 1936; silver medal in Modern Section, 1942, for encaustic painting, *A estatua e a Rua*. Honourable mention, Riverside Museum exhibition, New York, 1940, for *Exodo de Escravos*. Projects in years 1945–57 included architectural decoration and glass for Church of São Jorge and mural decorations for Cathedral of Jacarèzinho; also noted as printmaker and book and journal illustrator.

José Antônio da Silva (b. 1909, Salas de Oliveira, São Paulo, Brazil) Worked for many years as a rural labourer in state of São Paulo; began to paint scenes and portraits of workers in that state at age thirty-seven. First works exhibited, Casa de Cultura, São Paulo, 1946; first solo exhibition, Galeria Domus, São Paulo, 1949. Exhibited São Paulo Bienal 1951-67, receiving acquisition prize 1951, first prize 1961. Included in Venice Biennale, 1952 and 1966; Carnegie International, Pittsburgh, 1955; II Bienal Hispano-Americano, Havana, 1954; and exhibition 50 Años de Paisagem Brasileira, Museum of Modern Art, São Paulo, 1956. Autobiography, Romance de Minha Vide, published São Paulo, 1949.

David Alfaro Siqueiros (b. 1898, Chihuahua, Mexico – d. 1974, Mexico City)

Studied art, San Carlos Academy, Mexico City, and at Open Air Painting School, Santa Anita, 1911-13. Contributor to Carranzista paper La Vanguardia, 1913; served with Constitutionalist forces, 1914. In 1919, to Europe on a government grant; met Diego Rivera in Paris: enthusiasm for French modernist movements. In Barcelona, 1921, published his 'Manifesto to the Artists in America' in Vida Americana. In Mexico, 1922, worked on murals for National Preparatory School; with Rivera and others organized Union of Technical Workers, Painters and Sculptors, and edited its publication El Machete. Union organizer, 1925-30; painted during six months' internment, Taxco, 1930. First one-person exhibition, Casino Espinal, Mexico City, 1932. In Los Angeles the same year, painted murals on public and private buildings, became interested in use of industrial materials. Deported from U.S.A.; travelled to Uruguay and Argentina, 1933; experimental mural for publisher Botana in country house near Buenos Aires. Again in U.S.A., 1936, established Experimental Workshop, New York, using industrial materials and techniques and photography. To Spain, 1937, where he served as officer in Republican Army, 1937-9. Major mural projects in Mexico, Chile and Cuba, 1939-47; retrospective exhibition, Palace of Fine Arts, Mexico City, 1947. Imprisoned, 1960, for 'social dissolution'; on his release in 1964 began work on largest mural, The March of Humanity, modified before installation in Polyforum Cultural Siqueiros, Mexico City. Writings include his autobiography Me llamaban el Coronelazo (1977), Como se pinta un mural (published Havana 1985), and anthology Art and Revolution. Received National Prize for art from Mexican government, 1966, and Lenin Peace Prize from Soviet Union, 1967; major retrospectives, Mexico City, 1967, and Tokyo, 1972. Buried in Rotunda of Illustrious Men, Mexico City.

Xul Solar (b. 1887, San Fernando, Buenos Aires – d. 1963, Delta du Tigre, Argentina)

Born Oscar Agustín Alejandro Schulz Solarí, son of German-Italian immigrant parents; at sixteen, left home aboard a cargo vessel and visited Italy, Germany, England and France. In 1920, exhibited with the Italian sculptor Arturo Martini at the Galería de Arte de Milano; catalogue introduction by Emilio Pettoruti. Returned to Argentina, 1924; associated with the group 'Martín Fierro' in whose journal his work was featured. Exhibited Buenos Aires at the Salon de los Independientes, 1925, and at the Amigos del Arte, with Pettoruti in 1926 and with Antonio Berni in 1929. Formulated as early as 1925 a system of pictorial writing, 'neocriollo', based on Spanish, Portuguese, and other languages. Reflecting his study of philosophy, astrology, languages and musical notation, the work of this visionary and mystic evolved

over his lifetime: the early paintings, usually watercolour or tempera, displaying fantasy and humor; becoming after 1930 more esoteric and personal, depicting imaginary landscapes and futuristic cities, often in monochrome; the post-1960 work returned to the use of colour, but with images reduced to signs and forms. Retrospective, *Xul Solar*, 1887-1963, Musée d'Art Moderne de la Ville de Paris, 1977.

Jesús Rafael Soto (b. 1923, Ciudad Bolívar, Venezuela)

Eldest of five children in a peasant household abandoned by the father when Soto was eight; youth spent largely out of doors, in touch with Indian traditions in country along the Orinoco. At fifteen, began painting signs for Ciudad Bolívar cinema; at nineteen, won scholarship to Cristobal Rojas School of Fine and Applied Arts, Caracas, where he met Otero and Cruz-Diez. In 1947, named director School of Fine Arts, Maracaibo. First exhibition, 1949, Taller Libre de Arte, Caracas; in 1950 awarded six-month government scholarship to travel to Paris. Exhibited Salon des Réalités Nouvelles, Paris, 1951 and 1954; participated in exhibition Le Mouvement, Denise René Gallery, 1955, where interest aroused by Marcel Duchamp's optical machines in creating kinetic works not dependent on use of a motor. Further development of ideas, seen in work of Agam and Tinguely, for integration of movement in painting, 1955-9; in 1958 began his Vibration Series, with hanging elements in front of geometric structures; two kinetic murals created that year for Venezuelan Pavilion, Brussels International Exposition. Awarded Grand Wolf Prize, São Paulo Bienal, 1963; David Bright Prize, Venice Biennale, and second place at American Bienal, Córdoba, both 1964. Numerous architectural works include Volume Suspendu for Montreal World's Fair, 1967, and wall sculptures for Unesco Building, Paris (1970) and Museum of Contemporary Art, Caracas (1974). Retrospective exhibitions, Museo de Bellas Artes, Caracas, 1971, and Solomon R. Guggenheim Museum, New York, 1974.

Rufino Tamayo (b. 1899, Oaxaca, Mexico)

From a Zapotec Indian family; orphaned in 1911, moved to Mexico City, where helped an aunt sell produce in La Merced market. Enrolled in drawing classes, San Carlos Academy; met Roberto Montenegro, became partisan of cultural nationalism. In 1921, appointed chief of Department of Ethnographic Drawing, National Archaeological Museum. Visited New York, 1921, with composer Carlos Chávez; first exhibition there, Weyhe Gallery. Teaching, 1928-30, at National School of Fine Arts and at San Carlos Academy, then directed by Diego Rivera. Resided in New York, 1930-49, exhibiting at galleries of Julien Levy (1937), Valentine (1939, 1942, 1947), and Pierre Matisse (1947); worked for a time in US Works Progress Administration. Member, with Siqueiros and Orozco, of Mexican delegation to Congress of Artists, 1936. Solo exhibitions in Mexico, 1930s and 1940s; major retrospective, Palacio de Bellas Artes, Mexico City, 1948. Made frequent trips abroad in 1950s, settling in Paris, 1957. Remained active as a muralist, completing projects at Palacio de Bellas Artes, Mexico City (1952), Unesco building, Paris (1958), and Mexican Pavilion at Expo'67, Montreal. Represented in major exhibitions including Venice Biennale (1950, 1968), Carnegie International (third prize, 1952; second prize, 1955), São Paulo Bienal (Grand Prize for Painting, 1953), Documenta II, 1959. Among distinctions received are Chevalier, Légion d'Honneur, France, 1956; Guggenheim International Award, 1958; membership American Academy of Arts and Letters, 1961. Returned to Mexico, 1964. Collection of pre-Columbian art given to people of Oaxaca, 1974, for permanent display in Museo de Arte Prehispánico; Rufino Tamayo Museum of Contemporary Art opened 1981 to house his collection of Contemporary European and American art.

Tarsila, see Amaral, Tarsila do

Geraldo Teles de Oliveira ('GTO') (b. 1913, Itapecerica, Minas Gerais, Brazil)

Lived most of his life in Divinópolis, with a short stay in Rio de Janeiro where he worked in a foundry. In 1965 began to make wood sculpture, signed 'GTO', in which human figures carved within structure such as wheel, or column, reflecting his awareness of African art, as well as Brazilian popular tradition of the *ex-voto*. Included in São Paulo Bienal, 1969, 1971. Special exhibition of his work, XIII São Paulo Bienal, 1975; at Salão Global, Belo Horizonte, 1975, awarded a grant for travel to France. Represented in 1978 Venice Biennale; group exhibitions in Paris and Brussels.

Tilsa, see Tsuchiya, Tilsa

Francisco Toledo (b. 1940, Juchitan, Oaxaca, Mexico)

A Zapotec Indian, son of a shoemaker; grew up in Minatitlán region. Began art training at Taller Libre del Grabado, Mexico City. Solo exhibitions at age nineteen at Art Center, Fort Worth, Texas, and in Mexico City at Galería Antonio Souza. In Europe 1960-5; studied with engraver Stanley William Hayter in Paris. One-person exhibitions in Paris, New York, London, Geneva, Hanover and Toulouse; participated in Salon de Mai, Paris, 1963, 1964. In 1965 returned to Mexico; since 1969 has lived in Ixtopec, south-west of Oaxaca. Prints, water-colours and gouaches display a fascination with animals and with the mythology of Oaxaca; has also worked in ceramics and executed tapestry designs. Work widely exhibited internationally; participated in International Biennale of Graphics, Tokyo, 1972, and Spoleto Festival in Italy, 1973.

Joaquín Torres-García (b. 1874, Montevideo – d. 1949, Montevideo) Merchant father a Catalan immigrant; mother Uruguayan. Family returned to Catalonia 1891, where Torres-García initially studied painting and drawing with Vindarelli in Mataró, and at Academia Baixas; in 1900 entered Escuela Oficial de Bellas Artes, Barcelona. With Joan and Julio González, frequented bohemian art circles. Worked 1903-7 with architect Antonio Gaudí on stained glass windows for Sagrada Familia, Barcelona, and Cathedral in Palma de Mallorca. Frescos for Church of St. Agustin, Barcelona (with Joan González) and Church of Divine Shepherdess, Sarrià, 1908. Until 1909, taught drawing, Escola Mont d'Or. To Brussels, 1910, to decorate ceiling of Uruguayan Pavilion, International Exhibition; visited Paris, Florence and Rome, before returning to Barcelona, 1912, to paint series of murals, Saló de Sant Jordi, Palace of the Generalitat. First theoretical book, Notes sobra art, published 1913. At his villa in Tarrasa, 1914-19; designed his first wooden toys. In 1920 to New York; received support from Isabelle Whitney and exhibited with Stuart Davis at Whitney Studio Club, 1921; met Marcel Duchamp and Katherine Dreier. Returned to Europe, to Italy and then to Paris, exhibition Galerie A.G. Fabre, held 1926. Rejected by Salon d'Automne, 1928; exhibited with other refusé artists, Galerie Marck. Met Theo van Doesburg, Mondrian, Vantongerloo; with Michel Seuphor, founded review and group Cercle et Carré, which promoted first international exhibition of constructivist and abstract art. At Gallery Zak, where he had exhibited in 1928, organized first exhibition in Paris of Latin American artists. In Madrid, 1932, tried without success to form a school and museum of constructivist art. Left Spain in 1934 for Montevideo where, in 1935, he founded Asociación de Arte Constructivo, and following year published first number of Círculo y Cuadrado, primary vehicle for his theories, of which his Cosmic Monument (1938), erected in Parque Rodó, Montevideo, a visual model. His autobiography, Historia de mi vida, published 1939, and Universalismo Constructivo in 1944, same year he founded studio, the Taller Torres-García. In 1978, a fire at the Museu de Arte Moderna in Rio de Janeiro destroyed many of his paintings on temporary exhibition there, and also the portable murals he had painted (1944) for the Hospital of Saint Bois in Montevideo. Major retrospective exhibition Torres García: Grid – Pattern – Sign London, Arts Council, 1985.

Rafael Troya (1845 Ibarra, Ecuador – 1920 Ibarra)

Born in a province noted for the beauty of its lakes and valleys, Rafael Troya developed a personal conception of landscape painting. Studied with Luis Cadena who, with Rafael Salas, travelled on government grant to Rome. Troya also studied under Rudolf Reschreiter, a landscape painter trained in the naturalistic tradition of German academies. Reschreiter devoted himself to paintings of the Andean volcanos, and engaged Troya as his assistant. In 1872, Troya joined the German scientist Reiss and Stubel as draftsman on a expedition throughout the country. Troya recorded in sketches the exotic forest areas and scenes in the Andean mountains, which he later translated onto large scale canvases. His principle directive in art, 'do not destroy the forms of nature', resulted in canvases rich in meticulously detailed observation. In his idyllic views, the foreground planes are predominant with lush vegetation. Figures, usually *campesinos*, are often present gazing at the vast spectacle of nature.

Tilsa Tsuchiya (b. 1932, Lima, Peru – d. 1984, Lima)

At National School of Fine Arts, Lima, 1954-9, studied with the abstract expressionist Fernando de Szyszlo, the muralist Carlos Quizpez Asin, Manuel Zapata Orihuela, a realist painter of indigenous subjects, and the abstract painter Ricardo Grau; completed the programme with honours and a gold medal. In Paris, 1960-4, studied humanities at the Sorbonne, painting and engraving at the Ecole des Beaux Arts. Work shown at Institute of Contemporary Art, Lima, after 1959. Paintings often based on Peruvian Indian motifs, but reflecting European influences, as in 1976 series including *Myth of the Bird and Stones*, with image of single armless woman perched on tree or mountain top combining aspects of Surrealism and the artist's own mythic culture. Work chosen to represent Peru at XV São Paulo Bienal, 1979; participated in numerous group exhibitions, Europe, Mexico, USA and South America.

Juan Camilo Uribe (b. 1945, Medellín, Colombia)

First exhibited in group shows in Colombia, 1968; in 1972, awarded first prize, Salón Nacional Independiente, Bogotá, and first prize at III Salón de Arte Joven. First solo exhibition, Galería Oficina, Bogotá, 1975; began to show with group 'Los Once'. To Paris 1977, on a government grant. Exhibited in Venezuela, 1978, in *Los Novísimos Colombianos*, Museum of Contemporary Art, Caracas and *Primera Bienal del Grabado de América*, Maracaibo. Represented Colombia at São Paulo Bienal, 1977. Participated in *Proyectos*, series of exhibitions held at Museum of Modern Art, Bogotá, as forum for experimental activity in contemporary art.

Mario Urteaga (b. 1875, Cajamarca, Peru – d. 1957, Peru)

Vividly observed realistic work of this self-taught artist has been compared with that of Pancho Fierro. Exhibited, Lima, 1935, under auspices of artist Camilo Blas. Received first prize for painting, exhibition at Viña del Mar, Chile, 1937. Posthumous solo exhibition, 1976, Galería de Arte Enrique Camino Brent, Lima.

Remedios Varo (b. 1908, Angles, Spain – d. 1963, Mexico City) Youngest of three children, raised as conservative Catholic, although atheist father, a hydraulic engineer, taught her respect for science and techniques of mechanical drawing. Attended convent schools before entering Academia de San Fernando, Madrid, 1924. In Paris, 1930-2, before settling in Barcelona. In 1936 met French Surrealist poet Benjamin Péret, in Spain to fight with anarchists in Civil War; with him to Paris after fascist victory in Spain. Paintings reproduced in Surrealist magazines *Minotaure* and *Trajectoire du rêve*; participated in International Surrealist exhibitions, Paris, 1938, and Mexico City, 1940. Interested in dreams, alchemy and mysticism; with Oscar Domínguez and Marcel Jean practiced automatism in creation of *cadavres exquis*. With Péret, fled Paris after German occupation, arriving Mexico City 1942. Worked as

commercial artist, decorated furniture and restored pre-Columbian pottery, designed costumes for Chagall ballet *Aleko*. Inspired by Mexican culture steeped in magic and supernatural, began to paint full-time, 1953; some 110 works, meticulously painted from preparatory sketches, produced in last ten years of her life. First exhibition in Mexico City, at Galerie Diana, 1956, gained support of Diego Rivera, Octavio Paz and Luis Buñuel. Posthumous retrospectives, Museo de Arte Moderno, Mexico City, 1964, 1971, 1983; first major exhibition outside Mexico, New York Academy of Sciences, 1986.

José María Velasco (b. 1840, Temascalcingo, Mexico – d. 1912, Mexico City)

Son of a bourgeois couple who in 1849 moved to Mexico City. Catholic faith strengthened by early religious training at schools operated by Lancastriana Company. Left school at fifteen on death of father; enrolled in evening classes San Carlos Academy. Full-time instruction in landscape painting at Academy from 1858, under Italian painter Eugenio Landesio whose best student and friend he became; also studied botany, mathematics and physics. Appointed professor of perspective at Academy, 1868. His larger, more panoramic landscapes first painted in 1860s. In 1870s turned to photography, then to lithography, publishing Flora de los Alrededores de México (Flora of the Environs of Mexico), illustrated with lithographs and accompanying notes. In 1874, moved to northern suburb of Villa de Guadalupe, with near-by vantage point for his favourite subject, the Valley of Mexico. Appointed professor of landscape, San Carlos Academy, 1875, on resignation of Landesio. Awarded a prize at Centennial International Exposition, Philadelphia, 1876. To Europe 1889, where exhibited 78 paintings at Universal Exposition in Paris and was made a Chevalier de la Légion d'Honneur. Visited England, Spain, Italy and Germany, returning to Mexico 1890. In 1892 received highest Austrian award, the Franz Joseph Cross, and in 1893 won First Prize at Chicago World's Fair. In last years produced few large-scale works, often painting on postcards. Died at his home in Villa de Guadalupe.

Mestre Vitalino (b. 1909, Caruaru, Pernumbuca, Brazil – d. 1963, Caruaru)

Pereira do Santos Vitalino began to model small animals in clay as a child, selling them locally around his village. In the 1930s, he expanded his range of subjects to include images of local types such as bandits, soldiers, musicians and politicians. He worked in anonymity until the 1940s when he was included in the 1948 Exposição de Arte Popular in Rio de Janeiro, sponsored by the National Commission of Folklore. Mestre Vitalino influenced the popular artists Nó Caboclo and Zé Rodriquez. His sons continue to produce works on the same rural themes establishing this popular tradition.

Oswaldo Viteri (b. 1931, Ambato, Ecuador)

As a youth, displayed talent for drawing; entered Central University of Quito, 1951, to study architecture, but turned to study of art in 1954 under Dutch artist Jan Schreuder. Studied painting 1955-60 in studio of U.S. painter Lloyd Wulf: first solo exhibition 1957, Colonial Art Museum, Quito. In 1959 collaborated on crystal-mosaic mural at workshop of Oswaldo Guayasamín and mural commission for Ministry of Public Works, Quito. Returned to painting, 1960; first prize in Mariano Aguilera exhibition, 1960, 1964. Studied anthropology and folklore with Paulo de Carvalho Neto, 1961-7; appointed director of Ecuadorean Institute of Folklore, 1966. Also resumed study of architecture, completing degree in 1966 and becoming assistant dean of School of Architecture, Quito. First 'happening' performed Quito 1968; turned to medium of assemblage, incorporating objects into his canvases. Exhibited internationally in 1960s, in IV and X São Paulo Bienal (honourable mention, 1969), II Bienale of Cordoba, Argentina, 1964 (fourth prize), and 1966 Venice Biennale. In Madrid, 1968-9, began series of figurative drawings; 1972 series Multiples used rag dolls as

objects in assemblage. Also worked in lithography, sculpture and mosaics; in 1980 proposed a solar project to Guggenheim Foundation. In 1985, in Israel, participated in first Creative Workshop meeting of Latin American, Spanish and Portuguese artists; also in artist workshop programme in Chonging, China. Included in *Presencia de Siglos*, exhibition of Latin American art held in conjunction with conference of International Council of Museums, Buenos Aires, 1986. At work on a stone mosaic for Cathedral of Riobamba, Ecuador.

Pedro Weingärtner (b. 1853, Porto Alegre, Brazil – d. 1929, Porto Alegre)

Son of German immigrants; moved to Germany 1879. Studied painting Berlin, Munich, Hamburg and Karlsruhe; in Paris from 1882, studied with Adolphe Bouguereau. In 1885, enabled by subsidy from Dom Pedro II to complete his studies in Rome; remained there until 1920. Several visits to Brazil, to paint landscapes of Rio Grande do Sul such as *Vida Gaucha*, and portraits and scenes from everyday life in the area of his birth.

Alfredo Zalce (b. 1908, Pátzcuaro, Michoacán, Mexico)

Went at an early age with his parents, both professional photographers, to Mexico City. Attended San Carlos Academy 1924-29; 1931 studied lithography at San Carlos, with Carlos Mérida and others, and at the Escuela de Talla Directa. Interested in murals, first in Mexico to use coloured cement for exterior walls, at Ayotla School, Tlaxcala. Directed open-air painting school in Taxco. From 1932 appointed drawing professor for primary schools in Mexico, D.F., travelled through Mexican states with Federal Itinerant Teachers Institute; painted frescos in rural schools. In 1936 collaborated with Pablo O'Higgins, Leopoldo Méndez and Fernando Gamboa on 100 metres fresco, Workers against the War and Fascism for Talleres Gráficos de la Nación. 1933-7 member of LEAR (Liga de escultores y artistas revolucionarios); made first wood cuts. Undertook cultural missions throughout Mexico, 1935-41, working on murals and posters for public edification. Founding member of Taller de Gráfica Popular, published set of lithographs on his experience in the Yucatán (Estampas de Yucatán, 1945). Taught classes in painting and fresco, University of Mexico and at Department of Public Education's School of Painting and Sculpture. In 1948, organized art school for workers in Uruapan, Michoacán, and in 1951 founded School of Plastic Arts of Morelia, oriented towards applied arts and industrial design.

Select Bibliography

Amaral, Aracy, Tarsila: sua obra e seu tempo, São Paulo, 1986.

Arte Argentina dalla indipendenzia ad oggi 1810-1987, Rome, 1987.

Arte y tesores del Perú: pintora contemporánea, Lima, 1982.

Bardi, P.M. Profile of the New Brazilian Art, Rio de Janeiro, São Paulo, 1970.

Barker, F., et al. Europe and its Others, University of Essex, 1985.

Barragán, Elisa García, *El pintor Juan Cordero*, Universidad Nacional Autónoma de México, 1984.

Bayón, Damian (ed.), América Latina en sus artes, UNESCO, Paris, 1974.

Billeter, Erika, *Imagen de México*, Schirn Kunsthalle, Frankfurt, 1987-8.

Boulton, Alfredo, Los Retratos de Bolívar, Caracas, 1964.

Boulton, Alfredo, Historia de la pintura en Venezuela, Caracas, 1968.

Boulton, Alfredo, El Rostro de Bolívar, Caracas, 1982.

Boulton, Alfredo, El Arquetipo iconográfico de Bolívar, Caracas, 1984.

Brading, David, Roots of Mexican Nationalism, Cambridge, 1985.

Brading, David, 'Manuel Gamio and Official Indigenism in Mexico', Bulletin of Latin American Research, vol. 7, no. 1, 1988.

Breton, André, Surrealism and Painting, London, 1972.

Brotherston, Gordon, Latin American Poetry: Origins and Presence, Cambridge, 1975.

Calderón de la Barca, Frances, *Life in Mexico*, London, 1954 (1st publ. 1843).

Calzadilla, Juan, Armando Reverón, Caracas, 1979.

Casasola: Tierra y Libertad: photographs of Mexico 1900-35 from the Casasola Archives, Museum of Modern Art, Oxford, 1985.

Catlin, Stanton, & Grieder, T., Art of Latin America since Independence, Yale University Art Gallery, 1966.

Charlot, Jean, Mexican Art and the Academy of San Carlos 1785-1915, Austin, Texas, 1962.

Charlot, Jean, The Mexican Mural Renaissance, New Haven and London, 1963.

Cuadriello, Jaime, 'De la comemoración nacional a la dispersión del clasicismo', Museo Nacional de Arte, Salas de la colección permanente, México, no date.

Day, Holliday T., & Sturges, Hollister, Art of the Fantastic: Latin America 1920-1987, Indianapolis Museum of Art, 1987.

Debret, J.B., Voyage pittoresque et historique au Brésil 1816-1831, Paris, 1834-9.

Diego Rivera, Detroit Institute of Arts, 1986.

Edwards, Emily, Painted Walls of Mexico, Austin, Texas, 1966.

Escobar, Ticio, Una Interpretación de los artes visuales en Paraguay, Paraguay, 1982.

Favela, Ramón, Diego Rivera: The Cubist Years, Phoenix Art Museum, 1984.

Justino, Fernández, El Arte del siglo XIX en México, Mexico City, 1983. Fotografía latinoamericana desde 1860 hasta nuestros días, Kunsthaus, Zurich, 1981.

Franco, Jean, The Modern Culture of Latin America: Society and the Artist, London, 1970.

Frida Kahlo and Tina Modotti, Whitechapel Art Gallery, London, 1982. Gisbert, Teresa, Iconografía y mitos indígenas en el arte, La Paz, 1980.

Glusberg, Jorge, Del Pop art a la nueva imagen, Buenos Aires, 1986.

Graham, Martha, Journal of a Resident in Chile and Brazil, 1823, London,

1824.

Haiti: art naif art vaudou, Galeries Nationales du Grand Palais, Paris,

Herrera, Hayden, Frida: A Biography, New York, 1985.

Historia documental de México. UNAM, Mexico, 1984.

Honour, Hugh, The New Golden Land: European Images of America from the Discoveries to the Present Time, New York, 1975.

Humboldt, Alexander von, Voyage de Humboldt et de Bonpland, Paris, 1809-34.

Kalenberg, Angel, Seis maestros de la pintura Uruguaya, Museo Nacional de Bellas Artes, Buenos Aires, 1987.

Kosice, Gyula, Arte Madí, Buenos Aires, 1983.

Kubler, George, Studies in Ancient American and European Art: The Collected Essays of George Kubler, ed. T. Reese, New Haven & London, 1985

Latin American Spirit (The): Art and Artists in the United States 1920-1970, Bronx Museum of the Arts/Abrams, New York, 1988.

Martí, José, The America of José Martí, Selected Writings, New York, 1953.

Mexican Art, Tate Gallery/Arts Council of Great Britain, London, 1953.

Meyer, M.C., & Sherman, W.L., The Course of Mexican History, New York, 1979.

Mijares, Augusto, The Liberator, Caracas, 1983.

Modernidade: art brésilien du 20e siècle, Musée d'Art Moderne de la Ville de Paris, Paris, 1987.

Morais, Federico, Artes plasticas na América Latina, Brazil, 1979.

¡Orozco!, Museum of Modern Art, Oxford, 1980.

Orozco, José Clemente, An Autobiography, Austin, Texas, 1962.

Paz, Octavio, The Labyrinth of Solitude: Life and Thought in Mexico, New York, 1961.

Pendle, George, A History of Latin America, London, 1971.

Perazzo, Nelly, El Arte concreto en la Argentina, Buenos Aires, 1983.

Pontual, Roberto, Entre dois seculos: arte brasiliera de seculo XX na coleção Gilberto Chateaubriand, Rio de Janeiro, 1987.

Reyero, Manuel, Diego Rivera, Mexico, 1983.

Rivas, José (ed.), Bolívar el libertador: su vida, obra y pensamiento, Bogotá, 1981.

Rochfort, Desmond, *The Murals of Diego Rivera*, South Bank Centre, London, 1987.

Rodman, Selden, Where Art is Joy: Haitian Art, the First Forty Years, New York, 1988.

Rodríguez, Antonio, A History of Mexican Mural Painting, London,

Rodríguez Prampolini, Ida, *El Surrealismo y el arte fantástico de México*, Mexico City, 1983.

Rossetti, Marta, & Soares de Lima, Yone, Coleção Mário de Andrade, Universidade de São Paulo, 1984.

Serrano, Manuel, *Cien años de arte Colombiano*, Museo de Arte Moderno de Bogotá, 1985.

Siqueiros, David Alfaro, Art and Revolution, London, 1975.

Stastny, Francisco, Las Artes populares del Peru, Madrid, 1981.

Stephens, John, Incidents of Travel in Yucatán, New York, 1843.

Surrealistas en México, Los, Museo Nacional de Arte, Mexico, 1986.

Tamayo, Rufino: 70 años de creación, Museo de Arte Contemporáneo Internacional Rufino Tamayo, Mexico City, 1987.

Tibol, Raquel, Diego Rivera: arte y política, Mexico, 1978.

Twenty Centuries of Mexican Art, Museum of Modern Art, New York, 1940

Tyler, Ron (ed.), *Posada's Mexico*, Fort Worth & Washington, 1979. Villoro, Luis, *Los Grandes Momentos del indigenismo en México*, Mexico,

Wolfe, Bertram, The Fabulous Life of Diego Rivera, London, 1968.

Zannini, Walter, História geral do arte no Brasil, São Paulo, 1983.

Photographic Credits

The publishers are grateful for permission to illustrate the work of artists whose copyright is represented by DACS.

© DACS 1989: Jean Arp, Fernando Botero, Alexander Calder, Wifredo Lam, Roberto Matta Echaurren, Rufino Tamayo, Joaquín Torres-García.

The publishers have made every effort to contact all holders of copyright works. All copyright holders we have been unable to reach are invited to write to the publishers so that a full acknowledgment may be given in subsequent editions.

The publishers wish to thank the owners of works reproduced in this catalogue for kindly granting permissions and for providing photographs.

Photographs have been supplied by owners and by those listed below.

Photographs of the Mexican murals have been provided by the Instituto de Investigaciones Esteticas and Dawn Ades.

Photographs from Mexican public and private collections (except murals) are by Salvador Lutteroth/Jesús Sánchez Uribe except for those credited to Lourdes Almeida/Gérardo Suter, Banco Nacional de México S.N.C., John Cass, Galeriá OMR, Rudolf Nagel, Photographer's Gallery London, Armando Sales, John Webb, Carlos Ysunza Bañuelos.

Lourdes Almeida/Gérardo Suter 7.2, 7.3, 7.7, 7.14, 9.16, 9.17, 10.18, 10.20; Jorge Barrios Suárez 1.3, 1.4, 1.9, 1.10, 3.16, 3.17; Guy Brett 12.27, 12.39; Geremy Butler 3.56-9; Giuseppe Carlucci 12.66; John Cass 3.41, 3.107, 10.6, 10.8, 10.12, 12.25, 12.55, 12.56; CINIP-GAN 13.10; Mauricio Cirne 12.40; Mauricio Cirne/Lygia Pape 12.41-51; A. C. Cooper 10.42; Humberto Cordechio CINAP-GAN 3.101; Henry E. Corradini 12.20; D. James Dee 6.32, 6.33, 6.34, 11.14; Joseph Fabry 12.6; Rômula Fialdini 6.15, 8.20, 9.27, 9.28; Galeriá OMR 13.8; Carlos German Rojas CINAP-GAN 6.38; Daniel Giannoni 1.13, 1.20, 2.16, 3.70-3, 10.47; Government Art Collection 3.4; Luiz Hossaka 3.44, 3.51, 6.16, 9.25; Courtesy of The Indianapolis Museum of Art 10.43; Jaroslav Jerábek 4.2, 4.3, 4.4, 4.7, 4.16; Ardilay Lleras 13.27; Gabriele Mahn 11.13; Robert E. Mates 10.3; Pedro Maxim 12.10, 12.11, 12.19, 12.24; Don Myer 10.41; Rudolf Nagel 1.24; Paula Pape 12.68; Photographer's Gallery, London 10.4, 10.10, 10.11; Eduardo Quintana 1.5; Miguel Rio Branco 12.70; Sotheby's New York 3.11; Armando Sales, Portugal 12.61, 12.62, 12.65; Antonio Ugarte 13.23; Andreas Valentin 12.29, 12.34, 12.35, 12.36, 12.37, 12.38; John Webb 10.7, 10.9, 10.13; Sarah Wells 10.15; Carlos Ysunza Bañuelos 3.92, 9.15, 13.20; Sergio Zalis 12.30, 12.31, 12.32; Gerson Zanini 9.26.

		·	
	•		
		· · · · · · · · · · · · · · · · · · ·	
•			